The Royal City of Susa

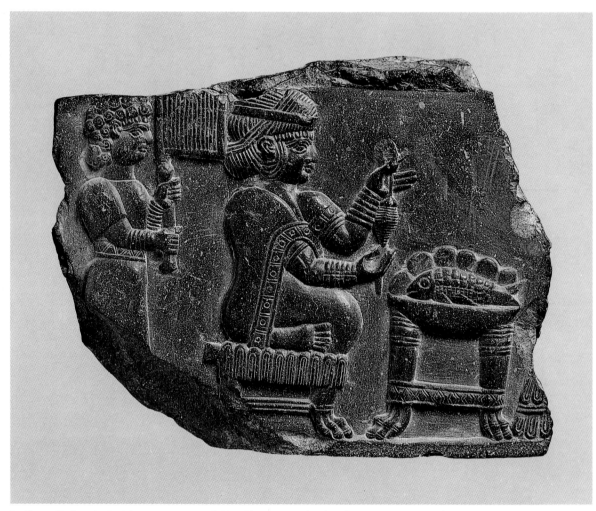

La fileuse (Lady spinning), bitumen compound, Neo-Elamite period, 8th–7th century B.C.; Number 141

The Royal City of Susa

ANCIENT NEAR EASTERN TREASURES IN THE LOUVRE

Edited by

PRUDENCE O. HARPER, JOAN ARUZ, AND FRANÇOISE TALLON

THE METROPOLITAN MUSEUM OF ART, NEW YORK

Distributed by Harry N. Abrams, Inc., New York

This volume is published in conjunction with the exhibition *The Royal City of Susa: Ancient Near Eastern Treasures in the Louvre* held at The Metropolitan Museum of Art, New York, from November 17, 1992, to March 7, 1993.

The exhibition is made possible by the Shumei Family.

It has been organized with the cooperation of the Musée du Louvre.

Additional support has been provided by Linda Noe Laine, by the National Endowment for the Arts, and by an indemnity from the Federal Council on the Arts and the Humanities.

The exhibition catalogue is made possible by a generous grant from The Hagop Kevorkian Fund.

Published by The Metropolitan Museum of Art, New York

JOHN P. O'NEILL, *Editor in Chief*

RUTH LURIE KOZODOY, *Editor*

ABBY GOLDSTEIN, *Designer*

PETER ANTONY, *Production*

Photographs of the catalogued objects by Oi-Cheong Lee and Joseph Coscia, Jr., The Photograph Studio, The Metropolitan Museum of Art, except Numbers 109 and 169 by Service de Restauration des Musées de France; Numbers 105, 106, and 107 detail by John Tsantes, Arthur M. Sackler Gallery, Smithsonian Institution; and Numbers 39, 41, and 107. For a complete list of illustration credits, see page 316.

Maps by Wilhelmina Reyinga-Amrhein
Drawings of the sealings Numbers 18, 21, 22, 23, 47, 76, 187, and 188 by Jo Ann Wood
Translations from the French by Gila Walker, except Conservation Report and Annie Caubet's Preface by Chantal Combes

Typeset by Trufont Typographers, Inc.
Printed and bound by Arti Grafiche Motta, S.p.A., Milan

Jacket: *Guard*, glazed brick, Achaemenid period, late 6th century B.C.; Number 155

LIBRARY OF CONGRESS CATALOGING-IN-PUBLICATION DATA

Musée du Louvre.
The Royal city of Susa : ancient Near Eastern treasures in the
Louvre / edited by Prudence O. Harper, Joan Aruz, and Françoise Tallon.
p. cm.
Exhibition catalog.
Includes bibliographical references and index.
ISBN 0-87099-651-7.—ISBN 0-87099-652-5 (pbk.)—ISBN 0-8109-6422-8 (Abrams)
1. Art, Ancient—Middle East—Exhibitions. 2. Art—Middle East—
Exhibitions. 3. Musée du Louvre—Exhibitions. I. Harper,
Prudence Oliver. II. Aruz, Joan. III. Tallon, Françoise.
IV. Metropolitan Museum of Art (New York, N.Y.) V. Title.
N5336.F8P36 1992
709'.35—dc20 92-28330
 CIP

CONTENTS

FOREWORD

The antiquities found during the French excavations at Susa over the last hundred years, which are now in the Louvre, include some of the masterpieces of ancient Near Eastern art. A selection of these objects comes to the Metropolitan Museum under fortuitous circumstances: a loan exhibition, initiated by our Department of Ancient Near Eastern Art, is taking place while the great collection of ancient Near Eastern art at the Louvre undergoes a comprehensive reinstallation. In a joint undertaking by the curatorial departments of Near Eastern art and archaeology and the conservation staffs of the Louvre and the Metropolitan Museum, Elamite and Mesopotamian works found at Susa were restored and photographed in both institutions preparatory to their display in New York. After the exhibition the antiquities will return for permanent installation in new galleries prepared for them in Paris.

As the art of the ancient Near East takes a significant place in both public and private collections and becomes better known to the general public as well as to students, visitors to the Museum have sought to familiarize themselves with the cultures that developed in this part of the Asian continent. The current exhibition and catalogue are a response to that growing interest and curiosity.

Susa's location in southwestern Iran between the kingdoms and states of Mesopotamia to the west and the highland powers of inland Iran to the east contributed to the city's importance, several thousand years ago, as a strategic intercultural center and a royal seat of both Elamite and Persian Achaemenid kings. The works in the exhibition were chosen with the intention of illustrating major cultural and historical developments as well as some of the extraordinary technical and artistic achievements of ancient man.

The authors of this catalogue, both American and French, bring to its readers the current state of knowledge in the field. Much has been learned since the earliest excavations of Jacques de Morgan and Roland de Mecquenem in the late nineteenth and early twentieth centuries. Nevertheless, much credit belongs to those pioneers in archaeological investigation and to the achievements of the Délégation Scientifique Française en Perse, established by the French government in 1897.

A great many people have contributed to making this exhibition and its catalogue possible. We are grateful to all of them and especially to Prudence O. Harper for her dedicated coordination of the entire effort.

As always, an exhibition of this magnitude could not have been realized without important financial assistance. We are, therefore, extremely indebted to the Shumei Family for its generous endorsement of this exhibition and to The Hagop Kevorkian Fund for its support of the accompanying catalogue. Additional funding was provided by the National Endowment for the Arts and by an indemnity from the Federal Council on the Arts and the Humanities. Finally, Linda Noe Laine granted further support for this project in loving memory of her parents, Governor and Mrs. James A. Noe of Monroe, Louisiana.

PHILIPPE DE MONTEBELLO
Director
The Metropolitan Museum of Art

PREFACES AND ACKNOWLEDGMENTS

*I*deas for an exhibition come from many different sources. In this case, recent archaeological fieldwork and art-historical research, as well as the anticipated reinstallation of the Louvre's superb collection of ancient Near Eastern art, all served as catalysts. The idea, which took shape in 1989, soon became a proposal to the Louvre that a significant group of antiquities excavated by French archaeological missions at Susa, in southwestern Iran, come to the Metropolitan Museum as a special exhibition. The loan would bring to this country, for the first time, a wide range of works of art made in many parts of the ancient world over a period of some 3500 years.

It was with few reservations that I approached Annie Caubet, head of the Département des Antiquités Orientales, with this proposal. The relationship between the departments of ancient Near Eastern art of the Louvre and the Metropolitan Museum had always been a close one. During Vaughn Crawford's tenure as curator at the Metropolitan, Director Thomas P. F. Hoving and the Direction des Musées de France brought together fragments of a major Mesopotamian work of art that is now on display alternately in the two museums: the head of the ruler Ur-Ningirsu (ca. 2100 B.C.), owned by the Metropolitan Museum, was joined to the body, in the collection of the Louvre. In recent years the collaborative relationship has been continued by Pierre Amiet of the Louvre, whose meticulous analysis of the vast collection of works of art excavated at Susa was one of the chief sources of inspiration for this exhibition.

With the benefit of studies by M. Amiet and of modern archaeological research as carried out at Susa by the distinguished French archaeologist Jean Perrot and his teams, we can now reconstruct with greater accuracy the history and culture of Elamite and Achaemenid Iran. To present this new knowledge through the works of art excavated at Susa and pre-

served in the Louvre has been the object of this exhibition and its accompanying catalogue.

Continuously occupied for almost five thousand years, Susa was destroyed and pillaged more than once by avenging armies; consequently, reconstruction of the archaeological record is difficult. Opinions differ concerning Elamite chronology, culture, and language, and this diversity is to some extent reflected in the present catalogue, written by a number of French and American scholars. Many of the authors worked at Susa with the archaeologists Roman Ghirshman and Jean Perrot in the 1960s and 1970s and are specialists who have devoted considerable time to analysis of the structures and artifacts excavated there.

The curatorial staffs of the departments of ancient Near Eastern art of both the Metropolitan Museum and the Louvre have directed their attention to questions of iconography and style, of form and purpose, in a detailed consideration of the objects in this catalogue. Their work has been complemented by the technical examination and analysis of many of the works of art coordinated by Brigitte Bourgeois, curator of the Service de Restauration des Musées de France, and other scientific advisors who are named below and in the catalogue text. In a unique collaborative effort between the two museums, some of the monuments were studied, restored, and cleaned in New York by Jean-François de Lapérouse, Objects Conservator for Near Eastern antiquities at the Metropolitan Museum.

In addition to members of the Metropolitan Museum's Department of Ancient Near Eastern Art, American contributors to the catalogue include: Elizabeth Carter and Matthew Stolper, authors of a definitive study of the historical and archaeological sources for Elam; Frank Hole, whose writings have given definition to the life and society of Susa in the earliest periods, particularly as they are reflected in the mass

burials and associated ceramics from the early cemetery; Holly Pittman, specialist on the glyptic materials excavated at Susa and Malyan (ancient Anshan); and Suzanne Heim, whose work for her dissertation on Elamite glazed materials led her to attempt the reconstruction of the plan of the sacred structures at Susa that appears in this catalogue.

The contributions of French colleagues are described below by Annie Caubet. These scholars brought expertise and focus to a variety of subjects, making the catalogue both current and comprehensive—a reflection of life and art at Susa and in the greater Near Eastern world.

Joan Aruz and I shared the scholarly editing of the catalogue with Françoise Tallon of the Louvre, who coordinated the contributions written and translated in Paris and then edited, reviewed, and corrected the catalogue texts while she was an Andrew W. Mellon Fellow here in New York. Holly Pittman was our chief advisor throughout, reviewing the manuscripts at various stages, and Matthew Stolper patiently responded to numerous queries concerning the ancient historical sources.

Many people participated in the preparation of this volume's final text. We are particularly grateful for editorial assistance from Megan Cifarelli, Norbert Schimmel Fellow, and Kim Benzel, Curatorial Assistant in the Department of Ancient Near Eastern Art. Robin Menczel, Senta German, and Arthur Tobias checked footnotes, and Kim Benzel collected comparative photographs. Cynthia Wilder coordinated various aspects of the publication.

Translations from the French were almost all done in Paris by Gila Walker, with additional translation done by Chantal Combes. Oi-Cheong Lee and Joseph Coscia traveled to Paris to take most of the photographs published here, which give ample evidence of their skill and concern for the objects. They worked with the support and direction of Barbara Bridgers, Manager of the Photograph Studio of the Metropolitan Museum. Drawings of the sealings were made by Jo Ann Wood. Catalogue and exhibition maps were made by Wilhelmina Reyinga-Amrhein.

Ruth Kozodoy was the expert editor of the catalogue. She was assisted by Joanna Ekman, Georgette Felix, Joanne Greenspun, Joan Holt, Kathleen Howard, and Mary Alice Rogers. Peter Antony ably directed the book's production, and Abby Goldstein is responsible for its elegant design. Greg Kaats, Steffie Kaplan, and Russ Kane were the mechanical artists. Arthur Tobias checked and assembled the bibliography, to-

gether with Robin Menczel and Jean Wagner. The index was compiled by Henry Engel. Keyboarding was skillfully performed by Mary Smith, assisted by Susan and Carol Birnbaum. The proofreaders were Jacolyn Mott and Carol Saltus.

The production of a major scholarly catalogue is a complex undertaking, and the editors are particularly grateful to John P. O'Neill, Editor in Chief, and Barbara Burn, Executive Editor, for their enthusiastic support of and high expectations for this publication. Anne de Margerie, director of publications for the Réunion des Musées Nationaux, shared this enthusiasm and is responsible for the translation into French and sale of the catalogue in Paris.

At an early stage in the planning of the exhibition, substantive consultations were held in Philadelphia with the Director of the University Museum, Robert H. Dyson, Jr., and Professors Ezat Negahban and Holly Pittman. These discussions helped us to formulate and define the exhibition. Here in New York a large number of people also made significant contributions. Particular thanks are due Michelle Marcus, who conceived the exhibition's graphic displays and text panels, sifting through a tremendous amount of material in order to make this exhibition accessible to the general visitor and place Susa in an understandable historical and cultural context. Dr. Marcus was ably assisted by Kim Benzel. Jeff Daly, head of the Museum's Design Department, brought to the exhibition his many skills and expertise. Working with him were Michael Batista and Barbara Weiss. The lighting was designed by Zack Zanolli.

Pierre Rosenberg, Conservateur général du Patrimoine chargé du Département des Peintures at the Louvre, has our most sincere thanks for agreeing to the Louvre's restoration and loan of the monumental paintings of Jules-Georges Bondoux that are displayed in the exhibition and published in this catalogue. Vincent Pomarède, Conservateur for the Département des Peintures, made it possible for these illustrations of the site of Susa during the early excavations to be brought to New York. Through Nicole Chevalier, archivist of the Louvre's Département des Antiquités Orientales, we met Mme. Étienne Pillet, who most generously acceded to our request to be allowed to exhibit and publish four watercolors painted at Susa by Maurice Pillet in 1913. Agnès Spycket, chargée de Mission, Département des Antiquités Orientales, made available to us her marvelous photographs taken at Susa, one of which has been mounted at the entrance to the exhibition. Other views of rock-cut monuments in

Iran were generously lent for the exhibition by L. and C. Bier.

Although the focus and substance of this exhibition are the antiquities excavated at Susa, a few other works of exceptional art-historical and historical importance were included and came from other sources: the British Museum, the Collection of Robin B. Martin on loan to the Brooklyn Museum, the Cincinnati Art Museum, and our own collection here at The Metropolitan Museum of Art. We acknowledge the loan of these objects with gratitude.

When this exhibition was first conceived, Annie Caubet had just taken charge of the Louvre's Département des Antiquités Orientales, following the retirement of Pierre Amiet. I am grateful for her valuable contributions and her careful attention to every aspect of this project. Our department is particularly indebted to the staff of the Département des Antiquités Orientales. They developed the project with us, gave us access to archival materials that were vital for the success of the exhibition, and contributed extensively to the catalogue. Their expert collaboration, good humor, patience, and courtesy during our many visits to Paris have, in a real sense, made this exhibition and this catalogue possible.

PRUDENCE O. HARPER
Curator
Department of Ancient Near Eastern Art
The Metropolitan Museum of Art

The exhibition taking place at The Metropolitan Museum of Art and documented in this catalogue grew out of an exceptional set of circumstances. Normally the Louvre would not loan such ancient, rare, and fragile works of art as these, nor would it allow the objects to travel across the Atlantic. However, the Near Eastern collection of the Louvre is being completely reinstalled—for the first time since 1945—in connection with the Grand Louvre project, and a large exhibition on the archaeological excavations at Susa, planned to coincide with the temporary closing of the Louvre galleries, was organized by the Metropolitan Museum in New York.

From the very beginning of their collaboration, the ancient Near East departments of the Louvre and of the Metropolitan Museum made the decision to focus on the recent research on Susa and Elam, an archaeological domain well represented at the Louvre, while simultaneously working to enhance a general understanding of this heritage. The antiquities from Susa make up more than a third of the Louvre's entire collection, accounting for about thirty thousand inventoried items. Quantitative strength goes hand in hand with the very great intrinsic value of the works, which is readily apparent from a reading of this catalogue.

The discoveries made at Susa are vital to an understanding of the entire ancient Near East. For example, Akkadian monuments unearthed at Susa illustrate a crucial moment in the history of Mesopotamia that would otherwise be known to us almost solely from texts. The archaeological heritage retrieved at Susa is now part of an international body of knowledge and includes famous works reproduced in textbooks all over the world, such as the Law Code of Hammurabi, the Naram-Sin stele, and the frieze of the Achaemenid archers, or guards.

The archaeological exploration of Susa is closely associated with the beginning and subsequent development of Near Eastern studies. Our understanding, appreciation, and thus, preservation of this heritage undoubtedly rest upon the sometimes heroic efforts of the nineteenth-century pioneers of archaeology, who made it possible for the peoples of western countries to discover civilizations that until then had been known only through the Bible.

This New York exhibition reflects the impact of recent archaeological and textual research on our interpretation of the works of art themselves. The exhibition also pays well-deserved homage to all members of the international scholarly community who have contributed to a widening of knowledge about the ancient Near East through their work on the site of Susa.

The history of Iran would not be known as it is today without the work carried out at the Louvre by Pierre Amiet, following that of Louis Le Breton. M. Amiet wrote the first comprehensive history of the land of Elam, detailing the role of Susa as a center of international trade. That he inspired many students and col-

leagues is demonstrated in studies made by Françoise Tallon on metals, Agnès Spycket on terracotta figurines, and Odile Deschesne on bitumen compound. The development of archeometry and advances in the environmental sciences and in physical chemistry laboratory facilities have helped make possible a greatly enlarged understanding of the techniques and materials of these ancient works.

Finally, from the very beginning, the New York exhibition was linked to a systematic restoration campaign (see the Conservation Report by Brigitte Bourgeois in the Technical Appendix). Part of this restoration was made possible by a gift from Dr. and Mrs. Raymond R. Sackler through the French-American Foundation. The remaining responsibility was jointly borne by France and the Metropolitan Museum. We hope that the New York exhibition will contribute to the preservation and better understanding of an artistic and historic treasure that is part of the heritage of all peoples.

This exhibition and its catalogue were made possible by the work of a great many people. Our gratitude to all of them is profound.

The authors of this catalogue in France, who read and commented on each others' research relating to the project, are Pierre Amiet, Béatrice André-Salvini, Agnès Benoit, Brigitte Bourgeois, Annie Caubet, Nicole Chevalier, Odile Deschesne, Agnès Spycket, and Françoise Tallon. We thank the following scholars who also contributed observations: Olivier Callot, Jacques Connan, Alek Kaczmarczyk, Audran Labrousse, Florence Malbran, and François Poplin.

Valuable organizational help within the Département des Antiquités Orientales at the Louvre was provided by Bernadette Contour, Aleth Echalier, Geneviève Teissier, and Isabelle Laferrière. Photographic documentation was carried out by Sylvie Gautier, Isabelle Laferrière, Patricia Kalensky, and Valérie Matoian. Actively involved in the project at the Service de Restauration des Musées de France, filière Archéologie, were Jeanne de Bremond D'Ars, Florence Geslin, Marie-Ange Potier, and Sylvie Watelet.

We are grateful to the institutions and individuals who conducted the following scientific examinations and analyses. At the CEBTP (Centre Expérimental de Recherches et d'Études du Bâtiment et des Travaux Publics)—A. Bouineau and B. Chagneaud: ultrasound measurements of the Naram-Sin stele. At Elf-Aquitaine's Direction Exploration, Centre Scientifique et Technique—Jean Feger and Jacques Conan: analysis of bitumen. The Laboratoire d'Archéologie des Métaux, Nancy: X-radiography of bronzes. At the Laboratoire de Recherche des Musées de France—Anne Bouquillon and Guirec Querre: petrography; France Drilhon (with the collaboration of SGS Qualitest): gamma-radiography of the statue of Napir-Asu and the Middle Elamite brick panels; Loïc Hurtel and Michel Menu: spectrometry. At the Muséum National d'Histoire Naturelle—François Poplin: identification of ivory and shell. Professor Lorenzo Lazzarini, University of Rome "La Sapienza": consultation on the Naram-Sin stele and analyses of previous treatments. At the BRGM (Bureau des Ressources Géologiques et Minières)—J.-L. Boulmier: porosity study of the Naram-Sin stele. At the IFROA Laboratory (Institut Français de Restauration des Oeuvres d'Art)— P. Ausset: salt content in the Naram-Sin stele.

Conservation and restoration of the works was coordinated by the Département des Antiquités Orientales at the Louvre and the Service de Restauration des Musées de France, filière Archéologie, headed by Brigitte Bourgeois. The following people performed restorations. Martine Bailly: ceramics and terracotta figurines. Béatrice Beillard: ceramics and terracotta figurines, Middle Elamite and Achaemenid bricks. Didier Besnainou: Naram-Sin stele. Atelier de restauration Marbrerie-Sculpture, Direction des Musées de France: stone sculpture (the monuments of Puzur-Inshushinak). Fabienne Dall'ava: ceramics, terracotta figurines, Middle Elamite and Achaemenid bricks. Pascale Klein: unbaked clay head; research program on unbaked clay sculpture. Laboratoire d'Archéologie des Métaux, Nancy: bronze sculpture (*sit shamsi*, statue of Napir-Asu). Angélique Laurent: jewelry. Juliette Levy: ivory and shell. Marie-Emmanuelle Meyohas: research program on bitumen compound. Véronique Motte and Bernard Le Huche: reconstruction of Middle Elamite brick panels. Paolo Nadalini: ceramics, cuneiform tablets, and sealings. Caroline Parrot-Grailhon: Middle Elamite bricks. Véronique Picur: stone sculpture, including the Naram-Sin stele; Middle Elamite and Achaemenid bricks; research program on bitumen and unbaked clay sculpture.

Photographic documentation was carried out by Pierre-Yves Boucharlat, Anne Chauvet, Gérard Dufresne, Christian Larrieux, and Joël Requile. Transportation was provided by Maison Chenue.

ANNIE CAUBET
Conservateur général
Département des Antiquités Orientales
Musée du Louvre

NOTE TO THE READER

Because the languages of the ancient Near East are incompletely understood, scholars do not entirely
agree on their transcription. In this catalogue, names are generally spelled following the
most commonly used transcriptions.
Most dates in this volume are approximate. Dates provided for a ruler give the time of the
individual's known activity and do not necessarily represent either a life span or the
duration of a reign.
The chronology for Elam and Mesopotamia presented here is based on: Stolper, 1984; J. A.
Brinkman, "Appendix: Mesopotamian Chronology of the Historical Period," in A. L. Oppenheim,
Ancient Mesopotamia, rev. ed. (Chicago, 1977), pp. 335–48; and Vallat, 1990.

The Royal City of Susa

SUSA IN THE ANCIENT NEAR EAST

Ancient Susa lay at the northwestern edge of the Khuzistan plain in the southwest of Iran. The region is an extension of the Mesopotamian plain and is linked to the highlands of the adjacent Zagros Mountains by the Karun, Diz, and Karkheh rivers. These rivers flow down from the mountains and into the confluence of the Tigris and Euphrates rivers, called the Shatt al-Arab, which empties into the Gulf. Blazing hot in the summer (with mean temperatures of over 100 degrees Fahrenheit) and temperate in the winter, this land was well watered and fertile, and from the late sixth millennium B.C. onward its northern part had been settled by farming and livestock-raising peoples. More than one thousand years after the appearance of those first permanent villages Susa was founded, in the northwest corner of the plain on the banks of a small stream called the Shaur. The site was occupied more or less continually from about 4000 B.C. until the 13th century A.D., when it was abandoned after the Mongol conquest. The ruins of Susa became a prominent local landmark rising some 120 feet above the flat alluvial surrounding lands. A shrine, built at the foot of the mound along the river, marks a spot thought to be the tomb of Daniel.

THE NEAR EAST

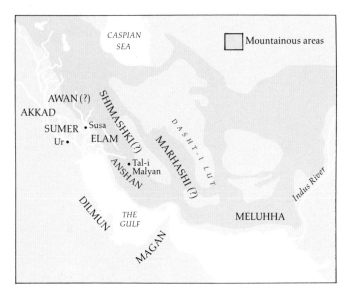

Probable locations of ancient states

Figure 1. Map of the Near East

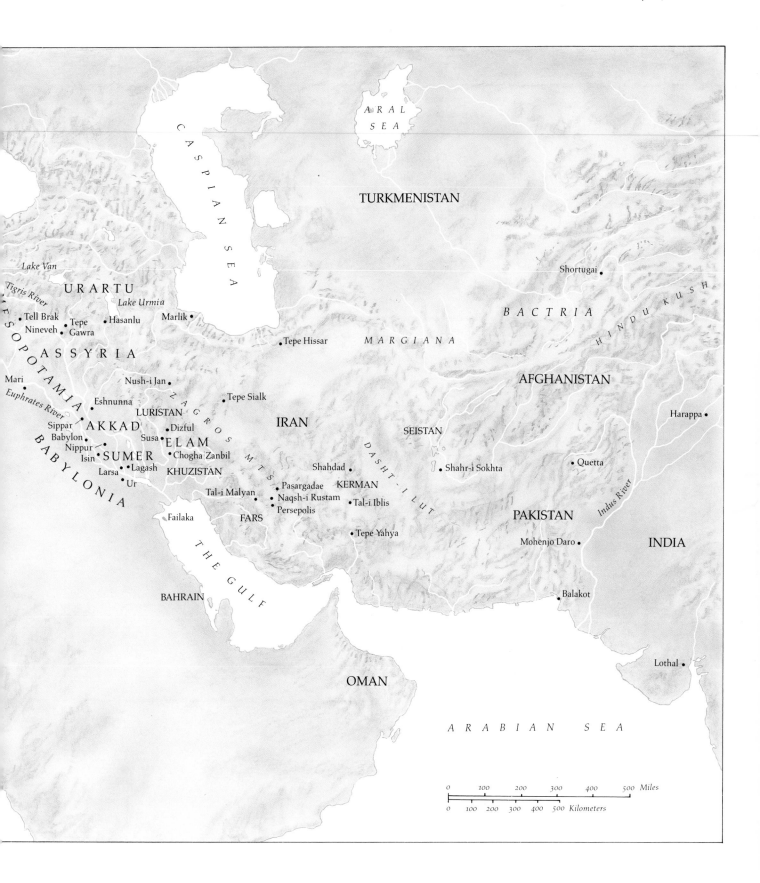

ARAL
SEA

TURKMENISTAN

CASPIAN SEA

Shortugai

Lake Van

URARTU

BACTRIA

HINDU KUSH

Tigris River

Lake Urmia

Tell Brak Tepe Hasanlu Marlik
Nineveh Gawra

Tepe Hissar

MARGIANA

ASSYRIA

AFGHANISTAN

MESOPOTAMIA

Nush-i Jan

ZAGROS

Mari

Tepe Sialk

Euphrates River Eshnunna

LURISTAN Dizful

IRAN

SEISTAN

Harappa

Sippar AKKAD Susa

Babylon
Nippur Isin SUMER ELAM Chogha Zanbil
Larsa Lagash KHUZISTAN
Ur

MTS

Shahdad

Shahr-i Sokhta

Quetta

KERMAN

DASHT-I LUT

BABYLONIA

Tal-i Malyan Pasargadae
Naqsh-i Rustam
Persepolis Tal-i Iblis

Failaka

FARS

Tepe Yahya

PAKISTAN

Indus River

INDIA

THE GULF

Mohenjo Daro

BAHRAIN

Balakot

OMAN

Lothal

ARABIAN SEA

| 0 | 100 | 200 | 300 | 400 | 500 | Miles |

| 0 | 100 | 200 | 300 | 400 | 500 | Kilometers |

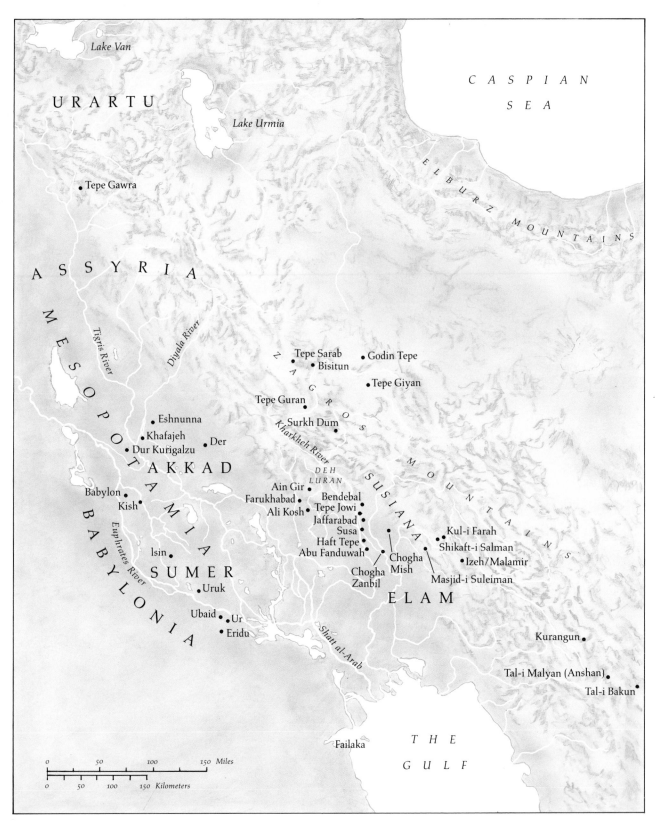

Figure 2. Mesopotamia and western Iran

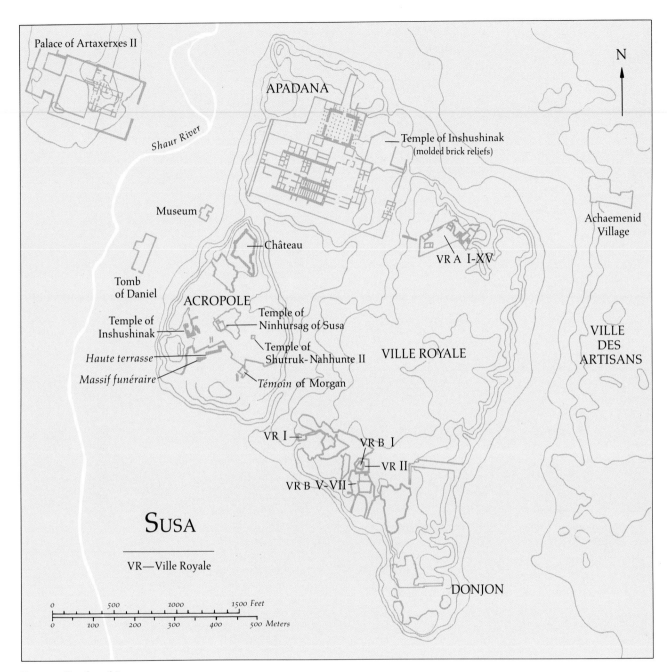

Palace of Artaxerxes II

Shaur River

N

APADANA

Temple of Inshushinak
(molded brick reliefs)

Museum

Château

VR A I–XV

Achaemenid
Village

Tomb
of Daniel

ACROPOLE

Temple of
Ninhursag of Susa

VILLE
DES
ARTISANS

Temple of
Inshushinak

Temple of
Shutruk-Nahhunte II

VILLE ROYALE

Haute terrasse

Massif funéraire

Témoin of Morgan

VR I

VR B I

VR II

VR B V–VII

SUSA

VR—Ville Royale

| 0 | 500 | 1000 | 1500 Feet |

| 0 | 100 | 200 | 300 | 400 | 500 Meters |

DONJON

Figure 3. Site plan of Susa

C H R O N O L O G Y

ELAM

DATE B.C.	ARCHAEO- LOGICAL PERIOD	HISTORICAL PERIOD	DYNASTY AND RULER
4000	Susa I	PREHISTORIC	
3500	Susa II	PROTOLITERATE:	
3100	Susa III	PROTO-ELAMITE	
2700	Susa IV	OLD ELAMITE	
2500			
2350			AWAN DYNASTY
			Eshpum, governor of Elam (ca. 2260)
			Epirmupi, governor of Susa, viceroy of Elam
			Puzur-Inshushinak, viceroy of Elam, last king of the dynasty of Awan (ca. 2100)
2000			SHIMASHKI DYNASTY
			Kindattu (ca. 2005)
			Idaddu I
			Tan-Ruhuratir
			Idaddu II
			SUKKALMAH DYNASTY
			Ebarat/Eparti II (ca. 1970)
			Shilhaha (ca. 1960)
1950			Kuk-kirmash (ca. 1950)
			Attahushu, *sukkal* of Susa (ca. 1927)
1700			Tan-Uli (early 17th century)
			Temti-halki (mid-17th century)
			Kuk-nashur III (ca. 1645)
1500		MIDDLE ELAMITE	Tepti-ahar (15th century)
			(at Haft Tepe)
1400			IGI-HALKID DYNASTY
			Igi-halki (1400–1380)
			Untash-Napirisha (at Chogha Zanbil) (1340–1300)
1200			SHUTRUKID DYNASTY
			Shutruk-Nahhunte (1190–1155)
			Kutir-Nahhunte (1155–1150)
			Shilhak-Inshushinak (1150–1120)
1000			Huteludush-Inshushinak (ca. 1120)
900		NEO-ELAMITE I	
800			
700			Shutruk-Nahhunte II (716–699)
			Hallushu-Inshushinak (698–693)
			Tepti-Humban-Inshushinak (664?–653)
			Adda-hamiti-Inshushinak (ca. 650)
650		Assyrian conquest of Susa (646)	Humban-haltash III (648–642?)
600		NEO-ELAMITE II	
550		ACHAEMENID	ACHAEMENID DYNASTY
			Cyrus II (559–530)
			Darius I (522–486)
500			Xerxes (486–465)
400			Artaxerxes II (404–359)
300		Conquest by Alexander	Darius III (335–330)

MESOPOTAMIA

DATE B.C.	HISTORICAL PERIOD	DYNASTY AND RULER	
4000	'Ubaid / Early Uruk		CHALCOLITHIC AGE
3500	Late Uruk		
3100	Jamdat Nasr		
2900	Early Dynastic I		BRONZE AGE
2750	Early Dynastic II		
2600	Early Dynastic III		
2334	Akkad	Sargon (2334–2279) Manishtushu (2269–2255) Naram-Sin (2254–2218) Gudea of Lagash (ca. 2100)	
2100	Ur III	Ur-Nammu (2112–2095) Shulgi (2094–2047) Ibbi-Sin (2028–2004)	
2000	Isin-Larsa	Bilalama of Eshnunna (early 20th century) Gungunum of Larsa (1932–1906) Sumu-abum of Babylon (1894–1881)	
1800	Old Babylonian	Hammurabi (1792–1750)	
1700		Ammi-saduqa (1646–1626)	
	Kassite		
1500			
1400		Burnaburiash II (1359–1333) Kurigalzu II (1332–1308)	
1200			IRON AGE
	Isin II	Melishihu (1186–1172) Nebuchadnezzar I (1125–1104)	
1000			
900	Neo-Assyrian	Ashurnasirpal II (883–859)	
800		Shalmaneser III (858–824)	
700		Sargon (721–705) Sennacherib (704–681)	
		Ashurbanipal (668–627)	
600	Neo-Babylonian	Nebuchadnezzar II (604–562)	
500	Achaemenid rule		

SUSA IN THE ANCIENT NEAR EAST

*T*he immense plateau of Iran lying north and east of the Persian Gulf rises from the alluvial plains of Mesopotamia but is set apart from them by the Zagros mountain chain (figs. 1 and 2, pp. xiv–xvi). West of these great mountains lies the lovely plain of Susiana, geographically an extension of the Tigris and Euphrates river valleys and historically the home of peoples with cultural and political ties to the inhabitants of Mesopotamia. Throughout the ages, however, the inhabitants of Susiana were also in close contact with the peoples who descended from the northern mountain valleys of Luristan and particularly from the southeastern Iranian plateau in the modern province of Fars. It was this highland region in the southeast that was to become the cradle of Elamite civilization during the third and second millennia B.C. and later the homeland of the Indo-European Persians, who were newcomers to Iran at the beginning of the first millennium B.C.

PA

An Introduction to the History of Art in Iran

For some seven thousand years, the rich region of Susiana alternated between the primacy of two centers of control and influence: southern Mesopotamia to the west, and the great tribal heartlands of Iran, both the central Zagros mountain region and the highland plateau, to the north and east. Whenever the Mesopotamian powers seized control of the Susiana plain they strengthened the cultural dependence of that region on Mesopotamia, while the people of the mountains and highland plateaus were thrust back into the obscurity of their tribal conflicts. But when the people of the mountains and the plateau achieved unity in the third millennium B.C., they were able to incorporate Susiana—with its highly developed urban civilization—into a powerful state, the first cultural and political entity recorded in the history of Iran: Elam. This double state had two complementary capitals, Anshan in the southeastern highlands and Susa, which had been founded around 4000 B.C., in the plains extending eastward from Mesopotamia.

The eighth millennium had witnessed the onset of the "Neolithic revolution": the domestication of crops and animals and the initiation of village settlements. This transformation occurred first in the valleys of the Zagros Mountains and subsequently throughout the region that later became Susiana. A village culture soon developed and, beginning in the sixth millennium, found its most accomplished artistic expression in painted pottery (Nos. 1–13). Initially geometric and nonfigural, the decoration of the vessels was gradually transformed as the artists looked to the real world for inspiration. Naturalism, however, was rejected in favor of a deliberately stylized evocation of animal life that sprang from an extraordinary artistic creativity. A form of small statuary vigorously stylized in the same spirit also arose and is exemplified by finds made at Tepe Yahya, southeast of Susa in the province of Kerman. In the copper-rich region of Kerman and in

central Iran a metallurgical industry flourished somewhat later, around the time of the founding of Susa in 4000 B.C.

The new settlement at Susa virtually supplanted an earlier one at Chogha Mish, situated sixteen miles to the east, where the long, slow, preliminary unfolding of archaic culture can be traced. Subsequently the first Susians, benefiting from links with their close relatives on the plateau, brought this culture to a high point—even in the physical sense, raising a huge terrace, an artificial citadel far larger than the contemporary one supporting the temple of Eridu in southern Mesopotamia.

Susian affinities with the inhabitants of the mountainous regions can be seen in the decoration favored for the painted vases that are among the earliest works of art unearthed at the site: the figure of an ibex, an inhabitant of the mountains, with enormous, harmoniously curving horns (Nos. 1, 4, 9). This motif is also found in the art of contemporary plateau villages: Tal-i Bakun near Persepolis, Tepe Giyan and Godin Tepe to the northeast of Luristan, Tepe Sialk on the frontier of the eastern central desert, and as far as Tepe Hissar in the northeast. Representations of living creatures are so forcefully stylized that early archaeologists took them for a form of pictographic writing. In fact the images, while meaningful, appear to be essentially decorative; they are never organized in terms of a discourse, but are arranged and often repeated to create a satisfying effect within an abstract scheme which is itself designed to harmonize with the shape of the vessel.

Susa's close relationship with the peoples outside the Susiana plain is confirmed by the presence, among the numerous examples of stamp seals, of some imported examples from the plateau, on which there appears the theme of the mythical "master of animals." For the first time an iconography was elabo-

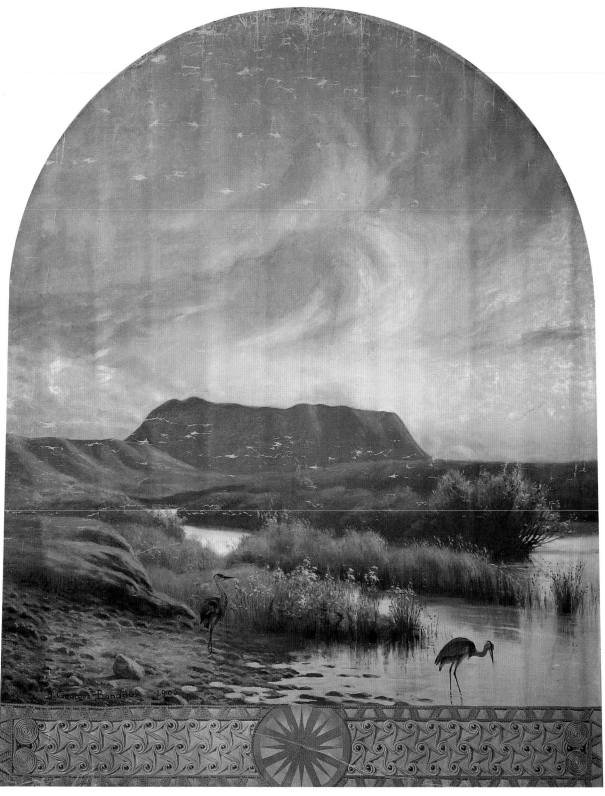

Figure 4. The mound of Susa as it appeared before the start of excavations. Jules-Georges Bondoux (1866–1919), *Le tell de Suse avant les fouilles*, 1905. Oil on canvas, H. 15 ft. 1 in. (460 cm). Paris, Musée du Louvre, 20802

rated on seals, with the figure of a human potentate related to the "master of animals," an image that perhaps prefigures that of the king in historical times. The images exhibit an archaic stylization and a purposeful avoidance of rendering the human face, characteristics also of the terracotta figurines and the extremely rare stone statuettes.

Sometime during the fourth millennium, in the urban center of Uruk (for which the archaelogical period is named), southern Mesopotamia acquired a specifically Sumerian historical identity. With the introduction of a system of writing, a gradual development from an earlier accounting system, a radical change occurred in the social organization and in the very foundations of thought. This decisive transformation in the history of human development found artistic expression in the abandonment of painted vase decoration and in a new impulse toward bas-relief and sculpture in the round. The figural iconography associated with these previously undocumented arts was to endure throughout the history of the ancient Near East. Susa, in its earliest period (Susa I) attached to the world of the Iranian plateau, was now (in Susa II) integrated into the early Sumerian civilization of Mesopotamia, which it interpreted with originality. Precise stratigraphic excavations conducted in recent decades have allowed us to trace developments at Susa in the Uruk phase, notably of an accounting system that preceded the slightly later appearance of writing.

The cylinder seal supplanted the earlier stamp seal at this time. Documents that still bore only numbers were impressed with these cylindrical seals, and the continuous designs rolled out on clay served as a sort of testing ground for the major arts. The designs were sometimes schematic and archaizing but at other times naturalistic and idealized, the visual antithesis of the stylized art of the prehistoric era. Alongside the traditional animal representations a new repertory of scenes was elaborated on the seals, inspired by the daily activities of a population that was apparently proud of its new status. Thus there appears a "priest-king," possibly representative of a type of monarchy that is known from later Sumerian literature.

Susa witnessed, along with Uruk, the vigorous growth of the sculptural arts in the late fourth millennium B.C.; especially numerous are vessels, often zoomorphic in form, and statuettes of exquisite delicacy (see pp. 58 ff.). There was also a flourishing metallurgy characterized by experimentation with alloys and the use of the lost-wax casting process to fashion pins decorated with delicate figures. Finally, like the early Sumerians, the Susians in this period became colonizers. They spread out along routes that led them to Godin Tepe and Tepe Sialk in west central Iran, organizing a trade network in which the agricultural wealth of Susa and its "colonies" was exchanged for precious minerals from even more remote regions. These exchanges enriched Susiana and introduced its developed culture to distant lands.

The prehistoric inhabitants of Fars, on the plateau to the southeast, seem to have been on the margin of the Susian expansion. There the village cultures had died out at the same time as that of Susa I (around 3700), and the villagers perhaps became nomads. But toward the end of the fourth millennium, when the brilliant civilization of the Uruk period had collapsed in Mesopotamia and at Susa, the population of Fars broke with the prehistoric past and achieved in their turn a kind of historical consciousness, establishing a large center which perhaps had already acquired its name, Anshan (modern Tal-i Malyan). The creativity of this first period of Elamite historical identity is apparent in the development at Susa and Anshan of a form of writing and an art that we call Proto-Elamite.

Susa was annexed by Anshan. Although it was a much smaller center than Anshan, its long previous period of cultural development enabled it to contribute to the formation of the new civilization, which expanded into ethnically related regions. Evidence of the Proto-Elamite civilization, in particular writing and a distinctive glyptic style, is widespread and is found at Tepe Sialk to the north (where, as in Susa, this stage followed a settlement of the Uruk type) and especially to the southeast at Tepe Yahya, which became a sort of outpost in the heart of Kerman province. Proto-Elamite influence even spread across the great eastern desert of Lut to Shahr-i Sokhta, where the Proto-Elamite accounting system is found in use by people whose cultural affinities lay not with the Proto-Elamite world but with the inhabitants of Turkmenia and the region south of the Hindu Kush mountain range. Clay tablets with Proto-Elamite writing also occur at Anshan in association with a large building embellished with paintings.

A considerable part of what we know about Proto-Elamite art is based on the designs carved on cylinder seals. Whereas the art of the Uruk period in Mesopotamia and Susa accorded a place of honor to the human being—expressing a very ancient form of "humanism"—the focus of Proto-Elamite art is almost exclusively on animals. Animals were often substituted for people (fig. 5), sometimes in apparently hu-

Figure 5. Kneeling bull holding vessel. Iran(?), Proto-Elamite period, ca. 3000 B.C. Silver, H. 6⅜ in. (16.3 cm). The Metropolitan Museum of Art, Purchase, Joseph Pulitzer Bequest, 1966 (66.173)

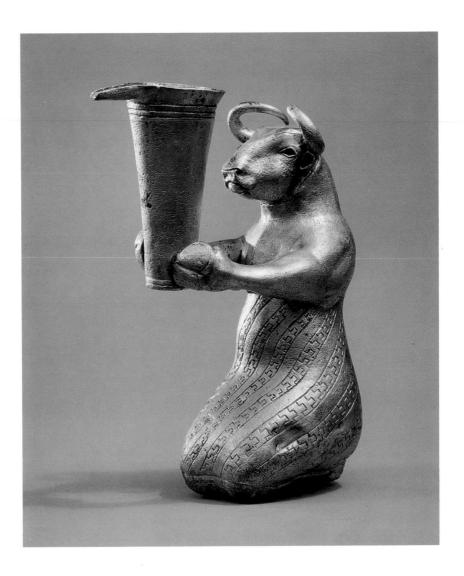

morous scenes that perhaps evoked fables. At other times the animals are shown in what may be mythological scenes, appearing gigantic (No. 47) and carrying mountains. These animals may personify elementary cosmic powers comparable to the mountain gods and genii of later Mesopotamian mythology. A new feeling of movement and a baroque stylization are also evident in Proto-Elamite art, both on seals and in the rare examples of sculpture in stone and metal.

The intrinsic duality of Proto-Elamite civilization, with its ties to both the plains of Susiana and the Iranian highlands and plateau, may have contributed to a lack of stability. This was compounded by the excessively rapid urbanization of the mountain heartland. With the subsequent urban collapse, the inhabitants of the plateau in Fars deserted their towns and villages and may have reverted to ancestral nomadism. But while Anshan was abandoned, as were Tepe

Sialk and Tepe Yahya to the north and southeast, Susa returned to the Mesopotamian orbit sometime around 2800–2750 B.C.

The collapse of Proto-Elamite civilization was undoubtedly due in part to the rise of powerful Early Dynastic Sumerian city states throughout southern Mesopotamia during the first half of the third millennium. One mark of the Mesopotamian development was the sudden appearance of a new art, characterized by a profusion of statuary placed in temples to perpetuate the presence there of a multitude of worshipers. The existence of at least one such temple on the Susian acropolis, known as the Acropole mound (see below, p. 21), is attested by a collection of characteristic statuettes of worshipers, some indistinguishable in both form and execution from the ones recovered in Mesopotamian temples. Initially the figures were stylized in an angular fashion (No. 50); this approach was

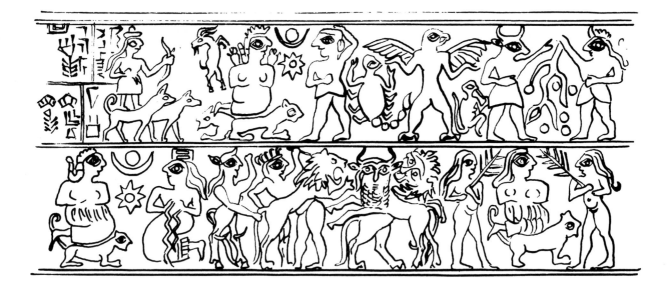

succeeded by a greater naturalism, although some of the works retain a "cubist" appearance, and a provincial quality characterizes even the sculptures of royal figures.

The seal carvers of Susa also fully embraced Mesopotamian artistic conventions, although there were exceptions. One seal dating from the end of the Early Dynastic period (about 2350), of which only the impression remains, is inscribed in Sumerian with what is thought to be the name of a Susian goldsmith (fig. 6). Although the inscription shows that the language and writing of Mesopotamia had been adopted in Susa, and the seal is decorated in the Sumerian style of the period of the princes of Lagash, some of the distinctive imagery is drawn from Elamite mythology with a characteristic emphasis on goddesses seated on felines and divinities holding plants, perhaps references to a vegetation myth or ritual.

A Susian originality is manifest in the objects made of a distinctive material, bitumen hardened by the addition of a fine sandy temper. Since the earliest period at Susa this bitumen compound had been used in imitation of exotic black stones. From the material were carved statuettes, vessels of various degrees of sophistication, and offering stands whose crudely stylized decoration has affinities with popular vase painting (Nos. 63–69).

In the middle of the third millennium the painting of vases recommenced in a "second style" (fig. 7) that had nothing in common with the style of the oldest Susa I vases. This second style of vase painting, emerging in an epoch of Mesopotamian hegemony, illustrates the Susians' underlying affinities with the

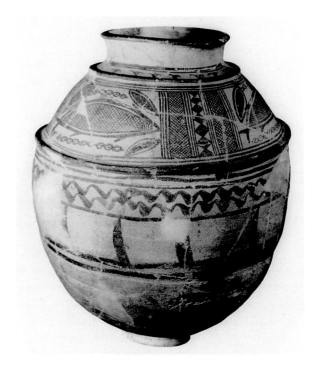

Figure 6 (top). Drawing of a seal impression depicting Elamite deities. Seal impression: Susa, ca. 2350 B.C. Clay, H. 1½ in. (3.8 cm). Paris, Musée du Louvre, Sb 6680

Figure 7. "Second style" painted ceramic jar. Susa, first half of the 3rd millennium B.C. Baked clay, H. 16¼ in. (42.5 cm). Paris, Musée du Louvre, Sb 6607

peoples of the mountainous regions of Luristan to the north. Although culturally and politically integrated into the Mesopotamian orbit, Susa remained a center where trade routes descending from the plateau converged and through which goods brought from the highlands in the north and in the east reached the western plain.

The semi-nomadic inhabitants of Tepe Yahya to the southeast, and certainly other sites as well, carved vessels of black and green chlorite that were richly decorated with architectural motifs, mythological figures mastering serpents, and other subjects. These distinctive objects reached Mesopotamia in part by sea routes. They enjoyed immense popularity from Susa to Ur in southern Mesopotamia and as far west as Mari in Syria during the mid- and late third millennium B.C.

In the second half of the third millennium the Akkadian kings, who had gained control over Mesopotamia, occupied Susiana. When the Akkadian empire fell, about 2200 B.C., a prince of Susa who was the last ruler of the Elamite dynasty of Awan, Puzur-Inshushinak,[1] threw off the Mesopotamian yoke. He drew together the peoples of the Susiana plain and the mountain principalities in southwestern Iran into a kind of Elamite empire. To that end he employed the cuneiform writing and the Akkadian language already in use at Susa and also the linear writing that transcribed the language of the Elamites, a script found in Fars and as far east as Shahdad in Kerman (see fig. 9, p. 8).

Puzur-Inshushinak's attempt at imperial expansion was short-lived, for the Neo-Sumerian kings of Ur soon captured Susa. They restored the ancient temple of the great nature goddess, called in Sumerian Ninhursag-of-Susa, adjacent to a new temple to the patron god of Susa, Inshushinak. The Ur III rulers imposed their suzerainty over the Elamite princes of Anshan, who were probably semi-nomadic, in the southeast, and over others, including the princes of Shimashki, in an area that is likely to have extended to the north and southeast of Susiana. In this historical setting, still poorly documented in highland Iran, a refined style of art influenced by the Neo-Sumerian art of Mesopotamia was born; it is exemplified at Susa by the works created during the reign of Puzur-Inshushinak (Nos. 54, 55).

While Elam was experiencing a revival in the late third millennium B.C., first under the independent king Puzur-Inshushinak and later under Mesopotamian hegemony, indigenous groups of people in the eastern province of Kerman were developing a "trans-Elamite" culture that lasted through the early second millennium. Artisans located at Shahdad on the border of the desert of Lut worked in alabaster and copper. A local pantheon of gods appears on the cylinder seals of the region (fig. 8). Farther to the east, two cultural centers comparable to Mesopotamia had also reached maturity in the second half of the third millennium B.C.: in the Indus Valley of present-day India and Pakistan; and in Turkmenia, northeast of Iran. Their history remains little known, however, because the

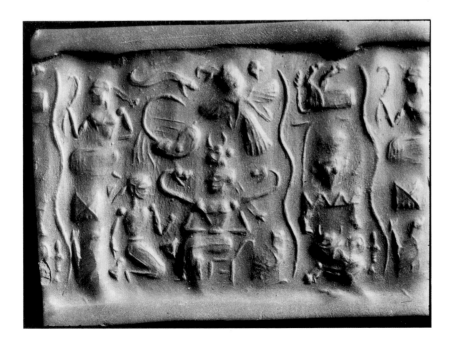

Figure 8. Modern impression of a cylinder seal depicting deities. Seal: eastern Iran, Akkadian period, ca. 2200 B.C. Shell, H. 1½ in. (3.9 cm). Formerly, Collection of Mohsen Foroughi

script of the Indus civilization is still not understood and no traces of writing from this period have been found in Turkmenia. The influence of the trans-Elamite culture is evident in the border regions of these lands as well: on the western frontier of India at Sibri, south of the Hindu Kush at Quetta, and farther north in Bactria and Margiana just east of Turkmenia, where objects similar to those found in Kerman have been excavated—vessels of chlorite and alabaster, ceremonial axes, and compartmented stamp seals. Mean-

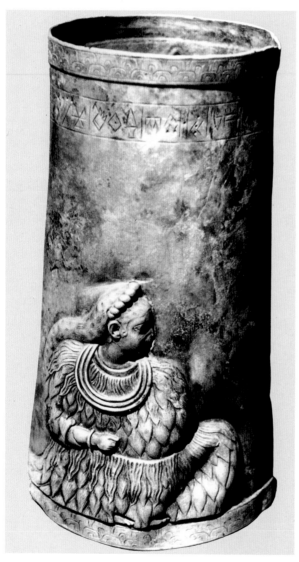

Figure 9. Vase with female figures and linear Elamite inscription. Marv-Dasht plain(?), Iran, reign of Puzur-Inshushinak, ca. 2100 B.C. Silver, H. 7⅝ in. (19.3 cm). Teheran, Iran Bastan Museum

while, at Shortugai in northeastern Afghanistan, colonists from the Indus Valley had settled.

In Elam, the princes of the new Shimashkian dynasty, who governed a vast area to the north and southeast of Susiana, drove out the Sumerians and gained control of Susa toward 2000 B.C. Anshan was soon restored as the major metropolis of the Elamite federation, and the rulers of Shimashki seem to have adopted the title "king of Anshan and Susa" sometime before 1900 B.C. That imperial title of the rulers of Elam was subsequently changed to *sukkalmah*, a term borrowed from the Sumerian administration and meaning "grand regent." Under the rule of the *sukkalmah*s, which continued until about 1500 B.C., Susa remained within the Mesopotamian cultural sphere, but local artistic traditions continued. During this period elegant luxury wares of bitumen compound were produced, often in the shape of an animal's body (Nos. 63–65). On cylinder seals a number of original motifs appear, notably figures of queens wearing full, flounced crinolines of sheepskin that are closely related to the figure on a silver luxury vessel dating to the reign of Puzur-Inshushinak (fig. 9).

It is significant that no extant stele or statue of royalty or divinity has been found that would testify to the existence of an official Elamite art at Susa during this period. Only outside this urban setting and beyond the borders of Susiana, in the highlands to the south and east, is a royal Elamite art to be found. In the seventeenth century the Elamite kings, although they may have wintered at Susa, created two open-air rock-cut sanctuaries in the highlands: at Naqsh-i Rustam, near the future site of Persepolis, and at Kurangun. Represented in the sanctuary at Kurangun is a figure identified as the great Elamite mountain god Napirisha, enthroned above a mythical serpent and accompanied by his wife. From both sides worshipers approach the divine couple, encircled by flowing waters (fig. 10).

In the kingdom of Elam during this time (about 1700 B.C.), the people of the southeastern plateau, whose princes had controlled Susiana, fell back into a semi-nomadic state. The trans-Elamite culture that extended across the plateau similarly collapsed, and India too was overwhelmed in a general crisis about which little is known.

Between the sixteenth and fourteenth centuries B.C. the Mitannian empire in northern Mesopotamia, apparently led by an Indo-European aristocracy who ruled over the Hurrian population, provided a link between the prosperous lands of the Levant and the

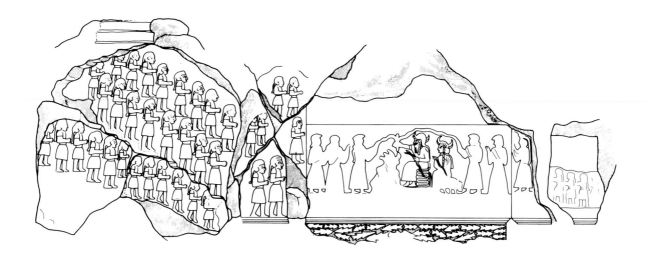

world of the Iranian plateau; meanwhile the Kassites, newcomers to the Tigris-Euphrates river valleys, reigned over a reduced Babylonia. The Elamites were concentrated in the Susiana plain but maintained their ancestral ties with the highlands, where Anshan was progressively deserted.

The Elamite civilization of the fifteenth century is best known from the excavations at Haft Tepe (ancient Kabnak), not far from Susa. There the king Tepti-ahar erected a great funerary temple for himself in which the place of worship, or *cella*, was situated above two large vaulted tombs. At Susa the ordinary inhabitants were also buried in vaults, but these tombs were in the ground beneath their houses. Portrait heads of unfired, painted clay, deposited in these tombs near the heads of the deceased, display a vigorous naturalism that is exceptional in the art of the Near East (No. 84). This Elamite civilization had affinities with those of the Kassites and the Hurrians.

Reacting against Mesopotamian cultural influences, an Elamite dynasty of the fourteenth century restored Anshan (henceforth called Anzan in inscriptions) to a kind of theoretical preeminence. Around 1340, with a view to assuring the cohesion of his empire, Untash-Napirisha, the fifth king of the dynasty, founded a new royal center that later bore his name, Al Untash-Napirisha (modern Chogha Zanbil), twenty-five miles southeast of Susa (fig. 11). This new foundation, excavated by Roman Ghirshman between 1951 and 1962, was built around a great national temple complex called the *siyan-kuk*, or "holy place." Originally the complex, dedicated solely to the patron god of Susa, Inshushinak, consisted essentially of a building resembling a secular caravanserai, with an open court

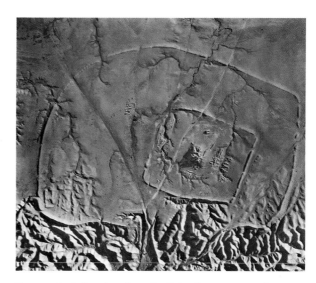

Figure 10 (top). Drawing of a rock relief at Kurangun, near Persepolis, Iran. Relief: Old Elamite period, ca. 17th century B.C. H. 63 in. (160 cm)

Figure 11. Air view of Chogha Zanbil, Iran, showing three enclosure walls and interior temples of the Middle Elamite period

surrounded by rooms, and containing two small sanctuaries. Cult ceremonies probably took place in the courtyard in the open air, as had been the custom in the high places of the mountain peoples outside the great urban centers. Later, in order to emphasize the primacy of the highlands, the king decided to transform this building into an imperial temple dedicated to both Napirisha, the patron god of Anshan, and Inshushinak, the god of Susa. In the courtyard he raised

massive blocks in a complex construction to form a ziggurat 165 to 200 feet high, of which the original building constituted the lower stage. Within an enclosure wall at the foot of this tower were the temples of the associated deities. Other temples were located near a second, outer enclosure wall, and a third wall surrounded the city (the houses were in fact never built because the site was soon deserted), which included a royal quarter. Within this royal quarter were some "palaces" that were simply groups of apartments around large courtyards, with nothing specifically palatial about their arrangement. In the same area a palace temple for the funerary cult was constructed above the burial vaults that housed the remains of the royal family, most of whom had been cremated, a practice attested also among the Hittite and Mitanni peoples. Finally, there was an unusual temple with a *cella* open to the sky, created for the cult of fire personified: the god Nusku.

Most artifacts found in this prestigious but short-lived complex were small objects, mainly made of glass and faience, dedicated by the king and founder of the city, Untash-Napirisha, and by humble pilgrims. Several important works of art were transported to Susa in the twelfth century during the reign of Shutruk-Nahhunte. Their reconstruction from fragments has revealed the existence of an official art of statuary and bas-relief sponsored by Untash-Napirisha (No. 80). This art departed from most of the Babylonian traditions that had flourished previously in Elam. One characteristic, perhaps derived from the culture of the inhabitants of the mountains around Anzan who were then predominant in Elam and who had imposed the use of Elamite rather than Akkadian in Susiana, is the apparent fondness for rendering embroidered garments in a curiously stylized fashion with small curvilinear crosses, resembling the hide of an animal. The snake, depicted naturalistically or as a fantastic composite creature (a serpent-dragon), was a favorite symbol of the inhabitants of the Elamite highlands and was probably their supreme emblem of divinity rather than the attribute of any specific god. On the stele dedicated by Untash-Napirisha to the god Inshushinak of Susa, the seated deity is associated with the snake. Similarly, the handle of a votive spade of Nabu, the god of writing, is in the form of a snake, and two serpents adorn a grand sacrificial table (fig. 12), an astonishing masterpiece of bronze casting surpassed only by the monumental statue of Queen Napir-Asu (No. 83). This image of the wife of Untash-Napirisha is an extraordinary technological and artistic achievement which is unparalleled in ancient Near Eastern art of this period.

The popular art of seals at the time was almost the antithesis of this royal art. The seals show significant affinities with the contemporary artwork of the Kassites of Babylonia and are devoid of imagery representing the Elamite god enthroned over the snake, a scene that had appeared on earlier Elamite seals (No. 76). Once again, the oscillation between influences from Mesopotamia and from the highlands of Iran is reflected in the art of Elam.

From the second half of the second millennium few archaeological traces remain of the inhabitants of the Elamite highlands. In the twelfth century B.C. Anzan shrank to a fraction of its previous size, although remains nevertheless exist of a large administrative building. The king Shutruk-Nahhunte and his two sons made Susa into what was for all practical purposes the sole capital of the empire. Successful in their

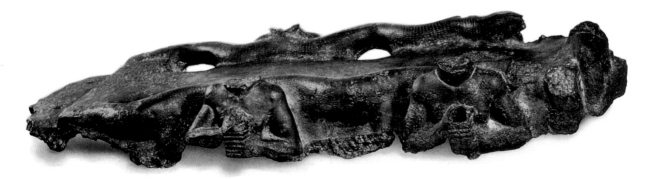

Figure 12. Table with serpents and water deities. Acropole mound, Susa, Middle Elamite period, 13th–12th century B.C. Bronze, L. 62 in. (158 cm). Paris, Musée du Louvre, Sb 185

Figure 13. Reconstruction drawing of brick architectural reliefs depicting a royal couple. Reliefs: Susa, Middle Elamite period, reign of Shilhak-Inshushinak, 1150–1120 B.C. Molded, glazed brick. Paris, Musée du Louvre; male: Sb 703, 11405–6, 11413–5, 11419–20, 11422; female: Sb 701, 724, 729, 760, 11408–9, 11412, 11418, 11422

Mesopotamian campaigns, they brought vast booty from the cities of Babylonia to Susa. Moreover, to confirm Susa's centrality as the preeminent Elamite city they relocated there works previously dedicated in the other major Elamite cities: the steles and statues of the *siyan-kuk* from Chogha Zanbil and a large bronze relief of a row of figures that originated in the highlands around Anzan. The relief appears to represent a procession of deified royal ancestors and is inscribed with the names of several Anzanite divinities.

Nothing is known of the architecture of Susa during this period, although it has been possible to reconstitute the wall surface of what must have been an imposing temple complex decorated in molded brick, a tradition borrowed from Babylonia (No. 88). On the Acropole, the inside walls of one chapel were ornamented with enameled reliefs representing the royal

couples of the dynasty in distinctively Elamite dress (fig. 13). There is no other evidence at Susa of an official art comparable to the program sponsored by Untash-Napirisha two centuries before. This form of dynastic art is, however, found in the highlands, where it can be seen in the rock-cut sanctuary at Kurangun and especially at Shikaft-i Salman (the reliefs there are dated to the twelfth century) near Izeh/Malamir, in the heart of the Bakhtiari Mountains north of Fars. At Shikaft-i Salman, two kings are represented with their wives. The figures are dressed like the royal couples on the enameled reliefs at Susa, and the kings' plaited hair falls onto their chests.

At the end of the twelfth century B.C. both Susa and Anzan were destroyed by Babylonian armies, and the Elamite civilization sank into an almost total obscurity that lasted until the eighth century. Rock-cut

reliefs east of Susiana, at Kul-i Farah near Izeh/ Malamir, may date from the period after this Babylonian destruction. On them kings are depicted carried on podiums and followed by a crowd of their subjects, a theme that evokes for the first time the concept of a people or nation surrounding their king, who is *primus inter pares* (fig. 14). No representations exist of the gods honored by these nomad kings.

It is in this period between 1400 and 1000 B.C. that local princes (apparently nomads) in the region of the Caspian Sea, enriched by exchanges with the Mesopotamian empires and Elam, were buried in sumptuous tombs near Marlik. Their vases of red or gray terracotta in the form of animals and humans and also numerous small bronze sculptures illustrate the vigor and originality of a people who have left no written documents and therefore remain outside recorded history. Inheritors of a tradition known in Bactria and Margiana, the people of Marlik were great admirers of vessels of gold and silver; they passed on this predilection to both the Achaemenids and the Sasanians. But the themes of their art were adopted from the great

historical civilizations of the Near East: Mitannian and Assyrian monsters, Elamite mythical creatures, Kassite winged bulls and crouching rams turning their heads toward the beholder like those on the Susian vases of bitumen compound of the early second millennium.

Also arising in the fifteenth century in northern and central Iran, outside of the known urban centers, were other traditions that developed over a long period. Local potentates ruled over the population from citadels; archaeologically the best known of these is at Hasanlu, south of Lake Urmia in northwest Iran. At that site, excavated between 1956 and 1974 by a University of Pennsylvania expedition with support from The Metropolitan Museum of Art, an original columned architecture was elaborated. This type of architectural setting corresponded to a need, unknown in the old Mesopotamian monarchies, to create meeting places for large assemblies. Hasanlu's prosperity was due in part to trade, and these economic exchanges were largely responsible for an artistic syncretism evident in the extraordinarily rich finds from the

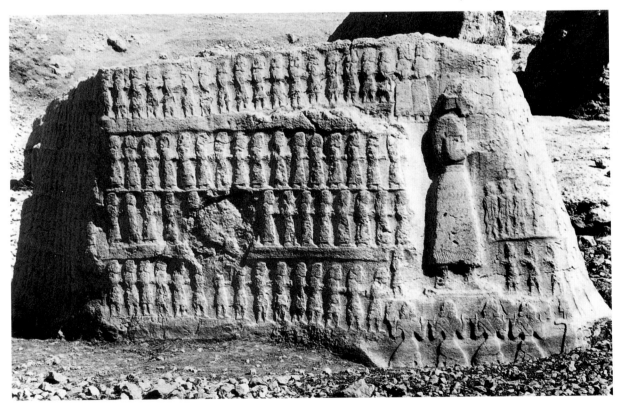

Figure 14. South face of a rock relief depicting a king and his subjects. Kul-i Farah, near Malamir, Iran, Neo-Elamite period, 8th–7th century B.C. H. 10 ft. 7 in. (322 cm)

grand columned halls at this site, which was destroyed about 800 B.C.

Only at the end of the eighth century, with the restoration of the "kingship of Anzan and Susa," does Elam reappear in the historical record. On the Susian Acropole, otherwise practically deserted, the king Shutur-Nahhunte built a small Neo-Elamite temple with polychrome enameled brick decoration displaying motifs related to contemporary art from the mountains of Luristan to the north, where a stylized animal decoration characterizes small bronzes.

In 646 B.C. the Assyrian king Ashurbanipal, retaliating against the Elamites for their support of his Babylonian enemy, launched his army against Susa. He destroyed the old capital and with it the Elamite kingdom, already divided from within. This defeat marked the dissolution of the illustrious Elamite civilization, a sister to the civilizations of Sumer, Akkad, and Babylon. The Mesopotamian kingdoms of Assyria in the north and Babylonia in the south were soon to experience a comparable demise.

The Medes, an Indo-European people, had appeared in northwestern Iran by the early first millennium B.C. but were not ready to take up the legacy of Elam. They have left no trace of writing or a recognizable dynastic art, but the distinctive columned architecture developed at Godin Tepe and Nush-i Jan, in the Zagros northeast of Susiana, betrays the presence of this newly arrived Indo-European people.

In the late seventh century B.C., when Susa once again became an administrative headquarters, an unidentified prince governed a population consisting of not only Elamites but also Persians, who were new Indo-European immigrants. The individual character of this mixed, literate society was expressed in a new and original art that combined Babylonian and Assyrian elements with indigenous traditions. Among the few works that have survived this period are seals, on which the preferred subject, a horse and rider, is delicately modeled and worked with great vivacity and naturalism.

The two populations, Elamite and Persian, must also have coexisted beyond the boundaries of Susiana on the Izeh/Malamir plain in the Bakhtiari Mountains to the east, which in the course of the seventh century became the center of a small kingdom called Aiapir. King Hanne and his minister, continuing an ancient Elamite tradition (see above, p. 11), appropriated the relief sculptures of princes whom they probably regarded as ancestors. To the reliefs representing the king surrounded by his people at Kul-i Farah, Hanne

added another relief in which he himself is depicted, wearing a fringed garment and a bulbous tiara similar to the headdress worn by Medes on the Persepolis reliefs.

The Indo-European Persians had made the Elamite highlands (modern Fars) their chosen land by the seventh or sixth century. Exposed through the Elamites to the achievements of older civilizations, they organized themselves into a national state. The Persians took over the illustrious monarchy of Anzan, while the indigenous Elamites themselves became Persian in a rapid process of acculturation. Their refined style of seal carving, found also in Susiana, can be considered the first expression of Persian art.

It was Cyrus the Great, conqueror of the Medes in the middle of the sixth century and then of Babylonia, who united all the people of Iran—Medes, Persians, and Elamites—in a single national entity that was both unified and imperial in its diversity.

Cyrus replaced Anzan, over which he had declared himself and his ancestors king, with a new capital at Pasargadae in Fars. There he commissioned architecture of a palatial type, intentionally rejecting an urban setting. Two columned halls, which were actually assembly halls for the Persian nobility and not residences, were integrated into a magnificent landscape in a vast, ingeniously arranged and irrigated garden. The columned architecture may have been essentially inherited from the Medes, who left traces of late-eighth-century buildings at Godin Tepe and Nush-i Jan in west central Iran. A "subtle and fugitive fragrance of Hellenism" (Pierre Amandry) was imparted to this Persian architecture by Ionian Greek stonemasons— the finest in the empire—to whom its execution was entrusted. In sponsoring the construction of architecture in a purely Iranian tradition, but clad in Greek clothing and associated with sculpted decoration of Elamite and Mesopotamian type, the new state expressed its desire to acknowledge the heritage of all its peoples. Rather than subjugated, they were to be integrated into what would be an immense realm of peace.

The characteristics of Persian art under the Achaemenid dynasty were definitively established by Darius I at the start of his reign (522–486 B.C.). He completely remodeled the urban center of Susa, in which there had stood only administrative or ceremonial edifices, by constructing a palace complex to the north. It included a royal residency of the Assyro-Babylonian type, arranged around three successive courtyards, the walls of which were covered with enameled baked brick reliefs (Nos. 155–168; fig. 15).

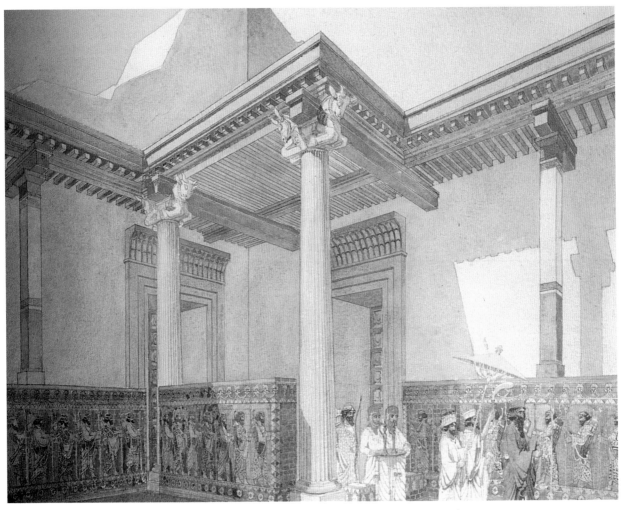

Figure 15. Maurice Pillet, *The Palace of Darius*, 1913. Watercolor on paper, H. 26 in. (66 cm). Coll. Mme. Étienne Pillet, Le Chesnay, France

In the heart of the complex, a suite of two ceremonial rooms reproduced those in Nebuchadnezzar's palace at Babylon; they were framed by storerooms that would have been incongruous in this setting had they not supported the upper-floor private apartments. Directly north of the palace rose the enormous *apadana*, or columned hall, for royal assemblies. The *apadana* was of a purely Iranian tradition developed in Media, but the decoration of its columns incorporated elements of the most admired arts of the peoples of the empire.

Darius next undertook the construction of Persepolis south of Pasargadae in the region where Anzan had been abandoned. He carved his tomb in the cliff-face of neighboring Naqsh-i Rustam, the old Elamite cult site (see above, p. 8). The tomb's facade imitates that of a columned palace; above is a large two-tiered podium supported by personifications of the peoples of

the empire, armed because they are free men. They replaced the mythical bearers of the elements of the world represented by the Assyrians, and an imperial concept supplanted a mythical cosmology that was no longer valid. At that time a revival occurred of the imagery associated with the birth of the first nations, a theme that had been illustrated on the Elamite rock reliefs of southern Iran at Kul-i Farah near Izeh/Malamir as early as the end of the second millennium (fig. 14, p. 12). On the symbolic podium of Darius' tomb facade, the king stands in prayer before a flaming altar and beneath a divine figure, which is inside a winged sun disk. Lacking precise literary references, we cannot be sure that the figure represents Ahura Mazda, the supreme Zoroastrian divinity, rather than a personification of the Achaemenid dynasty.

At Persepolis we do not find a single coherent

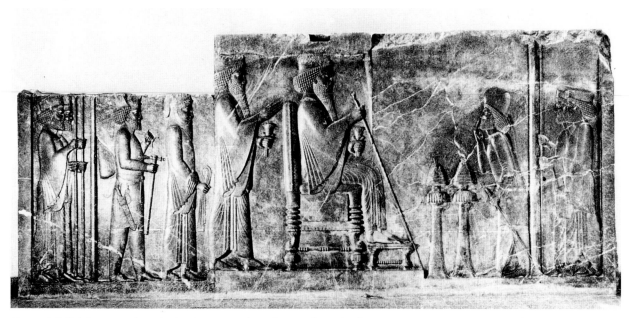

Figure 16. Relief showing enthroned ruler, from Persepolis. Achaemenid period, 5th century B.C. H. 82½ in. (210 cm). Teheran, Iran Bastan Museum

complex like the palace at Susa. Instead, the Iranian tradition asserted itself in the erection of independent but complementary buildings. Back-to-back against his residential palace Darius set the *apadana*, a replica of the one at Susa. Its two facades were punctuated by two pairs of stairways framing a large relief that represents the enthroned Xerxes, successor to Darius, receiving delegations of the twenty-three nations of the empire (fig. 16). This was the predominant theme of Achaemenid imperial art, elaborated here in proportions that harmonize with the monumental size of the building. The relief is sculpted with a goldsmith's refinement, and loving attention is given to the detailed representation of the precious metalwork so highly valued by the ancestors of the Persians. Xerxes later erected an even more enormous hall at Persepolis, its roof supported by one hundred columns. In the decoration of this hall the theme of empire was taken up again, with subject peoples carrying the royal podium. The old motif of the "master of animals" also recurs in the decoration of the buildings at Persepolis,

but by that time the figure must have been identified as the "Persian man," whose supreme embodiment was the Great King.

Ancient themes were thus infused with new symbolism, and the eclectic art of the Persians signaled the advent of a new age. A decisive historical turning point had been reached in the history of Iran. An era that lasted some three thousand years, inaugurated by the Sumerians of Mesopotamia in close association with the Susians, had come to an end. The age of classical antiquity had just begun, soon to be dominated by Greece and by a Greek philosophical humanism that would never be more than superficially adopted by the powerfully individual Iranians.

PIERRE AMIET

NOTE

1. [This is the Akkadian form of the ruler's name. The Elamite form has been reconstructed as Kutik-Inshushinak.—Ed.]

The French Scientific Delegation in Persia

In 1897 the French government created the Délégation Scientifique Française en Perse and provided it with more substantial funding than had ever before been available in the field of archaeology. The stakes were high, and arrangements on a large scale were imperative: in an agreement signed in 1895, Shah Nasir al-Din (r. 1848–96) had granted France the monopoly on excavations throughout Persia.

At the start of unofficial negotiations with the Persian government, France had not contemplated taking charge of all the archaeological research in Persia. The goal then was far less ambitious and more precise. Prodded by French scholars, the government simply intended to take the measures necessary to avoid possible eviction from the site of Susa, and by the same token to put an end to the rivalries with other nations that had marked the first explorations of the great Assyrian capitals in northern Mesopotamia, then under Ottoman Turkish rule. Great Britain had a certain claim to priority in the exploration of Susa, since the site had been identified in 1851 by two Englishmen, Colonel W. F. Williams and the geologist William Kennett Loftus, and excavations had been undertaken there by Loftus in 1853–54.

However, it is the French engineer Marcel-Auguste Dieulafoy, accompanied by his wife, Jane, who deserves the credit for demonstrating the site's exceptional interest. The couple visited Susa for the first time during a trip across Persia in 1881 and 1882, and on their return Dieulafoy convinced the National Museums to underwrite an excavation. Despite extremely modest financing, the excavations conducted between 1884 and 1886 in the area of the palace of Darius proved fruitful. The vestiges of the palace of the Great Kings, shipped to France aboard the cruiser *Sané*, still constitute the core of the Louvre's Susa collection.

Although the French government could take satisfaction in the achievements of these first campaigns, the future of the excavations remained uncertain. Because it was unable to guarantee the mission's safety, in 1886 the Persian government demanded a suspension of the work. Thereafter, no request for authorization could be presented to the Shah, who was unfavorably disposed to the project because it was causing disturbances among the local population.

For almost ten years the French Legation in Teheran watched over the site, awaiting the resumption of negotiations. Finally, on May 12, 1895, an agreement was signed by the Shah and the French Legation. The definitive text was not drawn up, however, until the summer of 1900, when Shah Muzzaffar al-Din (r. 1896–1907), son of and successor to Shah Nasir al-Din, signed a treaty on his way through Paris: everything discovered in Susiana would go to France, provided that a stipulated compensation was made for the gold and silver objects.

The Délégation, created to take full advantage of the monopoly obtained by France, remained in existence some fifteen years. The prestige of this organization derived entirely from the man who was master of its destiny: Jacques de Morgan. When he was appointed head of the Délégation at barely forty, Morgan stood at the pinnacle of his career. This mining engineer whose work had taken him around the world had harbored a passion for prehistory since childhood, and he had adroitly combined his professional activities as a prospector with his taste for archaeology. After a trip to the Caucasus he had explored northern Persia in the years from 1889 to 1891 and then traveled through the rest of the country, ending up at Susa.

When the French government entrusted the direction of the Délégation to Morgan he was head of the Office of Antiquities in Egypt, where he had been since 1892. Morgan's brilliant achievements there, which were diplomatic as well as scientific, had brought him great acclaim. His discoveries at the necropolis of

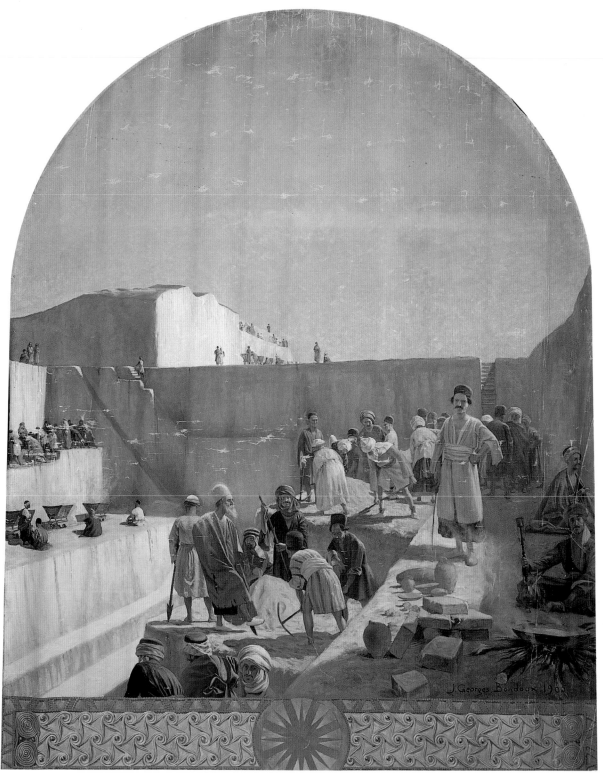

Figure 17. The mound of Susa during excavation. Jules-Georges Bondoux (1866–1919), *Les fouilles de Suse*, 1905. Oil on canvas, H. 15 ft. 4 in. (463 cm). Paris, Musée du Louvre, 20803

Dashur excited worldwide interest; his investigations into Egyptian prehistory were decisive. But Morgan had not forgotten Persia, and in 1897 he eagerly took up his new responsibilities, which were considerable. Never before had the head of a mission commanded such extensive resources and such complete authority, both scientific and administrative. In terms of diplomacy, it was Morgan, drawing on the extensive knowledge of the area he had acquired during his travels and working with the French Legation, who set in motion the developments that made possible the treaty of 1900.

The strategic center of the Délégation was Susa, where Morgan set up camp at the end of 1897. Conditions were insecure in this part of Iran, and the Délégation was beset by pillaging tribes who roamed from one side to the other of the Ottoman-Persian border. To protect his staff from these raids once and for all, early in 1898 Morgan began the construction of a

residence on the north of the Acropole that rapidly assumed the aspect of a medieval château (fig. 18).

Of the Délégation's original team, the majority were men who had earned Morgan's esteem in Egypt: Gustave Jéquier, an Egyptologist, and Georges Lampre, secretary-general of the Délégation, who knew Persia well. They were joined in 1898 by the eminent Assyriologist Father Vincent Scheil (see fig. 19). There were personnel changes over the years, but the Délégation was supported by the continuing efforts of Scheil and of Roland de Mecquenem, a young mining engineer hired in 1903. Despite his youth, Mecquenem often took Morgan's place in the field; from 1908 on, he did so permanently.

Morgan aspired to conduct an overall study of Persia's archaeological riches without neglecting other scientific fields of inquiry, notably geography, geology, and natural history. However, there were not enough funds to support such diversified research, so the Délé-

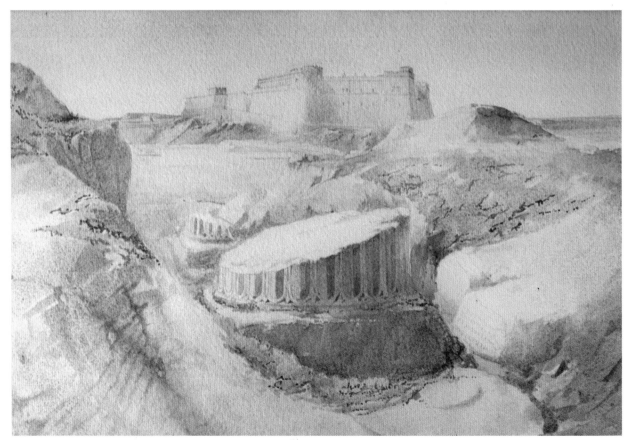

Figure 18. Maurice Pillet, *Apadana Columns and Château*, 1913. Watercolor on paper, H. 14½ in. (37 cm). Coll. Mme. Étienne Pillet, Le Chesnay, France

Figure 19. Jacques de Morgan and Father Vincent Scheil at the Louvre with the stele of Naram-Sin. Wood engraving from *L'Illustration*, February 4, 1902

gation directed its efforts to its principal objective: Susa. This decision seemed justified both by the importance of the findings, scrupulously published for the benefit of scholars in *Mémoires de la Délégation en Perse*, and by the prestige of the collections brought back to the Louvre. Nevertheless, Morgan found himself condemned for his choice, attacked by some of his collaborators, and fatigued by his overlong stays in the Orient. He resigned in 1912, and the Délégation Scientifique Française en Perse came to an end.

The agreement that had led to the creation of the Délégation was not repealed until 1927, although long before that time France had lost any real monopoly in the region. But if the Délégation was defunct, the mission in Susa lived on. Mecquenem assumed direction of the work until 1946, followed by Roman Ghirshman and finally, starting in 1968, Jean Perrot. Only the two world wars and the Islamic revolution of 1979 have interrupted nearly a century of French exploration in Susiana.

NICOLE CHEVALIER

A History of Excavation at Susa: Personalities and Archaeological Methodologies

Full of emotion, I struck the first blow with the pick on the Achaemenidaean tumulus and worked until my strength gave out. My husband then took his turn with the pick, while our acolytes carried away the loose earth. This is how the excavations at Susa were begun.[1]

JANE DIEULAFOY

*T*he history of the archaeological investigation of Susa begins well before 1884, the year that Marcel-Auguste Dieulafoy and Jane Dieulafoy, his wife and colleague (fig. 21), embarked on their excavations. In the first half of the nineteenth century, the conjunction of a variety of factors—among them the determination of western European nations to further their political interests, thorough familiarity with the Bible, and a general intellectual curiosity about exotic times and places—resulted in a flowering of archaeological exploration in the Near East. Excavations conducted at Susa and other ancient Near Eastern cities eventually played a major role in the transformation of archaeology from a hobby to an academic discipline.[2]

SOLDIERS AND DIPLOMATS (1850–53)

Susa (Shushan) was the opulent setting for the story of Esther and is described in the Book of Daniel as the "fortress of Susa in the province of Elam" (Dan. 8:2).

Figure 20. H. A. Churchill, *Double Demi-bulls*, 1852, a drawing of an Achaemenid column capital from the Apadana mound at Susa. Pencil on paper, H. 11⅝ in. (29.4 cm). London, the British Museum

Figure 21. Jane Dieulafoy, 1886

The ancient city's biblical pedigree and its location in a boundary zone between Mesopotamia and Iran inspired William Kennett Loftus—the discoverer of Warka (Uruk) in southern Mesopotamia—to visit, map, and then excavate Susa in the years 1850–53. Loftus and his colleagues, all members of a British boundary commission attempting to settle claims of the rival Persian and Ottoman empires, were moonlighting as archaeologists. They confirmed that Susa was indeed biblical Shushan, identified the *apadana* (the columned audience hall of the Achaemenid kings), and produced an accurate contour map of the mounds.

THE ROMANTIC DIEULAFOYS (1884–86)

Excavations at Susa resumed in 1884–85 under the direction of the Dieulafoys. Marcel-Auguste Dieulafoy (1844–1920) was an engineer, soldier, and architectural historian seeking "the oriental connections with Gothic art in Europe"; his plan reconstructing the Achaemenid fortifications and palaces is "possibly one of the greatest speculative *tours de force* extant in archaeological literature."[3] Jane Dieulafoy's colorful and richly illustrated accounts of the couple's adventures and their excavations in Susiana and Iran stimu-

lated public interest in her husband's scientific projects.[4] An enormous Achaemenid bull's-head capital (fig. 20) and the famous glazed brick frieze of the archers (Nos. 155, 156), said to have been restored with the assistance of the ceramic factory in Sèvres, were among the most spectacular treasures shipped back and exhibited in the Louvre.

THE MINING ENGINEERS: MORGAN (1897–1908) AND MECQUENEM (1908–46)

In 1897 Jacques de Morgan, a graduate of the École des Mines and an experienced miner, geologist, and archaeologist, took up the excavations at Susa. He and his assistants were unfamiliar with the excavation of mud-brick architecture, and they believed it was pointless to keep track of uneven natural levels that could not be identified.[5] Therefore they focused their efforts on the Acropole, which Morgan considered the most important and most ancient of the mounds at Susa. The principal mounds of Susa were given their names—Acropole, Ville Royale, Donjon, Ville des Artisans, and Apadana—during the period of their excavation by the Dieulafoys and Morgan (see fig. 3, p. xvii). Only the name Apadana has a historical

basis: an *apadana*, or columned audience hall, stood on this site (see pp. 14, 216).

Morgan devised a plan, almost frightening in its efficiency, for the complete excavation of the Acropole mound. He dug a series of mining tunnels into the high vertical face of the southeast corner of the Acropole at various heights, to obtain material from different levels and establish a relative chronology for the site; then he systematically excavated the mound, cutting trenches 16½ feet long and 16½ feet wide (5 m square).[6] Stripping the Acropole at a rapid pace, Morgan uncovered early on many of the most famous monuments in this catalogue. Immediately below Parthian and Achaemenid layers, toward the center of the mound, he discovered the richly adorned temples of the Elamite kings, where the booty captured from Mesopotamian cities may have been displayed (see pp. 159 ff.).

Morgan soon realized that completely excavating the Acropole was impossible. He made his trench smaller and began working downward in the *grande tranchée*, 333 feet (100 m) long, at the Acropole's southwestern edge (fig. 22). He started to find Proto-Elamite tablets[7] in 1901. By 1906–7 he had reached virgin soil and discovered the now-famous cemetery. At the top of Level III, approximately 50 feet (15 m) below the top of the mound, he ran into a mass of *terre pilée*, or hard-packed, archaeologically sterile earth, and stepped his trench in at this point to avoid it, giving the north wall of the excavation the appearance of an open pit mine.

The nature and shape of the mud-brick mass found on the Acropole by Morgan was only elucidated in 1972–77, when the sides and bottom of the *grande tranchée* were reexcavated (see below). The mud-brick core of the site has been given the name *haute terrasse* and is thought to have been a stepped temple platform (see fig. 23, p. 27). Opposite this high terrace toward the western flank of the tell and at a deeper level, Morgan's trench cut through a smaller mass of unbaked brick that was taken to be a town wall or the base of a rampart. Now called the *massif funéraire*, it is where the cemetery, containing a large number of burials (estimated at eight hundred to one thousand by Dyson), was found. Funerary gifts, which were a part of these burials, included finely crafted ceramics that have attracted the attention of art historians, archaeologists, and the lay public.

It is often said that the early excavators of Susa were mining the site only to bring objects back for display in the Louvre. Morgan, however, had hoped to discover the origins of civilization. He was disappointed in the yield of his *grande tranchée* because the fine ceramics and copper objects found in the earliest burials were still far removed from the early stage of human development whose tangible remains he sought.

Morgan's assistant, Roland de Mecquenem, took over as field director of the project in 1908. Mecquenem, like Morgan, was a graduate of the École des Mines. He continued work on the Acropole and excavated below the courtyards of the palace of Darius and east of the *apadana*. Later he expanded the excavations to the Ville Royale and into the area called the Donjon.

By the thirties and forties archaeology in the Near East had changed, with most excavators using the "organic" approach that called for following mud-brick buildings and their floor levels. Mecquenem, however, persisted in the application of Morgan's methods. He had little regard for the mud-brick architecture that made up the ancient city, and although he reported having excavated a well-preserved mud-brick structure in the Ville Royale which he identified as a temple on the strength of several terracotta lions found near it, a plan was never published.

Mecquenem's lack of interest in mud-brick architecture[8] and his ignorance of the Elamite practice of intramural burial (burial beneath the floors of houses) led him to the false conclusion that much of Susa, outside the Acropole and Apadana, had been enormous cemeteries, or *buttes funéraires*. In fact, these areas are city quarters with architectural complexes that contain intramural burials. Many of the small objects of the third and second millennia catalogued in this book, particularly the sculpted bitumen compound vessels and much of the metalwork, come from graves Mecquenem excavated in the Donjon and the Ville Royale.

ROMAN GHIRSHMAN, THE HUMANIST (1946–67)

Unlike his predecessors, Roman Ghirshman was interested in historical archaeology. In his first years at Susa he targeted for excavation the northern part of the Ville Royale, opposite the Achaemenid royal palace, and an area off the main mounds called the Ville des Artisans. Beginning in 1946 he excavated an area of about 2.4 acres (1 ha) in the northern part of the Ville Royale (Ville Royale A) and instituted a second major operation in a part of the Ville des Artisans called the Village Perse-Achéménide, or Achaemenid Village.[9]

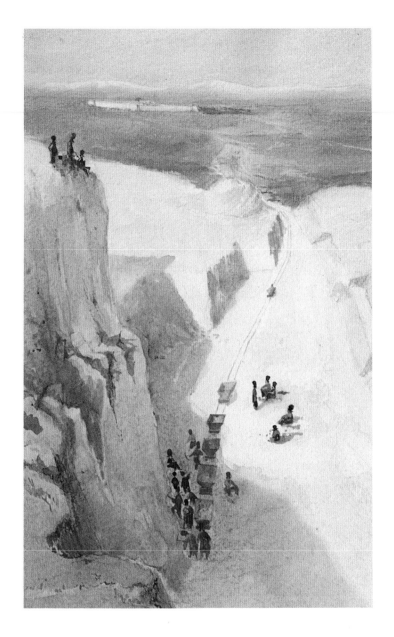

Figure 22. Maurice Pillet, *The Great Trench* (Jacques de Morgan's *grande tranchée*), 1913. Watercolor on paper, H. 19¼ in. (49 cm). Coll. Mme. Étienne Pillet, Le Chesnay, France

Subsequently, from 1951 to 1962, Ghirshman focused his attention on the city now known as Chogha Zanbil, 64 miles southeast of Susa on the banks of the Diz, particularly its ziggurat (stepped temple tower). This was the city of the Middle Elamite king Untash-Napirisha. Ghirshman's work there yielded results that are his most lasting contribution to Elamite studies.[10]

At Susa, each year Ghirshman cleared an architectural level greater than 2 acres in extent in the Ville Royale A, emphasizing horizontal exposure over stratigraphic precision. In 1966 he reached virgin soil at a level of about 50 feet (15 m) below the surface in Ville Royale A and opened a much smaller trench on the southwestern edge of the Ville Royale (Ville Royale B). These excavations have yielded information on city planning and urban life in addition to an almost continuous ceramic sequence reaching from the late third to the end of the second millennium B.C.

THE PREHISTORIAN, JEAN PERROT (1967–90)

Jean Perrot was the first to employ modern methods of stratigraphic excavation at Susa,[11] and to implement them he assembled a multidisciplinary international

team. In cooperation with the Iranian Centre for Archaeological Research under the direction of Firuz Bagherzadeh, active professional and student participation in all phases of the project was initiated. Perrot's aims included establishing an archaeological and cultural sequence within which all the findings could be located chronologically, both for the site of Susa and for the earlier prehistoric mounds of Susiana.[12] A reliable stratigraphic sequence would provide a cultural history of the city and would eventually lead to the establishing of dates for objects from Susa that are without clear provenance. Toward this end, stratigraphic control operations were carried out at the edges of the old trenches dug by Morgan and Mecquenem. In the operation called Acropole I, Alain Le Brun worked on sections dating from about 4000 to 3000 B.C., carefully cleaning a section of the old trench sidewall where a pillar of earth, called the *témoin*, or witness, had been left by earlier excavators as a record of all the excavated layers. Perrot and Denis Canal opened a second operation called Acropole II, attacking the earth mass or *haute terrasse* from the side of the old Morgan *grande tranchée* and eventually gaining some insight into the original size and orientation of the stepped temple platform.

In the Ville Royale (Ville Royale I), Elizabeth Carter worked on the period from about 3000 to 2000 B.C. The period from about 2000 to 1000 B.C. was known through the Ghirshman excavations in the Ville Royale (A and B), and Pierre de Miroschedji undertook to clarify the transition period from the last centuries of the second millennium to the middle of the first millennium B.C., focusing on the Late Middle Elamite through the Neo-Elamite period (ca. 1200–540 B.C.) (Ville Royale II).

This catalogue gives some indication of how much can be learned from a long-term archaeological project (in this case, more than one hundred years) focused on the history and culture of a single ancient city.[13]

ELIZABETH CARTER

NOTES

1. Jane Dieulafoy, 1887a, p. 10.
2. Hudson, 1981, pp. 69–98.
3. Dyson, 1968, pp. 25, 26.
4. Jane Dieulafoy, 1887b, 1888. An interesting biography is Eve and Jean Gran-Aymeric, *Jane Dieulafoy—une vie d'homme* (Paris, 1991).
5. Morgan's example should serve as a warning to present-day archaeologists who discard objects and disregard contexts that they cannot understand.
6. The mound, whose height was taken to be a fixed 35 meters (160 ft.), was divided into seven artificial levels each 5 meters (about 23 ft.) in height. Trenches, 5 meters wide and the length of the tell, were laid out at right angles to a central axis that bisected the tell from north-northwest to south-southeast. Slices of the mound were then removed, working from the outside of the tell toward the center. As many as 1200 workers were employed, as well as large numbers of mining wagons. Architectural remains, but only those of baked brick, were mapped in each strip, and several architectural levels were combined on each plan. Morgan left to his successor the impossible task of putting together the plans of the Elamite levels on the Acropole. Dyson (1968, p. 29) gives the details of this type of excavation method.
7. So called because they were clearly more archaic than the Elamite cuneiform inscriptions found in the upper levels of the Acropole.
8. Clearly expressed in his comments on the work conducted by Georges Lampre and J.-E. Gautier at Tepe Moussian in the Deh Luran plain: "Il nous est difficile de comprendre la méthode du fouilleur; nombreux grattages; fouille méthodique d'une maison en brique crues" Mecquenem, 1980, p. 15.
9. Ghirshman was interested in the coming of the Indo-Iranian populations into Iran and their establishment there. He thought he had identified the first settlement of a newly arrived Achaemenid population in Susa. We now know that the earliest level of the village dates to the Neo-Elamite II period (ca. 725–520 B.C.), but the name Achaemenid Village remains. See Roman Ghirshman, "Village perse-achéménide," *MDP* 36 (1954); Miroschedji, 1981b, pp. 38–40; idem, "Observations dans les couches néo-élamites au nord-ouest du tell de la Ville Royale à Suse," *DAFI* 12 (1981), pp. 143–67.
10. For a complete bibliography of his excavations in Susa and its surroundings, see Steve, Gasche, and De Meyer, 1980, pp. 107–16.
11. See Roche, 1990, pp. ix–xiii.
12. The establishment of the Susiana sequence was carried out by Geneviève Dollfus.
13. The results of the work of Perrot and his colleagues were summarized in Perrot et al., 1989. The most recent excavations are reported in the series *Cahiers de la Délégation Archéologique Française en Iran* (*DAFI*).

PREHISTORIC SUSA
CIRCA 4000 B.C.

*T*he first period of occupation at Susa, from about 4200 to 3700 B.C., is known as Susa I.[1] Susa became the regional center of what is now central Khuzistan province shortly after its foundation. Two discoveries, the *massif funéraire* with its many burials and the *haute terrasse*, a mud-brick platform with the remains of a local ceremonial center on top of it—both dated to this early period—suggest that Susa's importance as a religious center was a major reason for its growth.[2] Elaborate painted ceramics and stamp seals with complicated scenes link the material culture of Susa to the Iranian highlands and distinguish Susian artifacts from those of the contemporary 'Ubaid cultures that flourished 125 miles to the west in southern Mesopotamia. The political affiliations of Susa at this time are unknown.

EC

1. The first four periods of Susa's occupation are defined archaeologically because very little written documentation for them exists. See Frank Hole in Hole, ed., 1987, pp. 29–106.
2. The approximate dimensions of the *massif funéraire* are unknown. The lowest stage of the *haute terrasse* is about 260 feet (80 m) square and about 33 feet (10 m) high. Canal, 1978b, pp. 11–55; cf. p. 40 and figs. 1–3, 7.

The Cemetery of Susa: An Interpretation

EARLY-FOURTH-MILLENNIUM SUSA

Shortly after Susa was first settled six thousand years ago, its inhabitants declared the importance of the spot by erecting a temple on a monumental platform that rose dramatically over the flat surrounding landscape. The exceptional nature of the site is still recognizable today in the artistry of the ceramic vessels that were placed as offerings in a thousand or more graves near the base of the temple platform.

The thirteen vessels in the present exhibition are a mere sample of the two thousand pots recovered from this cemetery, most of them now in the Louvre. Workers under the direction of the eminent French archaeologist and geologist Jacques de Morgan found the cemetery in the first decade of this century while they were exploring the lowest layers of the site, whose elaborately painted ceramics had piqued the excavator's interest.[1] Although the records of the early archaeologists do not provide enough information to reconstruct the exact circumstances that led to the creation of the cemetery, the vessels themselves are eloquent testimony to the artistic and technical achievements of their makers, and they hold clues about the organization of the society that commissioned them.

Painted ceramic vessels from Susa in the earliest "first style" are a late, regional version of the Mesopotamian 'Ubaid ceramic tradition that spread across the Near East during the fifth millennium B.C. It is probable, although debated, that the Susa I pottery style persisted somewhat longer than the 'Ubaid style did in southern Mesopotamia. In any case, the ceramics from this site represent a florescence unparalleled in the 'Ubaid tradition and unequaled in any other prehistoric culture of the Near East. Nevertheless, despite its unique character, the Susa I style was very much a product of the past and of influences from contemporary ceramic industries in the mountains of western Iran.[2] It may be seen as the hybrid offspring of traditions of many regions, part of a brief surge of creative activity that occurred during a time of climatic change and consequent social upheaval in the last half of the fifth millennium.

THE CEMETERY AND THE FOUNDING OF SUSA

The vessels in this catalogue all came from a cemetery partially cut into a low mud-brick platform, called the *massif funéraire* by its excavators. It is located near the base of a monumental mud-brick platform, called the *haute terrasse*, which probably supported temples and other related buildings on the Acropole mound (fig. 23). Although funerary vessels were found on the site as early as 1902, the cemetery was not actually recognized as such until the seasons of 1906–8, when Morgan widened his 25-meter-deep trenches (82 ft.) in the area where the vessels had been found.[3] This excavation, along with work in 1927 and 1936–37 by Morgan's successor at Susa, Roland de Mecquenem,[4] and finally, further excavation by Jean Perrot and Denis Canal in the 1970s,[5] provides the basis for our understanding of the cemetery.

The brief published accounts by Morgan and Mecquenem differ in important details. Morgan, the principal excavator, reported[6] finding a cemetery of graves with at least one thousand fully extended skeletons (an estimate doubled in a later publication), each accompanied by three or four ceramic vessels (fig. 24). He stated that the cemetery covered an area of almost a fifth of an acre (some 750 square meters) and that the bodies had been stacked one on top of the other to a depth of ten feet.[7] Mecquenem, digging two decades

26

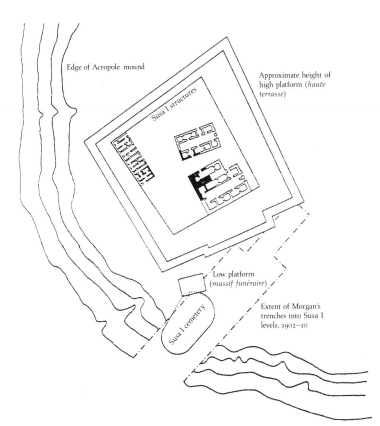

Figure 23. Plan of the Acropole mound ca. 4000 B.C. showing Susa I structures and cemetery, by Frank Hole and Nicholas Kouchoukos

Labels on figure:
Edge of Acropole mound
Susa I structures
Approximate height of high platform (*haute terrasse*)
Low platform (*massif funéraire*)
Susa I cemetery
Extent of Morgan's trenches into Susa I levels, 1902–10

Figure 24. Early reconstruction of a Susa I burial

later in the same area, apparently took the low mud-brick platform into which graves had been cut for the cemetery. He then "corrected" Morgan's description, asserting that the cemetery consisted of a circular area only forty feet in diameter in which secondary burials were stacked to a height of ten to thirteen feet.[8] According to his "recollections" (it is not certain that he actually witnessed the original excavation of the cemetery), the skulls were usually set in bowls and the long bones in tall beakers. In retrospect this seems unlikely, since there are no reported discoveries of bones of deceased adults placed in vessels at any other site in the Near East.[9] However, if we simply accept the premise that some burials in the cemetery were fractional— meaning that not all the bones are present—as has been demonstrated by Perrot and Canal, the necessary corollary is that interment took place after the flesh had decomposed.[10] Either the burials took place after bodies had lain in a charnel house, or the bones were exhumed from normal burials and reburied. Fractional burials take little space; if this was the typical mode of interment, and if the arrangement was very compact, Morgan's mound might conceivably have held the two thousand burials of his later estimate.

The most important points to be inferred from the limited evidence are: first, the cemetery covered a relatively small area; second, clean earth surrounded the bodies; third, the bodies were stacked closely one upon the other; fourth, many burials took place after the flesh had decomposed; and fifth, a large number of the burials occurred more or less simultaneously.

The last point needs to be stressed. Cemeteries were usually quite extensive, as there was a need to accommodate the individual tombs and to ensure that one grave would not encroach upon another. Rarely if ever were bodies closely stacked one above another. The most reasonable explanation for the apparent violation of these principles at Susa is that the bodies were all buried at the same time.[11] In this hypothetical reconstruction, sometime after the flesh had decomposed from the skeletons of a thousand or more corpses, their bones and pots were gathered up for interment in a huge common grave. After each layer of human remains and pottery was laid in place, it was covered with a thin layer of clean earth. Perhaps the bones of a number of the dead had been gathered and placed in the ceramic vessels associated with them, as Mecquenem indicated; however, it is clear from both the original excavations and the most recent ones that this was not always the case.

If a simultaneous interment seems the most probable explanation for this unusual find, what could have caused such an extraordinary event? In searching for answers we should consider the possibility of a widespread phenomenon and examine a region greater than Susa itself.

ENVIRONMENTAL CHANGES

In the period around 4000 B.C., southern Mesopotamia was undergoing a profound climatic change which resulted in the abandonment of many sites and the general depopulation of entire regions. The same phenomenon is seen particularly well in western Iran in the area stretching from the lowlands surrounding Susa to the mountain valleys and plateaus of the Zagros.[12] The depopulation began as early as 4500 B.C. and culminated just after 4000 B.C., when climatic conditions set in that were similar to those of the present day, and populations slowly began to grow again.

Underlying these changes was a gradual decrease in the amount of solar radiation absorbed by the Earth during the summer months, caused by changes in the planet's orbit and tilt in relation to the sun. The decrease in solar radiation affected the route of the monsoon storms, which today move through the southern part of the Arabian peninsula but which brought rainfall to southern Mesopotamia in the sixth and fifth millennia B.C.[13] At the same time the sea level rose rapidly, flooding the land around the Persian Gulf.[14] And, as they met the rising sea level, the Tigris, Euphrates, and Kharkheh rivers dropped enormous amounts of silt on the alluvial plain. Thus, the people of the fifth millennium experienced the rapid transformation of their landscape and what seems to have been a very abrupt change in patterns of rainfall, which must have seriously affected both their agriculture and the pastureland for their flocks.

Despite a general decline in the populations of most regions during the second half of the fifth millennium, a few sites grew considerably larger; some of these, such as Susa, Warka, and Eridu, had large temples.[15] The understandable emphasis on religion during this time of acute stress reflects one way people coped with exigencies that seemed to be out of direct human control, as climate certainly was.

During the latter part of the fifth millennium a number of populous sites apparently experienced

strife—burning and destruction. Susa may in fact have been founded in the aftermath of one such event. At the nearby site of Chogha Mish, fire destroyed the central precinct consisting of monumental buildings, and subsequently the town was abandoned;[16] at about the same time the first settlement was begun at Susa, perhaps by refugees from Chogha Mish. The new site was along the Shaur River on a pair of hills twenty-five feet high, a spot where no one had lived before.

Both these facts—the site's previously uninhabited state and the hills underlying it—are not easily explained. It is possible that the Shaur River changed course around 4000 B.C., allowing access to the site for the first time, but it is difficult to understand the presence of twenty-five-foot hills in a region of nearly flat landscapes. The excavation reports all agree that beneath Susa lie these hills of "yellow clay," an apparently natural geological deposit.[17] However, since such hills are not to be found elsewhere on the plain, we may at least speculate that they were raised by the first settlers to provide a base for their temple and village. A site that had recently emerged from a marsh, along a potentially flooding river, might have required such a foundation, although the size of this earthwork would have been unprecedented for its time and greatly exceeds that of the high platform built upon it.

Unlike its predecessor Chogha Mish, which sat squarely in the center of the fertile agricultural plain of Susiana, Susa was situated at the plain's edge. The relocation may have had something to do with the decrease in rainfall, which made river-bottom land more valuable for agriculture than plains land.

THE PLATFORM OR *HAUTE TERRASSE* ON THE ACROPOLE

Susa was the regional religious center, to judge from the presence in its midst of a platform some 260 feet long which stood perhaps 30 feet above the surrounding settlement and nearly 60 feet above the flat surrounding plain.[18] One of the first structures on the Acropole mound had been a low mud-brick platform, the *massif funéraire*, into which some Susa I burials were cut. Some time later the high platform, or *haute terrasse*, was built only 35 feet to the north.

The high platform probably rose in a series of steps; on the excavated, southern side, the lowermost step is preserved. Temples and associated buildings, such as storerooms and possibly a charnel house, stood

atop the platform.[19] Fragmentary remains of architecture recovered from the top of the platform allow a tentative reconstruction of the buildings. This stepped platform was unfortunately destroyed, perhaps when the buildings on its summit were burned. The facade of the platform collapsed around its base, along with burned debris. After rebuilding and a possible abandonment, the facade collapsed again. Although people continued to live at Susa, it is not clear whether they rebuilt the platform once more. Eventually the erection of other structures on the remains of the platform obliterated most traces of the earlier buildings.

The burning of buildings on the high platform on the Acropole mound is paralleled by the destruction of the contemporary Susa I settlement on the Apadana mound and reflects the tumultuous times of the late fifth–early fourth millennium B.C., which saw similar destructions at other large Iranian sites such as Tepe Sialk to the north and Tal-i Bakun to the southeast of Susa[20] as well as the abandonment of fertile regions, both on the lowland plains and in the mountains, that previously had been well populated.[21]

CERAMIC VESSELS FROM THE CEMETERY

Approximately one thousand restored vessels from the cemetery are in the Louvre and the National Antiquities Museum at Saint-Germain-en-Laye. Another five hundred or so remain in Iran, and perhaps five hundred more belong to the Louvre but are still unrestored. Thus, approximately two thousand of the three to eight thousand vessels reported by Morgan can be accounted for. Because this collection is large, intact, and accessible, it affords a unique opportunity for the study of stylistic variation and variability at one site over a short period of time. Moreover, vessels may be studied that were made primarily for display rather than for daily use and that make up a coherent burial assemblage. (Careful surface surveys of hundreds of prehistoric sites around Susa have turned up few ceramics of the type characteristic of burials, and excavations have shown that domestic pottery consisted largely of coarser, utilitarian wares. While we cannot be certain that the pottery pieces found with the burials had not been in daily use,[22] it is clear that most often only certain types of vessels, highly decorated and fragile, were included with the burials.)

The pottery is carefully made by hand. Although a slow wheel may have been employed, the asymmetry of the vessels and the irregularity in the drawing of encircling lines and bands indicate that most of the work was done freehand.

The recurrence in close association of vessels of three types—a drinking goblet or beaker, a serving dish, and a small jar—implies the consumption of three types of food, apparently thought to be as necessary for life in the afterworld as it is in this one. Ceramics of these shapes, which were painted, constitute a large proportion of the vessels from the cemetery. Others are coarse cooking-type jars and bowls with simple bands painted on them and were probably the grave goods of the site's humbler citizens, including adolescents and perhaps children. Infants were generally buried separately.

Individuality is the hallmark of the painted vessels. Although at first glance many of them appear quite similar, almost invariably each contains a motif or combination of motifs that is not to be found on another vessel. Clearly, these wares were not repetitively mass-produced. They were made to be different, although all strictly follow local canons of composition, layout, and the use of motifs. The entire corpus reflects a wide range of skills in manufacturing and painting, with only a few reaching the highest level. Some of the finest examples, very likely made for the elite of Susian society, were widely copied. The variety and individuality of these specialized wares indicate that there were many artisans producing them. The vessels apparently were used for display and on special occasions, and in the end they were placed in the grave with their owners.

This pervasive individuality is not, however, to be found in one group of tall beakers which displays little variation in design. They all show a band of large *V*-shapes encircling the body (No. 12). The anomalous uniformity of these beakers suggests that they were all manufactured and painted during one brief period and perhaps by one workshop. This might have occurred during a catastrophic episode of the type described earlier. The beakers' similarity of shape, proportion, and design seem to indicate mass production, whereas their large size and fragility suggest that they were not strictly utilitarian objects. However, sherds with similar designs have been found on the surfaces of other sites.

Analysis of the styles and forms of the cemetery vessels suggests that they were manufactured over several generations. However, as was already noted, the closely packed remains in the cemetery point to one general interment. How might simultaneous burials

be reconciled with the variations in age of the ceramic vessels? One possible explanation is that, as discussed earlier, bodies with their associated grave goods accumulated over a long period of time in a charnel house, and bones and pottery were later reburied en masse. To account for the debris and skeletal remains he found at the base of the platform, Canal inferred that a charnel house had burned during the Susa I destruction.[23] In this scenario, although the burials were simultaneous, the deaths took place over an extended period of time.

Another explanation is that the deaths themselves occurred simultaneously. In this case the chronological and stylistic range displayed by the pottery can be explained by assuming that people acquired fine ceramics during the course of their lifetimes and kept them until death, and thus the oldest persons owned vessels in styles that preceded the fashions current at the time of their death. The sacking of Susa that is suggested by the destruction of both the high platform on the Acropole and buildings of the Apadana mound might have been the occasion for so great a loss of lives, after which the survivors may have removed the remains of their fellow citizens from the ruins and buried them in the common grave. A thousand people or more might also have died during a raid on the site, or as a result of disease, famine, or other natural catastrophe. It is unlikely that we will ever know what happened with any certainty.[24]

METAL OBJECTS

In addition to ceramics the cemetery contained some fifty-five hammered copper "axes." They are similar in shape to stone examples that have been widely found at contemporary sites and were probably used as hoes. These objects contain greater quantities of copper than do finds from any other site of the same period. Unquestionably they represent considerable wealth. The metal was obtained from a source where raw copper occurs in nearly pure form, probably on the Iranian plateau near the site of Tepe Sialk.[25] Some of the axes contain traces of arsenic, commonly used in the making of bronze in fourth- and early-third-millennium Iran, and one is said to contain tin.[26] A few of the axes carry traces of a woven fabric, pre-

served through the action of copper oxides in contact with cloth.

There are also eleven copper disks, four of them pierced for suspension and perhaps worn hanging from a cord around the neck. Such disks, often thought to have been mirrors, were probably worn by priests during certain ceremonies (see No. 18). It may be that the copper disks and axes were used primarily in religious ceremonies and then buried with the individuals who performed them. It is interesting to note that they were apparently still in use several hundred years later, since they have been found in a burial on the Apadana mound dating from the Uruk period.[27]

SEALS AND SEALINGS

Two unfired clay sealings and a stamp seal of bitumen compound dating from the late fifth or early fourth millennium are catalogued below. They are part of a corpus of over 250 seals and sealings of this period found at Susa. Whereas the oldest seals from Susa and other Iranian sites have geometric designs, a series of motifs on seals and sealings that apparently dates to late Susa I times is partly figurative. Particularly noteworthy are images of the "master of animals," an anthropomorphic figure with a stylized or animal-like head, holding snakes.[28] Sometimes this figure is associated with the same animals that appear on the Susa ceramics.

The figural designs on the engraved seals supply, more fully than do the designs on the cemetery vessels, a context that can help us understand the nature of the site and perhaps of the cemetery itself. It seems clear that religious ceremonies were conducted on the temple platform in which ceramic vessels containing offerings were used. The priests wore symbols of their office such as copper disks; they emulated the forces of nature by wearing headdresses representing creatures epitomizing those forces, like the mountain goat. A number of these priests were buried in the cemetery along with the symbols of their office, but the majority of the deceased were probably ordinary citizens whose status was reflected by the lesser quality of their ceramic vessels.[29]

FRANK HOLE

NOTES

1. Those ceramics were found in gallery B, an exploratory tunnel dug by Morgan some 65 feet below the surface of the mound. Jacques de Morgan, 1900d, p. 83.
2. Le Breton, 1957, pp. 81–94.
3. Morgan, 1907, pp. 397–413; idem, 1908, pp. 373–79.
4. Mecquenem, 1928b, pp. 100–113; idem, 1943, pp. 3–161.
5. Canal, 1978a, pp. 169–76; idem, 1978b, pp. 11–55.
6. Morgan, 1908, p. 375.
7. Morgan, 1912, pp. 2, 7.
8. Mecquenem, 1943, p. 5.
9. Hole, 1990.
10. Canal, 1978b, pp. 33–34.
11. Hole, 1990, pp. 10–12.
12. Frank Hole, "Archaeology of the Village Period," p. 42, and "Settlement and Society in the Village Period," in Hole, ed., 1987, pp. 85–86.
13. COHMAP Members, "Climatic Changes of the Last 18,000 Years: Observations and Model Simulations," *Science* 241 (August 1988), pp. 1043–52. This study describes a general increase in rainfall between 10,000 and 4,000 B.C. across North Africa, Arabia, and Mesopotamia, lands that today are largely desert.
14. Paul Sanlaville, "Considérations sur l'évolution de la base Mésopotamie au cours des derniers millénaires," *Paléorient* 15 (1989), pp. 19–20.
15. For Eridu see Safar, Mustafa, and Lloyd, 1981, pp. 85–114; for Warka see Jürgen Schmidt, "Steingebäude," DAI, 1972, pp. 24–25.
16. Kantor, 1976, pp. 27–28.
17. Morgan, 1912, pp. 2–3; Steve and Gasche, 1990, pp. 24–25.
18. Dimensions quoted vary. See Canal, 1978b, p. 40, and Steve and Gasche, 1971, p. 41.
19. Steve and Gasche, 1971, p. 188; Canal, 1978b, p. 38.
20. Ghirshman, 1938–39, vol. 1, p. 58; Langsdorff and McCown, 1942, p. 15; Steve and Gasche, 1990, p. 26.
21. Hole, "Settlement and Society in the Village Period," in Hole, ed., 1987, pp. 85–86.
22. Sherds of some of the beaker styles are found on the surface at a number of sites, but the shallow bowls and little jars are rarely found. At Susa itself, both bowls and beakers have been found associated with the settlement. Le Brun, 1971, fig. 36, illustrates bowls; Morgan, 1900a, Appendix No. 1, pls. 17–20, illustrates sherds of beakers similar to those of the cemetery.
23. Canal, 1978b, pp. 38–39.
24. Hole, 1990, pp. 10–14. Perhaps as many as two thousand people lived in Susa. One estimate places the total occupied area of Susa (the Apadana and Acropole), including the platform and cemetery, at about 32 acres (13 ha). On the basis of the census of villages in the region today, archaeologists often assume that the residential areas of prehistoric sites held one to two hundred people per hectare. See Steve and Gasche, 1990, pp. 25–26.
25. T. Berthoud, "Étude par l'analyse de traces et la modelisation de la filiation entre minerais de cuivre et objets archéologiques du Moyen-Orient (IVe et IIIe millénaires avant nôtre ère)" (Ph.D. diss., Université Pierre et Marie Curie, Paris, 1979), p. 114.
26. Stech and Piggott, 1986, p. 43; Tallon, 1987, p. 314. [The fragmentary "axe" (adze) Sb 11347 (Tallon, 1987, no. 470) contains 0.82 percent tin. According to the Louvre inventory, it comes from the Susa I cemetery. However, of the 62 Susa I copper artifacts that have been analyzed, 61 have no trace of tin and one contains 0.01 percent tin. Since some objects described in the same inventory as coming from the cemetery are obviously later, it is reasonable to question whether Sb 11347 really dates from the Susa I period—FT].
27. Steve and Gasche, 1990, p. 22 n. 34, pl. 9.
28. See, for example, Amiet, 1972a, pl. 45, no. 144.
29. I am grateful to Nicholas Kouchoukos for many discussions about Susa's cemetery and ceramics and their relationship to those of other sites; for help locating sources; and for compiling the necessary information and then drafting figure 23.

Susa I Pottery

1 BEAKER WITH IBEXES
Baked clay, painted
H. 11⅜ in. (28.9 cm); DIAM. 6½ in. (16.4 cm)
Susa I period, ca. 4000 B.C.
Cemetery, Acropole; Sb 3174

The upper register of this beaker is filled with sche-matically drawn long-necked birds. In the next reg-ister are reclining dogs, and below that two vertical panels, each containing an ibex, or mountain goat, whose horns curve back to form a large circle over its body. Inside the arc of the horns a design within a circle appears, a type of motif that is the dominant decoration on many open bowls.

Relatively few beakers from the Susa cemetery match this one in style or quality of draftsmanship. Although ninety-one tall beakers have a similarly structured design with vertical panels, only ten dis-play the round, arching goat horns, generally enclos-

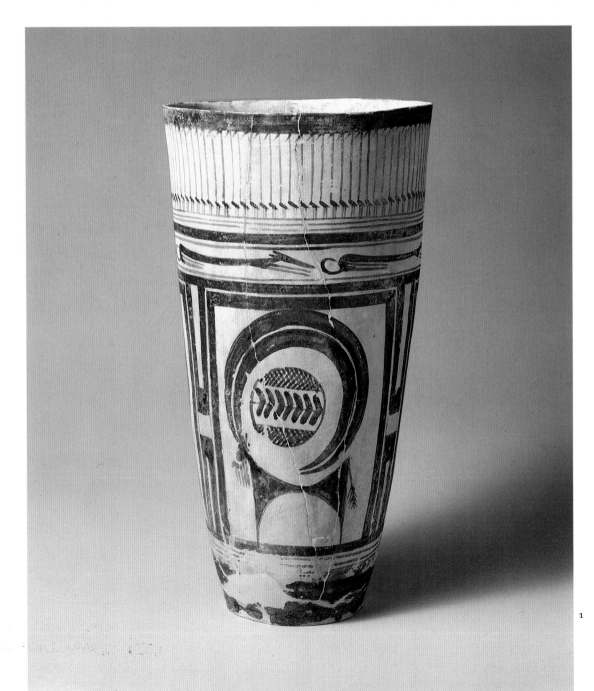

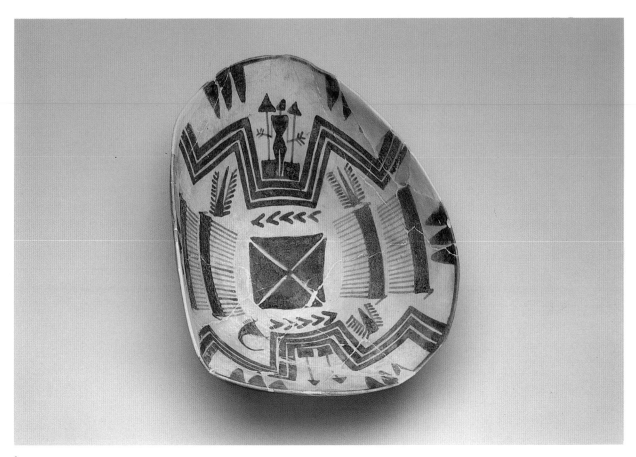

2

ing a circular motif. Both the proportions of the
vessel and the style of its decoration indicate that it
was produced late in the sequence. The vessel is very
large and can hold approximately one gallon of liq-
uid, weighing about eight pounds. As a drinking
vessel it would have been unwieldy and perhaps too
fragile to lift. It is likely that this kind of vessel
was made more for prestige and display than for
normal use.

The goat, *Capra hircus*, is native to the Zagros
Mountains a short distance from Susa and is the
wild ancestor of the domestic goat. Although the
meanings of the symbols on this beaker are not
clear, in Sumerian iconography the goat represented
fresh water as well as vital procreative forces. The
dogs are of the saluki or greyhound type, a slender-
bodied hunting dog typical of the hot desert regions.
The long-necked birds are generally thought to be
wading water birds of the kind often seen on the
Susiana plain in winter (fig. 4, p. 3).

FH

2 BOWL WITH A HUMAN FIGURE
Baked clay, painted
H. 4⅛ in. (10.6 cm); DIAM. 8¾ in. (22.3 cm)
Susa I period, ca. 4000 B.C.
Cemetery, Acropole; Sb 3157

This open bowl, which is greatly warped, has an in-
terior decoration that is basically bilaterally sym-
metrical. Framed by geometric design elements is
an anthropomorphic figure standing between two
pedestals surmounted by pointed staffs. There are
also two pairs of double-headed creatures ("comb-
animals"), which may be stylized sheep, and three
vulturelike birds. Instead of a fourth bird, as sym-
metry would dictate, a scorpion appears. None of
these motifs are to be seen on beakers, although
similar birds commonly occur on little jars like
Number 10 in this catalogue, and the "sheep" fre-
quently adorn open bowls. Pierre Amiet calls the
sheep one of the sacred animals of ancient Iran.[1]

Anthropomorphic figures appear on only four vessels from the cemetery and in general are rare on contemporary pottery from the Near East. The figure on this bowl is interesting iconographically because it stands with arms outstretched, perhaps grasping the two staffs. The stance is familiar from contemporary seal engravings of "masters of animals" who are usually depicted grappling with snakes, lions, or mythical beasts rather than holding inanimate objects (see No. 18). The two spadelike staffs in this image resemble the identifying sign later associated with Marduk, the Mesopotamian god who first assumed divine leadership after popular election by his peers. The digging spade was the principal tool of Marduk, who was known as the god of irrigation. The design niche on the opposite side of the bowl has no figure but does contain the double staff motif.[2]

By analogy to Mesopotamian examples, then, the figure on this bowl may be tentatively identified as an early leader, perhaps the personification of an agricultural deity. Indeed, the series of lines enclosing the figure might conceivably represent irrigation canals.

Any interpretation of the other figures is even less secure. The comblike creatures are double-headed. If they are sheep, the multiple vertical lines probably represent their wool. They can be thought of as exemplifying animal husbandry, the complement to agriculture; nevertheless, their meaning is obscure. The birds may be vultures, ubiquitous in this region, which as consumers of carrion are suggestive of death.

Thus the motifs on this bowl suggest elemental themes: the life-giving powers of a beneficent god, the bounty of agriculture and stock-raising, and the inevitability of death.

FH

1. Amiet, 1966, p. 28.
2. Ibid., p. 43; Morgan, 1912, p. 6.

3 BEAKER WITH SNAKES
Baked clay, painted
H. 11¾ in. (30 cm); DIAM. 8¼ in. (20.8 cm)
Susa I period, ca. 4000 B.C.
Cemetery, Acropole, Sb 3168

Although a vessel similar to this one was uncovered with an infant burial in the habitation area, at the north end of the Acropole mound, and a number of beaker sherds with snake motifs have been found at the south end of the same mound,[1] neither in the structure of its design nor in its morphology does this vessel fit comfortably among the finds from the cemetery. Designs on the cemetery vessels are rather rigidly structured, having motifs contained within lines or broad bands in horizontal or vertical series. This beaker, however, instead of framing or organizing elements has a solitary motif against a plain background: two snakes on opposite sides of the vessel, with a stepped divider between them.

The snakes, shown in side-winding locomotion, are almost certainly of the type *Echis carinatus* or *Echis coloratus*, species of saw-scaled vipers which are found across North Africa and the Near East.[2] This type of snake attains a length of up to three feet, possesses a highly toxic venom, and has been responsible for many deaths among local people. Very adept at moving through loose, sandy soil by means of its side-winding action, it produces a hissing sound by rubbing its scales against each other.

The snake occurs as an iconographic element on many types of objects. One example is Number 18, an impression of a seal from Susa that shows a goat-horned "master of animals" grasping a snake in either hand. Ceramic snakes are known from two 'Ubaid sites in southern Mesopotamia: a free-standing modeled snake from Temple VII at Eridu, and snakes modeled onto the surfaces of ceramic vessels from Warka.[3] All appear to represent the same type of viper as do those from Susa.

An incision marks off the upper third of this vessel from the lower body. The incision may have been made preparatory to removing the beaker's upper section, but neither the cutting of the groove nor the "decapitation" was ever completed.

FH

1. In soundings 1 and 2; Mecquenem, 1934, pp. 183–4.
2. Parker and Grandison, 1977, p. 34, pl. 15.
3. On Warka see Boehmer, 1972, pl. 51, nos. 190–91, 212–14; on Eridu see Safar, Mustafa, and Lloyd, 1981, p. 230, fig. 110.

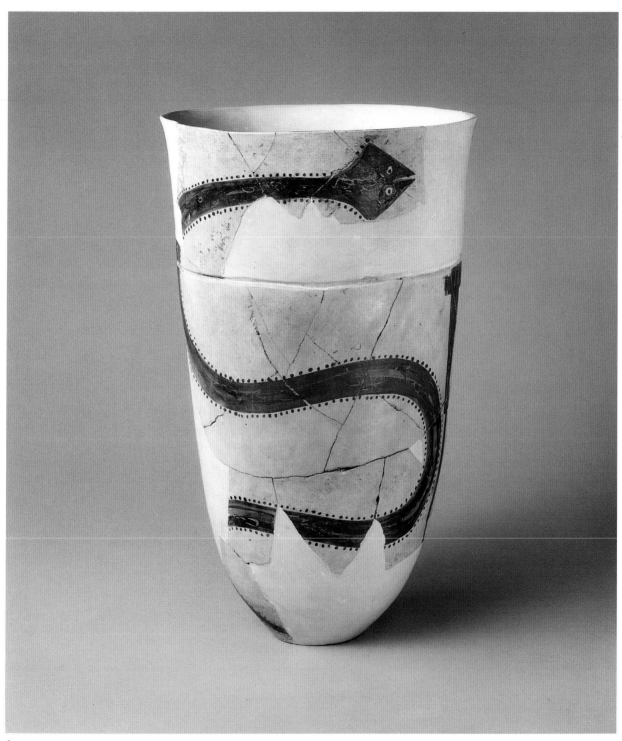

3

4

5

4 SMALL BOWL WITH IBEXES AND DOGS
Baked clay, painted
H. 2½ in. (6.2 cm); DIAM. 5¼ in (13.2 cm)
Susa I period, ca. 4000 B.C.
Cemetery, Acropole; Sb 3131

5 BOWL WITH "COMB-ANIMALS"
Baked clay, painted
H. 3⅞ in. (9.7 cm); DIAM. 8⅞ in. (22.6 cm)
Susa I period, ca. 4000 B.C.
Cemetery, Acropole; Sb 3178

The surface of this tiny open bowl is replete with goats and dogs, and its spaces are busily filled with small vertical zigzags or "bird" marks. The dense design and repetitive use of motifs are uncharacteristic for an open bowl from this cemetery, although Number 9 is similar.

The wild mountain goats (*Capra hircus*) are rendered less fluidly here than on Number 1 and other beakers, perhaps because of the difficulty of painting on a small concave surface. Beneath the goats' bodies are pyramidal designs which may represent mountains. The salukis, or greyhounds, are shown reclining, not running as is sometimes said. These dogs are known from the lowlands, where in historical times they were widely used for hunting, while the goats are denizens of the mountains. As with the ibex beaker (No. 1), this vessel's decoration alludes to the two major geographic domains of the Susa environment, the steppe-desert and the mountains, and depicts both the hunter and the hunted. It is possible that the wild goat refers not to the hunt but rather to powers of procreation and life-giving fresh water; in that context, however, the reason for the dogs' presence is obscure.

FH

A large number of the cemetery vessels, about 360, are open bowls. Some fifteen percent of them have a tripartite design on the interior. On this typical example the comb or sheep motif appears three times, along with filler designs that are probably purely geometric. As Georges Contenau notes, the comb motif has also been variously interpreted as a double-headed eagle with outstretched wings, a cloud with falling rain, and an ibex with multiple legs.[1]

FH

1. Contenau, 1938–39, p. 176 n. 1.

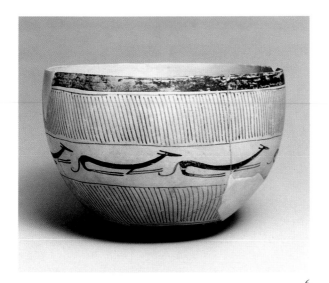

6

7

6 BOWL WITH SALUKIS
Baked clay, painted
H. 3⅜ in. (8.6 cm); DIAM. 4⅝ in. (11.9 cm)
Susa I period, ca. 4000 B.C.
Cemetery, Acropole; Sb 3208

7 BOWL WITH TURTLE AND COMB-ANIMALS
Baked clay, painted
H. 3⅛ in. (8.1 cm); DIAM. 6⅞ in. (17.4 cm)
Susa I period, ca. 4000 B.C.
Cemetery, Acropole; Sb 3154

The upper and lower registers on this bowl's exterior consist of nearly vertical parallel lines, perhaps a counterpart to the stylized stick-birds seen on some of the beakers. In the central register a row of saluki dogs lie in repose.

The bowl is one of only thirteen vessels of hemispherical shape found in the cemetery. Similarly shaped bowls are common finds in habitation areas, both at Susa and at other sites. They probably contained beverages for drinking. In decoration as well as form, the few hemispherical bowls from the cemetery differ markedly from most of the grave offerings found there.

FH

This is a rare example of an open bowl with a naturalistic motif in the central area of the base. In other respects the vessel is of a standard type commonly found in the cemetery; its border bands are deeply indented, dividing the design space into symmetrical halves and creating four enclosed spaces that hold subsidiary motifs. Two "comb creatures" oppose one another in each half of the vessel, while the indented niches hold "quiver" motifs, design elements seen on some tall beakers (e.g., No. 12). The animal represented in the center of the bowl is thought to be a turtle.[1]

FH

1. See Roland de Mecquenem, "Catalogue de la céramique peinte Susienne," *MDP* 13 (1912), p. 121, pl. 17:2; Edmond Pottier, *Corpus Vasorum Antiquorum*, France, part 4, Musée du Louvre, I (Paris, 1925), pls. 5:11, 9:17.

8

8 BEAKER WITH SALUKIS AND BIRDS

Baked clay, painted
H. 7½ in. (19.2 cm); DIAM. 4⅜ in. (11.2 cm)
Susa I period, ca. 4000 B.C.
Cemetery, Acropole; Sb 3165

A small beaker, this vessel seems suitable for indi-
vidual use as a drinking cup, unlike Number 1,
which probably was not meant to be raised to the
lips. The beaker's design is dominated by the typical
rigid framework of horizontal registers and vertical
panels. The upper register contains a row of long-
necked birds, perhaps herons, separated in charac-
teristic fashion from the panels below by three nar-
row horizontal lines and a broader band. In each of
the vessel's three large vertical panels, salukis repose
above and below a rectangle filled with parallel wavy
lines. One might interpret this as a scene of dogs
lying at the edge of a pool. The panels are separated
by geometric motifs in traditional Susiana style, and
the base of the vessel is marked by another series of
horizontal lines with a band.

A design of equally rigid formality appears
on beaker Number 1. Both stylistically and morpho-
logically, this beaker appears to be a late example.

FH

9 BOWL WITH IBEXES AND CHECKERBOARD PATTERNS

Baked clay, painted
H. 3⅜ in. (8.7 cm); DIAM. 8¾ in. (22.2 cm)
Susa I period, ca. 4000 B.C.
Cemetery, Acropole; Sb 3179

This open bowl shares with Number 4 both its deco-
rative theme—a series of goats surrounding the
base—and the absence of bands or other spatial di-
viders of the sort generally found on Susa bowls.
The goats on the two vessels might well have been
executed by the same hand, even though the arch of
the goats' horns is much more fully rounded on this
bowl, perhaps a possibility offered the artist by its
shallower surface. Beneath each goat are two wavy
lines suggesting water, which is often associated with
the wild goat, *Capra hircus*. The remaining motifs
are common Susian geometric design elements such
as checkerboard lozenges, stacked series of inverted
*W*s, and multiple pendant lines, all of which serve as

9

space fillers. The repetition of many elements creates an extraordinarily busy composition. This bowl's quadrilateral layout is a rare departure from the bilateral symmetry usually seen on Susa vessels.

FH

10 CARINATED JAR WITH BIRDS IN FLIGHT
Baked clay, painted
H. 3⅜ in. (8.5 cm); DIAM. 5 in. (12.8 cm)
Susa I period, ca. 4000 B.C.
Cemetery, Acropole; Sb 3167

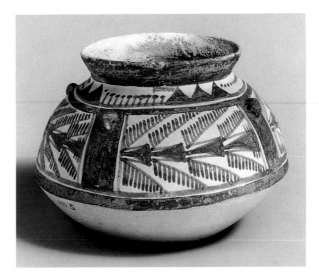

10

This small, carinated, short-necked jar is of a style commonly found in the Susa cemetery and other nearby deposits but rarely uncovered at other sites. These vessels characteristically have small lugs for suspension located in the vertical areas separating the design panels. The jars probably held liquids that were too valuable to be entrusted to a place on the floor, like honey or oil, although they also seem to have been of particular importance for burial rites.

 The decoration of the jars often features birds flying in tight formation. The birds might be any of several that occur in the region, perhaps eagles, vultures, storks, or herons.

FH

11 BEAKER WITH WAVY LINES
Baked clay, painted
H. 4 in. (10.3 cm); DIAM. 3½ in. (9 cm)
Susa I period, ca. 4000 B.C.
Cemetery, Acropole; Sb 3189

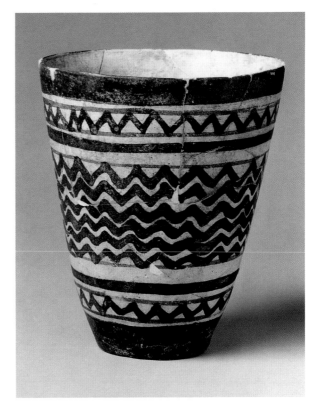

11

The decoration of this beaker is steeped in Susiana tradition. It consists of a series of rigidly defined horizontal registers, each containing a variant on a wavy line or a group of such lines. The vessel can be interpreted as one of the oldest in the cemetery group because of its proportions and its purely horizontal composition.

FH

12 BEAKER WITH ZIGZAG DECORATION
Baked clay, painted
H. 10¼ in. (26 cm); DIAM. 5⅞ in. (14.8 cm)
Susa I period, ca. 4000 B.C.
Cemetery, Acropole; Sb 14271

This tall beaker is of a particularly common type. It is encircled by a band of parallel lines making a zigzag pattern that is almost the full height of the vessel. Horizontal lines appear here only at top and bottom and do not break the vertical space as they do on all other beakers. Horizontality is introduced, however, by the motifs tucked into the angles of the zigzag.

These vessels are in general standardized, displaying less variation than do any other class of ceramics found in the cemetery. Differences appear principally in the handling of motifs in the zigzags. These are of two types, either checkerboard lozenges or a design that has been interpreted in various ways: as arrows in a quiver, as baby storks in their nest, and as reeds in a marsh.[1]

Vessels of this class are the tallest and largest of all beakers, although this example is of only average size.

FH

1. Contenau, 1927–31, vol. 1, p. 400 and 400 n. 2.

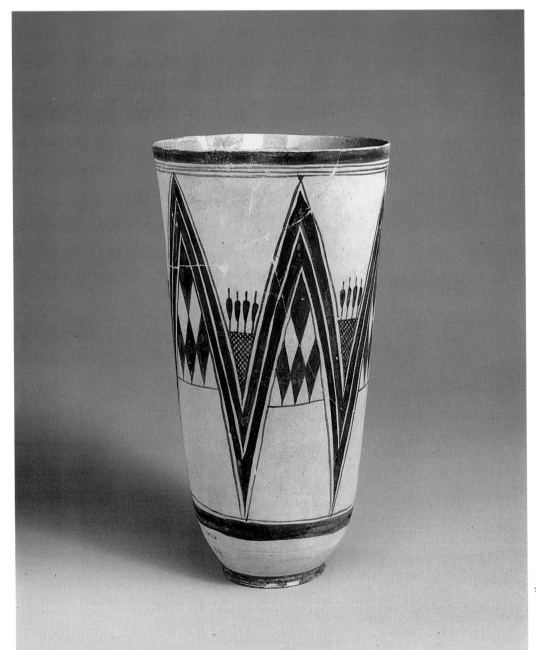

12

13 BOWL WITH GEOMETRIC DECORATION
Baked clay, painted
H. 3½ in. (9 cm); DIAM. 8 in. (20.3 cm)
Susa I period, ca. 4000 B.C.
Cemetery, Acropole; Sb 3182

13

Bilateral symmetry governs the organization of motifs, which are chiefly geometric, on this open bowl. The concentric bands ringing the perimeter are marked by two deep indentations that divide the round field and flank a square central motif. One indentation contains small vertical zigzags; the other, pairs of short vertical marks. Each of the two semicircular spaces created by the division is dominated by a circular motif enclosing a rectangular panel of parallel wavy lines (symbols of water). Curved triangles made up of smaller triangles fill the remaining spaces.

Although among the cemetery group there are nearly two hundred vessels with a bilateral decorative scheme in which sets of lines create deep niches, only fifteen of them have the circle motif. Most, like Number 2, have comb-animals or checkerboard lozenges as the dominant motif. The circle motif is commonly found, however, on open bowls with a three-sided layout.

FH

OBJECTS OF BITUMEN COMPOUND AND TERRACOTTA

14 SMALL VASE
Bitumen compound
H. 4⅛ in. (10.4 cm); DIAM. 2 in. (5.1 cm)
Susa I period, ca. 4000 B.C.
Sb 366

This elongated conical vase with a button base is made of bitumen compound, a material that was often used at Susa—perhaps as a substitute for dark stone.[1] Stone and terracotta vessels of the same shape were recovered from the cemetery at Susa. They were often found in association with mirrors in the graves identified by the excavators as female burials.[2]

ZB

1. For a discussion of bitumen compound see pp. 99–101.
2. Morgan, 1912, pp. 8–9, figs. 15–19, pl. 23.

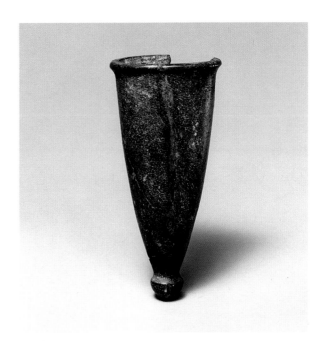

14

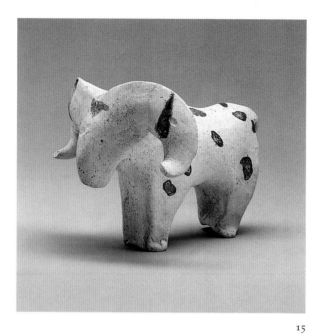

15

15 MOUFLON
Buff terracotta; painted brown spots
H. 2¼ in. (5.8 cm); L. 3⅜ in. (8.6 cm)
Susa I period, ca. 4000 B.C.
Sb 5883
Excavated by Mecquenem.

The animal and human figurines modeled of terra-cotta in the earliest days of Susa are schematic representations reduced to the bare essentials. Typically, quadrupeds have compact, stocky bodies and legs that are modeled two by two, with a characteristic rounded space separating the fore and hind legs. This animal is identifiable as a mouflon, or wild sheep, by its large stylized horns and its snout. The eyes and mouth are not depicted.[1]

AS

1. Mecquenem, 1934, p. 186, fig. 15, 1; Rutten, 1935–36, vol. 1, p. 172, B; Parrot, 1960, fig. 102; Amiet, 1966, fig. 5; Amiet, 1977, figs. 190, 192.

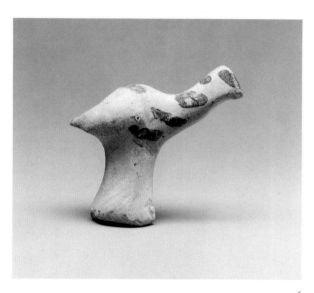

16

16 BIRD
Buff terracotta, hand modeled; painted brown spots
H. 1⅝ in. (4 cm); L. 1⅞ in. (4.9 cm)
Susa I period, ca. 4000 B.C.
Sb 19325
Excavated by Morgan.

Bird figures from the period of the first settlement at Susa, like the quadrupeds, had brown spots on their bodies. Perched high on its long legs, this is probably a wading bird like the stylized creatures that appear on Susa I painted vessels (No. 1). The eyes and beak are painted in the same way as the neck and back.

AS

LATE SUSA I GLYPTIC:
RITUAL IMAGERY, PRACTICAL USE

Surviving seals and sealings displaying elaborate imagery are valuable for interpreting the character of the society of the first inhabitants at Susa. The use of seal impressions on clay objects is first known to have occurred in the fifth millennium B.C. in northern Mesopotamia, and became the means, throughout the ancient Near East, of ensuring that the contents of containers had not been tampered with and of controlling access to storerooms—important functions in a society with many stored resources. At the site of Tal-i Bakun, near Persepolis, both container sealings and door sealings of the Susa I period were recovered in buildings that were probably warehouses.[1] At Susa itself, the actual contexts for the surviving sealings are lost. We know that there were domestic structures on both the Acropole and Apadana mounds.[2] Some sealings were found in upper Susa I deposits over a four-meter-square area at the southern part of the Acropole mound, but none in the cemetery.[3]

The two Susa I sealings in this catalogue (Nos. 17, 18) were pressed against the cloth that covered jars, and the impression of the cloth's weave is still visible on their backs.[4] The clay was stamped with circular seals carrying scenes that belong to a series of representations of supernatural or priestly figures engaged in ritual activity. The seal (No. 19) belongs to a different thematic group of seals and sealings with elaborate cruciform motifs.

Differing iconographic groups among the sealings may reflect distinctions in the society and in the ways stored goods were administered at Susa. Frank Hole has described Susa in this first phase as a ceremonial center, governed by a number of responsible individuals;[5] the use of distinct groups of iconographically related seals to provide secure storage may support this concept. It also seems likely that a number of individuals had access to storeroom doors, since four different seals occur on door sealings that have central impressions of wooden pegs or knobs.[6]

JA

1. Alizadeh, 1988, pp. 20ff.
2. Dyson, 1966, p. 370, as cited by Hole, 1983, p. 317; Amiet, 1986a, pp. 32ff.
3. Mecquenem, 1938c, pp. 65–66, fig. 1:1; idem, 1943, pp. 9–11, fig. 6.11. I thank Frank Hole for a communication on this matter.
4. Amiet, 1986d, p. 20, figs. 4–6; Le Brun (1971, p. 174 n. 10) notes that the imprint of cloth is visible on the interiors of certain jars.
5. Hole, 1983, pp. 321ff.
6. Amiet, 1986d, pp. 21ff; one door sealing, the only Susa I example stamped with two seals (unrelated in motif), may have been stamped by two different users. Amiet, 1972a, nos. 161, 164.

17

17 JAR SEALING SHOWING THREE FIGURES IN A RITUAL SCENE
Clay
H. 2½ in. (6.4 cm); W. 1⅝ in. (4.1 cm)
Impressed by a seal of DIAM. 1⅜ in. (3.6 cm)
Susa I period, ca. 4000 B.C.
South Acropole; Sb 2107

This is one of six container sealings bearing multiple impressions of the same convex circular seal.[1] The depiction is of a dominant central figure with a beak projecting from a birdlike head, a distinctive bulbous headdress with a vertical extension at the top,[2] and a long garment patterned with horizontal zigzags. The figure seems to be in motion, with arms extended in different directions. Behind the figure stands a second figure whose head, posture, and dress are similar. Another, smaller figure at the left, clad in a short garment—possibly a skin with a tail—stands or kneels with arm raised, holding a cup. This cup, with

its conical form and banded decoration, is compared by Frank Hole to Susa I painted beakers.[3] In the upper field are a rayed sun and a fish(?); other elements are unclear.

This depiction is one of a number of elaborate scenes that occur on Susa I sealings and seals. Dom-

inant motifs are animal-headed figures with bare chests and pronounced pectorals, wearing long skirts with a variety of patterns. On some seals the figures are further distinguished by circular pendants worn around the neck—possibly copper disks or even seals.[4] Those with birdlike heads seem to be engaged in a ritual activity with a number of attendant figures wearing short garments. In other scenes ibex-headed (or masked) figures, such as the "master of animals," stand with arms extended, grasping

either two quadrupeds or two snakes. A rare extant seal with this imagery is engraved on two faces, with a "master of animals" on one and an attendant figure kneeling before a number of quadrupeds on the other.[5]

The date of this glyptic, part of a Mesopotamian late 'Ubaid stylistic phenomenon that spread toward both Iran and Anatolia,[6] has been established as a result of the excavations of Le Brun on the Acropole mound, where two sealings were discovered in level 25 in an area with habitation walls, ovens, and painted pottery.[7] One of the sealings bears the image of a nude figure with a human body and the head of an ibex, standing with arms raised to hold two large snakes (fig. 25, opposite). He can be related to the series just described and also, particularly, to images of ibex-headed figures from sites in both Iran and northern Mesopotamia.

JA

1. Amiet, 1972a, p. 43, no. 231, pls. 2, 50; Charvát, 1988, p. 59.
2. Hole, 1983, p. 320, fig. 1:f, g, recognizes the superposed rings worn by figures in short kilts on Susa I pottery as a rendering of this headdress. It is described as "bulbous" by Amiet, probably correctly, and is depicted abstractly on pottery.
3. Hole, 1983, p. 321.
4. Hole, 1983, p. 320, who informs me that some disks were pierced. Françoise Tallon believes that the disks, which were mostly unpierced, served a different function.
5. Le Breton, 1956, p. 135:12, where the drawing shows a figure with a beaky nose and ibex horns.
6. Von Wickede, 1990, pp. 152ff.
7. Le Brun, 1971, pp. 169f.; idem, 1978, pp. 180ff.

18 JAR SEALING SHOWING IBEX-HEADED FIGURE
HOLDING SNAKES
Clay
H. 2¼ in. (5.7 cm); W. 2½ in. (6.4 cm)
Impressed by a seal of DIAM. 1⅝ (4.2 cm)
Susa I period, ca. 4000 B.C.
South Acropole; Sb 2050

This sealing was stamped three times with a circular
convex seal carrying the image of a standing ibex-
headed figure with a bare chest and a large circular
pendant hanging on a thick cord around his neck.
Serpents composed of triple undulating lines are
held in his raised hands, while snaky forms and
spadelike elements appear under his arms. The fig-
ure wears a belt and probably originally had a long
skirt, although the skirt is not preserved in any of
the three impressions stamped on this jar sealing.[1]

In general, interpretations of the imagery on
Susa I seals and sealings center on the identity of
the main figure, who is either a supernatural being
with human and animal attributes or a masked hu-
man priest or shaman wearing a long garment.[2]
This long garment and the animal-skin(?) kilt worn
by figures with their legs exposed indicate that their
wearers are humans. However, the distinction be-
tween human and animal is not so clear with the
"master of animals" on the Susa I sealing illustrated
in figure 25 nor with the figures on stamp seals
from northern Mesopotamia and other sites in Iran;
some of these have caprid or mouflon horns and
stippled or hatched bodies.[3]

18

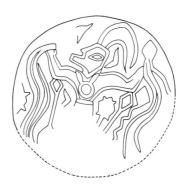

Figure 25. Drawing of a jar sealing. Sealing: Acropole, level 25,
Susa, late 5th millennium B.C. Clay. Susa, Shush Museum

Ibex, ram, and bovine horns distinguish divinities in many early and modern traditional societies, and shamans wear animal masks and skins to ascend to the supernatural realm and to enhance their power over the demonic forces of nature.[4] At Susa this role may have been shared by a number of men who were buried with copper disks but not (according to present evidence) with seals bearing ritual imagery. Few such seals were recovered in the early excavations, and the corpus is known mainly from their impressions—stamped from one to six times on jar and door sealings.[5] These seal impressions form a thematic group, distinguishable from other series of sealings with geometric designs.

JA

1. Amiet, 1972a, no. 220; idem, 1988a, p. 10, where it is identified as a jar stopper.
2. Amiet (1986d, p. 21), notes that this garment prefigures the robe of the Sumerian priest-king; Barnett, 1966, pp. 259ff.
3. Barnett, 1966, pl. 22; Porada (1962, pp. 31–33), notes that one example with a stippled body exhibits the gait of a human and is probably a priest in animal skins rather than a demon.
4. For references to figures with horns outside ancient Egypt and the Near East, see Jeffreys, 1954, pp. 25ff.; Eliade, 1972, pp. 459ff.; Elwin, 1951, figs. 58, 59.
5. For a seal with this imagery, see Amiet, 1972a, pl. 49:222.

19 STAMP SEAL WITH CRUCIFORM MOTIF
Bitumen compound
DIAM. 1¼ in. (3.1 cm); H. ⅜ in. (.8 cm)
Susa I period, ca. 4000 B.C.
South Acropole; Sb 1523

One group of Susa I seals and sealings bears an elaborate cruciform design. An example is this circular seal made of bitumen compound, which has a slightly raised knob at the back, now broken. The convex seal face is carved with a cross-based design that can possibly be interpreted as four horned animal heads joined by extensions to a central lozenge form. There is patterning on all the elements. This motif was engraved on a number of seals of different sizes at Susa, some of them used to stamp more than one container sealing.[1] A notable example appears as a partial impression on a jar sealing found in level 25 of Le Brun's Acropole excavation.[2]

JA

1. According to Charvát (1988, p. 59), Sb 2061 and 2229 are jar rim and sack(?) sealings using the same impression (see Amiet, 1972a, no. 212); Sb 2012 and 6936 are sack and pot sealings using the same impression (ibid., no. 214); Sb 2010 and 5310 have the same impression (ibid., no. 215) and wickerwork traces on the reverse.
2. Le Brun, 1971, fig. 35, no. 3.

19 Modern impression

PROTOLITERATE SUSA
CIRCA 3500-2700 B.C.

Writing, cylinder seals, mass-produced plain ceramics, and a variety of new items crafted of stone and metal appeared in Susa around 3500 B.C. Susa II is the name given to the period extending from 3500 to about 3100 B.C. The objects from that time are so close in style to objects found in the first Mesopotamian cities, however, that the term Uruk period, used to designate Mesopotamian developments during the same era, is often applied to Susa. Uruk was the major Mesopotamian city of the time.

What kind of change took place between Susa periods I and II is a matter of dispute. In one view, Mesopotamian cultural styles and social forms were gradually absorbed and adopted in Susiana after the collapse of the Susa I polity or polities.[1] Another view posits a more abrupt transformation, resulting directly from Uruk's cultural or military imperialism.[2] At that time Susa also ceased being the only major town in its region. Chogha Mish, seventeen miles to the east, and perhaps also Abu Fanduwah, seven miles to the south, became local centers of administration and exchange, with populations of 1,000 to 3,000. Susa, Chogha Mish, and Abu Fanduwah were far smaller than the cities of Mesopotamia to the west such as Uruk and Nippur, whose populations were probably three to four times those of the towns of Susiana.[3]

New developments took place during the Susa III period, which extended from about 3100 to 2700 B.C. Sometime just before 3000 B.C., Susiana slipped out of the Mesopotamian cultural sphere. Susa became once again the only major settlement in the region, and the surrounding Susiana plain lost much of its population. The ceramics and writing system employed in Susa at that time resembled those in use at Anshan (modern Tal-i Malyan) in Fars province, 320 miles southeast of Susa and the site of the later Elamite capital. Susa became a kind of gateway city on the western edge of the Iranian world; products of the highlands passed through it on their way to the rapidly growing Mesopotamian cities of the lowlands to the west. The distribution of contemporary sites on the plateau suggests that the foundations of the highland-lowland union that characterized the historical Elamite period were first laid in the early third millennium B.C. Thus the writing system of that time and the culture with which it was associated are called "Proto-Elamite."

EC

47

1. E.g., Wright and Johnson, 1975.
2. E.g., Algaze, 1989, pp. 571–608, especially pp. 574–77.
3. Gregory Johnson has suggested that competition in the late Susa II period between eastern Susiana with its center at Chogha Mish, and western Susiana with its centers at Susa and Abu Fanduwah, led to the decline in regional complexity seen in the subsequent Susa III period. Johnson, "The Changing Organization of Uruk Administration on the Susiana Plain," in Hole, 1987, pp. 107–39.

The Late Uruk Period

By the early part of the fourth millennium B.C., profound changes occurring in the social organization of communities in the Near East set the stage for what is sometimes called the urban revolution. The clearest evidence for such changes, identified through archaeological survey, suggests that there was a considerable shift in the patterns of settlement in the great Mesopotamian alluvial plain, which includes Khuzistan, and consequently Susa, in its eastern part (see figs. 1, 2, pp. xiv–xvi). From the distribution and size of the mounded remains of the ancient centers, we understand that during the fifth and early fourth millennia B.C. people dwelling in the alluvium moved from more or less equally spaced and sized villages into larger communities. As a result, by 3500 B.C. a small number of centers had grown to a size that is considered urban. That shift in the way people organized themselves was certainly a response to a number of different factors, including increased pressure on resources through both a growing population and what seems to have been a shift toward a drier climate.

One of the first "cities" in the alluvium was apparently Nippur, later the religious center of Sumer, whose size in the early fourth millennium B.C. is estimated at about one hundred acres.[1] Somewhat later there was an even greater agglomeration of people to the south at the site of ancient Uruk, referred to in the Bible as Erech and now called Warka. Because the period was systematically investigated first at Uruk and because that center was so important at that time, the phase of first cities is designated the Uruk period.

The early part of the period is poorly known, but there is enough evidence from its end—that is, the Late Uruk period (ca. 3500–3100 B.C.)—to provide some idea of the culture that had emerged together with the new social organization.

In social evolutionary terms, the Uruk phase has been described as the period of the formation of the state or of the rise of civilization. Books have been and will continue to be written on exactly what these terms mean, but however the debate proceeds, it is generally agreed that in the Near East those early states were composed of large population centers, some of whose inhabitants had specialized skills and responsibilities. It is believed that such increased specialization made it possible, at least in part, for a greater variety of activities to be undertaken in the large centers than in smaller communities, where most people were occupied primarily with meeting the basic needs of their existence. One result of the increased capability that specialization allowed was a far more complex coordination of the production of goods and of human relations. To sustain the specialization and to manage, mediate, and achieve the goals of this new organization, new ways of solving problems had to be found. These, in turn, effected major changes in the way people thought and behaved.

The British anthropologist V. Gordon Childe enumerated what he understood to be some of the most important traits of those early civilizations. His list, which has provoked much discussion, includes such things as the invention of the wheel, the development

of a complex irrigation technology, an increase in craft specialization and the presence of full-time specialists, and monumental architecture, as well as the invention of writing and the appearance of representational art.[2] Those elements are fundamental to all but an ever-diminishing few of today's cultures. Of the two spheres that were affected by those innovations, the first is the physical environment, altered by such tools and technologies as the wheel, the composite bow, complex irrigation, and metallurgy. The second is human relations, which were altered by the invention and development of symbolic technologies. The most obvious of these was the invention of writing and other systems of notation, although other modes of symbolic communication also fit into this category. Monumental architecture was constructed, not to increase crop yield, but to house social agencies and to provide public gathering places. Programs of figural art were developed, not to facilitate the movement of goods, but to express thoughts, to teach values, to communicate information, and to control. Obviously, tools and technologies that modified both physical and social conditions had existed from the beginning of human time, but both underwent a fundamental change during the urban revolution.

In the realm of art, it is actually possible to see the profound change that took place between the time of the earlier villages and that of these urban societies. Although the evidence is scanty, what survives of the pre-Uruk periods can be understood as essentially the residue or the focus of activity, rather than representations meant to be looked at. The artistic expression that has been preserved is mostly in the form of geometric and emblematic designs painted on vessels used for rituals and in daily life. One important category of evidence now missing is wall paintings—either abstract patterns or figural representations—which may have been discarded or eradicated after the creative/ritual event. Life-size sculptures are rare; three-dimensional representations are usually small works that may have served as fetishes more than as objects for contemplation or instruction.

With the appearance of larger, more complex social groups, such as those that appeared in the Uruk period, there is a quantum leap in the amount and complexity of symbolic elaboration of objects, accomplished in particular through figural representations. That phenomenon has been noted frequently but the reasons for it are rarely considered in any depth. Although this change certainly arose from a complex of factors, it seems clear that in the Near East at that time, one primary purpose of the increased invention and production of visual symbols was managing social interaction, for through them it was possible to replace actual human action with its representation. Actual and ritual action, used in the past for social management, it may hypothetically but consistently be suggested, was replaced or augmented to some degree by depictions of ritual actions and of relationships.

That new function of social communication required both the elaboration of existing images and the creation of a substantial number of new ones, which acquired meaning through convention and homology that encompassed both human relationships and mythological and cosmological precepts. A good example of this is the group of scenes on the Uruk vase (fig. 26), which shows what must be a ritual encounter of major importance to the Uruk community.

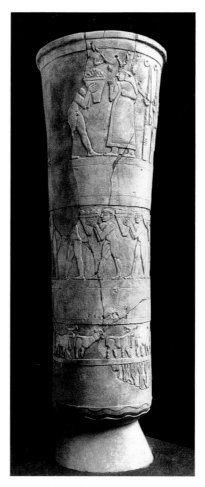

Figure 26. Vase depicting the ritual marriage of the goddess Inanna. Eanna precinct, Uruk, Iraq. Late Uruk period, ca. 3100 B.C. Alabaster, H. 36¼ in. (92 cm). Baghdad, Iraq Museum, 19606

SUSA DURING THE LATE URUK PERIOD

Our understanding of this period at Susa depends on interpreting the finds from the early excavations in light of those from the well-controlled soundings on the Acropole. In the periodization developed from the soundings, levels 20 through 17 have been designated Susa II—the ceramic and thus chronological equivalent of the Middle and Late Uruk periods at Uruk. We know little of the transition to this phase from the Susa I period, when the erection of the high platform and the presence of distinctive pottery and seal impressions suggest that Susa was an important ritual center. There is no evidence of abandonment of the site or of a disruption in occupation, and it seems that the high platform was rebuilt several times before it was finally abandoned in the Susa II period. A most serious drawback of the early excavations is the fact that the methods used destroyed the evidence of monumental public architecture that must have stood during the Susa II period. We do know, however, that Susa was not the only important center on the plain of Khuzistan at that time. Until the end of the period, a substantial center stood in the middle of the plain at the site of Chogha Mish.

Ceramics from the Middle and Late Uruk periods at both Chogha Mish and Susa are virtually identical to those from southern Mesopotamia. That tells us that there were close relations between Susiana and the Mesopotamian alluvial plain, but it does not help us to understand the mechanisms of the relations. Although cryptic, perhaps the most articulate evidence from the period is the visual arts—that is, the fragments of three-dimensional sculpture and the many seal images that are preserved through their impressions on administrative documents of clay. There are also tantalizing fragments of monumental-scale sculpture from the period, which, in combination with wall paintings, must have decorated the facades of major public structures (fig. 27). Smaller works of three-dimensional sculpture were found in hoards; objects from two such hoards, called the "archaic deposits," are included in this catalogue (pp. 58–67). A number of hoards of small-scale sculpture from the period of state formation have been found in the Near East and in Egypt, usually in temples or other special locations. Sculptures rendered in two different styles were found in one of the Susa hoards. One possible interpretation of the difference in style is that the sculptures were made in two succeeding periods, with the deposit laid down during the later period. The variant styles can also be understood as contemporaneous, with no necessary chronological priority. Thus, the distinctive three-dimensional mode of rendering animal mus-

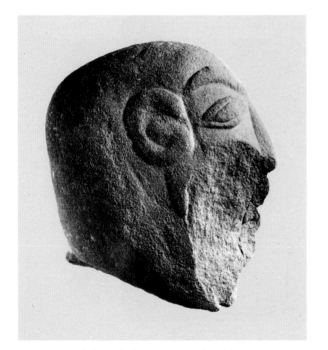
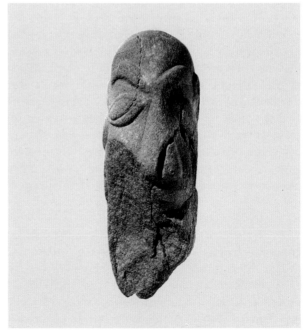

Figure 27. Head of a male from a statue; side and front views. Susa, ca. 3300 B.C. Stone, H. 7 in. (18 cm). Susa, Shush Museum

culature evident in the seals of the later, Proto-Elamite period (e.g., No. 47) might first have been defined in sculpture at the end of the Late Uruk phase (e.g., No. 27). Precursors of other Proto-Elamite stylistic features are discernible in other Late Uruk media as well.[3]

Virtually all the subjects known in three-dimensional sculpture are also found at Susa in the art of glyptic. From impressions on unbaked clay sealings, now mostly broken and worn bits, scholars have been able to discern the outlines of a stylistic and iconographic development in seal imagery.[4] The earliest of those images from Susa (see Nos. 17–19) were engraved on the convex surfaces of stamp seals. By the Uruk period the stamp seal had for the most part been replaced by the cylinder seal, whose curved surface was carved with figural and abstract compositions. This new format allowed the seal to be rolled easily across clay sealings and documents to produce a single continuous impressed band of the engraved design (No. 47).

There are impressions from Susa belonging to this earliest phase of cylinder seal use, the dates confirmed through well-stratified evidence from the nearby site of Sharafabad.[5] The imagery and style of the cylinders differ radically from those of the Susa I stamp seals. The cylinders were engraved by means of a drill with images of animals and humans in high relief, appearing as "baggy" masses. Unlike those of the Susa I period, these figures are not differentiated by garments and masks, but are distinguished by their posture and by such attributes as a distinctive hair style or a headband. One of the earliest identifiable figures on a Susa cylinder is a male wearing a broad fillet around his thick hair; he is not clothed and carries a long staff. The figure compares closely with an important personage in the Uruk visual repertory, but in these early seals he is never shown wearing the "net" skirt that is his hallmark in the Late Uruk phase. Other human figures, also not clothed, are shown squatting among wild animals, usually caprids, on the early seals.

Because of the immense scale of the early excavations, more glyptic images of the Late Uruk period are known from Susa than from any other site with the possible exception of Uruk itself. The compositional formulas and style of rendering on seals from the two sites are strikingly similar. Nevertheless, distinctly different themes occur at each site. Among the published glyptic from Uruk there is particular emphasis on the representation of rituals involving the bringing of goods to the temple. (The rituals relate to those shown on the Uruk vase, fig. 26.) Another important

theme is the domination of human beings by the figure with the rolled headband and net skirt. At Susa, however, the great majority of images are scenes of manufacturing. At both sites, heraldic compositions of wild animals or supernatural creatures alternating with vessels or rosettes or birds are found.

SUSA'S RELATIONSHIP TO THE WEST

Evaluating the relationship between Susa and lowland Mesopotamia during this formative period is a classic problem in the interpretation of archaeological evidence. The problem can be productively approached in two ways. The first begins with the hypothesis that Susa and Uruk had a particular type of relationship and then uses the evidence to illustrate that relationship; the second looks first at the evidence and through various types of analyses tries to piece together what the relationship might have been.

Scholars agree that the material cultures of Susa and Uruk were very similar during the Late Uruk period. What is a matter of interpretation is the degree to which Susa, despite those similarities, was a political and economic entity independent from Uruk—as one theory holds.[6] Others believe that Susa had a dependent relationship with Uruk, either as a separate but subservient polity or as an actual colony.[7] Though seemingly a fine point of pedantry, the question has ramifications for our understanding of how the first states evolved in the ancient world.

We know that the Late Uruk period is one during which there were close relations between distant communities in the Near East. Many scholars believe that at least some of these contacts had to do with the establishment of commercial colonies, probably with Uruk as the mother city. For example, most accept that the sites of Habuba Kabira and Jebel Aruda on the upper Euphrates and Nineveh on the Tigris were in some sort of colonial relationship to Uruk. A question still debated is whether Susa too was "colonized" by Uruk, perhaps during the early part of the Uruk period; or whether it was an independent, competing polity—that is, a smaller copy of the larger center. One of the most important images that comes from Susa can be used to support either interpretation. It is a glyptic image, impressed on a jar sealing, showing the man with the headband and long net skirt threatening, with a bow and arrow, long-haired enemies he has vanquished (fig. 28). This scene of imminent slaugh-

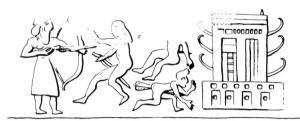

Figure 28. Drawing of a seal impression depicting a priest-king fighting enemies before a horned building. Seal: Susa, late Uruk period, ca. 3300 B.C. Clay, H. 1 in. (2.5 cm). Paris, Musée du Louvre, Sb 2125

ter, which takes place in front of a raised structure from whose sides animal horns emerge, has been interpreted as a representation of the ruler of Susa in front of a local temple.[8] This figure, sometimes referred to as the priest-king, is known in its greatest variety at Uruk, where it is seen on seals, in three-dimensional sculpture, and on depictions in low relief on votive objects such as the vase from Uruk in figure 26. The image is also known on seals from Habuba Kabira. Our interpretation of this figure depends on our understanding of the relationship between centers. Is he the paramount ruler of Uruk, who controls Susa by asserting power over local adversaries, or a local surrogate of the paramount at Uruk? Or, is this the image of an independent ruler at Susa who is represented as identical to the ruler of a competing polity? The last hypothesis is the one offered by those who believe that Susa was an independent polity in the Late Uruk period. But it is just as likely that the same person or, more probably, the same office that we see in Mesopotamia—at Uruk in particular—controlled the whole alluvium. Susa holds important clues to the dynamic of an enormously vital first civilization.

HOLLY PITTMAN

NOTES

1. R. M. Adams, *Heartland of Cities* (Chicago, 1981), p. 116.
2. Childe, 1969, pp. 123–47.
3. [For a different view on the date of objects in the "archaic deposits," see p. 58.—Ed.]
4. Amiet, 1972a, passim.
5. Wright, Miller, and Redding, 1980, passim.
6. Gregory A. Johnson, "The Changing Organization of Uruk Administration in the Susiana Plain," in Hole, 1987, pp. 107–39.
7. Algaze, 1989.
8. Amiet, 1959, pp. 39–44.

NOTES ON THE EARLY HISTORY OF WRITING IN IRAN

During the past twenty years considerable progress has been made in our understanding of the process that led to the invention of writing.[1] There is general agreement on the early stages, although important developmental and regional relationships will continue to be debated even as new information adds clarity. The evidence suggests that writing was invented around the middle of the fourth millennium B.C. in southern Mesopotamia, perhaps at Uruk, where the greatest number of early tablets have been found. Susa, while not the locus of the invention, holds an important place in the early history of this symbolic technology for two reasons: first, because the greatest number of examples of what some regard as the immediate precursors to writing were found in the excavations there; second, because a still-undeciphered script, called Proto-Elamite, was perhaps invented and was certainly used at Susa contemporaneously with the archaic Proto-Cuneiform script of southern Mesopotamia.

When one thinks of writing, the first thing that comes to mind is language. The most common definition of true writing is: a system of visible marks that represent the sounds of natural language. The alphabet, one system of writing used now, has a close but far from exact connection with the sounds in its natural language referent. The alphabet, however, is only one of many systems that have been developed for the same purpose and structured fundamentally according to shared principles. In other systems—particularly in early systems of writing—the distinction between the representation of spoken sounds and that of words or concepts was not so clear-cut as it is in alphabetic script.

Since no manual exists describing how writing came to be invented and how it worked, we are left to interpret the material residue of this extraordinary accomplishment. What the evidence shows is that writing did not appear in a vacuum but was one of several symbolizing systems used to store and to control the flow of information.

The evidence for these stages of prewriting is far more abundantly preserved at Susa than elsewhere, but seems in its general form to duplicate the more fragmentary assemblages from Uruk and from sites on the upper Euphrates. Although the relative chronology of the evidence is not positively established, some think that the following steps can be reconstructed.

First, clay or stone objects (called tokens) were used as counters and icons (symbols of commodities). Some tokens took on complex shapes and some were enclosed in hollow clay balls, or bullae. The bullae were then impressed with one to three engraved seals and sometimes also with objects identical in shape to the enclosed tokens. Also in use at the same time as the hollow clay balls were biconical clay tags and flat slabs impressed with numerical tally marks and seal impressions. It is clear that early on, all three artifacts were used together in an accounting system for the distribution of goods and labor. Only in level 18 (ca. 3300 B.C.) at Susa is this full system preserved.[2] The system is changed in level 17 (ca. 3200–3100 B.C.) of the Acropole. The hollow clay balls, tally tablets, and biconical tags have been replaced by tablets of a new, pillowlike shape having a more complex system of numbering—one that gives different values to marks of different shapes.[3] While this nonepigraphic recording system was in use at Susa, so-called true writing was developed to the west, most probably at Uruk.

The invention of writing must have happened very quickly, probably initially through the efforts of one ingenious mind; it entailed the linking of sound and mark through the device of a rebus. A rebus differs from an icon because it denotes the sound that is the name of an object rather than the object itself. For example, the picture of an eye denotes the idea/word "I" or the sound "ay" in the English language. There is no evidence that by the end of the Late Uruk period at Susa any system of rebus notation was in use. At Uruk, however, evidence we now have suggests that the rebus, that intellectual/technological breakthrough that would lead to writing, may have been conceived.[4] From the more than four thousand inscribed tablets from Uruk we know that in a relatively short time, signs and sign-combinations for commodities, for places, and for official positions—all critical for an economic administration and in conventional accounting procedures—were in place.[5] They mark the beginning of what has from 3300 B.C. been an unbroken tradition of literacy in southern Mesopotamia.

No tablets written in the Proto-Cuneiform script known from Uruk have been found at Susa, probably because the language underlying that script (hypothetically, Sumerian) was not the primary language spoken there. During the early excavations at Susa, however, more than fourteen hundred tablets were unearthed inscribed with a script that is related in some formal elements to the Proto-Cuneiform script found at Uruk. The stratigraphic location of the tablets was secured when more than a dozen of them were found in levels 16–14B of the Acropole sounding.[6] When it was first found, the script was called Proto-Elamite on the assumption that its underlying language was somehow related to the Elamite later spoken and written at Susa. The Proto-Elamite script has never been deciphered (No. 49), although some progress has been made toward understanding the overall organization of the tablets.[7] It is clear that this script was used, as were the Proto-Cuneiform tablets of Uruk, for account recording. The inscriptions begin with signs that are thought to designate the type of document and the authorizing agency. Following this introductory formula is the tabulation of either the distribution or the receipt of commodities or labor.

It is hard to believe that such an elaborate system for recording could have lasted only a century—the approximate time span assigned to the three levels in which the tablets are distributed. During those years, the script was exported as one element of an administrative assemblage (tablets, signs, seals) to a number of sites on the plateau. At none of those sites is there evidence that the script continued in its original form after it fell out of use at Susa. The cause of its demise is debatable, but must be related somehow to the strength of the developing cuneiform system.

HP

1. Gelb, 1963; idem, 1980; M. Green, 1981; Green and Nissen, 1987; Le Brun and Vallat, 1978; Powell, 1981.
2. Le Brun and Vallat, 1978.
3. Le Brun, 1978.
4. Powell, 1981.
5. Nissen, 1974.
6. Le Brun, 1971.
7. Damerow and Englund, 1989, passim.

20 TWO FRAGMENTS OF A JAR SEALING SHOWING
GRAIN STORAGE
Unbaked clay
H. 1¼ in. (3.3 cm); W. 1⅛ in. (2.7 cm); D. ¾ in.
(2 cm); and H. 1 in. (2.4 cm); W. ⅞ in. (2.3 cm);
D. ⅜ in. (.9 cm)
Late Uruk period, ca. 3300 B.C.
Sb 2027, Sb 2141

This fragmentary clay jar sealing was impressed by
a seal engraved with a scene showing the recording
and storing of cereals.[1] Two nude male figures are
seen moving grain into a granary. On the right, one
of them holds out a conical vessel, perhaps to receive
grain; the other, behind him on the left, holds an
identical vessel on his shoulder as he climbs a ladder
reaching to the top of a domed granary. To the right
are the remains of what was originally an account-
ing scene. Three groups of three sticks each are visi-
ble, the lowest of them grasped by another figure.
This is one of a dozen impressions of different seals
from Susa that have the storage of grain as their
subject. Unfortunately none of the sealings are com-
plete, and thus the variations on the theme cannot
easily be determined.

HP

1. Amiet, 1972a, pl. 81, no. 663.

20

21 BULLA WITH SEAL IMPRESSIONS, CONTAINING
TOKENS
Clay
DIAM. 2⅜ in. (6 cm)
Impressions: figures, H. 1⅜ in. (3.4 cm); animals,
H. 1⅞ in. (4.7 cm)
Late Uruk period, ca. 3300 B.C.
Sb 1932

The shape of this bulla, a hollow sphere, is identical
to that of bullae found in level 18 of the Acropole
sounding (for an explanation of bullae, see p. 53).[1]
The bulla was impressed by two different cylinder

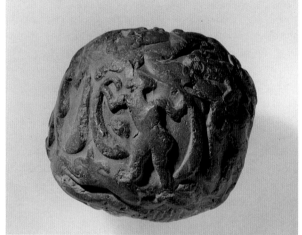

21

21

seals, each of which had one image carved twice on its surface. One seal shows a standing nude male figure holding a long curved object, perhaps the tail of an animal, a snake, or a commodity of some kind, in each raised hand. The other seal depicts a bird-headed feline, one of the few monstrous creatures known in the Late Uruk repertory. Emerging from the middle of the creature's back are two outward-facing felines arranged to appear as spread wings. In the field above is a small animal with prominent ears. On the body of one of the impressions of the monster six vertical strokes were incised, probably as tally marks. Both seals are cut in the massive style that is thought to be characteristic of the earliest cylinder seals.

The bulla contains clay tokens of various shapes and sizes.

HP

1. Amiet, 1972a, pl. 74, no. 598, pl. 72, no. 581.

22 BULLA WITH SEAL IMPRESSIONS, CONTAINING
TOKENS
Unbaked clay
DIAM. 3⅛ in. (7.8 cm)
Impressions: snakes, H. 1¼ in. (3.2 cm); figures,
H. 1⅛ in. (2.9 cm)
Late Uruk period, ca. 3300 B.C.
Sb 1967
Excavated by Mecquenem.

Fifteen clay tokens in the shape of tetrahedrons and spheres were found in the cavity of this bulla.[1] Its partly preserved surface is impressed with two cyl-

inder seals, but there are no impressions of tokens. It appears that the entire surface of the bulla was impressed with one cylinder and then a second cylinder was rolled over one section only. The first cylinder has the bold, highly legible design of two interlaced snakes, filled in the intervals by seven- or eight-petaled single rosettes. The image of the second seal is more fragmentary and more complex. It shows a standing figure holding a box in front of a high-prowed boat in which two figures sit. Nearby are a twisted snake emblem, a lattice structure, and a standard with a circular top. Above the boat are several figures: one squatting, one striding, and one bound.[2]

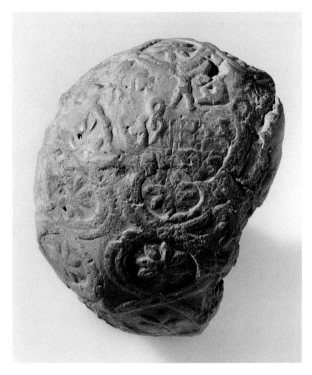

22

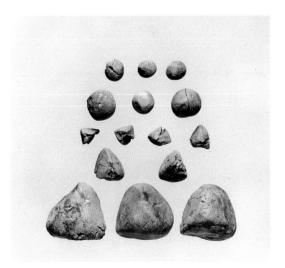

The snake interlace is found in both Susa and Mesopotamia (at Uruk) during this period. Although the motif of the rosette has no extant parallel from Mesopotamia, similarly structured compositions exist there. A virtually identical motif is embossed on the gold-covered handle of the Gebel el-Tarif knife from Egypt and on two more crudely carved ivory handles also found in Egypt.[3] There can be no doubt that this type of design came to Egypt from the alluvium to the east, perhaps through Uruk and perhaps through Susa. It is material evidence, along with other fragmentary remains, of what must have been a brief but highly significant encounter between the two emerging state systems.

HP

1. Amiet, 1980c, pl. 30, no. 488, pl. 47, no. 668.
2. This scene was first identified by Prudence O. Harper.
3. Asselberghs, 1961, pls. 33, 34.

23

23 BULLA WITH SEAL AND TOKEN IMPRESSIONS, CONTAINING TOKENS
Clay, slightly baked
DIAM. 2½ in. (6.5 cm)
Impression, H. 1¼ in. (3.1 cm)
Late Uruk period, ca. 3300 B.C.
Sb 1927
Excavated by Mecquenem.

This bulla, smaller than Number 22, was found intact. It contained seven clay tokens: one large cone, three small cones, and three disks, one marked in its center.[1] The surface of the bulla was impressed all over with a single cylinder seal, and over that there are impressions in shapes identical to those of the tokens the bulla contained. Thus, the outside of the document indicates the interior contents. Following Pierre Amiet, Denise Schmandt-Besserat has shown this act of notational redundancy to be an important step in the development toward writing.[2] The tokens, and by extension their impressions, are thought to represent the value of numbers and various types of commodities.

The impressed cylinder seal shows two or three birds of prey with comblike spread wings boldly arrayed, rising from the middle of the back. Although the impression is not well preserved, it can be seen that the head of each raptor is bent down to meet a

23

striated conical form. Beneath each bird's body is a lyre-shaped form, perhaps caprid's horns.

HP

1. Amiet, 1972a, pl. 168, no. 539.
2. Schmandt-Besserat, 1992.

24 TABLET WITH A SEAL IMPRESSION AND
MARKINGS HAVING NUMERICAL VALUE
Unbaked clay
H. *2¼ in. (5.8 cm);* W. *2½ in. (6.4 cm)*
Late Uruk period, ca. 3300 B.C.
Sb 2313
Excavated by Mecquenem, 1933–39.

24

The size of this tablet and its numerical markings set it apart from the type of tablet more commonly found in the latest Uruk levels of the Acropole sounding.[1] However, because it has no script and because of the design with which it is impressed, there can be little question of the tablet's Late Uruk date. The seal shows two files of calves, one above the other, calmly walking in opposite directions—a composition typical of seals used in the transitional time between the Late Uruk and Proto-Elamite periods. Files of animals are also found impressed on tablets having only one or two signs of writing. Although badly obscured by the impressed numbers, the engraving of the small animal figures is particularly fine. Numerous extant impressions of this seal show that it was used not only on three numerical tablets but also on sealed containers of various types.

HP

1. Amiet, 1972a, pl. 99, no. 922.

The Two Archaic Deposits

In 1909 Roland de Mecquenem found two deposits containing small sculptures, now known as the "archaic deposits," in trench 26 of the Acropole excavation site at Susa. They were situated only a meter apart, not far from the western edge of the mound. The artifacts of the first deposit "were in a heap in the earth." Those in the second "appeared to have been piled between thin limestone tablets placed upright."[1]

An exact tally of the objects in the two deposits has been drawn up from data provided by Mecquenem,[2] by his assistant Louis Le Breton, who conducted further examinations,[3] and by Pierre Amiet, who worked from the drawings of P. Toscanne, a member of the Mecquenem mission.[4] The first find consisted of seventeen small sculptures as well as "many beads of white paste . . . , two beads of rock crystal, a small bronze mirror, about fifty seashells," and stones.[5] The deposit is heterogeneous in material—mainly alabaster, but also terracotta, copper, pink and yellow limestone, ceramic, and clay—and contained a variety of objects, including animal sculptures, vessels, a lozenge-shaped bead, a pin surmounted by an ibex, a worshiper, and six objects catalogued below (Nos. 25–30).

The second deposit seems a more coherent group. It is largely made up of vessels, often zoomorphic, and the pieces are all of alabaster except for a painted terracotta bird. The vessels have cavities and were perhaps meant to hold offerings such as oil or perfume. This deposit also includes "shells and paste stones of rather bizarre shapes."[6]

The objects in the archaic deposits date from different periods.[7] Most of the alabaster sculptures are Mesopotamian Late Uruk in style, and can be compared with stratified material found by Alain Le Brun on the Susa Acropole.[8] However, three sculptures from the first deposit and one from the second, made of marble, are Proto-Elamite in style (Nos. 27–29). It is likely, then, that the archaic deposits were buried during the Proto-Elamite period. Le Breton and Amiet have interpreted them as foundation offerings.

The sculptures from the deposits resemble those found elsewhere on the Susa Acropole. Representations of birds, monkeys, bears, and hedgehogs are also known from other sites of the period, in particular Tell Brak.[9] The material from Susa, however, even in the Late Uruk period, exhibits a distinctive quality of its own, and to our eyes, a sense of humor. Humans are represented with fidelity, and animals sometimes adopt human activities and gestures. Later, in the art of the Proto-Elamite period, animal representations supplanted human figures altogether.

AGNÈS BENOIT

NOTES

1. Mecquenem, 1911b; and see pp. 51, 53.
2. Mecquenem, 1911b, pp. 51–55.
3. Le Breton, 1957, pp. 109–12, fig. 32.
4. Amiet, 1976c, pp. 62–63, pl. 19.
5. Mecquenem, 1911b, p. 53.
6. Ibid.
7. [For another view, see above, pp. 50–51.—Ed.]
8. Le Brun, 1971, fig. 54.
9. Mallowan, 1947, pls. 7, 10, 52.

25 FEMALE WORSHIPER

Alabaster
H. *2½ in. (6.2 cm);* L. *1¾ in. (4.5 cm);* W. *1⅝ in.
(4 cm)*
Late Uruk period, ca. 3300 B.C.
First archaic deposit, Acropole, trench 26; Sb 70
Excavated by Mecquenem, 1909.

The alabaster orants, or praying figures, found at Susa may be the earliest evidence of a custom commonly observed in Mesopotamia during the Sumerian period, that of worshipers placing images of themselves in temples to perpetuate their prayers.

Certain iconographic features are common to all the Susian female worshiper figures: almond-shaped eyes, an aquiline nose extending directly from the forehead, fleshy lips, and hair falling down the back in a curve and held in place by a band, here represented by an incision. In this case, the high breasts are supported by clasped hands.

The figure, who kneels, wears a long skirt. She has two small feet, seen from the back, with incisions separating the ten toes. The kneeling posture with a skirt that covers the knees is distinctively Elamite and is common to all the female worshipers. It reappears during the Proto-Elamite period in connection with a different kind of figure, the silver bull now in the Metropolitan Museum (fig. 5, p. 5).[1]

AB

1. See Mecquenem, 1911b, p. 52, fig. 15; *MDP* 13 (1912), pl. 39, no. 10; Le Breton, 1957, p. 111, fig. 32, no. 24; Parrot, 1960, fig. 85; Amiet, 1966, fig. 92; Orthmann, 1975, fig. 276a; Amiet, 1977, fig. 239, p. 356; Spycket, 1981, p. 35, no. 33, pl. 25.

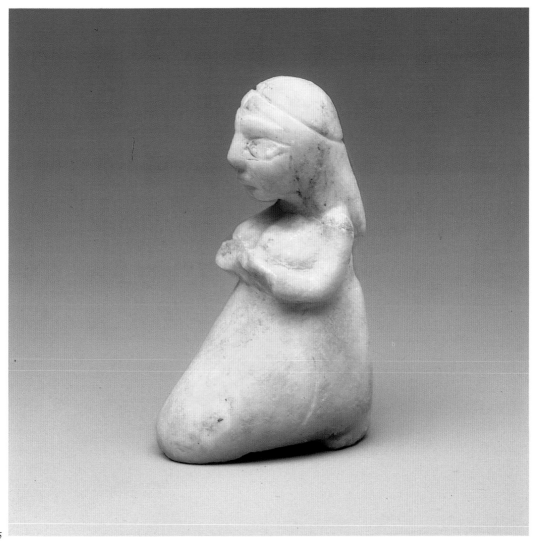

25

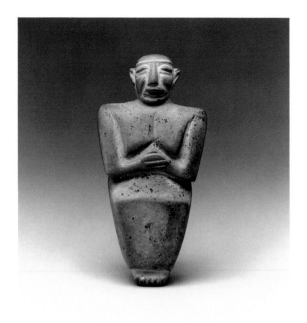

26

26 MALE WORSHIPER
Yellow limestone
H. 2⅝ in. (6.6 cm); W. 1¼ in. (3.3 cm); D. ½ in.
(1.3 cm)
Late Uruk period, ca. 3300 B.C.
First archaic deposit, Acropole, trench 26; Sb 72
Excavated by Mecquenem, 1909.

This sculpture is without parallel among contemporary Susian worshipers.[1] First, the figure is shown standing rather than kneeling or crouching; second, the body is out of proportion, with the upper part given greater emphasis than the lower part; and finally, the sculpture is essentially flat rather than volumetric. The angularity of the incised lines marking the chest, face, toes, and fingers led Pierre Amiet to call it "cubist" in style.

The worshiper appears to be wearing a long skirt, a garment which may have had some special significance and which does not appear on the seal impressions depicting men engaged in daily activities.

AB

1. See Mecquenem, 1911b, p. 51, fig. 4; *MDP* 13 (1912), pl. 39, no. 1; Le Breton, 1957, p. 111, fig. 32, no. 10; Amiet, 1966, fig. 48; Spycket, 1981, pp. 35f., fig. 26; Amiet, 1977, p. 356, fig. 238; idem, 1988b, p. 40, fig. 14.

27 MONSTROUS FELINE
Gray marble
H. 2 in. (5.1 cm); L. 3⅛ in. (7.9 cm); W. 1¼ in.
(3.2 cm)
Proto-Elamite period, ca. 3000–2900 B.C.
First archaic deposit, Acropole, trench 26; Sb 108
Excavated by Mecquenem, 1909.

A number of attached pieces completed this statuette of a humped animal, to judge from the holes that remain.[1] According to Pierre Amiet, the ends of the legs were of metal; on the base of the neck there was a mane or perhaps even a wing in profile, an indication that the animal would have been a griffin; and the tiny loop in back could have been joined to a multiple tail, like the tail of the contemporary lion-demon sculpture on loan to the Brooklyn Museum and the tails of lion-demons illustrated on seals (fig. 30, p. 69, and No. 47).[2]

On the basis of the rendering of the musculature and of the curls of hair on the animal's back, this piece is judged to be Proto-Elamite in style (see also No. 28).

AB

1. See Mecquenem, 1911b, p. 52; *MDP* 13 (1912), pl. 38, no. 1; Le Breton, 1957, p. 111, fig. 32, no. 8; Amiet, 1966, fig. 63; Spycket, 1981, p. 44, no. 87; Amiet, 1986a, pp. 98, 258, fig. 44; idem, 1988b, p. 59, fig. 23.
2. Amiet, 1988b, p. 59, fig. 23; idem, 1980c, figs. 543, 546, 574, 580.

27

28 HEADLESS STATUETTE OF A RESTING BOVINE
White marble
*H. 1⅜ in. (3.4 cm); L. 2¼ in. (5.7 cm); W. 1 in.
(2.5 cm)*
Proto-Elamite period, ca. 3000–2900 B.C.
First archaic deposit, Acropole, trench 26; Sb 110
Excavated by Mecquenem, 1909.

29

The animal shown here is incomplete: a head that
was probably of a different material, perhaps metal,
was originally fastened to the tenon at the front of
the body.[1] The loop on the back is broken. Other ar-
tifacts of the same period give evidence of having
been made with attached parts of different materials
(see No. 27 and fig. 30, p. 69).

The animal is at rest, its legs folded beneath its
body. The back hoof on the right side is not visible;
apparently the artist had observed that bovines tend
to turn their rear right leg toward the left when
lying down. The rendering of muscle masses and of
the curls of hair on the feet are in keeping with a
new, more decorative Proto-Elamite style.

In the Proto-Elamite period, images of bovines
and felines often occur together on seals.[2] Their as-
sociation, already seen on sculpted vases of the Late
Uruk period in Mesopotamia, may symbolize a
union of the domestic and the savage realms.

AB

1. See Mecquenem, 1911b, p. 52; *MDP* 13 (1912), pl. 38, no. 4;
 Le Breton, 1957, p. 111, fig. 32, no. 9; Amiet, 1966, fig. 64;
 Spycket, 1981, p. 44, no. 85, pl. 33; Amiet, 1986a, pp. 98 and
 258, no. 45.
2. Amiet, 1980c, nos. 585, 586, 591.

29 DEAD BIRD
White marble
*H. 1⅞ in. (4.9 cm); W. 1⅛ in. (3 cm); D. 1½ in.
(3.7 cm)*
Proto-Elamite period, ca. 3000–2900 B.C.
First archaic deposit, Acropole, trench 26; Sb 105
Excavated by Mecquenem, 1909.

The presence of a loop, its position marking the top
of this sculpture, indicates that the bird, probably a
dove, is dead. The head falls forward and the folded
wings, apparently tied together, have lost all
muscularity.[1]

The sculpture exhibits considerable three-
dimensionality. It was not meant to be seen from the
side only; in front view the wings project forcefully
where they join the body, giving the whole object a
triangular outline. Like other works in a Proto-
Elamite style (Nos. 27, 28), this sculpture is made
of marble.

AB

1. See Mecquenem, 1911b, p. 52, fig. 16; *MDP* 13 (1912), p. 38,
 no. 6; Le Breton, 1957, p. 111, fig. 32, no. 4; Amiet, 1966,
 fig. 85; Spycket, 1981, p. 44, no. 82.

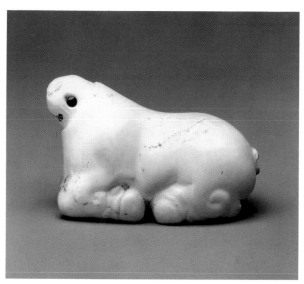

28

30 SMALL VESSEL WITH TWO NECKS
Painted alabaster
H. 2⅜ in. (6 cm); L. 4¼ in. (10.7 cm); W. 1⅜ in.
(3.5 cm)
Late Uruk period, ca. 3300 B.C.
First archaic deposit, Acropole, trench 26; Sb 4005
Excavated by Mecquenem, 1909.

Small alabaster vessels with two or three necks, some with zoomorphic appendages, are well known from the late fourth millennium in Susa (see No. 35). Traces of red and black paint are visible on this example, and its entire surface is incised with a zig-zag decoration.[1] The two necks lead to two small cone-shaped cavities that still display the marks left by a circular tool at the bottom. Most of the object has not been hollowed out, which explains its surprising weight. The capacity of this small receptacle is very limited; perhaps it was used for perfume.

AB

1. See Mecquenem, 1911b, p. 51; Le Breton, 1957, p. 111, fig. 32, no. 2.

31 FEMALE WORSHIPER
Gypsum alabaster
H. 4½ in. (11.5 cm); L. 2⅞ in. (7.2 cm); W. 1¾ in.
(4.5 cm)
Late Uruk period, ca. 3300 B.C.
Second archaic deposit, Acropole, trench 26; Sb 69
Excavated by Mecquenem, 1909.

One might be tempted to put this worshiper to-gether with the one from the first deposit (No. 25) on the basis of the kneeling posture, long hair held by a band (here in relief), high bosom, almond-shaped eyes, and aquiline nose.[1] Yet this figure—the loveliest of the worshiper series and "one of the most arresting ancient expressions of prayer," in the words of Pierre Amiet[2]—is sculpture of a very different order from the others. Its greater size has made it possible to render precisely the position of the hands in prayer, with the two little fingers crossed, the index and middle fingers touching, and the thumbs meeting beneath the chin. Attentive to other details as well, the artist hollowed out the space between the arms and sought to establish a balance between the arms and the face. This entailed a slight elongation

30

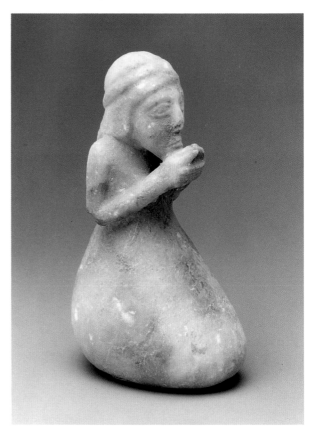

31

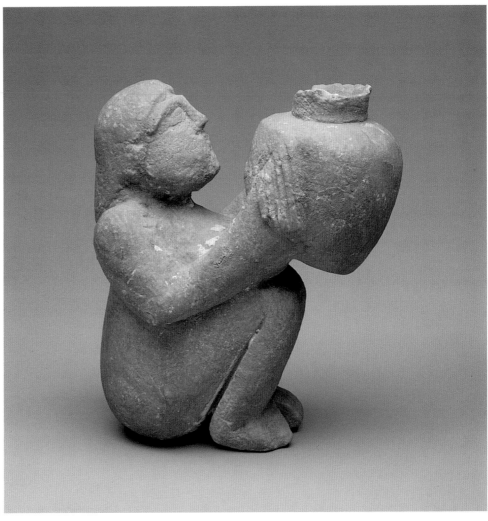

32

of the forearms and of the chin.[3] Like the statuette of a dead bird from the first deposit (No. 29), this figure was meant to be seen not just in profile but also from the front, where the symmetrically placed arms create a satisfying equilibrium.

The figure was carved from very fine alabaster; the sculptor may have turned the head toward the left in order to avoid a grayish vein discovered in the course of his work.

AB

1. See Mecquenem, 1911b, p. 54, fig. 19; *MDP* 13 (1912), pl. 39, no. 6; Le Breton, 1957, p. 111, fig. 32, no. 25; Strommenger, 1964, pl. 36, p. 59; Amiet, 1966, fig. 91; idem, 1977, fig. 237, p. 356; Spycket, 1981, p. 35, no. 33, pl. 25; Amiet, 1988b, fig. 19, p. 48.
2. Amiet, 1966, p. 128.
3. Agnès Spycket calls this a case of protruding jaw, or prognathism. Spycket, 1981, p. 35.

32 WORSHIPER WITH A VESSEL
Alabaster
H. *4½ in. (11.6 cm)*; L. *4⅛ in. (10.5 cm)*; W. *2½ in. (6.3 cm)*
Late Uruk period, ca. 3300 B.C.
Second archaic deposit, Acropole, trench 26; Sb 71
Excavated by Mecquenem, 1909.

This worshiper, unlike others in the archaic deposits, is represented sitting rather than kneeling.[1] The figure holds out a collared vessel, which is probably an offering, in a gesture seen on the later Proto-Elamite silver bull in the Metropolitan Museum (fig. 5, p. 5). The sex of the worshiper is unclear: the garments and the absence of breasts suggest a man, but the hair falling down the back in a curve suggests a woman. On seals of this period, men are usually depicted with short hair or even shaven heads.

The work is rather crude. The eyes are barely indicated; the forearms are of unequal length and not in proportion to the rest of the arm; the fingers are marked off by simple lines; and no space has been left between the arms or between the jar and the chest. The legs, joined together, are differentiated only by a groove, a stylistic device also found on the drinking bear from the same deposit[2] and elsewhere on statuettes of women.[3]

AB

1. See Mecquenem, 1911b, p. 55, fig. 21; *MDP* 13 (1912), pl. 39, no. 9; Le Breton, 1957, p. 111, fig. 32, no. 26; Parrot, 1960, fig. 103b; Strommenger, 1964, pl. 37, pp. 387–88; Amiet, 1966, fig. 94; Orthmann, 1975, fig. 276b; Spycket, 1981, p. 35, no. 36, fig. 11.
2. Amiet, 1966, fig. 73.
3. Amiet, 1976c, p. 62 and pl. 19, 1, 2; Le Brun, 1971, fig. 44.

33 SEATED MONKEY

Alabaster
H. 5¼ in. (13.5 cm); W. 2⅜ in. (6 cm); D. 3½ in. (9 cm)
Late Uruk period, ca. 3300 B.C.
Second archaic deposit, Acropole, trench 26; Sb 119
Excavated by Mecquenem, 1909.

According to the excavator, this figure "was originally fastened on a base by means of three pegs."[1]

A number of representations of monkeys have been found at Susa (see No. 61). This one is shown seated with its hands on its knees, meditating like a human. The portrayal of animals whose attitudes resemble those of people—another example being the drinking bear (No. 38)—is characteristic of the art of this period.

The creature sits huddled and immobile. The flat profile of the head, the height of the body, the absence of neck, the arching back, and the variation in thickness of the fur on the animal's front and back are all carefully observed and rendered, allowing it to be identified as *Papio hamadryas*.[2] Two holes represent the eyes.[3]

AB

1. Mecquenem, 1911b, p. 54.
2. Information from Francis Petter, deputy director of the Muséum National d'Histoire Naturelle, Paris.
3. See Mecquenem, 1911b, p. 54 and fig. 20; *MDP* 13 (1912), pl. 39, nos. 5, 7; Le Breton, 1957, p. 111, fig. 32, no. 27; Parrot, 1960, fig. 103c; Strommenger, 1964, fig. 37 and p. 388; Amiet, 1966, fig. 74; idem, 1977, p. 356, fig. 247; Spycket, 1981, p. 43, no. 78, pl. 32.

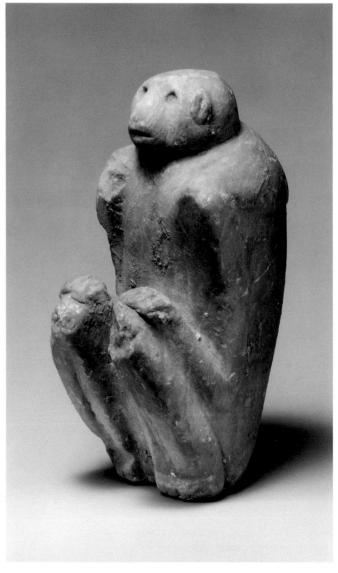

33

34 BIRD-SHAPED VESSEL

Alabaster, bitumen(?)
H. 2¼ in. (5.8 cm); L. 4 in. (10.2 cm); W. 1¾ in.
(4.5 cm)
Late Uruk period, ca. 3300 B.C.
Second archaic deposit, Acropole, trench 26; Sb 3015
Excavated by Mecquenem, 1909.

Three bird-shaped vessels were found in the second deposit. This example has a single opening on the back, probably originally surmounted by a short vertical neck.

The Susian artists' skill at capturing the poised bearing of animals is expressed here with originality. The bird's round, staring eye set off by black, its wings folded tightly against its body, and the feet drawn together with their two incised claws underneath all heighten the sense of the creature's vigilance.

The species of the bird is unclear; perhaps it is a water-hen or a partridge.[1]

AB

1. See Mecquenem, 1911b, p. 53, fig. 18; *MDP* 13 (1912), pl. 38, no. 12; Le Breton, 1957, p. 111, fig. 32, no. 17; Parrot, 1960, fig. 103a; Strommenger, 1964, fig. 35, p. 387; Amiet, 1966, fig. 69; idem, 1977, p. 356, fig. 242.

35 VESSEL WITH THREE NECKS AND AN ANIMAL HEAD

Alabaster, bitumen(?)
H. 3 in. (7.7 cm); L. 6¼ in. (16 cm); W. 1⅝ in.
(4.2 cm)
Late Uruk period, ca. 3300 B.C.
Second archaic deposit, Acropole, trench 26; Sb 3030
Excavated by Mecquenem, 1909.

This vessel is decorated with the head of a hedgehog that has pointed ears and an elongated muzzle.[1] The eye, a mere incised dot inlaid with a black material, equals in vivacity that of the bird from the same deposit (No. 34). The vessel is incised with a characteristic zigzag pattern. Within are three rather large unconnected cavities.

A three-necked vessel that seems to be much bigger than this one is represented on a sealed clay ball.[2] According to Pierre Amiet, zoomorphic vessels may have been brought as offerings to the temple, where they substituted for living animals.

AB

1. See Mecquenem, 1911b, p. 53, fig. 17; *MDP* 13 (1912), pl. 38, no. 10; Le Breton, 1957, p. 111, fig. 32, no. 19; Amiet, 1966, fig. 65.
2. Amiet, 1980c, pl. 16, no. 265.

34

35

36 VESSEL IN THE SHAPE OF A BAG
Alabaster
H. 2⅝ in. (6.7 cm); W. 2⅞ in. (7.2 cm); D. 2 in.
(5.2 cm)
Late Uruk period, ca. 3300 B.C.
Second archaic deposit, Acropole, trench 26; Sb 3012
Excavated by Mecquenem, 1909.

The vessel[1] reproduces in miniature a type of hide or
cloth bag that was used for transporting goods. Such
bags were secured against unauthorized opening by
seal impressions placed on the string that closed the
bag. The bags are rarely represented on seals and
seal impressions,[2] although images of jars with two
handles,[3] vessels with two or three necks,[4] and jugs
with spouts[5] are common.

AB

1. See Mecquenem, 1911b, p. 53; Le Breton, 1957, p. 111,
 fig. 32, no. 14.
2. One of these bags, closed, might be represented on the exam-
 ple shown in Amiet, 1980c, p. 14 bis O.
3. Ibid., nos. 262, 291, 321, 326, etc.
4. Ibid., nos. 261, 265, etc.
5. Ibid., nos. 333, 335, etc.

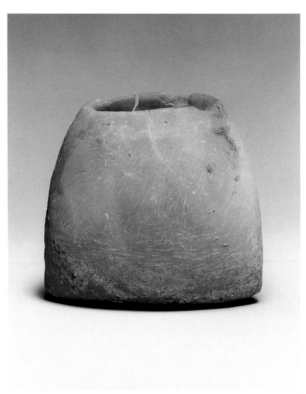

36

CONTEMPORARY SCULPTURE

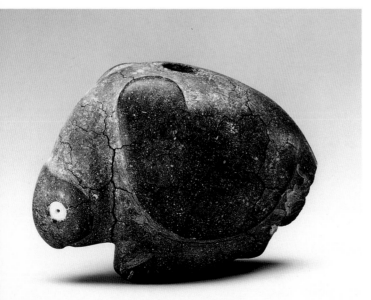

37 BIRD
Bitumen compound; shell inlay
H. 2¾ in. (7 cm); L. 4⅛ in. (10.5 cm)
Late Uruk period, ca. 3300 B.C.
Acropole; Sb 2918
Excavated by Mecquenem, 1934.

This statuette represents a predatory bird in a
crouching position, its legs tucked under its body.[1]
The bird's body is schematically and economically
rendered; the eyes are inlaid with shell. A hole run-
ning vertically through the middle of the statuette
indicates that in antiquity it was placed on a support
or staff. The object is a very early example of the
use of bitumen compound as a sculptural medium at

37

Susa. Bitumen compound was primarily employed at Susa in the subsequent Old Elamite period (ca. 2700–1600 B.C.).

ZB

1. Amiet, 1966, fig. 86.

38 DRINKING BEAR
Alabaster; gray paste inlay
H. 4 in. (10 cm); L. 2⅜ in. (6 cm); W. 1⅜ in. (3.6 cm)
Late Uruk period, ca. 3300 B.C.
Acropole; Sb 2984

A species of small tractable brown bears, *Ursus arctos syriacus* (also called Persian bears), can still be found in Iran today, especially in the Zagros region. When given a bottle filled with a sweet liquid, which it likes, this animal spontaneously settles back on its rear, bending its hind legs and wrapping its front paws around the container.[1] That amusing position twice engaged the attention of Susian artists,[2] who were sensitive to the kinship between man and animal[3] and had a keen sense of observation and a gift for vividly capturing a real-life posture. (The bear was probably domesticated by the beginning of the fourth millennium B.C.)

On this statuette[4] the animal's small ear, the length of its snout hidden by the paws, the roundness of its head and body, and its gluttonous concentration have all been faithfully rendered.[5] The artist was careful to separate the front limbs from the body and to reproduce the sweeping gesture with which the bear tilts the container into the most comfortable position possible.

AB

1. Information furnished by Francis Petter, deputy director of the Muséum National d'Histoire Naturelle, Paris.
2. Amiet, 1966, figs. 72, 73.
3. Ibid., figs. 72–74.
4. See Jéquier, 1905, p. 19, fig. 12; Pottier, 1912, pl. 39:2; Contenau, 1927–31, vol. 1, p. 371, fig. 275; Le Breton, 1957, p. 111, fig. 31, no. 7; Amiet, 1966, fig. 72; Spycket, 1981, p. 43 n. 79.
5. The bear in Amiet, 1966, no. 73, is represented in a much more cubist manner.

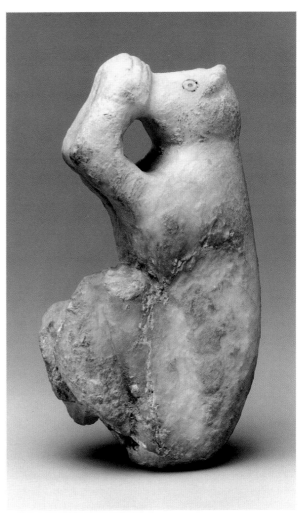

38

The Proto-Elamite Period

*V*irtually everywhere archaeologists have looked in the drainage basin of the Tigris and Euphrates rivers, they find evidence of significant contact between peoples in distant communities during the second half of the fourth millennium. There can be no doubt that Susa, whether as a peer polity of Uruk or directly dependent on it, shared cultural traits with that community, which had its center in southern Mesopotamia. Sometime around 3000 B.C., the seemingly coherent Late Uruk community changed. The most far-flung of its known extensions on the upper Euphrates, Habuba Kabira and Jebel Aruda, were abandoned; and, to judge from the material culture of sites closer to the heartland, regional differences began to develop.

Although difficult to interpret, the archaeological record shows that something also happened at Susa. There is a break in the stratigraphic sequence in the Acropole sounding and a corresponding change in some of the components of the material culture. Some scholars think this hiatus indicates that the entire site of Susa was abandoned and then, during the following phase, was annexed and resettled by people from the highland. Another interpretation is that the hiatus exists essentially in the sounding and reflects the diminution of western influence and the increased influence of a people more closely tied linguistically and culturally to communities living on the plateau. It was Susa's location, on the border between the alluvial floodplain of Mesopotamia and the highlands of Iran, that gave it special importance through its entire history. Rather than being understood as a peripheral outpost alternating between the domination of a lowland and of a highland polity, Susa can be seen as a pivotal locus for the control of various routes to the immensely rich resources found in the Iranian highland.

The period following the Late Uruk is called the Proto-Elamite. Although poorly known, this period

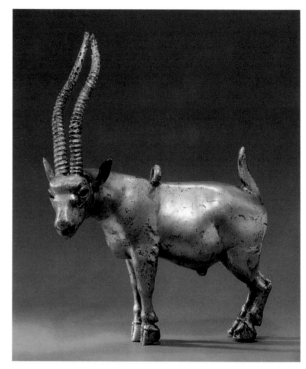

Figure 29. Antelope. Iran(?), Proto-Elamite period, ca. 3000 B.C. Silver, H. 4⅜ in. (11.1 cm). The Metropolitan Museum of Art, Rogers Fund, 1947 (47.100.89)

was certainly one of high artistic creativity in the ancient Near East. In the absence of other historical markers, the Proto-Elamite period is named after its most notable invention, a system of true writing used to record commodity transactions. Clearly inspired by and modeled on the Proto-Cuneiform script of Sumer, the Proto-Elamite script is an entirely independent script that represents a different underlying language, perhaps related to the later Elamite.

The ceramics found in Proto-Elamite levels at Susa suggest a turning away from some of the techniques and traditions of the Uruk period and the adoption of

others known in the highland of southern Iran, particularly from the valley of Marv Dasht in the present-day province of Fars. However, there is an important exception: in all Proto-Elamite contexts, the beveled-rim bowl and the low-sided tray, utilitarian ceramic types that were the hallmark of the Late Uruk phase, continued in use. Reflecting a relationship formally similar to the earlier one between Susa and Uruk, several sites on the Iranian plateau have material assemblages that are distinctively Proto-Elamite. These include seals, sculpture, tablets, and ceramics.

While the evidence is sparse, it is possible that the beginning of this change in orientation can be observed at the very end of the Late Uruk period, in level 17B of the sounding at Susa. At that moment a material culture related to Susa 17B first appeared at Godin, Sialk, and Malyan. These sites were located on the primary northern and southern routes for obtaining the raw materials in demand in the alluvium.

Future investigations will undoubtedly reveal a substantial Proto-Elamite presence along the northern route skirting the edge of the Kavir Desert. But only along the southern route, which follows the southern edge of the Desert of Lut, can this remarkable cultural expansion be traced. Abundant evidence substantiates the presence of Proto-Elamite culture at ancient Anshan, which later became a highland Elamite capital. Proto-Elamite occupation is clearly visible at sites investigated along the southern route, all the way to the Seistan Basin in eastern Iran. Proto-Elamite seals and tablets have been found at both Tepe Yahya and Shahr-i Sokhta. Tal-i Iblis and Shahdad, in the region of Kerman, probably also had a Proto-Elamite presence. The legacy of that initial lowland expansion onto the highland plateau, although elusive, was certainly a major one; it became the basis for modes of cultural expression used by the highland cultures, which were to flourish during the third millennium and emerge in a fully federated alliance with the lowland during the early part of the second millennium.

PROTO-ELAMITE ART

Sculpture and glyptic make up the majority of the evidence for the visual culture of the Proto-Elamites. Although there is no direct evidence of monumental sculpture, the notion of monumentality is clearly implied in certain of the glyptic representations. As in the Late Uruk period, some of the small-scale sculpture is

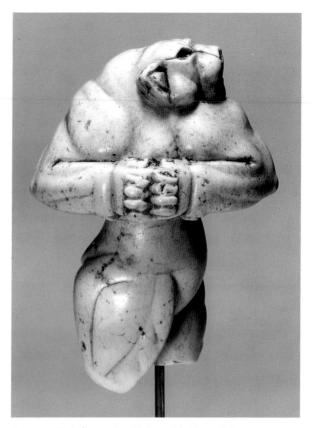

Figure 30. Lion-demon. Iran(?), Proto-Elamite period, ca. 3000 B.C. Crystalline limestone or magnesite, H. 3½ in. (8.8 cm). Collection of Robin B. Martin, on loan to The Brooklyn Museum, L48.7.9

of the highest quality. Three of the finest pieces, two in the collection of the Metropolitan Museum and the other in the collection of Robin B. Martin and on loan to the Brooklyn Museum, can be assigned to the Proto-Elamite period through comparison with the images in glyptic (figs. 29, 30).

As was the case with the Late Uruk period, the best view of the Proto-Elamites is gained from images on the seals, although in this period their meaning is less accessible. The ten examples selected for this catalogue from the more than three hundred Proto-Elamite seals and sealings from Susa housed in the Louvre provide fine examples of the most typical subjects and compositions. Certain characteristic features are immediately identifiable; all the examples depict what are probably wild animals, including two distinct types of bull, a variety of goats or sheep, felines, and wild boar. Except for demonic figures, most commonly combining features of birds and lions, and the extremely rare occurrence of other animal species and human beings, that is the extent of the subjects presented in Proto-Elamite seals.

Virtually unique to the Proto-Elamite period and confined almost exclusively to figural seals such as these is the material called heulandite, a light greenish, soft, talclike stone.[1] It would be interesting to know the precise source of this unusual material.

This selection also illustrates the stylistic range of Proto-Elamite imagery. The seals share such features as compact, segmented bodies, the linear definition of forms, and a flat, two-dimensional rendering of the figures. From the combination of perspectives in which the animal's body is presented, it can be argued that such Proto-Elamite images as the lion-demon (fig. 30 and No. 47), unlike their more sculptural Late Uruk counterparts, were conceived in two rather than three dimensions.

HOLLY PITTMAN

1. C. Lahnier, "Note sur l'emploi de l'heulandite et de la mordéntite dans la fabrication des sceaux-cylindres proto-élamites," *Annales du laboratoires de recherche des Musées de France* (1976), pp. 65–66.

Proto-Elamite Seals and Sealings

Unlike the seals of the Late Uruk period, which were cut according to a rather narrow range of stylistic conventions, Proto-Elamite seals, while they share fundamental stylistic features, display a great deal of individuality. For example, two seals describe the bodies of the animals with intense, nonrealistic internal patterning (Nos. 41, 43), but accomplished differently in each. The lines on the haunch of the animal in Number 41 are angular, while those on the haunch of Number 43 are curved. In the rendering of animals on the other seals the artists avoided internal patterning entirely, choosing to define body parts by varying the level of the flat relief of the body masses. In Numbers 40 and 44 a drill was used to define hair masses and joints of the body, while in the others all evidence of the drill was eradicated by the subsequent use of a graver. That sort of stylistic variation is one of the features that gives Proto-Elamite art such extraordinary vigor.

The compositions of the scenes engraved on the seals presented here are also typical. Animals are shown singly (No. 44) or in files (Nos. 39, 43); they are seen as confronted pairs (No. 40), in heraldic composition (No. 45), and engaged in an interaction that suggests attack (Nos. 40–42).

One striking feature of Proto-Elamite art is the depiction of animals in the context of a landscape. Though to us a commonplace of visual naturalism, landscape elements are rarely found in the art of the ancient Near East, and when they do occur they are generally emblematic. The only other consistent appearance of landscape, prior to the influence of Aegean artistic traditions in the middle of the second millennium, occurs in the equally vigorous art of the Akkadian period (2334–2193 B.C.). Landscape is particularly obvious in Numbers 41 and 42, both showing animals among plants, and Number 45, which displays two pairs of mountain goats, each pair flanking a tree placed on top of a pyramidal mountain. It should be mentioned that while elements of landscape are certainly denoted, both the mountain and the tree are signs used in the Proto-Elamite script.

Another device found in Proto-Elamite art is the metonymic mode of representation, in which a part of an animal is used to refer to the entire creature. That approach, employed to great advantage in the earliest phases of the Proto-Cuneiform and Proto-Elamite scripts, can be clearly seen in Number 41, where the head of a caprid emerges from a striated circle.

Other consistent patterns are suggested in the combinations of creature types. For example, caprids are not usually shown with other animals, although different species within the genus are often combined. Number 39 is an exception; there we see bulls, heads frontally depicted, arrayed in a file above which are two rows of caprids. Lions and bulls, however, are frequently combined, often shown in what seems to be a position of attack. The lion is usually the most active of the animals, shown walking, running, or in a threatening stance, but it can also appear in a defensive posture, its head turned back (No. 41).

Multiple-register compositions are common in the animal file depictions of this glyptic style. In these compositions, the field is often informally divided into three sections. The bottom register of animals occupies two-thirds of the field, with an upper register deployed in the remaining third. Although the theory is impossible to prove, Amiet has speculated that this variation in scale was used to suggest spatial perspective, with the smaller animals in the upper registers meant to be understood as being farther away.[1]

HP

1. Amiet, 1980c, pp. 111–14.

39 CYLINDER SEAL WITH ROWS OF ANIMALS
Green heulandite
H. 2⅝ in. (6.6 cm); DIAM. 1⅛ in. (3 cm); string hole
¼ in. (.65 cm)
Proto-Elamite period, ca. 3100–2900 B.C.
Sb 2428

Beneath two rows of caprids, walking to the left (in
the impression), is one row of bulls. This seal's com-
position, animals shown in files one above the other,
is typical of the Proto-Elamite period. However, the
combination of species displayed on the seal—bulls
with heads turned out below two rows of caprids—
is unusual, for caprids are not generally depicted
with other animals. The simple outline of the figures
emphasizes the graphic, two-dimensional nature of
Proto-Elamite glyptic.[1]

HP

1. Delaporte, 1920, pl. 26, no. 6.

40 UNPIERCED CYLINDER SEAL WITH BULLS AND
LION
Pink marble
H. 1⅝ in. (4.1 cm); DIAM. 1 in. (2.6 cm)
Proto-Elamite period, ca. 3100–2900 B.C.
Sb 6166
Excavated 1932.

The seal shows confronted kneeling bulls separated
by a flower. Above and on a slightly smaller scale is
a lion pursuing a bovid with its head turned back.
Next to them is a cross.

In rendering the animals on this seal[1] the artist
avoided internal patterning and used a drill only to
define hair masses and joints of the body. The com-
position, with confronted bovids below and a bovid
and feline attack scene above, is typical of the Proto-
Elamite period. The cross, here in the upper field, is

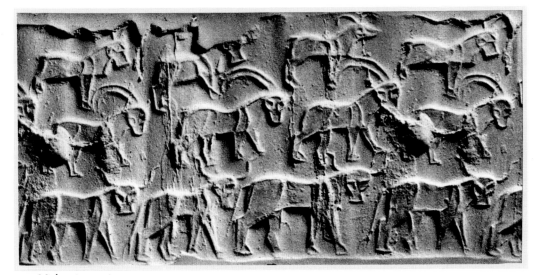
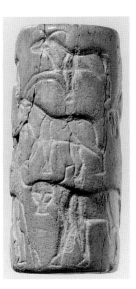

39 Modern impression

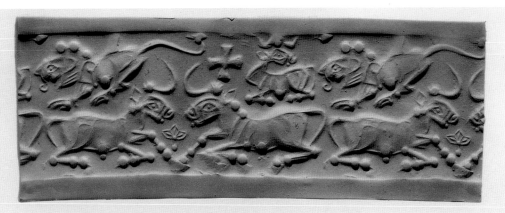

40 Modern impression

one of the signs most frequently used in Proto-Elamite script.

<div align="right">HP</div>

1. Amiet, 1972a, pl. 107, no. 999; Mecquenem, 1925, p. 13, fig. 22.

41 UNPIERCED CYLINDER SEAL WITH LION AND BULL
Green and purplish heulandite
H. 1¾ in. (4.3 cm); DIAM. 1¼ in. (3.1 cm)
Proto-Elamite period, ca. 3100–2900 B.C.
Sb 1488

Depicted are a bovid and a feline with its head turned back. In the upper field are the head of a horned animal and leafed branches.

This seal[1] exemplifies one striking feature of Proto-Elamite art, the representation of animals in the context of landscape (see p. 70).

<div align="right">HP</div>

1. Amiet, 1972a, pl. 102, no. 949; Mecquenem, 1934, p. 195, fig. 30:5.

42 CYLINDER SEAL WITH BOVID, CALF, AND LION
Bitumen compound
H. 1¼ in. (3.2 cm); DIAM. ⅝ in. (1.6 cm); string hole ³⁄₁₆ in. (.4 cm)
Proto-Elamite period, ca. 3100–2900 B.C.
Sb 1484

Above a bovid and a calf are a striding lion and a leafy branch. The stocky proportions of the animals' bodies are characteristic of Proto-Elamite–style seals. Interlocking curving forms that echo each other, as they do here, also characterize the best of the Proto-Elamite seals. The bull shown on this seal,[1] almost certainly an aurochs, is one of two types depicted in the period. The other type, seen for example on Number 40, is certainly of another species, perhaps domesticated. The aurochs is distinguished by the frontal position of the horns and the presence of long hair on the chest.

<div align="right">HP</div>

1. Amiet, 1972a, pl. 107, no. 1000.

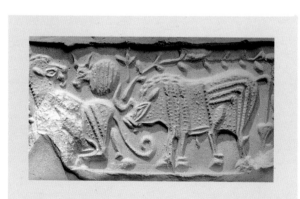

Modern impression

41

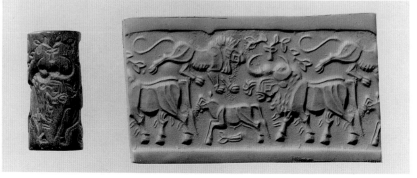

42 Modern impression

43 UNPIERCED CYLINDER SEAL WITH HORNED
ANIMALS
Heulandite
H. *1⅞ in. (4.9 cm)*; DIAM. *1⅛ in. (3 cm)*
Proto-Elamite period, ca. 3100–2900 B.C.
Sb 2429

The two files of creatures on this beautiful seal[1] in-
clude two types of horned mountain animals, proba-
bly goats, and mountain sheep, walking in a field of
flowers. As in Number 40, the bodies of the sheep
are differentiated by alternating body markings.

HP

1. Delaporte, 1920, pl. 26:7.

44 UNPIERCED CYLINDER SEAL WITH A LION
White limestone
H. *1¾ in. (4.6 cm)*; DIAM. *1¼ in. (3.1 cm)*
Proto-Elamite period, ca. 3100–2900 B.C.
Sb 2426

Only rarely is a single animal engraved on a cylin-
der seal.[1] Rolling out the seal to make an impres-
sion, however, produces an unending file of identical
figures. The body of this lion is formed by a simple
outline; his head and his powerful mane are created
by drillings of different sizes.

HP

1. Delaporte, 1920, pl. 26:2.

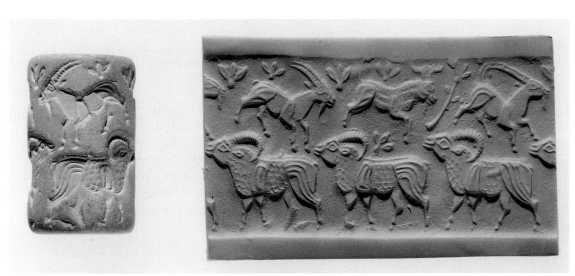

43 Modern impression

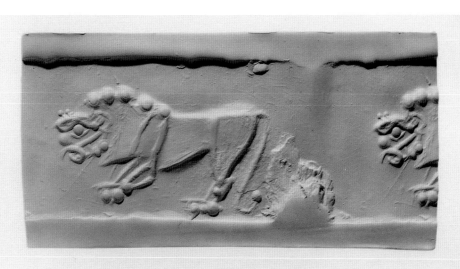

44 Modern impression

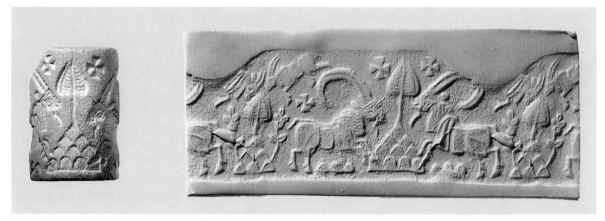

Modern impression

45

45 UNPIERCED CYLINDER SEAL WITH CAPRIDS
 AND TREES
 Heulandite
 H. 1⅜ in. (3.4 cm); DIAM. 1 in. (2.4 cm)
 Proto-Elamite period, ca. 3100–2900 B.C.
 Sb 2675

This is one of the masterpieces of Proto-Elamite
glyptic art.[1] Two powerful mountain goats are
shown facing a tree on a mountain in a formal, he-
raldic composition, its symmetry emphasized by the
repetition of forms in the field. The primary theme
is echoed by a small pair of caprids diagonally flank-
ing a tree on a mountain. The cross, shown three
times in the upper field, is a sign belonging to the
Proto-Elamite script. Although the tree on the
mountain is undoubtedly a landscape element, tree,
mountain, and the combination of the two are dis-
tinct script signs as well.

HP

1. Rutten, 1935–36, vol. 2, p. 74, no. 43.

46 TABLET WITH IMPRESSION OF A HORNED
 ANIMAL AND A PLANT
 Clay
 H. 2½ in. (6.4 cm); W. 1¾ in. (4.5 cm)
 Proto-Elamite period, ca. 3100–2900 B.C.
 Sb 4841
 Excavated by Morgan.

This tablet is inscribed with Proto-Elamite script
and impressed by a seal. The seal would have had
one caprid and a plant engraved on its surface, but
because of multiple rollings there are repeated im-
ages of the animal. As is obvious from this example,
seals were applied to the still-soft tablets first and
the inscriptions added afterwards.

HP

1. *MDP* 16 (1921), pl. 8, no. 125.

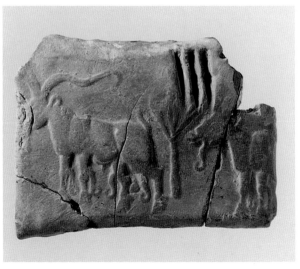

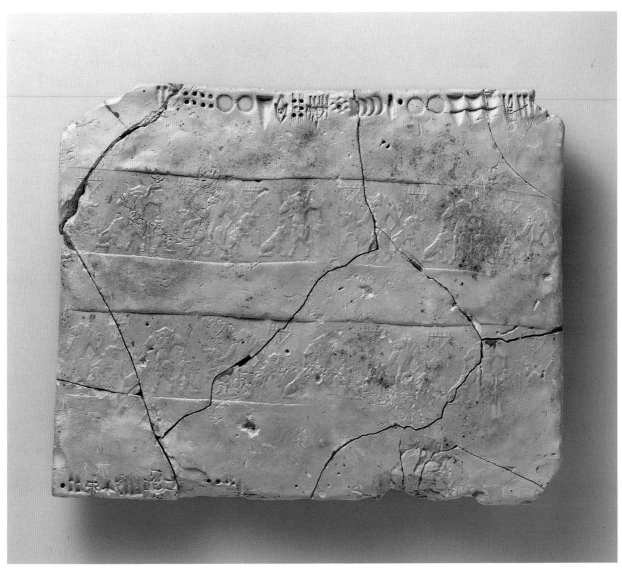

47

47 LARGE TABLET WITH IMPRESSIONS OF
DOMINATING ANIMALS
Clay
H. 8¼ in. (21 cm); W. 10½ in. (26.7 cm)
Impressed with a seal of H. 1⅝ in. (4.2 cm)
Proto-Elamite period, ca. 3100–2900 B.C.
Sb 2801
Excavated by Morgan.

This clay tablet[1] and Number 48 are impressed by
seals depicting the other major theme of Proto-
Elamite glyptic, animals acting as human beings.
Among figural Proto-Elamite seals there are fewer
than five representations of actual human figures.
But in their place are the animals familiar from the
animal files, shown engaged in human activities.
The three principal animals endowed with human
attributes are the lion, the bull, and the caprid. Al-
though what these figures represent is unknown, the
clear relationships established between them allow
us to see a hierarchy that may in some ways repli-
cate the power structure of Proto-Elamite society.

Impressed on this largest preserved Proto-
Elamite tablet is an image considered the epitome of
Proto-Elamite art. A massive bull standing on its
hind legs, head and horns facing frontally, dominates
two small flanking felines. Alongside this triangular
composition is its opposite in both formal and icono-
graphic terms. A massive feline demon embraces
two rampant bulls in an inverted triangular compo-
sition. Above the head of each of the dominated

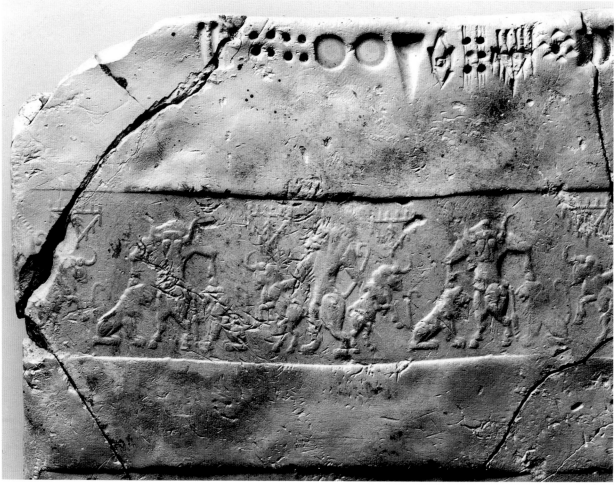

47, detail

bulls is a fringed triangular shape that is a fre-
quently occurring sign on inscribed tablets. Al-
though precisely who or what these two powerful
supernatural creatures represent is unknown, they
must refer to a great authority, either earthly or cos-
mic. They are often shown in balanced compositions,
like this one, which suggest their opposed but
equal—or almost equal—power or status.

This tablet also carries a Proto-Elamite inscrip-
tion on both sides.

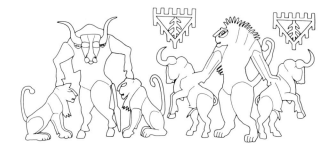

HP

1. Scheil, 1905, pl. 24; Léon Legrain, "Empreintes de cachets
élamites," *MDP* 16 (1921), pl. 23, no. 330; Delaporte, 1920,
pl. 43:8; Amiet, 1966, p. 101, no. 56.

48 TABLET WITH IMPRESSION OF A DEMONIC CREATURE IN A BOAT
Clay
H. 1¾ in. (4.5 cm); W. 2⅝ in. (6.7 cm)
Proto-Elamite period, ca. 3100–2900 B.C.
Sb 4832
Excavated by Morgan.

Impressed on a series of small tablets is an image of a demonic felinelike creature in a posture of reverence or power, kneeling in a high-prowed boat with its front legs held together at the chest. In front and back of the creature are two pointed forms that could be either spears or oars. Under the boat is a large fish; to the side is a tall bundle of tied reeds, a shape that is a sign in the Proto-Elamite script. The representation of a boat is most unusual among Proto-Elamite seals.

At least five tablets, in addition to this one,[1] are impressed with the same seal. They carry inscriptions which, although they cannot be read, were certainly written by the same hand and all end with the same series of signs.

HP

1. Léon Legrain, "Empreintes de cachets élamites," *MDP* 16 (1921), fig. 334; Delaporte, 1920, pl. 40:16.

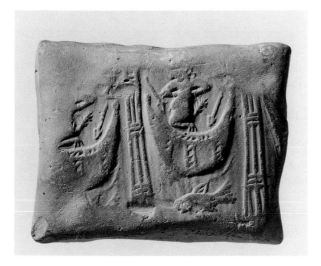

48

49 ACCOUNT TABLET
Clay
H. 4⅜ in. (11.1 cm); W. 6⅜ in. (16.2 cm)
Proto-Elamite period, ca. 3100–2900 B.C.
Sb 6353

Most Proto-Elamite tablets are, like this one, thick clay oblongs with sides in a ratio of about 3:2 (in this respect resembling the Proto-Cuneiform or "Archaic Sumerian" tablets drawn up in southern Mesopotamia at about the same time). The Proto-Elamite script reads right to left and ordinarily runs parallel to the long axis. Groups of numerals are conspicuous in almost all the texts; hence the loose characterization of these tablets as "accounting" documents. Often the text on the obverse consists of a series of more or less similar entries, sometimes preceded by a general heading, and the text on the reverse consists of a summation with totals of items found in the entries on the obverse. When there is insufficient space on the obverse for the entries, the text may continue on the lower edge and onto the reverse, so that the tablet turns on its long axis, vertically, like later cuneiform tablets. But when the only text on the reverse is a summation, the tablet ordinarily turns on the short axis, horizontally, like a page in a book. Some tablets bear the impressions of cylinder seals or stamp seals; this one does not.

The text of this document consists of single signs and pairs of signs separated by groups of numerals. The non-numerical signs are certainly logograms: they represent words rather than sounds. Although it is not now possible to read the Proto-Elamite script—that is, to identify and pronounce the words that the signs represent—it *is* possible to understand the structure of the document.

The broken upper left corner may have contained a heading of one or two signs. The obverse continues with fourteen parallel entries reading right to left, each with this structure:

a. Variable beginning
 i. One or two items identified with forms of the sign ⵕ, distinguished by diacritic inserts or adjacent signs, and followed by numerals.
 ii. One or two items identified with forms of the sign ⵔ, distinguished by diacritic inserts or additions, and followed by numerals.
 iii. An item identified either with the sign △ followed by numerals, or with the sign ⵙ followed by numerals.

b. Fixed conclusion

A sequence of nine signs, consisting of four items followed by numerals: || 1, ⊞ 1, ✶ 2, ⚲ 1. The boundaries between the entries are plainly marked by the fixed conclusion. Its first occurrence is at the left end of the first line.

The text on the reverse is a summation giving totals of the items found in the entries on the obverse, in the same order in which they appear in the entries: first, two forms of ⟨sign⟩, each followed by numerals; second, at least four forms of ⟨sign⟩, each followed by numerals; third, △ and ▲, the first followed by numerals and the second presumably originally followed by numerals as well. Of the totals corresponding to the items in the fixed sequence at the end of each entry, only the last is fully preserved: ⚲ followed by numerals.[1]

The Proto-Elamite texts use several different numerical systems. One is a sexagesimal system, with one sign to represent ones, another sign to represent tens, another sign to represent sixties, another sign to represent six-hundreds, and so on, thus:

●	⊍	∪	•	∩
3,600	600	60	10	1

Another is a decimal system, with one sign to represent ones, another to represent tens, another to represent hundreds, another to represent thousands, thus:

⊠	∩	•	∩
1,000	100	10	1

Another is called a ŠE system, with one sign to represent ones, another to represent sixes, another to represent sixties, another to represent 180s, and so on, thus:

⊍	∪	●	•	∩	⊃	⋈	✻
1,800	180	60	6	1	$\frac{1}{5}$	$\frac{1}{10}$	$\frac{1}{30}$

The sexagesimal and ŠE systems have close counterparts in Proto-Cuneiform and later Sumerian and Akkadian documents. The contemporary decimal system is special to Proto-Elamite.

In Mesopotamia the sexagesimal system was used to count most objects that can be identified as distinct items, e.g., animals, humans, containers, tools; in Proto-Elamite texts, to judge by the range of numbers and the pictographic character of the signs for the items counted, the sexagesimal and decimal systems have roughly this range of application. In Mesopotamia, the ŠE system (named with the Sumerian word *še*, "barley") was used to count measures of volume, especially of grain, and its use in Proto-Elamite seems to have been the same.

The possibility of confusion arises from the fact that the sexagesimal and ŠE systems use the same numerical signs, but with different arithmetical values. A similar situation would arise if we used, say, Roman numerals, but used a base 10 for centimeters, a base 12 for inches, a base 16 for fluid ounces, and a base 32 for avoirdupois measures. On the other hand, it is sometimes possible to gain at least a general understanding of Proto-Elamite texts, notwithstanding the fact that the script is undeciphered, from the use of numerical systems for discrete items, for units of volume, and for units of area, and from the size of the entries or ratios among them—to articulate, so to speak, the surviving arithmetic bones that carried the lost semantic flesh.[2]

Most of the items in this document are counted with the decimal and sexagesimal systems, since units occur in groups of six to nine and since the higher-order digit occurs once in a group of eight. Thus: [⟨sign⟩ (n × 10)] + 7, obverse line 2, and ⟨sign⟩ (8 × 10) + 9, reverse line 1; △ 10 + 6, obverse, line 5; ⚲ 8, reverse line 2. The final total makes sense as ⚲ 10 + 4, i.e., 14 entries with 1 ⚲ each, but not as ŠE-system 6 + 4 = 10. A distinctive feature of the entries is the fact that the item △ is counted in units up to 16 in sexagesimal or decimal notation, but its alternative, ▲, is counted only with fractions in the ŠE system: $(2 \times \frac{1}{5}) + \frac{1}{10} + \frac{1}{30}$, obverse line 1; $(3 \times \frac{1}{5})$, obverse line 2; $\frac{1}{10} + (2 \times \frac{1}{30})$ and again $(2 \times \frac{1}{30})$, obverse line 3; $\frac{1}{10} + (2 \times \frac{1}{30})$, obverse line 4 and again line 9.

Various contexts have led analysts of these texts to make the plausible conjectures that signs of the class ⟨sign⟩ indicate herded animals (more likely goats than sheep or bovines), that signs of the class ⟨sign⟩ indicate milk products, and that the sign ▲ indicates a grain product.[3]

MWS

49

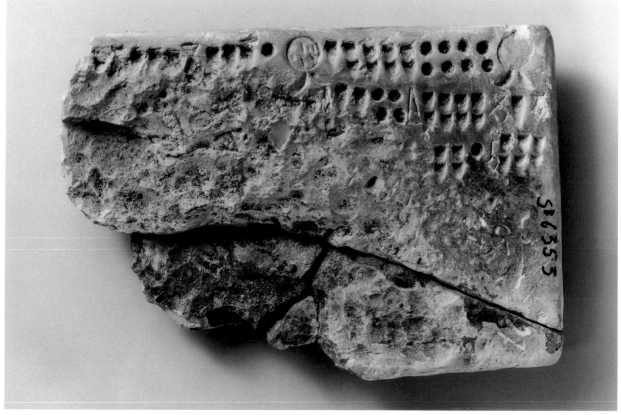

Reverse

1. The text was published by Vincent Scheil, *Textes de comptabilité proto-élamites (Nouvelle Série)*, MDP 17 (Paris, 1923), no. 97. Meriggi (1974, p. 115 H p 9) presents the text in an analytical transcription that displays its structure. Another Proto-Elamite tablet from Susa has identically structured entries and an identical overall structure (Scheil, op. cit., no. 85; see Meriggi, 1974, p. 116 H p 20).

2. For a lucid summary of these and the other Proto-Elamite numerical systems, see Damerow and Englund, 1989, pp. 22–27. The evidence for these systems, their reconstruction, and their implications for the interpretation of the texts are expounded by Jöran Friberg, "A Method for the Decipherment, through Mathematical and Metrological Analysis, of Proto-Sumerian and Proto-Elamite Semi-Pictographic Inscriptions," *The Third Millennium Roots of Babylonian Mathematics*, vol. 1 (Göteborg, Sweden, 1978).

3. Damerow and Englund, 1989, pp. 51–55; Meriggi, 1971, pp. 59–60.

THE OLD ELAMITE PERIOD
CIRCA 2700–1500 B.C.

*T*he end of the Susa III period was coincident with the disappearance of the Proto-Elamite sites from the southeastern highlands. Between 2700 and 2500 B.C., Susian material culture showed a strong relation to that of peoples living along the foothill road and in the mountain valleys of Luristan, to the northwest. The similarities suggest that there were political connections between Susians and the highlanders, perhaps forged in response to the threat posed by the militaristic Mesopotamian city-states of the Early Dynastic period (ca. 2700–2400 B.C.).

Susa lost its independence when it was conquered by the rulers of Akkad sometime between 2400 and 2200 B.C. The political change brought on an almost wholesale borrowing of Mesopotamian styles of art and manufacture and the adoption of the Old Akkadian writing and administrative systems. Susa became a transshipment point for commodities and troops along the foothill road that ran northwest to southeast, linking the southeastern Zagros Mountains with central Mesopotamia. The city was probably a staging point for expeditions farther to the east and a rear position where troops could wait out the winter season.

The material culture of Susiana in the late third millennium was predominantly Mesopotamian. However, local resistance is sometimes discernible in historical records of the period. Not surprisingly, it was when imperial rule over Susa was waning—first at the end of the Akkadian empire (ca. 2200 B.C.) and again near the end of the Ur III empire (ca. 2000 B.C.)—that powerful rulers of the Zagros regions tried to establish their independence. These revolts were centered not in Susa but in the highlands of Iran, and Susa was a prize to be won back from its Mesopotamian overlords.

After the collapse of the Akkadian empire, Susa was conquered by Puzur-Inshushinak, a king of Awan[1] and a contemporary of Ur-Nammu (ca. 2112–2095 B.C.), the first ruler of the Ur III empire in Mesopotamia. Shortly thereafter Susa was conquered and incorporated into the Ur III empire in the reign of Shulgi, the second king of the dynasty. However, it was won back by another group of mountaineers around 2000 B.C.: Shimashkian kings, whose home territory was located in the mountain valleys of Luristan northwest of Susiana and who held the city for several generations.

The Shimashki reign was short-lived and was replaced by the dynasty of the *sukkalmahs*. The name *sukkalmah* (or "grand regent") comes from the distinctive title used by Elamite rulers of the period.[2] Although the home territory of this dynasty was probably Anshan, some 320 miles to the

81

southeast in the Zagros Mountains, by 1900 B.C. the *sukkalmah*s had gained control of Susa. Their political acumen is evident in their scheme of shared kingship, effectively designed to unite the highlands and lowlands.[3] Kingship in Elam became a family affair consisting of a senior ruler, the *sukkalmah*; a senior co-regent, called the *sukkal*, or regent, of Elam and Shimashki, often a brother of the *sukkalmah*; and a junior co-regent, commonly called the *sukkal* of Susa, sometimes a son of the *sukkalmah*. This tight-knit hierarchy provided a unique system of governance quite unlike the monarchies of contemporary Mesopotamian states.

The economic strength of the Sukkalmah dynasty was based on control of the highlands, combined with the successful agricultural exploitation of both Susiana and the Kur River basin around Anshan by means of irrigation technology and administrative systems learned from Mesopotamian former rulers. Susa expanded, and early in the second millennium became a city of ten to twenty thousand people. New towns and villages appeared all over the plain and in the surrounding upland valleys. At this time Susa flourished as an independent regional capital and an international city active in Near Eastern politics, a locus of cultural and commercial interchange between the mountain folk of the Zagros and the inhabitants of the Mesopotamian plain.

EC

1. A list of kings, found at Susa and dating from sometime between 1800 and 1600 B.C., records twelve kings of Awan followed by twelve kings of Shimashki; Puzur-Inshushinak is listed as the last king of Awan. See Number 181 and Stolper, 1984, pp. 12–23. The location of Awan is unknown. On Awan and Shimashki, see Piotr Steinkeller, "On the Identity of the Toponym LÚ.SU(·A)," *JAOS* 108, no. 2 (1988), pp. 197–202. For a recent summary of the history see Piotr Michalowski, *The Lamentation over the Destruction of Sumer and Ur* (Winona Lake, Ind., 1989), pp. 1–3.
2. They had borrowed it from the Ur III imperial official (*sukkalmah*) who administered the eastern portions of the empire, including Susa.
3. [For a recent discussion of *sukkalmah* rule, see Vallat, 1990.—Ed.]

EARLY-THIRD-MILLENNIUM SCULPTURE

50 WORSHIPER
Alabaster
H. *5⅞ in. (14.8 cm)*; W. *2¼ in. (5.7 cm)*; D. *1⅝ in.*
(4 cm)
Ca. 2900–2334 B.C.
Acropole, 2nd level (temple site); Sb 77

The worshiper[1] is beardless and wears a long tiered garment, the uppermost layer of which forms a short mantle covering the left arm and shoulder while leaving the right side bare. The hands of this standing figure are clasped to the chest in a gesture of prayer. A circular depression on the left breast indicates a nipple. The figure's legs are summarily

carved in relief onto the base of the statue. Facial features are geometrically rendered, the mouth and chin in triangles, the eyes and eyebrows in arcs. The shoulder-length hair is stylized into a geometric pattern that from behind appears as rows of carefully arranged cubes carved in relief and from the sides as incised lozenges. This design was perhaps intended to represent a braided hairstyle. The sex of the worshiper is not readily apparent. In Mesopotamia the tiered costume covering one shoulder was worn by women in general and also by male rulers. Many male rulers were bearded, but clean-shaven male worshipers are also known. Nor is braided hair specific to one sex. An identification of the worshiper as male can be made only on the basis of the exposed

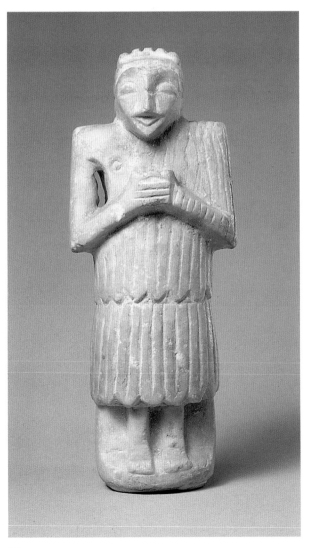

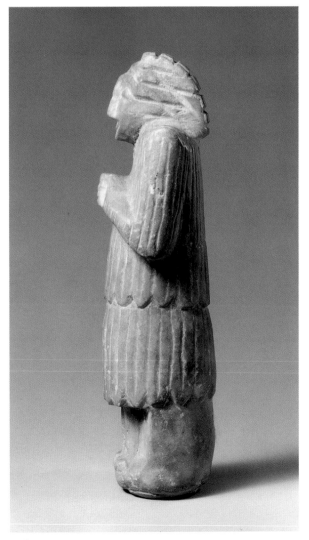

50

Side view

breast, a feature that is highly unusual, although not unknown, among statues of Mesopotamian female worshipers.[2]

Votive statues in an attitude of prayer originated in Mesopotamia, where they first appeared at the beginning of the third millennium B.C. They were placed in temples to represent the donor in perpetual prayer before the gods. While this worshiper is derivative of Mesopotamian votive statues, its geometric stylization, aptly characterized as "cubist" by Pierre Amiet,[3] is a purely local aesthetic preference.

ZB

1. Mecquenem, 1911b, p. 45, fig. 9; Pottier, 1912, pl. 40:7–8; Le Breton, 1957, p. 121, fig. 44:5; and see n. 3.
2. See Eva Braun-Holzinger, *Frühdynastische Beterstatuetten* (Berlin, 1977), pl. 2 a.b, no. 250.
3. Amiet, 1966, fig. 132; idem, 1988b, p. 62.

51 PLAQUE WITH BANQUET AND ANIMAL COMBAT SCENES
Alabaster
H. 6¾ in. (17 cm); W. 6¼ in. (16 cm)
Ca. 2750–2600 B.C.
Acropole, temple of Ninhursag; Sb 41
Excavated by Morgan and Mecquenem, 1908.

This plaque with a central perforation is divided into two equal registers, each having a scene carved in low relief.[1] The upper register depicts a banquet. At the right an enthroned, bare-chested male figure wearing a tiered skirt holds a cup in his right hand. Before him stands a nude male attendant clasping his hands to his chest. Behind the attendant is a male figure kneeling on one leg and facing to the left, where an enthroned female figure in a long gown faces him, holding a musical instrument. Although the instrument is identifiable as a harp, it is being held in an uncommon position. In ancient Near Eastern representations, the harp is usually played with the sound box placed against the musician and the strings away from the player. In this case the musician holds the harp with the strings next to her body.[2] In the lower register a nude hero appears, facing left. He has a beard(?) and long hair that falls to just above the shoulders, and he is aiming his dagger at a lion attacking a kneeling bull.

This object belongs to the category of perforated wall plaques of Mesopotamian origin that, it has been determined, were set vertically into the wall next to door jambs and had an association with the fastening of doors. A peg, either circular or square in section, inserted into a central hole secured a rope attached to the door.[3]

Stone figurative plaques with central holes are first documented in Mesopotamia in the Early Dynastic period. They are incised, carved in relief, or at times even inlaid with mother-of-pearl and shell. The subject of a banquet scene is common on Mesopotamian plaques. While the combination of a banquet with a hero and an animal combat in the lower register is not common,[4] combat scenes are frequently found on Mesopotamian seals of the Early Dynastic period, sometimes also in combination with banquet scenes. This particular theme, a nude hero aiming a dagger at a lion attacking a kneeling bull from the front, is paralleled on seals of the Early Dynastic I/II period (2900–2600 B.C.). An incised wall plaque of the same date from Nippur in southern Mesopotamia also depicts a lion attacking a kneeling bull from the front.[5]

The carving is local in style and is unlike the majority of Mesopotamian works of art in that the figures are more schematically rendered and for the most part lack interior details. Furthermore, the sculptor had some difficulty in accommodating the perforation, since the central figures in the upper register appear precariously balanced on the curved

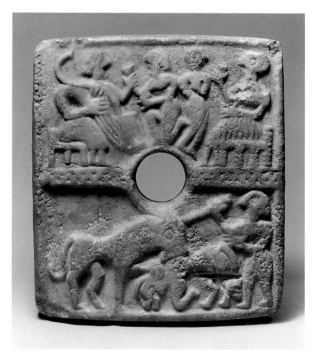

51

surface. His inability to fit the perforation into the pictorial space suggests that the sculptor was unused to working in this format. Mesopotamian sculptors usually integrated the scene with the central hole by leaving an uncarved square or rectangular space around the hole and arranging the subject matter into square or rectangular fields.

ZB

1. Mecquenem, 1911b, p. 47, fig. 12; Pottier, 1912, pl. 40:9; Le Breton, 1957, p. 121, fig. 45:10; Boese, 1971, pl. 24, no. s8, pp. 47–50.
2. I thank J. Kenneth Moore for this observation. A similar method of playing the harp can be seen in a fragment of a relief of Gudea (ca. 2100) from Telloh in southern Sumer; see Amiet, 1980a, fig. 392.
3. See Donald P. Hansen, "New Votive Plaques from Nippur," *JNES* 22 (1963), pp. 145–66, especially pp. 147–53. For a later version of a wall plaque, see Number 142.
4. Cf. the plaque from the Shara temple in Tell Agrab; Frankfort, 1943, pl. 63, fig. 314.
5. From the Inanna Temple, level VIII; Hansen, "New Votive Plaques," p. 156, pl. 3.

52 PLAQUE WITH MALE FIGURES, SERPENTS, AND QUADRUPED

Bitumen compound
H. 9⅞ in. (25 cm); W. 8½ in. (21.5 cm); D. 3⅜ in. (8.5 cm)
Ca. 2600–2500 B.C.
Acropole, temple of Ninhursag; Sb 2724

The plaque is carved in relief with one scene that takes up the entire picture field.[1] Two beardless, long-haired, nude male figures, their heads in profile and their bodies in three-quarter view, face the center of the composition. The heads are relatively large, as are the eyes and noses, and the long hair is represented by zigzag patterns. Each figure holds an arm to his chest and raises the other arm to the upper center, where two intertwined serpents with their tails in their mouths appear above the upraised hands. At the base of the plaque, between the feet of the two figures, a small calf or lamb strides to the right. An irregular oblong cavity or break was made in the center of the scene at a later date.[2]

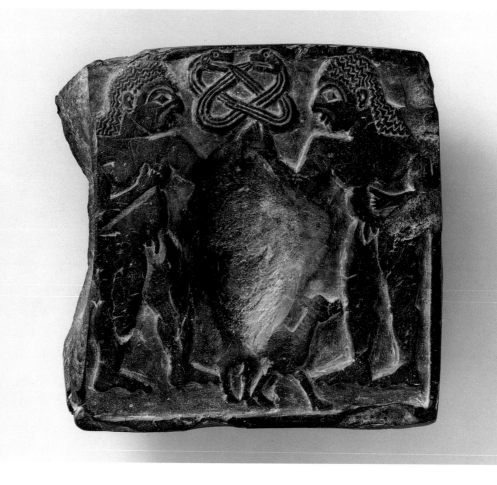

52

The figures' nudity can be interpreted as the indication of a ritual activity, an iconographic feature that occurred in Mesopotamia as early as the Uruk period (ca. 3500–3100 B.C.). The intertwined serpents and the calf or lamb also have religious associations. The serpent motif is usually associated with fertility, and lambs and calves were used as sacrificial offerings in the ancient Near East.

The dating of this plaque to the mid-third millennium B.C. is made on the basis of the treatment of the two main figures. The same proportion of head to body and the same profile with large drooping nose and large eyes can be seen on relief vases of chlorite of that date, which originated in eastern Iran but were exported throughout the ancient Near East.[3]

ZB

1. Amiet, 1988b, fig. 29; idem, 1966, fig. 124; idem, 1986a, fig. 65; Pottier, 1912, pl. 37:8; Le Breton, 1957, p. 121, fig. 43:9; Boese, 1971, pl. 24:3, pp. 50, 194.
2. Amiet (1966, p. 173) suggests that this was for the pouring of libations.
3. See, e.g., Amiet, 1980a, p. 361, fig. 269; this cylindrical carved chlorite vase from Khafajeh in Mesopotamia has a representation of bare-chested heroes in net skirts subduing animals. One of the heroes grasps a serpent in each hand.

53 STATUE OF ESHPUM
Alabaster; shell and bitumen inlay
Inscribed in Akkadian
H. *12¼ in. (31 cm)*; W. *9¼ in. (23.5 cm)*; D. *5⅛ in.*
(13 cm)
3rd millennium B.C.
Sb 82
Excavated by Morgan.

An eight-line inscription in Akkadian carved on the back of this statue[1] identifies it as a votive offering of Eshpum, governor of Elam during the reign of Manishtushu, king of the Akkadian empire (2269–2255 B.C.). The offering is made to Narundi, an Elamite goddess associated with the Mesopotamian Inanna/Ishtar.[2] The inscription reads:

Ma-an-iš-tu-šu	Manishtushu
LUGAL	King
KIŠ	of Kish
Eš₄-pum	Eshpum
ÌR-su	his servant
a-na	to
ᵈ Na-ru-ti	Narundi
A.MU.NA.RU	donated[3]

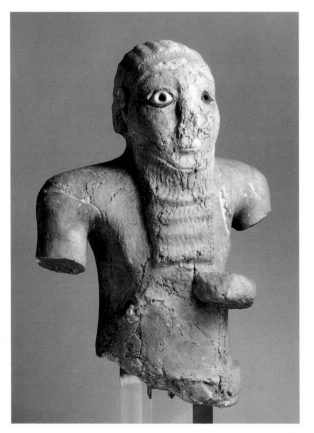

53

Back view

Despite the secure date of the inscription, some scholars assume that the inscription is a later addition and have assigned the statue to the Early Dynastic I/II period (2900–2600 B.C.) on stylistic grounds.[4] The long-waisted nude torso, broad shoulders, and arms carved partially in the round are typical of the sculpture of that period, as is the treatment of the spine as a sharp, deep incision. The bottom part of the figure is broken off, but the remains of a skirt tied directly above the hips are still visible. The hair, combed backward and bluntly cut at ear level, is indicated by incised zigzag parallel lines. The zigzag pattern is also used to portray the wavy hair of the long, squared-off beard. An inlay of shell set into bitumen remains in the right eye. The shell has been carved to receive yet another inlay, perhaps of lapis lazuli, for the iris. The mouth is small and thin-lipped, and the upper lips and cheeks are clean-shaven. The nose has been destroyed, as have the arms, for the most part; but from what remains of the forearms at waist level, it is clear that the figure represented a worshiper with hands clasped to the chest.

There is no direct parallel among Early Dynastic I/II Mesopotamian worshiper figures for the short hairstyle and the beard that covers only the lower chin. Nevertheless, Eshpum's statue is probably a locally made work derivative of Mesopotamian worshipers of that period, and it was probably already an antiquity when Eshpum had it inscribed and dedicated it to his goddess, Narundi.

ZB

1. Morgan, 1907, p. 398; V. Scheil, *MDP* 10 (1908), p. 1; Eva Strommenger, "Statueninschriften und ihr Datierungswert," *ZA* n.f. 19 (1959), pp. 30–36; Spycket, 1981, p. 73 n. 149.
2. See Number 55, the statue of this goddess excavated at Susa.
3. I. J. Gelb and B. Kienast, *Die Altakkadischen Königsinschriften des dritten Jahrtausend v. Chr.* (Stuttgart, 1990), p. 80.
4. Strommenger, "Statueninschriften," pp. 30–36; Spycket, 1981, p. 73 n. 149.

THE MONUMENTS OF PUZUR-INSHUSHINAK

Puzur-Inshushinak was the first Susian king to leave us large-scale statuary and a number of monuments.[1] The precise dates of his reign were unknown until the discovery in 1984 of a tablet[2] at the site of Isin in Mesopotamia which established a synchronism between Puzur-Inshushinak and Ur-Nammu, the first king of the Third Dynasty of Ur, who reigned from about 2112 to 2095 B.C. Puzur-Inshushinak, the last name listed as a "king of Awan" on the Susa king list (No. 181), was also probably a contemporary of the Sumerian prince Gudea of Lagash (ca. 2100 B.C.).[3] These parallels explain the powerful influence of "Neo-Sumerian"–period Mesopotamia on the style and the iconography of Susian artists during Puzur-Inshushinak's reign.

A conqueror and a builder, Puzur-Inshushinak had many monuments erected on the Acropole of Susa. Most of them bear bilingual inscriptions: in Akkadian, the spoken language of Susa, transcribed in cuneiform writing; and in Elamite, the spoken language of the highlands, transcribed in a linear writing that we still have difficulty deciphering.

The king patronized a stone-sculpture workshop that produced at least one large statue of him seated and also three inscribed statuettes. On the basis of stylistic similarities, some uninscribed monuments (one large statue and some alabaster statuettes) can be dated to his reign.

Several stone monuments must have come from the temples on the Acropole of Susa; these include a large statue representing the goddess Narundi/Narunte (No. 55), two foundation stones probably from the Inshushinak temple (No. 54), and a table adorned with a lion's head (Sb 17), which bears a dedication to Inshushinak and mentions yet another dedication, of either a nail or a stake of copper and cedar. A pair of recumbent lions probably guarded the entrance to one of the temples. A basin with an inscription written in linear Elamite (Sb 140B) was used for ceremonial cleansing.

The temples themselves were destroyed by time and weather and also by the first excavations at the site. Among the few surviving artifacts are seventeen steps from a stone stairway;[4] thirteen steps have Akkadian inscriptions and four have linear Elamite inscriptions. They bear a dedication to the patron god of Susa, which leads us to believe that they came from the Inshushinak temple. We also know of two door sockets, as well as terracotta foundation nails, that adorned the temple of the god Shugu.

Finally, an Akkadian inscription informs us that the king erected his statue before the temple of In-shushinak and dedicated to the god a copper and cedar stake (see No. 54) as well as a sword and a gold and silver axe.

B A–S

1. For the Puzur-Inshushinak monuments see Amiet, 1966, pp. 223–29; Boehmer, 1966 (on p. 350, a bibliography of monuments with Akkadian inscriptions); Hinz, 1969, pp. 11–44; Sollberger and Kupper, 1971, pp. 124–28; Amiet, 1976b (catalogue of monuments of Puzur-Inshushinak).
2. See Wilcke, 1987, p. 110.
3. Steinkeller, 1988, pp. 52–53.
4. André and Salvini, 1989, pp. 60–69.

54 VOTIVE BOULDER OF PUZUR-INSHUSHINAK
Inscribed in linear Elamite
Limestone, traces of bitumen
H. 22¼ in. (56.5 cm); W. 15⅜ in. (39 cm); D. 24⅝ in.
(62.5 cm); hole, DIAM. 3⅞ in. (10 cm)
Ca. 2100 B.C.
Acropole; Sb 6
Excavated by Morgan.
Approximate reconstructed dimensions of the
boulder: H. 25⅝ in. (65 cm); D. at least 31½ in.
(80 cm)

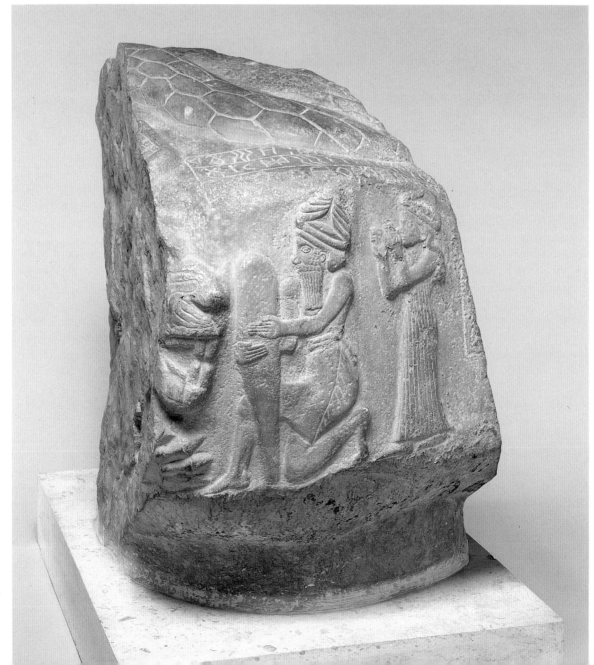

54

The monument[1] is fragmentary. At the top there is a large serpent coiled around a vertical hole, which must have been in the center of the block. On the front a god is depicted in a half-kneeling posture, driving in a nail. Similar representations of deities, figurines placed in the temples as foundation deposits, are known from the same period in Mesopotamia. Their function was to protect the buildings by the magical act of driving a stake into the ground and thereby taking possession of the terrain. A suppliant goddess of Sumerian type stands behind the god.

On the other side of the stone, a large guardian lion with gaping jaws was carved. Only the nose and a claw remain on this fragment, but we can reconstruct the lion on the left side of this stone if we attribute to the same monument the fragmentary relief (Sb 177)[2] representing the hindquarters of a lion and bearing an Akkadian inscription (see fig. 31). The lion is crouching in a waiting position, ready to strike out with one paw. Its body is twisted around the edge of the monument. The shoulders, chest, and part of the front paws are missing.

Traces of bitumen on the lower parts of the two fragments show the level at which the boulder was inserted into a base or the ground. The stone was ovoid in shape. The diameter of the hole is almost the same as that of another stone found on the Acropole, also carved with a snake and a linear Elamite inscription (fig. 32),[3] which may have belonged to the same group of cult objects.

The boulder bears several inscriptions. On the

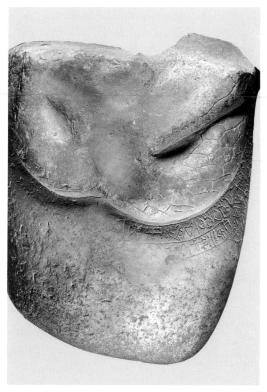

Figure 32. Fragment with snake and inscription. Acropole mound, Susa, reign of Puzur-Inshushinak, ca. 2100 B.C. Limestone, H. 20⅜ in. (51.9 cm). Paris, Musée du Louvre, Sb 6733

upper front part of Sb 6 is a three-line inscription in linear Elamite. It has not been deciphered completely, but since it begins with the name of the god Inshushinak, we know that it reads from left to right. Behind the goddess are traces of another inscription, which may be the vertical continuation of the first inscription. The added piece, Sb 177, provides us with the end of an Akkadian text, which is a curse.

The inscription, then, was bilingual. However, the curse probably was not reproduced in Elamite.[4] Indeed, the number of linear signs compatible with a syllabic reading would have made it impossible to reproduce such a long text.

The word "cedar" in the inscription on the lion might provide us with a clue to the meaning of the text that would correspond to the purpose of the boulder. Akkadian inscriptions on two other monuments state that Puzur-Inshushinak dedicated "a copper and cedar nail."[5] It is conceivable, then, that a cedar stake capped in copper was driven through the hole in the center of the boulder, thereby fixing the temple to the ground. This ritual would have

Figure 31. Reconstruction showing joining of lion fragment (Sb 177) to larger stone of votive boulder. Fragments: Acropole mound, Susa, reign of Puzur-Inshushinak, ca. 2100 B.C. Limestone, H. 25⅝ in. (65 cm). Paris, Musée du Louvre, Sb 6 and Sb 177

been enacted under the protection of the figures represented on the boulder, and of the gods named in the inscription—specifically Inshushinak and Nergal, the only gods whose names have survived in the Akkadian inscription.

B A-S

1. See, for Sb 6: Scheil, 1905, pl. 2, 2; Frank, 1912, pp. 32–34; idem, 1923, pp. 7–8; Mecquenem, 1949, pp. 9–10, fig. 4; Hinz, 1962, pp. 10–11 (text B); Amiet, 1966, pp. 224–25, no. 165; Hinz, 1969, p. 30, pl. 8; Meriggi, 1971, p. 186, para. 486; Amiet, 1976b, pp. 37, 129, no. 32 (provides the earlier bibliography). For Sb 177: Scheil, 1900, p. 66; Amiet, 1976b, pp. 37, 132, no. 62. For Sb 6 and Sb 177: André and Salvini, 1989, pp. 54–58, pls. 1–3.
2. Of limestone with traces of bitumen at the base; H. 15¾ in. (40 cm); W. 24¾ in. (63 cm); excavated by Morgan.
3. Vincent Scheil, MDP 10 (1908), pl. 4.
4. This is the case on another bilingual monument of Puzur-Inshushinak, Sb 17: Scheil, 1905, pl. 2.
5. Stele Sb 160: Sollberger and Kupper, 1971, pp. 126–27, IIG2f. See also the table with a lion's head, Sb 17: ibid., p. 124, IIG2b.

55 STATUE OF THE GODDESS NARUNDI/NARUNTE
Inscribed in cuneiform Akkadian and linear Elamite
Limestone
H. 42⅞ in. (109 cm); W. 18½ in. (47 cm); D. 17¾ in. (45 cm)
Ca. 2100 B.C.
Sb 54, the body, found in the temple located south of the Ninhursag temples; excavated by Morgan, 1907. Sb 6617, the head, found in 1904. The statue, broken in antiquity, was reassembled in 1968.

This cult statue[1] was dedicated by Puzur-Inshushinak in a temple on the Acropole of Susa. It is executed in Mesopotamian style. The Susian goddess is depicted with the characteristic features of the great Mesopotamian goddess Inanna/Ishtar and is associated with lions, Ishtar's animal attribute. She wears the distinctive clothing of deities: a flounced garment of lambswool and a headdress with horns over the hair, which is gathered in a chignon at the nape of the neck.

The face, which is crudely carved, was originally plated (probably with gold), as rivet holes attest. The eyes must have had shell and lapis lazuli inlays that were embedded in bitumen. The goddess holds a goblet and a palm leaf against her chest.

The backless throne has six lions sculpted in bas-relief. Two sit on either side of the throne; on the back, two others hold staffs and stand in the human posture of the hero-guardians at the entrance to the temple; and finally, on the front base, under the bare feet of the goddess, two recumbent lions flank a flower.

The throne bears a dual inscription written in cuneiform Akkadian and linear Elamite. Little remains of the inscription in Akkadian along the left edge other than the name of the dedicator, "Puzur-Inshushinak, prince [or governor] of Susa." The title indicates that the statue was dedicated by Puzur-Inshushinak before he became king. The Elamite inscription, on the right edge of the throne, gives the name of the goddess, probably Narundi or Narunte.

B A-S

1. See Mecquenem, 1905a, p. 125, fig. 448; Scheil, 1913, pp. 17–19, pls. 3–4; Frank, 1912, pp. 48–50; idem, 1923, pp. 14–15; Mecquenem, 1949, p. 15, fig. 12; Hinz, 1962, pp. 15–16; Amiet, 1966, p. 227, no. 166; Hinz, 1969, pp. 38–39; Spycket, 1968, pp. 67–73; Meriggi, 1971, pt. Ia, pl. 3, "I," and paras. 499–502, pp. 190–91; Amiet, 1976b, pp. 38–39, 129–30, no. 36; Spycket, 1981, pp. 144–46, pl. 96.

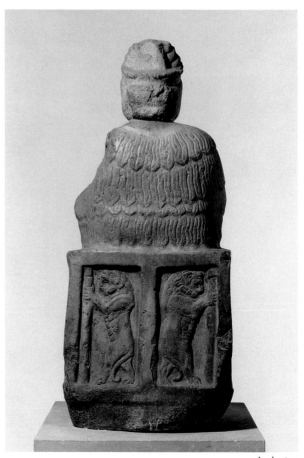

55, back view

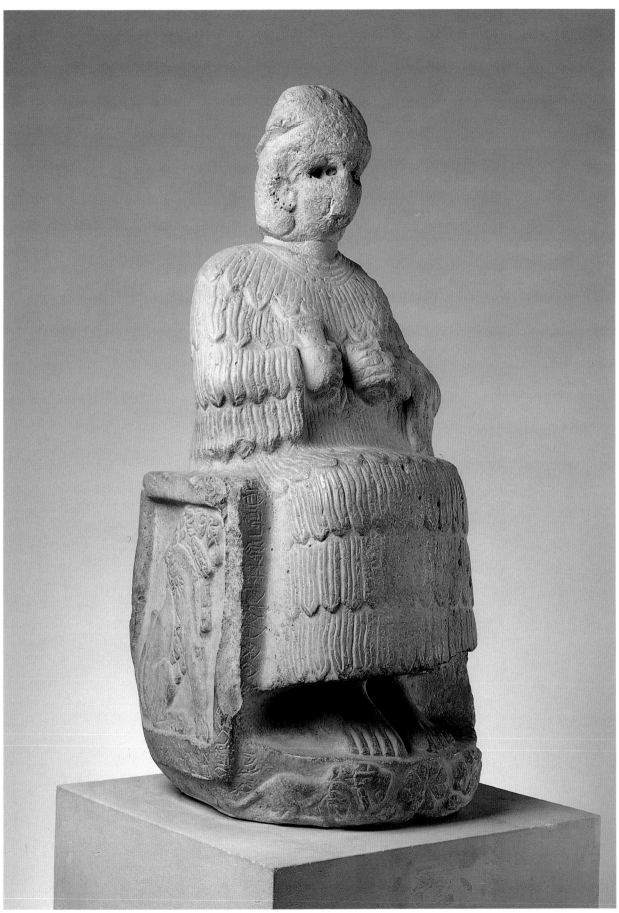

OBJECTS OF THE LATE THIRD AND EARLY SECOND MILLENNIUM

56 HAMMER DEDICATED BY SHULGI
Inscribed in Sumerian
Bronze
H. 4⅞ in. (12.3 cm); L. 4⅜ in. (11 cm)
Third Dynasty of Ur, reign of King Shulgi
(2094–2047 B.C.)
Sb 5634
Found in a ribbed sarcophagus, chantier no. 1,
Ville Royale.

This ceremonial weapon or standard top[1] is a cast bronze shaft-hole hammer with two bird's heads emerging from the top and three plumelike extensions at the back ending in curls.[2] The hammer bears a cuneiform inscription in Sumerian identifying it as a dedication by the Mesopotamian ruler Shulgi: "The divine Shulgi, the mighty hero . . . king of Ur, king of Sumer and Akkad."[3] Shulgi controlled part of Elam during his reign (2094–2047 B.C.) and was responsible for the construction of several buildings at Susa.[4] The weapon is of a type closely related to votive axes or tops of standards

from eastern Iran and Bronze Age Bactria in western Central Asia.[5] The long plumes on the bird's heads suggest that they may belong to supernatural birds, probably double-headed bird-demons—a type of fantastic animal that may have had its origins in eastern Iran.[6]

ZB

1. Amiet, 1966, no. 176; R. de Mecquenem, "Têtes de cannes susiennes en métal," *RA* 47 (1953), pp. 79ff., fig. 4 a, b; Porada, 1962, p. 54; idem, 1975, pl. 301b, p. 388; J. Deshayes, "Marteaux de bronze Iraniens," *Syria* 35 (1958), p. 287, fig. 3. Compare Peter Calmeyer, *Datierbare Bronzen aus Luristan und Kirmanshah* (Berlin, 1969), Abb. 38, 39, where the provenience is given as Nihavand, but without a clear reason for the attribution.
2. For an analysis of the metal: Tallon, 1987, vol. 2, no. 195, p. 29.
3. After Mecquenem, "Têtes de cannes," p. 82.
4. Carter and Stolper, 1984, pp. 16, 68 n. 90.
5. For votive weapons from that region, see Pittman, 1984, pp. 65ff. Two very similar hammers were bought in Iran early in this century by E. Herzfeld. Unfortunately, the exact findspot of these weapons is unknown.
6. See E. Porada, "Comments on Style and Iconography," in Pittman, 1984, p. 92.

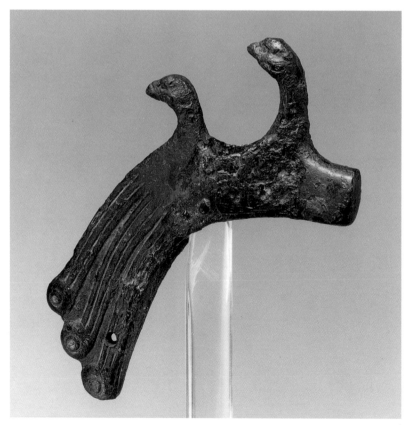

57 VOTIVE MACE WITH MASTIFF HEADS
Orange alabaster
H. 2¾ in. (7 cm); L. 2½ in. (6.5 cm)
Ca. 2100–1900 B.C.
Sb 2831
Excavated by Mecquenem, 1908.

This ceremonial or votive mace[1] is carved in relief
with three frontal animal heads. A hole running
vertically through the center of the object would
have enabled it to be placed on a staff or handle. The
animals can be identified as mastiffs rather than li-
ons, since they have wrinkled skin above the brows,
long ears, and drooping jowls, and lack the mane
usually depicted on lions. The mastiff, used as a
hunting dog in the ancient Near East, is well known
from numerous representations in Mesopotamian
art.[2]

Stone votive maces decorated with animal pro-
tomes are known in Mesopotamia as early as the
Jemdet Nasr period (3100–2900 B.C.). Maces carved
in the round with frontal lion's heads that were exca-
vated at the Shara temple, Tell Agrab, and at Telloh
in Mesopotamia date to the second half of the third
millennium B.C.[3] However, no direct parallel exists
for this unique object and little is known about its
archaeological context; therefore its date, usually
given as 2000 B.C., must remain a conjecture.

ZB

1. Amiet, 1966, fig. 180.
2. See, for example, Marie-Thérèse Barrelet, *Figurines et reliefs
 en terre cuite de la Mésopotamie antique* (Paris, 1968),
 no. 835; R. D. Barnett, *Assyrian Palace Reliefs* (London,
 1960), no. 103.
3. For the Tell Agrab example, see Pinhas Delougaz and Seton
 Lloyd, *Pre-Sargonid Temples in the Diyala Region*, OIP 58
 (Chicago, 1942), p. 238, fig. 185; for the mace head from
 Telloh inscribed with a dedication of Gudea of Lagash
 (ca. 2100 B.C.), see André Parrot, *Tello: vingt campagnes
 de fouilles (1877–1933)* (Paris, 1948), pl. 42h.

57

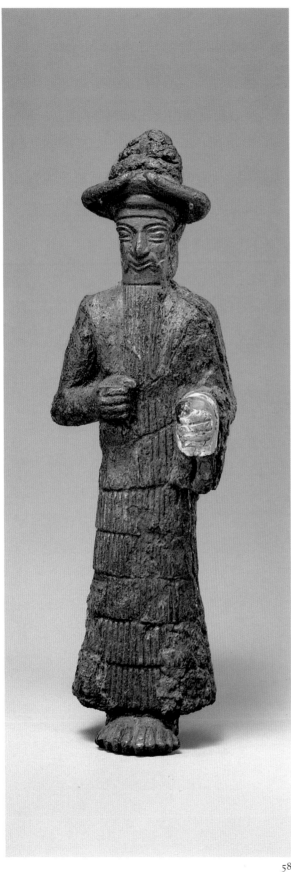

58 ELAMITE GOD
Copper and gold
H. 6⅞ in. (17.5 cm); W. 2⅛ in. (5.5 cm)
Ca. 2000 B.C.
Sb 2823
Probably excavated by Morgan.

The figure, identified as a god by his horned head-dress, wears a Mesopotamian long flounced garment that covers his left arm and shoulder, but leaves his right side exposed.[1] His right hand appears as a fist placed against his chest; his left arm, bent at the elbow, is extended forward. The left hand, overlaid with gold, is also in the form of a fist. The god's facial features are rendered with bold outlines. His heavy-lidded eyes are large and almond shaped; his nose is large and wide; and his lips, surmounted by a handlebar mustache, are curved upward into a smile. His beard, extending to the middle of his chest, is made up of straight flat ribs that terminate in curls, and his long hair is pulled back into a chignon at the base of the neck and tied by a fillet that also stretches across his forehead. The god's head-dress is composed of a three-tiered horned crown. The lowest pair of horns is cast in the round; the rest are represented in relief. A grooved channel running along the left side of the statuette indicates that the entire object was overlaid with a precious metal. The exposed parts of the god's body—the face, chest, arms, and feet—were probably once all covered with gold leaf, as the left hand is.

While the figure's costume and headdress are purely Mesopotamian in appearance, the technique of overlaying copper or bronze with precious metals is not well documented in that area. The stylization of the facial features, especially the smile, has no parallel in Mesopotamian works of art.

The headdress, in which the lowest pair of horns is much larger than the uppermost pair, is of a distinctive type seen toward the end of the third millennium B.C., and most closely resembles horned headgear of the Ur III period.[2] Therefore, a date just before the fall of the Ur III dynasty in 2004 B.C., when Susa was still under Mesopotamian control, seems most appropriate for this Elamite statue.

ZB

1. Amiet, 1988b, fig. 42; idem, 1966, fig. 234; Tallon, 1987, vol. 1, pp. 310, 351, vol. 2, p. 344, no. 1337; Rutten, 1935–36, vol. 1, p. 263-A; Braun-Holzinger, 1984, pl. 46, no. 211.
2. See, for example, the crown worn by Nannar on the stele of Ur-Nammu in Amiet, 1980a, fig. 404.

58

59 STATUETTE OF A FEMALE
Shell
H. 3¾ in. (9.4 cm); W. 1⅝ (4 cm)
Beginning of the 2nd millennium B.C.
Acropole; Sb 2746
Excavated by Morgan, 1899–1902.

The figure, her hands clasped against her chest, wears a floor-length fringed shawl that extends obliquely from under her right arm up over her left shoulder, drapes over her right shoulder, concealing it, and then hangs down over the right side of her body.[1] Visible on her left shoulder is the checkered pattern of the garment beneath. She is adorned with multiple bracelets and necklaces. The statuette consisted of several separately made parts, perhaps in a variety of materials. The mortise still exists that once held the head (now lost); there are concave marks of a necklace counterweight that ran all the way down the back of the statuette; and notches above the elbows indicate that the figure was adorned with arm-rings.

François Poplin's recent analysis has revealed that the statuette is made not of ivory, as was long thought to be the case, but of shell (see *Technical Appendix*, pp. 279–80). Based on stylistic characteristics, the piece can be dated to the beginning of the second millennium B.C.[2]

AC

1. *MDP* 7 (1905), p. 26, pl. 4; Amiet, 1966, no. 217; Spycket, 1981, p. 211, no. 136.
2. Amiet, 1966, no. 217; Spycket, 1981, p. 211, no. 136.

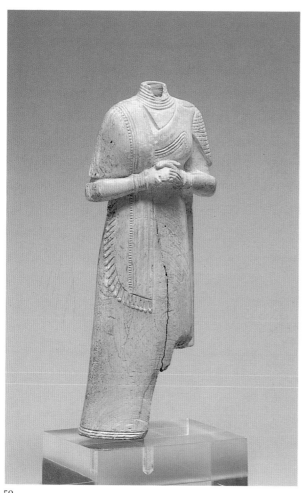

59

Back view

60 NECKLACE

Agate and gold
L. *ca. 10⅝ in. (27 cm)*
Beginning of the 2nd millennium B.C.
Sb 5700

The tombs of Susa contemporary with the Shim-ashkian dynasty yielded numerous jewels that be-speak an exceptional prosperity and material and cultural exchange with neighboring regions.[1] The dead, generally buried in tub-shaped terracotta sar-cophagi, were adorned with bracelets, rings, earrings of gold and silver, gold headbands over the forehead, skullcaps and breast-covers of silver, and necklaces with beads of gold, agate, carnelian, and lapis lazuli.

The ornament shown here, apparently incom-plete, consists of twelve agate beads—ten round ones of diminishing size and two cylindrical ones—and six gold beads, all made with the same alloy contain-ing approximately thirteen percent silver and one percent copper.[2] Five of these, basically round like the agate beads, are ribbed lengthwise; their two ends are flattened into disks, pierced to allow the thread to pass through. This type of bead was much used in Mesopotamia, Syria, and Susa during the first half of the second millennium.

In the center of the necklace is an elongated spindle-shaped bead, square in section, with en-larged disklike ends. Each of the four facets is deco-rated with three rows of stamped dots in imitation of filigree or granulation. A similar gold bead bearing

analogous decoration was found at Larsa in a trea-sure that can be dated to about 1738 B.C.[3] These elongated beads were intended to decorate the mid-dle of a necklace, as was very much the fashion during that period (this is evident on the statues of Eshnunna, Nos. 111 and 112). The origin of this custom dates back to the beginning of the Akkadian period (ca. 2334 B.C.); around that time, the larger central bead was often decorated with gold caps. At first these were without ornament, but during the Third Dynasty of Ur and at the beginning of the second millennium, some caps were decorated with filigree and even completed with gold bands encir-cling the bead to form an elaborate mount. Particu-larly luxurious examples have been found in Uruk. They date to the period of Shu-Sin, the penultimate king of the Third Dynasty of Ur (2037–2029 B.C.), and are inscribed with the names of the priestesses Abbabashti and Kubatum.[4]

The bead from Susa is a simplified imitation of these elaborate jewels. It is characteristic of Susian jewelry-making of that period, in which precious metals are lavishly employed, but the techniques are less refined than those used in Mesopotamia.

FT

1. Amiet, 1966, p. 249, fig. 184.
2. Mecquenem, 1934, p. 210, fig. 53:2; Amiet, 1966, fig. 195; Tallon, 1987, no. 1174.
3. Arnaud, Calvet, and Huot, 1979, pp. 48–49, fig. 76, pl. 3:1.
4. H. J. Lenzen, "Die historischen Schichten von Eanna," *UVB* 8 (Berlin, 1937), pp. 20–26.

61 FIGURE OF A SEATED MONKEY
 Red calcite
 H. 1⅞ in. (4.7 cm); W. 1⅛ in. (3 cm)
 Late 3rd millennium B.C.(?)
 Sb 5884
 Excavated by Mecquenem.

61

The monkey was represented as both a divine figure and a pet in many regions of the ancient world throughout the Bronze Age and was particularly prominent in art of the Mediterranean lands.[1] This small red stone sculpture is modeled in the form of a squatting monkey with round, hollow eyes beneath a brow line, semicircular ears with linear detail, and a line for a mouth. The stone is lighter in the area of the elongated muzzle, which is marked with horizontal lines. The monkey's tail, visible only in the back, extends in a curved line to the waist. This is one of a few early miniature ape figures from Susa and may date to the third millennium; it has no reported context.[2] Other examples come from the "archaic deposits," a collection of small alabaster figurines of humans and animals made in Susa and related in type and style to figurines of the Uruk period from Mesopotamia (see No. 33).[3]

This example, perhaps a rendering of the widespread Asiatic macaque,[4] is difficult to place in a specific artistic tradition. One early-second-millennium stone monkey from Ischali in Mesopotamia is quite different in style but is of interest because it comes from the Kititum Temple.[5] That seated figure has inlaid eyes, which may also have been true for the Susa sculpture. A number of copper-alloy cosmetic flasks from the Bactrian region of Afghanistan dating from the late third to the early second millennium B.C. were cast in the form of very slender monkeys and monkey demons with anthropoid bodies, in one case wearing boots.[6] These creatures, like the generalized anthropomorphic monkey from Ischali, are impossible to identify as to species.[7] Depictions of monkeys squatting and seated on stools like humans also occur on the distinctive compartmented metal stamp seals of Bactria. This type of seal was distributed as far west as Susa itself.[8] The imagery on these seals also includes standing and seated figures, some with wings or bird's heads, as well as snakes and dragons—indicating that monkeys or monkey demons were part of the supernatural world of the peoples of western Central Asia.

In contrast, monkeys are absent from the seals of the Indus Valley, where monkeys must have been abundant.[9] Among the few miniature representations of monkeys in Harappan (Indus Valley) art there is one example, of green faience, that relates to the Susa sculpture in posture and has very deep-set round eyes in a head with both human and monkey characteristics.[10]

Susa's relations with both the distant land of Meluhha, identified as the Indus Valley or the greater (Moloccan) Indies,[11] and the intermediary regions now part of Turkmenistan and Afghanistan can be confirmed in the archaeological record. Harappan imports at Susa include a clay head that may have been part of a statue of a seated figure; etched carnelian beads; and a cubic weight.[12] A seated male figure found at Susa, based on a Harappan prototype, has been identified as a Bactrian import, along with an axe carved with the head of a dragon.[13]

The monkey is not a prominent image in the Elamite world, although one seal from Susa with a scene of presentation to a seated figure in a wide flounced garment includes an ape seated on a raised stand.[14] It is possible that this red calcite figurine of an Asiatic macaque was imported from abroad, perhaps from the Indus Valley or another eastern region in close contact with Susa during the third millennium B.C.

JA

1. Dunham (1985, pp. 234ff.) collects Mesopotamian references to monkeys and illustrates some Bronze Age examples; J. Vandier d'Abbadie, "Les singes familiers dans l'ancienne Egypte (Peintures et Bas-Reliefs). I. L'Ancien Empire," *R d'E* (1964), pp. 147ff., discusses the monkey in third-millennium Egypt. Monkeys depicted in paintings of Aegean gardens, like monkeys in Mesopotamia and the Levant, were probably imported.

2. Amiet, 1966, p. 200, no. 150.

3. Ibid., nos. 73, 74 (see cat. no. 19).

4. I thank Ian Tattersall, Department of Anthropology, American Museum of Natural History, New York, for references to macaques. Van Buren (1939, p. 22) distinguishes the short-tailed Asiatic gibbons of Mesopotamian miniature sculptures from long-tailed monkeys on cylinder seals.

5. Frankfort, 1943, p. 20, pl. 74:335.

6. Ligabue and Salvatori, eds., 1988, p. 240, pl. 107; others are in private collections; for other types of Bactrian animal-form cosmetic containers, see Pittman, 1984, pp. 43ff., 97 n. 21.

7. Only one Bactrian small sculpture in a private collection, showing a squatting ape carrying a baby on its back, could, according to Ian Tattersall, indicate the artist's familiarity with an actual monkey—in this case, the southern Asiatic *Langur presbitis*.

8. Sarianidi, 1983, p. 521, pl. 36:9 (this example identified as the Indian macaque); Amiet, 1986a, p. 318, fig. 178, p. 286, fig. 105. Pittman (1984, pp. 52ff.) illustrates compartmented stamp seals in the Metropolitan Museum.

9. Monkeys are represented in Buddhist art as heroic, playful, and reverent: K. Bharatha Iyer, *Animals in Indian Sculpture* (Bombay, 1977), p. 81, pls. 164–66; according to A. Basham (*The Wonder That Was India* [New York, 1959], p. 319) the monkey, later worshiped as the god Hanuman, is not especially revered in early Hindu texts.

10. H. Mode, *Das Frühe Indien* (Stuttgart, 1959), pl. 51, top.

11. Reade, 1986, p. 331.

12. Amiet, 1986a, pp. 280–82, figs. 92–95; for local imitations of Indus seals, see ibid., fig. 94, and Parpola, Parpola, and Brunswieg, 1977, pp. 129–65. Amiet (1986a, p. 143) also relates the vaulted galleries adjacent to and perhaps part of Shulgi's Temple of Ninhursag of Susa to architectural constructions (the monumental granary) at Mohenjodaro.

13. Amiet, 1986a, pp. 147–48, 283–84, 286–87, who also discusses a fragmentary female figure related to sculptures in Afghanistan and Pakistan: p. 284, figs. 98, 99.

14. Seidl, 1990, p. 131, no. 2. They similarly occur on seals from Mesopotamia, Syria, and Anatolia: see Collon, 1986, p. 45, C18.

62 BOWL WITH BISONS, TREES, AND HILLS

Bituminous limestone
H. 3½ in. (9 cm); DIAM. 7⅛ in. (18 cm)
Ca. 2100–2000 B.C.
Acropole, beneath the temple of Inshushinak; Sb 2730

The exterior of the bowl is carved in relief with four recumbent bisons, all facing to the right.[1] Between the animals stand four hillocks surmounted by coniferous trees. The hillocks are rendered in a scale pattern that in the ancient Near East is used to indicate mountains—a motif first represented in the art of Iran during the Proto-Elamite period.[2] The same scale pattern surrounds the bottom of the bowl, directly above the base. There it is used as a ground

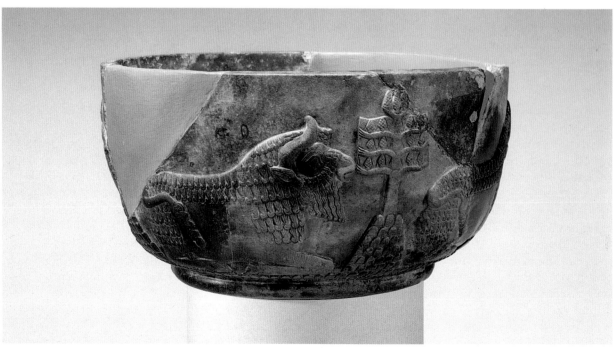

line to show that the animals and the trees are in a mountainous landscape. An eight-petaled rosette is on the exterior of the bowl's base.

The bisons' beards are depicted as long strands of wavy hair emerging from short tight curls at the cheeks and nose and ending in curls. The remainder of the hair is arranged in strict rows of curling locks. The tufts of the tails are in a guilloche pattern. The closest parallel to this treatment of the hair, in rows of locks curling to the front, is on a bearded human-headed bull from the Nintu temple at Khafajeh in Mesopotamia that is datable to the mid-third millennium B.C.[3]

ZB

1. Mecquenem, 1911b, pp. 41–42, fig. 2; Porada, 1975, p. 388, pl. 302a.
2. See Number 45 for a seal of this period representing ibexes and a tree on a hillock.
3. Frankfort, 1943, pls. 49, 50.

Vessels of Bitumen Compound

*F*rom the Neolithic period onward, bitumen, an asphaltlike substance, was put to a variety of uses in the Near East. At Susa it was employed in the traditional ways as a glue, a building mortar, and a waterproofing or caulk for floors, baskets, mats, and ceramics.[1] Beyond that, however, excavations at Susa have brought to light an abundance of varied objects executed in a material resembling stone but which analysis reveals is an artificial substance with a bitumen base. Two overall questions then arise. First, what kind of substance is this, what is its exact composition, and how was it worked? Second, why create a material similar to stone in a region where stone is plentiful, particularly if its manufacture requires a degree of technological mastery? Physical and organic geochemical analyses can furnish a partial response to the first question. The second is more difficult to answer.

There is nothing astonishing about the intensive use of bitumen at Susa, since the subsoil is rich in hydrocarbons. The city is surrounded by a crown of small deposits at Ain Gir, Dizful, Pol Doktar, and Mamatain. Farther east the important bed at Masjid-i Suleiman is still in use. Obtaining bitumen is easy. It flows from surface fissures, forming pools that spread more or less widely according to the contour of the land. It remains viscous in the center of the pool as long as the flow continues. At the outer edges the bitumen hardens as it mixes with the impurities of soil and air and as the volatile components gradually evaporate. For traditional purposes, the bitumen was collected soft. It could be used unprocessed or mixed with a fine or coarse mineral temper and/or a vegetable temper to obtain the desired consistency. Transporting the bitumen did not present a problem, since a dense network of rivers crisscrosses Susiana.

The objects from Susa described as being made of a bitumen compound (*mastic de bitume*) are composed of a unique material that differs from other bituminous mixtures.[2] Carefully ground calcite and quartz are mixed with the bitumen to produce a substance of a dull gray color that varies from dark to light. It is hard and homogeneous but not very dense. When struck, an object of bitumen compound emits a heavy thud that differs from the clear sonority produced by a stone object of similar type and size. If scratched it gives off a strong odor of hydrocarbon. White dots, either scat-

tered or concentrated in long strata or bands, are visible on the surface, creating a veined appearance; the structure within is consistent with the exterior. On most objects the surface is marked by a dense network of cracks, some very deep. Fragments of a uniform thickness have broken off certain objects.

In contrast, some pieces are made of a less sophisticated mixture (bitumen and silica) which is closer to mortar and caulking products and is not homogeneous. Objects in this material, unlike those of bitumen compound, are cast, and often serve as the base for a gold or silver overlay.

Bitumen compound had a vast range of applications at Susa. Objects made of this material include vessels both undecorated and decorated, the latter often carrying designs in relief or having parts sculpted in the shape of animal feet. Bitumen compound was used for sculpture, such as figurines and bas-relief plaques, and for many objects of everyday life, among them tool handles, maces, components of door fastenings, spindle-whorls, weights, stands, parts of furniture and wall decoration, and game pieces. Finally, jewelry items such as beads, pendants, and lip ornaments as well as about one-eighth of the cylinder seals from Susa are of bitumen compound.

To learn more about this material used at Susa, which resembles no other known substance, the Département des Antiquités Orientales of the Louvre and directors of the more recent excavations enlisted the help of the French petrochemical corporation Elf-Aquitaine. A study by its technicians of both the Susa bitumens and bitumen artifacts recently excavated at other sites is now in progress.

An analytical procedure was established. First, chloroform was used to extract the actual bitumen from the mineral part. Once separated, the bitumen was subjected in a gaseous state to chromatographical analyses and to analysis by chromatography coupled with mass spectrometry to determine its exact nature. X-ray diffraction of the mineral part identified those components, essentially calcite and quartz, and their percentages. Observation of thin strips of the material with an electronic scanning microscope revealed that the calcite had been artificially ground into granules of carefully calculated size and more or less regularly distributed through the bitumen. This accounts for the minuscule white dots visible on the surface and the bands where the calcite is incompletely blended in.[3] Since no natural stone meets this description, we are clearly dealing with a synthetic substance. It is hoped that the study by scanner of several objects from Susa,

recently undertaken in association with the American Hospital in Paris,[4] will yield conclusive additional information, especially about the methods of fabricating both the material and the objects.

Studies suggest that an object was fashioned of bitumen compound by first modeling or molding the material into the proper shape and then hardening the piece by a treatment still unknown (perhaps thermal). After that, the surface work was completed: the vessel was polished, the decoration carved, the finishing touches applied, or the inlaid and engraved details added. This interpretation—that the object was made by a combination of molding or modeling and carving—furnishes an explanation for the traces of cutting visible on most of the objects.

Why did the Susians go to considerable effort to manufacture a synthetic substance when stone, including bituminous gray limestone, was readily available? We lack the evidence that might provide an answer to this question. Elamite texts offer no information on the subject; Mesopotamian texts refer to deliveries of several varieties of bitumen and of materials associated with its use (straw, sand, tools) but not to technical matters. Archaeological evidence bearing on the working of bitumen is rare and does not shed light on the process by which the bitumen compound was manufactured, including the key final stage of hardening. Bitumen heaped up ready for use was uncovered at Ur;[5] bitumen mixers were found at Bendebal near Susa;[6] and bituminous material in different stages of manufacture was discovered by H. T. Wright in what seems to have been a bitumen-processing center at Farukhabad in the Deh Luran plain.[7] But these are only signs of the working of bitumen.

The bitumen compound substance seems to have already been developed by the time of the first settlement at Susa, as the mace from Jaffarabad and the cone-shaped cosmetic containers excavated from the cemetery of Susa I (No. 14) testify. This is all the more remarkable because numerous experiments must have preceded the successful production of this complex substance. The compound continued to be used, with varying frequency, throughout Susa's existence. The "recipe" seems to have been transmitted over the years with relatively few modifications. The two most representative periods of production are the early to mid-third millennium and around the end of the third millennium B.C. Bitumen compound of the latter period is characterized by more carefully calculated granularity, the systematic use of light and dark bands, and particularly meticulous polishing. Although pro-

63

duction at other times was somewhat limited, the material was employed uninterruptedly at least until the Neo-Elamite period (see No. 141).

Finally, it seems that the Susians made a specialty of the use of this medium. Future art-historical and technical analyses of works of art in bitumen compound found beyond the plain of southwestern Iran may indicate that some of these objects are in fact exports from Susiana. Bitumen compound is one more manifestation of the Susian originality so often demonstrated in other domains.

ODILE DESCHESNE

NOTES

1. R. J. Forbes, "Bitumen and Petroleum in Antiquity," in E. J. Brill, ed., *Studies in Ancient Technology*, vol. 1 (Leiden, 1964), pp. 1–123.
2. Most of the objects of bitumen compound from Susa have been published in *MDP*, vols. 7 (1905), 8 (1912), 25 (1934), and 29 (1943); see also Deschesne (forthcoming).
3. J. Connan, "Quelques secrets des bitumes archéologiques de Mésopotamie révélés par les analyses de géochimie organique pétrolière," *Bulletin des centres de recherches exploration-production Elf-Aquitaine* 12 (1988), p. 759. The results of work done on Mesopotamian objects can also be applied to objects from Susa.
4. The team is headed by Professor V. Bismuth, director of the Department of Medical Imaging, American Hospital, Paris.
5. Leonard Woolley, *Ur Excavations*, vol. 8: *The Kassite Period and the Period of the Assyrian Kings* (London, 1965), p. 61; idem, *Ur Excavations*, vol. 9: *The Neo-Babylonian and Persian Periods* (London, 1962), p. 12.

6. G. Dollfus, "Les fouilles à Djaffarabad de 1972 à 1974," *DAFI* 5 (Paris, 1975), pp. 35–39.
7. R.-F. Marschner, L. J. Duffy, and H. Wright, "Asphalts from Ancient Town Sites in Southwestern Iran," *Paléorient* 4 (1978), pp. 97–112.

63 TRIPOD WITH MOUNTAIN GOATS
Bitumen compound with gold, bronze, shell, and lapis lazuli
H. 7¼ in. (18.5 cm); DIAM. 11 in. (28 cm)
Early 2nd millennium B.C.
Apadana, second court, tomb I; Sb 2737
Excavated by Mecquenem, 1921.

The tripod has a round bowl with a flat base and a slightly flaring profile.[1] The rim is decorated with six rectangular plaques of white shell placed at even intervals, each riveted into place with two gold-headed bronze pins. The bowl rests on three legs attached to three projections from the bowl by means of tenons, each fixed by one or two bronze lateral pegs. Each leg is in the form of a mountain goat whose forelegs and hind legs are bent beneath its body. The goats' heads and forequarters are sculpted in the round, but the hindquarters are carved in relief onto the conical tripod legs. The hair at the neck is indicated by rows of sharply incised curved lines, that at the forehead and beard by straight lines. Six

incised wavy lines are on each horn. The eyes are inlaid with shell and lapis lazuli.

The tripod was recovered from a tomb under the floor of the central court in the *apadana*. The burial consisted of a ribbed terracotta bathtub sarcophagus turned upside down and placed on a surface paved with small bricks.

The technique used to manufacture this object and others like it is not fully understood.[2] It seems likely, however, that the piece was at least partly made in a mold. Perhaps the legs were originally molded, with the carved or incised details added as a final step. Objects made of bitumen compound have been found primarily at Susa. The material may have been used as a substitute for dark stone. Vessels of bitumen compound are objects of Elamite origin;[3] they were used as burial gifts in Elam in the early second millennium B.C. and were also imported into Mesopotamia during that period.

ZB

1. Mecquenem, 1922, p. 136, fig. 13; Amiet, 1966, fig. 210; idem, 1988b, fig. 39:302B; Porada, 1975, pl. 302b.
2. See preceding essay.
3. Rather than Mesopotamian; see Porada, 1965, pp. 52–53.

64 BISON PROTOME BOWL
Bitumen compound
H. *3 in. (7.5 cm);* L. *4 in. (10 cm)*
Early 2nd millennium B.C.
Sb 787
Excavated by Mecquenem, 1934(?).

This fragmentary vessel is in the form of a recumbent bison with forelegs tucked under the body.[1] The other side of the vessel is not preserved. The head, which is turned to the side and slightly raised, is modeled in the round; the body is rendered in relief along the side of the vessel. The animal's beard is incised with vertical striations; the hair on the neck and forehead is represented by rows of locks curling left and right in alternate rows. The hollow eyes originally would have been inlaid, probably with shell and lapis lazuli.

The object belongs to a class of Elamite vessels found primarily in graves and datable to the early second millennium B.C.[2]

ZB

1. Amiet, 1966, no. 204; G. Contenau, *MDP* 29 (1943), p. 191, pl. 7:4.
2. See Number 63. A similar vessel on which the animal's entire body is represented is in the Iran Bastan Museum, Teheran; see Amiet, 1966, fig. 205.

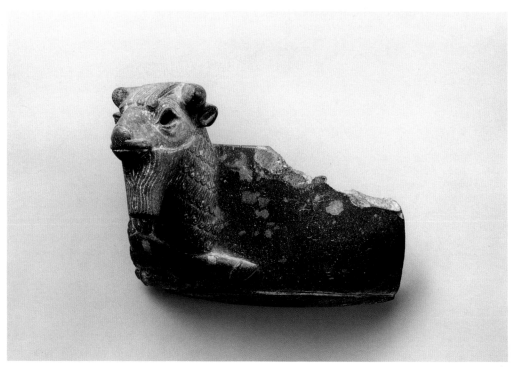

64

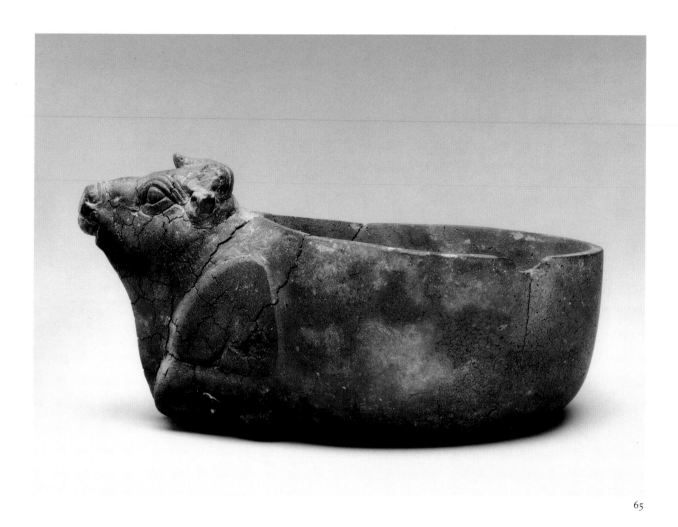

65

65 BULL PROTOME BOWL
Bitumen compound
H. 5½ in. (14 cm); L. 8½ in. (21.5 cm)
Early 2nd millennium B.C.
Donjon; Sb 2738
Excavated by Mecquenem.

Emerging from the body of this vessel is a protome in the form of the forepart of a recumbent bull, its head facing forward and tilted slightly upward, its front legs tucked under its body.[1] The bull's head is modeled in the round; the forelegs are carved in shallow relief. The hindquarters of the animal merge with the body of the vessel.

The bowl belongs to a category of Elamite vessels of which some were found in tombs, and is datable to the beginning of the second millennium B.C. The practice of using bowls decorated with animal protomes as burial gifts had already begun in the first half of the third millennium in Susa.[2]

ZB

1. Mecquenem, 1934, pl. 12:2, pp. 209–11; Rutten, 1935–36, vol. 1, p. 249A; Amiet, 1966, fig. 201.
2. Amiet, 1966, p. 143, fig. 104.

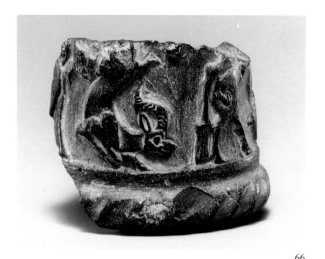

66

67

66 VESSEL WITH BULL-MEN AND CAPRIDS
Bitumen compound
H. *1¾ in. (4.5 cm)*; W. *2¼ in. (5.8 cm)*
Late 3rd millennium B.C.(?)
Sb 5635

This fragment of a cylindrical vessel is carved in re-
lief.[1] From what remains of the scene, it can be in-
terpreted as a frieze of three bull-men standing in
upright positions, each grasping a struggling caprid
by a hind leg.

The motif of bull-men dominating animals is
found frequently in glyptic art of the Early Dynas-
tic–Akkadian periods in Mesopotamia. The shape of
the vessel is known from a somewhat later date.

ZB

1. Amiet, 1966, no. 200.

67 VESSEL FRAGMENT WITH BISON
Bitumen compound
H. *2 in. (5 cm)*; W. *1⅛ in. (2.8 cm)*
Early 2nd millennium B.C.
Sb 5636

This fragment of a vessel carved in relief with a bi-
son's head[1] is of the same general type as the bison
bowl, Number 62. With its delicate modeling of the
animal, treatment of the large eye and eyebrow, and
delineation of the hair in rows of carefully arranged
curls, this fragment resembles the carving on
that bowl.

The tail of a second animal, perhaps also a bison,
can be seen at the lower right corner of the frag-
ment. The scale motif at the rim implies that the
scene is set in a mountainous landscape.

ZB

1. Amiet, 1966, no. 202.

68 CYLINDRICAL VESSEL
Bitumen compound
H. *3⅜ in. (8.5 cm)*; DIAM. *5⅜ in. (13.8 cm)*; L. *7 in.*
(17.9 cm)
Early 2nd millennium B.C.
Sb 11214

This cylindrical vessel with flared ledge foot and rim
and with central ribbing and spool-shaped handle
probably comes from a burial context. The same

vessel shape characterizes two burial gifts of bitumen compound from tombs in the Donjon area.[1] The first of these has a handle in the form of two suppliant goddesses in tiered costumes; the second has a recumbent goat with backward-turned head emerging from the body of the cup.

Although the cup shown here has no animal or figural decoration, it seems to belong to the same class of bituminous burial vessels dating to the early second millennium B.C. The shape with spool handle has no parallel in ceramic or stone vessels of the area; it appears to be used only for vessels of bitumen compound. The spool handles may represent the imitation of a metal form that has not survived.

ZB

1. Mecquenem, 1934, pp. 211, 230–31, pls. 12, 13; Amiet, 1966, figs. 208, 209.

69 DUCK WEIGHT
Bitumen compound
Second or first millennium B.C.
H. 2 in. (5 cm); L. 3⅛ in. (8.5 cm)
Weight: 4.75 oz. (135.8 g)
Sb 2832

Weights in the shape of a duck are first attested in Mesopotamia in the last quarter of the third millennium B.C. The type was subsequently borrowed in Iran, where it continued to be used until the Achaemenid period (6th–4th century B.C.).[1]

The ducks can be identified as standard weights because many examples bearing inscriptions of a unit of measure and the name of a guaranteeing authority survive. Diorite and hematite, both dark stones, are commonly used for these weights. The use at Susa of bitumen compound as the material for duck weights—several such exist—is unusual. As is the case with the carved vessels and other objects, bitumen compound may here have been an inexpensive substitute for stone.[2]

The form of the duck's body is abbreviated and the head is turned and rests on the body. There is no indication of wings, feet, or other anatomical details. The continued use of this shape over two millennia with little or no change or stylistic variation makes it impossible to date such objects unless they are from a good stratigraphic context or bear an inscription.

ZB

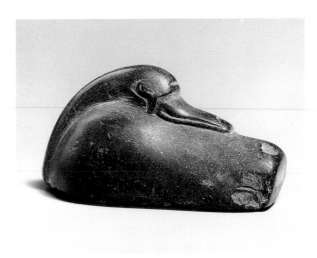

69

1. For weights and measures in the ancient Near East see Marvin A. Powell, Jr., "Ancient Mesopotamian Weight Metrology: Methods, Problems, and Perspectives," in M. A. Powell and Ronald H. Sack, eds., *Studies in Honor of Tom B. Jones* (Neukirchen-Vluyn, 1979), pp. 71–109; M. A. Powell, "Masse und Gewichte," in *RLA*, vol. 7, pp. 457–517. For a third-millennium example excavated at the Nintu temple level 7 and dated to the Early Dynastic III–Akkadian period, see P. Delougaz and S. Lloyd, *Pre-Sargonid Temples in the Diyala Region*, OIP 58 (Chicago, 1942), p. 150. For an example dated by inscription to the reign of the Mesopotamian ruler Shulgi (ca. 2070 B.C.), see Amiet, 1980a, fig. 409. A duck weight of the Achaemenid period was excavated from the floor of treasury room 33 at Persepolis: Schmidt, 1957, pl. 82, no. 3.
2. A duck weight of bitumen compound with an inscription giving the amount "five minas" was also excavated at Susa, further evidence that these bitumen compound ducks were used as weights: see Amiet, 1966, fig. 346. Weights at Susa are discussed by M.-C. Soutzo, "Description des monuments pondéraux assyro-chaldéens trouvés a Suse," *MDP* 12 (1911), pp. 5–50.

Seals of the Old Elamite Period

The site of Susa provides us with a wealth of glyptic material (that is, seals and seal impressions). Using evidence from the few instances of recorded archaeological context for these objects as well as inscriptions on seals and sealings and stylistic comparisons with known glyptic sequences in Mesopotamia, this corpus of seals has been arranged in chronological order, largely through the work of Pierre Amiet.[1] A study of these seals provides insights into official and religious iconography (Nos. 73, 76), levels of craftsmanship (Nos. 74, 77), and intercultural exchanges (Nos. 78, 79). Some of these topics are briefly discussed below.

SEALS OF ELAMITE RULERS AND OFFICIALS

During most of the third millennium Susa was largely under Mesopotamian domination. The majority of

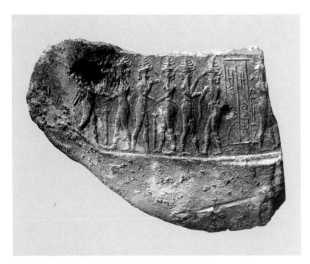

Figure 33. Seal impression depicting the battle of the gods. Susa, reign of Eshpum, governor of Susa, ca. 2269–2255 B.C. Clay, H. 1⅛ in. (3 cm). Paris, Musée du Louvre, Sb 6675

seals from that period found at the site are hard to differentiate from the Early Dynastic, Akkadian, and Neo-Sumerian glyptic of Mesopotamia. Occasionally, seals are marked by stylistic and iconographic peculiarities that lead us to recognize them as having been made in Elam (No. 70; fig. 6, p. 6).[2]

In the Akkadian period, Elamite rulers and high officials used Mesopotamian seals with scenes of "the battle of the gods," contest scenes, and presentation scenes; the last two themes are known from seal inscriptions to have belonged to officials in Mesopotamia as well.[3] One notable example from Susa is the seal of the Elamite governor Eshpum (fig. 33), vassal to the Akkadian king Manishtushu, who reigned from 2269 to 2255 B.C. (No. 107; see also No. 53).

At the end of the third and in the early second millennium B.C., there is again clear evidence that the iconography associated with official authority in the Mesopotamian world was used in a similar manner in Elam. During a period of repeated confrontations between Ur III rulers and rulers of the Shimashkian dynasty in Elam, the Sumerian presentation scene was pervasive in the art of both Susa and Mesopotamia. One important example, depicting an interceding goddess leading a petitioner to the king, is the seal inscribed with the names of the ruler Ebarat, founder of the Sukkalmah dynasty, the official Kuk-Kalla, and the ruler Shilhaha, who was Ebarat's son, co-regent, and successor (No. 73).[4] The seal of an official, "Buzua, a servant of Ebarat," depicts a petitioner directly before the king, but with a suppliant goddess behind—a second, slightly later version of the standard three-figure Sumerian presentation scene.[5] This is also the composition used on the seal of the official Kuk-Simut, accompanied by an inscription naming the ruler Idaddu (II) as bestower of the seal (fig. 34). Idaddu II was probably a contemporary of Ebarat.[6]

106

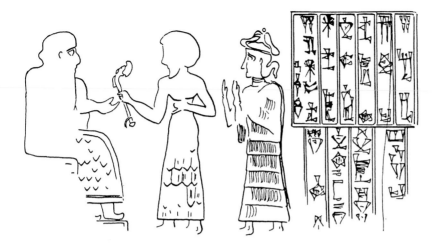

Figure 34. Drawing of a seal impression of Kuk-Simut. Seal impression: Susa, reign of Idaddu II, early 20th century B.C. Clay, H. 1 in. (2.6 cm). Paris, Musée du Louvre, Sb 2294

Both the legend and the image of Kuk-Simut holding a dragon-headed axe of a type actually found at Susa[7] appear to be explicit references to the granting of authority by the ruler to an official, and recall the Ur III seals that mention the presentation of the seal to a functionary by the king.[8]

The period when Susa was a major Elamite center under the Sukkalmah dynasty yields Sumerian-type glyptic as well as a group of seals that were not directly derived from Mesopotamia. Particularly noteworthy are the seal of the ruler Ebarat (fig. 38, p. 115), whose officials had Mesopotamian-type seals with presentation scenes, and related images of divine and royal figures in association with the fruits of the vine and life-giving water (No. 74; and see fig. 10, p. 9).

SEALS WITH RELIGIOUS IMAGERY

Seals and monuments of Elamite officials and rulers bear images that emphasize their relationship to the gods.[9] Rulers of the Old Elamite period with the titles *sukkalmah*, *sukkal* of Elam and Shimashki, and *sukkal* of Susa, as well as kings Tepti-ahar and Untash-Napirisha of the Middle Elamite period, are shown directly before a major Elamite deity seated on a human- or dragon-headed serpent (Nos. 76, 80).[10] A connection can be discerned between the image of an Elamite god on a coiled serpent throne, whom scholars have identified as either Napirisha or Inshushinak, and the earlier Mesopotamian snake god of the Akkadian period, which is transformed into a coiled serpent at the waist (No. 71). This snake god is sometimes also shown being approached by a worshiper.

The many gods and goddesses of the Elamite pantheon, known from textual references, are difficult to distinguish in Elamite art. Exceptional, however, is the goddess Narundi, who can be recognized on inscribed monuments and is associated with the lion (No. 55). An extraordinary seal, known to us from an impression that probably sealed a door, provides us with images of female figures seated(?) on lions—one female has vessels at the shoulders and one, wearing a fleecy garment, is between nude male figures with palm fronds—and an armed male figure standing on a quadruped. These images are juxtaposed with figures of demons and animals and a Mesopotamian-type Early Dynastic contest scene (fig. 6, p. 6). They may represent an early attempt at depicting the local pantheon.[11] Such rare images contrast with the numerous depictions of gods of the Mesopotamian pantheon that were either made at Susa during the Mesopotamian domination or imported from the west (No. 72).

Representations of the Elamite supernatural world, seen on the Susa door sealing mentioned above and on other objects as well, also include fantastic beings that combine human features or postures with those of lions, bulls, mouflons, birds, and fish (Nos. 47, 80).

SEALS AND INTERCULTURAL EXCHANGE

Mesopotamian seals of both the third and second millennia profoundly influenced the glyptic arts of Susa; this is evident in the adoption of the presentation scene (see No. 73). A different phenomenon is illustrated by the presence at Susa of a few seals from Bronze Age Bactria and the Persian Gulf (Nos. 78, 79), one Gulf

sealing, local imitations of Gulf seals in bitumen compound, and a circular stamp seal and a cylinder seal with Indus Valley–derived imagery and script. These seals had little influence on Old Elamite glyptic and appear at Susa as a result of commercial exchange.[12]

JOAN ARUZ

NOTES

1. Amiet, 1972a, passim; idem, 1971, pp. 217f.; idem, 1973a, pp. 3ff.; idem, 1973b, pp. 3ff.; idem, 1980b, pp. 133ff.
2. Porada, 1962, p. 47; Collon, 1987, pp. 39, 55.
3. Amiet, 1966, pp. 214 no. 157, 217 no. 159; Scheil, 1913, pp. 4–6; Richard Zettler, "The Sargonic Royal Seal: A Consideration of Sealing in Mesopotamia," in McGuire Gibson and Robert D. Biggs, eds., *Seals and Sealing in the Ancient Near East*, BM vol. 6 (Malibu, Cal., 1977), p. 34; Collon, 1982, pp. 70–71, no. 135, pl. 19:135; Winter, 1987, p. 73 n. 16.
4. Vallat, 1990, pp. 120–27. Winter (1987, pp. 76–77) notes that seals of very high-ranking officials may have a composition which places the petitioner directly before the king, with no intervening goddess. At Susa, only a few seals have this iconography: e.g., Amiet, 1972a, no. 1678, a servant of Idaddu.
5. Amiet, 1972a, no. 1686.
6. Lambert, 1971, pp. 218ff.; Amiet, 1972a, no. 1677; Stolper, 1982, p. 55.
7. Amiet, 1986a, p. 286, fig. 107. See Numbers 81 and 82 for a discussion of the serpent-dragon. For weapons inscribed with royal names, see Number 56 and Amiet, 1986a, p. 276, fig. 84.
8. Lambert, 1971, pp. 218ff.; Winter (1987, p. 73) considers these seals to be the property of particularly important personages in the secular administration.
9. A seal naming Aza, son and scribe of Id...(?) and Queen Mekubi, mother of Idaddu II, depicts a seated god extending a rod and ring toward a male figure, and a suppliant goddess: Amiet, 1980b, p. 135.
10. Miroschedji, 1981a, pp. 1ff. See Vallat, 1990, pp. 119ff., for the use of these titles by the Elamite ruler.
11. Amiet, 1970b, p. 23.
12. Amiet, 1986a, pp. 280, figs. 93, 94, 286, fig. 105. For a discussion of the use of local imitations by traders living abroad, see Parpola, Parpola, and Brunswig, 1977, pp. 155ff.

70 CYLINDER SEAL WITH MILKING SCENE
Shell
H. 1¼ in. (3.2 cm); DIAM. ¾ in. (1.9 cm)
Ca. 2600–2500 B.C.
Vase à la cachette, Acropole; Sb 2723/58
Excavated by Morgan, 1907.

The seal is part of a collection of objects that were discovered in 1907 inside two large clay jars on the Susa Acropole.[1] Known as the *vase à la cachette*, this find included eleven alabaster vessels; forty-eight copper and bronze vessels, tools, and weapons; gold rings and beads; a tiny lapis lazuli frog; and six cylinder seals. Only one of the two containers is now preserved, painted and covered by a second painted bowl (fig. 35).[2]

This seal is finely worked in shell, which has turned green from contact with the copper objects in the vase. Represented below a row of reclining goats is a scene of animal husbandry, with a standing kilted figure steadying a goat while it is being milked by a man seated behind it. Dominating the field, next to a tall stalk of grain(?) that resembles millet or sorghum,[3] is a large seated figure wearing

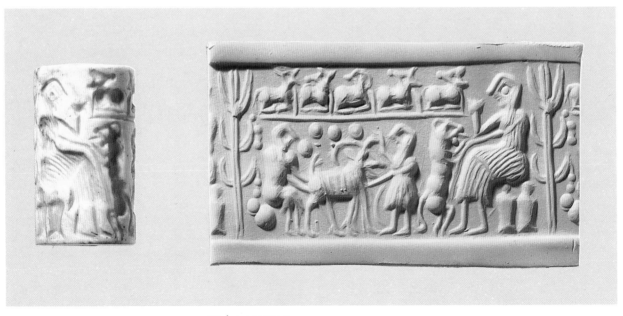

70 Modern impression

Figure 35. The *vase à la cachette*, shown with its contents. Acropole mound, Susa, Old Elamite period, ca. 2500–2400 B.C. Clay, H. 20⅛ in. (51 cm). Paris, Musée du Louvre, Sb 2723

a long striated garment and holding a cup. This figure seems to sit on two milk jars, before a large upright dog who licks him.

Scenes of milking and dairy production with figures seated behind cows are well known in Mesopotamia in the Early Dynastic period, particularly on inlaid friezes from Kish and Al 'Ubaid. The latter frieze is from a temple dedicated to Ninhursag, the goddess of wild and herd animals and "birth-giver" and nurturer of humans.[4] Goats are similarly shown being milked on cylinder seals, some of which have a second register of standing animals or human figures.[5] Registers of reclining goats are also common in the art of Mesopotamia. But certain peculiar features on this seal—such as the unusual plant, the pet dog, and the large seated figure, spanning both registers, in a vertically striated garment—suggest that it may be a local product, although carved with the distinctive use of the drill that is characteristic of Early Dynastic IIIA glyptic from Mesopotamia.[6]

Three other cylinders found in the vase are Mesopotamian in style, one with geometric patterns and two with animal contest scenes; they range in date from Early Dynastic I to IIIB (ca. 2900–2400 B.C.). One additional seal in the deposit, however, contains iconographic features that derive from an eastern source. It is engraved with the figure of a standing lion facing a zebu.[7] The zebu has its head lowered in a posture more characteristic of Harappan short-horned bulls.[8]

Many objects in the *vase à la cachette*—the seal with the zebu, objects made of copper from the region of Oman (identified as ancient Magan),[9] and eight bronzes produced with tin that may have been brought from Afghanistan along the sea route to Oman and Elam[10]—suggest that there was an active commercial network and cultural exchange in the middle of the third millennium B.C.[11] This is the period of the wide distribution of "intercultural style" carved chlorite vessels from eastern Iran and

the Persian Gulf to the Indus Valley, western Iran, Mesopotamia, and Syria.[12]

The *vase à la cachette* find, consisting of objects made over a five-hundred-year span and of diverse origins,[13] was deposited no earlier than about 2400 B.C. While other hoards of copper objects are known from third-millennium contexts,[14] examples with similarly diverse contents date from later periods. One hoard, the "Tôd treasure," was deposited in four bronze caskets in the foundations of the temple of Montu at Tôd in Egypt and consists of foreign silver vessels, seals, and lapis lazuli amulets.[15] Some of the vessels in the Tôd treasure were crushed and folded, suggesting that they were valued for their material rather than their finished form. The seals, of various dates and styles, may have been collected over generations. Porada believes that they belonged to a merchant charged with obtaining lapis lazuli for the king of Egypt.[16] While the contents of the *vase à la cachette* are much more modest than those of the Egyptian treasure, it is likely that the seals and the copper and other objects were part of a collection hoarded by a wealthy Elamite merchant.[17]

JA

1. Rutten et al., 1935–36, vol. 2, p. 71, fig. 33; Amiet, 1986a, pp. 125ff.; Tallon, 1987, pp. 328ff. For the cylinder seals: Le Breton, 1957, p. 117, fig. 39; Delaporte, 1920, pls. 14:12 (S37), 27:4 (S348), 30:5 (S410), 31:7 (S434), 32:12 (S459), 33:2 (S464). The find is mentioned in *MDP* 13 (1912), p. 144, and published in Mecquenem, 1934, pp. 188–89, fig. 21, and in Le Breton, 1957, p. 118. See also Herzfeld, 1933, pp. 58–59.

2. *MDP* 13 (1912), pp. 144f., pl. 24. Tallon (1987, pp. 328ff.) explains that a second unpainted vessel containing some of this material is no longer preserved. For stratified parallels for the surviving container, see Steve and Gasche, 1971, p. 90.

3. I thank Victoria John of the Brooklyn Botanic Garden for this possible identification; the similar stalk on the Uruk Vase, according to John, could also be millet. See Crawford, 1991b, p. 44.

4. Moortgat, 1969, p. 29, pl. 40; Jacobsen, 1976, pp. 104ff.

5. Al-Gailani Werr, 1982, pp. 72–73, no. 12; Amiet, 1980c, p. 432, pl. 87, nos. 1143, 1144, 1146, 1149.

6. Al-Gailani Werr, 1982, p. 73, nos. 10–11; Collon, 1987, p. 28, fig. 74.

7. Delaporte, 1920, pl. 25:15 (S299).

8. Joshi and Parpola, 1987, pp. 60–65; see also Amiet, 1986a, p. 280, fig. 94.

9. Potts, 1978, p. 36; for a discussion of Oman/Magan and its foreign relations, see Cleuziou, 1986, pp. 143ff.

10. Tallon (1987, p. 331) who notes that one object may be a Harappan import; Cleuziou and Berthoud, 1982, pp. 16ff. Afghanistan is also the source for lapis lazuli, the material used for the frog deposited in the vase.

11. Tallon (1987, p. 333) notes that tin-bronze is first known in Mesopotamia in Early Dynastic IIIA.

12. Philip Kohl, "Carved Chlorite Vessels: A Trade in Finished Commodities in the Mid-Third Millennium," *Expedition* 18, no. 1 (1975), pp. 18–31.

13. Amiet (1986a, p. 127) compares the alabaster material of stone vases in the deposit with examples from Shahr-i Sokhta.

14. Delougaz, Hill, and Lloyd, 1967, pp. 184ff., a hoard thought to be a ritual deposit because of a bowl dedicated to the deity Abu; Hansen, 1973, p. 69; Tallon (1987, pp. 336ff.) discusses a second hoard at Susa.

15. Porada, 1982, pp. 285ff. For a discussion of a jeweler's hoard from Larsa that contained seals, see Arnaud, Calvet, and Huot, 1979, pp. 1ff.

16. Porada, 1982, p. 291.

17. Amiet (1986a, pp. 125ff.) believes that some pieces functioned as weights and ingots and were hoarded for monetary value. He thinks the seals were thrown in to identify the owners, although the range of the dates and styles of the seals in the hoard may argue against that interpretation.

71 CYLINDER SEAL WITH SNAKE GOD AND
WORSHIPER
Shell
H. *1⅛ in. (2.8 cm)*; DIAM. *½ in. (1.3 cm)*;
string hole ³⁄₁₆ in (.5 cm)
Akkadian, ca. 2254–2154 B.C.
Donjon; Sb 1055
Excavated by Mecquenem.

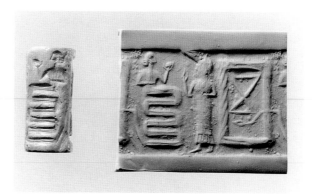

71 Modern impression

This Akkadian seal was found, probably out of its
original context, during Mecquenem's 1929–33 ex-
cavations in the Donjon area.¹ It depicts a figure
with a human head and upper body wearing a long
beard and hair bound at the back. His nude torso
changes at the waist into a serpentine body that de-
scends in coils, the lowest of these becoming the
curving neck and head of a snake. The snake head is
framed by a rectangular structure, probably a tem-
ple door,² that has two branchlike sides and a central
hourglass-shaped element. The serpent-figure
extends a cup toward a worshiper standing before
this structure.

The seal belongs to a well-known group of repre-
sentations of the Akkadian snake god, found at Susa
and also in Mesopotamia: at the southern sites of Ur
and Kish, at Eshnunna and Khafajeh in the Diyala
region, and at Suliemeh in the Hamrin basin.³
These seals are carved in a distinctive linear "cut"
style, marked by the use of the cutting wheel to cre-
ate short parallel lines. The Diyala region has been
suggested as the place of origin of this style.⁴ In
both Mesopotamia and Iran these seals are made of
shell or stone and show the snake god, at times
wearing a horned crown and occasionally with a
plant or flames rising from his shoulder.⁵ He has
coils terminating in branches or snake's heads and
appears to be seated in the company of other deities
or to be approached by worshipers. The snake god
may hold a cup or branch and face an altar or vessel
emanating flames or plants. The tall rectangular
structure in the field, sometimes winged or flaming,⁶
has horizontal divisions and is often embellished
with internal cross patterns. It closely resembles the
gates that frame the ascending sun god, Shamash,
and the winged temple gates on the backs of bulls,
on cylinder seals executed in a similar cut style.⁷

Seal imagery thus provides evidence that the
human-snake creature, a nature god, is associated
with both vegetation and fire. This connection is
suggested on an Akkadian seal impression from
Eshnunna, where a god in human form sits before a

flaming altar with entwined snakes behind him; he
is approached by a god leading worshipers, one with
a snake.⁸

Except for one seal that bears a personal name,
inscriptions are lacking on seals with the human-
snake deity, and his identification rests on the visual
and textual evidence for other gods with snake asso-
ciations. Frankfort's reconstruction of the scene on a
seal that was impressed on a number of sealing frag-
ments from Eshnunna shows snakes emerging from
the feet of a deity⁹ and bears a dedication to Tish-
pak, who in the Akkadian period replaced the under-
world deity Ninazu as city god of Eshnunna.¹⁰
Tishpak's snakelike character (like that of Ninazu's
son Ningizzida) is expressed a little later on seals by
the presence of the *mushhushshu*, or serpent-
dragon. On the lapis lazuli seal of the ruler Bilalama
of Eshnunna, whose daughter married Tan-
Ruhuratir, the king of Susa in the twentieth century
B.C., serpent-dragon heads emerge from Tishpak's
shoulders (fig. 36).¹¹

The close historical connection between Esh-
nunna and Susa in the late third and second mil-

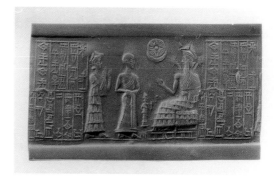

Figure 36. Modern impression of the seal of Bilalama depicting
the ruler before the god Tishpak. Seal: Eshnunna, Iraq, ca.
early 20th century B.C. Lapis lazuli, H. 1⅛ in. (2.8 cm).
Chicago, Oriental Institute, A 7468

lennia, documented in texts, is perhaps already discernible in the material record by the occurrence of cut-style seals at both sites in the Akkadian period.[12] The iconography of the snake gods of Eshnunna—where a deity with human head and torso has a lower body in serpent form and where Tishpak sits on snakes or a *mushhushshu*—may be reflected again in second-millennium Iran in depictions of a fully anthropomorphic god seated on a serpent throne with coils terminating in a human or dragon head (see Nos. 76, 80, and fig. 10, p. 9).[13]

JA

1. Mecquenem, 1934, pp. 232 fig. 82:5, 222–33.
2. Amiet, 1972a, pp. 191, 203, no. 1592; Boehmer, 1965, pp. 105ff., figs. 589–99; for actual shrine doors with wooden horizontals, see Hayes, 1953, p. 257, fig. 163.
3. Amiet, 1972a, pl. 150, nos. 1591–95; Boehmer, 1965, pp. 102ff., pl. 49; Porada, 1948, pl. 34, nos. 216–19; Collon, 1982, pl. 27; Frankfort, 1955, pl. 56, no. 589; Buchanan, 1966, pl. 27, nos. 342–44; Al-Gailani Werr, 1982, p. 81, fig. 40.
4. Laird, 1984, passim, who also lists other themes, such as bulls with winged gates, in the same style.
5. Boehmer, 1965, pl. 49, nos. 580, 586.
6. Ibid., no. 576; Al-Gailani Werr, 1982, p. 81, fig. 40.
7. Various other elements found on snake god seals also occur on seals with different imagery. The altar with shooting flames is found in introduction scenes: Porada, 1948, pl. 39, no. 245; the star-spade appears with both the snake god and the sun god: Collon, 1982, pl. 27, no. 189; Van Buren, 1945, p. 85, no. 6; snake god and sun god imagery merge in the figure of the "god-boat," a vehicle for Shamash that is composed of a human head and torso and an elongated tubular body that ends in a leonine or serpentine head.
8. Frankfort, 1955, pl. 56, no. 592.
9. The juncture between the lower part of the god's robe and the snakes is not clear on the thirteen preserved fragments bearing the impression of this seal (Oriental Institute, Chicago, AS 32-641 a-m); on the basis of fragments e and f, it is possible to interpret the two undulating lines below the seat not as its base, but as the tails of the snakes—although clear evidence is lacking.
10. Frankfort, 1939, p. 120, example dated to the early Akkadian period; Wiggerman, 1989, p. 120; Jacobsen, 1934, pp. 20ff.; for Ninazu and snake imagery, see Amiet, 1970a, pp. 9ff.
11. Frankfort, Jacobsen, and Preusser, 1932, p. 19; Porada, 1980, p. 262, who states that the dragon and inscription were added after the original cutting of the seal in Ur III; for eastern Iranian images of snakes emerging from the shoulders of deities that predate the Bilalama seal, see figure 8 above, p. 7.
12. Imported Elamite seals that can be dated to the post-Akkadian period and paralleled at Susa are also found at Eshnunna: Frankfort, 1955, pl. 56 no. 597, and Amiet, 1972a, pl. 153, no. 1641.
13. This is also the view of Seidl, 1986, p. 21.

72 CYLINDER SEAL WITH MESOPOTAMIAN DIVINITIES AND INSCRIPTION

Hematite
H. *1 in. (2.6 cm)*; DIAM. *⅝ in. (1.6 cm); string hole*
³/₁₆ in. (.4 cm)
Old Babylonian, 19th–early 18th century B.C.
Sb 1446

One of the finest seals found at Susa is a Mesopotamian or Syrian cylinder of the early Old Babylonian period, a time corresponding to *sukkalmah* rule in Elam.[1] The seal is carved in a modeled style with images of Mesopotamian divinities. The most important is the water god Ea, wearing a horned crown and flounced robe and standing on a goat-fish in an arc formed by the joined bodies of two water deities. These nature spirits hold vessels out of which rise the fishy streams that also flow from the god's shoulders and mix with waters emanating from a vase held in his left hand. Similar water divinities are depicted, supporting the throne of a seated water god with flowing streams, on the numerous impressions of the seal of a personage named Iluna-Kirish, found in the palace at Mari, on the Euphrates in eastern Syria.[2]

The water god on the seal from Susa faces right (in the impression); before him is a procession including the suppliant goddess, who follows her usual companion, the "figure with the mace." This figure wears a royal turban and has the distinctive windswept beard and short garment worn by kings such as Naram-Sin in scenes of war (see No. 109).[3] He also wears bracelets, and in addition to the mace held toward his body he is armed with a *harpé*, or sickle sword, carried in the right hand. This figure has most recently been identified by Franz Wiggermann as a guardian divinity, the Udug-spirit who, along with the goddess Lama, protected temple doorways.[4] He stands behind another figure in nearly identical dress (lacking only the pleating on the fringed panel of the kilt). This warrior has his arm raised to wield his *harpé* in a smiting gesture and stands on one leg of a nude enemy, who has been brought to his knees. The subdued man has a pointed beard and a distinctive cap with a flat brim and earflaps; a long, curling element that emerges from the top may be his hair or part of the hat. Above him, two tiny suppliant goddesses stand beneath a crescent and a sun disk.

There have been many attempts to identify war-

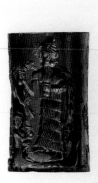 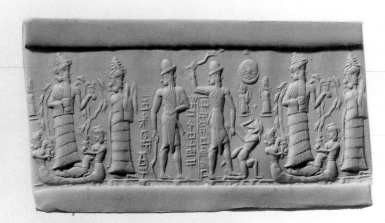

72 Modern impression

riors represented with one leg raised in an ascending posture as Ninurta or Nergal, major gods associated with fertility and death.[5] An identification as Nergal would agree with the later Elamite inscription on the seal, probably added at Susa,[6] which names the seal owner as "Kuk-inzu, scribe, son of Apikupi[?]lua, servant of [the god] Nergal."[7] Wiggermann, however, states that the Udug-spirit may also appear in the "killing posture" of a warring king, and some scholars have interpreted the scene as a sequential narrative with the same figure shown twice.[8] Amiet has noted that the owner of this seal may be the same Kuk-inzu who is the father of "Ahuwaqar, servant of Nergal," a man who owned two seals engraved with presentation scenes including a suppliant goddess.[9]

We cannot assess the social significance attached to the ownership of a fine seal brought to Susa from Babylonia or the Mari region of northeastern Syria (under Elamite control for a short time) on which the scribe, a devotee of Nergal, may have identified his god. Nergal, the Mesopotamian god of the underworld and protector against war and pestilence, is one of a number of Mesopotamian deities who were mentioned on seal inscriptions at Susa. They coexisted with the gods and goddesses of the Elamite pantheon, who were not only named in numerous inscriptions but were also occasionally depicted with their distinctive attributes on objects dating from the time of the Early Dynastic period through the second and first millennia B.C. (see Nos. 55, 76, 80, and figs. 6 and 10, pp. 6, 9).

1. Amiet, 1972a, pp. 226, 232, no. 1769, pl. 162; M. Rutten, *MDP* 30 (1947), pl. 11:4, where the seal is illustrated without information regarding findspot; Rutten, 1950, p. 173, no. 32; Börker-Klähn, 1970, p. 143, no. 118.
2. Amiet, 1960, p. 215, fig. 1; Parrot, 1959, pp. 194–97.
3. Wiggermann, 1985–86, p. 25. Some of these features appear on other seals from Mari with scenes of war: see Amiet, 1960, p. 230, where one figure in a short garment wears a divine headdress.
4. Wiggermann, 1985–86, pp. 5–7, 23–27.
5. Solyman, 1968, pp. 95–96, 108–10; Porada and Basmachi, 1951, pp. 66–68; Frankfort, 1939, p. 167, pl. 28a, c, d.
6. For a discussion of the relationship between image and legend in identifying deities on seals, see Wiggermann, 1985–86, pp. 5, 6 n. 7.
7. *Ku-uk-in-zu* DUB.SAR
 DUMU *A-pi-ku-pi*[?]*-lu-a*
 ARAD ᵈ*Nè-eri*₁₁*-gal*
 (Translation and transliteration provided by Matthew W. Stolper). Amiet, 1972a, pp. 226, 232, no. 1769.
8. Wiggermann, 1985–86, p. 25; Amiet, 1972a, p. 226. For a discussion of this type of narrative composition, see Winter, 1981, p. 10. On the Susa seal the warrior wields only a *harpé*, as on a clay plaque from Tell Harmal, see Opificius, 1961, p. 260, no. 480. On other examples he also holds a multi-headed mace and confronts the figure with the mace: see Frankfort, 1939, pl. 28a.
9. Amiet, 1972a, p. 226, nos. 1689, 1693.

JA

73 CYLINDER SEAL WITH PRESENTATION SCENE;
INSCRIPTION NAMING THE RULERS EBARAT
AND SHILHAHA
Hematite
H. *1⅛ in. (2.7 cm)*; DIAM. *⅝ in. (1.7 cm)*;
string hole ³⁄₁₆ in. (.45 cm)
Old Elamite period, 20th century B.C.
Sb 6225

This seal is carved with one of the best-known themes in the large corpus of Sumerian glyptic, the presentation scene, in which a goddess leads a male figure by the hand toward a seated god or king.[1] During the Ur III period of the late third millennium B.C. in Mesopotamia, a time of highly centralized authority,[2] this imagery was pervasive on seals of public officials. Such seals persist into the Isin-Larsa period of the early second millennium B.C., with a suppliant goddess replacing the interceding deity.[3] It has been suggested that seal owners and even rulers in presentation scenes are given specific features.[4]

This seal retains the earlier Mesopotamian formula, but differences in style and iconography mark it as a product of Elam. At the right (as seen in the impression) is a seated male figure extending a conical cup before a goddess wearing a frontal multiple-horned crown and a flounced robe. She leads by the hand a man in a long garment with a fringed hem, whose right arm is bent in the gesture of a worshiper. The seated figure has a (distinctively Elamite) rather large head with flat, caplike hair, and is bearded. (See fig. 56, p. 258, for a later, Middle Elamite engraving of a seated ruler with similar features.) He lacks the brimmed hat of the Mesopotamian ruler and the divine horned miter, but wears the god's flounced robe; however, he sits on a simple

stool. Before him is a small bird, and a crescent and disk(?) are in the field above. A four-line inscription identifies the ruler Ebarat and the seal owner(?) "Kuk-Kalla, son of Kuk-sharum, servant of Shilhaha."[5]

Ebarat II was the ninth ruler of the dynasty of Shimashki and the probable founder of the *sukkalmah* line in the twentieth century B.C.; his son Shilhaha (see Nos. 181, 184) probably also attained the position of grand regent, or *sukkalmah*.[6] One assumes that the seal owner who named both rulers on his seal was a high official. In contrast to other contemporaries, he used a seal with an older type of presentation format; in Mesopotamia, this format may have been used by functionaries below the highest-level officials who had direct access to the ruler.[7] Such distinctions may not have been significant at Susa.

JA

1. Franke, 1977, pp. 61ff.
2. See Winter, 1987, p. 74 n. 18, for a discussion of the relationship between uniformity in seal design and systemic cohesion in the Ur III state.
3. Collon, 1986, p. 60.
4. Winter, 1987, pp. 79ff.
5. *E-ba-ra-at* LUGAL
 Ku-uk-ᵈKal-la
 DUMU *Ku-uk-ša-rum*
 ARAD *Ši-il-ḫa-ḫa*
 (Translation and transliteration provided by Matthew W. Stolper). Amiet, 1972a, p. 218, no. 1685, and nos. 1687, 1689 for two other seals from Susa, perhaps of temple personnel, which have very similar imagery.
6. For a discussion of the tripartite rule by Ebarat, Shilhaha, and Attahushu, see Number 184; Stolper, 1982, pp. 54ff.; Lambert, 1979, pp. 16–17. Vallat (1990, p. 124), considers Attahushu to be a usurper and not the biological son of Shilhaha, and modifies the interpretation of tripartite rule.
7. Winter, 1987, p. 76.

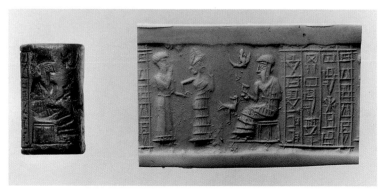

73 Modern impression

74 CYLINDER SEAL WITH SEATED FIGURES, ONE
UNDER A VINE
Bitumen compound
H. 1¼ in. (3.3 cm); DIAM. ¾ in. (1.8 cm); string hole
³⁄₁₆ in. (.4 cm)
Old Elamite period, early 2nd millennium B.C.
Sb 1515

One version of the Mesopotamian presentation
scene, showing a figure standing directly before the
king, has been transformed into a distinctly Elamite
image on this rather crude seal made of bitumen
compound, the popular local material.¹ Two seated
figures are depicted with their right (in the impres-
sion) arms extended, holding cups; before them
stands a male figure in a long robe next to a table,
above which is a bird. While the first seated figure,
probably the ruler, wears a wrapped robe and sits on
a throne, the second, perhaps his queen, is enveloped
in a wide, flounced garment and is elevated on a plat-
form beneath an overhanging vine. In the field are a
crescent and a spade or dagger.

This distinctive scene has parallels on other seals,
such as one in the Metropolitan Museum where the
seated female is much smaller than the seated male
(fig. 37).² On a stamp seal excavated at ancient An-
shan (Tal-i Malyan), an image of a lady under an
arbor and a standing figure appear. A jar(?) sealing
from the site has the impression of a cylinder seal
showing a couple flanked by two standing figures
who hold the ends of the vine canopy.³

Other seals depict only the royal figures without
the outdoor setting and approaching official. One
important example has been identified, on the basis
of its inscription, as the royal seal of the great ruler
Ebarat, who founded the Sukkalmah dynasty (see
No. 73). On this finely worked piece (fig. 38), made
of chalcedony, the king is the central figure, seated

on a tufted stool and wearing a flounced garment,
both marks of divinity on Ur III seals. His hair ar-
rangement is distinctive. Two females in voluminous
flounced robes appear to sit in attendance with arms
extended toward him. The figure before him, receiv-
ing a flower, may be his "beloved wife," as men-
tioned in the inscription.⁴ A seal impression on a

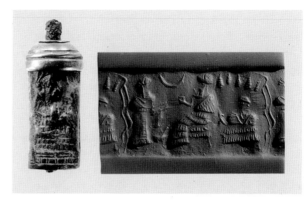

Figure 37. Seal and modern impression showing seated male and fe-
male figures and a vine. Seal: Iran(?), Old Elamite period, early 2nd
millennium B.C. Serpentine, H. 1¼ in. (3.3 cm). The Metropolitan
Museum of Art, Purchase, The Howard Phipps Foundation Gift, 1987
(1987.343)

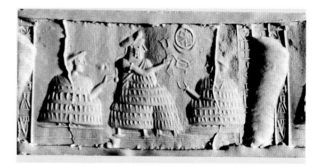

Figure 38. Modern impression of the seal of Ebarat. Seal: Iran, Old
Elamite period, 20th century B.C. Chalcedony, H. 1⅛ in. (2.8 cm).
Durham, Gulbenkian Museum of Oriental Art, University
of Durham, N2410

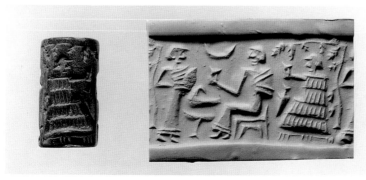

Modern impression

tablet from Susa shows a female in a full robe facing a larger seated male figure who holds a flowing vase; it is inscribed with the name of Pala-ishshan, *sukkalmah*, or grand regent, who ruled some years after Ebarat in the twentieth century B.C.[5]

The image of a female figure enveloped in a wide, fleecy robe is not restricted to seals. It achieves its fullest expression on small stone sculptures from Afghanistan and on a silver vase said to come from the area of Persepolis (fig. 9, p. 8).[6] The vase, with a linear Elamite inscription, is datable to the time of Puzur-Inshushinak in the late third millennium (see p. 87); it depicts a seated and a standing female, wearing similar garments, who are interpreted as devotee and goddess.

On the monumental rock carving from Kurangun near Malyan, probably dating to the seventeenth century B.C., a female deity with a horned headdress and a wide robe sits behind a god who is elevated on a double platform and serpent throne (fig. 10, p. 9). The god holds a rod and ring(?) with flowing waters that form a canopy over the couple; this illustration of divinities provides a parallel to the scene with royal figures(?) under a grape arbor. Seals with this imagery may have had a specific purpose, different from that of other Old Elamite seals depicting the ruler before his god (see No. 76).

JA

1. Amiet, 1972a, p. 248:1515, pl. 169.
2. Steve, 1989, pp. 20ff., fig. D.
3. Sumner, 1974, p. 172, fig. 12, 1 (Kaftari period, dating ca. 2000–1700 B.C.); Centre Iranien de Recherche Archéologique, *Exposition des Dernières Découvertes Archéologiques 1976–1977* ([Teheran], 1977), p. 51, no. 68. According to Holly Pittman, other sealings from the site have similar imagery.
4. Lambert, 1979, pp. 43ff., and Porada, 1990, pp. 171ff.; Steve, 1989, pp. 16ff., assigns the seal to Ebarat I, who ruled about

2040 B.C. For the chronology of the early Sukkalmah period, see Vallat, 1989d, pp. 23ff.; idem, 1990, pp. 119ff.
5. The owner of the seal was the royal scribe Illituram; Vallat, 1989d, pp. 23–24, referred to by Porada, 1990, p. 172; Vallat, 1990, p. 127.
6. M.-H. Pottier, 1984, pls. 36–40; Hinz, 1969, pl. 5, pp. 11ff., with an inscription naming the goddess Narundi.

75 CYLINDER SEAL WITH THREE FIGURES IN WIDE SKIRTS
Bitumen compound
H. 1⅛ in. (2.8 cm); DIAM. ⅝ in. (1.5 cm); string hole ⅛ in. (.35 cm)
Old Elamite period, early 2nd millennium B.C.
Sb 1333
Excavated by Mecquenem.

The wide skirts of the three standing figures on this seal seem somehow related in form to the voluminous garments worn by kings and queens on Old Elamite seals.[1] These bearded(?) personages have flat, caplike hair. Their arms are extended, one downward, the other raised and holding a triangular object that could be a dagger. Their skirts are ankle-length and are vertically striated, perhaps pleated rather than flounced. If pleated, the garments were probably quite different in texture from the fleecy clothing worn by seated dignitaries and deities.

This is one of a number of similar seals executed in a linear style characteristic of the glyptic made of bitumen compound in the early Sukkalmah period.[2] An example found in a deposit in the Inshushinak temple precinct on the Susa Acropole has the figure of a nude male added to the procession.[3]

It is interesting that these seals, although made in Elam, seem related to a series of cursory linear-style seals found in Syria and Anatolia that are dat-

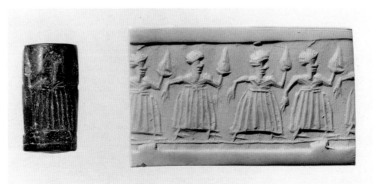

75 Modern impression

Figure 39. Drawing of a seal impression depicting a procession of figures. Seal: Karahöyük, Anatolia, ca. 19th century B.C. Black stone, H. ⅝ in. (1.6 cm). Konya, Turkey, Archaeological Museum

able to the early second millennium B.C. Those western examples depict three or four identical figures, generally proceeding left rather than right (in impressions), some of them carrying objects that resemble spades, daggers, or plants in the front raised hand (fig. 39).[4] Although their fringed garments seem to be quite different from the Elamite wide skirts, the large plants and snakes in the field can be paralleled on an unexcavated Elamite seal. It shows a figure in a wide pleated skirt, wielding a dagger in one hand and holding a snake in the other and facing two horned animals, possibly in some ritual encounter.[5]

JA

1. Amiet, 1972a, p. 256, no. 2001, pl. 175; Rutten, 1950, p. 176, no. 53; Börker-Klähn, 1970, pp. 130–31.
2. Amiet, 1972a, nos. 2001–6.
3. *MDP* 7 (1905), pl. 22:7. The diverse "foundation offerings" of this temple are catalogued by Mecquenem, 1905a, pp. 61ff.; included are a number of Mesopotamian and Elamite seals of various periods and styles.
4. Mazzoni, 1975, pp. 21ff., 40 n. 79, pl. 2.
5. Collon, 1987, p. 56, no. 230.

76 SEALED LEGAL TABLET WITH DEITY ON SNAKE THRONE AND WORSHIPER; INSCRIPTION NAMING TAN-ULI

Clay
H. 2¾ in. (6.9 cm); W. 2¼ in. (5.8 cm)
Impressed by a seal of H. 1½ in. (3.7 cm)
Old Elamite period, 17th century B.C.
Sb 8748

This fragment of a legal tablet from Susa preserves a partial impression of a seal inscribed with the name "Tan-u [li], the *sukkalmah*, the *sukkal* of Elam and Shimashki, sister's-son of Shilhaha."[1] The seal is carved with the well-modeled image of a god with

long hair and a flat cap, seated above a niched platform on a coiled snake that has a bearded human head. A small snake is held in the deity's left hand, while streams appear to flow from an object in his extended right hand which may be a rod and ring, Mesopotamian symbols of divine (just) authority. The streams flow into the hands of a standing figure, probably Tan-Uli himself, who ruled Elam in the early seventeenth century B.C.[2]

Similar imagery is present in impressions of seals of regents and court officials on other early-second-millennium tablets from Susa and is prominently displayed on the rock relief of Kurangun (fig. 10, p. 9).[3] Although derived from Mesopotamian iconography that served to legitimize the power of

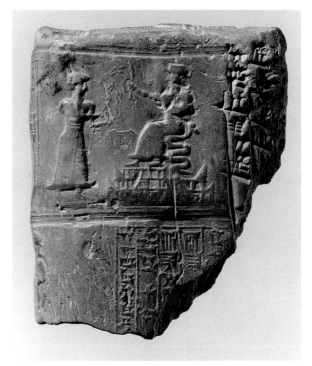

76

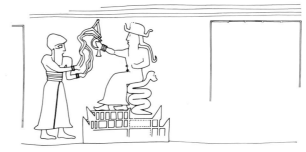

Drawing omits inscription

the ruler (No. 110 and fig. 44, p. 160), Elamite features include royal coiffures and divine headdresses, a distinctive platform terminating in hornlike forms, and the snake throne.⁴ The association of water and snakes is a prominent feature on Elamite monuments, most notably on the Untash-Napirisha stele, on which the ruler is depicted before a god holding a scaly-textured rod and ring and probably the head of a serpent-dragon. A coiled snake with a dragon's head is reconstructed in a drawing by Miroschedji as the deity's throne (see fig. 42, p. 128).

The god on a serpent throne, who bestows the right to rule, has been thought to be either Napirisha, sometimes considered the highest god in the Elamite pantheon, or Inshushinak, "the lord of Susa." His identity, however, is not clear from textual or iconographic evidence.⁵ On seal impressions of the Sukkalmah period, no deities are named along with the seal owners. A later, fifteenth-century seal impression from Haft Tepe (ancient Kabnak) with similar imagery is inscribed with the name of Tepti-ahar, king of "Susa and Anshan" and servant of both Inshushinak and another deity, Kirwasir. Another impression from this site, matched by one at Susa, depicts the god on a serpent throne approached by another deity; the inscription invokes not only Inshushinak but also Napirisha (fig. 40).⁶ While the stele of Untash-Napirisha is dedicated to

Inshushinak, one cannot be certain that the god with ophidian associations was always the same deity, and indeed, on the rock relief at Naqsh-i Rustam, two gods sit on coiled snake thrones.

JA

1. *Tan-ú-[li]*
 SUKKAL. [MAḪ]
 SUKKAL N [IM.MA-*tim*]
 [*ù*] *Ši-maš-ki*
 DUMU.NIN-*šu* {*šà*} *Ši-il-[ḫa-ḫa]*
 The translation and transliteration were provided by Matthew Stolper, who follows the reading by Vallat (1989c, p. 92, no. 117), which corrects the translation of M. Lambert in Amiet, 1972a, no. 2330.
2. Carter and Stolper (1984, pp. 24ff.) discuss three simultaneously held *sukkalmah* offices (and see above, p. 81); as the *sukkalmah* of Elam and Simashki, Tan-Uli would have been co-regent. However, Vallat (1990, p. 124) discusses the complexities of interpreting the evidence for this system.
3. No examples occur at the nearby site of Malyan (Anshan). For a survey of this material, see Miroschedji, 1981a, pp. 1ff.; Amiet, 1980b, p. 138, no. 10.
4. For Mesopotamian seals with a deity with the rod and ring next to a worshiper holding streams or pouring water into a vessel, see Collon, 1986, nos. 372–74.
5. Amiet (1973b, p. 17) believes that this figure on royal seals must be the chief god, Napirisha; Miroschedji identifies him as Inshushinak. For a discussion of the identification of Napirisha with the chief Elamite deity, Humban, see Miroschedji, 1980, pp. 129ff.
6. Miroschedji, 1981a, pp. 15ff.

77 CYLINDER SEAL WITH DEITY, WORSHIPER, AND HUMAN-HEADED SNAKE
Bitumen compound
H. *1 in. (2.4 cm)*; DIAM. *½ in. (1.2 cm); string hole ⅛ in. (.3 cm)*
Old Elamite period, early 2nd millennium B.C.
Sb 1053
Excavated by Mecquenem.

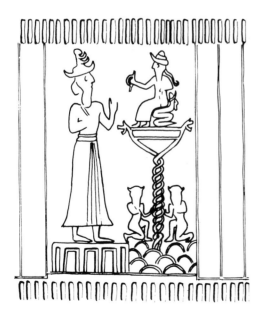

Figure 40. Drawing of a seal impression on a clay tablet with deity before a god on a serpent throne. Tablet: Haft Tepe, Iran, Old Elamite period, ca. 17th century B.C. Clay, H. 1½ in. (3.9 cm). Teheran, Iran Bastan Museum

The modeled style of the Tan-Uli seal (No. 76) contrasts with the hatched linear execution of a number of provincial-looking early-second-millennium seals found at both Susa and Anshan, most of them made of bitumen compound.¹ On this example, a large, coiled, human-headed snake looms behind a deity seated on a fleece-covered throne, who holds a cup toward a worshiper. A crescent and what appears to be a vessel are in the field. The snake is not depicted as an intimate part of the divine image, but its association with the god may be inferred from a statuette where snakes rise up behind a god seated on a

77 Modern impression

78 Modern impression

coiled serpent.[2] Other seals in this style include different elements, such as lions, goats, or birds in a natural setting. These seals do not have inscriptions of Elamite rulers, but like seals that do, they carry designs based on Mesopotamian official iconography, with the seated king approached by a standing figure.

JA

1. Amiet (1972a, pp. 239ff.) terms this the "Elamite popular style," and later (idem, 1986a, p. 153) regards these seals as coming from Anshan, where the style predominates among the seal stones; Börker-Klähn (1970, pp. 168ff.) relates them stylistically to glyptic found in the Assyrian merchant colony of Kültepe (II, ca. 1920–1840 B.C.) in Anatolia.
2. Miroschedji, 1981a, pl. 3.

78 PERSIAN GULF STAMP SEAL WITH TWO CAPRIDS
Burnt steatite
DIAM. ⅞ in. (2.2 cm); H. ⅜ in. (.8 cm)
Late 3rd–early 2nd millennium B.C.
Sb 1015
Excavated by Mecquenem

Many objects found at Susa reflect contacts with the Persian Gulf region. A number of foreign seals are executed in the distinctive style known mainly from sites in ancient Dilmun, on the islands of Bahrain and Failaka.[1] A mercantile document and a basket sealing were stamped with Gulf-style seals.[2] Elamite imitations of Gulf seals were made in the local bitumen compound.[3]

Perhaps the most characteristic type of Persian Gulf seal is illustrated by this piece, one of four burnt (whitened) steatite stamp seals found at Susa that have distinctive grooves and dot circles incised on a raised boss on the back.[4] The face of this seal is engraved with the figures of two goats crouching

head to foot on opposite sides of the circular field, the center of which is marked by a lozenge. Their slightly modeled bodies are defined by a curving outline, and distinctive details, such as large dot-circle eyes and striated necks, are sharply cut. Similar seals are known mainly from the Gulf region (and one example was found at Lothal in India).[5] They were also exported to, and imitated at, the southern Mesopotamian city of Ur,[6] a site with cuneiform texts that refer to the import of copper, semiprecious stones, and perhaps pearls from Dilmun.[7] They are datable to the end of the third and the beginning of the second millennium B.C.[8] That is the period when one elaborate Persian Gulf seal depicting a Mesopotamian-derived "banquet scene" was stamped on an Old Babylonian contract between two merchants. The tablet, written in the time of Gungunum, ruler of Larsa in the late twentieth century B.C., is in the Yale Babylonian Collection.[9] The document from Susa mentioning a Dilmunite merchant and ten *minas* of copper dates to the same period.[10]

JA

1. Amiet, 1986a, pp. 262ff.; idem, 1972a, nos. 1716–19, 1975; pp. 269ff. for mention of similar seals on the Arabian mainland. For a review of evidence for the location of Dilmun, see Potts, 1978, pp. 36, 47–48 n. 9.
2. Amiet, 1986a, p. 265, figs. 85, 86; idem, 1973b, no. 240; idem, 1974a, p. 109; M. Lambert, 1976, p. 71.
3. Amiet, 1972a, p. 222, nos. 1720–26, pl. 159.
4. Amiet, 1986a, p. 266.
5. Rao, 1986, pp. 376ff.
6. Gadd, 1932, pp. 191ff.; Mitchell, 1986, pp. 278ff. Ratnagar (1981, p. 199) is equivocal about a seal from Ischali.
7. Oppenheim, 1954, pp. 6ff.; for the identification of "fish-eyes" with pearls, see Howard-Carter, 1986, pp. 305ff.
8. For chronological evidence based on imported Mesopotamian seals and radiocarbon dating of Gulf contexts with seals, see Kjaerum, 1986, pp. 269–70; these seals belong to a second group of Persian Gulf seals. The earlier group relates more

closely in form and design to Harappan glyptic of the Indus Valley: ibid., p. 269.
9. Hallo and Buchanan, 1965, pp. 199ff.; Buchanan, 1967, pp. 104ff.: dated to ca. 1927 B.C. Kjaerum (1986, pp. 272ff.) and Porada (1971, pp. 331ff.) point out the possible Levantine and Anatolian elements in glyptic imagery of the Persian Gulf.
10. M. Lambert, 1976, pp. 71ff.

79 PERSIAN GULF CYLINDER SEAL WITH SEATED DEITY
Burnt steatite
H. 1⅛ in. (2.7 cm); DIAM. ⅝ in. (1.4 cm); string hole ⅛ in. (.3 cm)
Late 3rd–early 2nd millennium B.C.
Sb 1383
Excavated by Mecquenem.

The Mesopotamian influence on glyptic from the Persian Gulf area is very clearly illustrated in this example, one of the few cylinder seals executed in this distinctive style.[1] Close parallels are found at Failaka, in the Gulf.[2] Adopted here are not only the Mesopotamian cylinder-seal shape but also the theme of a worshiper standing before a seated horned deity in a flounced(?) garment and a version of the contest scene with crossed animals. Peculiar iconographic details also appear, however, such as the nude worshiper with his hand in a pot; the two "masters of animals," one nude and one kilted, grasping the animals' necks; and the snake framing the scene from above.

Glyptic and textual evidence suggests that the cities of Susa and Ur were trading centers in close contact with ancient Dilmun, located in the Persian Gulf.[3] This contact, however, does not seem to have been limited to an exchange of goods. François Vallat has noted, on the basis of textual evidence, that Enzak, the chief god of Dilmun, was one of a triad of deities worshiped on the Susa Acropole in the eighteenth century B.C.[4] Persian Gulf–style seals found at Susa and other foreign sites with Mesopotamian and Indus-derived themes incorporated into their iconography were created, some scholars believe, for Dilmunite traders living abroad.[5]

Very different, however, are the crude derivative stamp seals, probably made at Susa, that have grooves and dots on the back in imitation of seals from the Gulf.[6]

JA

1. Amiet, 1972a, no. 2021; Rutten, 1950, pl. 5, no. 39.
2. Kjaerum, 1983, p. 155, no. 373, for one that may belong to the same workshop. For a corpus of Persian Gulf cylinder seals, see L. Al-Gailani Werr, "Gulf (Dilmun) style cylinder seals," *Proceedings of the Seminar for Arabian Studies* 16 (1983), pp. 199–201 (cited in Collon, 1987).
3. For a reference to the earliest phase of Mesopotamian-Gulf contact, see J. Oates, 1977, pp. 221ff.
4. Vallat, 1983, pp. 93ff.; al-Nashef (1986, pp. 340ff., p. 348) suggests that the god was indigenous to both areas.
5. Parpola, Parpola, and Brunswig, 1977, pp. 154ff.
6. Of interest are three examples from Susa: Amiet, 1972a, nos. 1723–25. These all have the same image of a nude figure with outspread legs but lack the second figure below that is an essential part of a distinctive erotic scene known from many seals of Failaka and Bahrain: Crawford, 1991a, p. 261, no. K16:29:8. Whorl shells, found at many Gulf sites, also occur at Susa: Amiet, 1986a, p. 278, no. 91.

79 Modern impression

THE MIDDLE ELAMITE PERIOD
CIRCA 1500–1000 B.C.

Elam reached unprecedented heights of political and military power late in the second millennium B.C. under the kings of Anshan and Susa. The actual formation of the Elamite empire is difficult to trace because sometime after the middle of the millennium, both written and archaeological documentation from Susa comes to a halt. The Sukkalmah dynasty and its unique system of shared rule seems to have disappeared. Archaeological surveys indicate that the intense agricultural activity characteristic of the early second millennium in Susiana and around Anshan diminished. Many small rural settlements were abandoned and the number and size of urban centers grew, making it likely that the economy of Elam increasingly depended on the herding of livestock, trade, and plunder.[1]

Although previously Susa had been the unquestioned center of settlement in the region, the most important finds from the middle of the millennium are at Kabnak (modern Haft Tepe), nineteen miles to the southeast, excavated by Ezat O. Negahban.[2] There a major temple complex and associated workshops were constructed about 1450 B.C. by Tepti-ahar, who used the title "king of Susa and Anshan." Texts of the fifteenth and fourteenth centuries from Haft Tepe were still written in Akkadian, but the king's title and proper names they contain reflect an increasing "Elamization" of the written language.

Another challenge to Susa's local supremacy arose under the Igi-halkid king Untash-Napirisha (ca. 1340–1300 B.C.), who constructed his new capital, Al Untash-Napirisha, or the city of Untash-Napirisha (modern Chogha Zanbil), twenty-five miles southeast of Susa on a previously unsettled plateau above the banks of the Diz River. The city, centered around a ziggurat, or stepped temple tower, two hundred feet high, was built at a strategic point along a road leading to the southeastern highlands. Thousands of baked bricks inscribed in Elamite cuneiform were used in its construction. Studies of these inscriptions suggest that the establishment of Al Untash-Napirisha was an ambitious attempt to replace Susa as the political and religious center of the Elamite kingdom. The city seems to have been a kind of federal sanctuary where the gods of the highlands and the lowlands were worshiped on an equal footing. To found such ecumenical complexes at Susa, with its long history of cultural traditions influenced by Mesopotamia, might well have been more difficult. The Middle Elamite kings may have established temple-cities throughout southwestern and south central Iran to

121

strengthen control of their kingdom, although none was as large as Al Untash-Napirisha. However, the city was never finished and was practically abandoned after the death of its founder.

Susa regained its prominence less than a century later with the rule of the Shutrukid line. King Shutruk-Nahhunte I (1190–1155 B.C.) and his two sons, Kutir-Nahhunte and Shilhak-Inshushinak, battled the Kassite dynasty, which had ruled Mesopotamia since 1500, and were victorious. It was under the Shutrukid dynasty, in the last centuries of the second millennium B.C., that the Elamite kingship of Anshan and Susa reached the peak of its political supremacy. The Shutrukids' success was based on their ability to exploit and control both Susiana and the highland kingdoms to the southeast. They also controlled the foothill roads leading northwest into Mesopotamia, which made it possible for them to extend their rule to Mesopotamia.

The Shutrukid kings rebuilt the structures on the Acropole, replacing mud brick with baked inscribed bricks[3] and glazed bricks (see the essay below), and adorned the sanctuary of Inshushinak with the famous monuments of Naram-Sin (No. 109) and Hammurabi (fig. 44). Through the display of these captured monuments and other war trophies they attempted to establish Susa's position as a great city in the Mesopotamian tradition and to legitimize their dynasty as the successors of the defeated Kassite kings who had ruled Mesopotamia for some four centuries.[4]

Little direct evidence exists to document the role that Susa played in the international court politics and trade of the Late Bronze Age.[5] The sophisticated levels of metal and ivory work and of glass and glazing technology evident at Susa point to the city's involvement in the processes of procuring raw materials and manufacturing the luxury goods and weapons that were commonly traded in the ancient Near East at that time. Although the Susian role in international exchange is unknown, techniques and styles characteristic of Susian work are reflected in artworks produced slightly later in Assyria and western Iran,[6] indicating that lowland Elamite craft traditions exerted a major influence on those cultures.

EC

1. Carter and Stolper, 1984, pp. 144–81; Schacht, 1987, pp. 180–84.
2. See Negahban, 1991.
3. The brick inscriptions of Shilhak-Inshushinak pay homage to the king's predecessors, who built or refurbished the temple of Inshushinak, and ask for blessings upon his progeny. These important historical documents are the major source of information about the chronological sequence of the previous rulers of Elam: Matthew W. Stolper in Carter and Stolper, 1984, pp. 41–42.
4. This is well illustrated by a recut Babylonian stele (No. 117). Its original carving of a Mesopotamian ruler was reworked to represent an Elamite king, probably Shutruk-Nahhunte I, who is seen receiving the ring of kingship from a Mesopotamian deity. [For another dating of the reworking, see entry for No. 117.—Ed.]
5. A single text records dynastic marriages of Elamite kings to Kassite princesses, demonstrating that Elamite royalty participated in the international network: van Dijk, 1986, pp. 159–70. [See also Steve and Vallat, 1989, pp. 223ff.—Ed.]
6. See, for example, Irene Winter, *A Decorated Breastplate from Hasanlu, Iran*, University Museum Monograph 39, University of Pennsylvania (Philadelphia, 1980), pp. 11–21.

Royal and Religious Structures and Their Decoration

From the earliest explorations and excavations at Susa in the nineteenth century, the site has yielded numerous inscribed bricks and objects attesting to the great piety of the Elamite kings. This religious fervor, which had political overtones, is especially well documented in the Middle Elamite period. At that time many older monuments and temples were renovated and new ones were built, often using elaborate and sometimes new techniques.

Among the Igi-halkid kings, Untash-Napirisha (ca. 1340–1300 B.C.) was the most active builder and restorer of sanctuaries, but the evidence found on the Acropole is from secondary contexts, often in later Shutrukid renovations.[1] The next noted builder, Shilhak-Inshushinak (ca. 1150–1120 B.C.) of the Shutrukid dynasty, proudly states that he renovated or built new monuments at Susa with baked brick, replacing the more usual crude brick masonry of his predecessors. He used molded terracotta bricks of a type originally made during the reign of his brother Kutir-Nahhunte (ca. 1155–1150) in decorative panels (No. 88).

Shilhak-Inshushinak also freely employed an architectural faience, said to have been invented in the time of his father Shutruk-Nahhunte I (ca. 1190–1155), to embellish temples and gates.[2] The glazed bricks (*upat aktinni*) formed of this highly siliceous faience material and first made in the Shutrukid dynasty seem to have been reserved for special constructions: ones dedicated to Inshushinak (the *suhter* [interior chapel], a door of a temple of Inshushinak, and a door called "door of my god Inshushinak"); gates for the deities Kiririsha and Ishnikarab (along with Lakamar, divinities associated with the underworld);[3] and a temple for the goddess Beltiya (probably the Susian Inanna/Ishtar).[4]

Augmentation and reevaluation of the corpus of Elamite royal inscriptions, combined with analyses of known archaeological findspots, are increasing our understanding of the physical layout of the Ville Haute (the Acropole) so sacred to the Elamites (fig. 41).[5]

CENTRAL AND WESTERN ACROPOLE: THE TEMPLES OF NINHURSAG AND INSHUSHINAK

The best-known and best-preserved structures are the temples of Ninhursag and Inshushinak in the central and western parts of the mound, respectively. The temple to the goddess Ninhursag, dedicated by Shulgi in the third millennium, remained important throughout the Middle Elamite period.[6] It contained the massive, cast-bronze statue of Napir-Asu, wife of Untash-Napirisha, found in an upper level of the main sanctuary (No. 83),[7] as well as the bronze *sit-shamshi* sculpture inscribed by Shilhak-Inshushinak, found encased in plaster that, along with bricks, covered a tomb embedded in a wall (No. 87).[8]

The great temple dedicated to Inshushinak, chief god at Susa, was founded in the time of Shulgi and was constructed at the western edge of the tell. By the Middle Elamite period it was elevated above other Acropole buildings, and the majority of inscribed bricks in the renovated walls and floors date to the reigns. of Untash-Napirisha and Shilhak-Inshushinak.[9] While excavators give elaborate descriptions of some of the architectural details (crenelated roofs and polychrome inlaid terracotta wall knobs) that are hard to verify, they also mention glazed inscribed relief brickwork on the main doorways on the southeastern side of the temple of which we have examples.[10] This southeastern door could be the door of the temple of the god Inshushinak, mentioned in the inscriptions as dedicated by Shilhak-Inshushinak.

123

Figure 41. Site plan of the Acropole mound showing locations of major finds, by Suzanne Heim and Françoise Tallon

SOUTHERN ACROPOLE: THE VICINITY OF THE TEMPLE OF INSHUSHINAK

Important finds were uncovered in the area to the south of the temple of Inshushinak, including the celebrated rich deposits originally linked with the foundation of the temple (Morgan trenches 23–28).[11]

THE INSHUSHINAK DEPOSIT (*"Trouvaille de la statuette d'or,"* Morgan trench 27) (NOS. 89–99) This important group of objects includes gold, silver, and faience votary statuettes. The cache was found with animal bones on two rows of three glazed bricks each, on tightly packed earth.[12]

VAULTED TOMBS Near the edge of the tell (Morgan trench 7γ) and in the area of some of the deposits, a brick *massif* contained three corbel-vaulted tombs with human skeletons on bitumen beds. The fill had bricks, animal bones, sherds, and, most important, two glazed wall knobs of Shilhak-Inshushinak.[13]

COLUMNS AND LION SCULPTURES South of the temple of Inshushinak and in the midst of the area with tombs and deposits, an inscribed brick column erected by Shutruk-Nahhunte I and other fallen columns were uncovered. The pavements and the high, thick walls of the area were constructed of reused building materials inscribed by Untash-Napirisha, Shutruk-Nahhunte I,

Kutir-Nahhunte, and Shilhak-Inshushinak. The greatest number of *kudurrus* (boundary stones) were found in the debris here[14] as well as large-scale glazed terracotta lions, no doubt guardians of the Middle Elamite precinct of the Inshushinak temple.[15]

SOUTHWESTERN STRUCTURE

A very large but poorly preserved structure was excavated in the southwestern end of the Acropole (Morgan trenches 7γ through 15β). It had been reconstructed from numerous inscribed bricks of several Middle Elamite kings found just to the north of it. Here some of the famous Mesopotamian monuments taken by Shutruk-Nahhunte I as booty from his successful campaigns, broken and dragged from their locations elsewhere on the Acropole, were uncovered. The Elamite king rededicated several of these works to Inshushinak.[16] The monuments, ranging in date from the Akkadian period (Nos. 107, 109) through the second millennium, included many *kudurrus*, among them the elaborately carved one of Melishipak (Melishihu), king of Babylon (No. 115), whose daughter Shutruk-Nahhunte I appears to have married.[17] Elamite bronze monuments were also found in this area—an altar with figures holding flowing vases (fig. 12, p. 10) and a fragmentary relief with marching warrior gods.[18] The poorly preserved stele of Untash-Napirisha, which was originally dedicated by that ruler at Chogha Zanbil,[19] had been moved, perhaps by Shutruk-Nahhunte I, to this building as well (No. 80).

The large southwestern building can be related to other constructions associated with the column of Shutruk-Nahhunte I. Columns were found inside the larger rooms of the southwestern building (Morgan trenches 7 and 7α) along with great quantities of charred wood. Morgan likened this architecture, in its building techniques, to the Persian *apadana*.[20] These Elamite columned rooms and/or landscaped courts could be early prototypes for the Persian columned halls.

A number of important Elamite architectural elements of faience come from this southwestern building (most from Morgan trenches 7 and 7α): small blue, green, or white glazed bricks, either decorated or inscribed; molded, glazed bas-reliefs of draped human figures with bands of inscriptions; polychrome glazed wall plaques with checked patterns; and glazed, mushroom-shaped wall knobs, some with inscriptions of Shilhak-Inshushinak. Morgan wrote that the glazed bricks and wall knobs found together seem to have

decorated aediculas in the interior of the building[21] and that glazed bas-relief figures decorated the high, thick walls.[22] The excavators also found baked bricks with depictions in relief of humans and animals, which they said decorated such walls.[23]

Two steles probably erected on the Acropole by Shilhak-Inshushinak come from the southwestern building (the area of the last southernmost Morgan trenches 15α and β). They mention the construction of a *kumpum kiduia* (exterior sanctuary) and a *suhter* (interior chapel) among other Acropole structures dedicated to Inshushinak.[24] The two steles seem to be on the outskirts of the entire religious complex, as if at the entrance to the precinct. Archaeological and textual evidence of the Shutrukid dynasty suggests that the most probable site on the Acropole for the *kumpum kiduia* with its inner *suhter* is the large southwestern building. Glazed relief brick figures found here also have inscriptions mentioning the *kumpum kiduia* (fig. 13, p. 11). These figures have been interpreted as representations of the royal family at a doorway on the exterior of the *suhter*, the repository of royal images.[25] This doorway may have been the "door of my god Inshushinak" referred to in the texts. The *suhter* has been interpreted by Françoise Grillot as a chapel for a royal funerary cult within the exterior sanctuary (*kumpum kiduia*).[26] Unglazed, molded bricks carrying inscriptions also naming a *kumpum kiduia* were found in considerable number on the Apadana mound (No. 88); it is likely that they refer to another exterior sanctuary.

The southern tombs and deposits may have been related to the royal funerary cult function of the *suhter* and perhaps also associated with the secret, subterranean abode of Inshushinak (the *hashtu* hole or pit)[27] and his own funerary cult. The grove temples listed by Shilhak-Inshushinak on one of the two southern steles may also have played a role in the funerary rites connected with the god and his dwelling place.[28] The great quantities of charred wood found along with columns may be evidence for some of these temples. The characteristic Elamite system of aqueducts and cisterns for maintaining groves, seen here and elsewhere at Susa, was probably an integral part of the plans of these temples and other structures.[29]

NORTHERN ACROPOLE

At the northern end of the Acropole, Morgan trenches 3G and H13, 14, dug prior to the construction of the

modern excavators' chateau, revealed the charred remains of a very large Elamite building. Walls of baked brick some seven feet high formed numerous small rooms of a building that had been reconstructed incorporating many inscribed bricks of the Shutrukid kings and others. Here too, glazed, inscribed architectural faience bricks in different shapes were found, some decorated with parts of figures.[30]

SOUTHEASTERN ACROPOLE

In the southeast, at the edge of the tell (the junction of Morgan trenches 16 and 17), a small temple of blue-green glazed bricks 16½ feet (5.1 m) square was excavated. In addition to bricks of the Neo-Elamite kings Shutruk-Nahhunte II (716–699 B.C.) and his brother Hallushu (Hallutash)-Inshushinak (698–693 B.C.) carrying dedications to the god Inshushinak,[31] it contained other bricks, found reused in the walls, that were inscribed by Huteludush-Inshushinak (ca. 1120 B.C.), brother of Shilhak-Inshushinak.[32] Therefore the original construction was probably Middle Elamite in date. A mixed group of glazed architectural elements found nearby includes inscribed knobs of Shilhak-Inshushinak and glazed wall plaques inscribed by Shutruk-Nahhunte (most likely the first of the two kings) dedicated to the deity Ishnikarab.[33]

The remaining glazed bricks and reliefs found on the Acropole mound belong to monuments that are unidentified or cannot be located at this time. In their entirety, the remains found on the Acropole mound make the account of the destruction of Susa (ca. 646 B.C.) in the annals of the Assyrian conqueror Ashurbanipal all the more vivid: the ziggurat with blue-green glazed bricks torn down; the devastation of the royal tombs, both old and new; images of Inshushinak, the mysterious god who lived in a secret locale, and other gods taken to Assyria; the sacred groves, long closed to strangers, burned, their aura of secrecy and mystery shattered; and images of Mesopotamian gods that had previously been taken as booty restored to their homeland.[34]

APADANA

On the Apadana, northeast of the Achaemenid palace, a temple of Inshushinak was excavated along with Elamite burials that surrounded and later covered part of it. The structure, 66 feet (20 m) square, had, at least

at one end, a Middle Elamite wall (of which a 33-foot stretch was found) originally made up of inscribed terracotta relief bricks forming the representation of a frontal figure, a bull-man, and date palms (No. 88). A few bricks were found in situ, while others were discovered reused in aqueducts (some under the Achaemenid wall) and in later Achaemenid drains and walls.[35] These bricks have inscriptions of Kutir-Nahhunte and Shilhak-Inshushinak mentioning the *kumpum kiduia* (exterior sanctuary) of the god Inshushinak.[36] A few glazed relief bricks with figures were also found here.[37] These finds raise the question whether a *kumpum kiduia* was situated in this area.

VILLE ROYALE

As on the Apadana, several Elamite funerary mounds with remains of house and temple constructions in their midst were uncovered on the Ville Royale by Roland de Mecquenem. The burials doubtless extend over a long period of time, since the temples underwent reconstructions and were actually moved as the cemeteries grew.[38] Later excavations by Roman Ghirshman uncovered vaulted tombs containing funerary terracotta heads on the Ville Royale.

In the southwest Mecquenem reported finding a molded terracotta relief brick similar to the ones excavated on the Acropole and Apadana mounds. He used this evidence to identify a temple of Inshushinak in the area.[39] It is not clear, however, whether the brick comes from a wall or a cistern. It may have originally belonged to a Middle Elamite structure nearby, which would make that a third Middle Elamite temple dedicated to the chief god Inshushinak by Kutir-Nahhunte and Shilhak-Inshushinak.

The three main mounds at Susa—Acropole, Apadana, and Ville Royale—were clearly important locations for temples and sacred gates, as well as for tombs and funerary mounds. During the Middle Elamite period the Acropole and Apadana mounds were sites of major religious constructions, dating primarily to the reigns of Untash-Napirisha and rulers of the later Shutrukid dynasty.

SUZANNE HEIM

NOTES

1. Labat, 1975, pp. 389–93; Cameron, 1936, pp. 100–102.
2. Labat, 1975, pp. 487–88, 495–96; Françoise Grillot, 1983, pp. 13–14; Steve, 1968, pp. 291–94.
3. Grillot, 1983, pp. 21–23; idem, 1986, pp. 175, 179.

4. Steve, 1987, p. 33, no. 16.

5. Mecquenem, 1911a, pp. 65–78; idem, 1911b, pp. 38–55; Cameron, 1936, pp. 96–131 passim; Labat, 1975, pp. 497–99.

6. Labat, 1975, p. 497; Amiet, 1976c, pp. 50–52, figs. 12–13.

7. Amiet, 1976c, p. 52; Mecquenem, 1911b, pp. 46–47.

8. Mecquenem, 1911b, p. 47 (the excavator first thought that the findspot was secondary in a Parthian tomb built into a wall but later identified it as Elamite—see Amiet, 1976c, p. 52); Amiet, 1966, no. 297 (the location as intentional in the vault of an Elamite tomb); idem, 1988b, p. 107, no. 65; Elizabeth Carter in Carter and Stolper, 1984, pp. 166–67 (possibly as a "foundation deposit").

9. Labat, 1975, pp. 497–98; Mecquenem, 1911a, pp. 68–69; idem, 1911b, p. 41; Jacques de Morgan, "Temple of Susinak," *Harper's Monthly Magazine* 110, no. 660 (March, 1905), pp. 876, 878; Amiet, 1976c, pp. 48–50, fig. 11.

10. Mecquenem, 1911b, p. 41; Mecquenem and Pézard, 1911, p. 56; possibly also Morgan, 1905d, p. 878.

11. For the "foundation deposits": Morgan, 1905d, p. 880; Mecquenem, 1905a, pp. 61–130 passim. For funerary deposits/burials: Mecquenem, 1943–44, p. 141; Amiet, 1966, p. 390; idem, 1976c, pp. 50–51, 48, fig. 10 (plan); idem, 1988b, pp. 101–2.

12. Mecquenem, 1905b, passim; idem, 1980, p. 16; idem, 1943–44, p. 141; Amiet, 1966, pp. 416–21.

13. Jéquier, 1900, pp. 115–16, fig. 177.

14. Morgan, 1905e, passim; idem, 1905c, p. 138.

15. Lampre, 1905, pp. 164–65; Labat, 1975, p. 498; Mecquenem, 1980, p. 16; Amiet, 1966, no. 402; idem, 1988b, p. 106, no. 64.

16. Lampre, 1900, pp. 103–10, fig. 167; Jéquier, 1900, pp. 114–24, pl. 2 (plan of trenches); Mecquenem, 1911b, p. 50; Labat, 1975, pp. 498–99. For the Melishipak *kudurru*: Seidl, 1989, no. 32.

17. Steve and Vallat, 1989, pp. 226–29.

18. Lampre, 1900, p. 104, fig. 167A, B; Amiet, 1966, nos. 291, 305; idem, 1988b, pp. 97 no. 56, 108 no. 66.

19. Vallat, 1981, p. 32. For fragments found in Morgan trenches 7β and 15α, 1899–1902, see Jéquier, 1900, p. 124, pl. 3d; idem, 1905, pl. 1A.

20. Morgan, 1898, p. 50; idem, 1900b, p. 202241. For additional evidence for columns and construction techniques on the Acropole: Morgan, 1900a, p. 197, fig. 424; Mecquenem, 1911b, p. 73; Labat, 1975, p. 499. For other pre-Persian columned structures excavated in northwestern Iran (Hasanlu) and central western Iran (Godin Tepe, Nush-i Jan, and Baba Jan): Dyson, 1989, pp. 107–27; Muscarella, 1988, pp. 16, 19 n. 4, 207–8 especially n. 3.

21. Morgan, 1898, pp. 46–50; Heuzey, 1898, pp. 675–76; Morgan, 1900b, p. 202241; idem, 1900a, pp. 197–98; idem, 1902b, p. 164; also Lampre, 1900, pp. 103–10; Jéquier, 1905, pp. 38–39; Mecquenem, 1905a, p. 104.

22. Morgan, 1902b, p. 164.

23. Morgan, 1898, p. 48; idem, 1900a, pp. 197–98; idem, 1900b, p. 202241; Jéquier, 1905, pp. 38–39.

24. Jéquier, 1900, pp. 123–24; König, 1965, nos. 46–47 (steles nos. 1 and 2); Grillot, 1983, pp. 15–16, 19. For a different interpretation of the location of the sanctuary: M. Lambert, 1978, pp. 9–11.

25. Grillot, 1983, pp. 22–23.

26. Ibid., p. 11.

27. Ibid., p. 5; the *suhter* and *hashtu* are associated on stele no. 3 of Shilhak-Inshushinak: ibid., p. 11, and König, 1965, no. 48.

28. Grillot, 1983, p. 11.

29. Labat, 1975, pp. 496–97, especially p. 499.

30. Morgan, 1898, pp. 29–33, 76–77; idem, 1900b, p. 169; idem, 1900c, pp. 92–95, figs. 139 bis, 144; pp. 96–97, plan 2.

31. Jéquier, 1900, p. 128; Morgan, 1905a, pp. 34–35, fig. 66; Cameron, 1936, p. 163 n. 21; Steve, 1987, p. 50 n. 154.

32. Jéquier, 1905, p. 38; cf. Labat, 1975, p. 500 n. 3, and Cameron, 1936, p. 131.

33. Jéquier, 1900, pp. 126–27, fig. 295, pl. 6; Steve, 1987, p. 29, no. 11.

34. Cameron, 1936, pp. 205–7; Amiet, 1966, pp. 550–51 (with J. M. Aynard's translation of the Louvre prism AO 19939).

35. Mecquenem, 1920 ff. (*Rapport*), 1920–21, pp. 13–14, and 1923, p. 10; idem, 1922 ff. (*Journal*), March 24–30, 1922, and February 19–March 2, 1923, Susa excavations; idem, 1922, pp. 117–18, 127–29; idem, 1924, p. 115; Unvala, 1928, pp. 179–82; Mecquenem, 1947, pl. 2:3, pp. 14–15; idem, 1980, pp. 23–24 (1912–13, 1913–14 seasons), 28–29 (1921–23 seasons); Amiet, 1966, no. 299; Grillot, 1983, p. 21 n. 84; Carter and Stolper, 1984, p. 157, fig. 13 (plan).

36. Amiet (1988b, pp. 104–5) suggests that this building on the Apadana mound might be the *kumpum kiduia*.

37. Unvala, 1928, p. 181.

38. Mecquenem, 1943–44, p. 133, pl. 1 (plan).

39. Idem, 1920 ff. (*Rapport*), 1926, p. 17 (the *massif* near the eastern ravine excavation).

Stone Sculpture

80 STELE OF UNTASH-NAPIRISHA
Sandstone
Reconstructed H. 8 ft. 7⅛ in. (262 cm);
W. 31½ in. (80 cm)
Middle Elamite period, 14th century B.C.
Acropole; Sb 12

The stele of Untash-Napirisha[1] is an inscribed royal monument of major importance for the period of the Igi-halkid dynasty and is of particular interest because it adapts Mesopotamian religious imagery to depict Elamite mythology. It has been restored from five fragments found in the course of several excavation campaigns conducted between 1898 and 1909.[2] In 1916 Maurice Pézard[3] proposed the reconstruction illustrated here, with an arching summit and four registers separated by guilloche borders. An additional small piece showing a serpent-throne is in

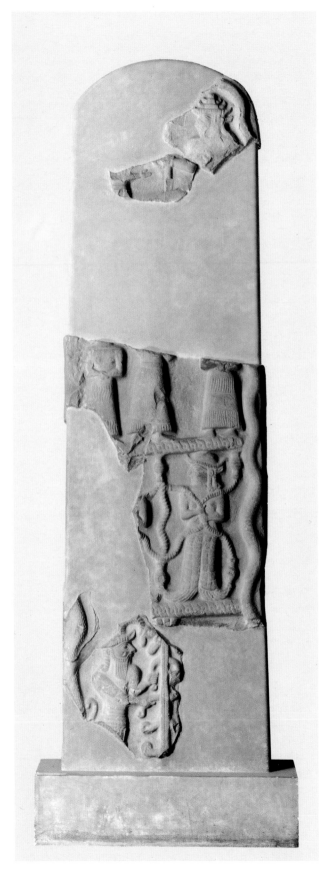

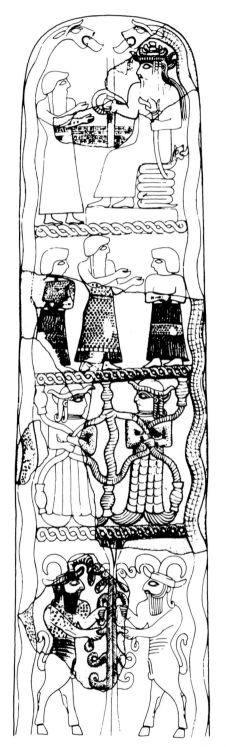

Figure 42. Reconstruction of the stele of Untash-Napirisha
by Pierre de Miroschedji

Upper register

one human and one animal ear—an unusual, Elamite feature.

Like the third register, the fourth register has a symmetrical composition. Two mouflon-men face each other on either side of a sacred tree, clasping its leaves. These mouflon-men can be regarded as a local adaptation of the Mesopotamian bull-man, and wear similar belts.[9]

Remains of two snakes coil up both sides of the stele, one covered with scales, the other with a dotted pattern. Their heads, as shown in the reconstruction, were probably identical to the fire-spitting horned serpent-dragons preserved in the upper register. In placement, they recall the contemporary bronze table with serpents running along the edges in a similar way (fig. 12, p. 10).[10]

storage at the Louvre.[4] Fragments of other similar steles are also known.[5]

The subject represented on the upper register, a king standing before a seated deity, is well known on Mesopotamian steles (fig. 44, p. 160, and No. 110). Depicted here are Untash-Napirisha, identified by an inscription on his arm, and the great Elamite god associated with snakes and flowing waters.

The drawing by Pierre de Miroschedji (fig. 42) attempts to reconstruct completely the iconography of the stele.[6] It shows the god seated on a serpent-throne of a type known from a free-standing example in the Louvre.[7] In one hand he holds the head of a fire-spitting horned serpent and in the other hand the traditional emblems of divine power, the rod and ring (here marked with two different snake-scale patterns). The god wears a multiple-horned crown. He has one human and one animal ear. A four-line Elamite inscription, now fragmentary, was placed between the two figures.

In the second register three figures are represented. From the names inscribed on their arms we know that the female behind the king is Napir-Asu, his queen, and the one in front of him is the priestess U-tik, believed by some scholars to be the king's mother.[8]

The third register depicts two minor goddesses with single-horned headdresses who grasp diverging cordlike streams of water springing from flowing vases that are at various places in the design. The two goddesses, their bodies covered with scales of two different sizes and ending in fishtails, recall Neo-Sumerian goddesses with flowing vases, but, like the god on the upper register, they each have

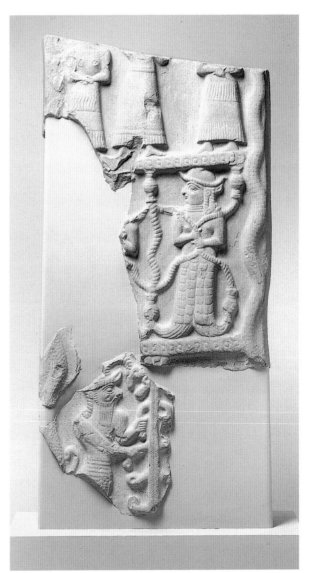

Lower registers

In the dedicatory inscription on the upper register, the king Untash-Napirisha prays that the god of *siyan kuk*, Inshushinak, grant him "a royalty and a dynasty of happiness."[11] *Siyan kuk* was the term used to designate the sacred precinct of the holy city of Chogha Zanbil built by Untash-Napirisha. François Vallat notes that the stele, like other monuments,[12] was originally set up at Chogha Zanbil and later brought to Susa. We also know that the Chogha Zanbil temenos underwent a change during the reign of Untash-Napirisha. At first limited to a large precinct with two temples dedicated to the god Inshushinak, the construction was later transformed into a ziggurat with a temple at the summit dedicated to both Inshushinak, the god of the Susiana plain, and Napirisha, god of the Elamite highlands (fig. 11, p. 9). The dedicatory inscription on the stele to a single god and the early spelling of his name suggest that the stele should be dated to the first phase of the Chogha Zanbil temenos.[13]

The iconography of the stele raises several points meriting discussion. A number of the god's attributes seem to be more evocative of the mountain god Napirisha than of Inshushinak, who is named in the inscription. In fact, the god with serpent and flowing water made its appearance on the rock reliefs in the highland region of Fars, at Naqsh-i Rustam and Kurangun (fig. 10, p. 9).[14] This deity, related to the Mesopotamian water god Enki/Ea, is the only Elamite god represented with specific attributes. Other deities of the Elamite pantheon, although designated by name, were never clearly differentiated in Elamite imagery. On the stele of Untash-Napirisha the great Elamite god is associated with Ea's traditional minions, fish-goddesses with flowing vases. However, the streams of water are depicted in a strange cordlike fashion, and they crisscross over the goddess's chest like the two snakes on a sculpture in the Louvre.[15] If the serpents and water motifs were interchangeable, it is possible that the snakes coiling up the sides of the stele are the equivalent of the waters of the *apsu*, that great liquid body encircling the world.[16] Ea also has nude heroes as acolytes. On the stele they appear to have been replaced by mouflon-men, who may be the equivalent of Mesopotamian bull-men, fantastic beings usually associated with the sun god in the art of Mesopotamia.

Thus the Elamites drew inspiration from Mesopotamian religious iconography but maintained a distinctive imagery of their own.

AB

1. See also Rostovtzeff, 1920, pp. 113–16; Contenau, 1931, vol. 2, pp. 908–12, figs. 626–28; Strommenger, 1964, pl. 181; Porada, 1965, p. 64, figs. 39, 40; Börker-Klähn, 1982, no. 124; Amiet, 1988b, pp. 93–94, figs. 53–54.
2. Lampre, 1900, pl. 3, fig. d; Jéquier, 1905, pl. 1, A; Toscanne, 1911, pl. 6, figs. 1–4.
3. Pézard, 1916, p. 120, fig. 1.
4. Toscanne, 1911, pl. 6, fig. 6.
5. See nos. 81, 82; Miroschedji, 1981a, pl. 9, figs. 1–3.
6. Miroschedji, 1981a, pl. 8.
7. Amiet, 1966, no. 286, A–C.
8. Pézard, 1916, p. 122.
9. For a representation of a Proto-Elamite mouflon-man, see the much earlier 4th-millennium copper sculpture in the Brooklyn Museum (Amiet, 1980a, fig. 26).
10. Amiet, 1966, no. 291.
11. Vallat, 1981, p. 28.
12. Vallat and Grillot, 1978, p. 82 n. 3.
13. Vallat, 1981, pp. 30–31.
14. Amiet, 1973b, p. 17.
15. Amiet, 1966, no. 289.
16. Amiet, 1980c, p. 151.

81 RELIEF FRAGMENT WITH HEAD OF A
SERPENT-DRAGON
Sandstone
H. 6½ in. (16.5 cm); W. 11⅝ in. (29.5 cm); D. 3 in.
(7.5 cm)
Middle Elamite period, 14th century B.C.
Sb 8559
Excavated by Mecquenem.

82 RELIEF FRAGMENT WITH HEAD OF A
SERPENT-DRAGON
Sandstone
H. 7¼ in. (18.4 cm); W. 9⅞ in. (25.1 cm); D. 4½ in.
(11.4 cm)
Middle Elamite period, 14th century B.C.
Sb 10294
Excavated by Morgan, 1898–1900.

These two stele fragments are carved with the heads of monstrous creatures, termed serpent-dragons.[1] Traces of their patterned, snaky bodies are preserved, and each head, seen in profile facing to the left or the right, is characterized by a gaping mouth with pointed teeth, a large eye, a textured horn curving forward, and a drooping ear more appropriate for a quadruped. This fantastic version of the venomous sidewinding horned snake (*Cerastes cornutus*)[2] lacks a forked or flaming tongue, but otherwise is paralleled on Middle Elamite representations of the divine

81

82

coiled-serpent throne (see entries for Nos. 76, 80).³ In the treatment of the horns and ears, the carving is similar to that of figures of the seated god and fish divinities on the Untash-Napirisha stele (No. 80). The divine couple represented on the Old Elamite (ca. 17th century B.C.) rock relief at Kurangun may also have animal ears (fig. 10, p. 9).⁴

The Elamite serpent-dragon, with a serpent body and features that exaggerate the appearance of the bulbous-headed horned *Cerastes* snake, is most often seen in Middle Elamite art but may have antecedents.⁵ On eastern Iranian seals of the Akkadian period in the late third millennium, snakes—some with bulbous heads—emerge from the shoulders or arms of a seated divinity (fig. 8, p. 7).⁶ The dragon with a snake's body differs considerably from Mesopotamian, Proto-Elamite, and also Central Asian dragons that are quadrupeds with leonine and ophidian characteristics and may also have the wings and claws of an eagle.⁷ On the impression of the seal of Kuk-Simut, an Elamite court official of the twentieth century B.C., the petitioner before the king holds an axe in the form of a horned(?), winged dragon (fig. 34, p. 107). The axe resembles an actual example found at Susa and thought to be an import from Central Asia.⁸ Images of both the serpent-dragon and the Central Asian dragon appear to have been potent symbols at Susa, used on an axe that may be a symbol of royal authority and also embodied in the serpentine throne of one of the supreme gods of the Elamite pantheon.⁹

The Untash-Napirisha stele (No. 80), a large monument, was reconstructed from five fragments found on the Susa Acropole. The fragments have no edges that match but are in an identical style and are convincingly related to one another by their guilloche borders and snaky frame. The two fragments of snake-dragon's heads, also in this style, lack addi-

tional features that would allow us to place them in a larger composition. Nevertheless, their head positions fit well with the reconstruction drawing of the heads surmounting the snaky bodies that frame the Untash-Napirisha stele. Indeed, the two fragments were originally thought to be part of this large monument.¹⁰ However, the fact that the dragon's heads are not quite the same size and the possibility that one is unfinished have led Pierre de Miroschedji to the conclusion that they come from two different steles.¹¹ This would mean that at least three steles executed in an identical style and probably with similar compositions were set up by Untash-Napirisha. Without a closer investigation of the shapes and material of these pieces and without information on their findspots, which were not clearly recorded, it is not possible to assess the matter further.

JA

1. Jéquier, 1900, p. 124, pl. 3b; Mecquenem, 1938b, p. 130, fig. 2.
2. *The Larousse Encyclopedia of Animal Life*, Robert Cushman Murphy, ed. (New York, 1967), p. 327.
3. Miroschedji, 1981a, pl. 9.
4. Seidl, 1986, fig. 2a.
5. Miroschedji (1981a, p. 4, pl. 2:4) notes that the divine serpent-throne in the Sukkalmah period has a human head, while later examples have serpent-dragon's heads.
6. Porada, 1988, pp. 139ff., pls. 1–4.
7. Van Buren, 1946, pp. 1–2.
8. Amiet, 1986a, p. 286, fig. 107. For western Central Asian representations of the dragon depicted as a quadruped, see Pittman, 1984, pp. 76–77, fig. 36.
9. See also the inscribed statue of a divinity holding two serpent-dragons: Miroschedji, 1981a, pp. 11–12, pl. 9:4.
10. Mecquenem, 1938b, p. 130, fig. 2. Börker-Klähn (1982, pp. 174–75, fig. 124d, e) notes a disparity in size between the two figures.
11. Miroschedji, 1981a, p. 11 and n. 38.

METAL, CLAY, AND IVORY SCULPTURE

83 STATUE OF QUEEN NAPIR-ASU
Bronze and copper
H. *50¾ in. (129 cm); W. 28¾ in. (73 cm)*
Middle Elamite period, 14th century B.C.
Acropole; Sb 2731
Excavated by Morgan, 1903.

Discovered in January, 1903 in the so-called Ninhur-sag temple on the Acropole of Susa, this life-size statue[1] represents Napir-Asu, the wife of Untash-Napirisha, who was one of the most important kings of Anshan and Susa in the Middle Elamite period and was responsible for the construction of Chogha Zanbil. Although the head and left arm of the statue are sadly missing, it remains an exceptional work on account of its size and the technique of its manufacture, which continues to astound modern scholars.

The queen wears a short-sleeved dress decorated with dotted circles; these probably represent embroidery work rather than appliquéd disks of precious metal, because the latter would have been bigger. The bottom of the skirt is flared and consists of long wavy fringes held in place at the top by a thin strip decorated with dots and triangles inside squares. As on almost all contemporary statues, the fringes must have been slightly raised in front to reveal the feet. The skirt seems to have wrapped around the body so that its outer edge, a wide band decorated with a geometrical embroidery pattern and fringed, runs down the front below the queen's hands.

This garment, which is identical to the one seen on a faience figurine excavated in the temple of the goddess Pinikir at Chogha Zanbil,[2] is worn with several more unusual accessories. A close-fitting shawl-like garment, of the same embroidered material as the dress, is wrapped around Napir-Asu's back and hugs her arm down to the elbow. It is held in place by a palmette-shaped clasp on her right shoulder and by a plain fibula at the middle of the upper arm. This curious garment is also worn by the praying queens seen on a glazed brick relief of the twelfth century B.C. that is inscribed with the name of Shilhak-Inshushinak and that apparently depicts the king, his wife, his father, and his brother.[3]

A second overgarment is a long flounce that covers the upper half of Napir-Asu's skirt in back and on the sides. Apparently made of fringes, it is suspended from a thin decorated strip at the waist analogous to the one above the bottom fringes of the skirt. The flounce has a straight edge on the queen's left side and a rounded contour on the right, and it is partially covered below her hands by a horizontal embroidered band similar to the wide vertical band described above. Protruding from this band on her right side is a triangular patch of long fringes. On the stele of Untash-Napirisha (No. 80), the queen and the priestess who flank the king are depicted wearing plainer flounces of this type that are not open in the front. Several terracotta figurines from Susa and Haft Tepe, which probably predate this statue, also have skirts partially covered by flounces with curved flaps crisscrossed in front. Unlike Napir-Asu's flounce, these are made of the same fabric as the rest of the clothing. The figurines also wear a shawl-like garment held to the dress by pins at the shoulders, although they cover only the figure's back and are not close-fitting.[4]

The queen wears a bracelet consisting of four plain bands on each wrist, and on her left ring finger a wide ring decorated with a chevron pattern on the flat middle part and a double ribbing on both edges. It is conceivable that she also had a necklace like the one that can be seen on her husband's stele, which has several rows of beads and a cruciform pendant of a type found in Kassite Babylonia. The statue's head probably resembled contemporary representations of female heads, which usually have fairly voluminous hairdos (see Nos. 84, 86).

An inscription on the front of the skirt is written in Elamite in the emphatic style typical for this type of text. In it the queen calls on the gods to protect her statue:

> I, Napir-Asu, wife of Untash-Napirisha. He who would seize my statue, who would smash it, who would destroy its inscription, who would erase my name, may he be smitten by the curse of Napirisha, of Kiririsha, and of Inshushinak, that his name shall become extinct, that his offspring be barren, that the forces of Beltiya, the great goddess, shall sweep down on him. This is Napir-Asu's offering. . . .[5]

Napir-Asu invokes the titular triad of the empire—Napirisha, the great god of Elam; Kiririsha, the great goddess; and Inshushinak, the god of Susa—as well as a deity referred to as Beltiya, or "My lady," a title that in Susiana seems to have been reserved for Ishtar, the goddess of love and also of war.[6]

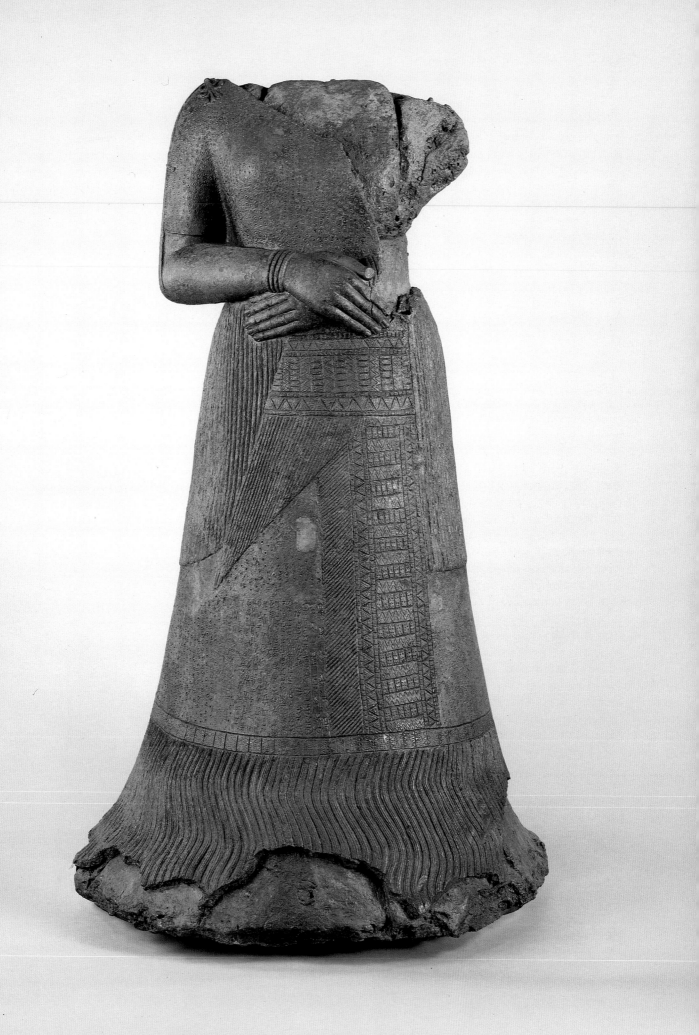

The statue, found in the temple, served to perpetuate the queen's prayer. The queen is represented standing, her right hand over her left in a gesture common to several depictions of high-ranking worshipers: the queen herself and the other female figure flanking the king on Untash-Napirisha's stele; the queens on the glazed brick relief of Shilhak-Inshushinak; the faience figurine from Chogha Zanbil mentioned above; and the king's companion on the Shikaft-i Salman relief that was usurped in the Neo-Elamite period by Hanni.[7] Napir-Asu's fingers are long and well modeled, with incisions to indicate the knuckles; but there is a certain clumsiness in the rendering of the left thumb, which is extremely long and flat.

Few statues of this size have come down to us, and even if a good number more were destroyed by pillage and reuse, it is likely that such works were quite exceptional. Of Untash-Napirisha himself we have only the bottom half of a white limestone statue, much smaller than Napir-Asu's and made of a simpler material (Louvre, Sb 62). We know, however, that this statue of the queen, of which 3,760 pounds (1750 kg) of metal remain, was not unique. It is one of a series of large Middle Elamite bronzes excavated at Susa that bear witness to the skill of the metalworkers of this period and to the might of the kingdom. Among the objects belonging to this series in the Louvre are a sizable bronze table adorned with snakes and busts of deities with flowing vases (fig. 12, p. 10)[8] and two impressive cylindrical objects of unknown use, one of them over 14 feet (4.36 m) in length and bearing an inscription of Shilhak-Inshushinak.

Already in the Akkadian period (2334–2154 B.C.) bronzeworkers of the Near East knew how to cast hollow statues of life-size proportions, and the technique is often seen on small-scale examples found at Susa dating to the Middle Elamite period. The choice of the manufacturing procedure used for this statue, however, is hard to understand. A copper outer shell seems to have been cast in the lost-wax method over a bronze core. Metal analysis shows that the core consists of an average of 11 percent tin and is extremely homogeneous throughout, which means that it was manufactured in a single casting. The outer shell contains about 1 percent tin, and it too is highly homogeneous. The copper here, however, contains higher proportions of lead, iron, silver, nickel, bismuth, and cobalt than the copper in the core. Copper core supports (drift pins) are still

clearly visible both on the uncovered part of the core and between the core and the outer shell.

Gammagraph analysis confirmed the solidity of the core and revealed the presence of a triangular stump under the intact shoulder symmetrical with the one that can be seen at the figure's left shoulder. The arm itself was solid cast with the rest of the outer shell. The head might also have been solid. The core is complete at the spot where the head was attached and contains remnants of a metal core support.

It is not clear why bronze was used for the core instead of the usual clay, but the technique was apparently specific to Susian bronzeworkers.[9] Indeed, this procedure was used on a smaller scale for the busts of deities on the serpent table, mentioned above, which is probably contemporary with the Napir-Asu statue.

The surface of the statue is executed with great care. Most of the details of the clothing were delineated in the wax, but the pointed dots, certain parts of the geometrical patterns, and the inscription were chased after casting. A vertical groove runs down the arm from the shoulder and along either side of

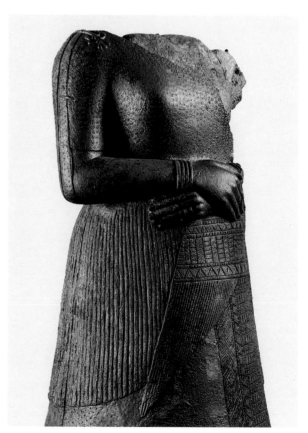

83, detail

the skirt from the waist down to the bottom flounce, where it follows the wavy line of the fringe. Grooves such as these were used on smaller sculptures to hold the edge of a sheet of precious metal plating. Here no trace of gold or silver has been detected, but one wonders whether the outer shell was made of a softer metal in order to facilitate the application of gold foil that has since disappeared.

In any event, study of the statue shows that every effort was made to produce an extraordinary monument. First, the use of such a large quantity of metal, especially bronze, is unusual. Analyses of small copper statuary from second-millennium Susa have demonstrated that tin was generally used sparingly.[10] The innovative technique and technical prowess of manufacture are also utterly exceptional. The metalworkers used a bronze alloyed with 10 percent tin, which permitted a practically flawless casting for an enormous amount of metal. Their second feat was casting the copper shell over this bronze core; nonalloyed copper is in fact extremely difficult to cast, but it is less brittle than bronze.

Thus the skill of the metalworkers reinforced the protection of the gods over this statue, a monument that both by its weight and by the type of metal used for its shell was made to last.[11]

FT

1. See Lampre, 1905, pp. 245–50, pls. 15–16; Frankfort, 1954, pl. 175; Porada, 1965, p. 61, fig. 37; Amiet, 1966, fig. 280; Spycket, 1981, pp. 313–14, pl. 204; Amiet, 1988b, p. 99, fig. 57.
2. Ghirshman, 1968, pl. 7, 1–3.
3. Amiet, 1988b, p. 105, fig. 63.
4. Amiet, 1966, fig. 245, A–B; Negahban, 1991, pl. 26, no. 184.
5. Translation based on that in König, 1965, pp. 69–71.
6. Steve, 1987, p. 33.
7. Louis Vanden Berghe, "Les reliefs élamites de Malamir," *IA* 3 (1963), pl. 24.
8. Amiet, 1966, fig. 291.
9. An alternate method has been suggested to me in which the original statue would have been cast in wax over a clay block core. Later the clay core would have been removed and the central cavity filled with bronze, which has a lower melting point than copper.
10. Tallon, Hurtel, and Drilhon, 1989.
11. The metal analyses were made at the Research Laboratory of the Musées de France by Loïc Hurtel, who helped me write the technical part of this entry. The surface decoration was studied by François Lemaire and Angélique Laurent, who restored the statue under the auspices of the Metal Archaeology Laboratory in Nancy.

FUNERARY HEADS

In a funerary practice peculiar to Susa, painted heads of unbaked clay were deposited in certain tombs, generally vaulted tombs containing collective burials. The first such heads were discovered by Roland de Mecquenem, who unearthed more than twenty of them between 1912 and 1939. The material was so fragile that adequate conservation was not always possible. Most of the heads that could be preserved were published by Pierre Amiet in *Elam.*[1] The one in the best condition and also the best known is a head of a bearded man with hair coiffed over his forehead in the Elamite style (Louvre, Sb 2836).

The heads are almost life-size. They were modeled in clay, probably at the time of death, and then painted; the eyes were made of terracotta or bitumen and set into the head. Sometimes all that remains of an otherwise ruined head is the eyes. At the bottom of the cylindrical neck there is frequently a hole that allowed the head to be set on a pole, perhaps to support it during the modeling process. A female head over eleven inches high was found on a skeleton buried directly in the earth. The head had been modeled around a terracotta vessel, the neck of which, encased in clay, served as a neck for the head.[2] The cheeks were painted yellow and the hair black.

We do not know why, among as many as twenty bodies buried in a collective tomb, only a few, male and female, had a painted head next to the skull. Roman Ghirshman found about a dozen such heads in several burial vaults.[3] The head of a woman catalogued here was discovered in a tomb containing fourteen skeletons and six clay heads. Only two heads could be saved; the other is male.[4]

Heads of polychromed unbaked clay were also found at the Middle Elamite site of Haft Tepe, situated midway between Susa and Chogha Zanbil, which was partially excavated between 1966 and 1968 by an Iranian mission under Ezat O. Negahban.[5] Two female heads and a mask, probably male, were discovered, not in tombs but in a workshop near the ziggurat. The elaborate female coiffures were held in place by painted headbands, yellow in imitation of gold and decorated with painted cabochons: white and black on one and white and yellow on the other. The eyes, circled with white, are inlaid. Negahban dated these heads, which are probably royal, to the middle of the second millennium B.C.

AS

1. Amiet, 1966, figs. 347–53, 362–64.
2. Roman Ghirshman, "Têtes funéraires en terre peinte des tombes élamites," *Festschrift Franz Hančar* (Vienna, 1962), pp. 149–51, pl. 14, 1–2.
3. Roman Ghirshman, "Suse, campagne de fouilles, 1962–1963, Rapport préliminaire," *AA* 10 (1964), pp. 9–10, figs. 21, 23, 24, and subsequent report in *AA* 11 (1965), p. 5, figs. 11–18; Ghirshman and Steve, 1966, p. 9, figs. 20–21.
4. Ghirshman and Steve, 1966, fig. 20.
5. Ezat O. Negahban, *Rahnemah-ye Muzeh va Hafari-ye Haft Tepe* (Guide to the Haft Tepe excavation and museum) (Teheran, 1351/1972), pp. 26–27 and figs. 42–44; idem, 1991, pp. 37–39 and frontispiece.

84 FEMALE FUNERARY HEAD

Painted unbaked clay, hand modeled; bitumen eyes
H. 6⅞ in. (17.5 cm); W. 6⅞ in. (17.5 cm);
D. 7½ in. (19 cm)
Middle Elamite period, ca. 1500–1000 B.C.
Sb 6767
Excavated by Ghirshman, 1964.

This head[1] was discovered in 1965 in a vaulted collective tomb constructed of baked bricks. Liquid paraffin was poured over the head to save it from destruction, but its original colors have practically disappeared. The yellow face is full, the inlaid bitumen compound eyes are wide open, and the brows, sculpted in relief, join at the bridge of the slightly hooked nose. Below the clearly delineated mouth is a dimpled chin. On each ear is an ornament painted red. The coiffure, set low over the forehead, consists of a short fringe and a heavy braid that frames the face and ends with a smooth lock holding the arrangement in front. Judging from the analogous coiffures on nude female figurines of the same era (compare No. 131), this appears to be a ready-made headdress rather than hair, even though it is painted black.

With its expressive and lifelike quality, this head is almost certainly an actual portrait of an Elamite lady from the second half of the second millennium B.C.

AS

1. Ghirshman and Steve, 1966, p. 26, fig. 21; Spycket, 1981, p. 316 n. 103, no. 206.

85 PAIR OF EYES

Clay; traces of bitumen
Each, H. ¾ in. (1.9 cm); W. 1¼ in. (3.1 cm);
D. ⅝ in. (1.5 cm)
Middle Elamite period, ca. 1500–1000 B.C.
Ville Royale, built tomb 4; Sb 19560
Excavated by Ghirshman, 1964.

This pair of eyes belonged to a funerary head of unbaked clay like Number 84.

AS

84

85

86

86 FEMALE HEAD
Elephant ivory(?)
H. 1⅜ in. (3.5 cm); W. 1 in. (2.6 cm);
D. ¾ in. (1.9 cm)
Middle Elamite period, ca. 1500–1000 B.C.
Sb 5638

This head,[1] the only preserved part of a statuette, is in the pure Susian tradition. The turbanlike head-dress placed over the wavy band of hair on the fore-head is found on other Elamite objects, such as the clay funerary heads (No. 84).[2] Also typically Elam-ite is the facial modeling—full, rounded cheeks and a flanged rim outlining the eyes. On the basis of its headdress, the head can be dated to the Middle Elamite period.

Although the material is difficult to identify be-cause of the head's poor state of preservation and its diminutive size, which makes it impossible to see the growth lines, it seems very likely that the head is of ivory.

AC

1. Amiet, 1966, no. 325; Spycket, 1981, p. 315, no. 101, pl. 207.
2. Amiet, 1966, no. 351.

87 MODEL, CALLED THE *SIT-SHAMSHI* (SUNRISE)
Bronze
L. 23⅝ in. (60 cm); W. 15¾ in. (40 cm)
Middle Elamite period, 12th century B.C.
Acropole; Sb 2743
Excavated by Morgan, 1904–5.

This three-dimensional representation of a cult scene[1] is especially interesting because it is the only example of its kind in the ancient Near East. The model bears an inscription from which we can date it and identify both the king who commissioned it and the ceremony represented. The inscription reads: "I, Shilhak-Inshushinak, son of Shutruk-Nahhunte, beloved servant of Inshushinak, king of Anzan and of Susa, enlarger of my kingdom, protec-tor of Elam, sovereign of the land of Elam, I have made a bronze sunrise [*sit-shamshi*]. . . ."[2]

The object's significance, however, is not clear to us, and its find context, which might have shed some light, is unfortunately not fully known. The model was discovered during the excavations conducted in 1904–5 in the northern part of the so-called Ninhursag temple on the Acropole. In 1909 the ex-cavator of this section, J.-E. Gautier, wrote that it had been found "at a shallow depth," embedded in a block of plaster and fitted into a wall construction of which only a few strata remained. The construction was apparently from a late period because the bricks set in with the plaster were datable to various eras.[3] Two years later Roland de Mecquenem stated that the *sit-shamshi* had been used, along with ordinary bricks, to cover a tomb made in a partially demol-ished wall; the vaulting had been made with bricks taken from that wall.[4] He dated the tomb to the Par-thian period, an attribution that corresponded to the details given by Gautier. Thirty-two years later Mecquenem reconsidered the attribution and dated the grave to the Elamite period.[5] The level given for the *sit-shamshi* was, according to the plan of the Acropole published in 1911,[6] less than a meter be-low the spot where the statue of Queen Napir-Asu (No. 83) was discovered. Thus the findspot informa-tion does not contradict Mecquenem's later hypothesis.

Study of the model itself has produced various interpretations. In the center of the scene, which

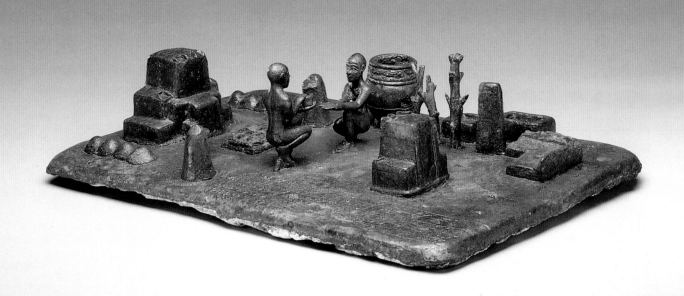

clearly takes place outdoors, are two nude men with shaved heads. Both are squatting; one stretches his hands out and the other seems about to pour water over them from a spouted vessel. The men are flanked by two quadrangular stepped structures. The higher structure has three levels and an element in the shape of a stairway rising to the second level on the side facing the men. On either side of this structure is a row of four conical piles, and in front is a low table with six rectangular depressions now visible. The table is in turn flanked by two conical pillars with a type of entablature at the top. The second stepped structure has two levels. Its long sides have bands in relief reminiscent of a door frame. Both structures have round depressions on the horizontal surfaces in the corners facing the men.

The remaining objects on the platform are: a large jar and two rectangular basins, cult accessories linked to water; a stele with a rounded top; an installation shaped in a right angle; and three trees. Opposite these, beyond the stepped two-level structure, the inscription is engraved.

The meaning of this unusual scene is obscure. If the model was deliberately buried in a Middle Elamite tomb, which, given its findspot in the heart of the sacred temenos, could only have been that of a king, it is legitimate to associate the ceremony represented with a royal funerary ritual, as a number of scholars have proposed.[7] On the other hand, nothing justifies this hypothesis if we are dealing with an artifact that was reused at a later date.

Père Vincent has related the installations on the

sit-shamshi model to Canaanite "high places."[8] These generally contained altars for sacrifices and libations; steles (*massebah*s); commemorative structures (*betyls*) symbolizing the venerated god; and sacred poles or trees (*asherim*) symbolizing the mother goddess.

Undeniably there were obvious similarities among all Near Eastern cult sites used for offerings or sacrifices to gods and requiring prior ritual washings. Yet some Canaanite cult accessories, although similar in appearance to the steles, pillars, and trees on the *sit-shamshi* model, appear to have been symbols of the deities rather than accessories. Thus it is more tempting to look at Babylonian and Elamite cult sites for parallels. One Iranian site in particular provides interesting analogies. At Chogha Zanbil (fig. 11, p. 9), twenty-five miles from Susa, on the southeastern esplanade of the ziggurat—where the sun rises—there was a series of cult installations. Two parallel rows of seven baked brick tables in the shape of truncated pyramids, each about ten inches (25 cm) high, were placed on a sloping pavement fitted with drains. An installation apparently used for libations was situated not far away. Nearby were three square offering tables made of brick, two platforms that may have served as stands for the seats of the king and queen, a large jar that still contained the remnants of two goblets, and the base of a lost stele. There was another brick offering table and a larger altar made of enameled brick close to the ziggurat. According to Ghirshman, who excavated this sacred city built by the king Untash-

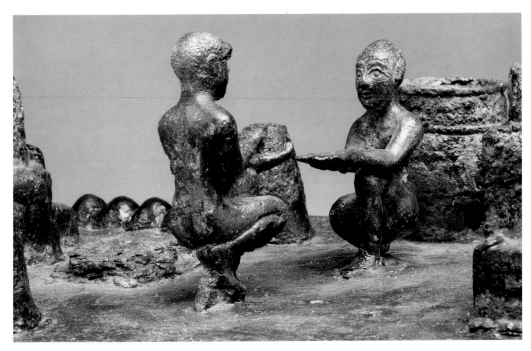

Detail

Napirisha in the fourteenth century B.C., these elements were used for open-air purification rites, offerings, sacrifices, and ritual cleansings.[9] We may therefore suggest that the *sit-shamshi* represents analogous installations in use at Susa two centuries later: here too one finds the two parallel rows of small pyramidal tables, the stele, the offering tables, perhaps the sacrificial altars, and the large jar for lustral water (the equivalent of the *apsu* of Babylonian sanctuaries and, incidentally, also of the brazen sea of the temple in Jerusalem).

The other accessories are also known to us, from artifacts or written references. Basins and steles were commonplace in Mesopotamian and Elamite temples. The Louvre has in its collection two rectangular stone basins excavated at Susa. One, inscribed with the name of Idaddu, prince of Susa at the very beginning of the second millennium, was dedicated in the temple of Inshushinak, the tutelary god of the city.[10] The other dates to the Middle Elamite period and is decorated with goatfish, the attribute of Ea, Mesopotamian god of the sweet water depths.[11]

The trees recall the many "grove temples" that Shilhak-Inshushinak had built in various locations of the kingdom; most of them were dedicated to Inshushinak. Other major deities of the Elamite pantheon also had such temples, for instance the goddess Kiririsha, mother of the gods, known as "Lady of life who has dominion over the grove." Sacred groves were a feature peculiar to the Elamite religion,[12] and this explains why Ashurbanipal, king of Assyria, was to boast during his conquest of Susa five centuries later that his soldiers profaned and destroyed by fire "the secret groves which no outsider had ever entered" (see No. 189).

The stepped structures are more difficult to interpret. If they are on the scale of the human figures they could be altars, the most probable hypothesis. Yet architectural and landscape elements on Near Eastern glyptic and reliefs are so often extremely small compared to the human figures that the discrepancy cannot be ascribed entirely to the artist's clumsiness in rendering perspective. Some scholars have proposed that the two structures on the model represent the two major temples on the Susa Acropole (the temple of Inshushinak and the temple of the great goddess);[13] or ziggurats;[14] or lastly, the high temple of Susa and perhaps the *kumpum kiduia* (exterior sanctuary).[15]

It is even more difficult to explain the function of the two pillars. There is a certain resemblance to a scene in relief on the bronze gate at Balawat, executed during the reign of the Assyrian king Shalmaneser III (858–824 B.C.).[16] It depicts an animal sacrifice conducted in the open air. There are four objects that look like boundary markers and seem to be the same size as the *sit-shamshi* pillars. A row of three or four small objects (indicated by circles) is

aligned with each post. Another parallel exists at Kul-i Farah near Malamir, on a rock carving that bears an inscription of the Neo-Elamite king Hanni. It depicts a sacrificial scene in which a priest pours a libation on a small pyre-shaped altar, above which are the bodies and severed heads of three rams; the altar appears to be about the same size as the *sit-shamshi* pillars.[17]

All of these considerations seem to indicate that this model represents a cult activity taking place at the break of day in which two persons, presumably priests, engage in ritual cleansing at the very spot where the day's sacrifices and libations will be carried out.

FT

1. See Gautier, 1909, pp. 41–49; idem, 1911, pp. 143–51; Porada, 1965, pp. 60–61, frontispiece; Amiet, 1966, pp. 392–93; Börker-Klähn, 1982, pp. 53, 175, no. 127.
2. Based on König, 1965, p. 136, no. 56.
3. Gautier, 1909, p. 41.
4. Mecquenem, 1911b, p. 47.
5. Mecquenem, 1943–44; idem, 1980, p. 17.
6. Mecquenem, 1911a, plan following p. 72.
7. Amiet, 1966, p. 392; Grillot, 1983, p. 12.
8. Vincent, 1948, pp. 253–55.
9. Ghirshman, 1966, pp. 72–82; Porada, 1965, p. 60.
10. Sb 18: Scheil, 1905, p. 16, pl. 5; Sollberger and Kupper, 1971, pp. 256–57.
11. Sb 19: Amiet, 1966, pp. 394–95.
12. Grillot, 1983, p. 4 n. 7, p. 11 n. 50.
13. Gautier, 1909.
14. Parrot, 1949, pp. 42–43; idem, 1957, pp. 79–83.
15. Grillot, 1983, p. 12.
16. King, 1915, pl. 59. Ghirshman (1966, p. 78) has pointed to parallels between the installations pictured on this relief and the ones he excavated at Chogha Zanbil.
17. Amiet, 1966, fig. 425.

TECHNICAL ANALYSIS

X-ray analysis[1] shows that the model consists of solid and hollow parts attached to the base (fig. 43). It also reveals a number of casting defects (i.e., porosity and bubbles). Visible on the underside are nine oval-shaped inlets where the metal was poured, symmetrically placed in relation to the median reinforcement line.

Some of the solid parts—the two pillars, the two rows of pyramidal tables, and the two basins—were cast with the base. The figures were solid cast separately and then locked into the base; the interlocking is clearly visible in relief on the underside. All these pieces were made using a bronze alloy containing an average of 2 percent tin.

The two altars, the jar, the table with depressions, and the installation in the form of a right angle were cast using a different bronze alloy, richer in tin (3.5 percent average) and with smaller proportions of trace elements (less iron, nickel, and cobalt), which means

Figure 43. Diagram of the *sit sham-shi* showing techniques of the metalwork manufacture, by Françoise Tallon

Cast with piece ◯

Added to piece ▧

Rivet heads ■ ▨

Hidden pins ●

Pour holes ⬝⬝⬝

Added support on reverse ‖ ‖

that a different copper was used. These segments are attached to the base by means of rivets. The altars and the jar are hollow. While the installation in the form of a right angle could be expected to be hollow because it is attached by rivets, X-ray analysis indicates that it might be solid. The table with depressions is made of two superimposed plates. The bottom one is attached to the base by rivets and the top one is pierced with holes.

The attachment mechanism used for the trees and the stele, all solid cast, was not elucidated by the X-ray analysis. The compositional analysis did show, however, that the trees are of an alloy similar to the one used for the parts attached by rivets.

There are fifteen or sixteen remnants of rivets attached to the upper surface. These are smaller than the ones used to hold the separate pieces to the base and are made of a bronze containing 2 to 3 percent tin, copper, and higher proportions of arsenic, nickel, and iron than the other rivets. The presence of these smaller rivets has yet to be explained.

It is interesting to note that the larger altar, of the same alloy as the separately made pieces, contains an exceptionally high proportion of silver (1.2 percent) and gold (.027 percent), perhaps evidence that it had a facing of precious metal, now lost.

FT & LH

1. The X-ray analysis was conducted by France Drilhon at the Research Laboratory of the Musées de France.

88 BRICK RELIEF WITH BULL-MAN, PALM TREE, AND FRONTAL FIGURE
Inscriptions of Shilhak-Inshushinak
Baked clay
H. *54 in. (137 cm); each panel, W. 14½ in. (37 cm)*
Middle Elamite period, 12th century B.C.
Apadana excavations east of the palace; Sb 14390, 14391 (old restoration), 19575, 19576, 19577
Excavated by Mecquenem, 1913–21.
(See Conservation Report, pp. 281–84.)

At Susa there is considerable evidence that molded bricks were used as a form of architectural decoration in the second and first millennia B.C. The finds from the Middle Elamite period (twelfth century B.C.) include decoratively modeled bricks, some of plain baked clay and some of a vitreous substance with a glazed surface. Regrettably, all of the Middle Elamite bricks, glazed and unglazed, were found out of context: the glazed bricks, which are relatively rare, were uncovered on the Acropole mound; and the unglazed bricks, from which this temple facade is reconstructed, were unearthed on the Ville Royale mound and the Apadana mound in an area east of the later Achaemenid palace.[1] The unglazed brick reliefs, many of them reused in the construction of a later aqueduct, were presumably intended for the decoration of the Middle Elamite building partially excavated on the Apadana mound by Roland de Mecquenem in the early decades of the twentieth century.

The new reconstruction of the bricks (Sb 19575–77) presented in this exhibition is based on the actual fragments that remain and differs from the panel displayed for years in the Louvre. On that panel the restored plaster head of the frontal figure was modeled on a glazed terracotta head found at the site that dates from the Neo-Elamite period (No. 147).

Across the surface of the molded bricks run inscriptions naming an Elamite king of the twelfth century, Shilhak-Inshushinak. In these inscriptions the ruler describes the restoration and reconstruction of the *kumpum kiduia* (exterior sanctuary) dedicated to the patron god of Susa, Inshushinak.[2] The largest number of bricks recovered during the excavations belong to the bull-man and the palm tree panels. Much scarcer are molded bricks depicting the frontal figure. Other unglazed bricks forming an abstract, zigzag design may also have had some place in the overall decorative scheme (see fig. 60, p. 282).

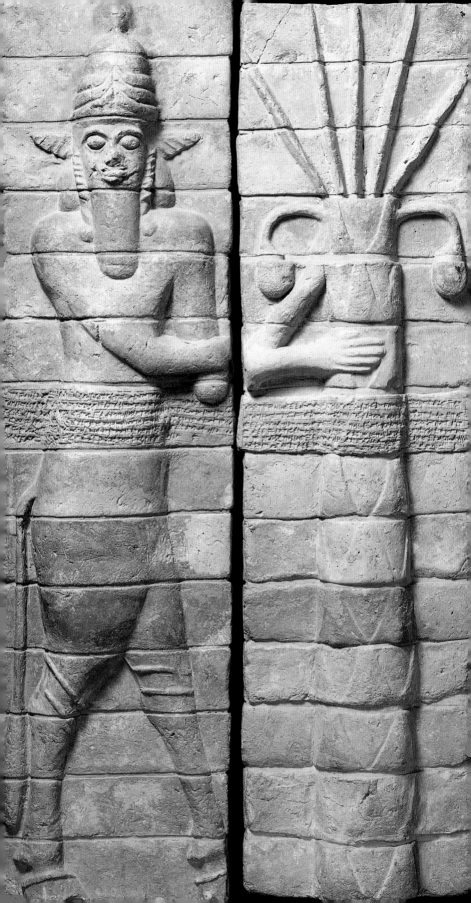

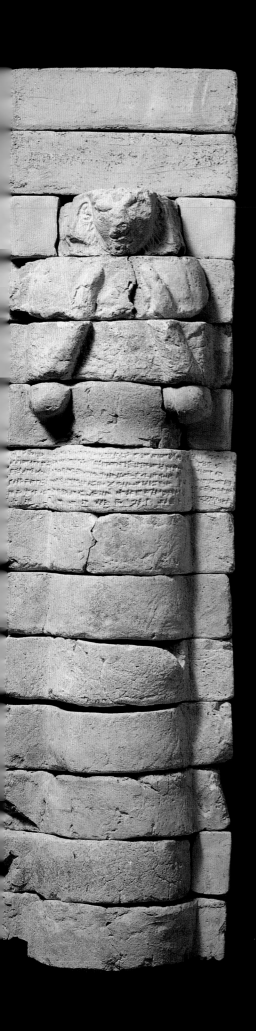

In spite of the disturbed contexts in which these bricks were discovered, it has proven possible to reconstruct in a convincing fashion the bull-man and the palm tree. More problematical is the frontal figure, since fragments of the head exist but there are none of the original headdress. At present this figure is accurately shown with arms raised in a gesture of supplication, a gesture that has led to the identification of the image as a representation of the goddess Lama or the Elamite equivalent of this Mesopotamian divine protector and intercessor for man before the greater gods.[3] However, because of the damaged condition and incomplete assortment of bricks that make up the figure, questions must remain concerning the identification of the image and the original appearance of the brick relief. The face of the figure is curiously foreshortened so that the head appears to bend forward in a position often seen on sculptures of humans during the Middle Elamite period (Nos. 89, 90).[4] In relief, projecting from the chin line, are short ridges that cannot be part of the hair falling from the head and are difficult to interpret except as a human beard or an animal ruff. Originally the image was called a sphinx, and it is possible that the figure may not be entirely human or female. In the first millennium B.C. the Lama (*lamassu*) figure underwent a transformation in the art of Mesopotamia and Syria, and the divinity took on the form of a human-headed bull.

In contrast to the mystery surrounding this enigmatic frontal image, the bull-man and palm tree are more standard in form and more reliably reconstructed. Rigid spikes surmount the palm trunk, a stylization, perhaps, of the natural curving branches or, alternatively, a reference to astral symbolism, since representations in other media often illustrate a star on top of the tree trunk.[5]

Prototypes for the use of molded-brick architectural decoration existed in Mesopotamia and Syria in the early and mid-second millennium B.C. A Kassite (fifteenth century B.C.) temple of the goddess Inanna at Uruk in southern Mesopotamia was decorated with unglazed brick images of frontal male and female divinities holding vases from which streams flow.[6] On this building the figures, which are on a scale comparable to the Susa reliefs, are sunk in niches so that the wall has a stepped surface, a possibility also for the Susa temple facade. At Tell Rimah, in western Mesopotamia, the facade of the main temple building of the early second millennium B.C. is decorated with bricks articulated as palm trunks,[7] a pattern that also appears on a con-

temporary temple building at Leilan in Syria.[8] Stone impost blocks of the early and mid-second millennium B.C. found at Tell Rimah, which were also used in the main temple building, display relief images of a striding bull-man between two palm fronds as well as a much damaged frontal figure who is placed between palm trees. The latter figure, about 23 inches (58 cm) in height, is thought to be a female because of the long skirt, but the head is defaced and eroded, and a positive identification is not possible. The figure has been variously identified as Lama and as a "Lady with Palms" associated with the realm of the Mesopotamian goddess Ishtar.[9] A large-scale molded terracotta relief of a bull-man and a doorpost, 23½ inches (60 cm) high, found at Ur in southern Mesopotamia in an early-second-millennium B.C. context (Larsa period), may also have been used in temple decoration.[10]

The association with sacred buildings of both a frontal figure and a bull-man wearing a horned headdress who holds a tree or doorpost is therefore widespread in the Near East during the second millennium B.C. These same motifs appear in both Mesopotamian and Syrian art on a smaller scale, on terracotta plaques and cylinder seals.

At present, the images on the Middle Elamite unglazed, molded bricks from Susa are probably best understood as representations of protective beings, whose appearance on the walls of the exterior sanctuary (*kumpum kiduia*) is noted in inscriptions. These benevolent divinities were watchful guardians of the sacred buildings and the royal family, whose images, the texts inform us, were sometimes placed in an interior chapel (*suhter*).

POH

1. Amiet, 1966, pp. 396–97, fig. 299; idem, 1976d, pp. 13–28; Mecquenem, 1922, pp. 127–30; idem, 1924, p. 115; Unvala, 1928, pp. 179–84; Mecquenem, 1947, pp. 13–14, pl. 1. As Suzanne Heim notes in her dissertation, there are references to the discovery of baked bricks with inscriptions and molded decoration on the Acropole mound, but whether these bricks belong to this same series is unclear: Heim, 1989, pp. 674–75.
2. Grillot, 1983, p. 13.
3. Spycket, 1960, pp. 73–84; Wiseman, 1960, pp. 166–71.
4. Amiet, 1966, pp. 418 fig. 318, 421 fig. 319, 458 fig. 350.
5. Danthine, 1937, pl. 85, figs. 571, 572.
6. Orthmann, 1975, Abb. 169, p. 295.
7. D. Oates, 1967, p. 80, pls. 33, 36; stone impost block p. 74, pl. 31a; Oates and Oates, 1991, pp. 134–35, pl. 4.
8. H. Weiss, "Tell Leilan on the Habur Plains of Syria," *Biblical Archaeologist* 48 (March 1985), pp. 11–13.
9. Howard-Carter, 1983, pp. 64–72.
10. Ibid., pl. 3b.

The "Trouvaille de la statuette d'or" from the Inshushinak Temple Precinct

*T*his cache of precious objects was found by Roland de Mecquenem on February 22, 1904, in the heart of the sacred area of Susa's Acropole.[1] It was situated slightly below a level of pavement often encountered during excavations and presumed to belong to the Middle Elamite level of the sector.

The objects were grouped closely together on a platform measuring about 38 by 25 inches (96 × 64 cm) and composed of two rows of three square bricks, each 12⅝ inches on a side and 2 inches thick (32 × 32 × 5 cm) covered with a very weathered green glaze. Mecquenem noted the presence of "tightly packed earth" (*terre pilée*) around and under the platform. Found with the objects were bones that Mecquenem surmised were those of a lamb or a goat and that he interpreted as remnants of a propitiatory sacrifice. He regarded this small cache as a deposit placed at the foundation level under a pavement that corresponded to the floor of a building. According to his plan of the Acropole,[2] the deposit was in front of the southern facade of the ziggurat, about midway between the so-called Ninhursag temple and the Inshushinak temple.

In addition to the objects exhibited here, which constitute the core of the deposit, there were five other statuettes in faience, a white limestone knob in the shape of a spool with a convex top and a slightly concave base, 4⅛ inches (10.6 cm) in diameter and 3⅛ inches (8 cm) high, and seventy-one carnelian and agate beads of varying shapes. With the exception of the knob, whose function is unknown, the deposit can essentially be divided into two categories: the statuettes of worshipers, and personal or votive items. Two of the eleven worshipers stand out from the others because of their material composition (gold and silver rather than faience) and their appearance (in particular the two-part beard and the special headdress sugges-

tive of royalty). These two statuettes may very well represent a single individual since they differ only in the metal employed, the portrayal of the animal offering, and the way the offering is held in the left hand. All the other statuettes of worshipers represent more ordinary people. They are beardless and their hair is arranged over the forehead in typical Elamite fashion; the skirts are rendered by a plain cylinder. Six of them hold a dove, while the other three have the left hand placed on the belt and the right on the chest.

The precious objects found with the worshipers include beads and pendants belonging to one or more sets of jewelry, a small figurine of a dove reminiscent of those held by some of the worshipers, and a whetstone(?) whose function remains unclear, since no other example of its type has been excavated at Susa, and no representation of such an object is known.

How can we interpret this cache of objects? Mecquenem based his original theory that it was a foundation deposit on several factors: the cache was situated in the center of the sacred quarter of Susa (in fact, at the foot of the ziggurat), slightly below the level of religious installations; it had been placed in a structure whose glazed-brick bottom was manufactured with particular care; and it included a group of votive statuettes, possibly royal, as well as rich offerings. Mecquenem later abandoned this theory without fully explaining the reasons for his change of mind, suggesting that the artifacts were the remnants of a funerary deposit from a vaulted tomb that had been looted.[3]

While the possibility that there was a royal necropolis on the Acropole in the time of Shilhak-Inshushinak (ca. 1150) cannot be discounted,[4] there are reasons to question Mecquenem's hypothesis about this deposit. First, the excavator made no mention in 1905 of a vault above the objects. Second, the artifacts do not correspond to the type of objects usu-

ally deposited in a burial site, and the block of bricks on which they rested, only about one yard long, seems too small for a tomb. Third, the Middle Elamite funerary complexes at Haft Tepe and Chogha Zanbil, dating to the fifteenth and fourteenth centuries B.C., include vaulted baked-brick tombs that are vast and deep. Such a tomb would have left more important remains than those found by Mecquenem on the Acropole, and the platform would have been much lower.

On the other hand, perhaps a clue to the purpose of this deposit can be found in Françoise Grillot's work,[5] which demonstrates that the temples of Susa in Shilhak-Inshushinak's time included several sites with specific functions; the *sit-shamshi* (No. 87) might illustrate one of these installations. In particular, there is a striking resemblance between the *trouvaille* and the objects deposited in *suhters*—that is, chapels intended for the royal funerary cult in which statues of the king, of living or deceased members of his family, and of protector gods were placed alongside precious objects. Indeed, the objects of our deposit seem more appropriate to a sanctuary than a tomb, even a royal one. It seems possible, then, that these objects, left by looters of the Acropole, originated in one of these cult sites, of which we know the Elamite names in some cases, but practically nothing else.

Be they funerary or sacred, these objects were almost certainly royal. An ordinary person could hardly have had access to so much precious material; nowhere else in Susa have excavations yielded statuettes of solid gold analogous to the one of the worshiper holding a young goat, and nowhere have blocks of lapis lazuli been discovered comparable in size to the one used for the dove. Finally, the bead inscribed with the name of a king of Babylon was probably part of the booty brought back to Susa by the Elamite kings Shutruk-Nahhunte and his sons and deposited in the temples. In that case, the deposit, if not all the objects in it, dates to the twelfth century B.C.

FRANÇOISE TALLON

NOTES

1. Mecquenem, 1905b, pp. 131–36.
2. Mecquenem, 1911a, p. 72.
3. Mecquenem, 1943–44, p. 141; idem, 1980, p. 16.
4. Amiet, 1966, p. 390; Carter and Stolper, 1984, p. 162 n. 345.
5. Grillot, 1983.

TWO STATUETTES OF OFFERING BEARERS

89 *Gold and copper*
 H. 3 in. (7.5 cm); W. 1⅜ in. (3.4 cm)
 Sb 2758

90 *Silver and copper*
 H. 3 in. (7.6 cm); W. 1⅜ in. (3.4 cm)
 Sb 2759
 Middle Elamite period, 12th century B.C.(?)
 Acropole, trench 27
 Excavated by Morgan, February 22, 1904.

The statuette in gold (No. 89)[1] is of a standing figure, his right hand raised in a typical gesture of prayer and his left hand holding against his waist a small horned animal, probably a young goat. The worshiper wears a skirt that is without visible seams or a vertical hem; the embroidery work is represented by a dotted pattern. The fringed border at the bottom of the garment is slightly raised in front to reveal the tips of the joined feet, a typical feature of Middle Elamite statues. The figures are usually barefoot, but this one wears shoes in the manner of royal figures depicted on a glazed brick bas-relief bearing an inscription of Shilhak-Inshushinak.[2] The skirt is held at the waist by a double belt.

The torso is apparently bare; it is clearly modeled in the back and has a star pattern incised on the front that is reminiscent of a motif representing the hair of the mouflon-men on the stele of Untash-Napirisha (No. 80). The figure has not only a mustache but also a beard, characteristic of sovereigns and deities, depicted in two sections with thick curls covering the cheeks and long waves descending from the chin. The hair, in the form of a checkered skullcap with a wide band over the forehead, is held in place by a thick twisted roll of hair. The pattern of squares on the hair is suggestive of a piece of material or a hairnet, and for this reason some scholars have compared these statues to a large male head in the Metropolitan Museum collection (fig. 49, p. 176).[3] That head antedates the statuettes by almost a millennium, however, and its Elamite background has not been ascertained. Furthermore, on the statuettes the upper part of the beard is also treated in a checkered pattern, suggesting that the design on the top of the head represents hair and not material.

The gold statuette, 2⅜ inches (6 cm) high without its base, contains 6.5 percent silver and 1 percent copper and is cast solid in the lost-wax process. An anchor-shaped tip at the bottom affixes the figure to the hollow, square base, which is of copper.[4]

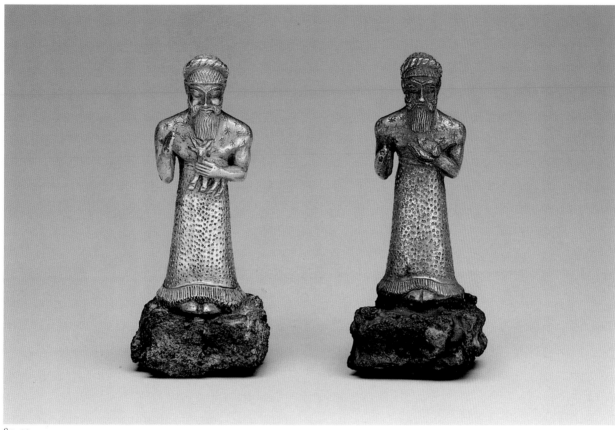

89, 90

The silver statuette[5] is identical to the gold one in all but a few details. It is slightly shorter and thinner, the band of hair on the forehead is narrower, and the figure holds a smaller recumbent animal in the palm of his left hand. Although the species cannot be identified, the animal may well be a quadruped, for its triangular head resembles that of the young goat held by the other figure. The statuette is cast solid like the gold one and is fixed to its base in a similar manner. The metal is silver alloyed with small amounts of gold, copper, and zinc.

These statuettes present the same basic characteristics as a relatively homogeneous group of bronze worshipers found in another deposit on the Acropole. Most of the bronze statuettes are similarly disposed, with the right hand raised and the left hand holding a quadruped or a bird as an offering. They too are generally portrayed bare-chested and wearing long skirts sometimes decorated with a dotted pattern. But unlike on our statuettes, the skirt is usually wrapped around the waist, it has a vertical hem, and there is a belt whose wide flap hangs down over the left hip. Some of the figures are bald; others have hair in typically Elamite fashion with a band

rising above the forehead. They are similarly small, but some are hollow cast.

The headdress and the beard are the two most important features that distinguish our statuettes from those of ordinary worshipers and point to their royal character. Unfortunately, few representations of Middle Elamite sovereigns have survived intact. The least fragmentary representation is of an Elamite king, identified by some scholars as Shutruk-Nahhunte I (1190–1155 B.C.), on an appropriated Kassite stele (No. 117). The beard is analogous but the headdress, which has only partially survived, is different: there is apparently no braid or coil of hair on top, and there are long side locks. The latter seem to be characteristic of royal coiffures of the period, inasmuch as they are also found on the glazed brick bas-relief, mentioned above, bearing an inscription of Shilhak-Inshushinak and representing the king along with members of his family.[6] On a chalcedony bead that Shilhak-Inshushinak gave to his daughter,[7] now in the British Museum, the king is bearded but his hair is worn in simple Elamite fashion with a band above the forehead and no braid (fig. 56, p. 258).

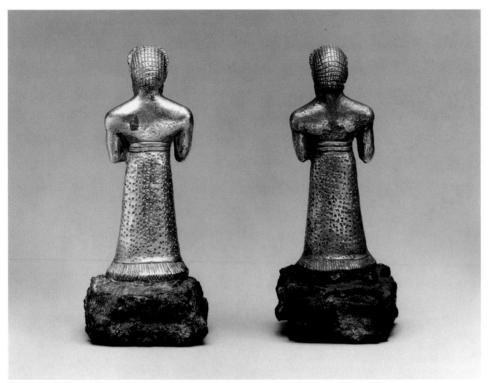

89, 90, back view

The representations of Untash-Napirisha that have been preserved show only the lower part of his body. On his stele (No. 80) he is dressed in the same manner as our statuettes, with a skirt decorated in a dotted pattern and bordered on the bottom by a row of fringe. On the statue in the Louvre (Sb 62) the same garment also has a vertical row of fringe. We can conclude, therefore, that our two statuettes are represented in garments that could apparently be worn by kings without being reserved exclusively for them, with beards that are specific to sovereigns and deities. As for the hairstyle, it is unique and does not correspond to any of the representations of the Shutrukids, who have side locks framing the face. While it is reminiscent of the hairstyle of third-millennium kings, the comparison is too distant to be conclusive. Nevertheless, it is certain that the two statuettes do not represent ordinary people, if only because of the material used. Gold statues were apparently extremely rare; they were always of kings or deities, always on a small scale, and even then the gold was usually only a plating over bronze.

Mesopotamian texts frequently mention the manufacture of royal statues, and it is known that kings used these occasions to designate the years of their reign. The texts usually specify the pose of the sovereign, the most common being as the bearer of a young goat. Sometimes two statues were made, such as "the two copper images of King Rim-Sin praying"[8] or the one in silver and one in gold of Samsuditana, last king of the first dynasty of Babylon.[9] It is conceivable, then, that our statuettes represent a single Middle Elamite king whose identity cannot be established. On the other hand, since we know that the Shutrukids deposited effigies of several sovereigns of the royal family in certain dynastic cult sites, it is equally possible that these statuettes represent two dynastic kings.

FT

1. Mecquenem, 1905b, p. 132, pl. 24:1; Porada, 1965, pp. 62–64, pl. 12; Amiet, 1966, fig. 319; Spycket, 1981, p. 309 n. 19, pl. 200.
2. Amiet, 1988b, p. 105, fig. 63.
3. Muscarella, 1988, pp. 368–74.
4. The statuettes were analyzed by the Research Laboratory of the Musées de France; the X-rays were done by France Drilhon and the X-ray fluorescence analysis by Alain Duval.
5. Mecquenem, 1905b, p. 133, pl. 24:2; Porada, 1965, pp. 62–64, pl. 12; Amiet, 1966, fig. 318; Spycket, 1981, p. 309 n. 19.
6. Amiet, 1988b, p. 105, fig. 63.
7. Sollberger, 1965, pp. 31–32.
8. Barrelet, 1974, p. 122.
9. Finkelstein, 1959, p. 47.

91 WHETSTONE WITH LION HEAD

Gold and schist
L. 6⅛ in. (15.5 cm); H. ¾ in. (1.8 cm)
Middle Elamite, 12th century B.C.(?)
Acropole, trench 27; Sb 2769
Excavated by Morgan, February 22, 1904.

This honing stone is circular in section and tapers off at the bottom.[1] The handle is in the shape of a stylized lion's head, with repoussé and chased decoration; behind the head is a band delicately decorated with filigree and granulation. A small rivet with a gold head held the stone in the handle. The stone itself bears no signs of use, and there are inexplicable traces of gold on it. It is undoubtedly a votive or ceremonial object and is unique in its genre at Susa.

Whetstones have long existed in the Near East. The earliest, without handles, are common in Mesopotamia and known at Susa. They are pierced with holes at the top to hold rings so that they could be attached to belts. One of the most precious examples of such a sharpening tool is the one in lapis lazuli with a gold ring found in the royal tomb of Meskalamdug at Ur.[2] Whetstones with zoomorphic handles appeared in the Early Iron Age at the end of the second millennium B.C.. Luristan has provided the most numerous and best known examples; the most ancient of these were found in the cemetery at Bard-i Bal and date from about the eleventh century B.C.[3] Elaborately decorated with animals cast in the round, they are the first examples of a type that became widespread in Iron Age II (ca. 1000–750 B.C.).

The Susa whetstone, more soberly decorated with the animal head a direct extension of the honing stone, belongs to a different type which also appeared in the last centuries of the second millennium B.C. For example, a similar tool with a ram's head handle, dating to the eleventh century B.C., was found at Sippar in Mesopotamia.[4] The hypothesis that this type dates back to the fourteenth century B.C. is supported by several finds. Two votive objects made of faience were discovered in chapel III of the enclosure wall of the ziggurat at Chogha Zanbil: a cylindrical ferrule or handle shaped like the head of a bird of prey and a fragmentary thick rod, quadrangular in section, with a ram's or mouflon's head. It is likely they were made in imitation of metal or stone objects, with the holes under the animals' heads probably holding rings that are now lost. Similarly, a faience imitation of a

91, detail

honing stone, this time with a gazelle's head, was excavated in the area known as the *palais hypogée* at Chogha Zanbil.[5] Neo-Assyrian reliefs show this type of whetstone worn in a sheath alongside a dagger.

Because of the delicacy of the gold work on this whetstone, comparable to that of contemporary Babylonian jewelry, Rachel Maxwell-Hyslop has suggested that the piece was made in Babylonia or crafted in Susa by a Babylonian artisan deported after the defeat of the last Kassite king, Enlil-nadin-ahhe (1157–1155 B.C.). This is a possible scenario. However, the whetstone was certainly manufactured during the Middle Elamite period, when Elamite metalwork was in its heyday, and therefore there is every reason to believe that it is the creation of a Susian goldsmith.

FT

1. Mecquenem, 1905b, p. 135, pl. 24:3; Porada, 1965, p. 64, pl. 12; Amiet, 1966, fig. 320; Maxwell-Hyslop, 1971, pp. 168–69, 187, pl. 128.
2. Woolley, 1934, p. 156, pl. 155:U. 10015.
3. Vanden Berghe, 1973b, pls. 17, 19.
4. Herzfeld, 1941, p. 138, fig. 253.
5. Ghirshman, 1966, p. 72, pls. 48:1c, 1a, 77:GTZ 439, 436; idem, 1968, p. 55, pls. 35:5, 82:GTZ 781.

92 WORSHIPER CARRYING A BIRD
Faience with traces of glazing
H. 3⅛ in. (8 cm); W. 1⅞ in. (4.9 cm)
Middle Elamite period, 12th century B.C.(?)
Acropole, trench 27; Sb 2899
Excavated by Morgan, February 22, 1904.

This upright figure wears a long skirt shaped like a plain cylinder and held at the waist by a belt with a wide flap hanging down in the front. It is unclear whether the torso is covered or naked. The hair is coiffed in Elamite fashion: in the back, three rows of curls fall down to the nape of the neck; on top, the hair is parted in the middle; and in front there is a thick band of hair over the forehead. The figure's left hand, supported by the right one, grips the feet of a bird that faces left. The bird's eye and feathers are indicated.[1]

FT

1. Mecquenem, 1905b, p. 133, pl. 23:5; Amiet, 1966, fig. 317:3; Spycket, 1981, p. 311 n. 87.

93 WORSHIPER
Faience with traces of glazing
H. 2¾ in. (7.1 cm); W. ⅞ in. (2.2 cm)
Middle Elamite period, 12th century B.C.(?)
Acropole, trench 27; Sb 6592
Excavated by Morgan, February 22, 1904.

Unlike the preceding worshiper figure (No. 92), this one carries no offering. His left hand touches his body at the waist, while his right hand is raised against his chest with one finger extended. The upper part of the garment has bordered edges and crosses in the back like the garment worn by the king on the Kassite stele brought back from Babylonia (No. 117). The hair is arranged in two rows of curls behind and a thick band over the forehead.[1]

FT

1. Mecquenem, 1905b, p. 133, pl. 23:6; Amiet, 1966, fig. 317:2; Spycket, 1981, pp. 311–12.

92, 94, 93, 95

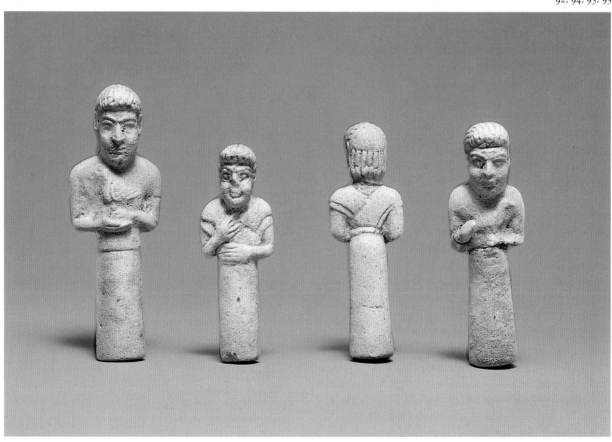

94 WORSHIPER
Faience with traces of glazing
H. 2⅜ *in. (6.2 cm);* W. *1 in. (2.4 cm)*
Middle Elamite period, 12th century B.C.*(?)*
Acropole, trench 27; Sb 2900
Excavated by Morgan, February 22, 1904.

This statuette is slightly smaller than the preceding figure (No. 93) but otherwise identical.[1]

FT

1. Mecquenem, 1905b, p. 133; Spycket, 1981, p. 311 n. 87.

95 WORSHIPER CARRYING A BIRD
Faience with traces of glazing
H. 2¾ *in. (7 cm);* W. ⅞ *in. (2.2 cm)*
Middle Elamite period, 12th century B.C.*(?)*
Acropole, trench 27; Sb 6593
Excavated by Morgan, February 22, 1904.

This worshiper resembles the two preceding ones (Nos. 93, 94) in posture, clothing, and hairstyle, but his right hand is raised away from his body and he grips the feet of a bird in his left hand.[1]

FT

1. Mecquenem, 1905b, p. 133, pl. 23:4; Amiet, 1966, fig. 317:1; Spycket, 1981, p. 311 n. 87.

96 DOVE
Lapis lazuli and gold
H. 1¾ *in. (4.5 cm);* L. 4½ *in. (11.5 cm)*
Middle Elamite period, 12th century B.C. *(?)*
Acropole, trench 27; Sb 2887
Excavated by Morgan, February 22, 1904.

Carved from a block of lapis lazuli and studded with gold, this dove was probably an offering made to a deity by a person of high rank.[1] It is reminiscent of the birds carried by several of the Susian worshiper figures in faience and bronze.

A separate beak and tail were held in place by means of bronze pegs, and a hole in the front of

96

the head shows where the now-missing beak was attached. (Mecquenem noted the presence in the deposit of two lapis lazuli fragments, perhaps remnants of the beak.) The wings jut out slightly and are incised to represent feathers. Three rows of gold studs adorn the base of the neck and the chest. Solid gold studs, ⅛ inch (.3 cm) thick and 3/16 inch (.45 cm) in diameter, are used to represent the eyes; the pupils are indicated by raised circles. The feet are not depicted, and a circular gold plate is inlaid on the underside where the feet would have been attached. Since the object is not freestanding, it is possible that it was meant to be held by a large statue.

Numerous faience figurines of birds, much smaller than this one, were dedicated in the temples of the goddesses Pinikir and Kiririsha at Chogha Zanbil. It is quite likely that this very beautiful dove was also made as an offering to a goddess.

FT

1. Mecquenem, 1905b, pp. 133–34, pl. 25:1–2; Amiet, 1966, fig. 332.

97 BULL'S HEAD PENDANT
Lapis lazuli and gold
H. ⅝ in. (1.5 cm); L. ¾ in. (1.8 cm)
Middle Elamite period, 12th century B.C. *(?)*
Acropole, trench 27; Sb 6589
Excavated by Morgan, February 22, 1904.

This small pendant is a fine example of animal art, in which realism is combined with elegantly stylized details, such as the zigzag pattern framing the head. The horns, which were separate and probably made of a different material, have disappeared. The suspension loop consists of a gold strip folded along the edges and curved to form a ring. It is attached to the head by means of a rod that is soldered to the loop and passes through a hole from the back of the head down to the base of the neck, where the rod is split in two and bent back on either side.[1]

FT

1. Mecquenem, 1905b, p. 134, pl. 13:12; Amiet, 1966, fig. 334.

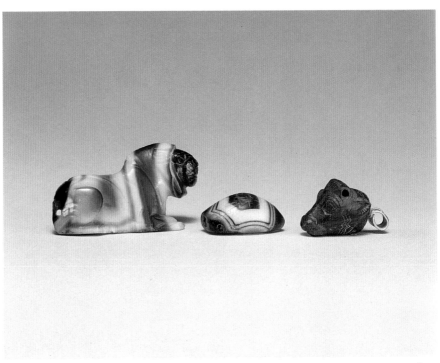

99, 98, 97

98 BEAD OF KURIGALZU
 Inscribed in Akkadian
 Agate
 H. ½ *in. (1.1 cm)*; L. *1 in. (2.4 cm)*
 Kassite period, 14th century B.C.
 Acropole, trench 27; Sb 6590
 Excavated by Morgan, February 22, 1904.

This bead, pierced lengthwise, is convex on the side
that was meant to be seen and flat in back.[1] It bears
the inscription: "To Ishtaran, Kurigalzu has dedi-
cated [this]." Ishtaran was the god of Der, a city
situated to the east of the Tigris River, between
Elam and Mesopotamia proper. The Kassite king
Kurigalzu II (1332–1308 B.C.) might have person-
ally deposited the jewel in a Susian temple at the
time of his conquest of Elam,[2] but it is more likely
that the bead was part of the booty brought back by
Shutruk-Nahhunte I and his sons and dedicated in
one of the sanctuaries of Susa. Two other artifacts
with inscriptions of Kurigalzu II were excavated at
Susa: a spool-shaped knob dedicated to Enlil and
probably originating in Nippur, and a fragment of a
statuette on which the king describes himself as the
one "who destroyed Susa and Elam, who ruined
Marhashi."[3]
 Agate beads were unusual during the Early
Dynastic period but became increasingly widespread
during the Akkadian period, when they were often
embellished with gold caps. Under the Third Dy-
nasty of Ur, agates were particularly popular and
were usually mounted in gold settings. The loveliest
of these were decorated with filigree, and sometimes
gold bands were added to the caps so that the bead
was surrounded by its mount. Kurigalzu's bead
bears traces of wear on the ends and along the sides,
perhaps indicating the existence of such a setting at
one time.
 Agate is a hard stone that can be given a beauti-
ful high polish and that seems to have been espe-
cially prized for the use that could be made of its
lovely natural patterns. The deposit contained an-
other agate bead, smaller than Kurigalzu's, carved in
the shape of a shell, with its stone bands imitating
the shell structure. From the Kassite period on, the
kings made votive offerings of agates with concentric
circular bands, known as ring or eye agates.
 The tradition of offering jewelry to statues of
deities is an extremely ancient one; it is well attested
in texts, and excavations have yielded many neck-

98, top view

laces of beads of gold, lapis lazuli, carnelian, and
agate, some of them bearing dedication inscriptions.

FT

1. Scheil, 1905, p. 30; Mecquenem, 1905b, p. 135.
2. The inscription does not mention the name of the king's father
 (as is usually the practice). It is possible that the bead be-
 longed instead to another, earlier king (ca. 1400–1375) who
 bore the same name.
3. Scheil, 1913, pp. 32–33; idem, *MDP* 28 (1939), pp. 11–12.

99 LION
 Agate
 H. *1 in. (2.5 cm)*; L. *1¾ in. (4.5 cm)*
 Middle Elamite period, 12th century B.C.*(?)*
 Acropole, trench 27; Sb 6591
 Excavated by Morgan, February 22, 1904.

This small recumbent lion is sculpted in low relief
except for its half-turned face, which is in high re-
lief.[1] Two holes pierced on a slant converge on the
back of the relief, one at the chest and the other at
the rump. These holes could not have been meant for
a necklace cord because they are pierced too low for
the lion to remain in an upright position while thus
suspended. Perhaps the lion is an inlay element,
which would explain why the back is completely flat
and the edges are not as highly polished as the rest
of the lion.

FT

1. Mecquenem, 1905b, p. 135, pl. 13:13; Amiet, 1966, fig. 333.

SMALL FINDS: SCULPTURES AND SEALS

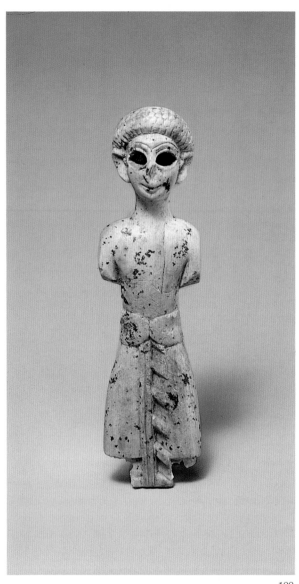

100

100 ARTICULATED FIGURE
Shell(?)
H. 4⅝ in. (11.8 cm); W. 1¼ in. (3.3 cm); D. 1 in.
(2.4 cm)
Middle Elamite period, ca. 1475–1100 B.C.
Ville Royale I, found in a jar containing various
objects of a deposit; Sb 2750
Excavated by Mecquenem, 1930.

Like the female statuette Number 59, this graceful figure[1] was long thought to be made of ivory, but its recent examination has revealed that it is more likely made of shell. Sculpting shell in the round is extremely difficult, and the work thus confirms the remarkable skill of Susian craftsmen.

The articulation of the separately made arms and legs was effected by means of joints fixed in mortises and held in place by rivets through two holes in the shoulders. The eyes were also separately made; the opening of the eye sockets is connected to a mortise cut vertically into the top of the head. The large rim of hair, covering the forehead like a turban, is apparently a feminine coiffure and has led to an interpretation of the figure as that of a young girl. No parallel is known for her clothing—a kilt, held at the waist by a wide belt, with a fringed vertical hem hanging between the legs.

The objects of the funerary deposit with which it was found, including many shells and jewelry made of stone beads, allow the figure to be attributed to the Middle Elamite period.

AC

1. Mecquenem, 1934, pl. 10:4–5, pp. 208–9; Amiet, 1966, no. 327; Spycket, 1981, p. 312, no. 91, fig. 78.

101 CART WITH LION

Bitumen compound and limestone
Lion: H. 1 in. (2.6 cm); L. 2½ in. (6.2 cm)
Cart: L. 3 in. (7.5 cm); W. 1⅜ in. (3.6 cm)
Middle Elamite period, 13th–12th century B.C.
Acropole, Inshushinak temple precinct; Sb 2905
Excavated by Morgan, 1904.

A limestone lion reclines upon a cart of bitumen compound.[1] The animal's features and exterior are reduced to a variety of decorative surface patterns. The hair of the mane is rendered in an arrangement of lozenge shapes, while the hair along the sides of the body is treated in a scalelike pattern. A ruff of long straight hair surrounds the face and the ears are abstracted into palmettelike shapes. A star pattern at each shoulder represents a swirling tuft of hair. The lion's eyes, which are round and hollow, must once have been inlaid with shell or semiprecious stones. The lion is joined to the cart by means of two tenons inserted into two holes placed in the middle of the cart. Four disk-shaped wheels are attached to the body of the cart by pegs.

ZB

1. Mecquenem, 1905a, pp. 99–100, pl. 25:3; Lampre, 1905, pp. 168–69; Amiet, 1966, fig. 329.

102 CART WITH HEDGEHOG

Bitumen compound and limestone
Hedgehog: H. 1⅛ in. (2.8 cm); L. 1⅝ in. (4 cm)
Cart: L. 2⅝ in. (6.8 cm); W. 2⅛ in. (5.5 cm)
Middle Elamite period, 13th–12th century B.C.
Acropole, Inshushinak temple precinct; Sb 2908
Excavated by Morgan, 1904.

The limestone hedgehog stands upright upon a cart of bitumen compound.[1] The animal is represented

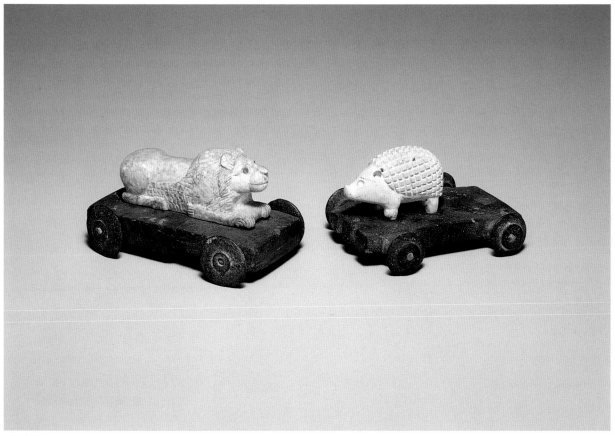

101, 102

with a minimum of detail. Its conical muzzle projects slightly upward and is flattened in front; the eyes are round and hollowed out to receive an inlay of another material. A pattern of rows of squares, carved in high relief, represents the animal's spiky bristles. Two holes are provided for inlay at the animal's neck, perhaps for the ears.

Four round depressions at the front of the cart hold the hedgehog securely in place. Eight similar but smaller depressions at the back of the cart indicate that two smaller animals must have once stood behind the hedgehog. A perforation at the front of the cart was used to attach a string for pulling the object.

The function of these animals on carts (see No. 101) is still disputed. They have been identified both as toys and as cult objects. The examples shown here were buried as part of a deposit in the temple of Inshushinak.[2]

ZB

1. Mecquenem, 1905a, p. 100, pl. 23:8; Amiet, 1966, fig. 330.
2. Mecquenem, 1905a, pp. 99–100. See Numbers 89–99, above, for another deposit from the same temple.

103 CYLINDER SEAL WITH WORSHIPER AND ALTAR WITH FLAMES
Faience
H. 1⅛ in. (2.7 cm); DIAM. ⅜ in. (.85 cm); string hole
1/16 in. (.2 cm)
Middle Elamite period, late 14th–13th century B.C.
Sb 6236
Excavated by Mecquenem.

Certain cylinder seals from Susa are related—both in their general style and in their depictions of ritual scenes—to the large number of seals, mainly of glass and faience, that were placed as votive offerings in the nearby sanctuary at Chogha Zanbil, an Elamite ritual center founded by Untash-Napirisha (1340–1300 B.C.). This seal, which has no recorded archaeological context,[1] depicts two figures in an outdoor setting, marked by a tree. One stands, wearing what seems to be a horned headdress and a long robe with a fringed lower border, and extends a branch toward a kneeling worshiper, apparently a nude male, whose arms are raised toward three curved lines resembling flames issuing from a vessel or lamp. Hatched horizontal borders frame the scene. The seal is carved in a simple style with clearly defined, sharply curved outlines, flat surfaces, deeply cut details, and drill marks defining the hair.

Examples from Chogha Zanbil depicting this ritual show clearly that the standing figure is a divinity. In one case the composition is more elaborate, bordered by rows of predatory birds and framed by an Akkadian inscription.[2] The inscription is re-

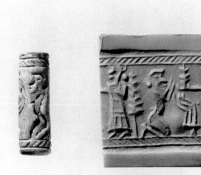

Modern impression 103

peated on fourteen cylinder seals from the site, most of them with banquet scenes interpreted by Edith Porada as court ceremonies. It reads: "It is for the god to [give] life, it is for the king to protect it; my god, I ask [or demand] of you."[3]

Porada noted in her study of the seals from Chogha Zanbil that a number of examples resemble the glyptic of early Kassite Mesopotamia, where we find parallels for the kneeling worshiper seen here.[4] Recent research by M.-J. Steve and François Vallat has revealed that the sanctuary was probably established in the second half of the fourteenth century B.C.; its founder, the Elamite king Untash-Napirisha, has been recognized as the son-in-law of the Kassite ruler Burnaburiash II (ca. 1359–1333 B.C.).[5]

The sanctuary contained a number of temples and chapels dedicated to Elamite and Mesopotamian deities; inscribed evidence suggests that one building was dedicated to the god of light, Nusku,[6] whose symbols also appear in Kassite art.[7] While there is no sure evidence of fire cults at that time, an emphasis on natural forces embodied in both vegetation and fire is manifest in the art and ritual of the Near East from the third millennium on.

JA

1. Mecquenem, 1927, p. 18, no. 37; Amiet, 1966, fig. 275; idem, 1972a, no. 2091; for another example see No. 149 in this catalogue, which has some stylistic similarities to this seal and may date to the late Middle Elamite period.
2. Porada, 1970, p. 34, nos. 30–32.
3. Translated from Akkadian to French as: "Il est au dieu de [donner] la vie, il est au roi de sauver; mon dieu, je te [le] demande" or "[mon] dieu exige de toi": Porada, 1970, p. 50; and E. Reiner, "Appendice: Légendes des cylindres," ibid., p. 134.
4. Porada, 1970, pp. 70ff.; see also idem, 1962, p. 48.
5. Steve and Vallat, 1989, pp. 226ff.
6. Steve, 1963, pp. 105ff.
7. Steve, 1962, p. 59; Seidl, 1989, pp. 129–30.

104 CYLINDER SEAL WITH CAPRIDS FLANKING A TREE

Bitumen compound
H. *1¼ in. (3.2 cm)*; DIAM. *½ in. (1.4 cm); string hole ⅛ in. (.3 cm)*
Middle Elamite period, ca. 13th–11th century B.C.
Sb 7392

As was noted in the discussion of Number 103, the glyptic arts of the Middle Elamite period at Susa reflect the close political ties between Elam and Kassite Babylonia. A striking manifestation of this connection is a seal from Susa that has parallels in Babylonia between the thirteenth and the eleventh century B.C., a time in which the Kassites were conquered by Elam and succeeded by the second dynasty of Isin. The glyptic art of this period has been characterized as late or post-Kassite.[1]

The seal, one of several similar seals, is engraved with a depiction of rampant animals before a stylized sacred tree.[2] Two caprids flank a central date-palm with five blossoms (or leaves?) in a heraldic composition. A small monkey sits between the caprids.

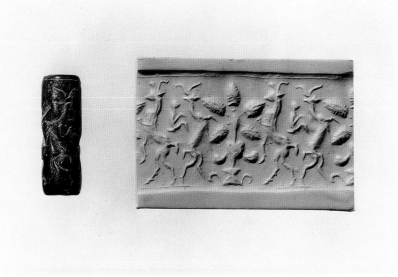

104 Modern impression

The slender caprids, with full chests and arched backs, are executed in a style characterized by strongly curving lines. They are closely related in appearance to the somewhat more ample figures of rampant bulls and goats with hatching on their bodies that flank trees on late-second-millennium Mesopotamian seals.[3] The tree on the seal from Susa, while lacking the ornamental quality of some Kassite examples,[4] shares their pointed oval leaves. It has two drooping blossoms and a triangular base with curving elements. Such trees also appear on bronze rings from Luristan that may date to the end of the second millennium B.C.[5]

The theme of animals flanking a stylized central tree is one of major importance in the art of the ancient Near East. It first occurs on Iranian seals in the Proto-Elamite period (see No. 45). The motif ap-pears during the Middle Elamite period at the sanc-tuary of Al Untash-Napirisha (Chogha Zanbil), on seals and on an ivory mosaic where a row of goats flanking ornamental trees is framed by an ornamen-tal border.[6]

JA

1. Trokay (1981, pp. 14ff.) reviews the problems surrounding this period. See also Boehmer, 1981, pp. 71ff.; Van Buren, 1954, pp. 1ff.
2. Amiet, 1972a, pl. 184, nos. 2121–23.
3. Collon, 1987, p. 60, no. 248; Beran, 1958, p. 275, fig. 28; Van Buren, 1954, p. 28, pl. 3, fig. 17; Trokay, 1981, pp. 14ff.
4. Trokay, 1981, fig. 3a–b, for an example with a curvilinear canopy prefiguring the trees in Neo-Assyrian art.
5. Porada, 1962, pp. 51–52, 76, fig. 47. For a discussion of this dating see Muscarella, 1988, pp. 132–33, fig. 210.
6. Porada, 1970, pp. 49–56, pl. 15:16.

THE MESOPOTAMIAN PRESENCE

Mesopotamian Monuments Found at Susa

With the publication of the first volume of the *Mémoires de la Délégation en Perse* in 1900 and then of six subsequent volumes between 1901 and 1905, a series of remarkable discoveries claimed the attention of the world. As the epigrapher Vincent Scheil wrote in 1902, Susa had proved, somewhat unexpectedly, to be an immensely rich source not only for the history of Iran but also for the history of Babylonia.[1] The French excavator Jacques de Morgan and his fellow workers had unearthed, in the early years of exploration on the Acropole mound, an extraordinary collection of Mesopotamian royal sculptures, victory monuments, and official records. The inscriptions on some of the works of art made it clear that the objects had been brought as booty to Susa from various cities in Mesopotamia plundered about 1158 B.C. by the victorious Elamite monarch Shutruk-Nahhunte I. As excavations proceeded at Susa, other objects executed in Mesopotamian style were unearthed—works that may have been made at the site during periods of Mesopotamian rule or that came as gifts or exchanges from Mesopotamia to Elam. In the absence of inscriptions and a meaningful archaeological context, it is not always possible to assign Mesopotamian works found at Susa to one or the other of these categories: booty, local production, or gift and exchange. The renowned "head of Hammurabi" (No. 113) for instance, is considered by some scholars to be part of the plunder brought to Susa from Babylonia by Elamite rulers, while others see in this sensitively rendered image the portrait of a Susian prince made by a craftsman working in a Mesopotamian style at the site.

Unquestionably the most impressive and significant Mesopotamian works of art are those booty objects that bear original Akkadian inscriptions naming the ruler who commissioned the work and the place where the monument was set up. Secondary inscriptions of the Elamite monarch Shutruk-Nahhunte occasionally name the vanquished enemy as well as the site from which the king carried off his prize. Into this class of objects falls the great victory stele of the Akkadian king Naram-Sin (2254–2218 B.C.), taken from Sippar in central Mesopotamia (No. 109). From Akkad, in the same region, Shutruk-Nahhunte brought the polished diorite[2] sculpture of the Akkadian king Manishtushu (No. 107).

According to the original Akkadian inscription, another famous Mesopotamian monument found at Susa, the Code of Laws of the Babylonian ruler Hammurabi (figs. 44, 45),[3] was erected at Sippar in the temple of the sun god Shamash. In this instance no secondary Elamite inscription exists to document the later history of the monument and to inform us of the circumstances under which it came to Susa. Only a smoothed area, perhaps intended to receive a later Elamite text, remains on the back of the stele.[4]

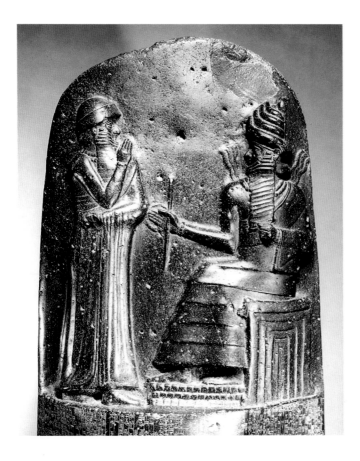

Figure 44. Detail showing the top of the Law Code stele of Hammurabi, found at Susa. Old Babylonian, ca. 1792–1750 B.C. Diorite; entire stele, H. 88½ in. (225 cm). Paris, Musée du Louvre, Sb 8

Figure 45 (below). Excavating the Law Code of Hammurabi during the 1901–2 season

The presence of the Akkadian inscriptions on some of the booty objects is evidence that defacement of the primary texts was not a standard policy of the Elamite conquerors. This hypothesis gains support from the text of Shutruk-Nahhunte's inscription on the victory stele of Naram-Sin. The Elamite king speaks of the monument and expressly states that he "protected it and . . . brought it to Elam." In fact, the original inscription, including the name of the Akkadian king, is still partly preserved. Other sculptures taken from Eshnunna in central Mesopotamia have suffered mutilation, and the Akkadian inscriptions have been almost completely removed, an act often attributed to Shutruk-Nahhunte. It is possible, however, that the defacement of the works occurred before the Elamite conqueror carried off his prizes to Susa, since the name of the ruler represented is omitted in the secondary Elamite inscriptions and may therefore have been unknown to the Elamite king (see No. 112). The condition of one of the Eshnunna sculptures found at Susa and of royal statues found at other Mesopotamian sites, such as Sippar and Larsa, testifies to recurring episodes of damage and mutilation. Holes for ancient repairs in the area where the head and hands were once reattached are proof that the royal sculptures were damaged on more than one occasion.

The Mesopotamian monuments set up at Susa in antiquity were both impressive and varied. Shutruk-Nahhunte and his son, Kutir-Nahhunte, are known from textual references to have taken objects not only from Sippar, Akkad, and Eshnunna, as the works in this exhibition demonstrate, but also from other sites in Mesopotamia—Dur Kurigalzu, Opis, and Babylon.[5] Moreover, Shutruk-Nahhunte gathered at Susa significant religious and dynastic monuments from cities within Elam as well, from Anshan and Chogha Zanbil (No. 80).

The history of the many Mesopotamian works of art that bear no Akkadian or Elamite inscriptions remains clouded. A stele surmounted by the image of a Mesopotamian ruler and a god (No. 110) was found, in part, in Morgan trench 7 on the Acropole mound. This trench and the ones adjacent to it were the source, in the early years of excavation at Susa, of many of the Mesopotamian booty monuments described above. The relief may therefore have been set up with the Mesopotamian spoils in the temple of the Elamite god Inshushinak, as the inscriptions on some of the other Mesopotamian works imply. But it is also conceivable that this official monument, possibly a law code, was erected at Susa when the city was under the control of the kings of Ur or some other Mesopotamian power.

As complex as the history of the Mesopotamian monuments before their arrival at Susa is the question of where they were installed when they reached the city. Because so many of the objects are among the earliest finds made at the site, the archaeological record is meager, and it is impossible to reconstruct their ancient setting with certainty. On the south side of the Acropole, Morgan and his colleagues dug tunnels and trenches into the mound with little attention to the ancient levels of occupation, whose significance they neither recognized nor investigated.[6] Descending into the mound in trenches each ninety meters long and five meters wide (295 × 16½ ft.)—Morgan trenches 7 and 7α—south of the temple of Inshushinak, they came upon remains of an extensive pavement and recorded the discovery of many of the major Mesopotamian works six to sixteen feet beneath the surface of the mound.

Were the Mesopotamian objects that Shutruk-Nahhunte claims in his inscriptions to have brought back to the glory of his god, Inshushinak, set up in a special location in a temple of this god? In Mesopotamia the great temple of the sun god, Shamash, at Sippar incorporated within its walls a similar treasure of ancient monuments, royal sculptures from different cities and lands, and Babylonian boundary stones.[7] Unfortunately, the record of the Sippar excavation is also inadequate. Hormuzd Rassam, who worked at the site on behalf of the British Museum, left only a plan of the great temple and little other relevant information. Where precisely he found the objects that subsequently entered the British Museum is for the most part unrecorded and unknown.

At other sites in Mesopotamia, notably Babylon and Nineveh, repositories for ancient objects and documents were located in palace areas. At Babylon a varied collection of antiquities gathered by the Neo-Babylonian kings was found in the area of the Northern Palace, or Principal Citadel.[8] At Nineveh the great library of Ashurbanipal (668–627 B.C.) was unearthed in the Northern Palace of Ashurbanipal and the Southwest Palace of Sennacherib. The tablets had been collected with care and design by the king, who claimed to have "arranged them in classes, revised them, and placed them in my palace so that I can read them."[9]

The term "museum" is often employed for such palace and temple collections, but this word in modern usage hardly reflects the meaning and significance that lay behind the search for and preservation of monuments and records. In the ancient Near Eastern

world both images and texts were believed to retain their power and relevance over the centuries. They were essential strands in the fabric of life, binding the past to the future and preserving evidence of divine sanction and authority.[10] In the ancient texts of Mesopotamia and Elam there are references to the seizure and transport of statues of gods and rulers from conquered cities. This was a bitter form of punishment, as the loss of the image of the city divinity represented "the inexorable disruption of the cult and implied the withdrawal of divine favors."[11] Similarly, the seizure of images of rulers and of official monuments signified a transfer of secular power and authority.

The present condition of the Mesopotamian monuments found at Susa is varied. Some works are relatively undamaged (the victory stele of Naram-Sin [No. 109], the Law Code of Hammurabi, certain Babylonian boundary stones [Nos. 115, 116]), while other objects were smashed and defaced (Akkadian victory monuments [Nos. 105, 106] and Babylonian boundary stones). As noted above, a few of the Mesopotamian pieces show signs of ancient repair and recarving, indicating a history of restoration, adaptation, and even, in some instances, mutilation while they were at Susa. A large share of the blame for the massive destruction of monuments and buildings at Susa generally falls on the Assyrian king Ashurbanipal, who counted among his enemies not only the Elamites but also the Babylonian rulers of southern Mesopotamia. The king boasts of his ravages of the site (646 B.C.) and graphically describes them in his palace reliefs and in his texts (see No. 189). However, Susa was destroyed and overrun at many other times before and after the reign of Ashurbanipal. Later, during the period of Seleucid Greek rule, some destruction of Achaemenid monuments may have occurred, and the French excavator Lampre suggested that it was the Greeks who contributed to the damage of many hard stone (diorite) sculptures (e.g., No. 111) by using these images, meaningless to them, as grinding stones on which to sharpen weapons or tools.[12] A final massive destruction of the city of Susa before the beginning of the Islamic era took place in the mid-fourth century A.D., when the Iranian Sasanian king Shapur II leveled the city after a revolt and "caused elephants to trample on the remains."[13]

The Mesopotamian works of art found at Susa provide important historical and art-historical information concerning both Mesopotamia and Elam, but they also raise a number of questions. In this respect they are a reflection of the complex history of Susa—an independent Elamite royal city, an occasional satellite of Mesopotamia, and, above all, a major cultural, political, and economic center on the plain of southwestern Iran.

PRUDENCE O. HARPER

NOTES

1. Scheil, 1902, p. 12.
2. Without analysis, diorite and gabbro cannot be distinguished. The term *diorite* is used in this catalogue.
3. [The correct name, historically and etymologically, is probably "Hammurapi," but "Hammurabi" has long been common usage, probably since antiquity.—MWS]
4. Morgan, 1905d, pp. 28–29; *MDP* 4 (1902), pp. 11–131. For a discussion of the extent of Babylonian control at Susa in the period of Hammurabi, see Carter and Stolper, 1984, pp. 30–31.
5. Carter and Stolper, 1984, p. 40.
6. Morgan, 1900c, pp. 100–110.
7. Walker and Collon, 1980, vol. 3, pp. 93–114, plan 3.
8. Koldewey, 1914, pp. 156–69; J. Oates, 1979, pp. 151–52, 162, figs. 82, 133. For a "museum" at Ur, see Woolley, 1962, p. 18.
9. Pallis, 1956, p. 724.
10. Cogan, 1974, pp. 22–41; Goossens, 1948, pp. 149–59; Hallo, 1983, pp. 1–17.
11. Hallo, 1983, p. 13.
12. Lampre, 1900, pp. 107, 108. This damage could as well have occurred in the later Parthian and Sasanian periods, when many of the monuments, some incorporated in walls, were still at hand. On gradual decay rather than violent destruction of the Achaemenid palaces, see Boucharlat, 1990a, pp. 225–33.
13. Richard N. Frye, "The Political History of Iran under the Sasanians," in E. Yarshater, ed., *The Cambridge History of Iran*, vol. 3:1 (Cambridge, 1983), p. 136.

105 FRAGMENT OF A VICTORY STELE
Diorite
H. 18⅛ in. (46 cm); W. 13¾ in. (35 cm)
Akkadian period, reign of Sargon, ca. 2300 B.C.
Acropole; Sb 3
Excavated by Morgan.

About 2340 B.C., Sargon of Akkad subjugated the old Sumerian-type cities and founded an empire. He commissioned an official art designed to exalt the imperial ideology; its predominant motif was the royal victory, illustrated on steles that were produced in series. Many of these were carried off to Susa by the Elamites twelve hundred years later. They were broken there by the Babylonians, ironically, during retaliatory campaigns at the end of the twelfth century.

Only a fragment of this stele survives.[1] An Akkadian warrior is pictured wearing a wide scarf that protects his chest and holding a weapon with a curved blade attached to a wooden handle. He pushes before him two prisoners, stripped of their clothing, whose hands are tied behind their backs. On what remains of an upper register we can see an enemy, who has been stabbed, falling at the feet of the conquerors. On the basis of style and subject we can attribute this fragment to a larger monument (fig. 46)[2] on which the king, Sargon, leads his army; his name is inscribed in front of his head. Above was a scene of the vanquished enemy being taken into captivity or massacred; only half of this register has survived.

The relief sculpture, unlike that of the preceding period, demonstrates a concern for realism that is manifested in the volumetric handling of anatomical features—still somewhat exaggerated, although to become less so subsequently. This artifact also illustrates mastery in the carving of diorite, a very hard stone imported by sea from a land called Magan in the texts, probably the Oman peninsula.

PA

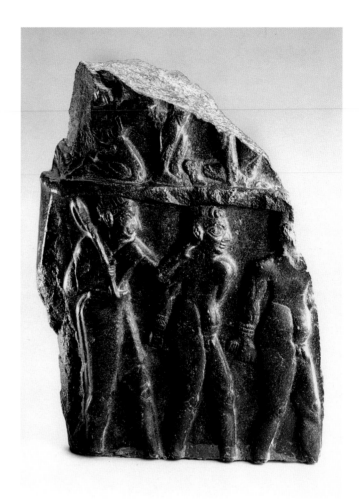

105

1. Jéquier, 1905, pp. 22–23, pl. 1B; Amiet, 1976b, pp. 11 fig. 6, 75 no. 5, 125 no. 5; Börker-Klähn, 1982, text: pp. 129–30, no. 20, plates: no. 20.
2. Amiet, 1976b, pp. 71–73 no. 1, 125 no. 1.

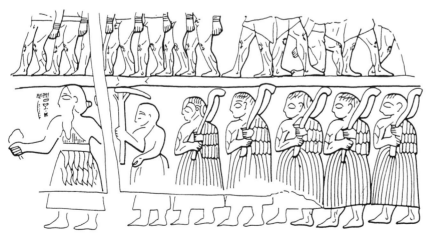

Figure 46. Drawing of fragments of a stele of Sargon I. Stele found on the Acropole mound, Susa; Akkadian, ca. 2334–2279 B.C. Diorite, H. 36 in. (91 cm). Paris, Musée du Louvre, Sb 1

106 FRAGMENT OF A VICTORY STELE
Diorite
H. 21½ in. (54.7 cm); W. 10¼ in. (26 cm)
Akkadian period, reign of Sargon, ca. 2300 B.C.
Acropole; Sb 2
Excavated by Morgan.

An ancient Sumerian theme, taken up much later in the Bible (Ezekiel 12:13), is depicted on this conical summit of a stele.[1] The king snares his enemies in a net, strikes their chief whose head juts out of the net, and dedicates their lives to Ishtar, the goddess of war (and, secondarily in this case, of love), who sits enthroned on a platform.

Little has survived of the king, who holds a mace, or of the goddess, adorned with curved weapons. This scene corresponds to an episode in the history of Sargon, transmitted to us by Assyrian sages: "Sargon . . . crushed their great army, [then] tied their possessions to them and declared: 'This is yours, Ishtar!'" The way the nude bodies of the vanquished enemies are stylized shows that this stele fragment and the preceding one (No. 105) belong to the same series. A few remnants of an inscription mention the god Aba, protector of the Akkadian monarchy.

PA

1. Nassouhi, 1924, pp. 70–72, figs. 5–7; Amiet, 1976b, pp. 12 fig. 7, 76 no. 6, 125 no. 6; Börker-Klähn, 1982, Text: p. 129, no. 19, Plates: no. 19.

106, two views

107 STATUE OF MANISHTUSHU

Diorite
H. *34⅝ in. (88 cm)*; W. *21⅝ in. (55 cm)*
Akkadian period, ca. 2260 B.C.
Acropole; Sb 47, hands Sb 9099
Excavated by Morgan; hands excavated by
Mecquenem, 1924

Manishtushu, the third king of Akkad, left a text in which he celebrates the maritime expedition he undertook and the diorite he brought back for his

sculptures. Thereafter, monumental statuary seems to have flourished, under the patronage of the king. From an Elamite inscription added in the twelfth century B.C. we know that this work was taken from the city of Akkad itself, whose location remains a mystery. The base of this statue probably had a scene like the one on a very similar statue showing the king trampling the corpses of enemies; thus, this statue too must have been a victory monument. A concern for realism finds expression in the unusually skillful rendering of the spiral folds of the garment

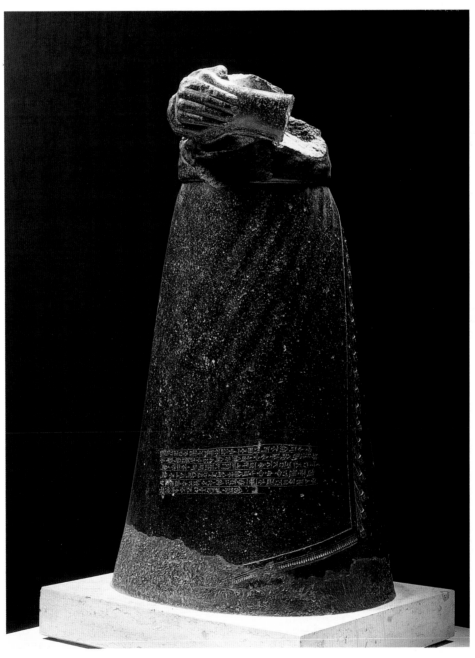

107, detail

and in the fluid, delicate treatment of the clasped hands.[1]

PA

1. Amiet, 1972c, pp. 99–103, figs. 2–4; idem, 1976b, pp. 19–20, 81, 126, no. 13; Spycket, 1981, pp. 151–52, pl. 100.

108 TRIBUTE BEARER

Diorite
H. 3⅞ in. (10 cm); W. 3⅞ in. (10 cm)
Akkadian period, ca. 2260 B.C.
Acropole; Sb 45
Excavated by Morgan.

This fragment from the carved base of a victory stele or a royal statue depicts a human figure carrying a footed cup.[1] Since the vessel is of a type char-

108

acteristic of the Indian Harappan civilization, the figure must be a foreign tribute bearer paying homage to the Akkadian king. The sculptural handling of anatomical features and the still awkward attempt to represent the bust in profile illustrate the concern with realism characteristic of the Akkadian period.

PA

1. Amiet, 1976b, pp. 24, 88, 127: no. 20.

109 VICTORY STELE OF NARAM-SIN

Limestone
H. 6 ft. 6¾ in. (200 cm); W. 41⅜ in. (105 cm)
Akkadian period, ca. 2254–2218 B.C.
Acropole; Sb 4
Excavated by Morgan, April 6, 1898.
(See the Conservation Report, pp. 285–86.)

The Elamite inscription added in the twelfth century B.C. states that this stele was taken from Sippar (to the north of Babylon), "protected" (instead of being destroyed as was customary), and "brought to the land of Elam," whose capital was Susa. The original inscription, which is fragmentary, describes the campaign of the deified Akkadian king Naram-Sin against the Lullubi mountain people. This subject is illustrated on the bas-relief in a scene centered around the monumental figure of the king, who wears the horned helmet symbolizing divine power. He is at the head of his army as they climb up the slopes of the mountain. The king tramples on the bodies of vanquished enemies while other prisoners beg for mercy. They wear animal hides like those worn much later in the same region by the Medes, who are represented in that garb on a relief from the period of Sargon of Assyria (721–705 B.C.).

The scene reproduces (or perhaps was the model for) scenes of the mythological combat of the young gods, patron-gods of the Akkadian kings, who hurl the vanquished gods into the depths of the mountain that symbolizes the netherworld. At the summit of the mountain shine at least three stars, symbols of the king's patron-gods. This grandiose scene thus unites all the episodes expressing the mythological and historical conceptions of kingship—usually elaborated in a series of registers—into a single comprehensive vision. The ascending composition and the sculptural quality of the figures characterize

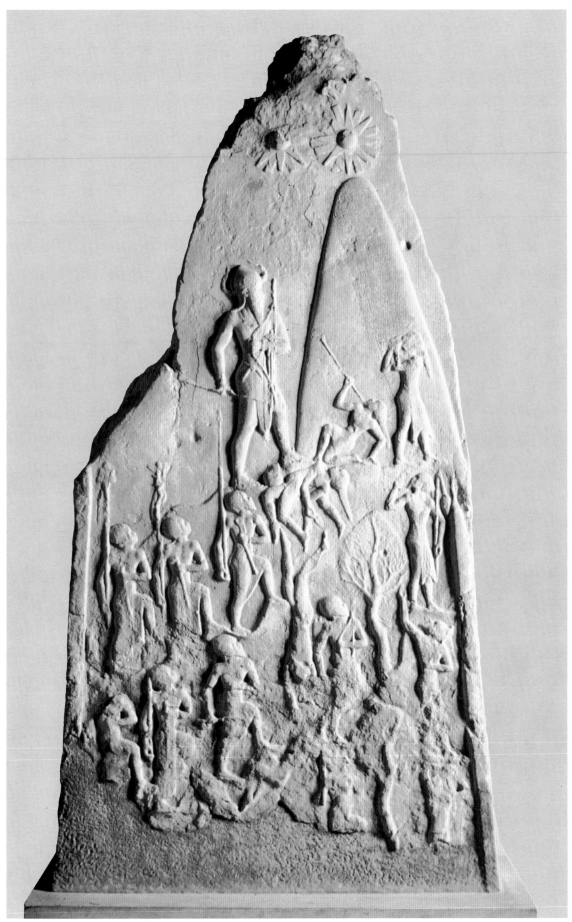

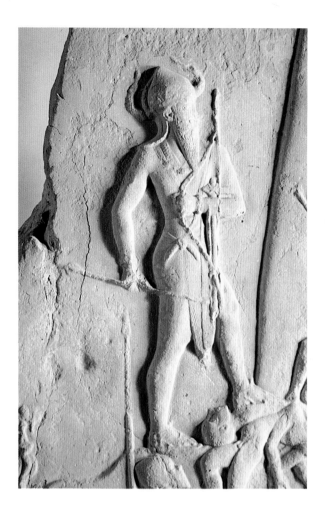

the finest works of art sponsored by the Akkadian monarchy.[1]

PA

1. Morgan, 1905d, pp. 106, 144ff., pl. 10; Amiet, 1976b, pp. 29–32, 93–95, 128, no. 27; Börker-Klähn, 1982, pp. 134–36, no. 26.

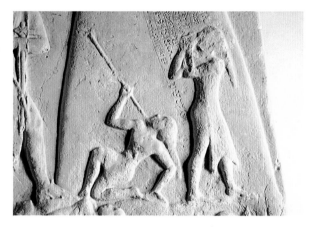

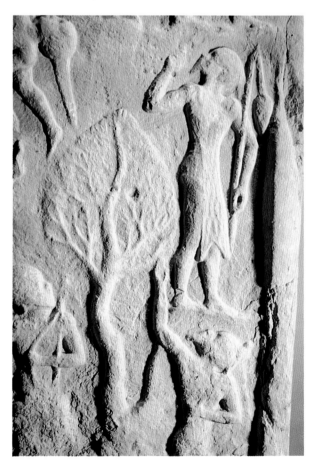

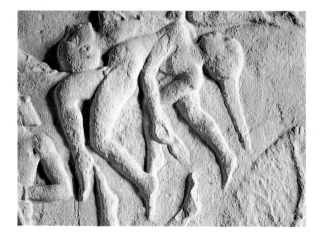

109, details

110 TOP OF A STELE WITH SCENE OF A LIBATION
BEFORE A GOD
White limestone
H. *26⅜ in. (67 cm)*; W. *24⅜ in. (62 cm)*
Late 3rd millennium B.C.
Acropole, trench 7 (lower fragment); Sb 7
Excavated by Morgan, 1898 (lower fragment).
(See the Conservation Report, pp. 286–87.)

This upper portion of a stele, reconstructed from pieces excavated at different times at Susa, is finely executed in a southern Mesopotamian style of the late third millennium B.C.[1] It is arched at the top and has vertical sides and a carved front surface. The back is rough and unfinished. Impurities in the limestone have left uneven holes in the surface, and a carved circular hole on the skirt of the seated god retains traces of lead. The lead held in place a stone plug, visible in the earliest photograph and still partially preserved.

On the front surface of the stele is a scene comparable to many representations in Mesopotamian art of the late third millennium B.C. The enthroned god, perhaps Shamash, facing to the left, holds in his right hand a rod and circlet. The god is approached by a male figure, probably a Mesopotamian ruler, whose head is now missing. In the right hand this figure holds a vessel with a long, almost vertical spout, from which a libation is poured onto an altar. A plant motif consisting of a palm frond and two clusters of dates rises from this altar.[2] At the summit of the stele is a representation of a disk on which there is a star with eight points alternating with eight groups of undulating rays. This form of the sun-disk motif has an exact parallel on the victory stele of Naram-Sin (No. 109), and it is similar but not identical to that of the disk carved on a cruder rock relief of Annubanini, a local king of the Lullubi tribe in southwestern Iran.[3] On all of these monuments the disk appears alone without the crescent moon below, an innovation that appears in the art of Mesopotamia at some point during the Ur III period (2112–2004 B.C.).[4]

The composition of the scene on the Susa stele resembles the imagery at the summit of the diorite Code of Laws of Hammurabi (ca. 1792–1750 B.C.) (fig. 44, p. 160).[5] However, the spacing of the figures on the limestone stele is open and uncrowded in spite of the inclusion of an additional element, the date-palm altar, which is not present on Hammurabi's monument. The elaborate temple-facade

throne on which the god sits is unusual in detail but is a common throne type on monuments dating from the late Akkadian period (ca. 2250) to the early second millennium B.C.[6] The curving terminals of the upper throne seat on the limestone stele are closer in form to throne supports on monuments dating to the Ur III period in Mesopotamia than to the throne of the god Shamash on the Old Babylonian Code of Laws of Hammurabi. On the stele found at Susa the dress of both figures and the crown of the god are shown full front, a common artistic device before the time of Hammurabi. The finely detailed, fringed garment of the god falls in registers over the body, and the layers of fleece are further divided vertically into bunches by open spaces that appear regularly between the groups of strands. As elaborate in detail as this garment (a type that appears commonly on works of the late third and early second millennia B.C.) but more unusual is one of the two necklaces worn by the god and partially covered by his long beard. Roundels, some perhaps beaded, alternating with narrow beads are strung around the neck.

The scene on the limestone stele is one that frequently appears on cylinder seals of the Early Dynastic (ca. 2900–2334 B.C.) through the Ur III period. It is considerably rarer in the following Old Babylonian period (ca. 1800–1600 B.C.). As Dominique Collon remarks, the iconographic motif of the ruler pouring a libation onto a date-palm altar before a deity is particularly common on cylinder seals found at Ur and also is found on seals from Tello (Girsu) in southern Mesopotamia.[7] Similar imagery appears on the great stone stele of Ur-Nammu (2112–2095) also found at Ur and now in Philadelphia (fig. 47).[8]

As only the upper part of the stele from Susa remains and there is no trace of an inscription, it is impossible to ascertain the original function of the piece or the identity of the ruler for whom it was made and of the god represented. In the art of Mesopotamia the scene of a ritual libation poured into a symbolic plant before a god reflects the role of the king as "maintainer of the fertility of the land," and the association of the king with the sun god, Shamash, on the Law Code of Hammurabi is a reference to the royal person as the administrator of justice.[9] In the Sumerian Law Code of Ur-Nammu, the role of the ruler is to "establish justice." The prologue to this early law code also mentions offerings made in the name of Ur-Nammu. This reference to a ritual

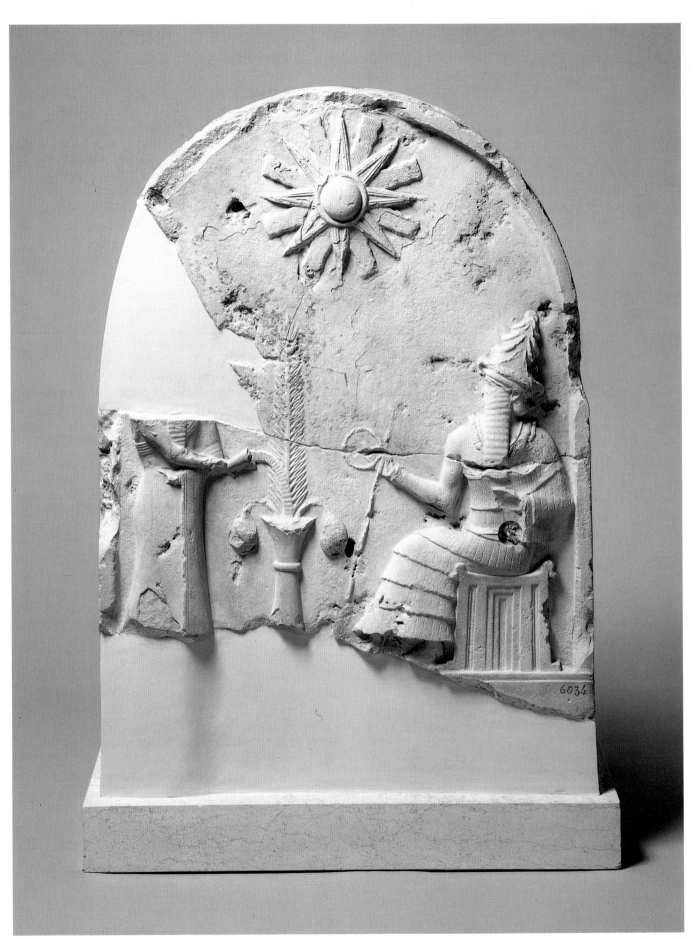

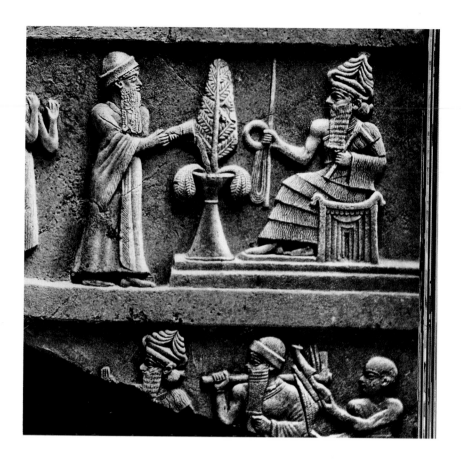

Figure 47. Detail of a stele depicting the Mesopotamian ruler Ur-Nammu pouring a libation before the god Nanna. Ur, Iraq, Ur III period, ca. 2112–2095 B.C. Limestone; entire stele, H. 9 ft. 11 in. (302 cm). Philadelphia, University Museum of Archaeology and Anthropology, University of Pennsylvania, B16676

act is absent in the prologue to Hammurabi's Code and, correspondingly, the image of the date-palm altar does not appear on that monument.[10]

In an inscription of the Elamite ruler Attahushu (ca. 1927 B.C.), mention is made of a "stele of justice" set up in the "market" at Susa.[11] If the enthroned god is indeed Shamash, the white limestone stele fragments found at Susa may be remains of such a code set up at Susa during an earlier period, by the kings of the Third Dynasty of Ur, when Susa was under Mesopotamian rule. Alternatively, this significant dynastic monument, which was found with other impressive Mesopotamian works of art in Morgan trench 7 on the Acropole mound, may have been booty carried off by an Elamite invader, perhaps Kindattu (ca. 2005 B.C.), who conquered Ur and was probably responsible for bringing Ibbi-Sin, the last king of the Third Dynasty of Ur, captive to Elam.[12]

POH

1. Morgan, 1900c, pl. 3; Pézard and Pottier, 1926, no. 7, p. 40, pl. 3; Börker-Klähn, 1982, no. 100, p. 161, pl. 100; Barrelet, 1974, p. 102, F. 109.
2. Danthine, 1937, pl. 78, no. 523.
3. Vanden Berghe, 1983, p. 21.
4. Collon, 1982, p. 132.
5. For a discussion of Babylonian and earlier law codes see Finkelstein, 1961, pp. 91–104.
6. Metzger, 1985, pp. 152–55, 170–72, 185–86, figs. 634, 635, 733, 734.
7. Collon, 1982, p. 139.
8. Winter, 1986, pl. 63.
9. Ibid., pp. 261, 264.
10. Seux, 1986, pp. 15–16; Kramer, 1983, pp. 453–56; idem, 1989, pp. 77–82. For texts describing a "considerable corpus of major representational sculpture" in the Ur III period, see Winter, 1987, pp. 69ff.
11. Scheil, 1939, pp. 4–7.
12. Carter and Stolper, 1984, p. 20.

111 STATUE OF A SEATED RULER
Inscribed in Akkadian and Elamite
Diorite
H. 35 in. (89 cm); W. 20½ in. (52 cm)
Late 3rd–early 2nd millennium B.C.
Sb 61

Brought to Susa from the city of Eshnunna in central Mesopotamia by the Elamite king Shutruk-Nahhunte about 1158 B.C., this substantial diorite figure of an enthroned Mesopotamian ruler retains only a trace of the original Akkadian inscription, which has largely been effaced. The secondary Elamite inscription, added by the conqueror, states:

> I am Shutruk-Nahhunte, son of Halludush-Inshushinak, king of Anshan and Susa, who has enlarged the realm, master of Elam, sovereign of the land of Elam. Inshushinak, my god, having granted it to me, I have destroyed Eshnunna; I have taken away from there the statue and I have brought it to the country of Elam. I have offered it to [placed it before] Inshushinak, my god.[1]

Among the images carried off from Eshnunna, this example is exceptionally large and is made of a prized stone, diorite, brought from a distant land.[2] These facts have led some scholars to suggest that the figure represents Hammurabi, the great ruler of Babylon (1792–1750 B.C.), who conquered Eshnunna and incorporated that state into his kingdom. However, attributions by scholars to this statue of another diorite fragment found at Susa and inscribed with the name of Hammurabi are inaccurate, as there is no break on the statue to accommodate the fragment.[3]

Some years ago Thorkild Jacobsen published a year name given by a ruler (*ishakku*) of Eshnunna, Ur-Ningizzida (early twentieth century B.C.): "The year in which a seated stone statue was made."[4] Although the seated figure referred to is, in Jacobsen's opinion, probably not the Susa diorite sculpture but rather a limestone statue (Sb 58) also found at Susa, the mention in a year name of the manufacture of such a statue is an indication of the significance of these royal images.

Missing from this sculpture are the head and parts of the feet, and the smoothed surface of the break at the neck implies extensive reuse of the sculpture at some time after the initial damage (see page 161). The seated ruler wears a plain togalike garment, which is wound around the body and leaves one shoulder bare. The seams of the garment are thickened and rounded but lack any other form of decoration. Jewelry includes a necklace and two bracelets. Strung on the strands of the necklace are two groups of triple beads rather than the more customary single set.[5] An elaborate bracelet on the right wrist is decorated with a stone.

Since the original Akkadian inscription has been largely obliterated, the identity of this figure and consequently the date of the statue are uncertain. Convincing art-historical arguments have been made for assigning this work to the end of the third millennium B.C., a period somewhat earlier than that of the other Eshnunna sculptures found at Susa.[6] In support of this early date is the form of the beard, in which the lower twisted locks are portrayed as short oblique lines rising from either side toward a central vertical line dividing the beard into two parts that are mirror images of each other. This method of depicting the lower locks of the beard has a parallel on an Akkadian copper head (ca. 2250 B.C.) found at Nineveh in northern Mesopotamia,[7] but on later monuments, of the early second millennium B.C., these curls are invariably defined by short lines that run down rather than up toward the central division.

The drapery worn by the figure lacks the elaborate tasseled fringes appearing on other, similar ruler images from Eshnunna, Larsa, and Nippur, but the chronological significance of this detail is uncertain, and the togalike garment was in general use both in Mesopotamia and at Susa in the latter part of the third and the early part of the second millennia B.C.[8] At present, a date for this monumental image in the late third millennium B.C., somewhat earlier than Hammurabi or Ur-Ningizzida, is probable if not certain.

POH

1. A single sign remains from an inscription earlier than the inscription of Shutruk-Nahhunte. In the Elamite inscription, only the first sign in the name *Eshnunna* is preserved. The word *statue* does not appear to have been followed by the name of a king (personal communications from Béatrice André-Salvini). This English text is based on the French translation by Françoise Grillot provided by Béatrice André-Salvini.
2. The source of diorite given in the ancient texts is Magan (Oman?); Amiet, 1976b, p. 18. For the availability of diorite in the central Zagros mountain region and in central Iran, see A. Schüller, *UVB* 19 (1963), cited by Seidl, 1989, p. 69.
3. A. Moortgat, 1969, p. 90, pl. 221; Pézard and Pottier, 1926, pp. 191–92, no. 463, and see also p. 62, no. 58; Barrelet

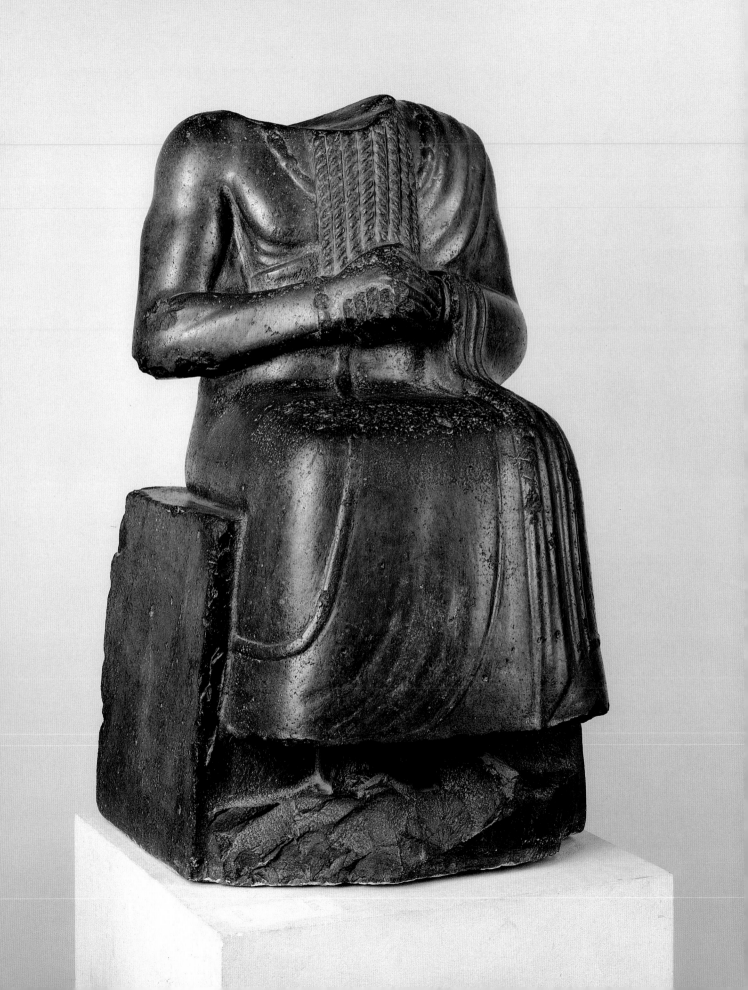

112

(1974, p. 106) questioned where the fragment might fit the statue.

4. Frankfort, Lloyd, and Jacobsen, 1940, p. 185, date formula 91; and see pp. 196–200 for the sequence of Eshnunna rulers in the late third and early second millennia B.C. See also William W. Hallo, "The Cultic Setting of Sumerian Poetry," in André Finet, ed., *Actes de la 17ᵉ Rencontre Assyriologique Internationale* (Brussels, 1970), pp. 116–34. I thank Holly Pittman for this reference.

5. The duplication of the triple set of stones on this statue and on another image from Eshnunna (Sb 58) may be an artistic device, as the beard covers the center of the necklace where the single group of triple beads usually appears (see No. 112). On a comparable statue from Nippur the artist has found a different solution and has simply rotated the necklace off center so that the single group of three beads appears over the right breast (see n. 8, below).

6. Schlossman, 1978–79, pp. 56–77. See also Spycket, 1981, p. 239.

7. Mallowan, 1936, pl. 6; Orthmann, 1975, no. 48.

8. For Nippur: Hilprecht, 1903, p. 385. For Larsa: Spycket, 1981, p. 239, pl. 164; Margueron, 1971, p. 280, pl. 17:1, 2.

112 STATUE OF A STANDING RULER
Inscribed in Akkadian and Elamite
Diorite
H. 24⅜ in. (62 cm); W. 10¼ in. (26 cm)
Early 2nd millennium B.C.
Sb 56

Of the group of statues carried off from Eshnunna in Mesopotamia to Susa by Shutruk-Nahhunte (ca. 1158 B.C.), this sensitive rendering of a standing male is perhaps the finest work of art.¹ A balance is maintained between modeled surfaces and linear decoration; the smooth, swelling muscles of the arms and the undulating surface of the drapery are complimented by the delicate linear rendering of the beard and the strands of the triple-beaded necklace and the bracelets. As is customary, the bracelet on the right wrist is the most elaborate in design.

The form of the beard, trimmed at the base in a curving line and lacking spiral curls, is without parallel on the other ruler images taken to Susa from Eshnunna. However, it also appears on sculptures made at Susa late in the third millennium B.C.² and in Mesopotamia and Syria in the late third and early second millennia B.C.³ A copper head of a ruler in The Metropolitan Museum of Art, made around 2000 B.C. probably in the region of western Iran bordering on Eshnunna (fig. 49, p. 176), displays the same naturalistic treatment of the beard curls.⁴

The original Akkadian inscription on the front of

the garment of this statue was almost completely effaced in antiquity, and a new Elamite inscription was added on the figure's right side by the Elamite king Shutruk-Nahhunte.[5] In this inscription the name of Eshnunna is given but not the name of the ruler who commissioned the image, which was later dedicated by Shutruk-Nahhunte to his god, Inshushinak. This omission may be an indication that the original Akkadian text had already been effaced before the statue was taken from Eshnunna (see p. 161).

POH

1. Scheil, 1905, pp. 12–13, pl. 3; Spycket, 1981, p. 238, pl. 162.
2. Amiet, 1976b, pp. 41, 108, figs. 56, 57 (Puzur-Inshushinak, ca. 2100 B.C.).
3. Amiet, 1980a, fig. 452 (20th–19th-century Ebla king Ibbit-Lim); see also an Akkadian sculpture from Assur: Orthmann, 1975, figs. 42a, b.
4. Accession no. 47.100.80; Orthmann, 1975, pl. 284, p. 381.
5. König, 1965, pp. 77–78, no. 24c; Scheil, 1905, p. 12, pl. 3. One curious feature of this inscription is the blank space where the name of the king might be expected to appear. Barrelet (1974, p. 108, F. 123) mistakenly attributes the inscription on Sb 57 to this sculpture, Sb 56. Similarly, Hallo (1961, p. 13) cites the illustration of Susa Sb 56 published in *MDP* 6, pl. 3, but then refers to the inscription quoted by Jacobsen, which in fact appears not on Sb 56 but on Sb 57. The only remains of the Akkadian inscription are a few "unreadable signs" (personal communication from Béatrice André-Salvini).

113 HEAD OF A RULER
Diorite
H. 5⅞ in. (15 cm); W. 4⅞ in. (12.5 cm)
Early 2nd millennium B.C.
Sb 95

One of the better known sculptures from the ancient Near Eastern world is this head of a man portrayed in the fashion of Mesopotamian rulers of the late third and early second millennia B.C. Identified by many scholars, including the late Henri Frankfort, a pioneer historian of ancient Near Eastern art, as a work of the Old Babylonian period (ca. 1800–1600 B.C.) and possibly as an image of the aged monarch Hammurabi (1792–1750 B.C.), the sculpture is a remarkable expression of character and strength.[1] The lines under the eyes and on either side of the nostrils give the cheeks a sunken, modulated form and the head a world-weary, disillusioned appearance, which is compared by Edith Porada to that of the portraits

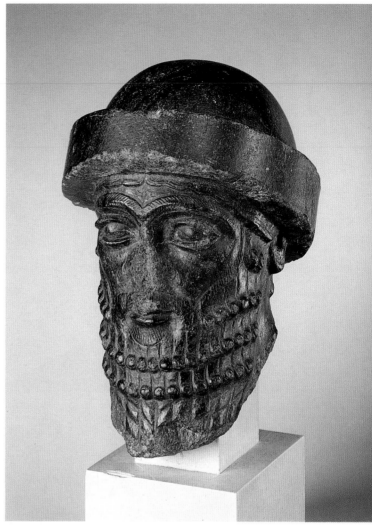

113

of the Egyptian pharaohs Sesostris III (1887–1850 B.C.) and Amenemhet III (1850–1800 B.C.).[2] Because of the shape of the cap, a Mesopotamian royal headdress, and the treatment of the eyebrows, hair, and beard, the head found at Susa is generally identified as a Mesopotamian work brought as booty to Elam, perhaps with other sculptures from Eshnunna in the twelfth century.[3]

Although hardly a portrait in our sense of the word, the head conveys a feeling of mood and personality that is distinctive and largely absent from the art of southern Mesopotamia and Syria in the late third and early second millennia B.C. Less well documented is the art of central Mesopotamia and neighboring western and northern Iran in the period around 2100–1900 B.C. Two copper heads, one in The Metropolitan Museum of Art and the other in the Cincinnati Art Museum (figs. 49, 48), were al-

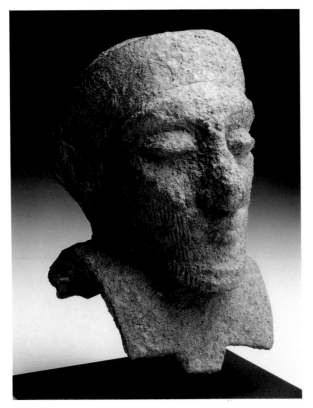

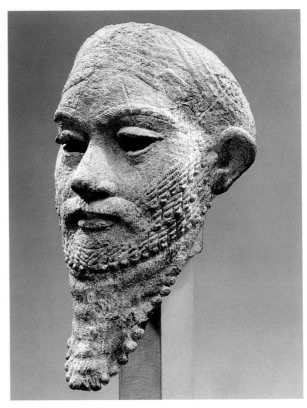

Figure 48. Head of a ruler. Iran(?), ca. 2000 B.C. Arsenical copper, H. 6⅛ in. (15.5 cm). Cincinnati Art Museum, Purchase, 1958.520

Figure 49. Head of a ruler. Iran(?), ca. 2000 B.C. Arsenical copper, H. 13½ in. (34.3 cm). The Metropolitan Museum of Art, Rogers Fund, 1947 (47.100.80)

legedly found in the part of Iran bordering on the region of Eshnunna in Mesopotamia.[4] They are also naturalistic renderings of individuals having a distinctive appearance. The larger of the two heads, the sculpture in the Metropolitan Museum, while quite different in style from the Susa head, displays some of the same naturalistic features: depressions under the eyes, modeled cheeks, and a beard that realistically follows the curve of the cheekbones. Although the date of the two copper heads is disputed, a period just before or after 2000 B.C. seems likely. The particular interest of the two copper sculptures and the diorite head from Susa lies in the fact that they provide examples of impressionistic and naturalistic sculptural styles for which there is little evidence in the stone and metal sculpture of southern Mesopotamia preserved from this period around the turn of the millennium.

The diorite head found at Susa probably predates the era of Hammurabi of Babylon because of certain stylistic details: the shape of the beard, the wavy strands of hair on the forehead, and the curls hanging down the neck at the back.[5] Nevertheless, this is

an unusual work of art, a sensitive rendering of a ruler that vividly reflects the mood of a world in movement during a time of uncertain stability in the kingdoms of Elam, Babylon, and Eshnunna.

POH

1. Frankfort, 1954, p. 59, pl. 63. See also Spycket, 1981, p. 245, pl. 168.
2. Porada, 1956, p. 123. At a later date Porada suggested that the head might be an image of a noble of Susa, in other words a local work of art made at Susa: Orthmann, 1975, p. 381.
3. Orthmann, 1975, no. 158, pp. 291–92. Another suggestion by B. Schlossman is that the head represents Sumulael (ca. 1880–1845 B.C.), a predecessor of Hammurabi: Schlossman, 1981–82, pp. 155–56. See also Porada, cited above in note 2.
4. In the earliest publications the two heads are described as having been found together; see Royal Academy of Arts 1931, p. 18, no. 19. The earliest provenience claimed was Hamadan: *Illustrated London News*, January 10, 1931, p. 35, "found near Hamadan"; A. U. Pope said the head was found near Hamadan (1931, p. 31 and illustration p. 87, where the caption reads "northwest Persia"). Other proveniences subsequently suggested are cited in Muscarella, 1988, p. 368.
5. Schlossmann, 1981–82, pp. 155–56.

114 STATUE OF A STANDING RULER
Green alabaster
H. 8¼ in. (21 cm); W. 4 in. (10.3 cm)
Early 2nd millennium B.C.
Sb 85

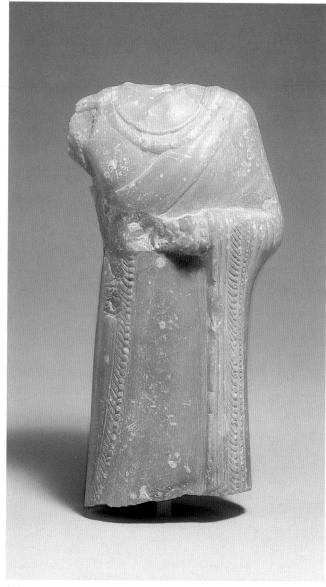

114

This finely executed small sculpture, presumably of a ruler or high official, is made of a greenish alabaster, a colorful stone used for other exceptionally fine works of art made in Mesopotamia in the Early Dynastic (ca. 2900–2334 B.C.) and Akkadian (2334–ca. 2200 B.C.) periods.[1] The statue is now missing the head and feet, but the high level of craftsmanship is evident in the sensitive execution of the drapery and rich jewelry. As there is no inscription, the identity of the figure and the city in which it was made remain unknown. One suggestion is that the image is a representation of a Susian prince that was carved by a craftsman residing at Susa during a period of strong Mesopotamian influence (2000–1900 B.C.).[2] This theory gains some support from the fact that there is no royal inscription on the statue identifying it as booty from Mesopotamia.

The figure wears two necklaces, one of them with three beads—a large, central elliptical bead framed by two smaller circular ones—strung on fine threads. Two bracelets are worn on the figure's left wrist, one a plain circlet and the other embellished with three beads. The right wrist is broken away. No traces of a beard remain, but it is possible that the figure had a short, trimmed beard closely following the chin line, a style that had some popularity during this period.[3]

The pure Mesopotamian style of this work is evident from a comparison with a black stone sculpture of similar size and appearance found by the nineteenth-century archaeologist Hormuzd Rassam at Sippar, a site in central Mesopotamia, and now in the British Museum.[4] Other Mesopotamian sculptures found at Susa, notably the group of ruler images that were booty from Eshnunna, are also closely comparable in style and detail to the green alabaster figure. Wherever the sculpture was originally executed, the artist must have been trained in a Mesopotamian workshop, as the image displays no distinctive Elamite features or details.

POH

1. Orthmann, 1975, pl. 2 (Early Dynastic statue found at Nippur); McKeon, 1970, p. 230 (Akkadian stele fragment, Museum of Fine Arts, Boston).
2. Amiet, 1966, p. 290, fig. 216; Pézard and Pottier, 1926, no. 77: "Prince Susien." See also Spycket, 1981, p. 238.
3. Orthmann, 1975, pl. 11. For a discussion of the chronological significance of the beard length, see Schlossman, 1981–82, p. 149.
4. Accession no. 114699; Walker and Collon, 1980, p. 98; G. P.F. Van den Boorn, "The Life and Times of a Leiden Torso," in L. de Meyer and E. Haerinck, eds., *Archeologia Iranica et Orientalis: Miscellanea in honorem Louis Vanden Berghe*, vol. 1 (Ghent, 1989), pls. 3b, 4, pp. 189–90.

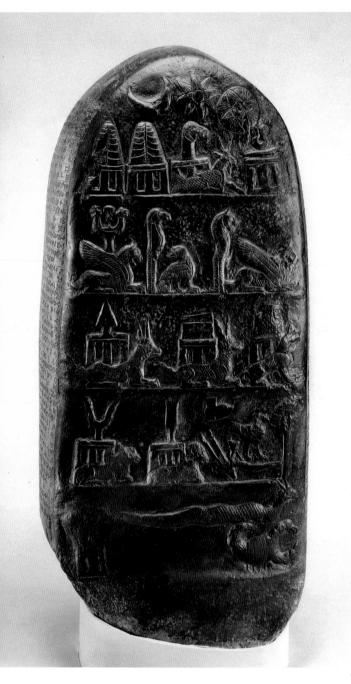

115

115 KUDURRU OF MELISHIHU

Inscribed in Akkadian
Black limestone; coated with wax early in this
century
H. 25⅝ in. (65 cm); W. 11¾ in. (30 cm)
Kassite period, early 12th century B.C.
Acropole, trench 7a; Sb 22
Excavated by Morgan.

116 KUDURRU

White limestone
H. 21¼ in. (54 cm); W. 14⅛ in. (36 cm)
Kassite period, 12th century B.C.
Sb 25

One distinctive type of official monument made in Babylonia between the fourteenth and seventh centuries B.C. and recovered in relatively large numbers at Susa is the boundary stone, or *kudurru*. Among the 110 examples catalogued by Ursula Seidl, over 40, many in fragmentary condition, come from this site.¹ The stone steles and irregularly shaped monuments are usually carved from limestone, and appear from the Akkadian texts inscribed on them to be copies of legal documents concerning boundaries and the ownership of land. Since the *kudurrus* show little sign of weathering, it is generally assumed that they were erected in temples and were not set up as actual boundary markers.

On many of the *kudurrus* found at Susa the inscriptions are effaced or otherwise damaged, but the two examples in this exhibition (one of which is unfinished) are in almost perfect condition. The black limestone example (No. 115) bears a lengthy inscription of the Kassite king Melishihu (1186–1172 B.C.), which records a gift of land by Melishihu to his son Marduk-apla-iddina I.²

The history of relations between Kassite Babylonia and Elam from the fourteenth to the twelfth century B.C. is obscure, although the two kingdoms were politically and culturally interconnected.³ Literary and judicial texts document troubled relations and alternating periods of conquest and control, but there were also times of independence and relative harmony in which marriages between the royal families were arranged. One of these periods was during the reign of Melishihu, whose eldest daughter, it has recently been suggested, married the Elamite ruler Shutruk-Nahhunte (1190–1155 B.C.).⁴

Both of the *kudurrus* in this exhibition were

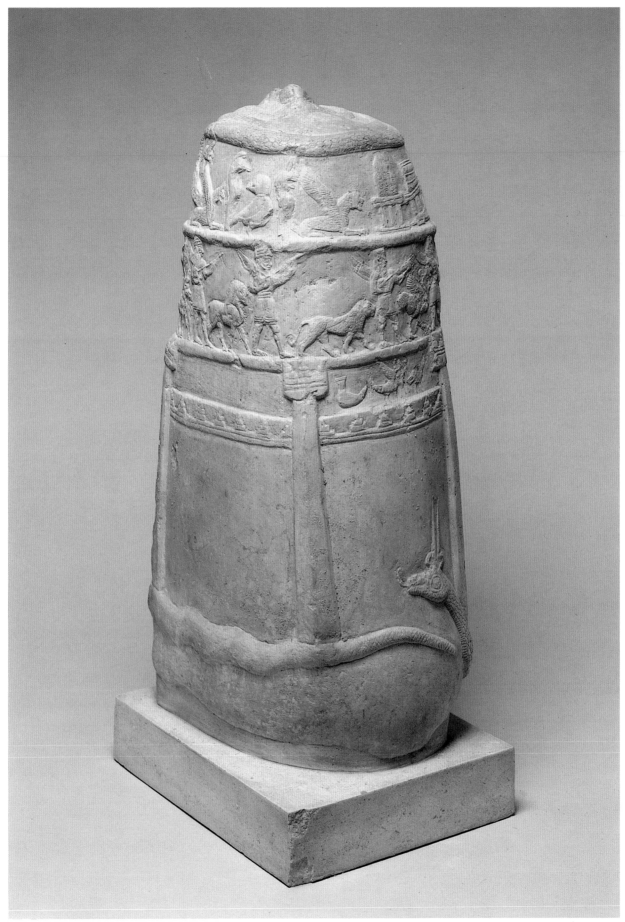

probably made during the reign of Melishihu, and the close diplomatic and political ties between the two realms at this time may have created a political environment favorable to the preservation of the monuments at Susa. An alternate hypothesis is that these *kudurrus* are part of the Mesopotamian booty taken to Susa from Babylonia by Shutruk-Nahhunte during one of his forays into Mesopotamia.[5] The *kudurru* inscribed with the name of Melishihu (No. 115) was uncovered in the same area (Morgan trench 7α; see fig. 41, p. 124) on the Acropole mound as other Mesopotamian booty monuments taken from Sippar, a site at which similar Kassite *kudurrus*, now in the British Museum, were found.[6]

The flattened surface of this black limestone stele is divided into five registers on which symbols and attributes of various Babylonian divinities appear that are, for the most part, familiar representations in the art of Babylonia. The majority of the images are animals and supernatural creatures. The only human represented is a bust surmounting a temple facade, which in turn rests on a dog. This imagery has led to the identification of the figure as the goddess Gula, whose attribute was a dog. In Seidl's comprehensive survey of Babylonian *kudurru* reliefs the stele of Melishihu falls into the third of ten groups, in which the canons for the images, form, and design were first set.[7]

Quite different and more unusual in appearance, but also attributed by Seidl on the basis of style and iconography to Melishihu, is a second, white limestone boundary stone (No. 116) found at Susa.[8] On this example the figural representations and the lined spaces prepared for the text encircle the stone. Some features, notably the row of divine symbols at the summit and the presence of a coiled snake and a horned serpent, are comparable to the images ap-

pearing on many Kassite *kudurrus*. Other elements, however, are more unusual: the crenellated fortification wall that surrounds the squarish stone[9] and the extraordinary procession of one female and seven male divinities playing musical instruments and accompanied by a variety of animals. The fortified city walls rest on a horned snake, symbolism that led Anton Moortgat to interpret the scene as a supernatural or mythical image rather than a representation of a historical city.[10] Another snake encircles the top of the monument and holds in its coils a figure of a quadruped, now damaged.

Processions of figures are common in Kassite art in various media, but the cult scene on this *kudurru* is particularly elaborate and is unique.[11] Seidl offers an interpretation of the male divinities as the tutelary gods of the animal world and compares some of the images to representations on a seal in the Louvre inscribed with the name of the Kassite king Kurigalzu.[12]

No detailed information exists concerning the precise location at which this *kudurru* was discovered. The absence of an inscription on the carefully prepared and partially lined surface raises questions concerning the place of manufacture, the purpose of the monument, and the explanation for its presence in this unfinished state at Susa.

POH

1. Seidl, 1989.
2. Sb 22: Pézard and Pottier, 1926, p. 51, no. 21; Morgan, 1900c, pp. 172ff., pl. 16; *MDP* 2 (1900), pp. 99ff., pls. 21–24; Seidl, 1989, p. 29, no. 32, Taf. 15a. Sb 25: Pézard and Pottier, 1926, p. 52, no. 24; Morgan, 1905d, pp. 146ff., pls. 27, 28; Seidl, 1989, pp. 30–31, no. 40, Taf. 18a.
3. Carter and Stolper, 1984, pp. 32–44 (with references to literature); Amiet, 1986b, pp. 1–5; Marcus, 1991, pp. 537–60.
4. Steve and Vallat, 1989, pp. 223–38.
5. Both alternatives were proposed in the early excavation reports: Morgan, 1905d, pp. 138ff. None of the *kudurrus* found at Susa have Elamite inscriptions on them, with one possible exception: Seidl, 1989, no. 41.
6. Walker and Collon, 1980, p. 101.
7. Seidl, 1989, pp. 80–81.
8. Seidl, 1989, pp. 30–31, 80–81.
9. Another example of the fortification wall design appears on a *kudurru* of unknown provenience in the British Museum (90829) inscribed with the name of Melishihu; Seidl 1989, p. 24, no. 12. For the suggestion that this stone comes from Sippar, see Walker and Collon, 1980, p. 101.
10. A. Moortgat, *Bildwerk und Volkstum Vorderasiens zur Hethiterzeit* (Leipzig, 1934), p. 14; cited by Seidl, 1989, p. 108.
11. Marcus, 1991, pp. 537–60.
12. Seidl, 1989, p. 207: reference to Delaporte, 1920, pl. 51, D56.

116, detail

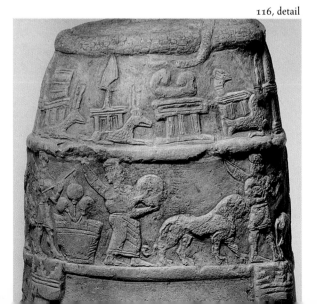

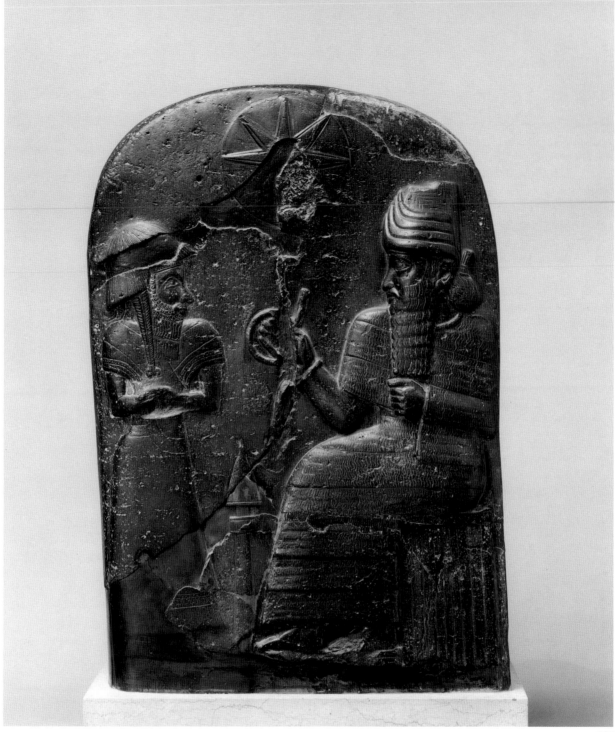

117 STELE WITH AN ELAMITE RULER APPROACHING
A SEATED GOD
Basalt
H. 24¾ in. (63 cm); W. 17¾ in. (45 cm)
Kassite period, 12th century B.C., and Neo-Elamite
period, 8th century B.C.
Sb 9
Excavated by Morgan.

Only the arched upper portion remains of this up-
right monument, or stele.[1] In the scene represented,
a male supplicant approaches an enthroned god. Be-

tween the figures is a fragmentary incense burner,
and above the heads a circular disk enclosing an
eight-pointed star. Comparable scenes appear on
other steles found at Susa, notably the diorite Code
of Laws of Hammurabi of Babylon (1792–1750 B.C.)
and an earlier, fragmentary white limestone stele
also made in Mesopotamia (No. 110).

A later recutting of this relief has distorted the
arched form and resulted in an awkward, crowded
composition. Since the stone is irregular in shape
and narrows toward the back surface, the width of
the front surface was diminished when the stone was
cut back on the left side and a new figure was carved

in place of the original worshiper. Careful examination of the front surface and an analysis of details in the design indicate that the figure of the enthroned god is probably a Babylonian work of the twelfth century B.C., while the approaching figure is an alteration made to the design at Susa during the eighth century B.C.[2]

Since there is no inscription preserved, the function of the stele is uncertain, but the figural design resembles that on the summit of the Code of Hammurabi (fig. 44, p. 160) and may be an indication that this relief, too, originally surmounted a code of laws.

POH

1. Pézard and Pottier, 1926, p. 42, no. 9; Morgan, 1905d, pl. 99; Amiet, 1966, p. 410, fig. 310; Börker-Klähn, 1982, no. 114, pp. 168–69, pl. 114; Barrelet, 1974, F. 135, p. 113.
2. Seidl, 1965, pp. 175–86 (stele A is Sb 9). For an earlier dating for the recarving of the stele, see p. 122 n. 4.

Terracotta Figurines

The terracotta figurines are among the most original of Susa's artistic productions. In successive phases over a period of about three millennia, the inhabitants of the Susiana plain fashioned the clay they found beneath their feet into animal and human forms, first by hand and later using molds. Produced outside the realm of official commissions, these small figures were intended for private individuals and their inspiration remained essentially popular. Although some of the cast examples were made by skilled craftsmen and are of very high quality, objects of this type are chiefly of interest for what they reveal about the Susians' daily preoccupations and the evolution of their mode of thought.

It should first be noted that the great majority of Susian figurines demonstrate a complete independence from Mesopotamian production, except in times when Susa was under Akkadian or Babylonian rule. During the Akkadian period, under the Third Dynasty of Ur, and at the beginning of the second millennium, original works are found alongside examples of western types, reflecting the exchanges between Assyria, Babylonia, and Elam.

Hundreds of these figurines have been discovered at Susa over a period of more than a century, in archaeological excavations that began with Marcel and Jane Dieulafoy in 1884–86 and resumed under Jacques de Morgan and Roland de Mecquenem in the years between 1897 and 1946. Yet the figurines attracted little attention from archaeologists and were difficult to classify because the circumstances of their excavation were not carefully recorded and, even more, because of their originality in comparison with the more easily dated Mesopotamian objects. It has been possible, however, on the basis of stratigraphic excavations conducted by Roman Ghirshman between 1955 and 1967, to propose a classification for the collections at the Louvre and at the Iran Bastan Museum in Teheran.[1]

Throughout the ancient Near East, and particularly in the mountains of Kurdistan beginning in the seventh millennium B.C. (as at Jarmo and Tepe Sarab), objects were fashioned of dried unbaked clay: faceless anthropomorphic silhouettes and, especially, animals.[2] Animal representations still predominated at the time of the founding of Susa in the beginning of the fourth millennium B.C. (Susa I); they were of refined clay, fired and painted. The animals most frequently represented are various types of horned beasts (e.g., No. 15) and birds (e.g., No. 16), whose bodies are speckled with brown spots. There are also some human figures with column-shaped bodies, pinched-nose faces, and neither eyes nor mouths.

Curiously, after the Susa I period, production of the figurines stopped for several centuries in both Mesopotamia and Iran. Only a few examples can be assigned to the long Early Dynastic period in the first three-quarters of the third millennium B.C. The great

outpouring of figurines representing humans began in the Akkadian period (2334–2154 B.C.), and from the start, nude female figures were very much in the majority. The application of clay parts was a characteristic technique; features such as eyes, hair, necklace, and breasts were attached to a rather crudely modeled body, and additional details were incised. The pinched-nose head, when it lacks a mouth, resembles a bird head (No. 118), and the arms might be outstretched or might be pinions (No. 119).

The single-face mold appeared at the end of the third millennium B.C. and was so successful that from then on the technique virtually supplanted hand modeling. Initially the molds were shallow (No. 121) and reproduced hand-modeled types.[3] The clay was cut away around the contour of the figurine, and the back was still hand modeled to give the impression of sculpture in the round (No. 120). But quite quickly the back was flattened and the clay left around the silhouette: thus was born the figurine-plaque (No. 136), which from the beginning of the second millennium became widespread.

During the era of the sovereigns who adopted the title *sukkalmah*, a large number of nude female figurines were produced. These are invariably depicted with hands joined, wearing a necklace and bracelets, and sometimes with a crossed band passing between the breasts (Nos. 131, 132). The male figurines, bearded or not, wear long mantles and ovoid tiaras and are shown playing a musical instrument (Nos. 123, 124) or carrying a monkey (No. 125). There are also figures of a worshiper carrying a young he-goat (No. 126). Beginning in this period, figurines were often coated with a glaze or slip, generally light in color.

With the Middle Elamite period, which occupied the second half of the second millennium, there came a change in the representations. Although the slender female nude with hands clasped (No. 129) disappeared only gradually, a new design that assumed enormous importance supplanted it. In this type, the female supports each of her breasts between a raised thumb and four joined fingers (No. 131); in addition to the pendant necklace she wears a kind of double band that crosses through a slip ring between the breasts, and anklets as well as bracelets (No. 133). The body became more and more fleshy, the shoulders and hips swelling to the point of deformity, while at the same time the figurine itself grew increasingly flat (No. 132). The

braided headdresses placed over the hair are identical to those on the funerary heads of polychrome baked clay found in collective burial vaults (No. 84).

Alongside this vast quantity of nude female figures are several types representing elegantly dressed women, some holding a naked baby in their arms (No. 134).

Compared to representations of women, those of men were, in the Middle Elamite period, a distinct minority. The most common male type is a more or less mythical representation of a small nude individual, bearded or beardless, with bowed legs, who plays a long-necked lute. He sometimes carries a small human figure on his right shoulder (No. 136).

In Mesopotamia as well, but most often in Susa, small four-legged beds of terracotta have been found. On some of these, a naked couple lies (No. 135); others are unoccupied.

The technique of hand modeling can be seen on some small painted heads (No. 137); these have hollow necks pierced with holes that allowed them to be fastened to a body. Although found in tombs, they can be distinguished from the clay funerary heads (No. 84) by their diminutive size.

With the exception of striding animal figures occasionally represented on cast plaques, animal figurines were always modeled by hand. One of the most popular animal figures in the second half of the second millennium B.C. was the bull, depicted with a stylized hump, a cylindrical body, and conical legs (No. 138). The holes in the muzzle represent eyes and at the same time permit the passage of a strap; apparently these animals could be harnessed to small chariots. Animals on wheels also existed,[4] like the mouflon with a massive body and tiny head (No. 139), and are thought by some archaeologists to have been toys.

AGNÈS SPYCKET

NOTES

1. Spycket, 1992.
2. For Jarmo: R. J. Braidwood and B. Howe, "Prehistoric Investigations in Iraqi Kurdistan," *Studies in Ancient Oriental Civilizations* 31 (Chicago, 1960), pl. 16, 1–6. For Tepe Sarab: Ch. Zervos, *Naissance de la civilisation en Grèce* (Paris, 1962–63), vol. 1, pp. 48–49, figs. 18, 20–23.
3. Spycket, 1986, pp. 79–82.
4. Amiet, 1966, pp. 391, 432f.

118 NUDE FEMALE
Pinkish buff terracotta, hand modeled
H. *4½ in. (11.5 cm)*
Akkadian period (2334–2154 B.C.*)*
Sb 7103
Excavated by Morgan, 1907.

The head of this standing female figure was pinched
to form the nose. The eyes are two pellets, and there
is no mouth. The headband over the forehead, made
of a strip of clay, meets the large *X*-shaped chignon
added on in back. The necklace is represented by a
curved incised line and six holes on the neck. The
breasts are cone-shaped attachments. The arms were
shaped from two rolls of clay stretched in a curve;
the right one covers the pubis, the left one hides the
left breast. Four notches roughly indicate the fingers.
A groove separates the legs in front and behind, and
the buttocks protrude. There are no feet.

AS

119 NUDE FEMALE
Light buff terracotta, hand modeled
H. *3⅜ in. (8.7 cm)*
Third Dynasty of Ur, 2112–2004 B.C.
Sb 7130
Excavated by Mecquenem, 1934.

The arms of this standing female are rendered as
pointed pinions extending horizontally. The features
were modeled separately and applied to her pinched-
nose head: eyes, thick lips, a headband on the fore-
head, and two large vertical strips with horizontal
incisions framing the face. A folded band forms the
chignon. The applied necklace is only on the front of
the neck. The breasts were also applied separately;
the left one has disappeared. The pubic triangle is
incised and scored with fingernail scratches, as are
the navel and the two lumbar dimples. The legs are
separated by two deep grooves in front and behind.
The feet are not rendered.

AS

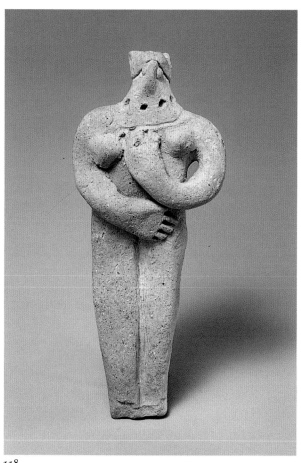

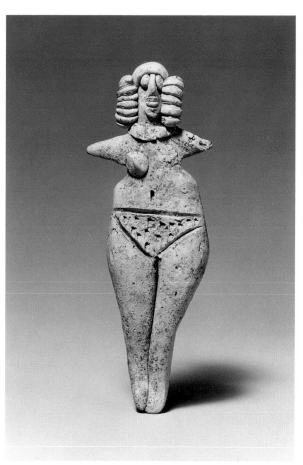

118

119

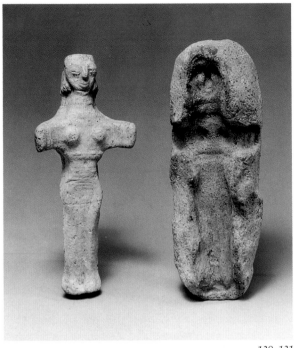

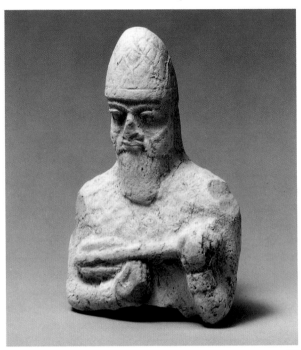

120, 121

122

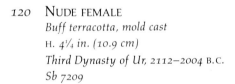

120 NUDE FEMALE
 Buff terracotta, mold cast
 H. 4¼ in. (10.9 cm)
 Third Dynasty of Ur, 2112–2004 B.C.
 Sb 7209

Flat pinions curving forward constitute the arms of
this female figurine. The face is heart-shaped; the
eyes, in relief, are elongated and slit; on the ears are
fluted earrings. A folded band high on the nape rep-
resents a chignon but can also serve as a head sup-
port when the figurine is laid horizontally. One
necklace encircles the neck, the other falls onto the
chest. There is a double ring in relief beneath the
breasts, and the navel is hollowed out. Three parallel
grooves are placed above the pubic triangle, which
is higher than it is wide and is scored with short ver-
tical incisions. Horizontal incisions mark the sides
of the legs. The feet are without detail. Except for
the chignon, the back of the figurine is a simple
rounded form.

 This kind of nude female figure with bust clearly
outlined is one of the oldest types cast from a mold.
The figurine shown here might have been cast from
the mold catalogued below, Number 121.

 AS

121 MOLD FOR FIGURINE OF A NUDE FEMALE
 Buff terracotta
 H. 4⅝ in. (11.9 cm); W. 1¾ in. (4.5 cm); D. 1⅛ in.
 (3 cm)
 Third Dynasty of Ur, 2112–2004 B.C.
 Sb 7410
 Excavated by Mecquenem, 1932.

The shallow mold is hollowed out of a tubular piece
of clay that is rounded in back and along the edges.
The cross shape of the mold's cavity corresponds to
that of the figurine of a nude woman with pinion-
arms (No. 120).

 AS

122 MUSICIAN WITH A LUTE
 Pink terracotta, mold cast; light buff slip
 H. 2¾ in. (7.1 cm)
 Sukkalmah period, first half of the 2nd millennium
 B.C.
 Sb 7814
 Excavated by Mecquenem, 1937.

Only the head and torso remain of this figure of a
bearded lute player, which is broken at the waist.
The ovoid tiara is decorated with a web of narrow
crisscrossing bands. The musician's eyebrows are

delicately striated. The beard covers his cheeks and falls onto his chest in wavy locks. The garment is imprinted with small circles.

AS

123 MUSICIAN WITH A LUTE
Buff terracotta, mold cast
H. 3⅝ in. (9.2 cm)
Sukkalmah period, first half of the 2nd millennium
B.C.
Sb 7805

The beardless face of this small figure is delicately sculpted. The lute player is dressed in an ovoid tiara and a long, plain, flaring mantle that covers his feet and is held at the hips by a wide belt. He wears a necklace with a pendant in the shape of a crescent, the tips pointing downward. He holds the elongated body of the instrument in the crook of his right elbow and grasps the tip of its short neck in his left

hand. The neck of the lute is grooved with perpendicular frets.[1]

AS

1. See Spycket, 1972, p. 192, fig. 40b and description of 40a (misplaced).

124 MUSICIAN WITH A "HARP"
Buff terracotta, mold cast
H. 4⅛ in. (10.4 cm)
Sukkalmah period, first half of the 2nd millennium
B.C.
Sb 6574
Excavated by Mecquenem, 1933.

The musician wears a plain long mantle with a triple-strand belt at the loins and an ovoid tiara. His beard is very short. A round, exceptionally large pendant hangs from his necklace. At his chest he holds an instrument not easily identified: an elon-

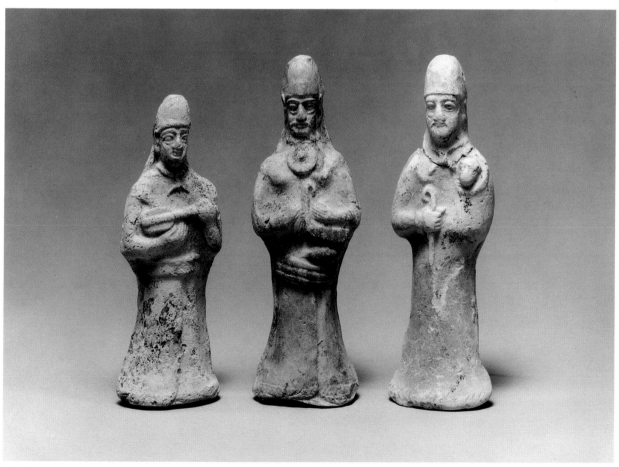

123, 124, 125

gated body surmounted by a vertical post that ends in a hook turned inward. No strings can be seen under the left hand and forearm. Visible under the right hand, at the juncture of the body and the post, is an oblique patch marked with several grooves. Beneath the body of the instrument is something resembling a cushion or inflated pouch, which led Francis Galpin to identify the object as a wind instrument and dub it a "'crooked' pipe."[1]

AS

1. Galpin, 1937, pp. 19, 90 n. 9. See also Amiet, 1966, fig. 227; Spycket, 1972, p. 187, fig. 36; Mecquenem, 1934, p. 233, fig. 84, 2.

125 MAN WITH A MONKEY
Light buff terracotta, mold cast
H. 4⅛ in. (10.6 cm)
Sukkalmah period, first half of the 2nd millennium B.C.
Donjon; Sb 7834
Excavated by Mecquenem, 1932.

This standing male figure wears an ovoid tiara and a long closed garment that covers his feet. A long mustache falls over the short beard on his cheeks. Suspended from a rectangular band on a rigid necklace is a thin crescent with tips pointed down, similar to the one worn by the lute player (No. 123). Under his bent right arm he holds the middle of a vertical rod that is curved into a hook at the top; on his right wrist is a bracelet. His left arm is entirely concealed by the garment. At his shoulder, seeming to emerge from a pocket with a spiked border, is the head of a monkey with round eyes.[1]

AS

1. See Amiet, 1978, no. 107 bis; and cf. Mecquenem, 1934, p. 233, fig. 84, 4.

126 MAN CARRYING A YOUNG HE-GOAT
Green-gray terracotta
H. 4¾ in. (12 cm)
Sukkalmah period, first half of the 2nd millennium B.C.
Sb 6572
Excavated by Mecquenem, 1934.

The standing figure wears a plain long robe edged with a double band at the hem. His shoulders and arms are covered by a fringed shawl that falls symmetrically in curves to the bottom of the garment. His fleecy cap, which comes down to his eyebrows, resembles the fur cap worn by the bronze and gold worshiper of Larsa dedicated to Hammurabi of Babylon.[1] The elongated eyes, in relief, are framed by raised rims, and the nose is flat. A long beard rendered in a chevron pattern covers the cheeks and falls onto the chest; on either side of it a beaded necklace is visible. He holds a young goat against his body with both hands. The goat, which faces outward, has a stylized fleece represented by rows of small squares. Its back feet hang beneath the man's left hand and its front feet rest on his right wrist. In his right hand the figure holds a shepherd's staff.[2]

AS

1. Parrot, 1960, fig. 350.
2. Amiet, 1966, fig. 230; Amiet, 1977, fig. 420.

126

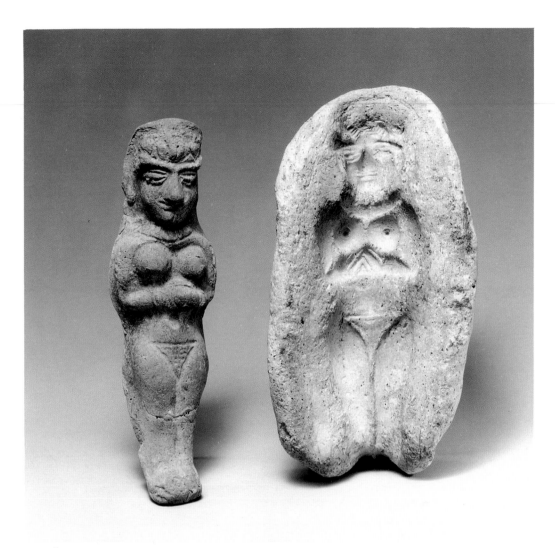

127, 128

127 NUDE FEMALE
Pink terracotta, mold cast; brown slip
H. *5¼ in. (13.2 cm)*
Sukkalmah period, first half of the 2nd millennium
B.C.
Sb 7259
Excavated by Mecquenem, 1933.

This figure's face, with its prominent nose, looks to us like a caricature. The head is oversized in comparison with the body; a striated cap descends to the eyebrows. The oblique, elongated eyes have a raised outline. A thick necklace adorns the throat. The woman's breasts, close together, are tightly framed by her arms; the nipples are indicated. The clasped hands are incised with large oblique lines, and bracelets encircle the wrists. The feet are formless.

The Musée du Louvre has one mold that corresponds to this figurine (No. 128) and about forty similar figures, somewhat crudely made, that were found near a potter's kiln by Mecquenem in 1933.

AS

128 MOLD FOR FIGURINE OF A NUDE FEMALE
Pinkish buff terracotta
H. *5⅜ in. (13.8 cm); W. 2⅞ in. (7.3 cm); D. 1½ in.*
(3.8 cm)
Sukkalmah period, first half of the 2nd millennium
B.C.
Sb 7402
Excavated by Mecquenem, 1933.

This mold produced figurines of the type of Number 127, above.

AS

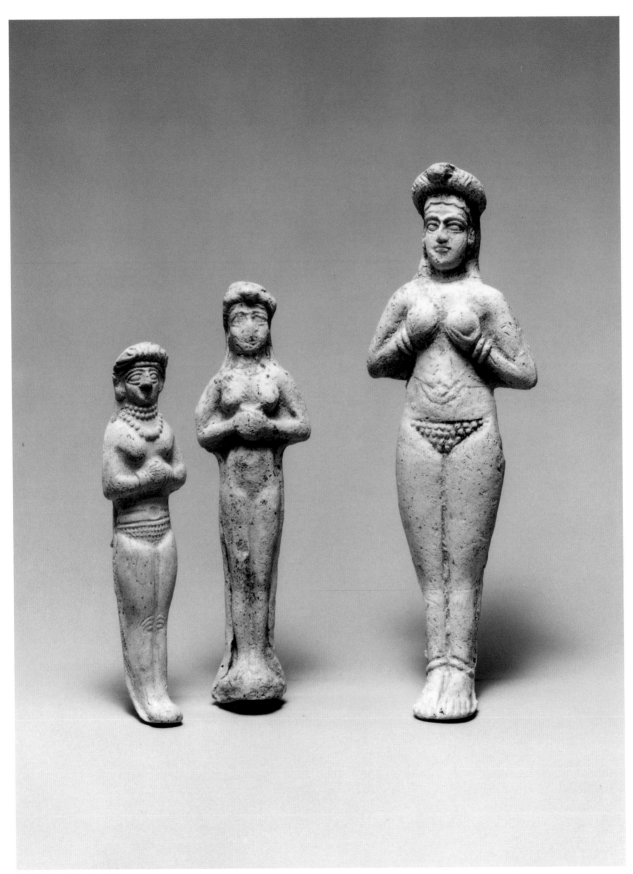

129 NUDE FEMALE
Light buff terracotta, mold cast
H. 4⅝ in. (11.9 cm)
Sukkalmah period, first half of the 2nd millennium
B.C.
Sb 7586
Excavated by Mecquenem, 1930.

The slim-hipped female stands with her hands clasped across her abdomen. Set low over her forehead is a braided turban with vertical fluting in front and a chevron pattern at the temples. The nose is short and pointed between large, heavily outlined eyes; the mouth is very small, and a dimple creases the chin. A double necklace of round beads encircles the woman's neck, while a third strand falls in an oval, a large horizontal bead at its center. On her wrists are three bracelets. She has sloping shoulders and small breasts. Her narrow pelvis is ringed by three horizontal grooves, the center one broken by the circular cavity of the navel. Three rows of shallow incisions describe the low pubic triangle. The thighs are narrow and convex; the knees are marked by three semi-circular grooves, and the toes are indicated. The back is flat.

The overall form is clearly delineated except where narrow flanges reinforce the figure at neck level, under the elbows, and along the legs. This type of figurine was extremely common at Susa in the first half of the second millennium.

AS

130 NUDE FEMALE WITH CLASPED HANDS
Terracotta, mold cast; light buff slip
H. 5⅜ in. (13.7 cm)
Middle Elamite period, second half of the 2nd millennium B.C.
Sb 7637
Excavated by Mecquenem, 1928.

The woman, thin and well-proportioned, stands on a small pedestal. A braided diadem with a projection in the center covers her hair, which is just visible as two wavy lines low on the forehead. A three-strand beaded necklace tightly rings her neck, and two wide bands rest on her chest. A band with a herringbone pattern descends obliquely from her right shoulder and passes between her breasts. The hands rest one in the other with the thumbs crossed above. Around the wrists are three rigid bracelets. The hips are slender and the long legs are narrowed at the knees. An edging of clay has been left all along the body.

AS

131 NUDE FEMALE SUPPORTING HER BREASTS
Pink terracotta, mold cast; light buff slip
H. 6⅞ in. (17.6 cm)
Middle Elamite period, second half of the 2nd millennium B.C.
Sb 7742
Excavated by Mecquenem, 1928.

The tall, slender woman holds each breast between an upright thumb and four fingers below. Over wavy hair, visible on her forehead, she wears a braided diadem that juts forward in the center. Her face is long, the eyes heavily outlined and a dimple showing in the middle of the chin. She wears a two-strand necklace at the base of her neck, a band crossing her chest with a herringbone pattern, two bracelets on each arm, and anklets. Because the bottoms of the feet curve toward the heels, the figure cannot stand. The contours of the body are well delineated and the back is completely flat.

AS

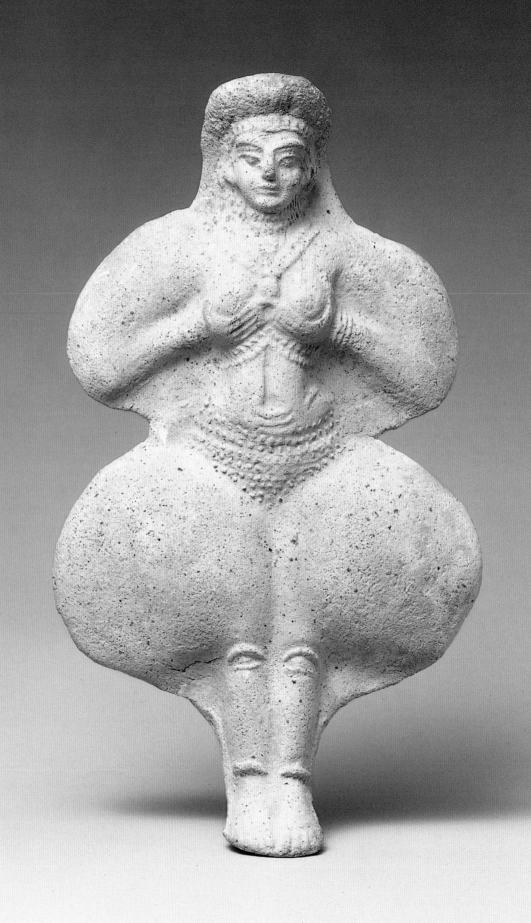

132 NUDE FEMALE SUPPORTING HER BREASTS
Buff terracotta, mold cast
H. 6½ in. (16.5 cm)
Middle Elamite period, second half of the 2nd
millennium B.C.
Sb 7797

This woman is deformed by exaggeratedly wide arms and hips. Only her head, with a braided tiara, appears normal. A rosette-shaped pendant hangs from the two strands around her neck. Three bracelets adorn either arm, and rings encircle the ankles. Crossed bands in a herringbone pattern pass through a sliding ring between her breasts; her nipples are ringed. The deformed thighs extend far beyond the knees, which are rendered as rimmed ovals. The back is completely flat except for the curvature of the head and feet.[1]

AS

1. Roland de Mecquenem, "Les derniers résultats des fouilles de Suse," *Revue des arts asiatiques* 6 (1929–30), pl. 15d; Pope, 1938, vol. 4, pl. 74 D; Porada, 1963, fig. 33, p. 49 (drawing); Amiet, 1978, no. 131.

133 NUDE FEMALE SUPPORTING HER BREASTS
Greenish terracotta, mold cast
H. 5⅝ in. (14.3 cm)
Middle Elamite period, second half of the 2nd
millennium B.C.
Sb 7763
Excavated by Mecquenem, 1932.

This figure has plump contours and wears the characteristic braided tiara, edged with a stippled band over the forehead, and shoulder straps that cross through a slip ring between the breasts. Hanging from a necklace at the base of her neck is a pendant in the form of a rosette with eight petals; horizontally striped earrings, three bracelets on each wrist, and anklets complete her attire. Her eyes are wide open and are delicately outlined. The pelvis shows a long slit above the navel and the pubic triangle is stylized with several rows of small curls. The knees are indicated by rimmed ovals.

AS

132

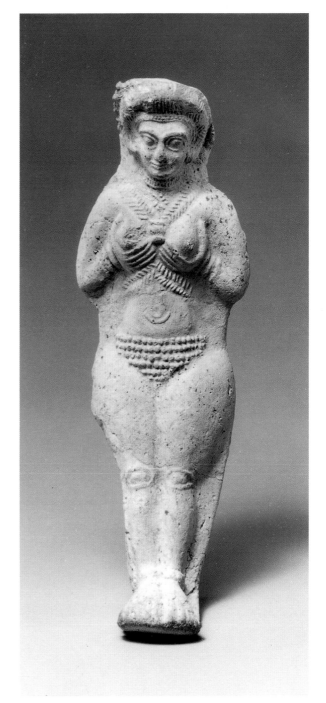

133

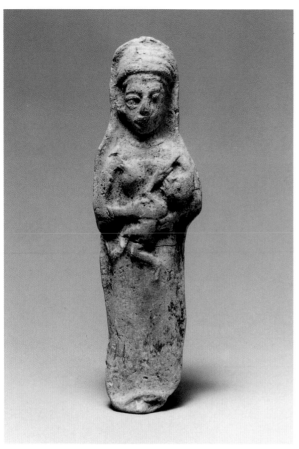

134

135

134 CLOTHED MOTHER WITH CHILD
 Light buff terracotta, mold cast
 H. 4 in. (10.2 cm)
 *Middle Elamite period, second half of the 2nd
 millennium* B.C.
 Sb 7722

135 WOMAN AND MAN ON A BED
 *Buff terracotta; bed: hand modeled; figures:
 mold cast*
 L. 4⅜ in. (11.2 cm); W. 2¼ in. (5.8 cm); H. 1⅜ in.
 (3.5 cm)
 *Middle Elamite period, second half of the 2nd
 millennium* B.C.
 Sb 7979
 Excavated by Morgan, 1907.

The woman is dressed in a plain straight garment
that falls to her feet, leaving only the toes visible.
Her delicate face is surmounted by wavy hair and a
turban consisting of four superimposed bands. The
neckline is square, and triangular epaulettes are at-
tached in front of the shoulders with pins (visible
only on the left). She holds a naked baby in her
arms. The child's legs are spread apart and its left
hand, wearing a bracelet, reaches up to the mother's
breast. This type of figure has also been found at
Chogha Zanbil.

A naked couple lie on a bed, the woman on the left.
They embrace each other around the neck and waist.
The woman's long hair descends to her shoulders;
the man's wavy hair projects over his forehead. The
bed has four legs, and the mattress seems to be
made of interwoven bands.

AS

AS

136

137

136 PLAQUE OF A NUDE LUTE PLAYER WITH
BOWLEGS
Yellowish buff terracotta, mold cast
H. 3⅞ in. (9.8 cm)
*Middle Elamite period, second half of the 2nd
millennium* B.C.
Sb 7876

137 MALE HEAD
*Pinkish buff terracotta, hand modeled; originally
painted*
H. 4¼ in. (10.7 cm)
*Middle Elamite period, second half of the 2nd
millennium* B.C.
Donjon; Sb 2816
Excavated by Mecquenem, 1933.

There are many representations of a nude, bow-
legged lute player, but this one has the peculiarity of
carrying on his right shoulder a small figure, proba-
bly a child, whose arms encircle his head. On the
basis of other less distinct examples it had been as-
sumed that the small figure was a monkey. The man
is bearded. He plays an instrument with a small
body and a long neck, which he holds at the tip. This
musician differs from the clothed lute players of the
Sukkalmah period who play instruments with elon-
gated bodies and short necks.[1]

AS

1. M. Rutten, "Scènes de musique et de danse," *Revue des arts
asiatiques* 9 (1935), p. 222, fig. 15 (drawing); Opificius, 1961,
no. 718, p. 194; Amiet, 1978, no. 108.

On the beardless head is a conical headdress. The
hollow neck is pierced with three holes so that it can
be attached to a body. Beneath the protruding ridge
of the brow are bulging eyes, with flanged rims that
serve as eyelids. The corners of the wide mouth are
raised. At the time of its discovery in 1933 the head
bore traces of slip, which have since disappeared.[1]

AS

1. Rutten, 1935–36, vol. 1, p. 281 A–B; Amiet, 1966, fig. 337;
Spycket, 1981, p. 316 n. 109.

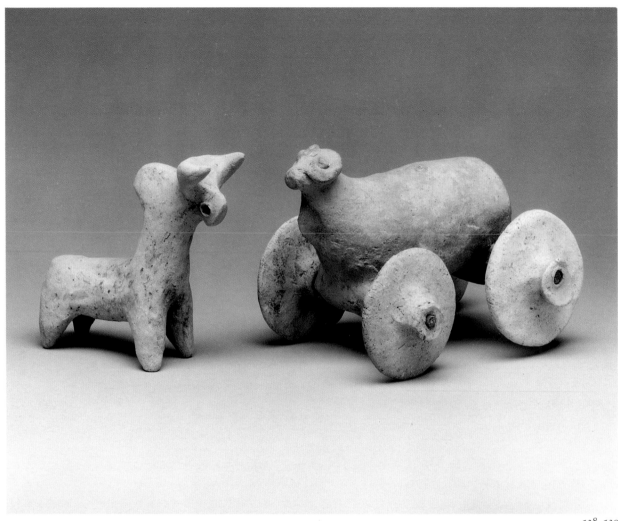

138, 139

138 HUMPED BULL
Gray-buff terracotta, hand modeled
H. *4 in. (10.3 cm)*; L. *4⅜ in. (11.2 cm)*
Middle Elamite period, second half of the 2nd
millennium B.C.
Sb 19323
Excavated by Mecquenem, 1931.

The massive horns of this humped bovine, modeled in a single unit, are pointed forward. The muzzle is pierced through from one side to the other. The hump is an extension of the head, and the cylindrical body rests on legs shaped like truncated cones. The tail is short and thick.

AS

139 ANIMAL ON WHEELS
Pink terracotta, mold cast
H. *of animal 3⅛ in. (8 cm)*; L. *5⅛ in. (13 cm)*
Middle Elamite period, second half of the 2nd
millennium B.C.
Sb 19324
Excavated by Morgan.

The animal, a mouflon with a hollow, cylindrical body and a tiny head, is mounted on four wheels. Each horn curves in an almost complete circle around a protuberance representing an eye. The dewlap in front was formed by pinching the clay. There is a vent hole on the animal's back and another where the tail should be. The wheel axles pass through holes pierced in the flanges under the front and rear of the body.

AS

THE NEO-ELAMITE PERIOD
CIRCA 900-600 B.C.

Susa rapidly fell from prominence at the end of the second millennium and continued to decline until about 700 B.C. The wars of the Babylonian king Nebuchadnezzar I (1125–1104 B.C.) against Susiana were only partly responsible for this reversal; there were also famines around the turn of the millennium that seriously affected both Mesopotamia and Susa. But it was probably the political unrest, as much as ecological disaster, that led formerly settled groups to take up a nomadic existence, retreating to the upland valleys of eastern Khuzistan.[1] Blocked by the Assyrian empire to the northwest, the Elamites were unable to maintain control of the foothill road leading toward Mesopotamia. The Median kingdoms held the uplands to the north and northeast. By about 1000 B.C. the Susian kings had also lost their foothold in Anshan, and new ethnic groups may have pushed the Elamites of Fars westward into the valleys of eastern Khuzistan.

Late in the eighth century B.C., both archaeological and historical records document Susa's renewal as part of the resurgence of Elamite power.[2] Allied with Babylonians and highland Elamites, the Susians challenged the powerful armies of Assyria repeatedly for almost a century. At Susa, a small temple of Inshushinak decorated with panels of glazed brick and glazed architectural ornaments crowned the Acropole mound. Large burial vaults dated to this period in which were found golden jewelry, richly decorated objects, and containers made of glazed frit are a sign of local prosperity. Susa continued to be a ceremonial and cultural center, but the towns of Madaktu and Hidalu, mentioned in texts, appear to have been the major centers of political and military activity.[3]

EC

1. Miroschedji, 1990, pp. 47–95. Both mobile pastoralism and agriculture were effective survival strategies in these regions.
2. The archaeological finds are summarized in Amiet, 1966; for historical sources, see Stolper, 1984, pp. 44–56.
3. Neither of these cities has been located, but Pierre de Miroschedji has suggested that Tepe Patak, forty miles northwest of Susa in the Deh Luran plain, should be identified as Madaktu; Hidalu probably lies in the Ram Hormuz, ninety miles from Susa, or in the adjacent Behbehan region of southeastern Khuzistan. See Carter, forthcoming.

SCULPTURE

140 STELE OF ADDA-HAMITI-INSHUSHINAK
Inscribed in Elamite
Limestone
Reconstructed H. *36¾ in. (93.5 cm);* W. *25⅞ in. (65.6 cm)*
Neo-Elamite period, ca. 650 B.C.
Sb 16
Excavated by Morgan.

Preserved are six separated fragments of a stele that has been plausibly restored to furnish important information.[1] It bears an inscription of a king who ruled over Anshan and Susa in the troubled, and still poorly understood, times during and after the major defeat of Elam by Ashurbanipal in the 650s and 640s B.C. (see No. 189).

The seated king faces right. He has wide shoulders but a narrow waist, held by a rosette-decorated belt. His garment is ankle-length and decorated with fringes, concentric circles in squares, and what may be crudely rendered rosettes. In his small right hand is a staff (the head is missing), and on his wrist is a bracelet in the form of two frontal feline heads.[2] The king is distinguished by his long, straight beard—it almost touches his waist—and a headdress that has a pointed projection, a bulbous back[3] that may hold his hair, and a rosette-decorated band. One fragment preserves a feline foot of the

140

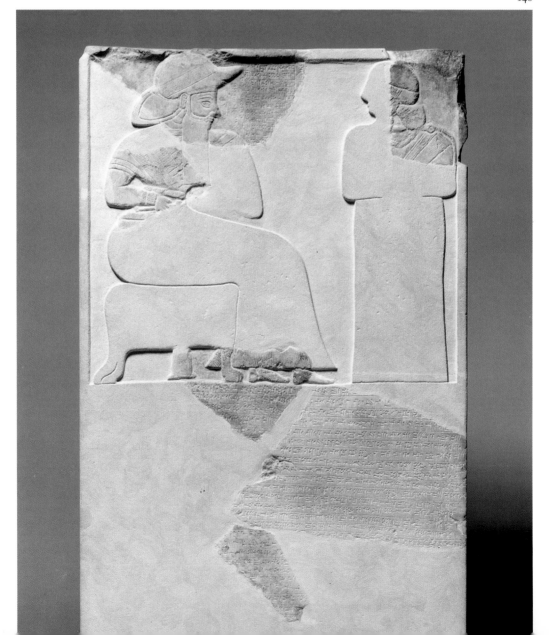

king's throne and most of his feet, in shoes that have bands and upturned tips. A cylindrical object to the left of the throne foot is probably an article of furniture. Another fragment preserves the right border of the stele and the back of the head and shoulders of a figure facing left, who wears a plain, round headdress with hair exposed below and a garment decorated like the king's. There is a round object on the shoulder that may be a brooch; if it is, the figure is probably a female, for Queen Napir-Asu (No. 83) wears a brooch on her shoulder.

A similar headdress projecting at the front is worn by broad-shouldered kings with long beards on Neo-Elamite rock reliefs.[4] The peculiar headdress, long beard, and broad shoulders are Neo-Elamite characteristics. The bracelet is neatly matched by penannular bracelets from Luristan in western Iran, to the north of Elam, that are decorated with frontal feline heads with large eyes.[5] The occurrence of such a bracelet on this dated stele supplies a date for the Luristan examples.

OWM

1. Amiet, 1966, no. 431; idem, 1988b, p. 117, no. 73; Calmeyer, 1976, p. 57, Abb. 2 (a drawing with details of the clothing decoration not precisely drawn; see n. 2 below).
2. The drawing in Calmeyer, 1976 (see n. 1) incorrectly shows rosettes on the bracelet.
3. The end is missing. It has been restored to approximate the type of headdress seen on some Neo-Elamite reliefs.
4. Amiet, 1966, nos. 421, 428.
5. Muscarella, 1988, pp. 170–71, no. 271.

THE INSCRIPTIONS

The two texts to the right of the bearded head at the top of this stele—one written left to right and another, bordering it, written top to bottom—identify the subject of the portrait as the king Adda-hamiti-Inshushinak, son of Hutran-tepti. He speaks in the first person in the fragmentary text below the reliefs.

Mesopotamian texts mention no such king, but one passage in the annals of the Assyrian king Ashurbanipal names a certain Attameti as one of the Elamite commanders dispatched to support the Babylonian rebellion in 652 B.C., and another passage names Attametu as the father of Humban-haltash III, who had the misfortune to occupy the Elamite throne when Ashurbanipal's armies made their ruinous sweeps through Khuzistan in the 640s.[1] Attameti and Attametu are likely Assyrian

renderings of the *name* Adda-hamiti-Inshushinak (just as Te-Umman is what Assyrian annals call the Elamite king called Tepti-Humban-Inshushinak in his own inscriptions). Thus it is possible, although not provable, that the *man* depicted on this stele is also the man referred to in these passages: a leader who participated in armed resistance to the Assyrians, came to power after Assyrian pressure provoked revolts in Elam, held Susa long enough to leave this extraordinary little monument there, and was succeeded within a few years by his son.

In the fragmentary Elamite inscription on the lower part of the stele, Adda-hamiti-Inshushinak gives himself titles and epithets that must have been drawn from the inscriptions of Middle Elamite kings: "King of Anshan and Susa, enlarger of the realm, master[?] of Elam, sovereign[?] of Elam." His assertion, in the text to the right of the figure, of his love for Susa and its people suggests that he himself did not originate there. In the main inscription he mentions his and a predecessor's activities at other places, notably at stations along the route from Susiana to the passes into Fars, and he invokes not only the god of Susa, Inshushinak, but also gods associated with Elamite territories in eastern Khuzistan. Like other Elamite leaders who confronted and evaded the Assyrians, it seems, he had his political base on the mountain fringe of Khuzistan, along the road to Anshan, and took possession of Susa when circumstances allowed. Therefore his grand historical titles were not empty, but they do reflect a precarious political reality.[2]

MWS

1. Maximilian Streck, *Assurbanipal und die letzten assyrischen Könige bis zum Untergange Niniveh's*, Vorderasiatische Bibliothek, vol. 7 (Leipzig, 1916), pp. 128f. vii 10, 144f. viii 73, 194f. no. 7:12.
2. See M.-J. Steve, "La fin de l'Élam: à propos d'une empreinte de sceau-cylindre," *Studia Iranica* 15 (1986), pp. 19f.; Steve *apud* J. Duchene, "La localisation de Huhnur," in *MM-JS*, pp. 65f.; Miroschedji, 1990, pp. 77–79; idem, "La fin du royaume d'Anšan et de Suse et la naissance de l'Empire perse," *ZA* 75 (1985), pp. 278f. For editions and conjectural translations of the texts on the stele, see Maurice Pézard, "Reconstitution d'une stèle de Adda-hamiti-In-Sušnak," *Babyloniaca* 8 (1924), pp. 1–26, and König, 1965, nos. 86–88.

141 *LA FILEUSE* (LADY SPINNING)
Bitumen compound
H. 3⅝ in. (9.3 cm); W. 5⅛ in. (13 cm)
Neo-Elamite period, ca. 8th–7th century B.C.
Sb 2834
Excavated by Morgan.

The complete scene on this small bituminous compound relief is unfortunately lost, but what is preserved is one of the finest works of Neo-Elamite art to survive from Susa.[1] A female figure sits in oriental fashion, with legs crossed beneath her solid, erect body. Her garment is plain except for its ornamented borders. She is spinning, for her right hand holds or turns a spindle, while her left hand holds the thread. The arms seem encumbered by six slightly penannular bracelets each, and the upper arms by armlets (or undergarment sleeves?). The composed face has a strong nose and chin, and full lips. The hair is tucked up and held by a ribbon, and strands surround the ear and fall loose on the forehead; this is the coiffure of a woman of significance. She is seated on a feline-footed stool, cushioned probably by a sheepskin that does not cover a projection at the back.

Behind the spinner is an unbearded servant with lovely curled hair, dressed in a long, plain, belted garment; six nonpenannular bracelets adorn each arm. The figure is probably a female, as would be appropriate.[2] She carries with both hands a large rectangular fan, to cool the air and chase away flies. In front of the spinner is a feline-footed stand with a bowl-like top containing a fish with six round objects on top of or behind it. Finally, in the lower right is what appears to be part of a garment. It has been interpreted as the garment of either a divinity or another seated figure.[3] However, if it were the latter one would expect feet to be visible (a seated figure would have to be facing the spinner), and the object actually touches the leg of the stand.

It is difficult to interpret the preserved scene.

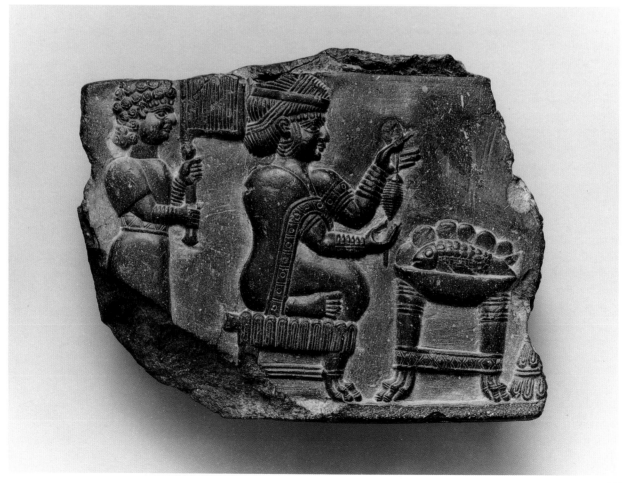

Some scholars have related it to the banquet scenes represented on small bronze nipple beakers that derive from western Iran (fragmentary examples have actually been excavated in Luristan), dated to the tenth or ninth century B.C.[4] In all features, however, the style of the beakers differs from that of the spinner plaque, and the only iconographical parallel is the presence of the fan bearer. But Edith Porada has recognized that a rectangular fan is carried by a servant depicted on earlier, Middle Elamite seals,[5] and there, significantly, it is held by both hands, whereas on the beakers it is held by one hand. Nor is there any iconographical indication that a banquet scene is represented on this plaque. Peter Calmeyer has suggested that we are viewing a religious event, with the spinner dedicating both the spindle and the fish to a deity.[6] But if that is so we must explain the casual seated position of the spinner and the presence of the personal fan bearer. Barthel Hrouda also sees this as a nonprofane scene, one connected with a cult of the dead.[7] The spinner spins the thread of life, fate, and Hrouda compares this figure to a spinner represented on what may be a funerary relief from Marash. But the question remains: is a banquet scene, for either the living or the dead, represented? I do not think so. Lacking the full scene, we can only speculate about what activity we are witnessing.

Those scholars who perceive an alleged relationship to the bronze beakers date the plaque to the tenth or ninth century B.C.; Jacques de Morgan assigned it to the eighth or seventh century B.C., a date that may not be far off.[8]

OWM

1. For bibliography, see Amiet, 1966, p. 540, no. 413, and below. Its locus is nowhere given.
2. Morgan (1900c, p. 160) thought the servant was a eunuch, and because of the curly hair, a black.
3. Ibid.; Porada, 1975, p. 386, no. 296a. The object does seem to be a garment, but it could also be a wing or a tail.
4. Amiet, 1966, no. 413; idem, 1988b, p. 112, no. 69; Calmeyer, 1973, p. 203; Porada, 1975, pp. 370, 386, no. 296a; Hrouda, 1990, p. 112, pl. 26:a.
5. Porada, 1965, p. 67 and figs. 23–25. Amiet, 1966, no. 414 (a banquet scene that Amiet compares to the spinner scene; see No. 149).
6. Calmeyer, 1973, p. 203 n. 433.
7. Hrouda, 1990, p. 112.
8. Morgan, 1900c, p. 160 (Sargonid period). Calmeyer stresses a Babylonian background, which is not very evident to me.

142 APOTROPAIC PLAQUE
Limestone
H. 5¾ in. (14.5 cm); W. 6⅛ in. (15.5 cm)
Neo-Elamite period, 8th–7th century B.C.
Sb 43
Excavated by Morgan.

Parts of all four sides of this plaque are preserved, enough to indicate that the scene represented is self-contained. A lotus pattern encloses the scene and a hole, surrounded by a rosette, pierces the plaque.[1] Two powerful figures are shown facing left, each in a smiting position. The left figure wears a fringed vest and skirt or a one-piece garment, with a triangular pendant, and on his head what seems to be a horned tiara. His right hand is held straight down in a fist; his left wields a dagger. Behind him is a figure dressed in the same type of skirt, with a sword at his waist. He has raptor feet, and the mane of what was originally a lion's head remains. He wields a mace in his right hand and originally held a dagger in his left.[2]

Although manifestly of Elamite background—as evidenced by the style, the hair form of the figure on the left, and the off-center hilt of the sword[3]—this scene matches, in iconography and in all details of style, one commonly seen in Neo-Assyrian art. Here too a figure with a lion's head and raptor's feet strides behind a smiting figure; the figures have the

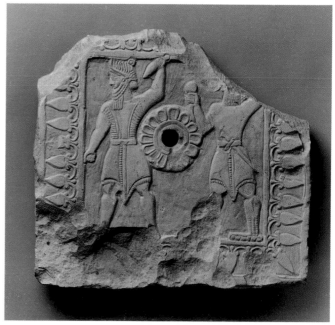

142

same posture and wield the same weapons as do those on the Susa plaque. In both cases their garments have a pendant (in the Neo-Assyrian scenes it is a separate unit below the skirt).[4] As Anthony Green has recognized, all the examples are apotropaic, created to ward off evil spirits and demons.[5] The Susa plaque was nailed to a wall to protect the inhabitants of a home or other structure.

The lotus border further emphasizes the Assyrian background of the plaque, which is surely to be dated to the late eighth or the seventh century B.C. The very same apotropaic scene continued into the early Achaemenid period, for it is represented in a large relief at Palace S at Pasargadae, built by Cyrus II.[6] Whether the Achaemenids received the concept from the Assyrians or the Elamites cannot be definitely determined, but one would tend to support the view that monumental art was probably the model for the relief at Pasargadae, rather than minor works such as the Susa plaque.[7]

OWM

1. The hole and rosette were apparently made after the figures were carved. The nail would have been disguised as the center of the flower.
2. Amiet, 1966, no. 407; A. Green, 1986, pp. 230–31, no. 149. The locus at Susa is nowhere given.
3. For the hair: Canal, 1976, pp. 85–86, fig. 14 (another stone plaque from Susa). For the sword: Hinz, 1969, p. 79; Calmeyer, 1988, p. 39.
4. A. Green, 1986, nos. 78, 79, 88, 89, 91, 92, 99–108.
5. Ibid., pp. 148ff.; Canal, 1976, pp. 84–85.
6. Stronach, 1978, p. 68, pl. 58, fig. 34.
7. For the view that this scene and another depicting a fish-garbed priest at Pasargadae derived from Assyria, see ibid., pp. 74–75, with other references.

GLAZED OBJECTS AND THE ELAMITE GLAZE INDUSTRY

In the fourth millennium B.C., glazing was used in Elam on ornaments and other objects; simple raw materials were enhanced by the creation of an attractive and colorful surface. Both glazed stones and man-made faience (glazed sintered quartz or other highly siliceous stone) were used. Grave goods at Susa dating to the Proto-Elamite period include glazed beads, ornaments, and cylinder seals.[1] In the late fourth millennium small glazed vessels appear in the graves,[2] and in the third millennium animal figurines as well as small vessels are found.[3] Similar material appears in Mesopotamia, beginning with beads in the later fifth millennium ('Ubaid levels).[4]

Not until the mid-second millennium were glazed objects in terracotta (new at this time) and faience made in quantity in the Near East. These were manufactured in centers controlled by the Kassites, Hurrians-Mitannians, or Assyrians, and in Elam. In the Middle Elamite period, beginning in the reign of Untash-Napirisha (ca. 1340–1300 B.C.) at Chogha Zanbil, a special terminology described glazed objects and bricks. The Elamite word *mushi* is thought to mean glazed terracotta, while *upkumia* occurs in inscriptions on glazed bricks describing the *kukunnum* sanctuary atop the ziggurat there.[5]

In the twelfth century the king Shutruk-Nahhunte I (1190–1155 B.C.) proclaimed that he was the inventor of a new technique (*akti*) for making bricks from a highly siliceous architectural faience (often called *grès émaillé* by the excavators[6] and more recently, *pâte siliceuse*) (see p. 123). By the time of the reign of the king Hallushu (Hallutash)-Inshushinak (698–693 B.C.) in the Neo-Elamite period, the same sort of bricks were inscribed with the word *uhna*, or stone, which indeed describes their appearance, similar to sandstone (*grès*).[7] Smaller objects such as vessels and statuettes were also made of the highly siliceous faience, but their consistency differs from that of the bricks.

The archaeological evidence in the Middle Elamite period begins with the glazed wall knobs found at Haft Tepe (reign of Tepti-ahar, fifteenth century B.C.). Some of these are probably faience and are thus the earliest architectural faience produced in Elam.[8] In the fourteenth century a great variety of glazed objects were produced at Chogha Zanbil: large glazed terra-

cotta plaques, knobs, decorated bricks, and winged bulls and griffins, plus the smaller faience statuary, vessels, ornaments, maceheads, and seals found in the ziggurat complex, in numerous temples, and in the *palais hypogée* (funerary palace).[9] Evidence of faience making was found in the workshop debris of the so-called temple of Kiririsha West.[10] Later Middle Elamite and early Neo-Elamite use of this site is documented by certain vessel shapes with parallels elsewhere—a faience carinated bowl with molded band found in the *palais hypogée* (cf. pottery from Ville Royale II, levels 10 and 9–8, and Malyan EDD IVA),[11] and fragmentary square and truncated conical boxes[12] (see below).

The lack of findspot information at Susa makes it more difficult to date glazed objects to specific dynasties. The Shutrukid kings, however, favored faience, and certain classes of inscribed architectural objects can be attributed to their twelfth-century reigns: quarter-rosette relief plaques (Shutruk-Nahhunte I), mushroom-shaped wall knobs (Shilhak-Inshushinak), and relief bricks that formed figural decoration[13] (see p. 125 and fig. 13, p. 11).

As at Chogha Zanbil, numerous vessels and statuettes of humans, divinities, and animals were found at Susa. Those that can be dated to the Middle Elamite period include votary figures from Acropole "deposits" (see Nos. 92–95) and round, molded boxes from the eastern Apadana excavations and the Ville Royale II, level 10 (late Middle Elamite).[14]

Quarter-rosette plaques were found at Malyan in the highlands, in the building of the late Middle Elamite period (end of EDD IVA, reign of Huteludush-Inshushinak, ca. late twelfth century B.C.). A later phase (IIIA, ca. 1000 B.C.) yielded a knob with a relief figure; if not a holdover, the knob indicates faience production into the early Neo-Elamite period.[15]

In Iran, unlike elsewhere in the Near East, faience-making persisted into the first millennium. In the Neo-Elamite period at Susa, earlier types of vessels and figurines continue according to relative stratigraphic contexts: molded cylindrical boxes (Ville Royale II, level 9–8),[16] small birds (Ville Royale II, level 8),[17] and decorated bricks.[18] New classes of objects were also made; among them were incised square and truncated conical boxes (Ville Royale II, level 9–8) (No. 145), figural protomes, and polychrome glaze-painted plaques (No. 144) and boxes (No. 146), some using black outlines for the first time. Comparable objects found at Surkh Dum, Chigha Sabz, and Karkhai

in Luristan (cylindrical, truncated conical, and square boxes, protomes, and bird figurines) demonstrate that interconnections existed in the faience industry at this time (Iron II–III period).[19]

Glazed terracotta became popular in the later Neo-Elamite period when different forms of bottles were included among tomb goods. Many are small and globular,[20] but some have pointed bases like those of contemporaneous glass vessels.[21]

Glazed objects were often intended for funerary use—for instance, knobs and plaques are dedicated to Ishnikarab, the chief intercessor of Inshushinak—and many glazed vessels come from tombs. Fragmentary texts from some of the eastern Apadana tombs refer to the great thirst of the deceased, who desire water as well as oil, and invoke Lagamal and Ishnikarab, the deities of the underworld who are intermediaries between the deceased and Inshushinak.[22] A glazed surface is impermeable to liquids and more suitable for long-term use than terracotta. Glazed objects may thus have been favored for special dedications and grave goods.

SH

1. Moorey, 1985, pp. 137, 142–43; technical analyses must be made in order to distinguish faience from glazed stone.
2. Ibid., pp. 143–44.
3. Ibid., pp. 144–46; for Susa *vase à la cachette* fragmentary faience vessel: Mecquenem, 1934, pp. 189–90, fig. 21, no. 9 (Sb 2723/54); for vessels and an animal figurine: Amiet, 1966, no. 172 b–d.
4. Moorey, 1985, pp. 137, 142–46.
5. Steve, 1987, p. 18; idem, 1968, p. 292 n. 5.
6. Steve, 1968, pp. 291–92; König, 1965, no. 17.
7. Steve, 1968, p. 293, especially n. 2.
8. Ferioli and Fiandra, 1979, pp. 310–11, figs. 4–6; fig. 4b is "frit" (i.e., faience) (E. Negahban, personal communication). For the new chronology of the early Middle Elamite period see Steve and Vallat, 1989, p. 226 and passim.
9. Ghirshman, 1966 and 1968, passim.
10. Ghirshman, 1966, p. 95; Carter and Stolper, 1984, p. 161 (should refer to Kiririsha West, not East).
11. Carter and Stolper, 1984, pp. 161–62, 184; Miroschedji, 1981b, p. 37; Ghirshman, 1968, pp. 59–74.
12. Mecquenem and Michalon, 1953, p. 44, fig. 7.
13. Plaques: Amiet, 1966, no. 300; for the date, see Steve, 1987, p. 29, no. 11. Knobs: Jéquier, 1900, pl. 4; König, 1965, no. 44. Bricks: Amiet, 1976d, pp. 13–28; Grillot, 1983, pp. 19–20, 22–23.
14. Susa pyxides: Mecquenem, 1922, pp. 127–28, fig. 9 (Sb 418) = Amiet, 1966, no. 372; Mecquenem, 1920ff. (*Rapport*), 1923, pp. 10–11; idem, 1924, pp. 115–16; idem, 1943, pp. 48–50, fig. 41:1 (Sb 420 and 421; vaulted tomb C, southeastern Apadana, at −10.25 m); see also: Miroschedji,

1981b, p. 38 n. 73 (tomb C as Middle Elamite in date); for Ville Royale II, *niveau* 10 fragment: ibid., p. 17.

15. Carter and Stolper, 1984, pp. 173, 188–89; idem, 1976, pp. 36, 38, fig. 1.
16. Miroschedji, 1981b, p. 38.
17. Ibid., p. 24, fig. 27:2.
18. Amiet, 1966, nos. 392, 395–400.
19. For Surkh Dum and Chigha Sabz: Schmidt, Van Loon, and Curvers, 1989, pls. 145d, 149j, 150a–b,d, 151b–c, 153a, 154c–d. For Karkhai: Vanden Berghe, 1973a, pp. 28–29.
20. Miroschedji, 1981b, p. 39, fig. 39, nos. 26–33 (*niveau* 7B tomb group).
21. Amiet, 1966, nos. 377–78; Mecquenem, 1922, p. 132, fig. 5.
22. Scheil, 1916, pp. 165–74; Mecquenem, 1920ff. (*Rapport*), 1920–21, p. 13; König, 1965, p. 84 n. 9; Bottéro, 1982, pp. 373–406, especially nos. 15 and 18.

143 STATUETTE OF A WORSHIPER
*Faience (*pâte siliceuse*); polychrome glaze: white, yellow, green*
H. 10¼ in. (26 cm); W. 4⅜ in. (11 cm)
Neo-Elamite period, ca. 8th–7th century B.C.
Southeast Apadana; Sb 458
Excavated by Mecquenem.

The angular features and stylized, crude execution of this piece set it apart from other small-scale statuary found at Susa. Articulated in glaze, now poorly preserved, are a yellow face with white eyes and mouth, yellow bracelets, and a green garment.[1] The hands are clasped high on the chest in prayer or supplication.

Other simply modeled but more fragmentary statuettes, with similar bell-shaped skirts (including the bustlelike back) and gestures, have been excavated at Susa, but their contexts and dates are unknown.[2] This complete statuette was found in the eastern Apadana excavations by Roland de Mecquenem near two tombs 20 to 26 feet deep (−6 to 8 m), both containing glazed terracotta vases and one also having iron arrowheads and fibulae, all associated with the Neo-Elamite period.[3]

A similar crude stylization is also found in statuette fragments from Luristan. Heads from Surkh Dum (Iron Age, ca. 800–600 B.C.) with prominent noses and chins, heavy brows, and caplike hairdos can be roughly compared to the Susa piece. A headless faience statuette from that site has the same broad, angular shoulders and columnar shape, and cast metal pin-head figures recall the gesture, profile, brows, and hairdo of the Susa piece.[4] All of these objects point to close connections between the art of Susa and Luristan in the Neo-Elamite period.

SH

1. Amiet, 1966, no. 365; Spycket, 1981, pp. 390–91, pl. 251.
2. Spycket, 1981, p. 390 (Sb 6726); also, Musée du Louvre, Département des Antiquités Orientales: E584 (bust only), F285, 8639.
3. Mecquenem, 1922, pp. 125–26, fig. 7 (*parvis est, coupe au sud*, tombs C and D, at −6 to 8 m); idem, 1920ff. (*Rapport*), 1920–21, pp. 8–11 ("*niveau supérieur*," Neo-Elamite period).
4. Schmidt, Van Loon, and Curvers, 1989, pp. 234, 244 (heads Sor 458, 1003), pl. 146 a, d; pp. 246–47, 252, pl. 153c (statuette Sor 79); pp. 271, 310–11, pl. 182b, d (bronze pin heads Sor 1132, 665).

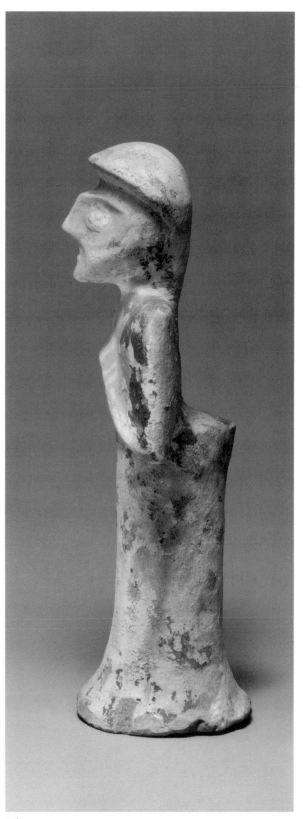

143

Side view

144 PLAQUE WITH FANTASTIC ANIMALS
*Faience (pâte siliceuse); polychrome glaze; yellow,
blue-green, white, with black outlines*
H. 7⅛ in. (18 cm); W. 7⅞ in. (20 cm); D. 1 in.
(2.5 cm)
*Neo-Elamite period, ca. 8th century B.C.
Ville Royale II, lower level; Sb 3352
Excavated by Mecquenem, March 3, 1927.*

This well-known fragment is the best preserved of
several polychrome faience plaques with a similar
five-figure composition excavated at Susa.[1] On this
example a demon with bird claws, wearing a fringed
garment with elaborate tasseled belt, stands on two
couchant lion-griffins while dominating feline mon-
sters; the left monster is partly preserved. The deco-
rative borders are made up of a guilloche and
crosses. The excavator stated that a two-colored ro-
sette knob was found with the fragment; it would
have fit in the central hole, in the torso of the
demon, for attachment of the plaque.[2]

The plaque and knob were found in one of the old
southwestern Ville Royale excavation trenches by
Roland de Mecquenem. These and other fragmen-
tary polychrome glazed plaques, wall knobs, tablets,
and stone figurines found nearby may have been as-
sociated with a temple on a *massif* that was sur-
rounded by an Elamite cemetery. Some plaque
fragments were found in the lowest level below the
so-called Neo-Babylonian, and Achaemenid, levels.[3]

The technique of outlining polychrome designs
with a black glaze sets some of these plaques apart.
Perhaps the earliest, a securely dated Elamite exam-
ple of the technique, is on a glaze-painted faience
box (No. 146) excavated in the Ville Royale A and
dated to the ninth century B.C. (early Neo-Elamite
period). Contemporary use of such outlines is found
on ninth-century and later Neo-Assyrian wall
plaques, and comparable types are found at Hasanlu
(level IVB).[4]

The composition of felines with one leg poised
on a demon has parallels in the glyptic of the Neo-
Assyrian, Neo-Babylonian, and Neo-Elamite pe-
riods.[5] In the art of Luristan, a bronze horse bit has
winged lions that stand in the same manner.[6] A date
in the early Neo-Elamite period seems appropriate
for this finely executed plaque.

SH

144

1. Mecquenem, 1928a, pp. 170–71, fig. 1; idem, 1943, pp. 38–39, fig. 31(3); Porada, 1964, pp. 29, fig. 3c, 30; idem, 1965, pp. 68–69, pl. 14 bottom, pp. 76, 78; Amiet, 1966, no. 383; idem, 1967, pp. 31 n. 2, 33; idem, 1972a, p. 273 n. 2; Moorey, 1971, p. 124; Porada, 1975, p. 387, pl. 35; Amiet, 1988b, p. 115, fig. 72. Other examples: Amiet, 1966, nos. 386, 391; Louvre Sb 3347, unpublished.

2. Mecquenem, 1928a, p. 171; idem, 1943, p. 40, fig. 33(4); cf. Amiet, 1966, no. 301.

3. Found 1927, Ville Royale II *"niveau inférieur"*: Mecquenem, 1920ff. (*Rapport*), 1926, p. 17 (an Inshushinak temple); ibid., 1927, pp. 5, 13 (*chantier C, "grand sondage"*); ibid., 1980, pp. 35–36; idem, 1922ff. (*Journal*), 1927. Other plaque fragments: idem, 1943, figs. 31:1 (same as Amiet, 1966, no. 386), 32:2 (same as Amiet, 1966, no. 391).

4. Andrae, 1925, pls. 7–8, 31–32; Pauline Albenda, "Decorated Assyrian Knob-Plates in the British Museum," *Iraq* 53 (1991), pp. 43–53, passim; de Schauensee, 1988, p. 49, fig. 18.

5. Smith, 1928, pl. 21e (B.M. no. 99.406); Porada, 1947, pp. 155–56; Amiet, 1973a, p. 8.

6. Johannes A. H. Potratz, "Das 'Kampfmotiv' in der Luristan Kunst," *Orientalia* 21, no. 1 (1952), Tab. II:5.

145 BOX WITH STRIDING MONSTERS
Faience (pâte siliceuse); traces of monochrome glaze
H. 6¾ in. *(17 cm)*; W. 6⅞ in. *(17.5 cm)*
Early Neo-Elamite period, ca. 9th–8th century B.C.
Apadana, west court; Sb 2810
Excavated by Mecquenem, March 28, 1935.

One of the finest of Elamite faience pyxides, this square piece carved in low relief has representations of two types of striding monsters, framed by hatched borders, on opposite sides: human-headed, bearded, winged leonine sphinxes wearing horned headdresses with bovine ears; and griffins flanking trees. Full rosettes and quarter-rosettes are filler motifs. A guilloche that runs around the top is interrupted by two pierced female heads that serve as handles and anchors for the missing lid.[1]

The piece was excavated by Mecquenem on the Apadana mound under the floor of the western court of the Achaemenid palace. It was found at the lowest level, along with other fragmentary vessels, glazed objects, and burned material including animal bones. This level is earlier than the so-called

145, two views

Neo-Babylonian (i.e., late Neo-Elamite) level, whose assemblage of objects was different.[2]

In Luristan at Karkhai, a similar pyxis with incised decoration was excavated in a tomb dating to the end of the Iron II period (eighth century B.C.).[3] That find supports an early Neo-Elamite date for the Susa box.

Art-historical parallels for the sphinx representations on this piece include similar images on Iranian beakers (ca. tenth to eighth century B.C.)[4] and on Middle Assyrian, Middle Elamite, and later Kassite and Isin II seals.[5] At Susa, winged sphinxes appear in the Neo-Elamite period as figural knobs, and similar head types exist on bull-god knobs.[6] The motifs of griffins, trees, rosettes, guilloches, and hatched borders also appear on incised, curved vessel fragments from Chogha Zanbil (unstratified outside the *temenos*; later Middle Elamite to early Neo-Elamite) and Surkh Dum (ca. 750–650 B.C.).[7] Griffins are also represented on Neo-Elamite glaze-painted bricks from Susa and elsewhere in Iranian art, including Luristan bronzes.[8]

SH

1. Amiet, 1966, no. 375; idem, 1988b, pp. 112–13, fig. 68; Porada, 1965, pp. 70–72, fig. 46.
2. At a depth of −6 m; *parvis ouest*. Mecquenem, 1943, pp. 35–36, fig. 28; idem, 1920ff. (*Rapport*), 1934–35, p. 7; idem, 1980, p. 43; idem, 1922ff. (*Journal*), March 28, 1935.
3. Vanden Berghe, 1973a, pp. 28–29 (tomb 1).
4. Porada, 1965, pp. 70–72; Muscarella, 1974b, pp. 248–49.
5. Kantor, 1958, pl. 75, no. 96; Moortgat, 1940, no. 580; Porada, 1970, pp. 75–76, nos. 88–90; Beran, 1958, pp. 259–61, Abb. 3; Moortgat, 1940, no. 688, pp. 71–72.
6. Sphinxes: Amiet, 1967, pp. 36–37, fig. 8; bull-gods: ibid., pp. 38–40, figs. 9b, 10b, 11; Mecquenem, 1943, pp. 49, 64, fig. 53:4.
7. Chogha Zanbil: Mecquenem and Michalon, 1953, p. 43, fig. 7 (1–5). Surkh Dum: Amiet, 1976a, p. 60, fig. 39; Schmidt, Van Loon, and Curvers, 1989, pp. 247–48, 490, pls. 151b, 154d (Sor 21).
8. Amiet, 1966, nos. 396–97, 400A; idem, 1976a, p. 59, no. 114.

146 BOX WITH GAZELLES

Faience (pâte siliceuse); pale green glaze with black outlines
H. 4⅜ in. (11.2 cm); W. 4⅝ in. (11.8 cm)
Early Neo-Elamite period, ca. 9th century B.C.
Ville Royale A, chantier A IX, tomb 27; Sb 4604
Excavated by Ghirshman, 1953–56.

Of all the faience pyxides found in Elam, only a few have glaze-painted decoration. This square one has gazelles passant on each side with a double hatched border at the top and hatched triangles around the bottom. Two pierced lugs hold the lid, which is decorated with leaf motifs filling a square. The background and interior color is now pale green, and the decoration is drawn with black outlines.

The box was excavated in the Ville Royale, *chantier* A, in an intrusive tomb that had been cut into level IX (ca. 1050–900 B.C.), and was dated to about the ninth century because of comparable pottery types found in Ville Royale II, level 9. Another glaze-painted pyxis with no preserved decoration comes from Ville Royale A IX as well, but its context is unpublished.[1]

The gazelles, with large eyes and flanks articulated by bars and necks by "collars," are executed in a stiff, awkward manner. They recall lesser-quality

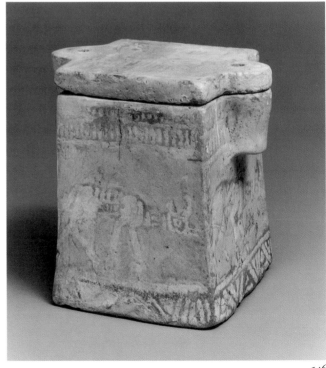

glaze-painted faience wall plaques of the Neo-Elamite period found at Susa, especially one with a poorly drawn passant bull with similar articulated details.[2]

The lower, hatched-triangle border is most similar to those on faience pyxides, both square and in the shape of truncated cones, from Luristan (Karkhai and Surkh Dum) and is exactly paralleled on a seal from Chogha Zanbil dated by Edith Porada to the first millennium.[3] Plain hatched bands are common on faience pyxides in general (see No. 145), including a glaze-painted one from Susa that also has a molded female head as a handle.[4]

The variety of styles seen among faience pyxides found in Elam and Luristan in the first millennium suggests that they were made by different hands and workshops, perhaps by itinerant craftsmen.

SH

1. Sb 4604 (G.S. 3546, tomb 27, A/IX), unpublished. The tomb was renumbered as 226 for a forthcoming publication in *MDP* 48 (H. Gasche, personal communication). For context and date: Steve, Gasche, and De Meyer, 1980, pp. 57–60, 76–78; for ceramic comparanda (reference courtesy of H. Gasche): Miroschedji, 1981b, fig. 23:4–5. Plain glaze-painted pyxis: Sb 4603 (G.S. 3435, A/IX, tomb 11), Département des Antiquités Orientales, Musée du Louvre.
2. Amiet, 1966, no. 391; Porada, 1965, pl. 14, top.
3. Karkhai: Vanden Berghe, 1973a, pp. 28–29. Surkh Dum: Amiet, 1976a, p. 60, fig. 39; Schmidt, Van Loon, and Curvers, 1989, pls. 151 b, 154 d (Sor 21). Chogha Zanbil: Porada, 1970, pp. 99, 103, no. 122 (temple of Simut and Nin-Ali).
4. Musée du Louvre, archive of the Département des Antiquités Orientales, excavation photo (unnumbered), context unknown.

147 HEAD WEARING ELABORATE HEADDRESS
Faience (pâte siliceuse); polychrome glaze: white, yellow, light green
H. 2⅝ in. (6.8 cm); W. 2⅛ in. (5.4 cm)
Early Neo-Elamite period, ca. 9th–8th century B.C.
Southeastern Apadana; Sb 457
Excavated by Mecquenem, 1921.

Of a group of statuette heads excavated at Susa, this is one of the finest and best preserved. The heart-shaped, smiling face has large eyes in white outlined in blue-green, and the visorlike headdress has bovine ears, a striated pattern, and a bulbous topknot, which almost looks like part of the hairdo, secured by the headdress.

This object was found east of the Apadana palace, where a large Elamite necropolis was discovered[1] and

147

where several other weathered faience heads of deities wearing differently styled horned headdresses with bovine ears were also found.[2] At least one comes from the same level as this head, −26 feet (−8 m), in the *"étage inférieur"* with faience vessels just above the level of the Middle Elamite temple floor and its debris (26 to 31 feet [8–9.5 m] in depth), but below the late Neo-Elamite material (*"étage supérieur"*).[3]

Another glaze-painted faience head, poorly made but with the very same knobbed headdress, details, and colors as this head, was excavated at Susa, but its context is unknown.[4] Different versions of high-crowned headgear are seen in Elamite art, usually with horns indicating divinity, as on the stele of Untash-Napirisha (No. 80), the bull-men on the Shutrukid baked brick relief facade (No. 88), the bull-god faience protomes, and the sphinxes on a faience pyxis (No. 145).[5]

Close parallels for the knobbed headdress worn on the statuette head appear on a deity and attendants on a seal dated to the Middle Elamite period (though in this case it is not clear whether bovine ears are present).[6] Because our piece lacks horns, it is not certain whether the head is divine; perhaps it represents a lesser deity identified by the bovine ears.

SH

1. E. 110, excavated 1921, Apadana, *parvis est, coupe au sud*, at −8 m: Amiet, 1966, no. 367; Mecquenem, 1922, p. 126, pl. 5 upper right; idem, 1920ff. (*Rapport*), 1920–21, p. 10 (*étage inférieur*).

2. Sb 3580 (E. 90), excavated 1921, Apadana, *parvis est, coupe au sud*, at −8 m: Amiet, 1967, pl. 5, 3, and see idem, 1966, p. 492; Mecquenem, 1922, p. 127, pl. 5, upper left (same as Mecquenem, 1943, p. 64, fig. 53:1–2). Sb 6659 (D.112; E. 439): Amiet, 1967, pl. 6, 1; idem, 1966, no. 369.

3. Mecquenem, 1920ff. (*Rapport*), 1920–21, pp. 8–11; idem, 1922, p. 127.

4. Sb 3583; Mecquenem excavation, 1933.

5. Protome: Amiet, 1967, figs. 9–10.

6. Porada, 1986, pp. 181–85, fig. 1 (British Museum).

148 BULL KNOB

Faience (pâte siliceuse); traces of green glaze, restored
H. 4⅝ in. (11.8 cm); L. 3 in. (7.5 cm); W. 2¼ in. (5.6 cm)
Neo-Elamite period, ca. 8th–7th century B.C.
Sb 6711
Excavated by Morgan.

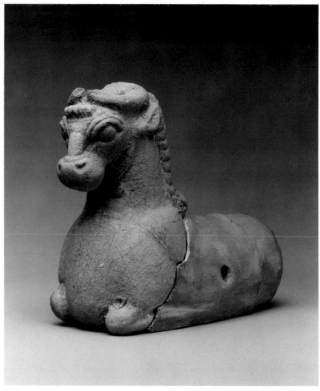

148

Knob figurines, protomelike sculptures decorating architecture or furniture, are found as early as the third millennium at Susa and also in Mesopotamia and Syria.[1] Faience examples were found in different but poorly documented locations at Susa (many of which may be temple sites); it is unclear whether any are Middle Elamite in date.[2]

Bull-knob figurines are the most numerous among the various types of these sculptures, which include bull-gods, "sphinxes," other fragmentary winged creatures, horses, monkeys, and humanlike figures.[3] This piece, with its elegant, mannered style and modeled details, is certainly the finest known example. The mane is decoratively braided and the long pendent curls and crownlike horns give the bull a supernatural quality that suggests the world of monsters. The figurine has been compared to the couchant griffins on the well-preserved Neo-Elamite polychrome glazed wall plaque with a demon dominating a feline creature (No. 144).[4] Several similar fragmentary bull protomes exist, some executed by other hands,[5] as well as miniature versions such as one attached to a vessel.[6]

In Luristan at Chigha Sabz (Iron III period), a closely related bull knob was found[7] that helps to confirm the Neo-Elamite date of the Susa piece. Similar couchant bulls appear on Luristan bronzes both in the round and chased on sheet metal.[8]

Prototypes for the Elamite knob protomes may perhaps be sought in Kassite art, where couchant animals and forequarters of creatures are depicted as symbols of deities on *kudurrus*;[9] many examples of these were taken to Susa by the Shutrukid kings (see Nos. 115, 116) and probably set up in the temples on the southwestern Acropole. A number of them may still have been visible in Neo-Elamite times. The Neo-Elamite knob figurines, in turn, may very well have inspired the addorsed bull capitals of the later Persian *apadanas*.

SH

1. Amiet, 1976c, p. 59 n. 55, pl. 16; idem, 1967, p. 31; Parrot, 1967a, pl. 74, no. 2274 (Mari).

2. Heim, 1989, pp. 200–202.

3. Amiet, 1967, passim, figs. 5–13, pl. 5, 1–2.

4. Porada, 1965, pp. 68–69, pl. 14.

5. Unpublished examples, Musée du Louvre, Sb 6721, 6722, 6724, 4279, M.-27. Other styles: Sb 6712, 3077 (Amiet, 1967, pl. 5, 1; p. 32, fig. 3).

6. Ibid., p. 33, fig. 4.

7. Schmidt, Van Loon, and Curvers, 1989, pp. 24, 233 (25B.6), pl. 145d.

8. Halberd, horse bits, disk-headed pins: Amiet, 1976a, pp. 38, 58, 61, 63; idem, 1966, no. 382; Moorey, 1971, pp. 213–14, no. 361.

9. King, 1912, pl. 91 (bull).

SEALS

149 CYLINDER SEAL WITH BANQUET SCENE
Faience
H. 1⅜ in. (3.6 cm); DIAM. ½ in. (1.2 cm); string hole
⅛ in. (.3 cm)
*Middle or Neo-Elamite period, late 2nd–early 1st
millennium B.C.*
Sb 6177
Excavated by Mecquenem, 1923.

This seal, which is rather crude in style, was initially placed in the Neo-Elamite period by Pierre Amiet, who related it to the figures of a seated lady and attendant on a plaque dated to the eighth to seventh century B.C. (No. 141).[1] The imagery on the seal can also be compared to that on faience cylinders of the Middle Elamite period, leaving some doubt regarding its date of manufacture—a situation reflected in Amiet's later dating of the piece to the Middle Elamite period.[2] We have no information regarding the seal's findspot.[3]

The central figure, drinking from a cup, wears a long Elamite robe with a fringed hem and sits on a stool. Before the figure is a table laden with vessels and an attendant who stands holding a rectangular fan in both hands. Both figures have distinctive Elamite coiffures that protrude at the front. The figures, rudely executed, are squat with large heads, exaggerated features, and flat, unmodeled bodies. A slightly raised, sharply curving outline defines the back of the head, shoulders, and waist. The table is rendered from two viewpoints: the bovine legs are seen head-on, while three vessels rest on one line of the rectangle that defines the tabletop as seen from above.[4]

A banquet, with an attendant (often holding a fan) before a seated figure and with food and drink in evidence, is one of the most common themes on faience cylinder seals that were perhaps left as offerings in chapels of the great sanctuary at Chogha Zanbil. A scene representing attendance in the royal court could, by analogy, refer to homage in the divine sphere. In all examples, however, the seated figure has no distinctively divine attributes. The inscription on many Chogha Zanbil seals of this type, but lacking here, is a prayer that invokes both god and king as protective forces.

The designs of banquet scenes and images on other seals from Chogha Zanbil (see discussion for No. 103) derive in part from the Kassite glyptic tradition of Babylonia. Differences include their rather cursory linear style and the placement of a rich array of food and vessels on the table.[5]

JA

1. Amiet, 1966, p. 541, no. 414. Porada (1962, p. 50) dates a similar seal to the early Neo-Elamite period (9th–8th century B.C.) and refers to the seated figure's pointed headgear; see also Edith Porada, ed., *Ancient Art in Seals* (Princeton, 1980), p. 30, fig. I-12.
2. Amiet, 1972a, p. 268, no. 2063, pl. 179; Collon, 1987, pp. 68, 69, 86, 88, no. 406.
3. Mecquenem, 1925, pp. 9–10, 15, no. 46.
4. This contrasts with the table on No. 141, which is rendered as one would perceive it.
5. This style has similarities to the later Neo-Assyrian linear style: Porada, 1948, pl. 97, no. 666.

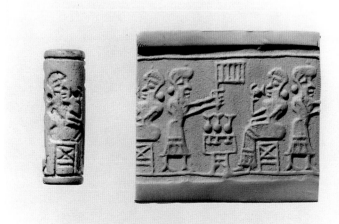

149 Modern impression

150 CYLINDER SEAL WITH ANIMAL MUSICIANS
Red marble
H. ⅞ in. (2.25 cm); DIAM. ⅜ in. (1 cm); string hole
⅛ in. (.3 cm)
Neo-Elamite period, 7th century B.C.
Sb 6281
Excavated by Mecquenem, 1928.

During the 1927–28 campaigns conducted by Mecquenem, a number of cylinder seals were discovered on both the Acropole and, in a funerary context, the Ville Royale mounds.[1] No further information exists on the specific archaeological findspot of Number 150, which came to light in those excavations. It has been dated on stylistic grounds to the Neo-Elamite period.[2] Its style is derived in part from the glyptic style of the late Middle Elamite period (see No. 104); the dynamic figures do not adhere to a single ground line and have curving, attenuated bodies with arched necks. The scene is of four animals taking part in a musical performance. An upright horse holding a harp with its front legs is confronted by a rampant lion with a rectangular object that seems to be suspended from a cord around its neck—perhaps a drum seen from the side. Between the two animals a tiny quadruped stands, one leg raised in a position known for human dancers.[3] Another small equid stands upright behind the lion in the upper field, playing a double flute.[4]

The harp depicted on the seal is defined by an upper diagonal line, a horizontal line for the soundbox, and four strings, two of which hang down from the bottom of the instrument. On the basis of the study of actual surviving instruments from a much earlier context—the royal cemetery at Ur in southern Mesopotamia (2600–2400 B.C.)—some scholars believe that this type of harp is simplified in the depiction and actually had many more strings.[5] Finds from that cemetery include harps and lyres made of precious materials, some lyres embellished with the heads of bulls.

Double pipes are less frequently depicted, but they occur along with harps and drums on an Assyrian relief from Nineveh depicting Elamite musicians.[6] The shape of the object held by the lion on the seal shown here is unusual for Near Eastern representations, where drums are generally shown in top view as circular or in side view as kettle-shaped.

In the Near East, images of musicians occur on a variety of objects, ranging from imposing architectural reliefs to seals and terracotta plaques. Musicians have a place in the royal activities of war and hunt and are represented on courtly objects, such as the lyre and inlaid standard from Ur. They are also depicted on objects with religious symbols, such as a Kassite *kudurru* found at Susa (No. 116).

Scenes of animals in human attitudes have been regarded as illustrations of myths or fables. Notable Sumerian examples depicting animal musicians come from Ur: one is an inlay on one of the surviving lyres with a scene of a seated equid playing a fanciful lyre with a bull-shaped soundbox, assisted by a bear and a smaller creature with a rattle; another is a seal with a row of standing equids playing harps.[7] A scene on one of the large orthostats from the palace at Tell Halaf in northern Syria, depicting a seated lion playing a lyre in the company of other animal musicians,[8] dates to the early first millennium B.C.

These animal musicians are different from Near Eastern demons, who also stand like humans but mix anthropomorphic and animal features (see No. 80). They more closely resemble the animal musicians and game players that illustrate Egyptian satirical papyri.[9]

JA

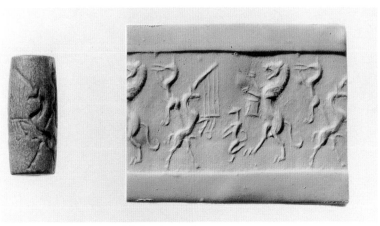

150 Modern impression

1. Mecquenem, 1928a, p. 169.
2. Amiet, 1972a, p. 282, no. 2184, pl. 188; Mecquenem, 1928a, pp. 169 no. 1, 175 no. 1.
3. Porada, 1948, pls. 74–75, nos. 555–56. For another Susa seal with this motif, see Amiet, 1972a, p. 277, no. 2136.
4. Amiet, 1972a, p. 282, no. 2184, pl. 188.
5. Duchesne-Guillemin, 1981, p. 292.
6. Rimmer, 1969, pp. 34–36, pls. 13, 14.
7. Orthmann, 1975, pl. 9; Galpin, 1937, pl. 5.
8. M. von Oppenheim, 1955, pl. 100.
9. Emma Brunner-Traut, *Altägyptische Tiergeschichte und Fabel* (Darmstadt, 1970), pp. 9ff., fig. 4.

151 CYLINDER SEAL WITH HUMAN-HEADED WINGED CREATURE AND INSCRIPTION
Blue chalcedony
H. ⅝ in. (1.7 cm); DIAM. ⅜ in. (.8 cm); string hole ¹⁄₁₆ in. (.2 cm)
Neo-Elamite period, late 7th–early 6th century B.C.
AOD 109

During the late seventh and early sixth centuries B.C., a fine style of seal carving emerged in Elam. It is characterized by dynamic, boldly modeled figures of real and fantastic animals, the former appearing mainly in scenes of hunt and war and the latter depicted alone or in formal groups. The seal from Susa is a very beautiful example of the latter type and shows a striding supernatural creature with the body of a bull, the head of a bearded human but with goat's horns, and long, curving wings. The human-headed winged bull, or *lamassu*, is a protective figure, perhaps best known from the colossal sculptures in Assyrian palace gates and doorways.[1] The spirited figure on this seal struts with a full chest, one leg forward, and one rear leg extended back. The beast's body is strongly modeled, with a definition of the musculature that may be seen as a precursor of the Achaemenid seal style.[2] The animal figure is

framed by an inscription: "Shuktiti, son of Huban-ahpi."[3]

Prancing animals are depicted on glazed bricks associated with a small Neo-Elamite temple on the Susa Acropole that has been dated to the time of Shutruk-Nahhunte II (716–699 B.C.).[4] However, the closest parallels for the motif of a single animal with an inscription are on seal impressions on administrative tablets, found at both Susa and Persepolis. One example with a striding winged human-headed creature occurs on a tablet that is part of a group of documents found near the Neo-Elamite temple at Susa, but in an archaeological level said to postdate the Assyrian destruction of about 646 B.C.[5] A royal seal of the same type, inscribed with the name of the son of the Elamite ruler Shutur-Nahhunte, also points to the dating of this glyptic in the period between the Assyrian devastation and the Achaemenid domination in the late sixth century B.C.[6] It is engraved with a formal composition of two upright *mushhushshu* dragons supporting a central spade, the symbol of the deity Marduk.

The imagery on these late Neo-Elamite seals is derived from Mesopotamia. However, their style—which combines strong modeling with a tendency to divide the musculature into discrete decorative parts—together with the somewhat exaggerated postures, may demonstrate an Elamite legacy that is manifest in the art of the Achaemenid empire (see No. 169). JA

1. Crawford, Harper, and Pittman, 1990, p. 25.
2. Delaporte, 1920, pl. 53:12, D116; Amiet, 1973a, p. 20, pl. 7:43.
3. ˡŠu-uk-
 ti-ti
 DUMU *Hu-*
 ban-a-
 ah-pi-na
 (The transliteration and translation were provided by Matthew W. Stolper, who follows Delaporte.)

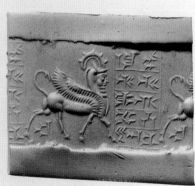

151 Modern impression

4. Amiet (1966, pp. 518–21, figs. 395–99) suggests that they formed a podium; idem, 1967, pp. 27–28.

5. Amiet, 1973a, pp. 3–4, 11, no. 13, pl. 3:13.

6. Amiet, 1973a, p. 18, pl. 6:34.

152 CYLINDER SEAL WITH MAN IN "MEDIAN" DRESS AND HERO CONQUERING BULL

Gray schist

H. 1⅛ in. (3 cm); DIAM. ½ in. (1.3 cm); string hole ⅛ in. (.3 cm)

Neo-Elamite–early Achaemenid period, late 7th–6th century B.C.

Ville des Artisans; Sb 1475

Excavated by Mecquenem.

This seal is reported to come from the Ville des Artisans, an area with remains from Achaemenid and later periods.[1] The engraving combines two themes: a Neo-Assyrian contest scene with a conquering hero subduing a bull by holding its legs and stepping on its head;[2] and a man possibly in Median dress, reminiscent of one of the processional figures on the Persepolis reliefs (fig. 53, p. 237).

The bearded conqueror lacks the wings of many "masters of animals" but has a tiny horn protruding from his head, which could indicate his divinity.[3] He wears a long togalike robe that is wrapped to allow freedom of movement for his left leg. His lowered right hand holds a curved weapon, the *harpé*. In both posture and choice of arms, this figure recalls depictions of warriors subduing human enemies on Babylonian seals (No. 72).

The standing figure, holding a spear with its tip upward, is wearing garments like those described by Herodotus as Median in origin: "soft felt cap, embroidered tunic with sleeves . . . and trousers."[4] His full hat has a flap hanging at the back over the hair; the short clothing has a fringe; and his leggings have a cross-hatched pattern. Pierre Amiet calls this figure an "Iranian warrior" and dates the seal to the period of Assyrian domination around 650 B.C.[5] While this date seems appropriate for the contest scene, it may be problematic for the dating of the warrior, who wears a costume otherwise first known in the Achaemenid period.[6]

JA

1. Amiet, 1972a, p. 281, no. 2181, pl. 187.

2. This version of the contest scene dates back to the early second millennium, where it occurs on Old Babylonian and Anatolian seals: Collon, 1987, pp. 46 fig. 159, 176 fig. 834.

3. Porada (1948, no. 747) depicts a conquering winged divinity with a tiny point protruding from a diadem.

4. Herodotus VII 62,1: *Herodotus: The Histories*, trans. Aubrey de Sélincourt (Harmondsworth, 1954), pp. 438–39; for the Median cap with hanging earflaps, see E. Ebeling and B. Meissner, *RLA* (Berlin, 1987–90), vol. 7, p. 615, fig. 1.

5. Amiet, 1973a, p. 17. For a commentary on the diverse population groups in the vicinity of Susa during the later Neo-Elamite period, see Matthew Stolper, below, page 259.

6. Amiet (1973a, pp. 16–17, no. 30) points to the earlier appearance of the full bonnet on Iranian seals and on an Assyrian relief.

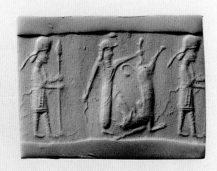

152 Modern impression

SUSA IN THE ACHAEMENID PERIOD
CIRCA 559–330 B.C.

*A*fter Susiana fell to the Assyrians in 646 B.C., the Elamites were no longer a major political force. By the middle of the sixth century they had come under the rule of the Persians, whose powerful Achaemenid dynasty rapidly conquered a vast territory. The Elamites became subordinate partners and were absorbed into that new, Iranian empire. Darius the Great (522–486 B.C.), recognizing the traditional importance of the old Elamite capital of Susa, fortified it and made it his lowland capital. Once more Susa was under the control of a highland dynasty, and again it became a vital, cosmopolitan city and a locus of interchange between peoples of the Mesopotamian plain and the Iranian highlands.[1]

In January of 330 B.C., Alexander of Macedon left Babylon for Susa, which surrendered as he approached. The palace of Darius had been abandoned, but the vast wealth of its treasury was intact, and the city was peacefully occupied. From Susa, Alexander marched to Persepolis, which experienced a different fate—plunder, massacre, and destruction—bringing the Persian empire to an end.

1. Miroschedji, 1985, particularly pp. 303–5.

Achaemenid Art and Architecture at Susa

*A*lthough ancient texts inform us that Cyrus II (The Great: 559–530 B.C.) called himself King of Anshan, which implies that he controlled Elam and Susiana,[1] no evidence of his sovereignty there or of that of his son and successor Cambyses (530–522 B.C.) has been recovered. Extensive excavations conducted over the course of a century have in fact yielded not one Achaemenid structure or inscription at Susa dating or referring to a time before the reign of Darius I (522–486 B.C.).[2] The Achaemenid remains at Susa are less extensive than those at Persepolis, and they seem to be the work of only two Achaemenid kings: Darius I and his great-great-grandson, Artaxerxes II (404–359 B.C.).

It is of course not improbable that structures were built at Susa by other Achaemenid kings, as at least one ancient source states (Strabo XV:3.21), but were later destroyed by post-Achaemenid building activity. Indeed, fragmentary inscriptions of Xerxes (486–465 B.C.) and allegedly, of Darius II (424–404 B.C.) have been recovered at Susa, but they are more ambiguous with regard to building activities presumably mentioned in them than has been recognized.[3] Nevertheless, some scholars believe, on the basis of these incomplete inscriptions, that structures, palaces, and an *apadana*, or columned hall, in addition to the complexes of Darius I and Artaxerxes II, existed at Susa,[4] perhaps in the area of the Donjon at the southern part of the tell, where stone reliefs have been recovered (see below). Surely, further analysis of the inscriptions is required before secure conclusions are drawn about the existence of royal structures other than those already revealed by archaeology.

The remains of Darius I's building activities are mainly on the so-called Apadana mound, the northwestern part of the tell; only a propylaion and gate were recovered on the eastern Ville Royale.[5] On a great gravel platform some 60 feet (18 m) in height and 32 acres (13 ha) in area, Darius I constructed an architectural complex comprising two units: one residential, his palace, in the south, and one official, an *apadana*, in the north. Both are oriented north-south. To the east of the palace he built a monumental gate, oriented east-west, that led to the compound or esplanade.

The monumental gate, 130 by 100 feet (40 × 30 m), consisted of a central hall with four columns—the passageway—flanked by two rectangular rooms, each of which had a spiral stairway that led to a second story or to the roof. An inscription on the columns reveals that Darius built the gate. It was here at the interior southwestern flank of the passage, facing the palace, that a fragmented, over-life-size statue of Darius I was found in situ (fig. 50, p. 220, and see No. 153).[6]

The *apadana*, 358 feet square (109 × 109 m), is the northernmost structure on the esplanade; its entrance is at the south, facing the nearby palace, from which it is separated by a court. It consists of a large hall 190 feet square (58 × 58 m) containing thirty-six columns, flanked on its four corners by towers and on its three long sides by columned porticoes, each with two rows of six columns. Four of the column bases bear an inscription of Artaxerxes II (A2Sa) recording that the *apadana* was built by Darius I, burned in the reign of Artaxerxes I (465–425 B.C.), and restored by him. Except for the absence of a great stairway for the main entry, the *apadana*'s square plan is similar to that of the *apadana* at Persepolis, planned by Darius; however, it is unlike that of the earlier, rectangular columned hall at Pasargadae ("Palace P").

The palace, to the south, was also constructed by Darius I, as is indicated by inscriptions on clay and stone tablets and glazed bricks found in or near the structure; some of these call the building a *hadish* (DSf) or a *tachara* (DSd), both Old Persian words for palace.[7] Its plan, incorporating a series of contiguous courts and surrounding rooms, is unique within Achaemenid architecture, for it is modeled after earlier Assyrian and Babylonian palaces.[8] Larger than

800 by 500 feet (246 × 155 m) and occupying about three times the area of the *apadana*, the palace consists of an entry gate and passageway at the east that lead to a large court (*cour est*). To the west of this court are three others aligned east-west, each surrounded by rooms. That the palace had interior brick stairways is indicated by the nature of the decorative bricks recovered.

Artaxerxes II's structures consist of a large complex, including an *apadana*, where wooden columns (as opposed to the stone columns in Darius I's *apadana*)[9] stood on stone bases, and a palace. They were built less than a quarter mile (350 m) to the west of the Darius buildings, across the Shaur River.[10] Here were recovered inscriptions on column bases (none found in situ), one of which mentions the *hadish* built by the king.[11] There is no certain evidence that Artaxerxes II built other structures at Susa.[12]

Another matter is worth noting. No domestic buildings of the kind that must have housed the many courtiers and their dependents were recovered at the site, nor were houses or ateliers of local workers or artisans. If these existed on the mound, they have been obliterated by subsequent building and clearing.

Although the Darius statue and fragments of other stone sculpture in the round (see No. 153) were recovered on the Apadana mound, no stone reliefs derive from there. Stone reliefs were discovered elsewhere on the tell, in the Donjon area, where they had been reused as filling in a later, Sasanian building. They depict guards carrying spears, Persian servants mounting stairs (one of whom carries on his shoulder a tray with a duck's-head projection), a head of a servant, a griffin, a winged lion, and plinths.[13] Their original location remains unknown and poses a complex question, but some of the reliefs must have come from a structure that had a stone stairway.

Artaxerxes II's *apadana* also contained stone reliefs, none recovered in situ. Parts that remain show a Persian servant walking up stairs carrying a tray with a duck's-head projection, part of a Mede servant (also mounting stairs), a head of a servant, fragments of guards carrying spears, and a plinth.[14] Some of these reliefs of guards, servants, and plinth parallel those from the Donjon. The Shaur finds indicate that the *apadana* of Artaxerxes II was embellished with representations in stone of servants and guards and that stone stairways existed here;[15] at Persepolis the Council Hall gateway and the palaces of Darius I and Xerxes had servants represented (see fig. 53, p. 237), but their *apadana* did not.

Decorated bricks that are glazed (enameled) and plain, molded in relief and flat, were recovered on the Apadana mound. All derive from within or near the palace, none from the *apadana*.[16] Figured glazed bricks are recorded as coming from the area of the east gate (depicting guards); the *cour est* (winged bulls, guards, perhaps lions passant); the *cour centrale* (sphinxes); the *cour intérieure* (griffins); and the *cour ouest* (griffins, winged bulls, guards).[17] Other bricks, a number with floral and geometric designs, were found scattered over the mound.

Glazed bricks (I am not sure whether any are in relief) were also excavated in Artaxerxes II's *apadana*; one published brick preserves part of a guard's clothing.[18] At Babylon, the Achaemenid structure yielded glazed bricks both flat and in relief, depicting guards similar to those at Susa, as well as floral and geometric patterns.[19] Persepolis produced fewer glazed bricks than Susa. Flat glazed bricks bearing inscriptions and floral patterns, but none with human figures, survived in the *apadana* and Council Hall.[20] It will never be known whether glazed bricks adorned walls extensively at Persepolis or whether the relative paucity of remains reflects a limited use of them there.[21]

The archaeological evidence suggests that only the palace of Darius, not the *apadana*, was embellished with panels and scenes of plain and glazed brick and had brick, not stone, stairways. Nevertheless, a number of scholars posit that the *apadana* was likewise decorated.[22] While this assertion cannot be demonstrated, neither can it be denied: Artaxerxes II's *apadana* contained reliefs of glazed brick and stone, as did the *apadana* of Darius I and Xerxes at Persepolis.

The glazed bricks at Susa continued a manufacturing and decorative tradition at the site that began in the Middle Elamite period (twelfth century B.C.) and reappeared in the Neo-Elamite period (eighth to seventh century B.C.). The composition in all periods consisted of a conglomerate of sand and chalk, a *brique siliceuse*. The same composition is found in the glazed bricks used in the Achaemenid structure at Babylon, where bricks in relief had previously been made of terracotta.[23]

Regarding the chronology of the glazed bricks, we may cite the inscriptions on them of Darius I as well as the inscriptions at Susa mentioning Darius I's building of an *apadana* and a *hadish* (A2Sa, XSa). The Artaxerxes II inscription mentioned above that records the rebuilding of Darius I's *apadana* (A2Sa) was taken by Roman Ghirshman to mean that the palace was burned and was rebuilt. Consequently he concluded that the

bricks date to the time of Artaxerxes II.[24] Other scholars, however, believe that some or most of the bricks, especially the guards in relief, date to the time of Darius I.[25] Other bricks depicting servants and additional guard series may be later, but it is difficult to determine chronology on the basis of style alone.[26]

OSCAR WHITE MUSCARELLA

NOTES

1. Carter and Stolper, 1984, p. 55; Miroschedji, 1985, pp. 276ff.

2. While it is unclear just when Darius began work at Susa, it has been argued by some scholars, on the basis of the style of the glazed brick guards, that it was before he founded Persepolis. If I am correct that a glazed brick fragment from Susa actually represents a local copy of the Bisitun relief (see No. 153, n. 14, and fig. 53, p. 237), it would (as P. de Miroschedji has called to my attention) be a valuable clue dating the Susa complex to 521/520, some years before Darius began work at Persepolis.

3. There are four inscriptions of Xerxes (486–465 B.C.): XSa, on a column base that refers to the *hadish* (palace) built by his father, Darius I; XSb, on a column base that is preserved primarily in Akkadian and where Scheil (1929b, no. 25) restores the word for "palace" in both the Akkadian and Old Persian versions; XSc, on tablets that Kent (1953, pp. 113–14, 152) restores as referring to a *hadish* built by Xerxes; and XSd, on the monumental gateway column bases, mentioning that Darius built it (Vallat, 1974). I am not convinced, however, that restorations justify the interpretation that Xerxes built at Susa. The same problem exists (for me) with the assumed Darius II (424–404 B.C.) texts from Susa (D2Sa, D2Sb, on column bases). In D2Sa the word *apadana* is restored and stone columns are mentioned; however, only the name Darius occurs: must this be Darius II, as Roland Kent believes ("The Recently Published Old Persian Inscriptions," *JAOS* 51 [1931], pp. 226–27, and "Old Persian Texts," *JNES* 1 [1942], pp. 422–23), or can it be a reference to Darius I's *apadana*? (Schmidt, 1953, p. 34, calls this inscription "controversial.") D2Sb (assigned to Xerxes by Scheil, 1929b, no. 25) is restored to state that Artaxerxes I built a *hadish* at Susa. Finally, an inscription of Artaxerxes III in Akkadian (Scheil, 1929b, no. 30) refers to constructing the rear part of a building, which is unidentified.

4. E.g., Ghirshman, 1964, pp. 142ff.; Vallat, 1974, pp. 177–78; Farkas, 1974, p. 77; Stronach, 1985, p. 435; Amiet, 1988b, pp. 133–34.

5. For a review of the remains, see J. Perrot, 1981; Boucharlat, 1990b.

6. Kervran, 1972. Vallat (1974, p. 178) and Perrot and Ladiray (1974, p. 51) believe that Xerxes' inscription (XSd) on the column bases indicates that he completed the construction started by his father. But could he not have added the inscription to a completed building?

7. Schmidt, 1953, p. 30; Stronach, 1985, pp. 433ff.; Vallat, 1979, p. 148.

8. Mecquenem, 1938a, p. 321; Amiet, 1974b; J. Perrot, 1981, pp. 93–94; Porada, 1985, p. 806.

9. I am not sure that Stronach is correct in his conclusion (1985, pp. 433ff. and n. 9) that only columned halls with stone columns were considered to be *apadana*s by the Achaemenid kings. Thus Stronach (p. 434) denies that term to the columned hall of Artaxerxes II, which has stone bases and wooden columns but is of the same plan as the *apadana*s with stone columns at Susa and Persepolis. He also believes that Artaxerxes II called his columned hall a *hadish* (A2Sc). Another inscription of Artaxerxes II recovered out of its original context in the Shaur complex, and also broken, refers to his *hadish* (duplicating A2Cd; Vallat, 1979, p. 146); but there is no compelling reason whatsoever to assume that these inscriptions refer to the columned hall specifically, and not to the other structures (Bâtiment II, III) with their neighboring gardens. The fact that D2Sa and A2Hb (which Herzfeld said he found at Hamadan) mention *apadana*s with stone columns need not signify that all *apadana*s were so equipped, only, I would suggest, that the use of stone was worthy of special mention. The French excavators of the Shaur palace call the complex a palace; and Kent, 1953, unfortunately always translates the words *hadish*, *tachara*, and *apadana* as "palace."

10. Labrousse and Boucharlat, 1972; Boucharlat and Labrousse, 1979.

11. Vallat, 1979, p. 146.

12. Boucharlat and Labrousse (1979, p. 55), Stronach (1985, p. 434), and Calmeyer (1987, p. 577) refer to other palaces of Artaxerxes II, but the texts they cite, A2Sd and A2Sc, do not to my mind indicate such a conclusion. A2Sc could be the Shaur palace.

13. Mecquenem, 1947, figs. 22, 23, 52:8, 9, 53:9, 10, pl. 6; Amiet, 1988b, fig. 82. Roaf (1983, p. 149 n. 182, no. 3) assigns to Susa a relief in Berlin of a servant carrying a tray with a duck's-head terminal, giving no reason (although perhaps because of the stone); this type of tray, I believe, signifies a Susian origin (see No. 165). Roaf dates the reliefs to Artaxerxes II.

14. Labrousse and Boucharlat, 1972, pp. 84–85, fig. 43, pl. 34; Boucharlat and Labrousse, 1979, pp. 60–61, fig. 23, pl. 9a.

15. It is of course assumed that the reliefs were not displaced from elsewhere—from Bâtiment II or III.

16. See Jéquier in Morgan, 1900c, pp. 79–80. See also Schmidt, 1953, p. 36—but he thought some bricks with floral and geometric patterns were recovered "in the debris" of the *apadana*, which Jéquier did not claim. A number of bricks were published without a locus.

17. Proveniences are revealed by a close reading of M. Dieulafoy, 1893, pp. 247ff., 276, 280ff., 424, fig. 265; and of Mecquenem, 1938a, pp. 321–24, and 1947, pp. 31, 47ff., 50, 52, 54, 58, 64, 70. See also J. Perrot, 1981, pp. 88–89.

18. Labrousse and Boucharlat, 1972, pp. 83–84, fig. 19.

19. Haerinck, 1973, pp. 118ff., fig. 3a, pl. 56.

20. Schmidt, 1953, pp. 70ff., 77–78, figs. 35, 42c.

21. Frankfort (1954, p. 267 n. 93) suggests that at Persepolis stone was used for reliefs in the way that brick functioned at Susa.

22. M. Dieulafoy, 1893, pp. 285ff., pls. 14, 15; Schmidt, 1953, p. 36; Ghirshman, 1964, p. 140; Haerinck, 1973, p. 123 n. 65; Farkas, 1974, p. 39; Calmeyer, 1987, p. 574; see Annie Caubet, pp. 224–25 in this volume.

23. Haerinck, 1973, pp. 118ff. He is unsure (p. 119 n. 51) whether there is a direct continuity of manufacturing technique from the Middle Elamite to the Achaemenid period—because DSf mentions that it was from Ionia that the ornamentation was brought. DSf only mentions wall decoration (Kent, 1953, p.

144), but this could refer to the glazed bricks (see also Mecquenem, 1947, p. 95). Farkas (1974, pp. 41–42) suggests an Iranian origin. Like Susa, Babylon had both glazed brick and stone relief friezes (Haerinck, 1973, p. 129; Seidl, 1976, pp. 125 ff., n. 4).

24. Ghirshman, 1964, pp. 140, 142; see also Perrot and Chipiez, 1890, p. 763.

25. E.g., Schmidt, 1953, p. 32; Farkas, 1974, pp. 39ff.; Calmeyer, 1987, p. 574; idem, in *AMI* 14 (1981), pp. 41ff., and 15 (1982), p. 125; Stronach, 1978, p. 96. See note 2, above.

26. The precise dating of the nonrelief, smaller-scale glazed bricks from Susa and Babylon depicting guards (No. 160) or servants (Nos. 164, 166, 168) remains a problem. Scholars date them to either Darius I or Artaxerxes II; for summaries of opinion and interpretation, see Haerinck (1973, pp. 128–29), Amélie Kuhrt in *The Cambridge Ancient History*, vol. 4 (Cambridge, Eng.,

1988), p. 115 n. 16, and idem, in Heleen Sancisi-Weerdenburg and Amélie Kuhrt, eds., *Achaemenid History* IV (Leiden, 1990), p. 181. It is perhaps significant that a guard at Babylon has the same pattern on his clothing as the guards from Susa (see nn. 18, 19, and No. 160), a pattern similar to that on a guard's clothing from Artaxerxes II's Shaur complex (Labrousse and Boucharlat, 1972, p. 84, fig. 19:1). The latter example could then date the others to the time of Artaxerxes II, but it could also be interpreted as having been copied by that king's artisans from earlier examples. The date of all the Apadana mound bricks need not be the same as that of the structure they adorned, and it is possible that they date to the time of Artaxerxes II. Note that Artaxerxes II's *apadana* also contained unique wall paintings (Labrousse and Boucharlat, 1972, p. 83, fig. 42).

SCULPTURE

153 FRAGMENT OF A ROYAL HEAD
Limestone
H. 10⅝ in. (27 cm); W. 11 in. (28 cm)
Achaemenid period, late 6th–early 5th century B.C.
Apadana; Sb 6734
Excavated by Mecquenem.

153

The fragmentary condition of this dark limestone head belies its importance. What remains are the mouth and parts of the nose and beard, executed in the round, probably from a representation of a royal man, not a human-headed creature (see No. 157). The statue to which the head belonged would have been almost ten feet (3 m) tall.[1] The fragment derives from the Apadana mound, where four other large fragments of sculpture in the round depicting humans were also found.[2] These are of light limestone; one fragment is part of a shoe, and the three others are parts of clothing. Fortunately the clothing fragments bear inscriptions, one of which states that the work carrying it is a statue commissioned by Darius I (DSn).

The significance of the five fragments—that they represent at least two or more large statues in the round—was not fully appreciated by scholars, most of whom cited only the head or only (parenthetically) the other fragments.[3] The fragments' importance was not recognized even when the headless

inscribed Egyptian granite statue of Darius I was discovered in 1972 at the exterior southwestern flank of the Darius gate on the Apadana mound (fig. 50).[4] Although the excavators postulated that a second Darius statue must have existed at the northern end of the passage and others at the east, they did not cite the sculpture fragments.[5] It was even claimed

that the Darius statue was the sole example of a sculpture in the round of a human being known in the Achaemenid period.[6]

Margaret C. Root, the first scholar to discuss the fragments in some detail as representative of more than one piece of sculpture, correctly noted that the

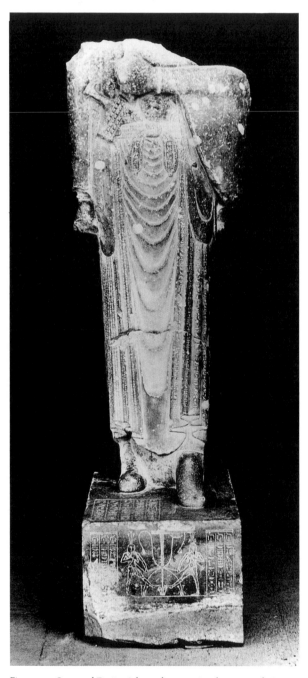

Figure 50. Statue of Darius I from the gate. Apadana mound, Susa, Achaemenid period, ca. 522–486 B.C. Egyptian granite, H. 98½ in. (250 cm). Teheran, Iran Bastan Museum

dark stone head had to be dealt with separately from the other, light stone fragments.[7] She concluded that it came from a statue originally about three meters in height.[8] Because the shoe has buttons, a feature never found on royal footwear, Root assigned it to a statue of a hero grasping a lion, a theme represented in relief on Darius I's palace at Persepolis, on seals, and apparently in a small statue in the round from Persepolis.[9] The two other fragments known to her (see note 2) she assigned to one or two royal statues, but accepts one of them as possibly belonging to the hero. Thus, she posited either two, three, or four statues in the round represented by the fragments. Puzzlingly, she did not discuss the fragments together with the Darius I statue but treated the latter separately, presumably because they are of different stone.[10]

In 1983, Heinz Luschey presented an important and a more detailed study.[11] He suggested that the head fragment was from a second statue of Darius I, for while its proportions matched those of the known Darius statue, its stone composition was different. He postulated that the two statues had formed a pair and that the second statue had stood at the northern flank of the gate.[12] With Root, Luschey assigned the shoe to a hero grasping a lion; he added to it one of the clothing fragments. At first he assigned the other two fragments to a third statue of Darius I, but in a postscript he mentioned that they derived from two separate statues. He thus concluded that the fragments represented at least four separate statues,[13] which would mean that fragments of at least five large statues in the round, including the Darius I statue, have been recovered at Susa.

The head fragment is from a large statue of a king, probably Darius I (or Xerxes?). We do not know if it once flanked the granite statue at the Darius I gate, but that is not an improbable conclusion (see note 12). As for the four associated fragments, they represent at least two statues—one, probably a hero, associated with the shoe, and another of Darius I (or Xerxes?)—or possibly a hero and three other statues. This means that there was a total of three or four statues of Darius I (and/or Xerxes?) and one of a hero in the Achaemenid complex at Susa.[14] Where these statues were situated is of course not known, but it remains a viable possibility that four royal statues were indeed placed at the four door jambs of the monumental gate.

OWM

1. The head was first published by Scheil, 1929b, p. 57, pl. 13; see also Mecquenem, 1938a, p. 324; idem, 1947, p. 47, pl. 5:3. Scheil and Mecquenem thought it was the head of a *lamassu* (composite animal); so did J. Perrot (see Luschey, 1983, p. 193). For its size, see Parrot, 1967b, p. 249; Root, 1979, p. 111; Luschey, 1983, p. 195; Azarpay, 1987, pp. 187, fig. 3, 189.

2. Scheil (1929b, pp. 57–58, pl. 13) knew of four fragments; Luschey (1983, p. 194) found a fifth in the Louvre. No specific locus on the Apadana mound is recorded. Scheil's text seems to suggest that these fragments were found together, but this cannot be asserted. Schmidt (1953, p. 31) says they came from the *hadish* but gives no evidence.

3. See Luschey, 1983, p. 195 n. 12, for references; also Mecquenem, 1938a, p. 324; Ghirshman, 1964, p. 140; Parrot, 1967b, p. 249; Stronach, 1972, pp. 245–46; Farkas, 1974, p. 45 n. 65a.

4. Kervran, 1972; Stronach, 1972; Perrot and Ladiray, 1974.

5. Kervran, 1972, p. 239; Perrot and Ladiray, 1974, p. 44; J. Perrot, 1981, p. 86.

6. Luschey, 1983, p. 193, quoting J. Perrot, who believed that the head discussed here belonged to a *lamassu*, which he restored to the western, outer passage of the Darius I gate; Perrot and Ladiray, 1974, pp. 49–50, fig. 17; see also Scheil, 1929b, p. 57, and Mecquenem, 1947, p. 47.

7. Root, 1979, pp. 110ff.

8. On page 111 she says it is from a statue, on page 112 that it could be from a human-headed bull capital.

9. Schmidt, 1953, pl. 147; idem, 1957, pls. 17, Pt. 5:1, 35:1; Walser, 1980, fig. 107; Root, 1979, p. 113 n. 214. The example in Ghirshman, 1964, fig. 295, is a modern forgery. The hero does not represent the king (Hinz, 1969, p. 74 n. 33; von Gall, 1972, p. 267 n. 32).

10. Root, 1979, pp. 68ff.

11. Superseding an earlier study in *AMI*, Ergänzungsband 6 (1979), pp. 207–17.

12. Luschey, 1983, pp. 197–98, fig. 4. Luschey (pp. 201–2) believes that Xerxes brought the Darius I statue from Egypt to Susa, where it and its postulated mate occupied a secondary position at the gate; see also Vallat, 1974, p. 168, and J. Perrot, 1981, p. 86. Porada (1985, p. 818) suggests that another statue of Darius was left in Egypt. Calmeyer (1976, p. 83, C 5 i) has ingeniously suggested (with cogent parallels, ibid., pp. 79ff.) that the second statue could have represented Xerxes, as co-regent with his father. This remains a strong possibility, albeit one not possible to demonstrate.

13. Luschey, 1983, pp. 198–99, 204, fig. 5. This was also one of Root's possible conclusions (1979, pp. 111, 113), not noted by Luschey. Although Luschey originally placed the hero and his Darius statue III at the outer, eastern passage of the gate, on p. 204 he admitted problems in assigning the five statues to a specific placement.

14. For textual and other evidence for the existence of Achaemenid statuary, see Root, 1979, pp. 125–26. Stronach's short list of extant Achaemenid sculpture (1972, p. 246 n. 16) is not short enough: he cites as genuine two small sculptures that are modern forgeries (Ghirshman, 1964, fig. 295, and Parrot, 1967b, pls. 13, 14).

Canby (1979, pp. 317ff., figs. 1, 3) reconstructs a glazed brick from Susa that shows part of a human figure, seemingly with its leg raised, as a hero stabbing a griffin. I think this is incorrect: on the stone reliefs the hero's leg is shown straight (Walser, 1980, figs. 90–96; Roaf, 1974, p. 97, fig. f), not curved as on the brick; and on the reliefs the griffin's claws do not extend above the bare knee. If the brick depicts a hero, he would be one grasping a lion (pace Canby, 1979, p. 320), like the one postulated in stone by Root and Luschey. This hero's leg is not straight, and the lion's body is placed against the hero's lower thigh and knee. However, Canby's alternate reconstruction, that of a triumphant king standing on an enemy as represented at Bisitun, is viable. In that case the brick relief would be a local copy of the Bisitun relief and inscription: we know versions of it were set up in various parts of the empire, and one copy has been recovered at Babylon (Seidl, 1976, pl. 34; Porada, 1985, p. 811). If this interpretation is correct, it furnishes valuable information supporting a dating of the construction of Susa close to 521/520 B.C.

154 LION WEIGHT

Bronze
H. 11¾ in. (30 cm); L. 20⅞ in. (53 cm)
Achaemenid period, 6th–4th century B.C.
Acropole, temple area; Sb 2718
Excavated by Morgan, February 1901.

Cast in bronze is a recumbent lion on a rectangular plinth, with a heavy loop handle on its back. This is a typically Achaemenid lion with hair rendered in regular rows of tufts that cover the back, sides, and chest, and curve around the shoulder; "wings" at the sides; a raised ruff; thick swellings under the eyes and depicting the muzzle; "figure-eight" thigh musculature; and a "tulip" pattern on the legs. The lion weighs 267 pounds (121 kg), or, in the units used in the ancient Near East, about 4 talents. It was recovered in the fill of the Ville Royale.[1]

In the 1840s, at Nimrud in Iraq, A. H. Layard excavated a group of sixteen bronze lions, each recumbent on a plinth and with a loop at the top; they vary in length from 1 to almost 12 inches (2.5–30 cm). Some bear inscriptions in cuneiform and/or Aramaic of late-eighth- and seventh-century Assyrian kings that include the amount of the weight.[2] Thus, the objects are manifestly weights. A similar, Assyrian bronze lion on a plinth with a top loop was recovered, also in the 1840s, at Khorsabad in Iraq. That example was fastened to a pavement by a pin on its underside and seems to have been a weight that was reused in some other function. It weighs 134 pounds (61 kg), half the weight of this piece.[3] Still another lion weight with a plinth and a loop, inscribed in Aramaic with its weight (68 pounds, or 31

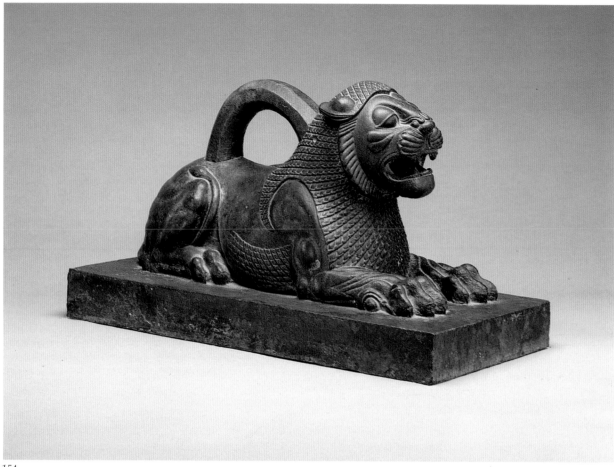

154

kg)—about one-quarter that of the Susa and one-half that of the Khorsabad example—probably derived from the Troad in northwestern Turkey.[4] Its style suggests that it is Achaemenid.

On this evidence it seems clear that the Susa lion is a weight,[5] one that continued a tradition established in eighth-century Assyria. Its date is not precisely established within the Achaemenid period.[6]

OWM

1. Lampre, 1905, pp. 171ff., pl. 9; Ghirshman, 1964, fig. 318; Porada, 1965, pp. 162–63, pl. 46; Amiet, 1988b, fig. 84; Braun-Holzinger, 1984, p. 112, pl. 73, no. 386.

2. Layard, 1852, vol. 1, p. 119; idem, 1853, p. 601, with chart opposite. Weights range from about 2 ounces to about 40 pounds; British Museum, *A Guide to the Babylonian and Assyrian Antiquities* (London, 1922), pp. 170–71, with figure; Lampre, 1905, pp. 174–75; Braun-Holzinger, 1984, pp. 111–12, pl. 72.

3. Frankfort, 1954, pl. 115; Mitchell, 1973, pp. 173–74, n. 10. Braun-Holzinger, 1984, p. 112, pl. 73, no. 384.

4. Mitchell, 1973, pls. 1, 2; Braun-Holzinger, 1984, p. 112, Taf. 73, no. 385.

5. It would weigh 4 talents, the Khorsabad weight 2 talents, the Troad weight 1 talent. Corrosion has caused a loss of weight, which accounts for the imprecise proportions.

6. Porada (1965, pl. 46) and Mitchell (1973, p. 174 n. 13) give a 5th-century date.

Achaemenid Brick Decoration

The Persian palace complex at Susa was constructed earlier than the one at Persepolis and is clearly distinguished from it by its decoration. Because stone is scarce in the Susiana plain, the palace walls were faced with decorated brick, in accordance with a Mesopotamian tradition that had been known and used at Susa since the Middle Elamite period (see No. 88).

The brick decoration, along with the overall organization and stonework of the palace, has been examined in studies by Marcel Dieulafoy (1893), M. L. Pillet (1914), Roland de Mecquenem (1947), and lastly, Audran Labrousse (1972), whose work provided much of the information contained in this essay. More recently, a physical chemistry research program investigating artifacts made of vitreous materials[1] has analyzed the colorants of selected glazes employed in the brick decoration and has revealed certain technical features peculiar to the Achaemenid workshops of Susa (see also the Conservation Report below, pp. 284–85).

Persian brick decoration at Susa can be divided into two broad categories: relief decoration made from uncolored clay bricks cast in molds, and colored decoration made from siliceous bricks with colored glazes. In the second category there are again two types: glazed bricks with designs in relief, and those with flat surfaces where the design is rendered solely by the colors.

CLAY BRICKS

Clay brick, the standard material for wall construction throughout the ancient Near East, was used at Susa to create several decorative panels and friezes. Each molded brick carried a relief on one side that was part of a larger design extending across a number of courses of brick. The bricks were not glazed. The clay from which they are made is of exceptional quality, very pure and with a temper, perhaps a lime mortar, that is invisible to the naked eye.[2] This mixture permitted modeling of great delicacy. The only subjects represented in this relatively small series, or group of bricks thought to come from the same frieze, are mythological animals such as winged bulls and griffins and striding lions, motifs also rendered in glazed brick.

Exceptionally, some of the clay bricks were given a colored glaze. They have either geometrical motifs, which probably belonged to the borders of friezes, or elements of Persian dress, as seen on the frieze of archers (guards). It is possible that these bricks were "repair" pieces made to match missing or broken pieces they replaced in the larger series of siliceous brick.

GLAZED SILICEOUS BRICKS

By far the greatest quantity of polychrome decoration at Susa was made of siliceous brick, which has a non-plastic composition with a base of sand and lime. Each brick was shaped (with or without a relief decoration) in a mold and fired up to three times. The first firing of the body produced what potters today call a biscuit. In the second firing, the enamel cloisons, or partitions, of the design were fixed. The Persian craftsmen of Susa had in fact developed a technique of "cloisonné"; they outlined the designs with threads of thick glaze, creating separate compartments to contain the different colored enamels. They set the bricks edgewise, decorated side up, to apply these glazes, as we know from traces of color that dripped down the wide undecorated sides of the brick. Then came a final refiring.

Analysis of samples of different glaze colors by X-ray diffraction shows the glaze to be a siliceous preparation that occurs as a vitreous fluid, colored by the addition of various oxides: lead-antimony for the yellows, copper for the blue-greens, ferrous man-

ganese for blacks and browns, and tin to make the glaze opaque and produce white. Mixtures of oxides yielded variations in the intensity of the hues, although the chromatic range remained fairly narrow. A few examples from one limited series include bright blue, obtained by the addition of cobalt. Remarkably, true red is absent. Red never appears in Susian faience or glasswork, even though it was known to Assyrian and Egyptian glassmakers and was frequently used in mural paintings in both Mesopotamia and Susa.

The glazed bricks are of quite uniform dimensions, generally 3⅜ inches (8.5 cm) high and 13 inches (33 cm) long. They are slightly wedge-shaped, narrowing toward the back to allow the decorated faces to be fit together more easily. Square tiles, about 13 by 13 by 4 inches (33 × 33 × 10 cm), were probably used to adorn stairways and door and window sills (No. 159). They usually carry stylized foliage motifs, although there are some fragments with mythological subjects as well, like the ones with horned lion's heads (No. 158).

ICONOGRAPHY AND PLACEMENT OF GLAZED BRICK PANELS

Almost all the decorated bricks were recovered in later levels, where they had been reused haphazardly. How the different decorative elements fit into overall designs on monuments can only be conjectured. However, it has been possible to reconstruct some frieze elements and isolated panels.

In some cases, an identical iconography appears on both glazed siliceous bricks in relief and unglazed clay bricks. The subjects are winged bulls and griffins represented as on earlier friezes at the palace of Babylon, in profile, striding in a repeating procession. The few fragments of a winged bull that were found in a courtyard permitted the reconstruction of only a single example.[3] The griffins[4] were also found in a courtyard, but there were enough fragments to reconstruct two panels.

The frieze of roaring lions[5] was found, still intact, where it had fallen: at the foot of the north wall of the eastern court of the palace. Its bricks, unlike those from most of the other friezes, had not been reused at a later date. Labrousse[6] shows that the frieze must have decorated the upper part of that wall, which was a series of wide pylons separated by narrow recesses where staffs or poles were placed. The lions all moved toward the center of the composition, where a door was

surmounted by a trilingual inscription, also in colored bricks.

Finally, the most celebrated decoration and also the one with the greatest number of fragments is the frieze of archers (guards; Nos. 155, 156), whose elements were found scattered or reused in later constructions. The modern restoration took the arrangement of the lion frieze as a model, but the frieze of archers should probably be restored in two or more superposed registers. The archers, who are shown in left or right profile, must also have converged toward a central element bearing a trilingual inscription. Rather than a flat surface, the frieze probably adorned a facade of projecting pilasters alternating with recessed niches, a traditional method of decoration in the Near East. This explains why some of the bricks, the corner pieces, were glazed on two sides.

All these friezes had non-figurative designs that framed the figural scenes, although we do not know at what height on the wall these borders were placed. Bricks in the shape of merlons, or elements with step-shaped tops, indicate that some walls were faced with glazed bricks all the way up to the coping.

In addition to friezes, the monumental decoration included isolated panels, like the series of confronted sphinxes under a winged sun disk (No. 157). These glazed panels probably adorned pilasters, window recesses, or lunettes above windows or doors. Fragments of the bases of colonettes also survive, glazed and decorated in relief, that might have framed doors, windows, or niches. Finally, some fragments probably came from stairways.

As at Persepolis, the terrace on which the Susa palace complex stood must have been reached by a monumental stairway of which nothing remains but some pieces of decoration reused in later buildings. On most of these the design appears only in colored glaze in cloisonné. However, some of them show the same technique of relief combined with glaze as the friezes described above, but with the figures on a smaller scale. The motifs are similar to those on the stone stairways at Persepolis: crenellated battlements decorated with rosettes and palmettes, spirals, oblique bands of daisies, and bull-and-lion combats on the angles of the parapets.[7]

Again as in Persepolis, processions of servants were placed on the stairway (fig. 51). Fragments that remain (Nos. 163, 164, and 168) are decorated in a delicate style and in a range of colors slightly different from that of the series described above: the cloisonné line is darker and the skin is rendered in a pinkish brown. The

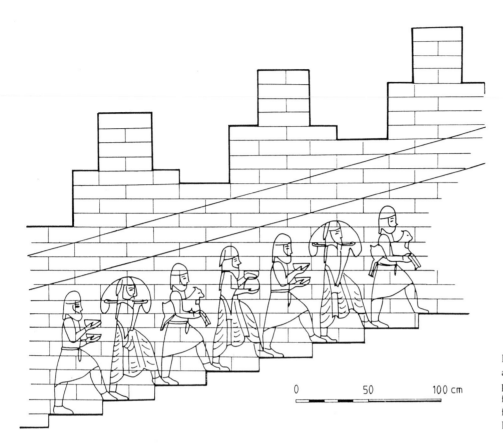

0 50 100 cm

Figure 51. Reconstruction of an Achaemenid glazed brick panel, based on stone reliefs from Persepolis and bricks from Susa; by Audran Labrousse

figures are on a smaller scale than the archers, nine rows of bricks high instead of seventeen.[8]

Judging from the decoration of the square tiles, glazed in the cloisonné technique without relief work, it seems probable that they too adorned a stairway or pavement. One exceptional tile shows a band of lion's heads (No. 158), but the other designs are limited to stylized vegetal motifs. In a separate category are the "marbled" tiles: they were made of a siliceous paste colored yellow, brown, and white, then mixed in the mold to create the appearance on the surface of veined stone. This technique, which is related to the frit technique, produced a relatively porous, fragile material that probably was not intended to be exposed to the open air.[9]

UNGLAZED SILICEOUS BRICKS IN RELIEF

Some siliceous bricks did not receive a colored glaze. This small series includes pieces in a variety of sizes, such as flat bricks with the relief on the edge (No. 165) and tiles 6¾ inches square (17 × 17 × 11 cm), half the length of a standard brick. The relief work on these bricks is extremely delicate and precise because its contours are not blurred by the addition of a layer of glaze. There are a few fragments of this type representing servants, personages wearing Persian tunics and boots, and large animals (the muzzle of a bull). We do not know the provenience of these pieces, but iconographically they are very similar to the decoration of the stone stairway at Persepolis, suggesting that they too adorned a stairway parapet.

ANNIE CAUBET

NOTES

1. Jointly undertaken by the Département des Antiquités Orientales of the Louvre, the Research Laboratory of the Musées de France, and Dr. A. Kaczmarczyk.
2. Bigot, 1913, p. 275.
3. Sb 3329; Mecquenem, 1947, pp. 64–67, fig. 37.
4. Sb 3323, Sb 3326; M. Dieulafoy, 1893, p. 310, pl. 11; Mecquenem, 1947, pp. 70–72, fig. 39.
5. M. Dieulafoy, 1893, p. 275, fig. 152, pl. 3; idem, 1913, p. 11; Mecquenem, 1947, pp. 54–55, fig. 30.
6. Labrousse, 1972, pp. 128–35.
7. Mecquenem, 1947, p. 83, fig. 52:7.
8. Labrousse, 1972, p. 138.
9. Sb 3382; Mecquenem, 1947, p. 35, fig. 15.

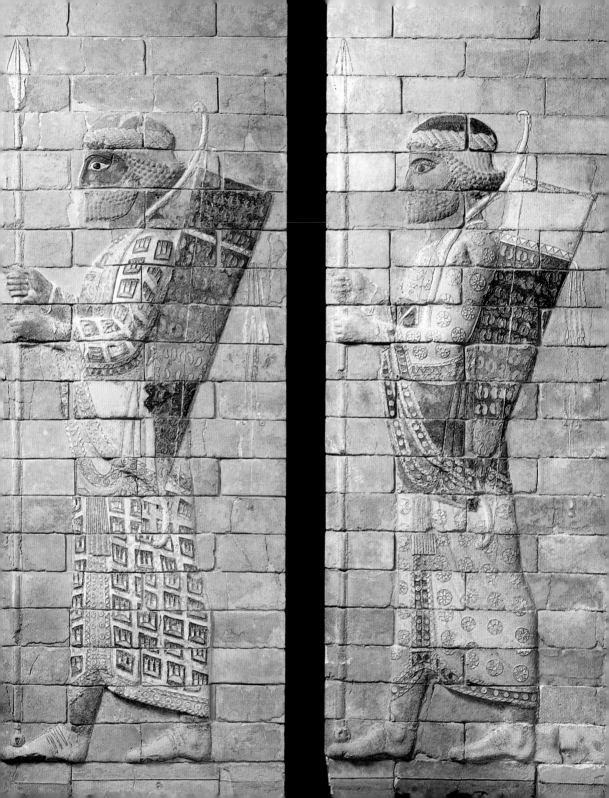

155, GUARDS
156 *Siliceous brick, decoration in relief; glazed brown,*
 pale green, yellow, white, with gray-black outlines
 H. 79⅛ in. (201 cm); W. (each) 27⅛ in. (69 cm);
 D. 3½ in. (9 cm)
 Achaemenid period, late 6th century B.C.
 Apadana, eastern door of the palace;
 Sb 3302 (No. 155), Sb 3309 (No. 156)

These two glazed relief brick panels depict bearded
guards shown in profile facing left, each armed with
a long spear and a bow with its quiver. The spear
butt is a ball with a triangle in relief and rests on
the forward left foot (note the arch of the rear right
foot); the upper end of the bow terminates in a
duck's head, and tassels are pendant from the quiver.
Earrings and penannular (not always clear) gold
bracelets are worn, and around the head is a braided
fillet. The long, loose garments are richly decorated
in relief, with patterns of rosettes on Number 156
and tower motifs on Number 155, and with borders
of concentric circles or lotus flowers framed by tri-
angles.[1] The quiver surface has a pattern of pairs of
ovals that might represent animal skin.

Each figure is seventeen bricks in height (cf. No.
160), with the upper tip of the bow extending to the
eighteenth (the lower tip appears from between the
sleeves below the quiver on the guards moving left);
the shaft and blade of the spear extend two or more
bricks over the head.[2] The colors are quite vivid. The
skin is dark (brown), one of the two conventional
skin colors used for guards at Susa (see Nos. 160,
162).[3]

The bricks constituting the guard panels were re-
covered scattered in the area around the entrance to
the palace in the western part of the *cour est*.[4] At
least eighteen guards have been successfully re-
stored, and isolated bricks with parts of others exist.
While it is manifest that the guards face to the left
and right, not known is the original number of
guards exhibited, where and how they were situated
in or near the entrance, and whether guards with
clothing of one pattern were grouped together or al-
ternated with those wearing another pattern.

Persian guards on the stone reliefs at Persepolis
are shown in single file approaching each other or
approaching and flanking an inscription; and guards
dressed exactly like the examples shown here (except
lacking a bow and quiver) are arranged in two tiers
and all moving in the same direction.[5] The Persepo-
lis reliefs suggest possible ways that the Susa brick

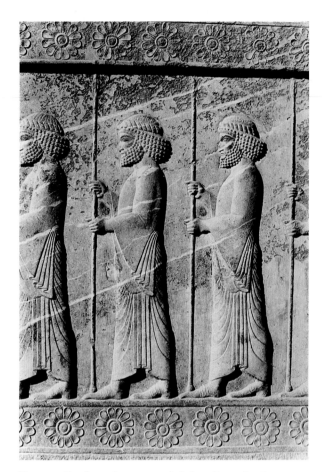

Figure 52. Royal guards on stone reliefs from Persepolis. Eastern
stairway of the *apadana*, Achaemenid period, reign of Darius I,
ca. 522–486 B.C.

guards may have been placed. Since glazed bricks
bearing an inscription of Darius I were recovered
with the guards, who face left and right, restorers
have thought that at least some guards flanked this
inscription;[6] whether other guards were in a tier
above cannot be known (see above, pp. 224–25).
Guards facing both left and right were also repre-
sented on flat glazed bricks at Susa (see No. 160), but
there too we do not know how they were arranged.[7]

The ethnic identity of these guards is an unre-
solved issue. From the time of Dieulafoy's publica-
tion in 1893, some scholars have interpreted the
guards as units of the Ten Thousand, elite troops of
Persians mentioned by Herodotus (VII.41); one thou-
sand of those troops had gold spear butts and the
other nine thousand, silver ones. Because butts on
the Susa bricks are glazed white, the guards are to
be recognized as units of the nine thousand, accord-
ing to this interpretation.[8] If they are part of the
Ten Thousand—an identification that remains

speculative—they would be Persian troops, not Elamite, and indeed in all features including shoes, and only excepting the fillet, they wear Persian clothing.[9] However, because of the fillet, which is a distinctive item of Elamite dress (see fig. 52), and the bows ending in a duck's head, also an Elamite feature, it has been argued that the Susa guards are local Elamite troops.[10] On the other hand, differing scholars have cogently noted that identified Elamites always wear boots, not Persian shoes, and for this reason have rejected an Elamite attribution.[11] The association here of the Elamite fillet with the Persian shoe needs to be explained before a secure identification can be made.[12]

OWM

1. A third pattern of quatrefoils may also have existed as restored by M. Dieulafoy (1893, pl. 6); see Mecquenem, 1947, fig. 26:6 (in relief?). The only other place where the tower motif occurs is on a tapestry from Pazyryk: see Lerner, 1991, pp. 10–11, fig. 10.
2. M. Dieulafoy (1893, fig. 154) restores it high over the head, up to the twenty-fourth brick; Mecquenem (1947, fig. 25) restores it to the twenty-first brick; the Louvre examples have been restored to the nineteenth brick. Azarpay, 1987, pp. 193–94; figs. 6 and 7 illustrate Dieulafoy's reconstruction, and the upper tip of the bow is misplaced. Spearheads extending high over the bearers' heads may be seen at Bisitun and Persepolis: Ghirshman, 1964, fig. 283; Schmidt, 1953, pls. 50, 51, 58, 59.
3. M. Dieulafoy (1893, pp. 27ff., 44, 55, 60, 108ff.) believed that the Elamites were a mixed race, including Negritos (associated with Asian, not African, blacks) and white-skinned peoples. He thought the dark-skinned guards were Negritos, and also restored a glazed relief of white-skinned guards (pl. 7) for which the evidence was some nineteen bricks, some of which must, however, have represented white-skinned servants (p. 430 and fig. 286). He also believed that Elamites represented on the Assyrian reliefs are clearly identifiable as Negritos, an assertion that is manifestly incorrect.
4. Mecquenem, 1938a, p. 324; idem, 1947, pp. 31–32.
5. Schmidt, 1953, pls. 17, 22, 23, 25, 50, 51, 58, 59, 62, 63, 100–102. In pl. 58 the "Elamite" guards wear bracelets; in pls. 50 and 51 they do not.
6. Mecquenem, 1947, fig. 25, where the position of the two right-facing guards is an interpretation. M. Dieulafoy (1893, pl. 15) restored them over the *apadana* entrance, although there is no evidence for that placement and in fact the guards' findspot contradicts their being in the *apadana*.
7. For stone reliefs depicting guards from the Donjon area and the complex of Artaxerxes II at Susa, see Mecquenem, 1947, pl. 6:1, 2, fig. 23; Labrousse and Boucharlat, 1972, pl. 34:1, possibly 2, fig. 43:3, 4.
8. M. Dieulafoy, 1893, p. 291; Haerinck, 1973, p. 123 n. 65; von Gall, 1972, p. 270; cf. Mecquenem, 1947, p. 53.
9. In general, Persian dress was the same as Elamite (except for the shoe problem, below). Hinz, 1969, p. 70; von Gall, 1972,

p. 265; Miroschedji, 1985, pp. 299–300; Calmeyer, 1988, pp. 27–28, 31, figs. 11, 12.
10. M. Dieulafoy, 1893, pp. 28, 280ff.; Hinz, 1969, pp. 67, 70, 79, 80, 92; Porada, 1965, pp. 151ff., pl. 42. See also Calmeyer, 1988, p. 31.
11. Von Gall, 1972, pp. 264, 270; Calmeyer, 1988, pp. 33 n. 38, 47. They also reject an Elamite attribution for the guards at Persepolis who are dressed like those at Susa. Von Gall believes that they are a Persian tribe.
12. Root (1979, pp. 76 n. 98, 85 n. 123) suggests that the guards might have represented specific historical individuals because the name Otanes seems to have been mentioned in the brick inscriptions (see M. Dieulafoy, 1893, p. 284). For the guards' chronology, see above, pp. 218–19 nn. 2, 25.

157 CONFRONTING SPHINXES
Siliceous brick with decoration in relief; glazed brown, light green, yellow, white, with gray-black outlines
H. 47¼ in. (120 cm); W. 46 in. (117 cm); D. 2 in. (5 cm)
Achaemenid period, late 6th–early 5th century B.C.
Apadana, central court of the palace; Sb 3324
Excavated by Mecquenem, 1911.

On this panel, two winged lions with human heads—that is, sphinxes—confront each other but with their heads turned backward. They have multi-tiered squared beards and short bull's ears with pendant earrings, and they wear tall cylindrical headdresses. The headdress has a rear ridged guard and is topped by what may be feathers, with a floral petal above and a row of circles below; three horns reinforce the sphinxes' otherworldly nature. Only the tips of the tails are visible, protruding from the right thigh of the left sphinx and the left thigh of the right one. This indicates lateral rotation; the sphinxes are not mirror images. Above them is a sun disk of typical Achaemenid form.[1]

Bricks making up the sphinxes and sun disks of several panels were recovered in the northeastern corner of the *cour centrale*.[2] The winged sun disks were restored to fit directly above the sphinxes, and although there is no proof that this was the original placement,[3] it is a viable reconstruction, as parallel representations suggest (see below). Four such panels have been reconstructed, and other isolated bricks indicate that originally there were more. Each panel consists of ten rows of bricks for the lions and four for the sun disks. The glazing on the sides of the end bricks shows that the panels were not placed flush with walls as a continuous frieze but rather

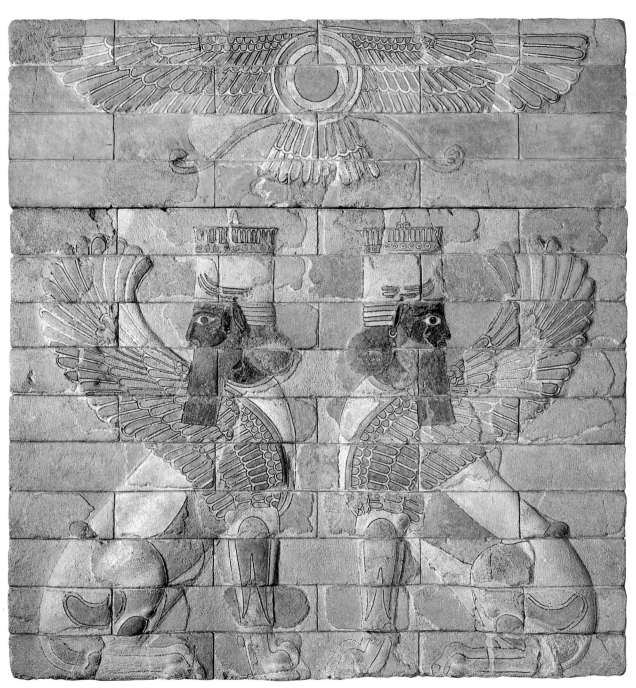

157

set into projecting pilasters, niches, or recessed
doorways.

Heraldic seated lions and sphinxes are common
motifs in Achaemenid art. A number are repre-
sented in stone reliefs at Persepolis, in the *apadana*,
the Council Hall, and the palaces of Darius I and
Xerxes.[4] All have the beard, bull's ears with ear-
rings, and cylindrical headdress with an ornament at
the top seen on this brick relief; some lack the band
of circles (which may originally have been painted).
These sphinxes, like the ones from Susa, have heads
that share the features of royal human heads (see
No. 153) and the headdress of the bull-man gate
guardians.[5] However, the Persepolis sphinxes all face
each other, having one raised paw and full tails, and
flank (rather than sit under) either a sun disk, an
Ahura Mazda figure, or a blank space (perhaps orig-
inally for an inscription).

Achaemenid seals also depict heraldic seated
sphinxes facing each other with one paw raised,
sometimes with an ornament at the top of the
headdress and sometimes beneath a sun disk.[6]
Achaemenid gold plaques from Sardis in Lydia show
the same combinations of motifs as do the seals,[7]
and an unprovenienced gold plaque representing a
winged, human-headed bull-sphinx[8] with back-
turned head has the same beard structure, ears (but
without earrings), and cylindrical headdress, lacking
only the upright petal at the top. This plaque might
very well have been made in the reign of Darius I
or Xerxes.

OWM

1. See Roaf, 1983, pp. 133ff., fig. 138.
2. Mecquenem, 1947, pp. 58–59, fig. 32; J. Perrot, 1981, pl.
 36:6. The *cour centrale* is C2 of Mecquenem, 1947, Plan 2.
3. Mecquenem, 1947, pp. 58, 60. M. Dieulafoy (1893, pp. 305–6,
 fig. 184), published a glazed brick fragment with a bearded
 head that could belong to a royal personage, a sphinx, or a
 lamassu. He also cited another brick with part of a wing pre-
 served (p. 308, fig. 187), which he interpreted as an Ahura
 Mazda form and restored on the *apadana* (pl. 14). These
 pieces deserve better publication.
4. Schmidt, 1953, pls. 22, 63, 127, 169; also Mecquenem, 1947,
 pp. 63–64, 83, fig. 52:11.
5. Schmidt, 1953, pls. 9, 11.
6. E.g., Pope, 1938, vol. 7, pl. 123:K; Boardman, 1970, pls. 1, 5;
 Legrain, 1925, pls. 56:888–91, 58:953, 59:954.
7. C. Densmore Curtis, *Sardis*, vol. 13, pt. 1 (Rome, 1925),
 pl. 1, no. 1.
8. Vanden Berghe, 1959, p. 109, pl. 135:C.

158 TILE WITH LION'S HEADS

*Siliceous brick; glazed brown, yellow, light green,
white, with gray-black outlines*
H. 14⅛ in. (36 cm); W. 12¼ in. (31 cm); D. 3⅛ in. (8 cm)
Achaemenid period, late 6th–5th century B.C.
Apadana, east of the palace; Sb 3336
Excavated by Mecquenem, March 1914.

This flat, glazed plaque or tile was recovered to the
east of the palace on the Apadana mound, where it
had apparently been reused; part of the surface has
been accurately restored.[1]

The preserved uppermost panel displays two
isolated lion-griffin heads depicted in classic
Achaemenid style. The snarling mouths with non-
protruding tongues are naturalistically rendered;
more fantasied is the presence of bull's horns and
ears and a thickly rendered mane with ends termi-
nating in concentric circles, perhaps to indicate curls.
Below the heads, and also in the lowermost zone pre-
served, are rows of concentric circles set between op-
posed triangles; they frame a frieze of joined lotus
flowers and palmettes. The lotus and palmette motif
is a common Achaemenid design[2] that, along with
opposed triangles, appears on many objects recov-
ered at Susa. Also characteristically Achaemenid are
the lion-griffin and the use of isolated heads.

Heads of horned lion-griffins, beneficent crea-
tures, appear as terminals on throne seats, on col-
umn capitals, and on seals.[3] Sometimes the lions
have caprid's horns as they do on a glazed panel
from Susa,[4] on gold plaques,[5] and as protomes and
handles on silver vessels. There are also full-bodied
horned lion-griffins with eagle's claws that must
be malevolent, since they are shown being killed by
a hero.[6]

The best-known examples of isolated heads are
those found on gold bracteates; they have flaring
manes terminating in circles, lion's ears, and no
horns.[7] Isolated lion's heads of the same form are
found on a stamp seal from Ur and on another, with
four heads one above the other, in Oxford.[8] The type
is also depicted in modified wolflike character on
the well-known felt hanging from Pazyryk in the
Altai Mountains, which reflects an Achaemenid
background.[9]

It has been suggested that this isolated head mo-
tif derives from nomadic cultures, perhaps from

Central Asia,[10] but the earliest occurrences known to date are the Achaemenid examples discussed here.

OWM

1. Mecquenem, 1947, pp. 79–80, fig. 48; see also Toscanne, 1916, pp. 70 ff., fig. 1 (shown unrestored); Kantor, 1957, p. 11, fig. 7; Amiet, 1988b, fig. 76.

2. Mecquenem, 1947, pp. 80–81, figs. 50, 51; Toscanne, 1916, pp. 79 ff.

3. Toscanne, 1916, p. 74, figs. 11, 13; Ghirshman, 1964, p. 215, fig. 263; Walser, 1980, figs. 119, 120, 123; Boardman, 1970, pl. 1:4, 8.

4. Mecquenem, 1947, p. 70, fig. 39.

5. Ghirshman, 1964, p. 266, fig. 327.

6. Schmidt, 1953, pls. 145, 196.

7. Kantor, 1957, pp. 8 ff., pls. 4 right, 6:B; Lerner, 1991, fig. 8; Schmandt-Besserat, 1978, p. 70, no. 79. None has been excavated by archaeologists.

8. Kantor, 1957, p. 9, fig. 5:A; Moorey, 1978, p. 144, fig. 4.

9. Kantor, 1957, p. 10, fig. 6; Lerner, 1991, pp. 8–9, fig. 7.

10. Kantor, 1957, pp. 10–11.

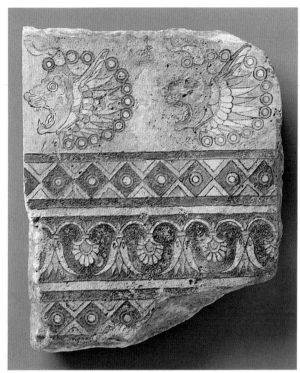

158

159 TILE WITH A ROSETTE
Siliceous brick; glazed brown, light green, yellow, white, with gray-black outlines
H. 14⅜ in. (36.5 cm); W. 13⅜ in. (34 cm); D. 3½ in. (8.8 cm)
Achaemenid period, late 6th–5th century B.C.
Sb 3337

159

This flat tile is decorated with a central sixteen-petaled rosette flanked on all sides by a row of different-colored triangles; the four short sides are plain but glazed.[1] Its findspot was not recorded, nor whether other examples like it were recognized, but many flat glazed tiles, some quite similar to this one, have been recovered, some south of the *apadana* in the area where the palace was later found.[2] One of these tiles has a central sixteen-petaled rosette and three small rosettes on one short side but lacks framing triangles; another is the same but is framed by triangles only on three sides; and another form has two half-rosettes per tile, with the other halves completed on neighboring sections.[3] There are also standard-sized bricks that have an ornamentation of glazed rosettes.[4]

Both Dieulafoy and Mecquenem interpreted these tiles as stairway decorations—a correct interpretation if the published reconstructions are accurate in depicting bricks with oblique triangles on the stairways.[5] The tile shown here and those with rosettes on one short side would then have been the

topmost elements of merlons. Brick and stone reliefs from Susa depicting servants mounting stairs (see Nos. 161–167 and fig. 51, p. 225) indicate the existence of both stone and brick stairways; these decorated tiles would point to yet another brick-decorated stairway.

Glazed bricks decorated with rosettes of sixteen petals also occur at Persepolis,[6] and in the earlier palace of Nebuchadnezzar at Babylon.[7] Twelve-petaled rosettes are one of the most common forms of border decoration on the stone reliefs at Persepolis.

OWM

1. See Mecquenem, 1947, pp. 78–79, fig. 47:1; Perrot and Chipiez, 1890, p. 537, fig. 344.
2. M. Dieulafoy, 1893, p. 297.
3. Ibid., p. 301, fig. 176, pls. 7, 10, fig. 173; Schmandt-Besserat, 1978, p. 62, no. 69.
4. M. Dieulafoy, 1893, pls. 8, 9, figs. 174, 175, 177; Mecquenem, 1947, fig. 43.
5. M. Dieulafoy, 1893, pl. 8. Schmidt, 1953, p. 32, and Labrousse and Boucharlat, 1972, p. 85, accept the restoration as a stairway.
6. Schmidt, 1953, p. 91, fig. 35.
7. Mecquenem, 1947, figs. 61, 62. Note the same use of glazed rosette bricks on a facade at Carchemish: C. Leonard Woolley and R. D. Barnett, *Carchemish*, pt. 3 (London, 1952), frontispiece, p. 169.

160 HAND IN SLEEVED GARMENT
Siliceous brick; glazed cobalt blue, yellow, white, with black outlines
H. 2½ in. (6.3 cm); W. 4¾ in. (12 cm); D. 3⅛ in. (8 cm)
Achaemenid period, late 6th–5th century B.C.
Sb 14229

This fragment of a flat glazed brick preserves the left arm and sleeve of a figure moving left; on the wrist is a penannular bracelet that may have animal-head terminals.[1] The arm is white and the garment is yellow, the sleeve undecorated except for rows of circles on the blue borders. A whitish triangular section above the left arm may be part of the extended right arm. The cobalt blue color was also common at Babylon.[2] If the panel were completely restored to its original height, it would be an estimated nine bricks high.[3]

This brick is one of two published fragments from the same frieze. The other, depicting a figure moving right and carrying a spear, which by an artist's oversight does not pass through the hand, is a mate in all details to this figure.[4] The two bricks were part of a frieze of two or more guards facing each other. Another, complete, glazed brick (in relief) from Susa shows a guard with a penannular

160

bracelet carrying a spear, but he wears clothing ornamented differently, with triangles and circle patterns, that precisely matches the garment worn by a guard on a glazed brick from Babylon.[5]

Both series of guards are distinguished from the better-preserved relief guards (Nos. 155, 156) by clothing, skin color, ornamentation, scale, and position of the extended arm holding the spear.[6] Obviously they were placed in different areas of the palace. Mecquenem reported that flat glazed brick panels of "spearmen of the guard" were recovered in the *cour ouest* of the palace;[7] surely he must have been referring either to his figure 27:1 or to this fragment and its mate.

<div align="right">OWM</div>

1. Mecquenem, 1947, pp. 51ff., fig. 26:17; Schmandt-Besserat, 1978, p. 61, center left; Canby, 1979, p. 316, no. 2.
2. Haerinck, 1973, p. 120, for colors employed at Babylon.
3. Information from Annie Caubet.
4. Mecquenem, 1947, pp. 51ff., fig. 26:16, published upside down.
5. Ibid., pp. 50ff., fig. 27:1, pp. 53–54, fig. 29; Haerinck, 1973, pp. 121, 123, fig. 3:a, b. Compare a similar garment on a guard from Artaxerxes II's Shaur complex (Labrousse and Boucharlat, 1972, p. 84, fig. 19:1).
6. Canby (1979, p. 316) doubts that the present figure and its mate are guards, a conclusion rejected here.
7. Mecquenem, 1938a, p. 323; his court H1 on fig. 75; idem, 1947, p. 54.

161 HEAD WITH TURBAN

Siliceous brick, decoration in relief; glazed pinkish brown and white, with gray-black outlines and hair
H. 3⅛ in. (8 cm); W. 5⅛ in. (13 cm); D. 3 in. (7.5 cm)
Achaemenid period, late 6th–5th century B.C.
Sb 18653

This fragment of a brick depicts in relief the head of a person facing right. He wears a wound turban that covers the top of his head, passes down the side, and, as we know from other examples, wraps around the chin just below the mouth. Curls of hair are exposed at the forehead along the edge of the turban, and enough of the upper lip survives to show that there is no mustache. The top of the brick is extant; the bottom is broken away, but the preserved height suggests that little is missing.

Two comparable bricks from Susa have been published. One, not in relief, is also a fragment of a glazed turbaned head facing left.[1] The other is a complete, unglazed relief brick that belongs to a series of bricks forming a frieze of Persian servants mounting stairs (see No. 165).[2] It shows part of a head, without a mustache, wearing a turban that crosses the chin. On both examples there are ends of hair at the forehead edge of the turban.

161

The head shown here is surely that of a Persian servant, as indicated by the form of the turban and the absence of a mustache (see No. 167 for a possible Mede servant). At Susa two almost completely preserved Persian figures on stone reliefs, who are certainly servants because they carry trays, wear the same turban and have no mustache.[3] Two other very similar stone reliefs from Susa that preserve only the head also have the turban and lack a mustache;[4] they too are clearly Persian servants. At Persepolis all the Persian servants wear the same kind of turban, and half of them are unbearded.[5]

Servants were also depicted in glazed brick in the Achaemenid structure at Babylon; on one of the fragmented bricks, which preserves the lower part of a figure's nose and mouth, it can be seen that there is no mustache and that the chin is covered by the turban.[6]

At Susa, then, there were several friezes of servants carrying food: in stone at Artaxerxes II's complex and the Donjon, and in glazed bricks (Nos. 161, 164, 167) and plain relief bricks (No. 165), all presumably from Darius I's palace.

OWM

1. Mecquenem, 1947, pp. 52, 86, fig. 27:2; Canby, 1979, p. 316, no. 1.

2. Mecquenem, 1947, pp. 84–85, fig. 53:1; nos. 2–7 are the other servant figures. Mecquenem thought fig. 53:1 was a female, ignoring the evidence of other servants and the fact that females are not represented in major Achaemenid art. On the possibility that the servants are eunuchs, see Roaf, 1974, p. 96; idem, 1983, p. 115; see also Peter Calmeyer in Heleen Sancisi-Weerdenburg and Amélie Kuhrt, eds., *Achaemenid History* IV (Leiden, 1990), p. 13 n. 17, and ibid., VI (Leiden, 1991), p. 289.

3. From Artaxerxes II's complex and the Donjon: Labrousse and Boucharlat, 1972, fig. 43:2, pl. 34:4; Mecquenem, 1947, fig. 53:10, pl. 6:5.

4. Amiet, 1988b, fig. 82; Boucharlat and Labrousse, 1979, p. 60, fig. 23, pl. 19:a. Artaxerxes II's columned hall was also decorated with paintings; one is a head with an odd turban that the excavators compare to Delegation VII on the *apadana* at Persepolis: Labrousse and Boucharlat, 1972, p. 83, fig. 42:2.

5. Roaf, 1974, pp. 96–97, fig. e; Schmidt, 1953, p. 240 and pls. 82, 85, 86, 132–35, 161, 163, 165, 168–72, 185–87.

6. Haerinck, 1973, p. 127, pl. 56, top. Haerinck, following Koldewey (1931, p. 122, pl. 39:b), calls the chin band a mustache.

162 HEAD IN RIGHT PROFILE

Siliceous brick, decoration in relief; glazed pink, light blue, black, yellow, with blue-black outlines
H. 3½ in. (9 cm); W. 4⅜ in. (11 cm); D. 2¾ in. (7 cm)
Achaemenid period, late 6th–5th century B.C.
Sb 9510

163 HEAD IN RIGHT PROFILE

Siliceous brick, decoration in relief; glazed brown, light green, yellow, with gray-black outlines
H. 3⅜ in. (8.5 cm); W. 5⅛ in. (13 cm); D. 3⅛ in. (8 cm)
Achaemenid period, late 6th–5th century B.C.
Sb 14228

Both brick fragments are in relief and glazed, and both preserve just the forepart of the face, including the eyes and nose but not the mouth.[1] The face of Number 163 is brown; on Number 162 the face is cream pink.

Although the faces are very similar in size and facial form, the outlines of their noses differ. This and the color distinction indicate that the two heads belonged to separate scenes.

The only other human figures at Susa with dark skin (cf. No. 157) are those in the large relief frieze of guards (Nos. 155, 156). However, Number 163 clearly does not belong with them. On the guards, the nose terminates at the base of the brick and the beard is molded on the brick below,[2] which is not the case here.

Number 162 could be a guard or a servant, since examples from both these categories are represented with white skin at Susa (see Nos. 161, 164, 165).[3]

Because both finds are small fragments, without specific loci, it is best to avoid specific interpretations.

OWM

1. Schmandt-Besserat, 1978, p. 61, upper center.

2. Also, it seems that the right end of the brick is closer to the nose than on Number 163.

3. For another published brick fragment of a white face—perhaps with a mustache—see M. Dieulafoy, 1893, p. 430, fig. 286. For one from Babylon, see Koldewey, 1931, Taf. 39:a; Haerinck, 1973, pl. 56:a. Koldewey calls it a female (p. 122).

164 HAND

Siliceous brick; glazed pink and yellow, with black outlines
H. 1⅞ in. (4.7 cm); W. 4¼ in. (10.7 cm); D. 3 in. (7.5 cm)
Achaemenid period, late 6th–5th century B.C.
Sb 14232

Preserved on this flat (non-relief) brick fragment is a hand, glazed white, with a solid bracelet in yellow.[1] The positions of the thumb and smallest finger identify it as the right hand of a person facing right. From this angle, however, one might expect the bracelet to display open ends terminating in animal heads, like those on Number 165; on the stone reliefs only the servants have solid, closed bracelets.[2]

A dark line extending the pinkie may be all that remains of an object—perhaps a knob—held between the thumb and pinkie. If so, we may interpret the hand as belonging to a servant who performs the same duties as the one in Number 165 (although this figure is from a different banquet procession). In these two cases the fingers are arranged differently, but in both examples fingers not normally employed for the task are used to hold objects. The delicacy of the finger positions might reflect an etiquette expected of those serving the king.[3]

OWM

1. Schmandt-Besserat, 1978, p. 61, middle center; Canby, 1979, p. 317, no. 4.
2. Mecquenem, 1947, fig. 53:10; Labrousse and Boucharlat, 1972, fig. 43:2.
3. The hand cannot belong to a woman, as females are not represented in monumental Achaemenid art.

162

163

164

165 HAND HOLDING A VESSEL

Unglazed siliceous brick, decoration in relief
H. *3⅜ in. (8.5 cm); W. 13⅜ in. (34 cm)*
Achaemenid period, late 6th–5th century B.C.
Sb 3344

This standard-sized unglazed siliceous brick is shaped in relief to represent part of a human torso; the body would have been completed on neighboring bricks. The right hand holds between the thumb and two fingers (cf. No. 164) what appears to be the knob of a vessel. On the wrist is a typical Achaemenid bracelet with open animal-headed terminals. The end of a pendant from a headdress hangs at the figure's back.[1]

The torso is that of a Persian servant—identifiable as Persian by the clothing and the turban with a pendant, typically Persian, and identifiable as a servant because he carries an object (see Nos. 164, 167).[2] Other unglazed relief bricks recovered are clearly part of the same scene: a Persian servant's head, a live sheep (see also No. 167), and several segments showing Persian servants' clothing, one of which reveals that the figure was mounting a stairway.[3]

Thus, represented on unglazed relief bricks was a procession of servants mounting a brick stairway, ap-

parently not the same stairway as the one decorated with tiles with rosettes and other floral and geometric motifs (No. 159). Furthermore, other groups of servants were represented in both glazed relief and flat bricks at Susa, and some of these are mounting stairs (see Nos. 161, 165, 167). These glazed and unglazed brick representations of servants mounting a stairway duplicate the scenes executed for stone stairways on the Donjon reliefs (whose original locus remains unknown), in Artaxerxes II's columned hall across the Shaur, and, extensively, in the palaces at Persepolis (fig. 53).[4]

It is noteworthy that, like the one on Number 164, this servant wears a bracelet (cf. No. 167), and that the vessel has a knob by which it is held. A closed bracelet is apparently worn by the Persian servant on a stone relief from the Donjon mentioned above, but no servant on the Persepolis reliefs wears one, to my knowledge.[5] And while small lidded vessels are carried on the Persepolis reliefs, they are flatter than the Susa example and do not have knobs.[6] On those reliefs the servant sometimes covers the vessel with his hand to steady it.

There are other minor differences between the objects carried by servants at Susa and at Persepolis. For instance, servants on the stone reliefs from the Donjon and Artaxerxes' columned hall carry trays on their shoulders that have a reversed duck's head at

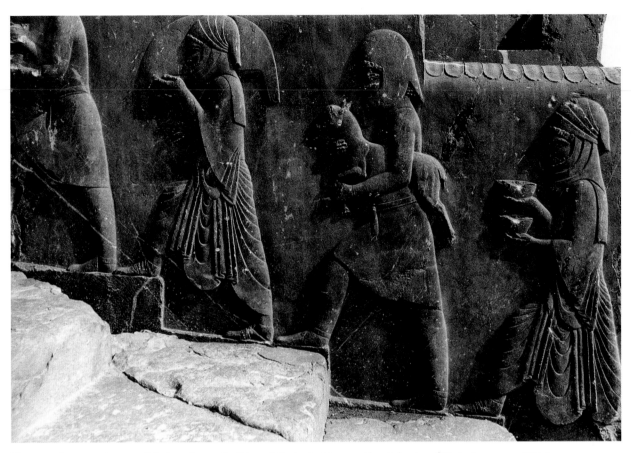

Figure 53. Servants on stone reliefs from Persepolis. Palace of Darius I, Achaemenid period, reign of Darius I, ca. 522–486 B.C.

one end. At Persepolis no trays are carried, although an actual stone tray with a reversed duck's head at one end was excavated there.[7]

OWM

1. Mecquenem, 1947, pp. 84–85, fig. 53:2.
2. E.g., Roaf, 1974, pp. 98–99, fig. e; idem, 1983, pl. 43a, b.
3. Mecquenem, 1947, fig. 53:1–8. The findspot has not been published for any of these.
4. Ibid., pl. 6:3, 5, fig. 53:9, 10; Labrousse and Boucharlat, 1972, pl. 34:3, 4, fig. 43:1, 2.

5. Bracelets are worn at Persepolis by other social groups besides the king: nobles, Medes, Persians, guards (as at Susa—see Nos. 155–56, 160), and grooms (Roaf, 1974, p. 101). Might the Susa servants belong to a special category of this service, or do we have another example of a difference between Susa and Persepolis?
6. E.g., Walser, 1980, figs. 111, 112, 117.
7. Schmidt, 1957, p. 88 and n. 78, pls. 53:5, 54:3. Roaf (1983, p. 149 n. 182, no. 3) assigns to Susa a relief in Berlin of a servant carrying a tray of this type, but does not mention that it was the tray that determined the attribution.

166 HEAD WITH WREATH(?)
Siliceous brick; glazed brown, light green, yellow,
with gray outlines
H. *3⅛ in. (8 cm);* W. *3⅛ in. (8 cm);* D. *3 in. (7.5 cm)*
Achaemenid period, late 6th–5th century B.C.
Sb 14428

This fragment is both unique and tantalizing: unique because nothing else like it is known from Susa or Persepolis, tantalizing because it cannot readily be interpreted. The height of the flat glazed brick is intact, preserving the upper and lower sides and also one short side.

The fragment seems to show a wreath—a braided band with petals—bound around an object. One is inclined to see the object as a head facing left, but no hair or ear is indicated. The ear might have been represented on the brick below, but the hair remains a problem. And what is represented if not a head? It should further be noted that wreaths, on heads or elsewhere, are not otherwise seen in Achaemenid art, which makes it even more difficult to understand this fragment.

This is a good example of the kind of problem involved in interpreting the meaning of isolated bricks from Susa that were parts of large scenes and in determining what the original form and content of those scenes were.

OWM

167 SERVANT CARRYING AN ANIMAL
Siliceous brick, in relief; glazed brown, yellow, green
H. *3⅛ in. (8 cm);* W. *5⅞ in. (15 cm);* D. *5⅛ in.*
(13 cm)
Achaemenid period, late 6th–5th century B.C.
Acropole; Sb 14392
Excavated by Dieulafoy.

Only part of the length of this glazed relief brick is preserved, but enough exists to allow one to recognize the original full form of the figure depicted here and on the neighboring bricks: a servant facing left, carrying cradled in his arm a live animal, probably a kid or lamb. Only the front legs of the animal are extant. The servant's left hand holds the animal's chest, and the right hand no doubt held it at the neck. That the servant is mounting a stairway is evident from the raised position of his thigh. He wears an elaborately decorated garment, adorned with rosettes of alternating white- and dark-glazed petals.[1] No bracelet is worn (cf. Nos. 164, 165).

Other bricks preserved from Susa show animals being carried by servants; two are published.[2] One is a glazed relief brick preserving only the animal's front legs, and another, from a different series of servants depicted on plain siliceous bricks (see No. 165), preserves a sheep's head. The former may have been part of the same scene as Number 167, while Number 165 was also part of a series of servants mounting a brick stairway. At Persepolis there are

166

167

many examples of servants who mount stairways and carry live animals—sheep and deer (see fig. 53, p. 237).[3] These scenes show processions of alternating Persians and Medes carrying food, but it is of interest that only the Medes carry live animals. Whether this is significant—may Medes have played a special role in slaughter or sacrifice?—eludes us.

Given these parallels, it is possible that the fragment shown here represents a Mede, assuming that the same details and cultural situation noted at Persepolis obtained at Susa. And if that is the case, it is also possible that Number 161, the head of a Persian servant facing right, was part of the same scene as this piece, in a depiction of alternating Persians and Medes mounting stairways, one group mounting from the right, the other from the left.

OWM

1. Mecquenem, 1947, p. 51, fig. 26:7–11, contains examples of brick fragments that show garments decorated with rosettes. They have eight petals, like the present example, but the drawings do not indicate alternating light and dark colors. If this is an error and the colors do indeed alternate, then the brick fragments could be servant's garments. The piece in fig. 26:7 is not in relief (information from A. Caubet); if the others are also not in relief, they are clearly not from the same series as the present example, even if the petal colors alternate.
2. Mecquenem, 1947, pp. 52, 86, fig. 27:3; pp. 84–85, fig. 53:4.
3. Schmidt, 1953, pls. 82, 85, 86, 133–35, 155, 156, 161, 163–65, 168, 171. Note that even when an animal is depicted walking, it has a Mede escort (pl. 187).

168 FEET IN SHOES
Siliceous brick; glazed brown, light green, yellow, white, with gray outlines
H. 3⅜ in. (8.5 cm); W. 5⅞ in. (15 cm); D. 3⅛ in. (8 cm)
Achaemenid period, late 6th–5th century B.C.
Sb 14227

The lower parts of two legs and two shoes, one overlapping the other, are represented on this flat glazed brick, which is fully preserved in height but missing at least half its length.[1] There is a zigzag pattern on the hose or trousers of the right leg, and the right shoe has an ankle strap with two hanging ends. The left leg wears dark, monochrome hose or trousers, and the left shoe has three straps, each with a button exposed above the foot, and an extending tongue. The feet belong to two striding individuals, and in such depictions the left foot traditionally leads. Thus, the far foot is a rear right foot; overlapping it is a (forward) left foot.[2] The brick's specific findspot is unknown.

Because ethnic groups are distinguished by clothing and footwear in ancient art, and certainly in Achaemenid art, we know that individuals from two distinct ethnic groups are represented. Furthermore, Achaemenid artists were consistent in their depiction of the shoe forms worn by kings, princes, commoners, and different ethnic groups. Here the right

168

shoe is worn by a Mede, the left by a Persian: Persian shoes always have three straps with buttons and a tongue shown,[3] and the shoes of Medes always have an ankle strap with hanging ends.[4]

It is more difficult to determine the activities of the two individuals. Shoes shown overlapping are not uncommon on the Persepolis reliefs but are depicted only with figures of the same ethnic background, either all Persians or all Medes.[5] Although Persian and Mede servants often alternate on these reliefs, their feet never overlap; nor do those of the tribute bearers at Persepolis. This image is another example of divergence between Susa and Persepolis in the representation of figures (see No. 165).

One might tentatively suggest—against the Persepolis evidence—that the two feet are part of a servant scene in glazed brick in which the servants wear elaborately decorated clothing (see No. 167) or that the scene depicts Persian and Mede dignitaries; there is no evidence that tribute bearers were represented at Susa.[6]

The zigzag pattern occurs on clothing depicted on glazed bricks at Susa,[7] but this is the only example on hose in Achaemenid art (although the pattern could have been painted on the stone reliefs at Persepolis). Peter Calmeyer has cited patterned hose (trousers) worn by horsemen on the Pazyryk carpet;[8] such hose (like our argyle socks) may have been more common than has been realized.

The zigzag hose and shoe appear to be separate elements. Gerald Walser has argued that on the stone reliefs the hose and shoes of the Medes seem constructed from one piece of leather, and that there was no separate shoe;[9] our example suggests otherwise.

OWM

1. Mecquenem, 1947, p. 51, fig. 26:14; Schmandt-Besserat, 1978, p. 61, lower right; Calmeyer, 1972–75, p. 475, fig. 3.
2. The left foot traditionally leads, even though damage here prevents one's seeing the instep. Stronach, 1978, p. 97; Calmeyer, 1988, p. 36 n. 57.
3. Sometimes the button projects above the straps. See Walser, 1980, figs. 103, 104; Hinz, 1969, pl. 26, left; Mecquenem, 1947, figs. 23, 53:8, pl. 6:2. Heroes also wear the Persian shoe: Hinz, loc. cit.
4. E.g., Roaf, 1983, p. 11, fig. 4. For the shoes of a Mede and a Persian standing together, see Roaf's figs. 122, 123; Walser, 1980, figs. 42, 43. For shoes, see Calmeyer, 1972–75, p. 475, and idem, 1988. Mede tribute bearers (Delegation I) appropriately wear this shoe—but so do Delegations III, IX, XXI: see Walser, 1966, pl. 32, 38, 54, 56, 77.
5. Schmidt, 1953, pls. 72:A, 73:B, 74; Roaf, 1983, pl. 47:a; Walser, 1980, fig. 101, 102, 109, 110, 113.
6. Stronach (1978, p. 97) misunderstands the shoe with the zigzag hose, calling it "a royal shoe." Furthermore, a royal shoe is never overlapped.
7. Mecquenem, 1947, fig. 26:10, 11.
8. Calmeyer, 1972–75, pp. 474–75; see Ghirshman, 1964, fig. 467.
9. Walser, 1966, p. 68.

169 PARTS OF LIONS AND A LION-GRIFFIN
Unglazed brick, in relief
Lion's foot: H. *ca. 12¼ in. (31 cm); Sb 20557*
Lion's head: H. *ca. 17¼ in. (44 cm); Sb 20556*
Lion-griffin: H. *ca. 41½ in. (106 cm); Sb 20558*
Achaemenid period, late 6th–early 5th century B.C.
(See the Conservation Report, pp. 284–85.)

Many hundreds of unglazed relief bricks representing animals moving to both the left and the right have been recovered at Susa. They all seem to have been reused as pavement and wall fillings in later structures.[1] Shown here are reconstructed panels depicting a lion, a winged lion-griffin, and a lion's foot.

Glazed brick panels of animals in relief have also been recovered at Susa, within the palace complex.[2] They include striding lions and winged bulls and griffins and are among the most spectacular of the site's glazed brick decorations. Thus the same animals appear on the glazed and the unglazed panels, which seem to resemble each other in all details.

OWM

1. M. Dieulafoy, 1893, pp. 308, 312, fig. 195; Mecquenem, 1947, pp. 57f., 64, 71, fig. 31.
2. Mecquenem, 1947, pp. 54f., 64f., 70f., figs. 30, 37, 39, pl. 8.

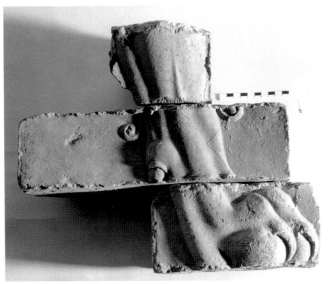

169, lion's foot (restoration photograph)

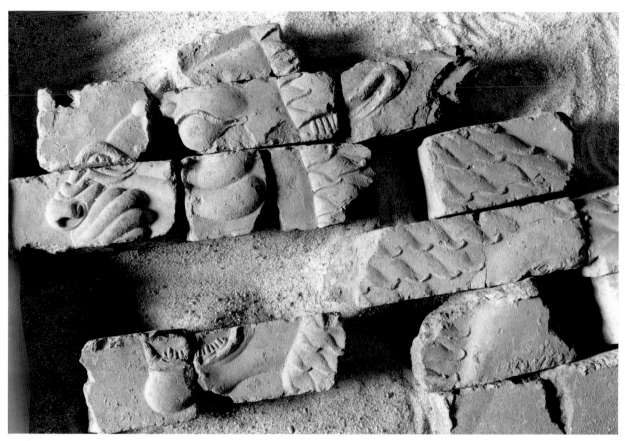

169, lion (restoration photograph)

169, lion-griffin (restoration photograph)

The Achaemenid Tomb on the Acropole

From the unanimous reports of Greek historians we know that the Persians were fond of gold and luxury wares, but relatively few pieces of jewelry have come down to us, probably because of the scarcity of tombs of this period. That is why the group of objects discovered by Jacques de Morgan on February 6, 1901, in an Achaemenid tomb on the Acropole of Susa is particularly valuable.[1] In a plain bronze sarcophagus shaped like a tub was a skeleton on its back, the upper part of the body covered with gold jewelry and semiprecious stones (fig. 54). A silver bowl and two alabaster vessels completed the funerary furnishings. It may be posited from the fallen bricks found in the sarcophagus that it had been placed in a vaulted tomb.

Two Aradus coins dating between 350 and 332 B.C. seem to indicate that the burial took place at the end of the Achaemenid period.[2] Unfortunately, we have no textual references to help us identify the corpse. Morgan surmised that it was a woman because the bones were small and there were no weapons in the sarcophagus; he also speculated that she was elderly because of the worn state of the teeth. On the other hand, the jewelry could well belong to a man, an hypothesis that is supported by visual representations and textual references. The Greek historian Arrian reported that the body of Cyrus the Great in his tomb at Pasargadae was covered not only with gold materials, embroidered clothes, and daggers but also with necklaces, bracelets, and pendants made of gems and gold.[3] According to Herodotus,[4] the ten thousand immortals who constituted the elite soldiers of Xerxes distinguished themselves not only by their bravery but also by "their vast quantities of gold ornaments."

The multiple jewels in the Susa tomb were undoubtedly not all meant to be worn at the same time. In addition to the objects presented in this exhibition, there was also in the tomb a three-strand necklace of fine pearls separated at regular intervals with gold spacer beads inlaid with colored stones. The pearls were most likely imported from the Persian Gulf region, reputed in antiquity to be the source of the finest pearls.

The charter of the Palace of Darius (No. 190) states that Egyptian and Median goldsmiths, then considered the most skilled artisans in the trade, worked on the decoration of the palace. Yet there were certainly many centers for the production of precious objects. On the reliefs in the *apadana* at Persepolis, several delegations can be seen bringing bracelets (the Medes, the Scythians, and perhaps the Sogdians) or vessels of silver and gold (the Lydians and the Armenians). On the other hand, texts from Persepolis mention Carian goldsmiths. It is therefore difficult to attribute the manufacture of these jewels to a specific region because their style and iconographic motifs were common all across the empire, and they were made using techniques that had long been mastered throughout the Near East.

Indeed, by the first half of the third millennium B.C., goldsmiths knew enough about the properties of gold and gold alloys to practice the techniques of metal-joining; they either heated the parts that were to be joined to just the temperature of fusion, or used a copper or silver alloy that lowered the fusion point where the two pieces were to be joined. Thanks to these working methods, decoration in cloisonné and filigree began to appear by about 2600 B.C., as can be seen in the jewelry from the royal tombs of Ur. Granulation is evidenced in the second half of the third millennium B.C. in the treasures discovered at Troy, and its use was expanded in the following millennium. Because inlaying weapons and jewelry with colored materials became highly popular in the Middle Kingdom of Egypt, Morgan considered the Dashur jewels, and Egyptian jewelry in general, to be the antecedents of Susian jewelry. However, the jewelry recently dis-

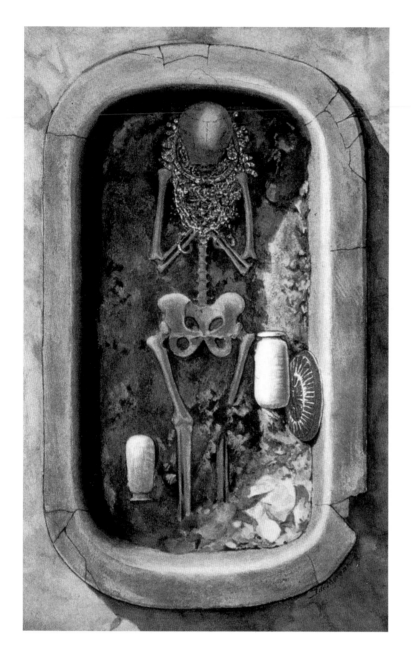

Figure 54. Reconstruction of the Achaemenid tomb discovered on the Acropole in 1901. Watercolor on paper

covered at Nimrud proves that inlays of colored stones were equally popular in the Assyrian court just before the Persian period.

At any rate, the find of jewelry presented here provides us with a glimpse of the splendor of the Susian court and of its taste for bright colors, evident as well in the enameled brick decoration of its palaces.[5]

FRANÇOISE TALLON

NOTES

1. Other Achaemenid treasures are known. In the Vouni Palace on Cyprus, a treasure was found in a jar that consisted of jewelry, vessels, and gold and silver coins; see Gjerstad, 1937, pp. 238 no. 292, 278, pls. 90–92. More recently, David Stronach discovered a treasure, also contained in a jar, in one of the buildings of the royal gardens of Pasargadae, the ancient capital of Cyrus the Great: Stronach, 1978, pp. 168–77. Finally, the Oxus treasure remains a major reference despite its discovery under mysterious circumstances, apparently in 1877; see Dalton, 1964.

2. Morgan, 1905a, p. 57.

3. Exp. Alex. VI, 8.

4. VII.83.

5. See also Morgan, 1905a.

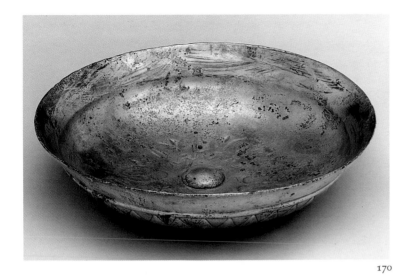

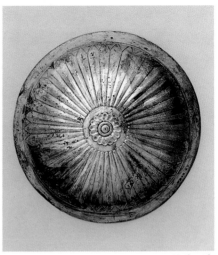

170 Underside

170 BOWL

Silver
H. 1⅝ in. (4.3 cm); DIAM. 7¼ in. (18.4 cm)
Achaemenid period, 4th century B.C.
Acropole; Sb 2756
Excavated by Morgan, 1901.

The shape of the bowl,[1] with the convex base separated from the concave flaring rim by a slight shoulder, is characteristic of the Achaemenid period. Numerous bowls of this type, in bronze, gold, or silver, have been excavated throughout the Persian empire. They are almost always decorated with a radiating floral motif with several variations. Here, on the inside, a lotus flower and bud garland encircles the omphalos. On the underside the design consists of forty petals, each with a median vein and a triangular tip, radiating from a sixteen-petal rosette in the center. A raised circular band is placed between these petals and the rim. A similar motif can be found on a silver bowl with a plain interior from the Oxus treasure.[2]

The shape and decoration of these Achaemenid bowls were inherited from the Neo-Assyrian period, as was their use: these were drinking bowls, as can clearly be seen in a painting on a fifth-century B.C. Lycian tomb at Karaburun, where the deceased is depicted reclining on a bed at a banquet with a phiale of this type in one hand.[3] The weight of this bowl, well over a pound (562 g), suggests that the bowl might have been cast. This would explain why the relief decoration of the exterior is not visible on the interior.

FT

1. Morgan, 1905a, p. 43, pl. 3.
2. Dalton, 1964, no. 19, p. 9, pl. 5.
3. Mellink, 1971, pls. 55–56.

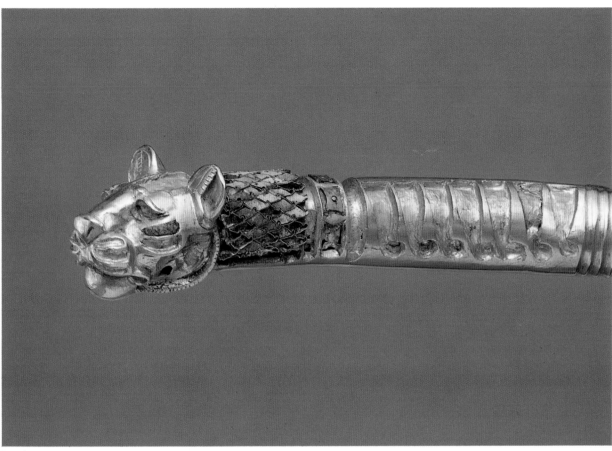

Detail

171 TORQUE WITH LION'S-HEAD TERMINALS
Gold, lapis lazuli, turquoise, and mother-of-pearl
DIAM. *8 in. (20.2 cm)*
Achaemenid period, 4th century B.C.
Acropole; Sb 2760
Excavated by Morgan, 1901.

This torque,[1] probably cast in the lost-wax process,
consists of a fluted tube, ½ inch (1.27 cm) in diame-
ter, in two units that fit into each other over a sec-
tion of 1½ inches (3.7 cm) at the back of the neck
and were attached by means of a pin. Each extremity
of the torque is decorated with a lion's head and with
the stylized representation of the forepart of the
lion, inlaid with mother-of-pearl and colored stones.
The head itself is executed in champlevé. The muz-
zle, jowls, and collar have lost their inlays, but some
lapis lazuli and turquoise remain in the folds of the
muzzle and the cheekbones; the eyes and the top of
the head were embellished with mother-of-pearl, of
which only highly altered fragments remain. The
outer part of the ears was also probably inlaid. The

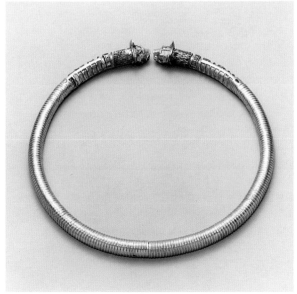

171

cylindrical section behind the head is decorated in very delicate cloisonné work representing the tufts of the mane and is filled with small turquoise inlays. These cells were soldered not to the torque itself but to a separate thin plate of gold, which was then rolled and attached to the torque.

Behind this section are three narrow bands; although they are now almost devoid of inlays, their decorative elements can be reconstructed on the basis of the bracelets that went with the torque (Nos. 172, 173) as well as details supplied by Morgan. The first band had alternating lapis lazuli and turquoise triangles separated by a zigzagging line of gold; the second, which here retains its decoration, consists of alternating lapis lazuli and turquoise squares with concave sides and a gold stud in the center; the third had narrow rectangular strips of turquoise. Finally, there is a 1⅜ inch (3.5 cm) section decorated in champlevé evoking the backbone of the animal, represented by a straight gold line; at its end is a tear-shaped inlay, and on either side of it are inward-curving forms representing tufts of hair, inlaid alternately with lapis lazuli and turquoise.

The lion is stylized in a manner typical of the portrayal of wild animals on Persian reliefs and luxury tableware; the open mouth, the parallel folds of the jowls and muzzle (rendered here by spots of color), the rounded ears pearled on the inside, and the mane composed of hooked triangles are all characteristic features. The same overall design, which consists of treating the mane in delicate cloisonné and the curled tufts of the backbone in champlevé, is found on bracelets and torques from the Oxus treasure, although it should be noted that they differ from the Susian jewelry in the treatment of the head.[2] We can conclude, therefore, that this design was in use in different workshops.

Darius III can be seen wearing a torque of this type in a mosaic depicting the Battle of Issus in the National Archaeological Museum in Naples. The statue of Ptahhotep in the Brooklyn Museum, probably from Memphis, shows this important Egyptian official dressed in Persian fashion and wearing, in addition to his Egyptian pectoral, a Persian torque with ibex terminals sculpted in the round.[3]

FT

172, PAIR OF BRACELETS WITH LION'S-HEAD
173 TERMINALS
Gold, lapis lazuli, turquoise, and mother-of-pearl
2½ x 3 in. (6.4 x 7.7 cm) and 2½ x 3⅛ in. (6.3 x 7.9 cm)
Achaemenid period, 4th century B.C.
Acropole; Sb 2761, 2762
Excavated by Morgan, 1901.

These two bracelets[1] form a set with the torque (No. 171). They are composed of smooth, solid cylindrical tubes, round in section, 5/32 inch (6 mm) in diameter, with an inward curve at the center. The tips are decorated like the torque, but there are fewer inlays and the lion's head is simplified. The lion's jowls and the top of its head are in turquoise, the collar in lapis lazuli; judging from what remains of the single, highly altered inlay element of the eyes, it seems to have been in mother-of-pearl; the muzzle has lost its inlays. The mane is decorated in delicate cloisonné with turquoise inlays, and the backbone is treated in the same manner as the torque.

A relatively large number of Achaemenid bracelets have come down to us. Most of them take the same shape as the ones shown here, but some are circular. They are always penannular and are usually decorated with the heads or bodies of real or imaginary animals: griffins, horned lions, lions devouring other animals, felines, lambs, ibexes, gazelles, and swans. The Achaemenid bracelets revive a tradition that began in northern Iran at the end of the second millennium and became extremely popular from the ninth to the seventh century B.C. in Assyria and even more so in Luristan.

Representations show these bracelets worn in pairs, one on each arm, which is how they were found in the sarcophagus in Susa. The archers (guards) on the glazed brick panels (Nos. 155, 156) can be seen wearing them in this fashion, as can Darius himself on a statue found at Susa (fig. 50, p. 220), his bracelets decorated with the heads of young bovines.

FT

1. See Morgan, 1905a, pp. 48–49, pl. 5:1–2; Amandry, 1958, pl. 9:7–8; Porada, 1965, p. 170, pl. 51 bottom.

1. Morgan, 1905a, pp. 43–48, pl. 4:1; Amiet, 1988b, p. 135, fig. 86.
2. Dalton, 1964, pp. 34–35, nos. 117–19, fig. 65, pls. 17, 21.
3. Bothmer, 1960, no. 64, pl. 60, fig. 151.

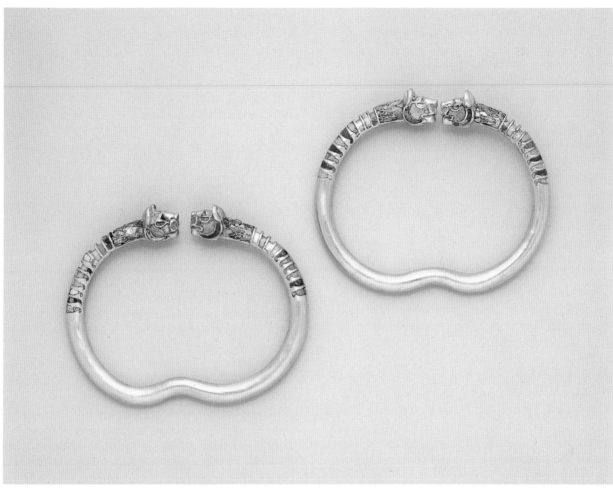

172, 173

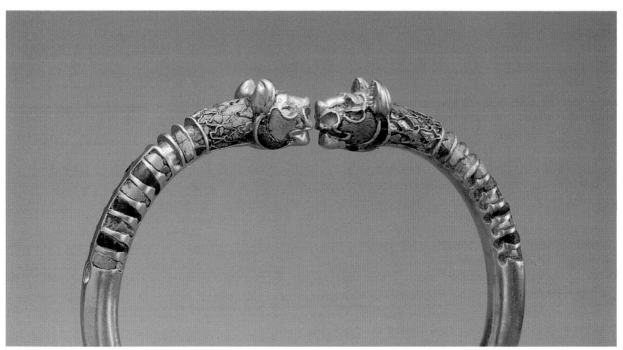

Detail

174 NECKLACE WITH PENDANTS
Gold, lapis lazuli, turquoise, and carnelian
L. 27½ in. (70 cm)
Achaemenid period, 4th century B.C.
Acropole; Sb 2763
Excavated by Morgan, 1901.

This necklace consists of round beads with longitudinal grooves inlaid with turquoise and lapis lazuli. In the center are four larger beads, and interspersed at regular intervals throughout are eighteen pendants, each with a loop linked to another loop on the bead. The pendants are complex in composition and fairly rough in execution. Each is composed of a hook-shaped gold sheet to which various elements have been soldered or fused. The upper part has a convex rectangular section decorated with crudely executed granulation, at right angles to which is a semicircular plate with a row of granules along the outer edge. Below this gold cap the pendant is treated in openwork created by thin strips of gold joined to the edges of the back plate. Inside these strips are triangular-shaped inlays, with convex upper sides and a flat base that can be seen between the gold strips; the spaces are filled with a type of thick cement holding the inlays in place. All the pendants present the same pattern of inlays from top to bottom: lapis lazuli, turquoise, carnelian, turquoise, lapis lazuli, turquoise, carnelian.[1]

FT

1. See Morgan, 1905a, pp. 49–50, pl. 6:1.

175 NECKLACE
Gold and semiprecious stones
L. 12⅝ in. (32 cm)
Achaemenid period, 4th century B.C.
Acropole; Sb 2768
Excavated by Morgan, 1901.

This necklace[1] is composed of gold beads, either plain barrels or granulated rings, and beads of lapis lazuli, carnelian, and turquoise. The oblong carnelian bead and the two smaller cylindrical lapis lazuli beads in the middle of the necklace have gold caps. Two pendants complete the ornamentation: one is disk-shaped and has a suspension ring carved in the carnelian stone; the other is semicircular and consists of a white translucent agate in a tubular

gold setting. The arrangement of this pendant resembles that of a seventh-century B.C. Lydian gold jewel in the Louvre.[2]

FT

1. See Morgan, 1905a, pl. 5:5.
2. Akurgal, 1961, pp. 216–18, fig. 186.

176 NECKLACE
Gold and semiprecious stones
L. 48⅞ in. (124 cm)
Achaemenid period, 4th century B.C.
Acropole; Sb 19355

The four-strand necklace of which this is a single strand is composed of four hundred gold beads and an equal number of barrel-shaped beads made of a wide variety of colored stones: turquoise, lapis lazuli, emerald, agate, jasper of different hues, carnelian, feldspar, flint, quartz, amethyst, hematite, marble, and breccia. The strands were attached at the back by means of a large ribbed gold bead.[1]

The technique of creating a pattern on gold beads by the application of rows of granules of varying sizes is characteristic of the Achaemenid period. First, one or two rows of granules were joined to a strip, and then the ends of the strip were united by the fusion of the granules to each other. This process was generally accomplished by exposure to heat, making the granules appear to be "pasted" together. Several beads of this type have been found at Pasargadae.[2] In Susa itself, eight larger gold beads of this type were excavated from the grave; judging from their position, they seem to have been part of a head ornament.

FT

1. See Morgan, 1905a, pp. 52–54, pl. 4:2.
2. Stronach, 1978, p. 207, fig. 88:9, pls. 155a, 159a–b.

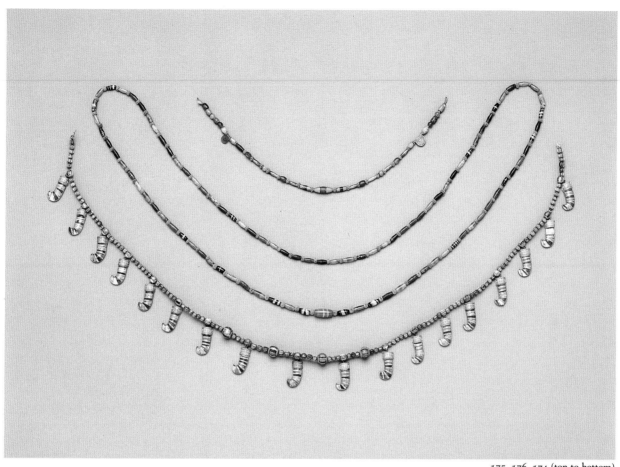

175, 176, 174 (top to bottom)

177 BEADS
 Agate
 L. 10⅜ in. (26.5 cm)
 Achaemenid period, 4th century B.C.
 Acropole; Sb 12070
 Excavated by Morgan, 1901.

Despite a careful study soon after their discovery, Morgan was unable to determine the function of these sixty-five agate beads, the two largest of which were found close to the neck of the skeleton (see p. 242). Nonetheless, he regarded them as ornaments meant to be sewn on garments rather than as pieces of a necklace.[1]

Whatever their use, these beads are of the finest quality. Each bead was carved to make the most of the intrinsic decorative pattern of the white or very pale blue bands that characterize the different colored stones. The two largest beads, measuring 1¼ by ¾ inches (3.2 × 2.1 cm), are shaped like oval medallions, with a milky band separating the light brown center from the darker brown edge. Fourteen

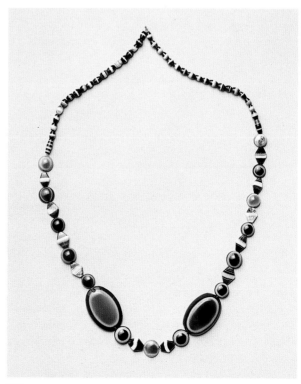

177

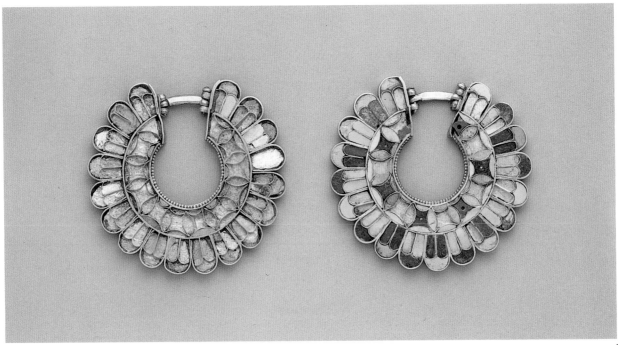

178, one earring reversed

round beads with flat backs, approximately ⅜ inch (1 cm) in diameter, have a light-colored band setting off the brown, beige, black, or gray center. The eleven rhomboid beads, each approximately ⅜ inch (1.1 cm) in length, and the small beads—thirty-four round and two barrel-shaped—have a white band in the middle. Two striped oblong beads complete this very beautiful ensemble, which is presented here in a purely hypothetical arrangement.

FT

1. See Morgan, 1905a, pp. 56–57, fig. 93, pl. 6:4–6.

178 PAIR OF EARRINGS
Gold, lapis lazuli, and turquoise
H. 1⅝ in. (4.1 cm); W. 1¼ in. (4.4 cm)
Achaemenid period, 4th century B.C.
Acropole; Sb 2764, 2765
Excavated by Morgan, 1901.

The earrings[1] are in the shape of a wide, flat ring with an opening on the top for the closing mechanism. They are decorated in cloisonné on both sides with the same motif, which is divided into two concentric circles. The inner circle consists of quadrangular sections—alternately inlaid with lapis lazuli and turquoise—which have concave sides and gold studs in the center;[2] between these sections are oval turquoise inlays. The outer circle is composed of petals, each with two smaller petals at the base. Every other large petal is in lapis lazuli with the twin petals in turquoise; the pattern is reversed for the ones in between. Along the inner circle of the earring is a thin gold band with a row of small granules on either side. The closing mechanism is a gold pin fixed to a hinge on one side with a movable cotter pin on the other.

This type of earring is typical of the Achaemenid period. It can be seen pictured on reliefs in Susa and Persepolis, and several examples have survived. Those excavated at Deve Hüyük are made of simple metal sheets decorated with lobes and wire spirals.[3] Other Achaemenid earrings are in more precious materials: openwork examples inlaid with colored paste or equipped with pendants (such as those found at Pasargadae);[4] or cloisonné examples using semiprecious stones.[5] The closing mechanism is generally the same as the one seen here.

FT

1. See Morgan, 1905a, pp. 50–51, fig. 78, pl. 5:3–4.
2. On the torque (No. 171), one of the bands behind the lion's mane bears this decorative motif. Hence it is possible that these earrings are part of the same set.
3. Moorey, 1980, p. 82, fig. 13:300.
4. Stronach, 1978, p. 201, fig. 85:1–3, pls. 148–50.
5. Muscarella, 1974a, no. 156.

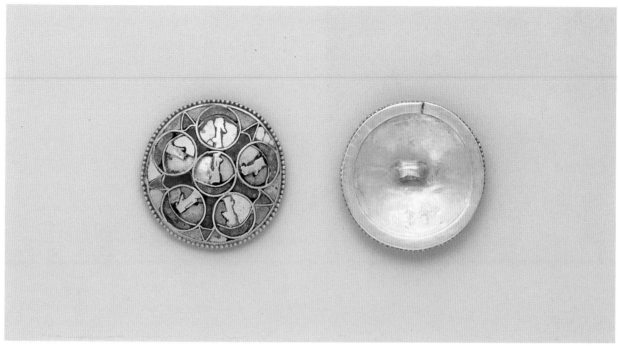

179, one button reversed

179 PAIR OF BUTTONS

Gold, lapis lazuli, turquoise, and carnelian
Each, DIAM. ¾ in. (2.1 cm)
Achaemenid period, 4th century B.C.
Acropole; Sb 2766
Excavated by Morgan, 1901.

Found close to each other on the left side of the skeleton's chest (see p. 242), these small buttons[1] are decorated on the convex side in cloisonné. A loop is soldered or fused to the reverse side, and granulation embellishes the rim. The decoration consists of six similar circles, five on the edge and one in the center. These have a turquoise ground and a schematic design on the upper part perhaps depicting a human figure above a crescent of lapis lazuli. The figure, shown wearing a tiara and with one hand raised, is cut in gold foil and is attached to a folded gold strip that is in turn soldered or fused to the gold ground. Between the circles on the rim side are lapis lazuli triangles on a turquoise background, and carnelian fills the spaces near the center.

The spacer beads of the fine pearl necklace found in the sarcophagus of Susa present the same design motif, which also appears on other Achaemenid jewelry[2] and on seals. The figure may represent a lunar divinity or—more plausibly—Ahura Mazda, the supreme god of the Persians, who is assumed to be the deity depicted emerging from a winged disk on reliefs and in glyptic.

A button of this type, executed in the same manner but with a floral motif, was excavated at Pasargadae.[3]

FT

1. See Morgan, 1905a, p. 51, fig. 79, pl. 4:2–3; Amiet, 1988b, p. 136, fig. 87.
2. Kantor, 1957, pp. 14–18, pl. 6:A; Muscarella, 1974a, no. 156.
3. Stronach, 1978, p. 205, fig. 87:2.

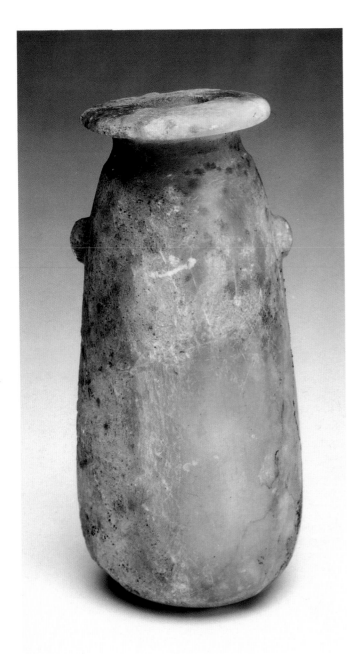

180 ALABASTRON
Alabaster
H. *8¼ in. (21 cm);* DIAM. *3⅝ in. (9.1 cm)*
Achaemenid period, 4th century B.C.
Acropole; Sb 524
Excavated by Morgan, 1901.

Vessels made of stone were highly valued in the Achaemenid court, and many such objects have been excavated in the capitals of the empire, particularly at Susa and at Persepolis. They are carved in a wide variety of stones, the most common being serpentine, limestone, and alabaster. Several of them bear royal inscriptions.

This Susian tomb contained two uninscribed alabastra of a type that was widespread throughout the Near East during the Neo-Babylonian and Persian periods.[1] Their characteristic form—a more or less elongated ovoid body with two lug handles and a wide horizontal lip—is of Egyptian origin. These vases were most likely meant for ointments or other cosmetic products. On the reliefs at Persepolis, royal attendants are represented holding a receptacle of this type in one hand and a towel in the other.

FT

1. See Morgan, 1905a, p. 42, fig. 68.

180

Cuneiform Texts from Susa

Like other centers of the ancient Near East, Susa was a city of many languages: polyglot in writing certainly, and probably in speech as well. This fact of its ancient experience shapes the process of recovering its history.

LANGUAGES, SCRIPTS, AND DECIPHERMENT

Many of the cuneiform texts found at Susa are in Sumerian and Akkadian, the ancient languages of Mesopotamia that were written wherever the cuneiform script was used. Others are in Elamite, a language original to ancient southern and western Iran but rarely found elsewhere in the ancient Near East. Inscriptions of the Achaemenid Persian rulers in Elamite or Akkadian or in both languages are sometimes accompanied by versions in Old Persian, the court language of the Achaemenid empire, written in a different, quasi-alphabetic script whose appearance was modeled on Mesopotamian cuneiform. The statue of Darius I that was brought from Egypt and set up in Susa (fig. 50, p. 220) even has a version of its inscriptions in a fourth language, Egyptian, written in hieroglyphics.

All of these languages became more completely extinct than ancient Greek or Latin ever did, for the ability to read and understand them, and even the memory of them, were utterly lost. Sumerian, the

first language to be written in the cuneiform script—before 3000 B.C.—was preserved by Mesopotamian scholarship and literature long after it had died out as a spoken language, but it vanished when the cuneiform script went out of use in the first century A.D.; it has no demonstrable relationship to any known ancient language, and no ancient or modern descendants. Akkadian, the language of Babylonia and Assyria, is Semitic, but it belongs to a branch of the Semitic family different from those of Hebrew, Arabic, and other modern languages, and it too had no direct descendants. Elamite *may* be remotely connected to an ancestor of the Dravidian languages of India and *may* have survived in the mountains around Khuzistan until early medieval times, but it has no known close ancient relatives and no direct descendants. Only Old Persian is dimly familiar to modern ears; it is an Indo-European language, in fact an Iranian language, a representative of an ancestral stage of modern Persian, though not itself a direct lineal ancestor.

The recovery of these dead languages was the consequence of some of the great achievements of nineteenth-century research: the decipherment, first, of Old Persian cuneiform writing, and then, with Old Persian as a key, of Mesopotamian cuneiform. This new science recovered the very words of ancient societies that had been only dimly known from the Bible

or from the classical historians, and those of other societies that had been wholly lost to history.

The keys to the decipherments were the multilingual inscriptions of the Achaemenid Persian kings: those at Persepolis, the great palace complex built by Darius I (522–486 B.C.) and his successors near modern Shiraz, and the great rock inscription of Darius at Bisitun in the central Zagros (fig. 55). Travelers who visited the sites and decipherers who worked on facsimiles of the texts were quick to realize that two of the languages in the inscriptions were not original to Persia. One was recognized as existing on older monumental reliefs from Assyria and on bricks and tablets from Babylonia, and the decipherers correctly inferred that it was Babylonian. Another was also found in rock inscriptions near Izeh in eastern Khuzistan, but especially in texts from Susa that seemed still older, and so one of the several names proposed for the language that is now called Elamite was, appropriately, "Susian."

Since those nineteenth-century beginnings the Babylonian, Assyrian, Sumerian, and Elamite variants of the cuneiform *writing system* have come to be thoroughly understood, but the several *languages* that were written in the cuneiform script are understood to varying degrees. Sumerian and Akkadian are well enough known to be confidently translated—although the evidence drawn from Sumerian and Akkadian

texts can still be easily misinterpreted. The understanding of Elamite, however, is comparatively poor, for various reasons including the absence of close cognate languages, the relatively small size and narrow range of the corpus, the small number of bilingual texts, and the almost complete absence of ancient native lexical and grammatical scholarship. Translations from Elamite commonly involve a large measure of conjecture—although Elamite texts can still be sensibly interpreted as historical evidence.

LANGUAGES AND HISTORICAL CONTEXT

The use of both Mesopotamian and "Susian" languages is emblematic of a general condition in the history of Susa. Susa stood at a boundary between two ancient realms; it was central to neither, but it participated in both. It was tied to the cities, kingdoms, and tribal territories of Sumer, Babylonia, and Assyria to the west but also to the populations and Elamite states of the Iranian highlands to the north and east, and above all to ancient Anshan, in modern Fars. The cultural and political life of Susa was strongly affected by contact and confrontation between these realms. Eventually, when the Achaemenids came to dominate the formerly Elamite Fars and then to incorporate both Mesopotamia and the region of Susa into their conti-

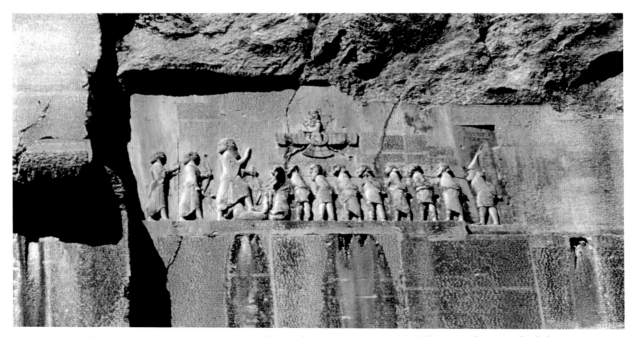

Figure 55. Rock relief showing Darius I receiving conquered foreign kings, with inscriptions in Old Persian, Elamite, and Babylonian. Bisitun, Iran, Achaemenid period, reign of Darius I, ca. 522–486 B.C.

nental empire, they made Susa one of the preeminent royal residences of the empire. It overshadowed Babylon and even Persepolis itself in Greek and Roman notions about the play of Achaemenid politics. No class of artifacts from Susa reflects the city's changing cultural and political ties with more detail and complexity than the cuneiform texts.

The cuneiform writing system itself is the very hallmark of Mesopotamian culture. Texts characteristic of cuneiform study and scholarship were produced wherever cuneiform was used. Among the Sumerian and Akkadian texts found at Susa are exercise tablets of student scribes; syllabaries and lexical lists that helped them learn the languages; aids to the study of arithmetic and geometry (Nos. 194, 195); occasional manuscripts of Akkadian and Sumerian literary or literary-historical texts (No. 192); and parts of omen texts, the reference tools of the queen of Mesopotamian sciences, divination.

Other Sumerian and Akkadian texts from Susa reflect some of the vicissitudes of its political history. In the late third millennium B.C., Mesopotamian conquerors—first the Old Akkadian successors of Sargon, and later the rulers of the Third Dynasty of Ur—took Susa, held it, and ruled it as a province, sometimes leaving their commemorative inscriptions there (No. 56), and installing governors whose clerks left Sumerian and Akkadian administrative texts. Although Susa fell to later Mesopotamian armies several times in its long history, and sometimes with disastrous consequences (as, for example, under the Assyrian king Ashurbanipal; see No. 189), it never experienced sustained rule from the Mesopotamian capitals after the beginning of the second millennium. Yet the plains around Susa were always open to the traffic of Mesopotamian armies, tribesmen, traders, diplomatic couriers, and political refugees, all agents of sustained connections between Susa and the Mesopotamian states.

From early in the second millennium until well into the first, many rulers of Susa used as their first and foremost title "king of Anshan and Susa" (the usual word order employed in Elamite texts; in Akkadian texts the title is usually "king of Susa and Anshan"). Susa and Anshan, the plains of Khuzistan and the mountain valleys of Fars, were the poles of an enduring political entity, at least in the rulers' aspirations. Even if conditions of geography and history made for a fragile political connection at the best of times, even if the royal title sometimes asserted a claim rather than a reality, even when Anshan itself was no longer a great city commanding a large hinterland, the historical tie between Susa and Anshan was intimate enough to be revived and asserted at Susa for more than a thousand years.

HISTORICAL RECONSTRUCTION AND HISTORICAL IDENTITY

When Vincent Scheil, the great epigrapher of the Susa excavations, published his first volume of texts from Susa at the turn of this century, he began with the assertion "Here begins the history of Elam."[1] These ringing words are often quoted, and they are quoted again here with particular emphasis.

In the first place, the emphasis falls on the word *begins*, for deducing and interpreting the past from the texts is a continuing process. The cuneiform texts are not books of history that need only to be deciphered, translated, put in order, and then consulted for the answers to whatever questions seem important to a modern reader. They are artifacts of ancient life and like tools or pots or other artifacts, they have attributes of style and use. They are evidence of the purposes for which they were meant, of the processes and techniques by which they were formed, of the circumstances in which they were used, deposited, preserved, and discovered, and of the status, organization, or expectations of the people who produced them. But their preservation and discovery are subject to some chance, and the preserved texts are bound to lack answers to some of the most rudimentary questions. They form a very discontinuous pattern: legal texts with evidence of ordinary commerce may survive from one time and place, inscriptions commemorating the works of kings from another, and no texts at all from another, while still other texts remain that cannot be confidently attributed to a particular time and circumstance. The shape of the pattern changes, sometimes dramatically, when new texts are found. The process of recovering history from the texts is cumulative, by and large, but its conclusions—outwardly simple statements about what happened in ancient history, and how, and when—may change sharply as the study advances, in much the same way and for many of the same reasons that some propositions of modern physics, for example, seem to be very different from those of the eighteenth-century physics that gave rise to the modern state of the science.

In the second place, the subject of the history that emerges from these texts needs some emphasis. When

Scheil wrote of the beginning of the history of Elam, he used "Elam" solely as a geographical and political term whose ancient reference changed with the circumstances of political history.[2] He preferred to distinguish as "Anzanite" the language now ordinarily called Elamite, to underscore his view that it was imported by rulers from Anshan and was not indigenous to Susa (whose original and determinant population he believed to be speakers of a Semitic language, like the populations of Mesopotamia).[3]

Since Scheil's day, Susa and its vicinity have remained the source of most pre-Achaemenid texts in Elamite. The surrounding regions of Iran were for many years scantily explored and almost completely devoid of ancient texts. Despite Scheil's precision, therefore, a concentration on Susa came to dominate even the most careful historical considerations of Elam and Elamite. In less careful treatments Susa was portrayed as the permanent center and capital of Elam, and Elam was portrayed as a near neighbor of Mesopotamia with a provincial, idiosyncratic, sometimes impressive but sometimes merely barbarous variant of Mesopotamian culture. But recent scholarship, sparked by remarkable results from archaeological work of the late 1960s and 1970s in Fars, Kerman, and Seistan, has increasingly turned away from this historical oversimplification and toward reconsiderations of some of the central issues that Scheil confronted.

One complex of such issues is "ethnic duality" at Susa: the interrelated questions arising from the confrontation of Mesopotamian and Elamite states and the cohabitation of Mesopotamian and Elamite culture at Susa.[4] Another is historical geography: the interrelated questions involved in determining the locations of places and polities of ancient southern and western Iran and in comprehending the scale and character of the interactions that ancient mentions of these places imply.[5] Evidence pertinent to these questions can be found in cuneiform texts from Susa itself, in the relative frequency of Sumerian and Akkadian and of Elamite texts over time; the relative frequency of Elamite and Akkadian personal names; invocations of Mesopotamian and of Elamite deities; use of Elamite loanwords in Akkadian texts and of Akkadian loanwords in Elamite; geographical names expressing territorial and political claims in the titles of Mesopotamian and Elamite rulers or their officials, and so on.

Yet the texts from Susa cannot be understood in isolation. Their interpretation relies on the Mesopotamian historical record. Texts from Babylonia and Assyria supply the outline of ancient chronology and the occasional synchronisms between rulers that give dates to evidence from Susa, as well as much of the usable information on the historical geography of ancient Iran. They are the source of almost all the information now employed for reconstructing narratives of certain episodes in Elamite political history that affected Susa. They contain the traditions of Mesopotamian learning against which some of the scholarly texts from Susa can be evaluated, and they even supply some ethnographic information on Elamite society and religion that helps in the interpreting of Elamite inscriptions. In short, they tie Susa and Elam to the continuum of Mesopotamian and Near Eastern history.

If this connectedness is often obtained at a cost of bias, selection, exaggeration, or misapprehension in the work of ancient Mesopotamian scribes, and of a Mesopotamian chauvinism in the work of modern interpreters, texts from Susa can offset this cost, at least in part. They sometimes corroborate the claims of Mesopotamian rulers and sometimes qualify them, often supplying the names and accomplishments of dynasts whom Mesopotamian sources scarcely mention or ignore entirely (No. 140). In some periods they document day-to-day legal behaviors of inhabitants of Susa (No. 187), or the operations of state administrative bureaus (No. 188).

It is fair to say that over the long course of its ancient history Susa became increasingly Elamite, and conversely, Elam became increasingly identified with Susa. At the beginning of the second millennium, Susa could be seen, at least from Mesopotamia, as an eastern salient of the Mesopotamian political system, where Akkadian was the dominant language and where Elamite influence was strong but at least partly extraneous. The Elamite heartland, certainly in a political sense and probably also in a linguistic sense, was in the highlands, with Anshan rising to the importance that would give it such a conspicuous place in the titles of later Elamite kings. By the first quarter of the first millennium, however, Babylonian and Assyrian rulers certainly called the surroundings of Susa Elam and considered Susa, although not the political capital, the symbolic center of what was Elamite. And under the Achaemenid Persian kings, the province that was ruled from Susa was called Elam; the territory of which Anshan had once been the center had become Persia proper.[6]

This long-run development has a counterpart in the languages of the cuneiform texts from Susa. The overwhelming majority of the texts from the late third

millennium and the first part of the second millennium are in Akkadian and Sumerian; the overwhelming majority of texts from the later second millennium and the first half of the first millennium are in Elamite. Nevertheless, two observations must qualify this general statement. First, the choice of language in the several genres of texts—royal inscriptions, legal and administrative texts, scholarly texts—is not in itself a simple, direct indicator of political or cultural ascendancy. Second, the texts do not simply bespeak a long process in which one language and culture replaced another; on the contrary, the metropolis of Susa with the territory around it remained meaningfully, even increasingly, polyglot throughout its ancient history. To treat Susa as a mere stage on which a confrontation of modern historical constructs called Mesopotamians and Elamites was played out would be to beggar the realities of its past.

ANCIENT HISTORY AND ANCIENT HISTORICAL TRADITIONS

SHIMASHKIAN AND SUKKALMAH The process of interpreting the list of early rulers from Susa (No. 181) exemplifies the interplay of Susian and Mesopotamian texts. The list itself is no more than two series of names, labeled in Akkadian "Twelve kings of Awan" and "Twelve Shimashkian kings," respectively. Some of the kings named ruled over Susa, as dedicatory inscriptions found there corroborate. But others on the list are better known from Mesopotamian texts: two of the "kings of Awan" are mentioned in Old Babylonian copies of Old Akkadian royal inscriptions as being among the opponents of Sargon of Akkad in a series of wars that led to Akkadian domination over Susa (this is confirmed by Old Akkadian inscriptions and by administrative texts found at Susa itself); an Old Babylonian copy of a Sumerian royal inscription provides a crucial chronological datum, the synchronism between the last of the kings of Awan, Puzur-Inshushinak, and the Sumerian Ur-Nammu, king of Ur (ca. 2100 B.C.);[7] several of the early Shimashkians appear in Sumerian administrative texts of the Third Dynasty of Ur, where they are mentioned inconspicuously as seemingly petty rulers from the interior of Iran at a time when the kings of Ur controlled Susa and installed their governors there (this dominion, too, is confirmed by inscriptions of the kings and governors, and by Sumerian administrative texts); and it is a Sumerian literary text that identifies one of the

Shimashkians, Kindattu, as the Elamite conqueror of Ur and by implication the ruler who brought Susa under Shimashkian rule, laying the foundations of a large-scale Elamite state that controlled much of southern and western Iran.[8]

The political origins of this large state were in the Elamite highlands of Iran, and the names of the rulers were all Elamite. But almost all of the inscriptions of the rulers, especially those at Susa, are in Sumerian and Akkadian, and the characteristic title of the rulers who succeeded the Shimashkians in control of the state, *sukkalmah*, was drawn from the Sumerian title of a high official who had claimed to control the eastern frontiers of the empire of Ur. This royal style was a conscious effort to portray the Elamite rulers, however un-Mesopotamian their realm and mores, as successors to Mesopotamian imperial claims—much as a medieval European sovereign might adopt Roman consular titles, and for similar effect.

The legal and administrative texts from the reigns of the Shimashkian and *sukkalmah* rulers primarily represent activities of the local population, and only secondarily reflect the intentions of the rulers. These texts, too, are almost all in Sumerian and Akkadian. The Akkadian dialect used, the formal properties of the legal texts, and some of the underlying legal practices differ significantly from those found in contemporary Mesopotamia, implying that these are not cultural imports but the results of long indigenous developments. The texts also include Elamite personal names, and apparently Elamite legal or administrative terms, which perhaps testify not only to contemporary rule by an Elamite state, but also to a long prior history of interaction.

The school texts from these periods at Susa are in the Mesopotamian tradition: exercise tablets in which the student copied a text set by the master, excerpts from the syllabaries with which the students learned the cuneiform script, excerpts of the great lexical series HAR.ra = *ḫubullu*, lists of gods, and so on.[9]

The list of rulers from Susa is the record of an indigenous historiographic tradition, but the historical realities behind this tradition, even in their broadest strokes, must be derived piecemeal from diverse Mesopotamian and Susian documents. The tradition is not focused on Susa itself, for scarcely half of the named rulers actually held Susa. It was not the only tradition studied by scribes at Susa, where manuscripts of the Sumerian King List and manuscripts of an Old Babylonian literary version of diplomatic correspondence from Shulgi of Ur have also been found.[10]

In fact, the list of early rulers was very likely modeled on the Sumerian King List, and composed to serve similar rhetorical aims. Just as the Sumerian King List reduced the complex history of competing Sumerian states to a single succession of dynasties holding dominion over an ideal Mesopotamian state, the Susa list reduces contemporary local dynasts to a single line of successors holding an ideal, unified Elamite kingship. And as the Sumerian King List gave the claims of later Sumerian rulers a historical legitimacy that could be traced back to the time "when kingship descended from heaven," so the Susian list projects into the remote past the political achievements and claims of the later Elamite kings, the *sukkalmah*s of the late twentieth century B.C. and later, and so clothes them with the power of venerable antiquity and foreordination.

MIDDLE ELAMITE Texts from Susa in the period of Middle Elamite rule (ca. 1400–1100 B.C.) present a very different aspect. The great majority of them are in Elamite, and most are building or dedicatory inscriptions (Nos. 185, 186). Only a few have narrative sections. Much of the little that is known about political events of the Middle Elamite reigns comes from Mesopotamian texts, above all from literary texts preserved in manuscripts that are much later than the events. These Mesopotamian texts describe Elamite invasions of Mesopotamia and Elamite spoliation of Mesopotamian cities in terms that are richer in ethnic and religious judgment than in historical verisimilitude.

The origins of the first Middle Elamite dynasty and the locus of the Middle Elamite state's early political development are not well established. The characteristic title "king of Anshan and Susa" evokes the glorious past, but at the time Anshan was a modest place at best. The Elamite inscriptions from Susa no longer show any effort to assume a Mesopotamian style, but some of them do include an indigenous historiographic tradition. Some inscriptions of Shilhak-Inshushinak (ca. 1125 B.C.) list earlier rulers: not only his Middle Elamite predecessors, but also Shimashkian and *sukkalmah* rulers of the more remote past. Moreover, some of the Sumerian and Akkadian inscriptions on bricks are actually copies made by Middle Elamite kings from the inscriptions of earlier rulers, supplied with accompanying inscriptions in Elamite, in the names of the Middle Elamite rulers themselves (No. 185)—thus confirming what the few bilingual inscriptions and a few nonmonumental texts

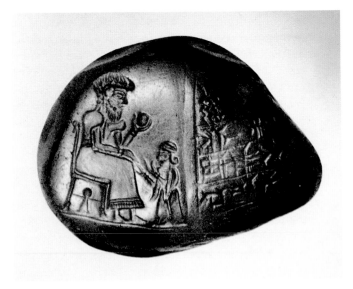

Figure 56. Pebble engraved with royal images and an inscription of Shilhak-Inshushinak. Middle Elamite period, ca. 1150–1120 B.C. Blue chalcedony, H. 1⅛ in. (2.8 cm). London, the British Museum, 113886

of the period imply, that the scribes who drafted Elamite inscriptions could also use the Mesopotamian languages, albeit somewhat awkwardly. Some Middle Elamite rulers claimed descent from Shilhaha, the man treated in texts from Susa as the effective founder of the state and dynasty of the *sukkalmah* rulers in the twentieth century B.C. This figurative claim, the citing of early rulers, and the copying of earlier brick inscriptions all imply a consciousness of the Elamite past and an espousal of it as a model and source of value for the Middle Elamite present.

Yet the way this past was invoked in the texts from Susa is highly specific to Susa and in fact is tied to a few monumental buildings there. The Akkadian texts that the Middle Elamite rulers copied were inscriptions on bricks of earlier temple builders. The lists of predecessors in Shilhak-Inshushinak's inscriptions are not meant to summarize the history of Susa or the Elamite states with a list of the great dynasts of the past to whom Shilhak-Inshushinak compared himself, but to serve a far narrower purpose: to summarize the history of the temple at Susa with a list of the rulers who had constructed or restored it. Not every earlier king was among the builders, and thus the historical outline that can be obtained from the building and dedicatory inscriptions of Susa is incomplete and must be filled out from other sources. The most dramatic source of such complementary information is a recently published Babylonian text, a literary version of

a royal letter that mentions political marriages between the ruling families of Babylon and Elam. It has forced a drastic revision of thinking about the number, succession, and chronology of the Middle Elamite kings that had been derived chiefly from royal inscriptions at Susa, pushing the reign of the great builder Untash-Napirisha back about a hundred years earlier than had commonly been supposed, to the last part of the fourteenth century B.C.[11] And, conversely, it implies that Susa became a center in the history of this dynasty and its kingdom only after prior political development elsewhere, which is why some of Untash-Napirisha's forebears were unable to leave their names on the buildings of Susa or in the vicinity.

The persistence of a local tradition of Mesopotamian scholarship at Susa is exemplified by compilations of omens read from the entrails of sacrificial animals, malformed fetuses, celestial phenomena, dreams, and other portentous occurrences.[12] Arcane or foolish as they may seem to a modern reader, these quasi-scientific texts represent the most important and most richly documented activities of ancient Mesopotamian intellectual life. Unfortunately, few of the pertinent texts from Susa can be dated with much confidence, but most of them certainly predate the Neo-Elamite period, many must come from the earliest Middle Elamite period or more likely shortly before, and a few fragments may be still older. They belong to categories well known in Mesopotamian scholarship, but they are not simply manuscripts of canonical Mesopotamian texts that were copied in Susa. The texts in Akkadian show distinctive spellings, the mark of a consistent local scribal tradition. One text in Elamite is, if not an actual translation of an Akkadian original, at least a compilation that was deliberately modeled on a canonical Mesopotamian series. These documents are the traces of a continuing knowledge and use of Mesopotamian languages, and of a continuing practice of scholarship, modeled on Mesopotamian originals but developed in a style particular to the region, in which at least occasional efforts were made to transpose Mesopotamian scholarly work into Elamite.

NEO-ELAMITE For the Neo-Elamite period at Susa (approximately the second quarter of the first millennium B.C.), Babylonian chronicles, Assyrian royal annals, and state correspondence of the late Assyrian kings give information on warfare and diplomacy among Assyria, Babylonia, Susiana, and the territories of Elamite kings. These sources, unparalleled in detail and complexity, name fifteen or more Elamite kings, but only five or perhaps six are now documented by Elamite inscriptions from Susa itself (see No. 140), and not all of them can be identified with kings named by the Assyrians. There are historical reasons for this discrepancy. Because many of the Elamite kings of the seventh century B.C. ruled very briefly in turbulent times, there was no opportunity for them to commemorate their reigns by building shrines at Susa where they might have left inscriptions. More important, the military and political strongholds of most of these embattled rulers came increasingly to be on the northern and eastern fringes of Khuzistan, apparently not at Susa itself. Susa did not become a target of Assyrian arms until the 640s, during the reign of Ashurbanipal. Nevertheless, the attention that Ashurbanipal's annals lavish on the Assyrian destruction of Susa conveys both an Assyrian understanding of Susa's immense importance at that time and some Assyrian historical assumptions about past relations among Susa, Elam, and Mesopotamia (No. 189). Susa was not a military stronghold and not a political center from which a greater Elamite state could be governed and annexed, but it was not just another city to be taken from the control of Neo-Elamite kings. It was the perduring center and visible monument of Elamite civilization as the Assyrians saw it: the site of temples, tombs of kings, and trophies of past wars with Mesopotamia. That is, the Mesopotamian sources include an ancient historical view of Elam and Mesopotamia in which Susa was the emblem of Elam. The annals' vengeful narration of what purports to be a complete eradication of this monument has an ironic aspect, for by its description of the monumental landscape of Susa and its unparalleled testimony about Susian religious and funerary practices it preserves precisely what was to be destroyed.

The Mesopotamian sources also make it clear that there was an important non-Elamite population in the vicinity of Susa. Chaldeans, Arameans, and Babylonians crossed between southern Mesopotamia and Khuzistan, and perhaps coastal Fars, often in flight from Assyrian armies. Refugee Babylonian political leaders consorted with Elamite kings and leaders. Some Babylonian enclaves formed in the vicinity and kept legal records in the language and form usual to Babylonia proper.[13] The presence of such refugees and enclaves, conspicuous in late records, must have been constant throughout the ancient history of Susa.

That the eradication of Susa was not as absolute as the Assyrian annals assert emerges from about three

hundred texts from Susa, written in Elamite sometime between Ashurbanipal's destruction and the Achaemenid occupation. One archive, the record of a reasonably complex administrative apparatus, implies that Susa was in the hands of an Elamite state that controlled Susiana and points to the east and south as far as the vicinity of modern Izeh and Behbehan, a state otherwise unmentioned in the historical record (No. 188). A smaller group of roughly contemporary legal texts is extraordinary evidence for the use of the Elamite language to record day-to-day private contracts at Susa during the last decades of Elamite independence (No. 187).

ACHAEMENID These Neo-Elamite tablets also represent the less conspicuous elements of the Achaemenid Persian empire's historical inheritance. After 520 B.C. Darius I began to construct palace complexes, first at Susa and later at Persepolis. At Susa he left a particularly dramatic trilingual inscription that describes the peoples who supplied exotic materials and skilled workmen to build the palace (No. 190). The inscription emphasizes how vast and variegated was the world that the Achaemenids ruled, but it does not even hint at a glorious Elamite or Susian past. The Achaemenids did not portray themselves as the successors of earlier kings, nor their empire as something founded on earlier states.

The links to the past showed at a humbler level. Both Persepolis and Susa were centers of regional administrative regimes under Darius and his successors. The administrative records processed at Persepolis and perhaps those processed at Susa were written in Elamite, and continued some usages found in earlier Neo-Elamite administrative texts at Susa. At Persepolis thousands of these Achaemenid administrative texts have been found, gathered in two archives. Only one tablet of this kind is thought to have been found at Susa, although its actual findspot is a matter of uncertainty. It bears the impression of a seal that is also found on texts of the same kind archived at Persepolis. If Number 191 is indeed from Susa, it may be the relic of another sizable archive of the same kind as those kept at Persepolis, and the seal impression on it would confirm the administrative link between Susa and Persepolis at the most specific level.[14]

The population that surrounded the Achaemenid royal residence was more international and polyglot than ever, including transported workers, emissaries, refugees, craftsmen, and enclaves of resident aliens drawn from an area of unprecedented scale. The few known Achaemenid legal texts from Susa, all written in Akkadian, evidently document some of the affairs of resident enclaves.[15] Even at the height of Achaemenid rule, then, the day-to-day expenditures of a government agency may have been recorded in Elamite, while the day-to-day legal undertakings of residents were apt to be recorded in Akkadian. The mix of languages used is evidence of contemporary social realities but also the product of long tradition, rooted in ancient conflict and interdependence.

MATTHEW W. STOLPER

NOTES

1. Scheil, 1900, p. vii.

2. Ibid., p. ix.

3. Scheil, 1901, p. vii.

4. Ibid.; cf. Amiet, 1979a, pp. 2–22, restated in an English version in Amiet, 1979b, pp. 195–204.

5. See especially Vallat, 1980, a programmatic statement that outlined a complex geographical argument and set many of the terms for a continuing debate. Scholars still disagree sharply about the locations of many ancient places.

6. The distinction between "Susa" and "Elam" and developments in the use of the terms have been forcefully and engagingly expounded by François Vallat (1980). For a thumbnail sketch and graphic representation of Susa between Mesopotamia and Elam over the historical long run, see Vallat, 1989b, pp. 16–17.

7. Wilcke, 1987, pp. 108–11.

8. Stolper, 1982, pp. 49–54.

9. See Tanret, 1986, pp. 139–50, with references to earlier literature and texts.

10. Jacobsen, 1939, pp. 10–11; D. O. Edzard, "Deux lettres royales d'Ur III en Sumérien 'syllabique' et pourvu d'une traduction accadienne," in Labat and Edzard, 1974, pp. 9–34.

11. VAS 24 91 (Staatliche Museen zu Berlin, Vorderasiatisches Museum); see Steve and Vallat, 1989, pp. 223–38.

12. E.g., Labat and Edzard, 1974; A. L. Oppenheim, 1956, pp. 256–61; Scheil, 1917b, pp. 139–42; idem, 1917a, pp. 29–59; and cf. Biggs and Stolper, 1983, p. 162.

13. Erle Leichty, "Bel-epuš and Tammaritu," *Anatolian Studies* 33 (1983), pp. 153–55; David B. Weisberg, "The Length of the Reign of Hallušu-Inšušinak," *JAOS* 104 (1984), pp. 213–17; Matthew W. Stolper, "A Neo-Babylonian Text from the Reign of Hallušu," in *MM-JS*, pp. 235–41.

14. M. B. Garrison, "Seals and the Elite at Persepolis: Some Observations on Early Achaemenid Persian Art," *Ars Orientalis* (in press); idem, "A Persepolis Fortification Tablet Seal at Susa" (in preparation).

15. Rutten, 1954, pp. 83–85; Joannès, 1984, pp. 71–81; idem, 1990, pp. 173–80. Although the texts are in Babylonian, many of the persons involved in the transactions they record have Egyptian names, and some of the texts are striking for their departures from the standard legal formulas of contemporary Babylonia.

HISTORICAL, ECONOMIC, AND LEGAL TEXTS

181 TABLET WITH A DYNASTIC LIST OF THE KINGS
OF AWAN AND SHIMASHKI
Inscribed in Akkadian
Clay
H. 3¼ in. (8.2 cm); W. 2½ in. (6.4 cm); D. 1⅛ in.
(2.7 cm)
Old Elamite, Sukkalmah period, ca. 1800–1600 B.C.
Sb 17729

The tablet contains twenty-six lines of text: twelve
names followed by the comment "twelve kings of
Awan," and twelve others defined as "twelve Shim-
ashkian kings."¹ Translated, it reads:

Obverse:	Pi-e-li[?] [or We(?)-e-te(?)]
	Ta-a-ri/ip[?]
	Uk-ku-ta-hi-esh
	Hi-i-shu-ur
	Shu-shu-un-ta-ra-na
	Na[?]-pi-il-hu-ush
	Ki-ik-ku-tan-te-im-ti
	Luhhishshan
	Hishepratep
	Hi-e[?]-lu[?]
	Hita
	Puzur-Inshushinak
	Twelve kings of Awan
	Girnamme
	Tazitta
	Ebarti
	Tazitta
	Lu[?]-[x-x-x]-lu-uh-ha-an
Bottom edge:	Kindattu
	Idaddu
	Tan-Ruhurater
Reverse:	Ebarti
	Idaddu
	Idaddu-napir
	Idaddu-Temti
	Twelve Shimashkian kings

Several Mesopotamian and Elamite king lists
have been preserved. They are a precious source of
information for historians, although they must be
used with caution. The longest of these is the "Sum-
erian King List," compiled about 2000 B.C., which
traces back to kings with mythically long reigns
from "before the Flood."²

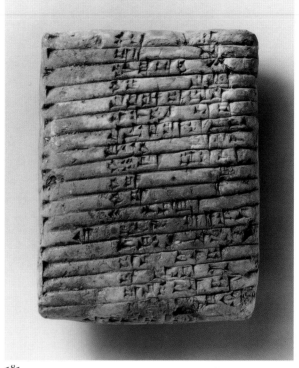

181

This list is considerably less extensive and indi-
cates neither the length of the reigns nor the filiation
of the rulers. Unlike Mesopotamian king lists, it is
not a genealogical document. Still, it is a relatively
reliable historical source, since several of the rulers
are known from other written documents originat-
ing both in Susa (contemporary or later, Middle
Elamite period texts) and in Mesopotamia.

THE KINGS OF AWAN The exact location of the king-
dom of Awan is unknown, but from references in
Mesopotamian texts dating to the second half of the
third millennium B.C. we can identify it as an Elam-
ite state not far from Susa, situated somewhere in
the mountainous hinterland region.

The Sumerian King List attributes 365 years to a
dynasty of Awan. Three of its rulers are mentioned
on the list and can be dated to about 2500–2400 B.C.
on the basis of synchronisms with Mesopotamia,
but their names are no longer visible. For this rea-
son we do not know if the first sovereigns on the
Susa tablet, for whom we have no other textual ref-

erences but who could have reigned during the same period, belonged to this dynasty. Additionally, one cannot be sure that the Susa tablet provides a complete dynastic list in chronological order. The last five names on the tablet can be dated to between 2300 and 2100 B.C. on the basis of references found in Mesopotamian texts. Only the twelfth ruler, Puzur-Inshushinak, left monuments and inscriptions in Susa.

The eighth name on the list, Luhhishshan, is mentioned along with those of several rulers defeated by the Mesopotamian king Sargon of Akkad, who reigned about 2334 to 2279 B.C. and whose conquests included Susa and Awan.[3] Luhhishshan is identified as the son of the king of Elam, Hishi-prashini, who is probably Hishepratep, the ninth ruler on the list. The inversion of the two names could be merely a scribal error. Starting with the reign of Sargon's successor, Susa came under the control of the kings of Akkad; but Awan seems to have remained an independent kingdom, since Naram-Sin of Akkad (ca. 2254–2218) concluded a treaty with one of its kings, perhaps Hita, the next-to-last ruler on the list. Hita might be the same person as the king called Hidam, who is named along with several Akkadian sovereigns in an invocation to the wise kings of ancient times in a fourteenth-century text, written in Hurrian, from the Hittite capital, Boğazköy.[4]

The last king on the list is Puzur-Inshushinak; we know that he was a contemporary of Ur-Nammu, the king of Ur who reigned from about 2112 to 2095 B.C.[5] Because of the time gap we might hypothesize either that the list is incomplete, or that there was an important chronological break between the reigns of the last two kings of Awan.

Puzur-Inshushinak was a conqueror and a builder. Many of his monuments on the Acropole of Susa (see Nos. 54, 55) bear dedicatory inscriptions that have been used to reconstruct his political career.[6] His name indicates that he was probably of Susian origin. He seems to have been, successively, "governor of Susa," "governor of Susa, prince [or viceroy] of Elam," and "king of Awan." He probably took the last, prestigious title when he acceded to the throne after the victorious campaigns described on a statue excavated at Susa.

As far as we now know, Puzur-Inshushinak was the first prince to claim a dual monarchy encompassing both Susiana and the Elamite highlands. In order to reflect the ethnic and linguistic duality of his empire, most of Puzur-Inshushinak's monuments bear bilingual inscriptions in two scripts: Akkadian, the language spoken in Susa, transcribed in cuneiform writing; and Elamite, the language spoken in the highlands, transcribed in a linear writing that disappeared after his reign (see Nos. 182, 183).

Puzur-Inshushinak was probably defeated by Shulgi, king of Ur about 2094 to 2047 B.C., who seized control of Susa. Awan disappeared from the political scene, absorbed by a confederation of states that would give rise to the Shimashki dynasty.

THE SHIMASHKIAN KINGS The name Shimashki appears for the first time in a text on a statue of Puzur-Inshushinak[7] which mentions that a king of Shimashki rendered homage to him. Contemporary Mesopotamian texts show that this was an inter-regional group of at least six principalities in southwest Iran, scattered along the northeastern and southeastern perimeter of Susiana[8] and in close contact with the kingdom of Ur, which controlled Susa. This entity, organized to block the expansion of the kings of Ur, was probably held together by marriage alliances. In this way a vast "family" arose and subsequently a "line" of kings known as the Shimashkians, who governed their extremely scattered territories through family alliances.

The first kings on the list are regional rulers whose reigns partially overlap. The first three, Girnamme, Tazitta, and Ebarti (or Ebarat I), are known from Mesopotamian texts establishing food rations issued to messengers. These documents can be dated to 2044–2032 B.C.[9]

Shortly before 2000 B.C., the "king of Shimashki and of Elam," Kindattu, formed an alliance with Ishbi-Erra of Isin. They vanquished the kingdom of Ur and brought its last king, Ibbi-Sin, captive to Elam.

The triumphant Elamites, "kings of Shimashki," found themselves at the head of a complex state encompassing both Susa and the mountainous hinterland. Contemporary inscriptions confirm the reign in Susa of several sovereigns on the list. Idaddu I, whose name is an abbreviation of Indattu-Inshushinak, was initially governor of Susa and then viceroy of Elam before he came to the throne, adopting the title "king of Shimashki and of Elam."[10] His son Tan-Ruhuratir, whom he appointed governor of Susa, married the daughter of a prince of Eshnunna.

Idaddu II, son of Tan-Ruhuratir, was deposed, perhaps after a raid by Gungunum, king of Larsa

(ca. 1932–1906 B.C.), who ruled briefly over Susa. It seems that a junior Shimashki branch represented by a prince of Anshan, Ebarat (or Ebarti II), retook Susa and founded the Sukkalmah dynasty.

Thus, this list of kings might have been written at a later date in an attempt to legitimize the Sukkalmah line. The last two kings on the list, not mentioned in any Susa texts, might have been members of the older branch.

B A-S

1. Scheil, 1931; idem, 1932, pp. IV–V; König, 1965, p. 1; Boehmer, 1966; van Dijk, 1978; W. G. Lambert, 1979, pp. 16–17, 38–44; Stolper, 1982; idem, 1984, pp. 10–23; idem, 1989; André and Salvini, 1989.
2. Jacobsen, 1939.
3. H. Hirsch, "Die Inschriften der Könige von Agade," *AfO* 20 (1963), pp. 46–47 (Sargon b 9); 49–50 (Sargon b 13).
4. This is a hypothesis. See V. Haas and I. Wegner, *I. Abteilung die Texte aus Boğazköy*, vol. 5/1, Corpus der Hurritischen Sprachdenkmäler (Rome, 1988), no. 87.
5. See Wilcke, 1987, pp. 109ff.
6. See the list in Boehmer, 1966, p. 350; completed in André and Salvini, 1989, p. 70 n. 35.
7. Scheil, 1913, pp. 7–16.
8. For a detailed analysis see Stolper, 1982, pp. 45–46.
9. For complete bibliographical references see ibid., pp. 49–50.
10. Scheil, 1913, p. 26: line 4 and pl. 3, no. 4: line 4.

at Shahdad in the Kerman region;[2] the other reportedly came from the vicinity of Persepolis, not far from Anshan, the capital of the Elamite highlands (fig. 9, p. 8).[3]

Attempts to decipher this writing began with the discovery of the first documents at the beginning of the twentieth century, but the work is still not completed.[4] It has recently been ascertained[5] that nearly all of the Elamite inscriptions on Puzur-Inshushinak's monuments at Susa were associated with Akkadian inscriptions on or closely related to the monuments and are therefore directly or indirectly bilingual. The texts are read from left to right on some monuments and from right to left on others.

There are several linear Elamite inscriptions on small terracotta objects.[6] On three cones (with inscriptions J, K, L) of which this is one, all the signs are known from monumental inscriptions, which probably means that their inscriptions too are votive texts. An inscription (M) on a fragmentary disk-shaped object contains several new signs. Finally, on two tablets with inscriptions N (which might date to an earlier period) and O, the signs are nearly all hapax legomena (i.e., without other known occurrence), which probably indicates that the textual content is different.

B A-S

182 CONE INSCRIBED IN LINEAR ELAMITE
Baked clay (chipped on the bottom)
H. 2⅛ in. (5.5 cm); DIAM. 2¼ in. (5.6 cm)
*Old Elamite period, reign of Puzur-Inshushinak,
ca. 2100 B.C.
Acropole; Sb 17829*

The two-line inscription (inscription J) runs around the top of the cone. A vertical dividing line on the object marks where the lines of writing begin. The inscription is probably incomplete and may be votive. It reads from left to right around the summit.[1]

Puzur-Inshushinak united Susa and the Elamite backcountry into a dual state in which a bilingual culture emerged. Alongside the Akkadian language, written in cuneiform, a new, linear, script was adopted to transcribe the Elamite language. Twenty-one inscriptions in linear Elamite are known and are designated by the letters A through U. Nineteen of them were excavated in Susa and date to the reign of Puzur-Inshushinak. Of the remaining two, one is on a fragment of a ceramic vase excavated in a cemetery

1. Scheil, 1935, XI:J; Hinz, 1969, p. 39, Abb. 11; Meriggi, 1971, p. 191 par. 503, pl. 3:J.
2. W. Hinz, "Eine altelamische Tonkrug-Aufschrift vom Rande der Lut," *AMI* NF 4 (1971), pp. 21–24.
3. Hinz, 1969, pp. 11–27; Peter Calmeyer, "Beobachtungen an der Silbervase aus Persepolis," *IA* 24, Mélanges P. Amiet II (1989), pp. 79–85.
4. The first genuine attempt to decipher the script was made by the German scholar C. Frank; see Frank, 1912; idem, 1923. There followed F. Bork, *Die Strichinschriften von Susa* (Königsberg, 1924). See also the more recent syntheses of Hinz (1969, pp. 11–44, with an earlier bibliography, p. 28) and Meriggi (1971, pp. 184–220).
5. André and Salvini, 1989.
6. Hinz, 1969, pp. 39–43.

183 CONE INSCRIBED IN LINEAR ELAMITE

Clay
H. 2⅞ in. (7.4 cm); DIAM. 2⅜ in. (6 cm)
Old Elamite period, reign of Puzur-Inshushinak, ca. 2100 B.C.
Acropole; Sb 17830

An inscription of six horizontal lines runs around the cone. Only the first line is complete (inscription K).[1]

See the discussion for Number 182.

BA-S

1. Scheil, 1935, XI:K; Hinz, 1969, p. 40, Abb. 12; Meriggi, 1971, p. 191 no. 503, pl. 3:K.

184 FOUNDATION DOCUMENT COMMEMORATING THE CONSTRUCTION OF THE NANNA TEMPLE BY ATTAHUSHU

Clay
H. 7½ in. (19.1 cm); DIAM. 3 in. (7.6 cm); DIAM. of hole, at top ¾ in. (2 cm); thickness of walls ¼ in. (.6 cm)
Inscribed area: H. 5¼ in. (13.3 cm); W. top 2⅝ in. (6.8 cm), base 2½ in. (6.4 cm)
Old Elamite, Sukkalmah period, ca. 1900 B.C.
Sb 15440

This hollow cylinder[1] is slightly conical toward the bottom. It bears signs of restorations and its base is broken.

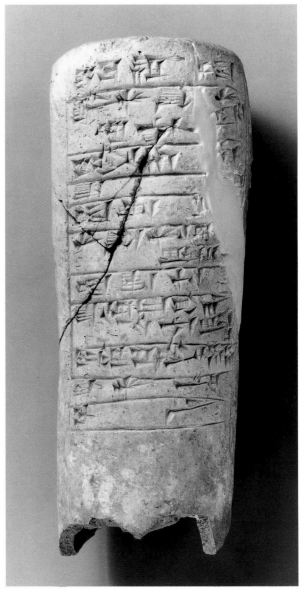

An eleven-line framed inscription covers one-third of the side of the object. Translated, it reads:

> Ebarat, king of Anshan and of Susa, Shilhaha, *sukkalmah* and father of the land [?] of Anshan and of Susa, Attahushu, *sukkal* and *ippir* [magistrate?] of Susa, son of the sister-wife of Shilhaha, constructed the temple of Nanna.

This text is the basis for our understanding of the complex system of government characteristic of the Sukkalmah period, which followed the Shimashkian period. One interpretation of the evidence is that this system was founded on the principle of co-regencies linking three members of the ruling family.

Sometime around 1925 B.C., Gungunum, the king of Larsa, apparently put an end to the Shimashkian kings' control of Susa and brought about the downfall of Idaddu II.[2] Several years later, the Elamite prince Ebarat—who is most probably Ebarti, the ninth Shimashkian sovereign on the king list of Susa (No. 181)[3]—retook Susa. He founded a new dynasty[4] or, more likely, provided for the passage of power from one branch of the ruling family to another.

Ebarat, who in all likelihood came from the land of Anshan, adopted a title that was to remain unique in his dynasty, "king of Anshan and Susa." This double title emphasized the extent of the new monarchy and the dual character of Elam, which encompassed both the Susiana plain and the outlying region, populated by mountain-dwellers, whose capital was the city of Anshan (present-day Tal-i Malyan).

Ebarat organized the government according to a complex hierarchical system, which was intended to guarantee his own succession while taking into consideration the different regional components of Elam in order to maintain the unity of this composite entity. He adopted a tripartite scheme—which had antecedents in the Shimashkian period—in association with two members of his family: his son Shilhaha,[5] and Shilhaha's son Attahushu.[6]

Shilhaha was given the Sumerian title *sukkalmah*, meaning "grand regent." This term originally designated the office of a Sumerian dignitary, but in Elam it took on a royal meaning. Shilhaha was later purported to be the true founder of the dynasty, and his successors, the last *sukkalmah*s, called themselves "sons of the sister(-wife) of Shilhaha."[7] The later Middle Elamite princes used the same claim to

legitimize the *sukkalmah* rulers and their own reigns.

Attahushu, who was named regent of Susa with the title "*sukkal* and *ippir* [magistrate] of Susa," left a series of inscriptions and monuments that mention his constructions in the city. He was probably contemporary with Sumu-abum, king of Babylon (1894–1881 B.C.).[8] There is no evidence that he ever rose to the position of *sukkalmah*.[9]

BA-S

1. See Scheil, 1929a; idem, 1939, pp. 7–8; König, 1965, pp. 4–5; Sollberger, 1968, p. 31; Sollberger and Kupper, 1971, p. 260: IVO6a; Stolper, 1982, pp. 54–56; idem, 1984, pp. 27–28; Vallat, 1989a; Grillot and Glassner, forthcoming.
2. For this reconstruction of events, see Stolper, 1982, p. 56.
3. W. G. Lambert, 1979, p. 16; Stolper, 1982, pp. 55–56.
4. Later inscriptions of the Middle Elamite ruler Shilhak-Inshushinak name Ebarat after the Shimashkian rulers, but without filiation, unlike the princes before and after him on the list; this implies that he was regarded as the founder of a new line; see König, 1965, pp. 110, 113–14: Inschrift 48, 48a, 48b.
5. On this filiation, see the stele of Shilhak-Inshushinak: ibid., Inschrift 48a,3. We know that Ebarat and Shilhaha ruled at the same time because their names are associated in the oath formulas on Susian legal contracts: L. De Meyer, "Epart Sukkalmah?," in M. A. Beek et al., eds., *Symbolae Biblicae et Mesopotamicae Francisco Mario Theodoro de Liagre Böhl Dedicatae* (Leiden, 1973), pp. 293–94; and on seal impressions: Vincent Scheil, "Passim," *RA* 22 (1925), p. 159; Amiet, 1972a, no. 1685, pp. 211, 218, pl. 157.
6. The filiation of Shilhaha and Attahushu and the contemporaneity of their reigns are contested by François Vallat in three recent articles: Vallat, 1989d; idem, 1989a; idem, 1990, pp. 119–27.
7. Compare the inscriptions of Kuk-Nashur II or III, Tan-Uli, and Temti-halki. The expression "son of the sister of Shilhaha" designates the son that the king had with his sister (M. Lambert, 1971, p. 217). What probably originated as an actual relationship quickly turned into a mere titular element.
8. Vincent Scheil, "Textes élamites-sémitiques," *MDP* 10 (1908), p. 18, no. 2: tablet dated to "the year of Sumu-abum."
9. His tenure was apparently long, since it seems that three generations of one family served him. An axe and a bronze tankard give the name of the servant Ibni-Adad, the grandfather; the name of the son, Rîm-Adad, is known from two impressions on sealings, while the name of the grandson, Adad-rabi, appears on three impressions on tablets. See the bibliography in Sollberger, 1968, p. 31; and the summary in Vallat, 1989d, p. 23. However, these are frequently used names and also might be mere homonyms, in which case there is no evidence of filiation between the three.

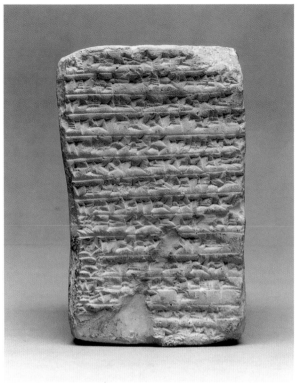

185

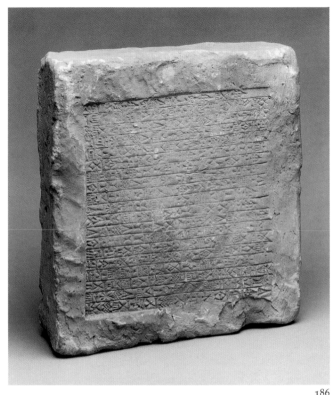

186

185 BRICK WITH SUMERIAN AND AKKADIAN
INSCRIPTION OF KUK-KIRMASH AND ELAMITE
INSCRIPTION OF SHILHAK-INSHUSHINAK I
Baked clay
H. 6⅛ in. (15.7 cm); W. 6⅛ in. (15.5 cm); D. 3½ in.
(8.9 cm)
Middle Elamite period, reign of Shilhak-Inshushinak,
ca. 1140 B.C.
Sb 1619
Excavated by Morgan.

186 BRICK WITH STAMPED ELAMITE INSCRIPTION
OF SHILHAK-INSHUSHINAK I
Baked clay
H. 13⅛ in. (33.3 cm); W. 13 in. (33 cm); D. 3⅞ in.
(9.9 cm)
Middle Elamite period, reign of Shilhak-Inshushinak,
ca. 1140 B.C.
Sb 1626
Excavated by Morgan.

When Elamite rulers of Susa built or rebuilt temples, they commemorated their work as Mesopotamian rulers did, with inscriptions placed on the very bricks from which the structures were made. Most

of the inscribed bricks of the *sukkalmah*s and the Middle Elamite kings have their texts on the narrow edges of the bricks, so that they could be laid with the text visible on the exposed face of the wall. They were sometimes produced by the hundreds to be laid in ornamental bands, panels, or corners, with the same inscription repeated many times. They were most often written by hand, each scribe writing the same text on brick after brick, one at a time.

Number 186 is an exception. The text is not handwritten but impressed with a stamp, probably made of baked clay, that had a mirror image of the text in raised relief; also, the stamp was applied not to the edge but to the face. In the text, written in Elamite, Shilhak-Inshushinak I (ca. 1140 B.C.) commemorates his building work. He states his name and the name of his father, the king Shutruk-Nahhunte I, but he claims no title for himself beyond "beloved servant of Inshushinak" (the chief god of Susa). When the temple of Inshushinak, built of plain brick, fell into ruins, he says, he rebuilt it with baked brick and decorated its gateway with glazed bricks and gilded beams, dedicating the work to his god, Inshushinak, not only on his own behalf but also on behalf of his consort, Nahhunte-utu, and their children. He reinscribed on newly made bricks

the names and titles of earlier kings who had built the temples, and put them into the construction. He closes with an invocation of Inshushinak.[1]

Once this brick was laid, the text on its face could not be seen until the temple began to fall into ruins again. Then, a later ruler could see it and know whose work it was that needed to be restored, and could restore not just the structure but the inscription too, as Shilhak-Inshushinak had done with the inscriptions of his predecessors.

Number 185 illustrates what Shilhak-Inshushinak meant. The first eleven lines, partly damaged, are a copy of an inscription by the *sukkalmah* Kuk-kirmash (ca. 1950 B.C.) in Sumerian and Akkadian in which the ruler states that he did not disturb the temple, already ancient in his day, but restored the temple precinct for Inshushinak with a construction of baked brick. Exemplars of the original text on Kuk-kirmash's own bricks, found by modern investigators of Susa, confirm that Shilhak-Inshushinak's copy of it on this brick is faithful. The balance of the inscription is in Shilhak-Inshushinak's own words, in Elamite. After giving his name and patronym, again with no royal title, he states that Kuk-kirmash had built a shrine for Inshushinak and that when it had decayed, he, Shilhak-Inshushinak, rebuilt its brickwork, restoring the inscription of Kuk-kirmash to its place and putting his own inscription there as well. Again he offers the work on his own behalf and on behalf of his spouse, Nahhunte-utu, and their family, and he closes with an invocation, not of the god, but of the deceased ruler Kuk-kirmash.[2] Similar texts commemorate Shilhak-Inshushinak's restoration of constructions by other *sukkalmah*s.[3]

The text of Number 185, written by hand, covers three edges of the brick, so that only part of it could have been visible in a wall surface or corner. Two or three identical bricks, laid next to each other in different orientations, would have been needed to display the complete text.

MWS

1. The text was first published by Scheil, 1901, pp. 66ff., no. 48, and edited by König, 1965, pp. 86f., no. 35. The most recent edition, with a grammatical analysis and French translation, is by Françoise Grillot-Susini, *Éléments de grammaire élamite*, Synthèse No. 29 (Paris, 1987), pp. 56f., no. 7.
2. The brick of Shilhak-Inshushinak was first published by Scheil, *Textes élamites-anzanites, Deuxième série, MDP* 5 (1904), pp. 56ff., no. 78. The Elamite text was edited with a German translation by König, 1965, pp. 88f., no. 38. The original inscribed bricks of Kuk-kirmash, first published by

Scheil, 1900, pp. 74ff., and edited by François Thureau-Dangin, *Die sumerischen und akkadischen Königsinschriften*, Vorderasiatische Bibliothek, vol. 1, part 1 (Leipzig, 1907), pp. 182f., no. 5, are available in a contemporary French translation by Sollberger and Kupper, 1971, p. 264, nos. IVO11, IVO11a.
3. See König, 1965, pp. 89ff., nos. 38a, 38b, 39; Sollberger and Kupper, 1971, pp. 262 no. IVO8b, 264 no. IVO10b.

187 NEO-ELAMITE LEGAL TABLET WITH SEAL
IMPRESSION
Clay
H. 1⅝ in. (4.1 cm); W. 3⅞ in. (9.8 cm)
Impressed by a seal of H. ¾ in. (1.8 cm)
Neo-Elamite period, ca. 600 B.C.
Apadana; Sb 13077

188 NEO-ELAMITE ADMINISTRATIVE TABLET WITH
SEAL IMPRESSION
Clay
H. 2 in. (5.2 cm); W. 3 in. (7.6 cm)
Impressed by a seal of H. ⅝ in. (1.6 cm)
Neo-Elamite period, ca. 600 B.C.
Acropole; Sb 12804

Number 187 belongs to a group of seven tablets excavated in 1909 on the Apadana mound, below the remains of the Achaemenid palace; Number 188, to a group of 299 tablets excavated in 1901 on the Acropole. The script and language of both groups are Neo-Elamite, but none of the associated texts mentions a regnal year of any securely dated ruler. The dates assigned to the groups rely on the seal impressions found on some of the tablets and on the archaeological contexts of similar seal impressions. Both groups date to a time at the end of the seventh century B.C. and the first part of the sixth century, between the catastrophic Assyrian raids on Susa and the moment when the Achaemenids assumed power and began to make Susa one of the political centers of their empire. These modest archives are evidence for the revival in that interval of an Elamite monarchy at Susa, whose control probably extended at least to easternmost Khuzistan.[1]

The texts from the Apadana are legal documents: contracts drawn up among private citizens, witnessed, signed by the scribe, and sealed. As such they are a rarity among known texts in Elamite.

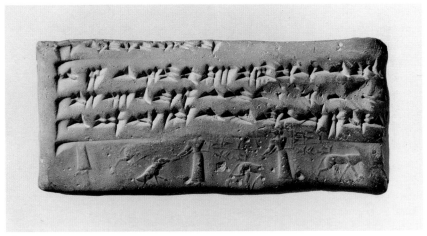

187

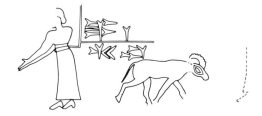

Most are promissory notes for silver and gold, but Number 188 is a receipt for sheep, perhaps part of a herding agreement. Following the main body of each text is a list of witnesses, then a closing section that names the scribe who wrote the tablet (in Number 188, he is named Bakish) and the man whose seal was impressed on the tablet (in Number 187, Nap-dutash [or Nap-dur], the first of the witnesses).[2]

The texts from the Acropole, including Number 188, are administrative texts, full of uncertainties. Most deal with textiles, leather items, and tools, weapons, utensils, and vessels of bronze, iron, silver, and gold. They record outlays and receipts of materials, receipts of finished goods, and other transfers. Two are envelopes, probably from administrative memoranda sent in from elsewhere to be archived at Susa. Many name a single man as the responsible official, so the archive covers a short period of time. Most indicate a month, but not the day or regnal year, so they may reflect a practice of monthly audits. Many also name a place at or near the end of the text, evidently to indicate the place where the text was written. Susa itself is by far the most frequently named, but some of the other places are also named in other Elamite and Mesopotamian texts. The place named at the end of Number 188 and of

several other texts in the archive—Bupila—is called Bubilu by Ashurbanipal, who lists it among the royal cities of Elam that he captured and destroyed. The seal impressed on Number 188 was also applied to other texts in the archive, some of which name Susa at the end; therefore, if the texts were drawn up at Bupila and Susa, those towns were close enough for the user of the seal to move easily between them. Other texts in the archive, however, were drawn up in more distant places and show that the administrative province for which these records were kept at Susa extended east and south at least to the mountains that separate Khuzistan from Fars.[3]

Both tablets bear the impressions of small cylinder seals. The reverse of Number 187 has several incomplete impressions of a delicately carved scene showing a standing robed figure, his hands outstretched, probably toward a quadruped approaching him; part of the owner's name and patronym, written in Neo-Elamite signs, is in the field above. The seal on Number 188 shows two bull-men with their arms raised on either side of their heads, facing each other and separated by a slightly smaller human figure in a tunic, whose hands are raised to grasp the bull-men's biceps.

MWS

188

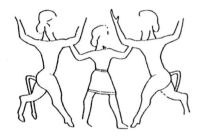

1. See Miroschedji, 1982, pp. 57–59, 62f.; François Vallat,
 "Kidin-Hutran et l'époque néo-élamite," *Akkadica* 37 (1984),
 pp. 7–9; M.-J. Steve, "La fin de l'Élam: à propos d'une em-
 preinte de sceau-cylindre," *Studia Iranica* 15 (1986), pp. 7f.,
 13f.; Miroschedji, 1990, pp. 78–81.
2. The primary publication of Number 187 is by V. Scheil,
 Textes élamites-anzanites, Quatrième série, MDP 11 (1911),
 pp. 99f., no. 307; the seal impression is published by Amiet,
 1973a, p. 28 and pl. v, no. 19.
3. Number 188 was first published by V. Scheil, *Textes élamites-
 anzanites, Troisième série, MDP* 9 (1907), pp. 37f. and pl. i,
 no. 34; the seal is published by Amiet, 1973a, p. 27 and pl. ii,
 no. 7. Texts impressed with the same seal that name Susa at
 the end are *MDP* 9: 16, 75, 119, 135, and 217. General inter-
 pretations of this administrative archive are offered by Y. B.
 Yusifov, "Elamskie khoziaistvennye dokumenti iz Suz"
 (Elamite economic documents from Susa), *Vestnik Drevneii
 Istorii* 84 (1963, no. 2), pp. 191–222, and 85 (1963, no. 3),
 pp. 200–261; and Walther Hinz, "Zu den Zeughaustäfelchen
 aus Susa," in G. Wiessner, ed., *Festschrift für Wilhelm Eilers*
 (Wiesbaden, 1967), pp. 85–98.

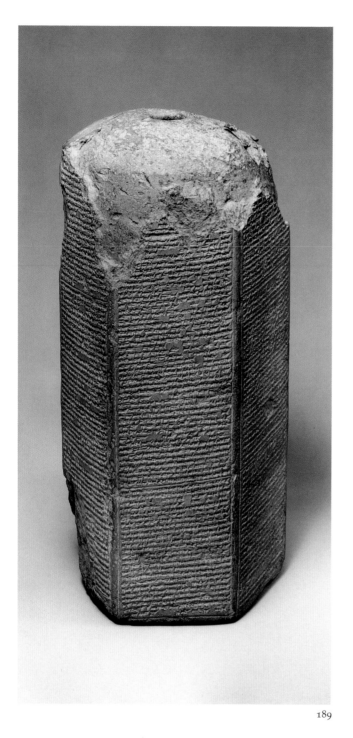

189

189 PRISM OF ASHURBANIPAL, KING OF ASSYRIA, DESCRIBING HIS CAMPAIGNS AGAINST ELAM AND THE PILLAGE OF SUSA (PRISM F)
Six-sided, pierced in the center from top to bottom
Baked clay
H. *13 in. (33 cm)*; W. *each side, 3⅛ in. (8 cm)*
Neo-Assyrian period, reign of Ashurbanipal, 646 or 645 B.C.
Nineveh; AO *19939*

Each year the Assyrian kings conducted campaigns at the order of their dynastic god, Ashur, and had their exploits recorded by scribes. Several prisms bear historical texts concerning the military campaigns of Ashurbanipal (668–627 B.C.). These were foundation documents buried in the walls of buildings. Each document concentrates on recent campaigns, with a reminder of earlier events. "Prism F"[1] focuses almost entirely on the king's wars against Elam.[2] The text was recopied and appears on several clay tablets, cylinders, and prisms.[3] No mention is made of the first military expeditions of 667 B.C. and 664 B.C. against the king Urtaku (whose name in Elamite is unknown). However, on the bottom of side 2 (lines 53ff.) and on sides 3, 4, and 5, a description appears of Ashurbanipal's later campaigns: against Te-Umman (Tepti-Humban-Inshushinak in Elamite) in 653 B.C., and thereafter against Ummanaldash (Humban-altash III), who had seized the throne of Elam and supported the revolt of Ashurbanipal's brother, Shamash-shum-ukin, the king of Babylon, against Ashurbanipal. These events led to the pillage of Susa, which took place in 647 B.C. or 646 B.C.[4] and was probably recorded the following year.

The fourth and fifth sides give a lengthy description of the sack of Susa, the destruction of the city, and the deportation of the inhabitants and their gods to Assyria. The description of the city's treasures is remarkably precise; mention is even made of the booty brought home from Mesopotamia by the early Elamite kings. With quickening pace the text illustrates the mounting violence that culminated in the total devastation of Susa:

> [. . .] Ummanaldash, king of Elam, fled naked and took refuge in the mountain [. . .]. Susa, the great holy city, abode of their gods, seat of their mysteries, I conquered according to the word of Ashur and Ishtar. I entered its palaces, I dwelt there in rejoicing; I opened the treasures where silver and gold, goods and

wealth were amassed [. . .] the treasures of Sumer, Akkad, and Babylon that the ancient kings of Elam had looted and carried away [. . .]. I destroyed the ziggurat of Susa [. . .]; I smashed its shining copper horns. [In]shushinak, god of the oracles, who resides in secret places, where no man sees his divine nature [along with the gods that surround him], with their jewelry, their wealth, their furniture, with the priests, I brought as booty to the land of Ashur [. . .]. I reduced the temples of Elam to naught; their gods, their goddesses, I scattered to the winds. The secret groves where no outsider had ever penetrated, where no layman had ever trod, my soldiers entered, they saw their mysteries, they destroyed them by fire. The tombs of their ancient and recent kings who had not feared [the goddess] Ishtar, my lady, and who were the cause of torments to the kings, my fathers—those tombs I devastated, I destroyed, I exposed to the sun, and I carried away their bones toward the land of Ashur. [. . .] I devastated the provinces of Elam and [on their lands] I spread salt [. . .]

<div align="right">BA-S</div>

1. Aynard, 1957.
2. The first campaigns that are related on prism F's first side and on the beginning of the second, against Egypt, the king of

Tyre, and the Manneans, are found in all of Ashurbanipal's later historical texts, for they symbolize the victories of Ashur over the regions to the south, west, and north of Assyria. The last side recounts the restoration of the palace of Nineveh, the capital.
3. See the list in Mordechai Cogan, "Ashurbanipal Prism F: Notes on Scribal Techniques and Editorial Procedures," *JCS* 29 (1977), pp. 97–107.
4. For a detailed study of the chronology, see A. K. Grayson, "The chronology of the reign of Ashurbanipal," *ZA* 70 (1981), pp. 227–45.

190 TABLET WITH OLD PERSIAN TEXT OF THE "FOUNDATION CHARTER" OF THE PALACE OF DARIUS AT SUSA

Clay
H. *8⅞ in. (22.5 cm)*; W. *10⅛ in. (26.5 cm)*; D. *1 in. (2.5 cm)*
Achaemenid period, reign of Darius I, ca. 518 B.C.
Sb 2789
Excavated by Mecquenem.

The text DSf, sometimes called the Foundation Charter of Susa, was drawn up for the Achaemenid

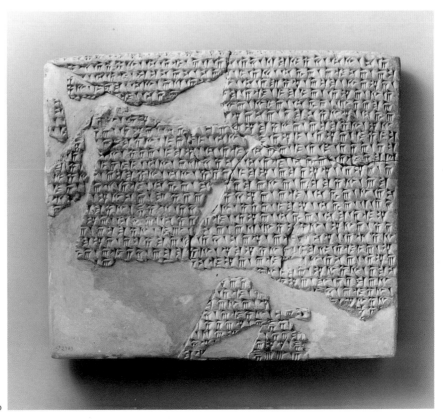

190

Persian king Darius I (522–486 B.C.) in three languages: Old Persian, Elamite, and Akkadian. This damaged tablet is the best preserved exemplar of the Old Persian version.[1]

The inscription commemorates the building of the Achaemenid palace at Susa. It invokes Ahura Mazda, the god who created earth, heaven, mankind, and the king, Darius; recites the titulature and descent of Darius, the Achaemenid; and then introduces the balance of the text as the words of Darius himself. The king tells that Ahura Mazda bestowed the empire on him while his father, Hystaspes, and his grandfather, Arsames, were both still living. His palace at Susa was built of materials brought from afar, and he describes the earliest stages in the construction, the materials used, and the peoples and nations that took part in transporting the materials and working them. Babylonian workers dug a foundation pit and filled it with packed rubble. Timber was brought from Lebanon in the west and from Gandhara and Carmania in the east; gold from Sardis in the west and Bactria in the east; ivory from Egypt and Ethiopia in the west and from Sind and Arachosia in the east, and so on; the stone columns were quarried nearby, in Elam. Among the craftsmen were stonecutters from Ionia and Sardis, goldsmiths from Media and Egypt, woodworkers from Sardis and Egypt, brickmasons from Babylonia, and so on. Exclaiming how excellent was the work ordered at Susa and how excellent the work that was done, Darius closes the text with a prayer for Ahura Mazda's protection of himself and his father, Hystaspes.

DSf is one of the earliest of Darius's inscriptions, composed immediately after his rise to power. Stone tablets with monolingual Elamite and Akkadian texts similar to DSf were excavated in the foundations of the palace walls themselves,[2] but none of the exemplars of DSf itself was found in situ; in fact, fragments of many exemplars of the Old Persian, Elamite, and Akkadian versions were found in many parts of the Apadana and Ville Royale.[3] They are inscribed on large baked clay tablets like this one, on larger stone blocks, on clay barrel-cylinders, and on glazed bricks. Some of the cylinders and stone blocks and even some of the tablets may have been buried in the foundations, but the glazed bricks formed part of a decorative frieze on the walls of the palace: at least some versions of the inscription were meant to be seen.

Ancient visitors who saw and understood the inscription, or who had it read to them, would have had no difficulty finding the political meaning in this description of precious materials carried from afar and worked by men of many nations. The palace was the emblem of the empire, its workmanship the token of the order to which the subject peoples submitted, its precious materials a sample of the tribute that order would cost. Conspicuous by their absence as contributors, transporters, or workers are the Persians, the rulers themselves.

This delicate omission and the nuances of this message stand in plain contrast to the starker terms of Darius's later inscriptions, both from Susa (DSe) and from Persepolis and nearby Naqsh-i Rustam in Persia proper. At the beginning of his reign, with his power newly imposed and delicately poised, Darius had his scribes write: "This palace which I built at Susa, its building materials were brought from far away." On his tomb at Naqsh-i Rustam, however, he was to portray his rule more bluntly: "If now you wonder 'How many are the countries which King Darius held?' look at the sculptures of those who carry the throne [depicted on the facade of the tomb], then you will know, then it will be clear to you: the spear of the Persian has gone forth far."[4]

MWS

1. The first edition of this exemplar is by Scheil (1929b, pp. 18ff., pls. 8, 9); editions of all three versions, and the primary publications of the exemplars then known, are given on pp. 3–34. These are supplemented by Scheil, 1933, pp. 105–14, and by Steve, 1974, pp. 135–61, and François Vallat, "Un Fragment de tablette achéménide et la turquoise," *Akkadica* 33 (1983), pp. 63–68. The standard English edition of the Old Persian text is Kent, 1953, pp. 142–44, with additions from Steve, 1974, pp. 145–47. The standard edition of the Elamite version is François Vallat, "Deux inscriptions élamites de Darius Ier (DSf et DSz)," *Studia Iranica* 1 (1972), pp. 8–11; the standard edition of the Akkadian version is Steve, 1974, pp. 155–61.

2. For DSz (Elamite): François Vallat, "Table élamite de Darius Ier," *RA* 64 (1970), pp. 149–60, and idem, "Deux inscriptions," pp. 10–13; other probable exemplars of the Elamite version and fragments of a probable Old Persian version are treated by Steve, 1974, pp. 161–68. For DSaa (Akkadian): François Vallat, "Table accadienne de Darius Ier (DSaa)," in *MM-JS*, pp. 277–85.

3. The manuscripts are listed in Steve, 1974, pp. 135–36 (thirteen Old Persian pieces), 147 (twelve Elamite pieces), and 151 (twenty-six Akkadian pieces).

4. DNa §4: see Kent, 1953, p. 138.

191 ELAMITE ADMINISTRATIVE TABLET WITH
IMPRESSION OF A ROYAL NAME SEAL
Clay
H. 1½ in. (3.8 cm); W. 1⅞ in. (4.8 cm); D. 1 in.
(2.5 cm)
Impressed by a seal of H. ¾ in. (1.8 cm)
*Achaemenid period, reign of Darius I, regnal year
22 = 500/499* B.C.
Sb 13078

191, two views

The great epigrapher Vincent Scheil made this un-
prepossessing document known in 1911, but even he
could make little sense of it then except to recognize
its contents as administrative, its language as Elam-
ite, and its date—clear from the incomplete seal
impression—as Achaemenid.[1] Only after Elamite
administrative texts were excavated in the fortifica-
tion wall at Persepolis in 1934, and a large sample of
those texts was published in 1969, could the contents
and historical context of this tablet be better under-
stood.[2] It is a record of oil disbursed "on behalf of
the king," in Susa and five villages, in the twenty-
second regnal year; the king (unnamed in the text)
is Darius I, so the date is 500/499 B.C. The seal im-
pression on the tablet shows a figure in crown and
Persian robe grasping in each outstretched hand the
horn of a winged bull, the scene framed by palm
trees on both sides and with the winged disk of
Ahura Mazda in the field overhead.[3] The archive of
administrative texts from the Persepolis fortification
wall includes many texts of the same formal type.[4]

Recently, an ongoing study of the seal impres-
sions on the Persepolis texts led to a startling obser-
vation: the impression on this tablet was made by
precisely the same seal that was applied to some of
the Persepolis texts of the same type.[5] Furthermore,
impressions on the Persepolis tablets show that the
seal was inscribed in Old Persian, Elamite, and Bab-
ylonian: "I, Darius, the King [in the Babylonian
version: Great King]."[6] In fact, impressions of this
seal appear *only* on texts of this administrative cate-
gory, texts that record the disbursal of royal provi-
sions. The seal indicates that the disbursal was
authorized by an office or officer in general charge
of the royal food supply. If this tablet was indeed
found at Susa[7] it is an extraordinary indication of
the range of that office's administrative jurisdiction.

MWS

1. V. Scheil, *Textes élamites-anzanites, Quatrième série, MDP*
11 (1911), pp. 89, 101, no. 308.

2. Richard T. Hallock, *Persepolis Fortification Tablets*, OIP 92
(Chicago, 1969), p. 25.

3. On the seal impression, Persepolis Fortification seal 7, see
ibid., p. 78; idem, "The Use of Seals on the Persepolis Forti-
fication Tablets," in McG. Gibson and R. D. Biggs, eds., *Seals
and Sealing in the Ancient Near East*, BM 6 (Malibu, 1977),
p. 128.

4. Hallock, *Persepolis Fortification Tablets* (PF 691–740 and
2033–35); idem, "Selected Fortification Texts," *DAFI* 8 (1978),
p. 118 (PFa 6 and many unpublished examples); on the text-
type (category J), see Hallock, *Persepolis Fortification Tablets*,
p. 24.

5. M. B. Garrison, "Seals and the Elite at Persepolis: Some Ob-
servations on Early Achaemenid Persian Art," *Ars Orientalis*
(in press); idem, "A Persepolis Fortification Tablet Seal at
Susa" (in preparation).

6. Manfred Mayrhofer, *Supplement zur Sammlung der altper-
sischen Inschriften*, Sitzungsberichte der Österreichischen
Akademie der Wissenschaften, phil.-hist. Klasse, 328
(Vienna, 1978), p. 16 3.11.1.; Rüdiger Schmitt, *Altpersische
Siegelinschriften*, Sitzungsberichte der Österreichischen
Akademie der Wissenschaften, phil.-hist. Klasse, 381
(Vienna, 1981), p. 22 SDe.

7. Although the tablet was recovered by the Susa mission, there
is no record of its excavation or provenience.

LITERARY, RITUAL, AND MATHEMATICAL TEXTS

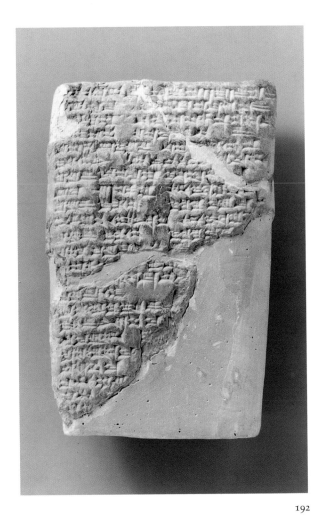

192

192 TABLET WITH PART OF AN OLD BABYLONIAN
VERSION OF THE LEGEND OF ETANA
Clay
H. 4¾ in. (12 cm); W. 3 in. (7.5 cm)
Old Babylonian period, 17th century B.C.
Sb 9469
Excavated by Mecquenem.

Among the first kings who ruled after the Deluge,
according to the Sumerian King List, was "Etana the
shepherd, who ascended to heaven." Among the den-
izens of the Netherworld, according to the *Epic of
Gilgamesh*, was the same Etana.[1] Ancient listeners
knew the allusion. Portrayals of. Etana, who rode to
heaven on an eagle's back, appear on Old Akkadian
cylinder seals from Mesopotamia and Iran (fig. 57);[2]
manuscripts of a mythological tale about Etana were
drafted by Old Babylonian and Middle Assyrian
scribes; and copies of a first-millennium retelling of
it were kept in the libraries of Nineveh.[3] The later
version is listed in a catalogue of literary works from
the Nineveh libraries as "The Series of Etana, by
Lu-Nanna," immediately after "The Series of Gilga-
mesh, by Sin-leqe-unninni."[4] The Susa tablet,
found in the Mecquenem excavations before 1927, is
a manuscript of the old version, probably late Old
Babylonian (ca. 1600 B.C.), and like the Susa frag-
ments of the Sumerian King List, it probably came
from the hand of a student in a scribal academy.

The fragments of the tale as we have it are dis-
jointed, but they weave together tales of gods and

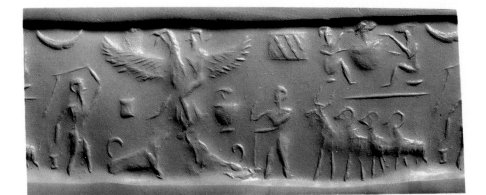

Figure 57. Modern impression
of a seal depicting the myth of
Etana. Seal: Akkadian period,
ca. 2200 B.C. Black serpentine,
H. 1½ in. (3.65 cm). The Pier-
pont Morgan Library, New York.
PML 236 E

men with an animal fable. They tell how the gods made Etana the first king; how he sought the Plant of Birth to get an heir; how an eagle formed a pact with a serpent but broke its oath and was punished by the sun god; how Etana befriended the eagle and rode to heaven like the Greek mythological figure Ganymede.

In the Susa manuscript, Etana himself does not appear. The fragment tells some of the story of the serpent and the eagle: they swore an oath of friendship and then brought forth their young, the serpent at the base of a poplar tree, the eagle in its branches; the serpent hunted and brought in game to feed the eagle's young as well as its own; when the serpent's young were grown, the eagle broke its oath and devoured them, against the warnings of its own offspring; the grieving serpent cried for vengeance to the sun god, who empowers oaths. Here the Susa text breaks off. It is another Old Babylonian manuscript that tells of the eagle's punishment and its meeting with Etana.

MWS

1. Jacobsen, 1939, pp. 80f. line 16. For *Gilgamesh* VII iv 49: see, most recently, Maureen Gallery Kovacs, *The Epic of Gilgamesh* (Stanford, 1989), p. 65, line 192.
2. See Porada, 1965, p. 41f., fig. 16; Collon, 1987, pp. 178–81.
3. J. V. Kinnier Wilson, *The Legend of Etana, a New Edition* (Warminster, England, 1985), includes a full description of the manuscripts, a proposed reconstruction of the Akkadian texts of the several versions, English translations, commentaries, and a survey of older editions and translations. Another recent reconstruction and English translation of the first-millennium version appears in Stephanie Dalley, *Myths from Mesopotamia* (Oxford, 1989), pp. 190–202.
4. W. G. Lambert, "A Catalogue of Texts and Authors," *JCS* 16 (1962), p. 66f., lines 11f. Lu-Nanna may be the sage who lived at Ur in the reign of Shulgi, commemorated in Sumerian literary tradition: see W. G. Lambert, "Ancestors, Authors, and Canonicity," *JCS* 11 (1957), p. 7, and Kinnier Wilson, *The Legend of Etana*, p. 27.

193 FUNERARY TABLET
Clay
H. 1⅜ in. (3.4 cm); W. 3 in. (7.7 cm); D. 1⅛ in. (2.8 cm)
End of the Sukkalmah period, ca. 1500 B.C.
Sb 19319
Excavated by Mecquenem, 1914.

A tomb dating to the middle of the second millennium, built of brick, was discovered below the palace of Darius in 1914 by Roland de Mecquenem. A small compartment adjoining the tomb contained seven small tablets.

In this tablet,[1] the dead man seems to invoke his protecting deity:

> Come, and I shall go, O god my master. . . . I shall take thy hand before the supreme gods; hearing my sentence, I shall grasp thy feet. Illuminating the house of shadows, O my god, thou shalt help me cross the swamp of weakness and pain. In this place of difficulties, thou shalt keep watch over me. Thou shalt slake my thirst with water and oil in this parched field.

The text of the other tablets is obscure; it is possible that it bears upon the voyage of the deceased toward the underworld and his judgment, or even a reward, as in this passage:

> He shall see [the goddess]. May she bestow upon thee the abundant oil, the excellent oil, and fill thy mouth with it! May the god be propitious to thee!

BA-S

1. Scheil, 1916, pp. 165–74; Georges Dossin, "Autres textes sumériens et accadiens," *MDP* 18 (1927), p. 88, no. 250; Bottéro, 1982, pp. 393–406.

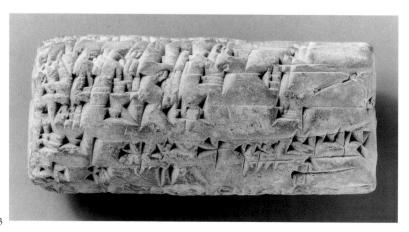

193

194 TABLET ILLUSTRATING A METHOD FOR
CALCULATING THE AREAS OF REGULAR
POLYGONS, IN AKKADIAN
Clay
H. 4¾ in. (12.2 cm); W. 4¾ in. (12.2 cm); D. 1 in.
(2.6 cm)
Old Babylonian period, 17th century B.C.
Sb 13088
Excavated by Mecquenem.

195 MULTIPLICATION TABLE
Clay
H. 2¼ in. (5.8 cm); W. 1¾ in. (4.5 cm); D. ⅞ in.
(2.2 cm)
Old Babylonian period, 17th century B.C.
Sb 13090
Excavated by Mecquenem.

In 1933 Mecquenem's excavations found a group of
twenty-six mathematical tablets on the Ville Royale.

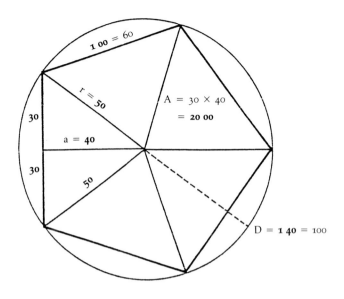

Figure 58. Derivation of the constant for calculating the area of a
regular five-sided figure. Numbers in light type are decimal; num-
bers in bold type are sexagesimal.

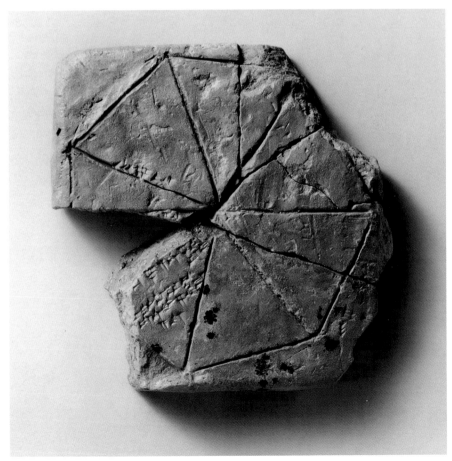

194

Their archaeological context was badly disturbed, but the forms of the cuneiform signs date them to the Old Babylonian period (ca. 1600 B.C.), roughly contemporary with the writing exercises and scholarly texts found in other parts of the Ville Royale and with a large number of the known mathematical texts from Babylonia.[1] Some of the Susa texts are simple, others surprisingly sophisticated.

Number 195 is a simple multiplication table giving products of the number 25: the multiplier is in the left column, the product in the right column. The numbers are expressed in sexagesimal place value notation, using "sexagesimal double digits."

In our decimal place value notation, based on 10, each digit is a whole number smaller than 10, with its position indicating a power of 10: e.g., 123 = $(3 \times 10^0 = 3) + (2 \times 10^1 = 20) + (1 \times 10^2 = 100)$. Similarly, in the Babylonian sexagesimal notation, each digit is a whole number smaller than 60, with its position indicating a power of 60: e.g., sexagesimal 1 2 3 = $(3 \times 60^0) + (2 \times 60^1) + (1 \times 60^2)$ = decimal 3 + 120 + 3,600 = decimal 3,723. But each digit—that is, each number below 60—is written in decimal form, with vertical wedges indicating ones and angle wedges indicating tens, from 1 (𒁹) to 59 (𒐐𒐕).

So, the first two lines of Number 195, with the first two products of 25, read simply 1—25, 2—50. But the third and following lines show the sexagesimal double digits: 3—1 15 (i.e., decimal 60+15), 4—1 40 (i.e., decimal 60+40), 5—2 5 (i.e., decimal 120+5), and so on.

A decimal multiplication table needs only eight entries, giving products for multipliers from 2 to 9. A complete sexagesimal table would need fifty-eight, giving products for multipliers from 2 to 59. This table (like other Old Babylonian multiplication tables) is abbreviated, giving products for multipliers from 1 to 20, then for 30, 40, and 50, so that the missing products can be obtained by a single addition of two entries.[2]

The geometrical tablet Number 194 illustrates the use of arithmetic constants to calculate the areas of regular six- and seven-sided figures ("polygon" is a slightly misleading term, for in Babylonian mathematics the figures are conceived as multisided rather than as multiangled). The constants are listed in another tablet from the same group: for a five-sided figure (in sexagesimal form) 1 40, for a six-sided figure 2 37 30, for a seven-sided figure 3 41 (00).[3] The length of a side of the figure multiplied

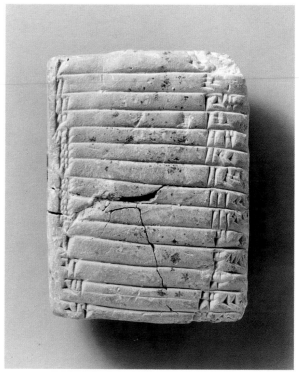

195

by the appropriate constant produces the area of the figure.

The derivation of these constants is easiest to illustrate for the five-sided figure (fig. 58). Consider the figure to be inscribed in a circle and stipulate as an approximation that the perimeter of the figure is identical to the circumference of the circle. Let each side of the figure = 1 00 (decimal 60). Then the perimeter of the figure = 5 00 (decimal 300) ≈ the circumference of the circle. Assume $\pi \approx 3$ (the common approximation in Babylonian mathematical texts, still common in Hellenistic mathematical texts). Then $\pi D \approx 3D = 5\ 00$. Then D = 1 40 (decimal 100), r = 50. Then the figure is composed of five identical triangles, each with sides 1 00, 50, 50 (decimal 60, 50, 50). Bisecting one of these triangles with an altitude from the center gives two right triangles, each with a side 30 and a hypotenuse 50; each is therefore a 10 × (3,4,5) right triangle. The area of each double triangle is half the base multiplied by the altitude, hence 30 × 40. The area of the whole five-sided figure with a side of length 1 00 is then $A_5 = 5 \times 30 \times 40 = 1\ 40\ 00$ (decimal 6,000), the constant listed in the table.

The corresponding area constants for the other figures are obtained similarly, using approximations

of square roots: for the six-sided figure $A_6 = 6 \times 30 \times 30\sqrt{3}$ (with the approximation $\sqrt{3} = 1;45$ [decimal 1.75]) $\approx 6 \times 30 \times 30 \times 1;45 = 6 \times 26$ $15 = 2\ 37\ 30$; for the seven-sided figure $A_7 = 7 \times 30 \times 20\sqrt{10}$ (with the approximation $\sqrt{10} \approx 3;10$ [decimal 3.1616...]) $\approx 7 \times 30 \times 20 \times 3;10 = 7 \times 31\ 40 = 3\ 41\ 40$, rounded to $\approx 3\ 41$ (00).[4]

Number 194 illustrates these relationships for a six-sided figure on the obverse and for a seven-sided figure on the reverse, in each case at half-scale, that is, with each side of each figure equal to 30 (i.e., half of 1 00). Parts of the circles around the figures are lightly indicated; the identical triangles are clearly indicated, one bisected by an altitude. The diagram of the six-sided figure indicates the length of one side, 30. The length of a radius is indicated on each side: 30 for the six-sided figure and 35 for the seven-sided figure. The length of the altitude was indicated but is broken off.

The diagram of the six-sided figure gives the area of one of the equilateral triangles: 6 33 45.[5] The diagram of the seven-sided figure includes instructions for the computation: "[for a] seven-[sided figure] you multiply (the length of one side) by four and subtract one twelfth and (the result is) the area"—that is, the constant for the seven-sided figure has been rounded down from 3 41 to 3 40, expressed as four minus one-twelfth of four ($4 - \frac{4}{12} = 3\frac{2}{3} =$ sexagesimal 3 40).

MWS

1. On the date of the Susa tablets, see Tanret, 1986, pp. 140–41. Excellent English-language surveys of cuneiform mathematical texts in general are J. Friberg, "Mathematik," *RLA*, vol. 7, part 7–8 (Berlin, 1990), pp. 531–85, and the classic O. Neugebauer, *The Exact Sciences in Antiquity*, 2nd ed. (New York, 1969), pp. 29–70. The primary edition of Numbers 194 and 195 is E. M. Bruins and M. Rutten, *Textes mathématiques de Suse*, *MDP* 34 (1961), pp. 23ff. with pls. iif., 2f., no. II, 35 with pl. 6, no. IV K.
2. See O. Neugebauer and A. Sachs, *Mathematical Cuneiform Texts*, American Oriental Series, no. 29 (New Haven, 1945), pp. 19–24; Neugebauer, *The Exact Sciences in Antiquity*, pp. 31f.; Friberg, *RLA*, vol. 7, pp. 545f.
3. *MDP* 34, no. III 26–28.
4. Friberg, *RLA*, vol. 7, p. 557.
5. Where a = altitude of the triangle and A = area of the triangle, and A_6 = area of the polygon: $a^2 = 30^2 - 15^2 = 11\ 15$ (decimal 675); $a = 15\sqrt{3} \approx 15 \times 1;45$ (decimal 1.75) = 26 15. $A = 15a = 15 \times 26\ 15 = 6\ 33;45$ (decimal 393.75). $A_6 = 6A = 6 \times 6\ 33;45 = 39\ 22;30$ (decimal 2,362.5).

Shell, Ivory, and Bone Artifacts

Recent investigations of ancient Near Eastern objects made of shell, ivory, and bone have combined the analytic methodologies of natural science and archaeology. It is especially difficult to determine the precise material of these objects because of their diminutive size and because they have frequently been so extensively polished or eroded that the original anatomical form of the material is completely transformed. Often, wear and modern restorations prevent analysis altogether. When identification is possible, however, it opens the way to new classifications that shed light on trade in raw materials and finished products over long distances. In this field, François Poplin's investigations of worked calcareous animal material and, more particularly, of ivory artifacts[1] have provided an invaluable complement to the pioneering research of M. Tosi and R. Biscione[2] on the shell industry of the ancient Near East. We are particularly indebted to François Poplin, of the National Museum of Natural History in Paris, who generously agreed to study the works from Susa for this exhibition.

At Susa as in Mesopotamia, shell was the most extensively worked type of calcareous animal material. Ivory was extremely rare, and the use of bone was limited to utilitarian objects such as tools, until the bone "dolls" of the Parthian period. Shellfish were imported from the Arabo-Persian Gulf, a region with which southwestern Iran had long-standing trade re-

lations. At first, shellfish (in particular, *Conus ebraeus* and dentalium) were used in the manufacture of jewelry, with the shells simply perforated or crosscut to make beads or rings.

In the third millennium B.C. the Susians began creating other objects from shell, such as mosaic plaques, although these were not as common in Susa as in Mesopotamia (a Mesopotamian example is the "standard of Ur"). The neighing equid, Sb 5631,[3] a remarkable piece both in workmanship and in choice of imagery, is probably an element of a mosaic plaque. That type of inlaid plaque was manufactured using traditional flint tools, including small drills and blades.[4] In the Early Dynastic period the use of shell became more widespread, especially that of the columella of large gastropods from the Gulf, which served as an inexpensive material for cylinder seals carved with schematic eye or fish motifs.[5]

A more unusual example is the large bracelet made of a *Fasciolaria trapezium*. Such bracelets were a speciality of the workshops of the great centers to the east such as Mohenjo-Daro, Balakot, and Lothal, which imported the shells from the Gulf of Oman and the coast of Makran and exported the finished products to eastern Iran, Susa, and Mesopotamia. The presence of the bracelet in Susa provides irrefutable proof of trade with the Indus Valley.[6]

The exceptional skill of Susian craftsmen in work-

ing shell—which, unlike ivory, is not easily sculpted in the round—can be seen in the statuette Number 59; it was long thought to be of ivory, but M. Poplin recently discovered that it is made from a large shell. The shell's growth rings are now visible on both sides of the figure. The material of the articulated human figure (No. 100), while particularly difficult to identify, is probably also shell.

A few fragments of carved tridacna,[7] discovered at Susa, bear witness to contacts between Elam and the Levant (fig. 59). In the eighth and seventh centuries B.C., these giant clams were extremely popular with Phoenician craftsmen, who typically carved on them scenes of flowers and animals surrounding a fantastic bird with a human head and a feather headdress that adorns the hinge of the bivalve. The same fabulous creature also appears on a type of fine metal vessel that was popular from Urartu to Lydia and all the way to Greece. The tridacnae found in Susa are the easternmost evidence of the diffusion of these luxury goods from the Levant.

It seems that elephant ivory was only occasionally available in Susa. Even from the most resplendent era, the Middle Elamite period in the second millennium B.C., the number of elephant ivory fragments that have come down to us is minuscule (see No. 86). The Elamites do not appear to have been familiar with hippopotamus ivory, on which a large artistic industry was based in the Levant during the third and second millennia. We know from recent research[8] that the Syrian elephant was rarely exploited for its ivory; the

workshops of Mesopotamia and the Levant either imported elephant ivory, probably from Africa via Egypt, or made use of the hippopotamuses that inhabited the coastlands of the Levant. It might be expected that the Elamites, whose relations with the Indus Valley are well established, had ivory brought from the East along with lapis lazuli, carnelian, and shell jewelry. If that was the case, the imports must have been limited in quantity, as were those of lapis, which is strikingly rare in Susa as compared to Mesopotamia.

It is only with the Persians that the use of ivory at Susa seems to have become widespread. We know from Persian written sources that this exotic, costly product was employed abundantly: the foundation charter of the Darius palace (No. 190)[9] tells us that the "king of kings" had ivory brought from Ethiopia, the Indus Valley, and Arachosia (eastern Iran). It was probably imported in the form of tusks and crafted at palace workshops by Sardians (Greeks from Asia Minor) and Egyptians. Unfortunately, we have very few examples of ivory workmanship at Susa during the Persian period. The scanty remains of plaques carved in relief and incised and of fragmentary figurines, found in the wells of the Susa Donjon on the site of a palace from the Persian era, while not always clearly identifiable, are probably of ivory. Those objects, despite their fragmentary state, are proof of the extraordinary skill of the ivory workers and of their capacity to incorporate the multiple artistic traditions that were a characteristic feature of Achaemenid eclecticism. Thus, some of the design motifs are in an Egyptian style inspired by Phoenician creations of the ninth to seventh centuries B.C.;[10] others are in the pure Greek tradition,[11] and were perhaps either imported or carved by Greek artists at Susa. Still other carvings are consistent with Persian concepts both in style and in iconography.[12]

ANNIE CAUBET

NOTES

1. Caubet and Poplin, forthcoming.
2. Tosi and Biscioni, 1981.
3. Amiet, 1966, p. 143.
4. Coqueugnot, forthcoming.
5. Amiet, 1972b, nos. 784, 787, 795, etc.
6. Sb 14473; Pierre Amiet in Jarrige, 1988, No. A 10.
7. Amiet, 1976e.
8. Caubet and Poplin, 1987, and idem, forthcoming.
9. Scheil, 1929b, pl. 9.
10. Mecquenem, 1947, p. 84, fig. 53:3 and 7.
11. Ibid., fig. 53:6; Amiet, 1972b, p. 327, fig. 39, "Female smelling a flower."
12. Mecquenem, 1947, fig. 56; Amiet, 1972b, pl. 5:2a–b.

Figure 59. Drawing reconstructing a carved tridacna shell. Shell: Susa, ca. 8th–7th century B.C. Paris, Musée du Louvre, Sb 9202, 9204–6

Conservation Report

From the very beginning the Susa exhibition project was exceptional, and not only because of the number and quality of the objects loaned by the Louvre and the wide range of conservation treatments that needed to be performed, some of them major, on outstanding pieces (the statue of Napir-Asu, the stele of Naram-Sin). Also remarkable was the principle, agreed upon from the project's inception, that since particular attention had to be paid to conservation the effort would be shared by the Metropolitan Museum and the Louvre, and some conservation treatments would be performed in New York. In this respect the Susa exhibition is a pilot project, a model for other collaborative ventures between major museums.

This exhibition is one of the first and most important undertakings of the newly created archaeological division of the Service de Restauration des Musées de France. The division was officially set up in 1989, the time that the Susa project was initiated—a very beneficial coincidence. At this early stage in its development, the division was able to meet an essential requirement for the Susa restoration work by providing a large empty space in its headquarters at Versailles where all the Middle Elamite and Achaemenid brick fragments could be displayed and sorted out. Later, a laboratory was installed at Versailles so that special conservation treatments could be performed under adequate working conditions. Because of its importance the Susa project drew considerable attention to the specific problems of archaeological conservation.

Preparation for the exhibition involved a variety of activities too numerous to detail; therefore this report concentrates on a few major topics.

Many of the objects in the Louvre that were excavated at Susa had received some kind of conservation treatment in the past. It was essential to take this into consideration before planning any new action. Unfortunately, information on when, how, and by whom these earlier restorations were done is often missing or limited, and is scattered in various sources. To collect the information requires a patient search through many documents, including written and photographic archives, previous publications, inventory books, oral testimonies, and reports on scientific analyses and technical examinations of the objects.

ARCHITECTURAL BRICKS: PAST AND PRESENT RESTORATIONS

Let us consider, for example, the series of architectural baked bricks made in various periods. They are among the most impressive finds made by the French missions. It was a tremendous achievement to unearth, pack, and transport these remains and then to restore the numerous wall panels made of hundreds of heavy, fragile, fragmentary bricks. The following description of the main events in this undertaking reflects the present state of our knowledge.[1]

MIDDLE ELAMITE UNGLAZED BRICKS (SEE NO. 88) According to Roland de Mecquenem's report, the bricks were first found, reused in a drainpipe, during the excavation season of 1912–13.[2] Later, during the 1921 season, the team dug up an aqueduct made of approximately two hundred bricks, some inscribed, some not, in the same area.[3] The bricks represented "a fairly large number of types, a selection of which has been brought back to the Louvre."[4] But how the bricks were selected and exactly how many entered the museum collection is unknown.

One year later Mecquenem suggested an initial reconstruction of three figurative panels: a bull-man, a palm tree with an arm, and a figure thought to be a sphinx, as well as a geometric frieze (fig. 60).[5] An actual restoration of a bull-man and a palm tree

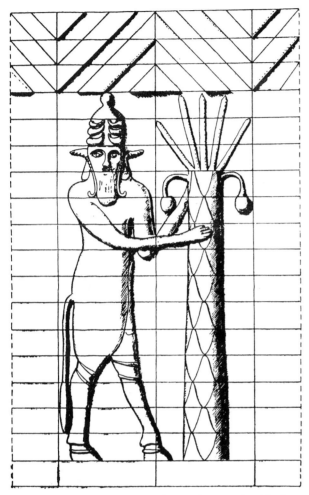

Figure 60. Early reconstruction of Middle Elamite unglazed brick panels with bull-man, palm tree, and zigzag pattern (see No. 88)

mounted separately in two different panels (Sb 2732 and 2733), and of a diamond-shaped frieze motif, may have been attempted at that time. This information comes from a note made in 1947 by Mecquenem.[6] However, it should be emphasized that no mention of restored brick panels from the Inshushinak temple is made in the *Catalogue des Antiquités de Susiane* published by Maurice Pézard and Edmond Pottier in 1926.[7]

What we know for certain is that a restoration campaign took place around 1928. In the preceding years excavations had continued at Susa, and in 1924 new bricks were unearthed, including two major pieces of the puzzle: the shoulders of the bull-man (the fourth course from the top) and the hands of the so-called sphinx, sometimes interpreted as a goddess in prayer.[8] A new assembly of the bricks was adopted following Mecquenem's interpretation, developed by J.

M. Unvala: a newly restored bull-man and palm tree formed a single panel (Sb 2735) because this fantastic being and the sacred tree were thought to belong to a single iconographic group. The restoration of the "goddess" panel was also undertaken, but it proved more problematic. No parts of the two top courses, corresponding to the headdress, had been found during the excavations, and the motif was incomplete. Furthermore, the face was badly damaged.[9] Because the aesthetic sensibility of the time made it impossible to display an incomplete and fragmentary restoration, the "goddess" was given "a sort of a bonnet"[10] and her features were reworked (Sb 2734 panel).

In a study published in 1928, Unvala recorded that two "goddess" panels were restored,[11] but we cannot follow him on this point. Every other source leads us to believe that he was mistaken.

The restored Middle Elamite panels were shown in connection with the exhibition of oriental antiquities held at the Musée de l'Orangerie in 1930. In the catalogue, R. Dussaud described only one example of the "goddess" and two examples of the bull-man–palm tree group, one reconstructed as two separate panels and the other as a single panel. Also included was the brick frieze that forms a geometric motif.[12] (A third coupling of a palm tree with a bull-man was restored at an unknown date but appears, from visual analysis, to illustrate the same techniques of restoration as those employed in the 1920s.)[13]

Dussaud further explained that "these various Elamite panels were assembled by the marble cutters' workshop at the Louvre," and in the preface of the catalogue paid gracious homage to the "zeal" and "skills" particularly demonstrated by this workshop "under the direction of M. Dausque."[14] There is only one reference in the archives[15] to Gustave Dausque, an obscure figure in the history of the restoration of the Louvre collections; now at last he is emerging from oblivion.

Because of insufficient information, we cannot determine with precision the methods used at that time to restore the panels. However, in connection with our current research we have tried to document the old restorations as fully as possible, using visual and radiographic examinations, soundings, and partial cleaning tests. Thus both the prevailing spirit and the methods employed in this restoration, carried out between the two world wars, can be roughly apprehended. First, the missing parts were filled in with pigmented plaster. Then the surface was almost entirely inpainted with oil colors in order to create an

illusion of completeness and give the old bricks—which were of clay of varying shades, some pale green, some beige, some red ocher—a uniform color. False cracks were drawn on the surface of the plaster fills to imitate the original appearance of the ancient terracotta. Every chip was filled in, and the edges of every brick as well as the joints between the courses were redone. Clearly the outcome was required to be beautiful, with as undamaged and rectilinear a surface as possible. In order to reduce the weight of the ensemble and facilitate assembly, bricks were sawn across their depth and the panels were framed within metal supports, clearly visible with the radiography.

Conservation Treatment 1990–91 Three new panels of previously unrestored bricks were assembled in 1990–91 (No. 88). All the fragments of bricks left in reserve by the first restorers, about 350 in number, were moved to the workshops of the Service de Restauration in Versailles, where they were dusted off and sorted out during the summer of 1990 (fig. 61). The preliminary analysis of this material had several positive results. It revealed the presence of elements that could be used to restore three new panels: a bull-man, a palm tree, and a "goddess." It confirmed that traces of about fifteen samples existed for each of those three motifs (for example, fifteen heads of bull-men, sixteen inscribed parts of palm tree trunks, fourteen arms of a "goddess"). Finally, it made possible the verification of numerous details regarding the iconographic or technological study of the bricks.

Since this was a long-term conservation project, it was decided that all the elements should be treated, not just those to be used in the new mounting. This process was carried out in several stages:

• Scientific examination and analysis (types of clays, traces of slip, bitumen decoration, traces of mortar, burial deposits and accretions).

• Condition report and diagnosis.

• Cleaning: after some preliminary tests (dry cleaning, wet cleaning, poultices), the bricks were gently cleaned with water, and preliminary consolidation was performed whenever necessary. Some extremely hard siliceous and gypseous concretions remaining on a few bricks could be only partially eliminated because to remove them entirely by mechanical means might have caused damage to the surface.

• Consolidation: with paraloid B 72, in a stronger or weaker solution in acetone according to each case (about three percent for the easily crumbling areas, in more concentrated injections for the areas with lifting chips or crusts).

• Gluing of joint fragments—after more puzzle work than one can imagine!—with polyvinyl acetate in an aqueous emulsion (Mowilith).

Finally, as a measure of preventive conservation, the storage conditions were improved for the isolated elements being sent back into the storeroom of the Département des Antiquités Orientales after treatment.

Mounting the new panels did not produce any major discoveries about iconography. As our predecessors had already observed, the headdress of the

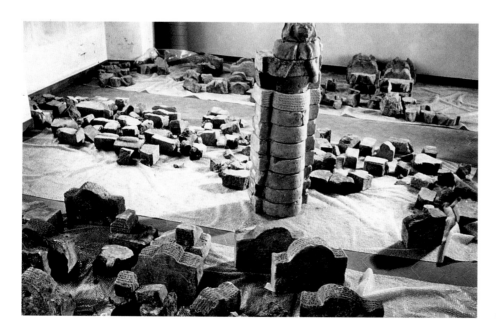

Figure 61. Middle Elamite brick facade fragments during recent restoration efforts by the Service de Restauration

"goddess" was missing. Some notches on the side of the bricks corresponding to the "arm" of the palm tree and the forearm of the bull-man (both on the sixth course) appeared clearly. These marks suggest a connection between the two panels.

What makes this current restoration campaign more innovative and represents an improvement over older attempts is the adoption of and adherence to the principles of readability, faithfulness to the original, and maximum flexibility in terms of assembly. As a consequence, these methods were followed:

• The use of a single material (clay) and a single manufacturing technique (modeling) to reconstruct the missing courses (fig. 62).

• The choice of a modern terracotta that in texture and color is clearly distinct from the ancient bricks but that integrates well into the general ensemble.

• Great care in the reconstruction choices, notably regarding unknown elements (e.g., the headdress).

• Minimal restoration. Except for a little glue and consolidant, no foreign substance was introduced into the original materials. The ancient elements remain distinct from the modern ones; each course is independent, and the whole piece is an assembly of independent parts. The display of the three panels relies upon a custom-made mounting system that prevents the superposed courses from crushing into each other.

MIDDLE ELAMITE GLAZED BRICKS The few elements of this series gathered by Jacques de Morgan on the Susa Acropole[16] constituted a group too sparse and fragmentary to be easily reconstructed. It was not until Pierre Amiet's detailed study, published in 1976, that a restoration of these "disjecta membra" could be attempted (fig. 13, p. 11).[17] The work was executed by Guy Cosset of the marble cutters' workshop, then under the direction of M. Bretonnière.[18]

In comparison to methods of the 1920s, the restoration technique chosen by Cosset shows a movement away from illusionistic effects and a greater attempt to suggest the architectural features of the original work. Missing courses in the two royal figures were redone in Saint-Maximin limestone; some less important missing parts were filled in with slightly recessed plaster, and cavities were carved out for the insertion of the preserved ancient fragments, attached with metal dowels (e.g., the face and feet of the queen). A light patina made from shellac mixed with pigments smoothes the surface of the stone.

GLAZED AND UNGLAZED PERSIAN BRICKS While the discovery of glazed bricks from the Achaemenid pe-

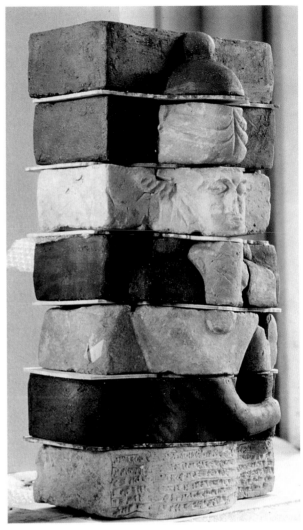

Figure 62. Detail of a newly restored section of the Middle Elamite brick facade (No. 88) showing modern (darker) bricks before firing, together with ancient bricks

riod is a recurring motif in the writings of archaeologists digging in Susa, the different stages of their successive restorations have fallen into oblivion. Let us recall the most significant facts.

In the late 1880s, after a first restoration campaign, the archers and the lion frieze discovered during the Dieulafoy excavations were exhibited at the Louvre in their newly restored splendor.[19] On the site, Jane Dieulafoy had been concerned about the bricks' great fragility, expressing that worry in her very personal style.[20] Consequently, the treatment of the bricks included a strengthening process, executed in the "classical" fashion of the time: with spermaceti.[21] This last detail confirms our hypothesis that the work was carried out at the Louvre in the workshop specializing in the restoration of antiques, because we know from

archival sources that the same process was used at the museum in the 1900s.[22]

While the nineteenth-century restoration was totally illusionistic and as such had elicited the admiration of the shah of Persia during his visit to Paris in 1900, in subsequent, less ambitious restorations made between the two world wars the figures were completed more visibly. During the Morgan excavations, quantities of better preserved elements from representations of archers and fantastic animals had been discovered. G. Le Batard, a very seriously disabled veteran, undertook their restoration. Le Batard is mentioned two or three times in publications, where he is described as a "skilled artist" and a "repair artist." We learn that he spent many years working for the Susa Mission and that he restored most of the objects found during the excavations.[23] His work on vases, bronze objects, ivory objects, and other pieces is documented in the archives between 1920 and 1940, as is his restoration of many Achaemenid panels.[24] He worked with an assistant in his workshop in Marines, Seine-et-Oise. We do not know if any other hands, perhaps from the Manufacture de Sèvres, were involved in the restoration.[25] Further research is needed in this area.

Finally, the marble cutters' workshop appears to have executed partial or extensive reconstructions of some Persian panels at a later date (1950–60?).[26]

Conservation Treatment 1991–92 For the Susa exhibition, a conservation campaign on Achaemenid unglazed brick panels similar to the project conducted on the Middle Elamite series was undertaken. All the fragments that had been put aside during the past restorations and left piled up in a storeroom were taken to Versailles, cleaned, inventoried, and photographed. Then the conservators dedicated themselves once again to a giant puzzle, this time working with approximately 950 fragments.

The bricks represent motifs already known, the lion, the winged bull, and the lion-griffin (No. 169); and it may be possible in the future to restore a new lion panel. Some fragments also illustrate unknown motifs that so far are difficult to interpret (other animals? vegetal ornaments?).

Technical features are being studied—for example, incised marks in the shape of arrows on the sides of some bricks. The various types of clays are being analyzed, as are traces of bitumen. In several cases one can observe that the surface layer, which bears the low-relief decoration, was molded separately (as a stamped plaque) and then attached to the body of the brick. The clay used for this layer may be different from that used for the main bulk of the brick (e.g., green clay on a pale ochre body). With time, and after millennia of aging in the ground, the stamped surfaces have deteriorated more or less severely and tend to lift up from the brick. In some cases the surface is completely detached and allows us to observe the fingermarks on the reverse of the plaque. The bricks are in very fragile condition and frequently require consolidation.

CONSERVATION OF OTHER MATERIALS

STONE Both French and American participants carried out the conservation treatment of the works in stone.

In France, the most outstanding event was no doubt the restoration of the Naram-Sin stele (No. 109), generously made possible by funding by Dr. and Mrs. Raymond R. Sackler. It was carried out in several stages. Preliminary examinations and analysis included ultra-violet examination, measurement by ultra-sound to determine the degree of deterioration of the stone and locate the main areas of weakness, petrographic examination—which proved the stone to be a limestone and not a sandstone—study of the porosity, and identification of salts and previous restoration materials. Particularly of interest was the question of the effects induced by plaster consolidation carried out during the excavations:[27] what was the nature and the chemical stability of this plaster? In the long term, this treatment might have contributed to the stele's deterioration because of salts in the plaster.

The condition report showed that although the lower part of the stele is badly damaged, the deterioration process appears to be more or less stabilized; no alarming change, such as saline efflorescence, chipping, or exfoliation, has been observed in many years. Using the photographic archives of the Département, we can compare the current state of the stele with its condition at exhumation and its successive states during presentation in the Louvre galleries: undoubtedly there were losses in the sculpted bas-relief, notably at the left bottom corner, but these seem to have occurred at an early date, possibly during the shipping from Susa to Paris. Thus, the situation was less dire than we had first envisioned. Nevertheless, the stone had to be treated before it could be moved.

The conservation treatment of the Naram-Sin stele was undertaken in 1992 and involved:

• Preventive consolidation of the bas-relief with Japanese paper in order to avoid all loss of material.

• Careful mechanical removal of the plaster (reinforced with fragments of modern bricks, stone, and wood pieces) that had been applied on the entire surface of the stele's reverse side. This plaster held the metallic support that attached the stele to the pedestal.

• Removal of the pedestal.

• Cleaning.

• Consolidation treatment (by impregnation with ethyl silicate).

Because of the monument's importance, a study will be published when all the conservation work has been completed.

METAL Two major conservation projects funded by Dr. and Mrs. Raymond R. Sackler were completed: the statue of Napir-Asu (No. 83) and the *sit shamshi* (No. 87; see the technical report by Françoise Tallon and Loïc Hurtel, pp. 140–41).

ONGOING CONSERVATION RESEARCH PROJECTS In connection with the Susa exhibition, programs of research into the conservation of specific materials such as bitumen compound (see pp. 99–105) and unbaked clay (the series of funerary heads; see pp. 135–36) have been developed. These investigations are in progress and the results will be published at a later date.

BRIGITTE BOURGEOIS

NOTES

1. I am very grateful to the following people who helped in my research: Pierre Amiet, former Inspecteur général of the Département des Antiquités Orientales, Musée du Louvre; Geneviève Teissier, documentation assistant, Département des Antiquités Orientales, Musée du Louvre; and Evelyne Cantarel-Besson, attachée, Archives des Musées Nationaux.
2. Mecquenem, 1980, p. 23.
3. Ibid., p. 28.
4. Mecquenem, 1922, p. 128.
5. Ibid., p. 129 and pl. 6.
6. Mecquenem, 1947, pp. 13–14: "Since the bricks did not have alternated courses, both motifs of the bull-man and palm tree had initially been restored separately; they were reproduced as such in the *Revue d'Assyriologie* (Mecquenem, 1922, pl. 6)."
7. This is the second edition. The first edition dates to 1913, preceding the discovery of the bricks, which may be why the authors did not mention the discovery in the second edition.
8. Mecquenem, 1980, p. 32, and idem, 1924, p. 115: "We discovered several elements belonging to the relief panels we had previously attempted to reconstruct, including in particular two samples of the brick bearing the shoulders and the beard of the bull-man, missing until now." And further, "the discovery of a nearly complete brick that gives us the very rough hands" of the goddess.

9. Unvala, 1928, p. 182.
10. The term is Unvala's, p. 182: "The headdress, which was a sort of a bonnet, is wholly missing."
11. Ibid., p. 182: The bricks "were numerous enough to permit a restoration of a pair of complete panels of the man-bull worshiping the sacred date-palm and that of another pair of the panels of the woman in the praying attitude, in which latter some bricks are still missing."
12. Musée de l'Orangerie, 1930, pp. 72–73, no. 100: bull-man and stylized palm tree; no. 101: goddess; no. 102: coronation frieze; pl. 4.
13. Kept in reserve; Sb 14390 and 14391.
14. Musée de l'Orangerie, 1930, p. 6.
15. Archives des Musées Nationaux, 0-28-S, application for aid dated May 20, 1922 (unpublished).
16. Morgan, 1900c, p. 96.
17. Amiet, 1976d, pp. 13–28, and in personal communication.
18. I am indebted to Mr. Cosset for the information that he has kindly given me in conversation.
19. Mecquenem, 1980, pp. 3–4.
20. J. Dieulafoy, 1888, p. 158: "What terrible worries I have about the discovery and the removal of the enamels!" and pp. 132–33: "invisible cracks are parting these materials: when moved, they break and crumble."
21. Musée de l'Orangerie, 1930, introduction by R. Dussaud, pp. 5–6, 20–21.
22. Archives des Musées Nationaux, A 16, February 1908 (unpublished); answers to an inquiry sent by the Royal Museums of Berlin on the conservation and restoration of antiquities.
23. Pézard and Pottier, 1926, pp. 148–49. Musée de l'Orangerie, 1930, pp. 6, 20, 75.
24. Archives des Musées Nationaux, B 16 (unpublished).
25. According to the information given by P. Amiet. P. Munier, director-in-chief of the Institut de Céramique Française at Sèvres, has extensively studied the Middle Elamite and Achaemenid enameled frit objects. See P. Munier, "Les faiences siliceuses et la classification générale des faiences," *Silicates Industriels* 14, no. 8 (1949), pp. 1–8. I am grateful to P. Amiet, who brought this study to my attention.
26. Information from G. Cosset.
27. The stele was found buried 10 feet (3 m) down; see Morgan, 1905d, p. 8; also idem, 1900c, p. 145: "When it was dug up, this stele was chipping so much that it had to be strengthened in several areas with plaster. Since then, in contact with the air, the stone has hardened, making the shipping of this important monument possible." While at the Louvre, the stele has been treated with potassium silicate; see A. Parrot, *Archéologie mésopotamienne*, vol. 2 (Paris, 1953), p. 89.

STELE WITH SCENE OF A LIBATION BEFORE A GOD

After its arrival at the Metropolitan Museum, this limestone stele found at Susa (No. 110) was brought to the Objects Conservation Department for treatment prior to its exhibition. This treatment included the cleaning of the limestone surface, the consolidation of this surface in several areas, and the refinishing of the

existing plaster fills. During the treatment, a number of interesting features were noted.

Numerous irregularly shaped holes and pits were found on the surface of the stone. These losses appear to have occurred naturally during burial, either because soft and/or soluble deposits eroded from original cavities in the stone, or because inclusions harder than the surrounding limestone matrix were lost. Since limestones are typically formed by a sedimentary process, such inclusions and infilled cavities are not uncommon.

In contrast to these naturally formed cavities, the hole below the proper left hand of the seated figure was drilled or chiseled out and smoothed. This hole appears to have been filled with a stone plug that was held in place with a lead-tin alloy (93.7 percent Pb and 6.3 percent Sn as determined by EDS elemental analysis conducted by Mark Wypyski). A rectangular mass of this alloy lies across the diameter of the hole and a thin layer partially lines the wall of the hole. Although most of the stone plug is now lost, early photographs of the stele suggest that it protruded above the surrounding limestone surface.

Although the back surface of the stele is broadly covered with restoration plaster, it is possible to discern areas where at some time the uneven surface was polished. These polished areas suggest that the stone was reused or adventitiously placed in a way that exposed it to repeated wear.

J-F de L

CONTRIBUTORS TO THE CATALOGUE

PA Pierre Amiet

B A-S Béatrice André-Salvini

JA Joan Aruz

ZB Zainab Bahrani

AB Agnès Benoit

BB Brigitte Bourgeois

EC Elizabeth Carter

AC Annie Caubet

NC Nicole Chevalier

OD Odile Deschesne

POH Prudence O. Harper

SH Suzanne Heim

FH Frank Hole

LH Loïc Hurtel

J-F de L Jean-François de Lapérouse

OWM Oscar White Muscarella

HP Holly Pittman

AS Agnès Spycket

MWS Matthew W. Stolper

FT Françoise Tallon

CONCORDANCE

Musée du Louvre Number	Catalogue Number	Musée du Louvre Number	Catalogue Number	Musée du Louvre Number	Catalogue Number
AO 19939	189	Sb 1488	41	Sb 2831	57
AOD 109	151	Sb 1515	74	Sb 2832	69
Sb 2	106	Sb 1523	19	Sb 2834	141
Sb 3	105	Sb 1619	185	Sb 2887	96
Sb 4	109	Sb 1626	186	Sb 2899	92
Sb 6	54	Sb 1927	23	Sb 2900	94
Sb 7	110	Sb 1932	21	Sb 2905	101
Sb 9	117	Sb 1967	22	Sb 2908	102
Sb 12	80	Sb 2027	20	Sb 2918	37
Sb 16	140	Sb 2050	18	Sb 2984	38
Sb 22	115	Sb 2107	17	Sb 3012	36
Sb 25	116	Sb 2141	20	Sb 3015	34
Sb 41	51	Sb 2313	24	Sb 3030	35
Sb 43	142	Sb 2426	44	Sb 3131	4
Sb 45	108	Sb 2428	39	Sb 3154	7
Sb 47	107	Sb 2429	43	Sb 3157	2
Sb 54	55	Sb 2675	45	Sb 3165	8
Sb 56	112	Sb 2718	154	Sb 3167	10
Sb 61	111	Sb 2723/58	70	Sb 3168	3
Sb 69	31	Sb 2724	52	Sb 3174	1
Sb 70	25	Sb 2730	62	Sb 3178	5
Sb 71	32	Sb 2731	83	Sb 3179	9
Sb 72	26	Sb 2737	63	Sb 3182	13
Sb 77	50	Sb 2738	65	Sb 3189	11
Sb 82	53	Sb 2743	87	Sb 3208	6
Sb 85	114	Sb 2746	59	Sb 3302	155
Sb 95	113	Sb 2750	100	Sb 3309	156
Sb 105	29	Sb 2756	170	Sb 3324	157
Sb 108	27	Sb 2758	89	Sb 3336	158
Sb 110	28	Sb 2759	90	Sb 3337	159
Sb 119	33	Sb 2760	171	Sb 3344	165
Sb 366	14	Sb 2761	172	Sb 3352	144
Sb 457	147	Sb 2762	173	Sb 4005	30
Sb 458	143	Sb 2763	174	Sb 4604	146
Sb 524	180	Sb 2764	178	Sb 4832	48
Sb 787	64	Sb 2765	178	Sb 4841	46
Sb 1015	78	Sb 2766	179	Sb 5634	56
Sb 1053	77	Sb 2768	175	Sb 5635	66
Sb 1055	71	Sb 2769	91	Sb 5636	67
Sb 1333	75	Sb 2789	190	Sb 5638	86
Sb 1383	79	Sb 2801	47	Sb 5700	60
Sb 1446	72	Sb 2810	145	Sb 5883	15
Sb 1475	152	Sb 2816	137	Sb 5884	61
Sb 1484	42	Sb 2823	58	Sb 6166	40

MUSÉE DU LOUVRE NUMBER	CATALOGUE NUMBER	MUSÉE DU LOUVRE NUMBER	CATALOGUE NUMBER	MUSÉE DU LOUVRE NUMBER	CATALOGUE NUMBER
Sb 6177	149	Sb 7722	134	Sb 14232	164
Sb 6225	73	Sb 7742	131	Sb 14271	12
Sb 6236	103	Sb 7763	133	Sb 14390	88
Sb 6281	150	Sb 7797	132	Sb 14391	88
Sb 6353	49	Sb 7805	123	Sb 14392	167
Sb 6572	126	Sb 7814	122	Sb 14428	166
Sb 6574	124	Sb 7834	125	Sb 15440	184
Sb 6589	97	Sb 7876	136	Sb 17729	181
Sb 6590	98	Sb 7979	135	Sb 17829	182
Sb 6591	99	Sb 8559	81	Sb 17830	183
Sb 6592	93	Sb 8748	76	Sb 18653	161
Sb 6593	95	Sb 9099	107	Sb 19319	193
Sb 6617	55	Sb 9469	192	Sb 19323	138
Sb 6711	148	Sb 9510	162	Sb 19324	139
Sb 6734	153	Sb 10294	82	Sb 19325	16
Sb 6767	84	Sb 11214	68	Sb 19355	176
Sb 7103	118	Sb 12070	177	Sb 19560	85
Sb 7130	119	Sb 12804	188	Sb 19575	88
Sb 7209	120	Sb 13077	187	Sb 19576	88
Sb 7259	127	Sb 13078	191	Sb 19577	88
Sb 7392	104	Sb 13088	194	Sb 20556	169
Sb 7402	128	Sb 13090	195	Sb 20557	169
Sb 7410	121	Sb 14227	168	Sb 20558	169
Sb 7586	129	Sb 14228	163		
Sb 7637	130	Sb 14229	160		

BIBLIOGRAPHY

ABBREVIATIONS

AA	*Arts asiatiques*
AfO	*Archiv für Orientforschung*
AMI	*Archäologische Mitteilungen aus Iran*
BaM	*Baghdader Mitteilungen*
BM	Bibliotheca Mesopotamica. Malibu, Cal.
BTA	*Bahrain Through the Ages: The Archaeology.* Edited by Shaikha Haya Ali al Khalifa and Michael Rice. London, 1986.
CRAI	*Comptes rendus des séances de l'Académie des Inscriptions et Belles Lettres*
DAFI	*Cahiers de la Délégation Archéologique Française en Iran*
DAI (UVB)	*XXVI und XXVII vorläufiger Bericht über die von dem Deutschen Archäologischen Institute und der Deutschen Orient-Gesellschaft aus Mitteln der Deutschen Forschungsgemeinschaft unternommenen Ausgrabungen in Uruk-Warka.* Berlin, 1972.
IA	*Iranica Antiqua*
JA	*Journal asiatique*
JAOS	*Journal of the American Oriental Society*
JCS	*Journal of Cuneiform Studies*
JESHO	*Journal of the Economic and Social History of the Orient*
JNES	*Journal of Near Eastern Studies*
MDP	*Mémoires de la Délégation en Perse,* pre-1913; *Mémoires de la Mission archéologique de Susiane,* vol. 14, 1913; *Mémoires de la Mission archéologique de Perse,* vol. 15, 1913; *Mémoires de la Mission archéologique de Perse. Mission de Susiane,* vols. 16–28, 1921–39; *Mémoires de la Mission archéologique en Iran. Mission de Susiane,* vols. 29–37, 1943–65; *Mémoires de la Délégation archéologique en Iran. Mission de Susiane,* vol. 39, 1966, to present. Paris.
MJP	*Contribution à l'histoire de l'Iran: Mélanges offerts à Jean Perrot.* Edited by François Vallat. Paris, 1990.
MM-JS	*Fragmenta Historiae Elamicae: Mélanges offerts à M.-J. Steve.* Edited by Léon De Meyer, Herrmann Gasche, and François Vallat. Paris, 1986.
NABU	*Nouvelles assyriologiques brèves et utilitaires*
OIP	Oriental Institute Publications, The University of Chicago. Chicago.
RA	*Revue d'assyriologie et d'archéologie orientale*
Rd'E	*Revue d'égyptologie*
RLA	*Reallexikon der Assyriologie und Vorderasiatischen Archäologie.* Berlin, 1932–present.
UVB	*Vorläufiger Bericht über die von der Notgemeinschaft der Deutschen Wissenschaft in Uruk-Warka unternommenen Ausgrabungen,* Abhandlungen der Preussischen Akademie der Wissenschaften, philosophisch-historische Klasse, vols. 1–5. Berlin, 1930–34. Succeeding volumes under slightly different titles (see *DAI*).
WVDOG	Wissenschaftliche Veröffentlichung der Deutschen Orient-Gesellschaft. Leipzig.
ZA	*Zeitschrift für Assyriologie und verwandte Gebiete,* to 1939; *Zeitschrift für Assyriologie und vorderasiatische Archäologie,* 1940–present.

Aachen, City of

 1987 *Vergessene Städte am Indus: Frühe Kulturen in Pakistan vom 8.–2. Jahrtausend v. Chr.* Exh. cat., City of Aachen. Mainz.

Akurgal, Ekrem

 1961 *Die Kunst Anatoliens von Homer bis Alexander.* Berlin.

Al-Gailani Werr, Lamia

 1982 "Catalogue of the Cylinder Seals from Tell Suliemeh-Himrin." *Sumer* 38, pp. 68–88.

Algaze, Guillermo

 1989 "The Uruk Expansion: Cross-cultural Exchange in Early Mesopotamian Civilization." *Current Anthropology* 30, no. 5, pp. 571–608.

Alizadeh, Abbas

1988 "Socio-Economic Complexity in Southwestern Iran During the Fifth and Fourth Millennia B.C.: The Evidence from Tall-i Bakun A." *Iran* 26, pp. 17–34.

Amandry, Pierre

1958 "Orfèvrerie achéménide." *Antike Kunst* 1, pp. 9–23.

Amiet, Pierre

1959 "Représentations antiques de constructions susiennes." *RA* 53, pp. 39–44.

1960 "Notes sur le répertoire iconographique de Mari à l'époque du palais." *Syria* 37, pp. 215–32.

1966 *Élam*. Auvers-sur-Oise.

1967 "Éléments émaillés du décor architecturale néo-élamite." *Syria* 44, pp. 27–51.

1970a "Une masse d'armes présargonique de la collection M. Foroughi." *RA* 64, pp. 9–16.

1970b "Rois et dieux d'Élam, d'après les cachets et les sceaux-cylindres de Suse." *Archéologia* 36, pp. 22–29.

1971 "La glyptique de l'Acropole (1969–1971): Tablettes lenticulaires de Suse." *DAFI* 1, pp. 217–33.

1972a *Glyptique susienne: Des origines à l'époque des Perses achéménides*. MDP 43.

1972b "Les ivoires achéménides de Suse." *Syria* 49, pp. 167–91, 319–37.

1972c "Les statues de Manishtusu, roi d'Agadé." *RA* 66, pp. 97–109.

1973a "La glyptique de la fin de l'Élam." *AA* 28, pp. 3–32.

1973b "Glyptique élamite, à propos de documents nouveaux." *AA* 26, pp. 3–64.

1974a "Antiquités du désert de Lut: À propos d'objets de la collection Foroughi." *RA* 68, pp. 97–110.

1974b "Quelques observations sur le palais de Darius à Suse." *Syria* 51, pp. 65–73.

1976a *Les antiquités du Luristan: Collection David-Weill*. Paris.

1976b *L'art d'Agadé au Musée du Louvre*. Paris.

1976c "Contribution à l'histoire de la sculpture archaïque de Suse." *DAFI* 6, pp. 47–82.

1976d "Disjecta Membra Aelamica: Le décor architectural en briques émaillés à Suse." *AA* 32, pp. 13–28.

1976e "Tridacnes trouvés à Suse." *RA* 70, pp. 185–86.

1977 *L'art antique du Proche Orient*. Paris.

1978 (Ed.) *Art et histoire de l'Iran avant l'Islam: Collections du Musée du Louvre*. Paris.

1979a "Alternance et dualité: Essai d'interprétation de l'histoire élamite." *Akkadica* 15, pp. 2–22.

1979b "Archaeological Discontinuity and Ethnic Duality in Elam." *Antiquity* 53, pp. 195–204.

1980a *Art of the Ancient Near East*. Translated by John Shepley and Claude Choquet. New York.

1980b "La glyptique du second millénaire en provenance des chantiers A et B de la Ville Royale de Suse." *IA* 15, pp. 133–47.

1980c *La glyptique mésopotamienne archaïque*. 2d ed. Paris.

1985 "À propos de l'usage de l'iconographie des sceaux à Suse." *Paléorient* 11, no. 2, pp. 37–38.

1986a *L'âge des échanges inter-iraniens, 3500–1700 avant J.-C*. Paris.

1986b "Kassites ou Élamites?" In Marilyn Kelly-Buccellati, ed., *Insight Through Images: Studies in Honor of Edith Porada*, pp. 1–6. BM 21.

1986c "Susa and the Dilmun Culture." In *BTA*, pp. 262–68.

1986d "L'usage des sceaux à l'époque initiale de l'histoire de Suse." In *MM-JS*, pp. 17–24.

1988a "Les modes d'utilisation des sceaux à Suse au IVe millénaire." *AMI*, N.F. 21, pp. 7–16.

1988b *Suse: 6000 ans d'histoire*. Paris.

Andrae, Walter

1925 (Ed.) *Coloured Ceramics from Ashur and Earlier Ancient Assyrian Wall-Paintings*. London.

1935 *Die jüngeren Ischtar-Tempel in Assur*. WVDOG 58.

André, Béatrice, and Mirjo Salvini

1989 "Réflexions sur Puzur-Inšušinak." *Mélanges P. Amiet II*. IA 24, pp. 53–78.

Arnaud, Daniel, Yves Calvet, and Jean-Louis Huot

1979 "Ilšu-Ibnišu, orfèvre de l'E.babbar de Larsa, La jarre L.76.77 et son contenu." *Syria* 56, pp. 1–64.

Asselberghs, Henri

1961 *Chaos en Beheersing: Documenten uit aeneolithisch Egypte*. Leiden.

Aynard, J.-M.

1957 *Le prisme du Louvre AO 19939*. Paris.

Azarpay, Guitty

1987 "Proportional Guidelines in Ancient Near Eastern Art." *JNES* 46, no. 3, pp. 183–213.

Barnett, Richard D.

1966 "Homme masqué ou dieu-ibex?" *Syria* 43, no. 3-4, pp. 259–76.

Barrelet, Marie-Thérèse

1974 "La 'figure du roi' dans l'iconographie et dans les
 textes depuis Ur-Nanše jusqu'à la fin de la I^re dy-
 nastie de Babylone." In Paul Garelli, ed., *Le palais
 et la royauté (Archéologie et civilisation)*, Compte
 rendu de la XIX^e Rencontre Assyriologique Inter-
 nationale, 29 juin–2 juillet 1971, pp. 27–138. Paris.

Beran, Thomas

1958 "Die babylonische Glyptik der Kassitenzeit." *AfO*
 18, no. 2, pp. 255–78.

Biggs, Robert D., and Matthew W. Stolper

1983 "A Babylonian Omen Text from Susiana." *RA* 77,
 pp. 155–62.

Bigot, Alexandre

1913 "Les frises du palais de Darius et leur fabrication."
 CRAI, pp. 274–80.

Boardman, John

1970 "Pyramidal Stamp Seals in the Persian Empire."
 Iran 8, pp. 19–45.

Boehmer, Rainer M.

1965 *Die Entwicklung der Glyptik während der Akkad-
 Zeit*. Berlin.

1966 "Die Datierung des Puzur/Kutik-Inšušinak und
 einige sich daraus ergebende Konsequenzen." *Ori-
 entalia*, n.s. 35, pp. 345–76, tab. 43–56.

1972 "Die Keramikfunde in Bereich des Steingebäudes."
 In *DAI*, pp. 31–42.

1981 "Glyptik der späten Kassiten-Zeit aus dem nord-
 östlichen Babylonien." *BaM* 12, pp. 71–81.

Boese, Johannes

1971 *Altmesopotamische Weihplatten: Eine sumerische
 Denkmalsgattung des 3. Jahrtausends v. Chr.* Berlin.

Börker-Klähn, Jutta

1970 *Untersuchungen zur altelamischen Archäologie.*
 Berlin.

1982 *Altvorderasiatische Bildstelen und vergleichbare
 Felsreliefs*. Baghdader Forschungen 4. Mainz.

Bothmer, Bernard V.

1960 *Egyptian Sculpture of the Late Period: 700 B.C. to
 A.D. 100*. Exh. cat., Brooklyn Museum. Brooklyn.

Bottéro, Jean

1982 "Les inscriptions cunéiformes funéraires." In
 Gherardo Gnoli and Jean-Pierre Vernant, eds., *La

mort, les morts dans les sociétés anciennes*, pp.
 373–406. Cambridge.

Boucharlat, Rémy

1990a "La fin des palais achéménides de Suse: Une mort
 naturelle." In *MJP*, pp. 225–33.

1990b "Suse et la Susiane à l'époque achéménide: don-
 nées archéologiques." In Heleen Sancisi-
 Weerdenburg and Amélie Kuhrt, eds.,
 Achaemenid History, vol. 4, *Centre and Periph-
 ery*, pp. 149–75. Leiden.

Boucharlat, Rémy, and Audran Labrousse

1979 "Le palais d'Artaxerxès II sur la rive droite du
 Chaour à Suse." *DAFI* 10, pp. 21–136.

Braun-Holzinger, Eva Andrea

1984 *Figürliche Bronzen aus Mesopotamien*. Munich.

Buchanan, Briggs

1966 *Catalogue of Ancient Near Eastern Seals in the
 Ashmolean Museum*. Vol. 1, *Cylinder Seals*.
 Oxford.

1967 "A Dated Seal Impression Connecting Babylonia
 and Ancient India." *Archaeology* 20, no. 2, pp.
 104–7.

Calmeyer, Peter

1972–75 "Hose." In *RLA*, vol. 4, pp. 472–76.

1973 *Reliefbronzen in babylonischem Stil*. Munich.

1976 "Zur Genese altiranischer Motive: IV. 'Persönliche
 Krone' und Diadem; V. Synarchie." *AMI*, N.F. 9,
 pp. 45–95.

1987 "Art in Iran, iii. Achaemenian Art and Architec-
 ture." In Ehsan Yarshater, ed., *Encyclopaedia
 Iranica*, vol. 2, pp. 569–80. London and New York.

1987–90 "Meder, Tracht der." In *RLA*, vol. 7, pp. 615–17.

1988 "Zur Genese altiranischer Motive: X. Die
 elamisch-persische Tracht." *AMI*, N.F. 21, pp.
 27–51.

Cameron, George G.

1936 *History of Early Iran*. Chicago.

Canal, Denis

1976 "Note sur un fragment de carreau décoré." *DAFI* 6,
 pp. 83–91.

1978a "La haute terrasse de l'Acropole de Suse." *Palé-
 orient* 4, pp. 169–76.

1978b "Travaux à la terrasse haute de l'Acropole de Suse
 (1)." *DAFI* 9, pp. 11–55.

Canby, Jeanny Vorys

1979 "A Note on Some Susa Bricks." *AMI* 12, pp. 315–20.

Carter, Elizabeth

forthc. "Bridging the Gap Between the Elamites and the
Persians in Southeastern Khuzistan." In Heleen
Sancisi-Weerdenburg, Amélie Kuhrt, and Marga-
ret C. Root, eds., *Achaemenid History*, vol. 8,
Continuity and Change. Leiden.

Carter, Elizabeth, and Matthew W. Stolper

1976 "Middle Elamite Malyan." *Expedition* 18, no. 2,
pp. 33–42.

1984 *Elam: Surveys of Political History and Archaeol-
ogy*. University of California Publications: Near
Eastern Studies, vol. 25. Berkeley and Los Angeles.

Caubet, Annie, and François Poplin

1987 "Matières dures animales: Étude de matériaux."
In Marguerite Yon, ed., *Ras Shamra-Ougarit*, vol.
3, *Le centre de la ville*, pp. 273–306. Paris.

forthc. "La place des ivoires d'Ougarit dans la production
du Proche-Orient ancien." In L. Finton, ed., *Ivory
in Greece and the Eastern Mediterranean, from
the Bronze Age to the Hellenistic Period*. 14th
British Museum Classical Colloquium, 1990.
London.

Charvát, Petr

1988 "Archaeology and Social History: The Susa Seal-
ings, ca. 4000–2340 B.C." *Paléorient* 14, no. 1, pp.
57–63.

Childe, V. Gordon

1969 *New Light on the Most Ancient East*. 4th ed. New
York.

Cleuziou, Serge

1986 "Dilmun and Makkan During the Third and Early
Second Millennia B.C." In *BTA*, pp. 143–55.

Cleuziou, Serge, and Thierry Berthoud

1982 "Early Tin in the Near East: A Reassessment in
the Light of New Evidence from Western Af-
ghanistan." *Expedition* 25, no. 1, pp. 14–19.

Cogan, M.

1974 *Imperialism and Religion: Assyria, Judah and
Israel in the Eighth and Seventh Centuries B.C.E.*
Missoula, Mont.

Collon, Dominique

1982 *Catalogue of the Western Asiatic Seals in the Brit-
ish Museum: Cylinder Seals*. Vol. 2, *Akkadian-
Post Akkadian-Ur III Periods*. London.

1986 *Catalogue of the Western Asiatic Seals in the Brit-
ish Museum: Cylinder Seals*. Vol. 3, *Isin-Larsa
and Old Babylonian Periods*. London.

1987 *First Impressions: Cylinder Seals in the Ancient
Near East*. London.

Contenau, Georges

1927–31 *Manuel d'archéologie orientale depuis les origines
jusqu'à l'époque d'Alexandre*. Vols. 1, 2. Paris.

1938 "The Early Ceramic Art." In Pope, 1938, vol. 1,
pp. 171–94.

Coqueugnot, E.

forthc. "Un atelier spécialisé dans le palais de Mari." In
Dominique Charpin and Jean-Marie Durand, eds.,
Mari, annales de recherches interdisciplinaires 7.
Paris.

Crawford, Harriet

1991a "Seals from the First Season's Excavation at Saar,
Bahrain." *Cambridge Archaeological Journal* 1,
no. 2, pp. 255–62.

1991b *Sumer and the Sumerians*. Cambridge and New
York.

Crawford, Vaughn Emerson, Prudence O. Harper, and Holly
Pittman

1980 *Assyrian Reliefs and Ivories in The Metropolitan
Museum of Art: Palace Reliefs of Assurnasirpal II
and Ivory Carvings from Nimrud*. New York.

1990 *Assyrian Reliefs and Ivories. . . .* Rev. ed. New
York.

Dalton, Ormonde M.

1926 *The Treasure of the Oxus*. 2d ed. London.

1964 *The Treasure of the Oxus*. 3d ed. London.

Damerow, Peter, and Robert K. Englund

1989 *The Proto-Elamite Texts from Tepe Yahya*. Pea-
body Museum of Archeology and Ethnology,
American School of Prehistoric Research Bulletin
39. Cambridge, Mass.

Danthine, Hélène

1937 *Le palmier-dattier et les arbres sacrés dans l'ico-
nographie de l'Asie occidentale ancienne*. Paris.

Delaporte, Louis

1920 *Catalogue des cylindres, cachets, et pierres gravées
de style oriental*. Vol. 1, *Fouilles et missions*. Paris.

Delougaz, Pinhas, Harold D. Hill, and Seton Lloyd

1967 *Private Houses and Graves in the Diyala Region*.
OIP 88.

Deschesne, Odile

forthc. *Le travail du bitume à Suse: Inventaire archéologique.* Paris.

Dieulafoy, Jane

1887a "The Excavations at Susa." *Harper's New Monthly Magazine* 75, no. 445, pp. 3–23.

1887b *La Perse, la Chaldée, et la Susiane.* Paris.

1888 *À Suse: Journal des fouilles, 1884–1886.* Paris.

Dieulafoy, Marcel-Auguste

1893 *L'Acropole de Suse d'après les fouilles exécutées en 1884, 1885, 1886.* Paris.

1913 *Les antiquités de Suse: Découvertes et rapportées par la Mission Dieulafoy (1884–1886).* Paris.

Dijk, Jan van

1978 "Išbi'Erra, Kindattu, l'homme d'Élam, et la chute de la ville d'Ur: Fragments d'un hymne d'Išbi'Erra." *JCS* 30, pp. 189–208.

1986 "Die dynastischen Heiraten zwischen Kassiten und Elamern: Eine verhängnisvolle Politik." *Orientalia,* n.s. 55, pp. 159–70.

Duchesne-Guillemin, Marcelle

1981 "Music in Ancient Mesopotamia and Egypt." *World Archaeology* 12, pp. 287–97.

Dunham, Sally

1985 "The Monkey in the Middle." *ZA* 75, no. 2, pp. 234–64.

Dyson, Robert H., Jr.

1968 "Early Work on the Acropolis at Susa: The Beginning of Prehistory in Iraq and Iran." *Expedition* 10, no. 4, pp. 21–31.

1989 "The Iron Age Architecture at Hasanlu: An Essay." *Expedition* 31, no. 2–3, pp. 107–27.

Eliade, Mircea

1972 *Shamanism: Archaic Techniques of Ecstasy.* Princeton.

Elwin, Verrier

1951 *The Tribal Art of Middle India: A Personal Record.* Bombay.

Farkas, Ann

1974 *Achaemenid Sculpture.* Istanbul and Leiden.

Ferioli, Piera, and Enrica Fiandra

1979 "The Administrative Functions of Clay Sealings in Protohistorical Iran." In Gherardo Gnoli and Adriano Rossi, eds., *Iranica,* vol. 10, pp. 307–12. Naples.

Finkelstein, Jacob Joel

1959 "The Year Dates of Samsuditana." *JCS* 13, pp. 39–49.

1961 "Ammiṣaduqa's Edict and the Babylonian 'Law Codes.'" *JCS* 15, pp. 91–104.

Forbes, Robert James

1964 *Studies in Ancient Technology.* 2d ed. Vol. 1. Leiden.

Frank, C.

1912 *Zur Entzifferung der altelamischen Inschriften.* Berlin.

1923 *Die altelamischen Steininschriften.* Berlin.

Franke, Judith A.

1977 "Presentation Seals of the Ur III/Isin-Larsa Period." In McGuire Gibson and Robert D. Biggs, eds., *Seals and Sealing in the Ancient Near East,* pp. 61–66. BM 6.

Frankfort, Henri

1939 *Cylinder Seals: A Documentary Essay on the Art and Religion of the Ancient Near East.* London.

1943 *More Sculpture from the Diyala Region.* OIP 60.

1954 *The Art and Architecture of the Ancient Orient.* Baltimore.

1955 *Stratified Cylinder-Seals from the Diyala Region.* OIP 72.

Frankfort, Henri, Thorkild Jacobsen, and Conrad Preusser

1932 *Tell Asmar and Khafaje: The First Season's Work in Eshnunna, 1930/31.* Oriental Institute Communications 13. Chicago.

Frankfort, Henri, Seton Lloyd, and Thorkild Jacobsen

1940 *The Gimilsin Temple and the Palace of the Rulers at Tell Asmar.* OIP 43.

Gadd, Cyril John

1932 "Seals of Ancient Indian Style Found at Ur." *Proceedings of the British Academy* 18, pp. 191–210.

Gall, Hubertus von

1972 "Persische und medische Stämme." *AMI,* N.F. 5, pp. 261–83.

1974 "Die Kopfbedeckung des persischen Ornats bei den Achämeniden." *AMI,* N.F. 7, pp. 145–61.

Galpin, Francis W.

1937 *The Music of the Sumerians and Their Immediate Successors, the Babylonians and Assyrians.* Cambridge.

Gautier, Joseph-Étienne

1909 "Le 'sit šamši' de Šilhak-In Šušinak." *Recueil des travaux relatifs à la philologie et à l'archéologie égyptiennes et assyriennes* 31, pp. 41–49.

1911 "Le 'sit šamši' de Šilhak In Šušinak." *MDP* 12, pp. 143–51.

Gelb, Ignace J.

1963 *A Study of Writing.* Rev. ed. Chicago.

1980 "Principles of Writing Systems Within the Frame of Visual Communication." In Paul A. Kolers, Merald E. Wrolstad, and Herman Bouma, eds., *Processing of Visible Language*, vol. 2, pp. 7–24. New York and London.

Ghirshman, Roman

1938–39 *Fouilles de Sialk près de Kashan, 1933, 1934, 1937.* Musée du Louvre, Série archéologique 4. 2 vols. Paris.

1964 *The Arts of Ancient Iran, from Its Origins to the Time of Alexander the Great.* New York.

1966 *Tchoga Zanbil.* Vol. 1, *La ziggurat. MDP* 39.

1968 *Tchoga Zanbil.* Vol. 2, *Temenos, temples, palais, tombes. MDP* 40.

Ghirshman, Roman, and Marie-Joseph Steve

1966 "Suse. Campagne de l'hiver, 1964–1965: Rapport préliminaire." *AA* 13, pp. 3–32.

Ghirshman, Tania

1970 *Archéologue malgré moi: Vie quotidienne d'une mission archéologique en Iran.* Neuchâtel and Paris.

Gjerstad, Einar

1937 *The Swedish Cyprus Expedition.* Vol. 3. Stockholm.

Glassner, Jean-Jacques, and Françoise Grillot

1989 "Les textes de Haft Tépé, la Susiane et l'Élam au 2e millénaire." Paper presented at the 36th Rencontre Assyriologique Internationale, Ghent.

Goossens, G.

1948 "Les recherches historiques à l'époque Néo-Babylonienne." *RA* 42, pp. 149–59.

Green, Anthony

1986 "The Lion-Demon in the Art of Mesopotamia and Neighboring Regions." *BaM* 17, pp. 141–254.

Green, Margaret W.

1981 "The Construction and Implementation of the Cuneiform Writing System." *Visible Language* 15, no. 4, pp. 345–72.

Green, Margaret W., and Hans Jörg Nissen

1987 *Zeichenliste der archaischen Texte aus Uruk.* Berlin.

Grillot, Françoise

1983 "Le 'suhter' royal de Suse." *IA* 18, pp. 1–24.

1986 "Kiririša." In *MM-JS*, pp. 175–80.

Grillot, Françoise, and Jean-Jacques Glassner

forthc. "Problèmes de succession et cumuls de pouvoirs: Une querelle de famille chez les premiers sukkalmah?" *IA.*

Haerinck, Ernie

1973 "Le palais achéménide de Babylone." *IA* 10, pp. 108–32.

Hallo, William W.

1961 "Royal Inscriptions of the Early Old Babylonian Period: A Bibliography." *Bibliotheca Orientalis* 18, pp. 4–14.

1983 "Cult Statue and Divine Image: A Preliminary Study." In William Hallo, James C. Moyer, and Leo G. Perdue, eds., *Scripture in Context II: More Essays on the Comparative Method*, pp. 1–17. Winona Lake, Ind.

Hallo, William W., and Briggs Buchanan

1965 "A 'Persian Gulf' Seal on an Old Babylonian Mercantile Agreement." In Hans G. Güterbock and Thorkild Jacobsen, eds., *Studies in Honor of Benno Landsberger on His Seventy-fifth Birthday, April 21, 1965*, pp. 199–209. Assyriological Studies 16. Chicago.

Hansen, Donald P.

1973 "Al-Hiba, 1970–1971: A Preliminary Report." *Artibus Asiae* 35, nos. 1–2, pp. 62–78.

Hayes, William C.

1953–59 *The Scepter of Egypt: A Background for the Study of the Egyptian Antiquities in The Metropolitan Museum of Art.* 2 vols. New York.

Heim, Suzanne

1989 "Glazed Architectural Elements from Elam and Related Material from Luristan." Ph.D. dissertation, Institute of Fine Arts, New York University.

Herrero, Pedro, and Jean-Jacques Glassner

1990 "Haft Tépé: Choix de textes, 1." *IA* 25, pp. 1–45.

Herzfeld, Ernst E.

1933 "Aufsätze zur altorientalischen Archäologie." *AMI* 5, pp. 1–124.

1941 *Iran in the Ancient East: Archaeological Studies Presented in the Lowell Lectures at Boston.* London and New York.

Heuzey, Léon

1898 "Exposé sommaire du rapport de M. J. de Morgan sur les fouilles de Perse." *CRAI*, pp. 670–79.

Hilprecht, Hermann Vollrat

1903 *Explorations in Bible Lands During the 19th Century.* Philadelphia.

Hinz, W.

1962 "Zur Entzifferung der Elamischen Strichschrift." *IA* 2, pp. 1–21.

1969 *Altiranische Funde und Forschungen.* Berlin.

Hole, Frank

1983 "Symbols of Religion and Social Organization at Susa." In T. Cuyler Young, Jr., Philip E. L. Smith, and Peder Mortensen, eds., *The Hilly Flanks and Beyond: Essays on the Prehistory of Southwestern Asia Presented to Robert J. Braidwood, November 15, 1982*, pp. 315–33. Studies in Ancient Oriental Civilization 36. Chicago.

1987 (Ed.) *The Archaeology of Western Iran: Settlement and Society from Prehistory to the Islamic Conquest.* Smithsonian Series in Archaeological Inquiry. Washington, D.C.

1990 "Cemetery or Mass Grave? Reflections on Susa I." In *MJP*, pp. 1–14.

Howard-Carter, Theresa

1983 "An Interpretation of the Sculptural Decoration of the Second Millennium Temple at Tell Al-Rimah." *Iraq* 45, pp. 64–72.

1986 "Eyestones and Pearls." In *BTA*, pp. 305–10.

Hrouda, Barthel

1990 "Zur Bedeutung des Fisches in der 'späthethitischen' Kunst: religiöse oder nur profane Darstellung?" In Paolo Matthiae, Maurits van Loon, and Harvey Weiss, eds., *Resurrecting the Past: A Joint Tribute to Adnan Bounni*, pp. 109–16. Istanbul and Leiden.

Hudson, Kenneth

1981 *A Social History of Archaeology: The British Experience.* London.

Illustrated London News

1931 "A Ruler of the Double Line: An Achaemenian King." *Illustrated London News*, vol. 178, January 10, p. 35.

Jacobsen, Thorkild

1934 *Philological Notes on Eshnunna and Its Inscriptions.* Assyriological Studies 6. Chicago.

1939 *The Sumerian Kinglist.* Assyriological Studies 11. Chicago.

1976 *The Treasures of Darkness: A History of Mesopotamian Religion.* New Haven.

Jarrige, Jean-François

1988 (Ed.) *Les cités oubliées de l'Indus. Archéologie du Pakistan.* Exh. cat., Musée Guimet. Paris.

Jeffreys, M. D. W.

1954 "Ikenga: The Ibo Ram-Headed God." *African Studies* 13, pp. 25–44.

Jéquier, Gustave

1900 "Travaux de l'hiver, 1898–1899." *MDP* 1, pp. 111–38.

1905 "Fouilles de Suse de 1899 à 1902." *MDP* 7, pp. 9–41.

1968 *En Perse, 1897–1902: Journal et lettres de Gustave Jéquier publiés et annotés par Michel Jéquier.* Neuchâtel.

Joannès, Francis

1984 "Contrats de mariage d'époque récente." *RA* 78, pp. 71–81.

1990 "Textes babyloniens de Suse d'époque achéménide." In *MJP*, pp. 173–80.

Johnson, Gregory A.

1978 "Information Sources and the Development of Decision-Making Organizations." In Charles L. Redman et al., eds., *Social Archeology: Beyond Subsistence and Dating*, pp. 87–122. New York, San Francisco, and London.

Joshi, Jagat Pati, and Asko Parpola

1987 (Eds.) *Corpus of Indus Seals and Inscriptions.* Vol. 1, *Collections in India.* Helsinki.

Kantor, Helene J.

1957 "Oriental Institute Museum Notes, no. 8: Achaemenid Jewelry in the Oriental Institute." *JNES* 16, pp. 1–23.

1958 "The Glyptic." In Calvin W. McEwan et al., eds., *Soundings at Tell Fakhariyah*, pp. 69–85. OIP 79.

1976 "The Excavations at Čoqā Miš, 1974–75." In Firouz Bagherzadeh, ed., *Proceedings of the 4th*

Annual Symposium on Archaeological Research in Iran, pp. 23–41. Teheran.

Karageorghis, Vassos

1973–74 *Excavations in the Necropolis of Salamis.* Vol. 3. Nicosia.

Kent, Roland Grubb

1953 *Old Persian: Grammar, Texts, Lexicon.* 2d ed., rev. New Haven.

Kervran, Monique

1972 "Une statue de Darius découverte à Suse: Le contexte archéologique." *JA*, pp. 235–39.

1974 "Les niveaux islamiques du secteur oriental du tépé de l'Apadana." *DAFI* 4, pp. 21–41.

King, Leonard William

1912 *Babylonian Boundary-Stones and Memorial-Tablets in the British Museum.* 2 vols. London.

1915 *Bronze Reliefs from the Gates of Shalmaneser, King of Assyria, B.C. 860–825.* London.

Kjaerum, Poul

1983 *Failaka/Dilmun: The Second Millennium Settlements.* Vol. 1, no. 1, *The Stamp and Cylinder Seals.* Aarhus, Denmark.

1986 "The Dilmun Seals as Evidence of Long Distance Relations in the Early Second Millennium B.C." In *BTA*, pp. 269–77.

Koldewey, Robert

1914 *The Excavations at Babylon.* Translated by Agnes S. Johns. London.

1931 *Die Königsburgen von Babylon.* WVDOG 54.

König, Friedrich W.

1965 "Die elamischen Königsinschriften." *AfO*, suppl. 16.

Kramer, Samuel Noah

1983 "The Ur-Nammu Law Code: Who Was Its Author?" *Orientalia* 52, pp. 453–56.

1989 "Law and Justice: Gleanings from Sumerian Literature." In Marc Lebeau and Philippe Talon, eds., *Reflets des deux fleuves: Volume de mélanges offerts à André Finet*, pp. 77–82. Akkadica Supplementum 6. Louvain.

Labat, René

1975 "Elam c. 1600–1200 B.C.," pp. 379–416, and "Elam and Western Persia c. 1200–1000 B.C.," pp. 482–506. In *The Cambridge Ancient History*, vol. 2, no. 2. Cambridge.

Labat, René, and Dietz Otto Edzard

1974 *Textes littéraires de Suse.* MDP 57.

Labrousse, Audran

1972 "La charte de fondation du palais de Darius Ier." Unpublished paper, University of Paris, EUR 3. In Département des Antiquités Orientales, Musée du Louvre.

Labrousse, Audran, and Rémy Boucharlat

1972 "La fouille du palais du Chaour à Suse en 1970 et 1971." *DAFI* 2, pp. 61–167.

Laird, Marsa

1984 "Linear-Style Cylinder Seals of the Akkadian to Post-Akkadian Periods." Ph.D. dissertation, Institute of Fine Arts, New York University.

Lambert, Maurice

1971 "Investiture de fonctionnaires en Élam." *JA* 259, pp. 217–21.

1976 "Tablette de Suse avec cachet du Golfe." *RA* 70, pp. 71–72.

1978 "Disjecta Membra Aelamica (II): Inscriptions du décor architectural construit par Shilhak-Inshushinak." *AA* 34, pp. 3–27.

Lambert, Wilfred G.

1976 "Introductory Considerations." *Orientalia* 45, no. 1–2, pp. 11–14.

1979 "Near Eastern Seals in the Gulbenkian Museum of Oriental Art, University of Durham." *Iraq* 41, pp. 1–45.

Lampre, George

1900 "Travaux de l'hiver, 1897–1898, tranchées nos. 7 et 7α." *MDP* 1, pp. 100–110.

1905 "La représentation du lion à Suse," pp. 160–76, and "Statue de la reine Napir-asou," pp. 245–50. *MDP* 8.

Langsdorff, Alexander, and D. E. McCown

1942 *Tal-i Bakun A: Season of 1932.* OIP 59.

Layard, Sir Austen Henry

1852 *Nineveh and Its Remains: With an Account of a Visit to the Chaldaean Christians of Kurdistan, and the Yezidis, or Devil-Worshippers; and an Inquiry into the Manners and Arts of the Ancient Assyrians.* 2 vols. New York.

1853 *Discoveries in the Ruins of Nineveh and Babylon; With Travels in Armenia, Kurdistan and the Desert: Being the Result of a Second Expedition Undertaken for the Trustees of the British Museum.* London.

Le Breton, Louis

1956 "À propos de cachets archaïques susiens (I)." *RA* 50, pp. 134–39.

1957 "The Early Periods at Susa, Mesopotamian Relations." *Iraq* 19, pp. 79–124.

Le Brun, Alain

1971 "Recherches stratigraphiques à l'Acropole de Suse, 1969–1971." *DAFI* 1, pp. 163–216.

1978 "Suse, chantier 'Acropole 1.'" *Paléorient* 4, pp. 177–92.

Le Brun, Alain, and François Vallat

1978 "L'origine de l'écriture à Suse." *DAFI* 8, pp. 11–59.

Legrain, Léon

1925 *The Culture of the Babylonians: From Their Seals in the Collections of the Museum.* University Museum, Publications of the Babylonian Section 14. Philadelphia.

Lerner, Judith

1991 "Some So-called Achaemenid Objects from Pazyryk." *Source* 10, no. 4, pp. 8–15.

Ligabue, Giancarlo, and Sandro Salvatori

1988 (Eds.) *Bactria: An Ancient Oasis Civilization from the Sands of Afghanistan.* Venice.

Limet, Henri

1971 *Les légendes des sceaux cassites.* Brussels.

Loftus, William Kennett

1857 *Travels and Researches in Chaldaea and Susiana; With an Account of Excavations at Warka, the "Erech" of Nimrod, and Shush, "Shushan the Palace" of Esther, in 1849–1852.* London.

Luschey, Heinz

1983 "Die Darius-Statuen aus Susa und ihre Rekonstruktion." *AMI,* suppl. 10, pp. 191–206.

McKeon, John

1970 "An Akkadian Victory Stele." *Boston Museum Bulletin* 68, pp. 226–43.

Mallowan, Max E. L.

1936 "The Bronze Head of the Akkadian Period from Nineveh." *Iraq* 3, pp. 104–10.

1947 "Excavations at Brak and Chagar Bazar." *Iraq* 9, nos. 1–2.

Marcus, Michelle

1991 "The Mosaic Glass Vessels from Hasanlu, Iran: A Study in Large-Scale Stylistic Trait Distribution." *Art Bulletin* 73, pp. 536–60.

Margueron, Jean

1971 "Larsa: Rapport préliminaire sur la cinquième campagne." *Syria* 48, pp. 271–87.

Maxwell-Hyslop, Rachel

1971 *Western Asiatic Jewellery, c. 3000–612 B.C.* London.

Mazzoni, Stefania

1975 "Tell Mardikh e una classe glittica siro-anatolica del periodo di Larsa." *Annali dell'Istituto Orientale di Napoli* 35 (n.s. 25), no. 1, pp. 21–43.

Mecquenem, Roland de

1905a "Offrandes de fondation du Temple de Chouchinak." *MDP* 7, pp. 61–130.

1905b "Trouvaille de la statuette d'or." *MDP* 7, pp. 131–36.

1911a "Constructions élamites du tell de l'Acropole de Suse." *MDP* 12, pp. 65–78.

1911b "Vestiges de constructions élamites." *Recueil de travaux relatifs à la philologie et à l'archéologie égyptiennes et assyriennes* 33, pp. 38–55.

1920ff. "Rapport sur la campagne de fouilles de la Mission de Susiane." Manuscript. Archives of the Département des Antiquités Orientales, Musée du Louvre.

1922 "Fouilles de Suse: Campagnes des années 1914, 1921, 1922." *RA* 19, pp. 109–40.

1922ff. "Journal." Manuscript. Archives of the Département des Antiquités Orientales, Musée du Louvre.

1924 "Fouilles de Suse." *RA* 21, pp. 105–18.

1925 "Inventaire de cachets et de cylindres (Suse, 1923–1924)." *RA* 22, pp. 1–15.

1927 "Inventaire de cachets et cylindres (Suse, 1925–1926)." *RA* 24, pp. 7–21.

1928a "Choix d'intailles susiennes." *RA* 25, pp. 169–77.

1928b "Notes sur la céramique peinte archaïque en Perse." *MDP* 20, pp. 99–132.

1934 "Fouilles de Suse, 1929–1933." *MDP* 25, pp. 177–237.

1938a "The Achaemenid and Later Remains at Susa." In Pope, 1938, vol. 1, pp. 321–29.

1938b "Le marre de Nabu." *RA* 35, pp. 129–31.

1938c "Suse." *L'anthropologie* 48, pp. 65–70.

1943 "Fouilles de Suse, 1933–1939: Archéologique susienne." *MDP* 29, pp. 3–161.

1943–44 "Notes sur les modalités funéraires susiennes et leur chronologie." *Vivre et penser* 52, pp. 133–47 (*Revue biblique,* ser. 3).

1947 "Contribution à l'étude du palais achéménide de Suse." *MDP* 30, pp. 1–119.

1949 "Épigraphie proto-élamite." *MDP* 31, pp. 5–150.

1980 "Les fouilleurs de Suse." *IA* 15, pp. 1–48.

Mecquenem, Roland de, and J. Michalon

1953 *Recherches à Tchogha-Zembil. MDP* 33.

Mecquenem, Roland de, and Maurice Pézard

1911 "Compte-rendu sommaire des fouilles de Suse de l'hiver 1910–1911." *Bulletin de la Délégation en Perse* 2, pp. 51–58.

Mellink, Machteld J.

1964 (Ed.) *Dark Ages and Nomads, c. 1000 B.C.: Studies in Iranian and Anatolian Archaeology.* Istanbul.

1971 "Excavations at Karataş-Semayük and Elmalı, Lycia, 1970." *American Journal of Archaeology* 75, pp. 245–55.

Meriggi, Piero

1971 *La scrittura proto-elamica.* Part 1a, *La scrittura e il contenuto di testi.* Rome.

1974 *La scrittura proto-elamica.* Part 3a, *Testi.* Rome.

Metzger, Martin

1985 *Königsthron und Gottesthron.* Neukirchen-Vluyn.

Miroschedji, Pierre de

1980 "Le dieu élamite Napirisha." *RA* 74, pp. 129–43.

1981a "Le dieu élamite au serpent et aux eaux jaillissantes." *IA* 16, pp. 1–25.

1981b "Fouilles du chantier Ville Royale II à Suse (1975–1977): Les niveaux élamites." *DAFI* 12, pp. 9–136.

1982 "Notes sur la glyptique de la fin de l'Élam." *RA* 76, pp. 51–63.

1985 "La fin du royaume d'Anšan et de Suse et la naissance de l'Empire perse." *ZA* 75, pp. 265–306.

1990 "La fin d'Élam: Essai d'analyse et d'interprétation." *IA* 25, pp. 47–95.

Mitchell, T. C.

1973 "The Bronze Lion Weight from Abydos." *Iran* 11, pp. 173–75.

1986 "Indus and Gulf Type Seals from Ur." In *BTA*, pp. 278–85.

Moorey, Peter Roger Stuart

1971 *Catalogue of the Ancient Persian Bronzes in the Ashmolean Museum.* Oxford.

1978 "The Iconography of an Achaemenid Stamp-Seal Acquired in the Lebanon." *Iran* 16, pp. 143–54.

1980 *Cemeteries of the First Millennium B.C. at Deve Hüyük, near Carchemish, Salvaged by T. E. Lawrence and C. L. Woolley in 1913.* BAR International Series 87. Oxford.

1985 *Materials and Manufacture in Ancient Mesopotamia: The Evidence of Archeology and Art: Metals and Metalwork, Glazed Materials and Glass.* BAR International Series 237. Oxford.

Moortgat, Anton

1940 *Vorderasiatische Rollsiegel: Ein Beitrag zur Geschichte der Steinschneidekunst.* Berlin.

1969 *The Art of Ancient Mesopotamia: The Classical Art of the Near East.* Translated by Judith Filson. New York.

Morgan, Jacques de

1898 *Comptes-rendus sommaires des travaux archéologiques exécutés du 3me novembre 1897 au 1er juin 1898.* Paris.

1900a "Constructions élamites." *MDP* 1, pp. 196–98.

1900b "Excavations in the Akropolis and Palaces of Susa." *Scientific American* 82 (March 17, 1900), pp. 169–70, and supplement 49 (no. 1263), pp. 20241–42.

1900c (Et al.) *Recherches archéologiques. MDP* 1.

1900d "Travaux au tell de la citadelle: Travaux souterrains; Travaux en tranchées." *MDP* 1, pp. 81–99.

1902a *La délégation en Perse du Ministère de l'Instruction Publique, 1897 à 1902.* Paris.

1902b "L'histoire de l'Élam d'après les matériaux fournis par les fouilles à Suse de 1897 à 1902." *RA* 40, pp. 149–71.

1905a "Découverte d'une sépulture achéménide à Suse." *MDP* 8, pp. 29–58.

1905b *Histoire et travaux de la Délégation en Perse, 1897–1905.* Paris.

1905c "Koudourrous." *MDP* 7, pp. 137–53.

1905d (Et al.) *Recherches archéologiques. MDP* 7.

1905e "Trouvaille de la colonne de briques." *MDP* 7, pp. 49–59.

1905f "Trouvaille du masque d'argent." *MDP* 7, pp. 43–48.

1907 "Les travaux de la Délégation Scientifique en Perse au cours de la campagne de 1906–1907." *CRAI*, pp. 397–413.

1908 "Les résultats des derniers travaux de la Délégation Scientifique en Perse au cours de la campagne de 1907–1908." *CRAI*, pp. 373–79.

1912 "Observations sur les couches profondes de l'Acropole à Suse." *MDP* 13, pp. 1–25.

Muscarella, Oscar White

1974a (Ed.) *Ancient Art: The Norbert Schimmel Collection.* Mainz.

1974b "Decorated Bronze Beakers from Iran." *American Journal of Archaeology* 78, no. 3, pp. 239–54.

1988 *Bronze and Iron: Ancient Near Eastern Artifacts in The Metropolitan Museum of Art.* New York.

Musée de l'Orangerie

1930 *Catalogue de l'exposition d'antiquités orientales: Fouilles de Tello, de Suse et de Syrie.* Paris.

Nashef, Khaled al

1986 "The Deities of Dilmun." In *BTA*, pp. 340–66.

Nassouhi, Essad

1924 "La stèle de Sargon l'ancien." *RA* 21, pp. 65–74.

Negahban, Ezat O.

1991 *Excavations at Haft Tepe, Iran.* University Museum Monograph 70, University of Pennsylvania. Philadelphia.

Nissen, Hans Jörg

1974 "Zur Frage der Arbeitsorganisation in Babylonien während der Späturuk-Zeit." *Acta Antiqua Academiae Scientiarum Hungaricae* 22, pp. 5–14.

1977 "Aspects of the Development of Early Cylinder Seals." In McGuire Gibson and Robert D. Biggs, eds., *Seals and Sealing in the Ancient Near East*, pp. 15–23. BM 6.

1986 "The Development of Writing and of Glyptic Art." In Uwe Finkbeiner and Wolfgang Röllig, eds., *Ǧamdat Naṣr: Period or Regional Style?*, pp. 316–31. (Suppl. to *Tübinger Atlas des Vorderen Orients*, ser. B., no. 62.) Wiesbaden.

1988 *The Early History of the Ancient Near East, 9000–2000 B.C.* Translated by Elizabeth Lutzeier, with Kenneth J. Northcott. Chicago.

Nunn, Astrid

1988 *Die Wandmalerei und der glasierte Wandschmuck im alten Orient.* Handbuch der Orientalistik, ser. 7, vol. 1, part 6. Leiden.

Oates, David

1967 "The Excavations at Tell Al Rimah, 1966." *Iraq* 29, pp. 70–96.

Oates, David, and Joan Oates

1991 "A Human-headed Bull Statue from Tell Brak." *Cambridge Archaeological Journal* 1, no. 1, pp. 131–35.

Oates, Joan

1977 (Et al.) "Seafaring Merchants of Ur?" *Antiquity* 51, no. 203, pp. 221–34.

1979 *Babylon.* London.

Opificius, Ruth

1961 *Das altbabylonische Terrakottarelief.* Berlin.

Oppenheim, Adolf Leo

1954 "The Seafaring Merchants of Ur." *JAOS* 74, pp. 6–17.

1956 *The Interpretation of Dreams in the Ancient Near East.* Transactions of the American Philosophical Society, n.s. 46, part 3. Philadelphia.

Oppenheim, Max von

1955 *Tell Halaf.* Vol. 3. Berlin.

Orthmann, Winfried

1975 *Der alte Orient.* Propyläen Kunstgeschichte. Vol. 14. Berlin.

Pallis, Svend Aage

1956 *The Antiquity of Iraq.* Copenhagen.

Parker, H. W., and A. G. C. Grandison

1977 *Snakes: A Natural History.* 2nd ed. rev. London.

Parpola, Simo, Asko Parpola, and Robert H. Brunswig, Jr.

1977 "The Meluhha Village: Evidence of Acculturation of Harappan Traders in Late Third Millennium Mesopotamia?" *JESHO* 20, pp. 129–65.

Parrot, André

1949 *Ziggurats et Tour de Babel.* Paris.

1957 *Le Musée du Louvre et la Bible.* Neuchâtel and Paris.

1959 *Mission archéologique de Mari.* Vol. 2, no. 3. *Le palais: Documents et monuments.* Paris.

1961 *Sumer.* Paris.

1967a *Mission archéologique de Mari.* Vol. 3. *Les temples d'Ishtarat et de Ninni-zaza.* Paris.

1967b "Acquisitions et inédits du Musée du Louvre: 21.—Tête royale achéménide?" *Syria* 44, nos. 3–4, pp. 247–51.

1981 *Sumer.* Rev. ed. Paris.

Perrot, Georges, and Charles Chipiez

1890 *Histoire de l'art dans l'antiquité.* Vol. 5. Paris.

Perrot, Jean

1981 "L'architecture militaire et palatiale des achéménides à Suse." In *150 Jahre Deutsches Archäologisches Institut, 1829–1979*, pp. 79–94. Mainz.

1989 (Et al.) "Suse: Dernières découvertes." *Dossiers histoire et archéologie* 138 (May), pp. 1–90.

Perrot, Jean, and Daniel Ladiray

1974 "La porte de Darius à Suse." *DAFI* 4, pp. 43–56.

Pézard, Maurice

1913 *Catalogue des antiquités de la Susiane*. Paris.

1916 "Reconstitution d'une stèle d'Untaš [NAP] GAL." *RA* 13, pp. 119–24.

Pézard, Maurice, and Edmond Pottier

1926 *Catalogue des antiquités de la Susiane (Mission J. de Morgan)*. 2d ed. Paris.

Pillet, Maurice L.

1914 *Le palais de Darius 1er à Suse, Ve siècle av. J.C.* Paris.

Pittman, Holly

1984 *Art of the Bronze Age: Southeastern Iran, Western Central Asia, and the Indus Valley*. New York.

Pope, Arthur Upham

1931 "Exposition internationale d'art persan à l'Académie Royale de Londres (I and II)." *Cahiers d'art* 6, pp. 26–34, 83–92.

1938 (Ed.) *A Survey of Persian Art: From Prehistoric Times to the Present*. 15 vols. Oxford.

Porada, Edith

1947 "Suggestions for the Classification of Neo-Babylonian Cylinder Seals." *Orientalia* 16, pp. 145–65.

1948 *Corpus of Ancient Near Eastern Seals in American Collections. Vol. 1, The Collection of the Pierpont Morgan Library*. Washington, D.C.

1956 Review of Henri Frankfort, *The Birth of Civilization in the Near East* and *The Art and Architecture of the Ancient Orient*. *Art Bulletin* 38, pp. 121–24.

1962 *Alt-Iran: Die Kunst in vorislamischer Zeit*. Baden-Baden.

1963 *Iran ancien*. Paris.

1964 "Nomads and Luristan Bronzes: Methods Proposed for a Classification of the Bronzes." In Mellink, 1964, pp. 9–31.

1965 *The Art of Ancient Iran: Pre-Islamic Cultures*. New York.

1970 *Tchoga Zanbil (Dur-Untash). Vol. 4, La glyptique. MDP* 42.

1971 "Remarks on Seals Found in the Gulf States." *Artibus Asiae* 33, pp. 331–37.

1975 "Iranische Kunst." In Orthmann, 1975, pp. 363–98.

1980 "The Iconography of Death in Mesopotamia in the Early Second Millennium B.C." In Bendt Alster, ed., *Death in Mesopotamia*, pp. 259–70. *Mesopotamia*, vol. 8. Copenhagen.

1982 "Remarks on the Tôd Treasure in Egypt." In M. A. Dandamayev et al., eds., *Societies and Languages of the Ancient Near East: Studies in Honour of I. M. Diakonoff*, pp. 285–303. Warminster.

1985 "Classic Achaemenian Architecture and Sculpture." In Ilya Gershevitch, ed., *The Cambridge History of Iran*, vol. 2, pp. 793–827. Cambridge.

1986 "Le cylindre élamite du British Museum no. 134766." In *MM-JS*, pp. 181–85.

1988 "Discussion of a Cylinder Seal, Probably from Southeast Iran." *IA* 23, pp. 139–43.

1990 "More Seals of the Time of the Sukkalmah." *RA* 84, pp. 171–82.

Porada, Edith, and Faraj Basmachi

1951 "Nergal in the Old Babylonian Period." *Sumer* 7, no. 1, pp. 66–68.

Pottier, Edmond

1912 "Étude historique et chronologique sur les vases peints de l'Acropole de Suse." *MDP* 13, pp. 27–103.

Pottier, Marie-Hélène

1984 *Matériel funéraire de la Bactriane Méridionale de l'âge du bronze*. Paris.

Potts, Daniel T.

1978 "Towards an Integrated History of Culture Change in the Arabian Gulf Area: Notes on Dilmun, Makkan and the Economy of Ancient Sumer." *Journal of Oman Studies* 4, pp. 29–51.

1983 (Ed.) *Dilmun: New Studies in the Archeology and Early History of Bahrain*. Berlin.

Powell, Marvin A.

1981 "Three Problems in the History of Cuneiform Writing: Origins, Direction of Script, Literacy." *Visible Language* 15, no. 4, pp. 419–40.

Rao, S. R.

1986 "Trade and Cultural Contacts Between Bahrain and India in the Third and Second Millennia B.C." In *BTA*, pp. 376–82.

Ratnagar, S.

1981 *Encounters: The Westerly Trade of the Harappan Civilization.* Delhi.

Reade, Julian E.

1986 "Commerce or Conquest: Variations in the Mesopotamia-Dilmun Relationship." In *BTA*, pp. 325–34.

Reiner, Erica

1970 "Appendice: Légendes des cylindres." In Porada, 1970, pp. 133–37.

Rimmer, Joan

1969 *Ancient Musical Instruments of Western Asia in the Department of Western Asiatic Antiquities, the British Museum.* London.

Roaf, Michael

1974 "The Subject Peoples on the Base of the Statue of Darius." *DAFI* 4, pp. 73–160.

1983 "Sculptures and Sculptors at Persepolis." *Iran* 21.

Roche, Claude

1986 "Les ziggurats de Tchogha Zanbil." In *MM-JS*, pp. 191–98.

1990 "Jean Perrot et l'Iran." In *MJP*, pp. ix–xiii.

Root, Margaret Cool

1979 *The King and Kingship in Achaemenid Art.* Acta Iranica 19, Ser. 3, Textes et mémoires 9. Leiden.

Rostovtzeff, Michael I.

1920 "La stèle d'Untaš-GAL." *RA* 17, pp. 113–16.

Royal Academy of Arts

1931 *Catalogue of the International Exhibition of Persian Art.* London.

Rutten, Marguerite

1935–36 (Ed.) *Encyclopédie photographique de l'art.* Vols. 1, 2. Paris.

1950 "Glyptique susienne: Empreintes et cylindres." *RA* 44, pp. 161–84.

1954 "Tablette no. 4." *MDP* 36, pp. 83–85.

Safar, Fuad, Mohammad Ali Mustafa, and Seton Lloyd

1981 *Eridu.* Baghdad.

Sarianidi, Victor I.

1983 "Anthropomorphic Divinities of Ancient Bactria." In Peter Snoy, ed., *Ethnologie und Geschichte: Festschrift für Karl Jettmar,* pp. 515–25. Wiesbaden.

Schacht, Robert

1987 "Early Historic Cultures." In Hole, 1987, pp. 171–203.

Schauensee, Maude de

1988 "Northwest Iran as a Bronzeworking Centre: The View from Hasanlu." In John Curtis, ed., *Bronzeworking Centres of Western Asia, ca. 1000–539 B.C.* London and New York.

Scheil, Vincent

1900 *Textes élamites-sémitiques, première série. MDP* 2.

1901 *Textes élamites-anzanites, première série. MDP* 3.

1902 *Textes élamites-sémitiques, deuxième série. MDP* 4.

1905 *Textes élamites-sémitiques, troisième série. MDP* 6.

1913 *Textes élamites-sémitiques, cinquième série. MDP* 14.

1916 "Textes funéraires." *RA* 13, pp. 165–74.

1917a "Déchiffrement d'un document anzanite relatif aux présages." *RA* 14, pp. 29–59.

1917b "Un fragment susien du livre *Enuma Anu (ilu) Ellil.*" *RA* 14, Notules, no. 27, pp. 139–42.

1929a "Documents et arguments," no. 1, "Inscription d'Adda-Bakšu." *RA* 26, pp. 1–7.

1929b *Inscriptions des achéménides à Suse. MDP* 21.

1931 "Dynasties élamites d'Awan et de Simaš." *RA* 28, pp. 1–8.

1932 *Actes juridiques susiens. MDP* 23.

1933 "Inscriptions de Darius." In *Actes juridiques susiens, MDP* 24, pp. 105–15.

1935 *Textes de comptabilité proto-élamites, troisième série. MDP* 26.

1939 "Textes historiques," nos. 2–4. In *Mélanges épigraphiques, MDP* 28, pp. 4–8.

Schlossman, Betty L.

1978–79 "Portraiture in Mesopotamia in the Late Third and Early Second Millennium B.C., I: The Late Third Millennium." *AfO* 26, pp. 56–77.

1981–82 "Portraiture in Mesopotamia in the Late Third and Early Second Millennium B.C., II: The Early Second Millennium." *AfO* 28, pp. 143–70.

Schmandt-Besserat, Denise

1978 *Ancient Persia: The Art of an Empire.* Exh. cat., University Art Museum, University of Texas, Austin.

1992 *Before Writing: From Counting to Cuneiform.* Austin.

Schmidt, Erich F.

1953 *Persepolis.* Vol. 1, *Structures, Reliefs, Inscriptions.* OIP 68.

1957 *Persepolis.* Vol. 2, *Contents of the Treasury and Other Discoveries.* OIP 69.

Schmidt, Erich F., Maurits N. Van Loon, and Hans H. Curvers

1989 *The Holmes Expeditions to Luristan.* OIP 108.

Seidl, Ursula

1965 "Zur Umarbeitung zweier Stelenbekrönungen aus Susa und anderer altorientalischen Reliefs." *Berliner Jahrbuch für Vor- und Frühgeschichte* 5, pp. 175–86.

1968 "Die babylonischen Kudurru-Reliefs." *BaM* 4, pp. 7–220.

1976 "Ein Relief Dareios' I in Babylon." *AMI*, N.F. 9, pp. 125–30.

1986 *Iranische Denkmäler.* Berlin.

1989 *Die babylonischen Kudurru-Reliefs: Symbole mesopotamischer Gottheiten.* Orbis Biblicus et Orientalis 87. Göttingen.

1990 "Altelamische Siegel." In *MJP*, pp. 129–35.

Seux, M.-Joseph

1986 *Lois de l'ancien Orient.* Supplément au Cahier Évangile 56. Paris.

Smith, Sidney

1928 *Early History of Assyria.* London.

Sollberger, Edmond

1965 "A New Inscription of Šilhak-Inšušinak." *JCS* 19, pp. 31–32.

1968 "A Tankard for Atta-hušu." *JCS* 22, pp. 30–33.

Sollberger, Edmond, and Jean-Robert Kupper

1971 *Inscriptions royales sumériennes et akkadiennes.* Paris.

Solyman, Toufic

1968 *Die Entstehung und Entwicklung der Götterwaffen im alten Mesopotamien und ihre Bedeutung.* Beirut.

Spycket, Agnès

1960 "La déesse Lama." *RA* 54, pp. 73–84.

1968 "Une grande déesse élamite retrouve son visage." *Syria* 45, pp. 67–73.

1972 "La musique instrumentale mésopotamienne." *Journal des savants*, no. 3, pp. 153–209.

1981 *La statuaire du Proche-Orient ancien.* Leiden and Cologne.

1986 "Transposition du modelage au moulage à Suse à la fin du IIIe millénaire av. J.-C." In *MM-JS*, pp. 79–82.

1992 *Les figurines de Suse, I: Les figurines humaines. MDP* 52.

Stech, Tamara, and Vincent C. Piggot

1986 "The Metals Trade in Southwest Asia in the Third Millennium B.C." *Iraq* 48, pp. 39–64.

Steinkeller, Piotr

1988 "The Date of Gudea and His Dynasty." *JCS* 40, pp. 47–53.

Steve, Marie-Joseph

1962 "Textes élamites de Tchogha-Zanbil." *IA* 2, pp. 22–76.

1963 "Textes élamites de Tchogha-Zanbil." *IA* 3, pp. 102–23.

1968 "Fragmenta Elamica." *Orientalia*, n.s. 37, pp. 290–303.

1974 "Inscriptions des Achéménides à Suse (suite)." *Studia Iranica* 3, no. 2, pp. 135–69.

1987 *Nouveaux mélanges épigraphiques: Inscriptions royales de Suse et de la Susiane. MDP* 53.

1989 "Des sceaux-cylindres de Šimaški?" *RA* 83, pp. 13–26.

Steve, Marie-Joseph, and Herrmann Gasche

1971 *L'Acropole de Suse. MDP* 46.

1990 "Le tell de l'Apadana avant les Achéménides." In *MJP*, pp. 15–60.

Steve, Marie-Joseph, Herrmann Gasche, and Léon De Meyer

1980 "La Susiane au deuxième millénaire: À propos d'une interprétation des fouilles de Suse." *IA* 15, pp. 49–154.

Steve, Marie-Joseph, and François Vallat

1989 "La dynastie des Igihalkides: Nouvelles interprétations." In Léon De Meyer and Ernie Haerinck, eds., *Archaeologia Iranica et Orientalis: Miscellanea in honorem Louis Vanden Berghe*, vol. 1, pp. 223–38. Ghent.

Stolper, Matthew W.

1982 "On the Dynasty of Šimaški and the Early Sukkalmahs." *ZA* 72, pp. 42–67.

1984 "Political History." In Carter and Stolper, 1984, pp. 3–100.

1989 "Awan." *Encyclopaedia Iranica*, vol. 3, pp. 113–14.

Strommenger, Eva, and Max Hirmer

1964 *Cinq millénaires d'art mésopotamien.* Paris. Published in English as *5000 Years of the Art of Mesopotamia.* New York.

Stronach, David

1972 "Description and Comment," in "Une statue de Darius découverte à Suse." *JA* 260, pp. 241–46.

1978 *Pasargadae: A Report on the Excavations Conducted by the British Institute of Persian Studies from 1961 to 1963.* Oxford.

1985 "The Apadana: A Signature of the Line of Darius I." In Jean-Louis Huot, Marguerite Yon, and Yves Calvet, eds., *De l'Indus aux Balkans: Recueil à la mémoire de Jean Deshayes,* pp. 433–45. Paris.

Sumner, William

1974 "Excavations at Tall-i Malyān, 1971–72." *Iran* 12, pp. 155–80.

Tallon, Françoise

1987 *Métallurgie susienne 1: De la fondation de Suse au XVIIIᵉ siècle avant J.-C.* 2 vols. Paris.

Tallon, Françoise, Loïc Hurtel, and France Drilhon

1989 "Un aspect de la métallurgie du cuivre à Suse: La petite statuaire du IIᵉ millénaire avant J.C." *IA* 24, pp. 121–51.

Tanret, Michel

1986 "Fragments de tablettes pour des fragments d'histoire." In *MM-JS,* pp. 139–50.

Toscanne, P.

1911 "Études sur le serpent: Figure et symbole dans l'antiquité élamite." *MDP* 12, pp. 154–228.

1916 "Motifs nouveaux de décoration susienne." *RA* 13, pp. 69–89.

Tosi, M., and R. Biscione

1981 (Eds.) *Conchiglie, il commercio e la lavorazione delle conchiglie marine nel medio oriente dal IV al II millenio a. C.* Exh. cat., Palazzo Brancaccio. Rome.

Trokay, Madeleine

1981 "Glyptique cassite tardive ou postcassite?" *Akkadica* 21, pp. 14–47.

Unvala, Jamshedji Maneckji

1928 "Three Panels from Susa." *RA* 25, pp. 179–85.

Vallat, François

1974 "L'inscription trilingue de Xerxès à la Porte de Darius." *DAFI* 4, pp. 161–80.

1979 "Les inscriptions du palais d'Artaxerxès II." *DAFI* 10, pp. 145–49.

1980 *Suse et l'Élam.* Recherche sur les grandes civilisations, mémoire 1. Paris.

1981 "L'inscription de la stèle d'Untash-Napirisha." *IA* 16, pp. 27–33.

1983 "Le dieu Enzak: Une divinité dilmunite vénérée à Suse." In Potts, 1983, pp. 93–100.

1989a "L'expression ADDA LUGAL an-ša-an ù MÙS.ERENᵏⁱ dans un texte de Atta-hušu." *NABU,* no. 4, notes brèves no. 101, pp. 75–76.

1989b "Une histoire cinq fois millénaire." In *Suse: Dernières découvertes, Dossiers histoire et archéologie* 138, pp. 16–17.

1989c "L'inscription du sceau-cylindre du sukkalmah Tan-Uli." *NABU,* no. 4, notes brèves no. 117, p. 92.

1989d "Le scribe Ibni-Adad et les premiers sukkalmah," *NABU,* no. 2, notes brèves no. 34, pp. 23–24.

1990 "Réflexions sur l'époque des sukkalmah." In *MJP,* pp. 119–27.

Vallat, François, and Françoise Grillot

1978 "Le verbe élamite 'pi(š)ši'." *DAFI* 8, pp. 81–84.

Van Buren, Elizabeth Douglas

1935–36 Review of Andrae, 1935. *AfO* 10, pp. 287–93.

1939 *The Fauna of Ancient Mesopotamia as Represented in Art.* Rome.

1945 *Symbols of the Gods in Mesopotamian Art.* Rome.

1946 "The Dragon in Ancient Mesopotamia." *Orientalia* 15, pp. 1–45.

1954 "The Esoteric Significance of Kassite Glyptic Art." *Orientalia* 23, pp. 1–39.

Vanden Berghe, Louis

1959 *Archéologie de l'Iran ancien.* Leiden.

1973a "Le Luristan à l'âge du fer, la nécropole de Kutal-i Gulgul." *Archéologia* 65, pp. 16–29.

1973b "Recherches archéologiques dans le Luristan. Sixième campagne, 1970: Fouilles à Bard-i Bal et à Pa-yi Kal; prospections dans le district d'Aivan (rapport préliminaire)." *IA* 10, pp. 1–79.

1983 *Reliefs rupestres de l'Iran ancien.* Exh. cat., Musées Royaux d'Art et d'Histoire. Brussels.

Vandier d'Abbadie, J.

1964 "Les singes familiers dans l'ancienne Égypte, peintures et bas-reliefs, I: L'ancien empire." *Rd'E* 16, pp. 147–77.

Vincent, L.-H.

1948 "La notion biblique de haut-lieu." *Revue biblique* 55, pp. 245–78.

Walker, Christopher B. F., and Dominique Collon

1980 "Hormuzd Rassam's Excavations for the British Museum at Sippar in 1881–1882." In Léon De Meyer, ed., *Tell ed-Der*, vol. 3, pp. 93–112. Louvain.

Walser, Gerold

1966 *Die Völkerschaften auf den Reliefs von Persepolis: Historische Studien über den sogenannten Tributzug an der Apadanatreppe.* Berlin.

1980 *Persepolis: Die Königspfalz des Darius.* Tübingen.

Weisberg, David B.

1984 "The Length of the Reign of Ḫallušu-Inšušinak." *JAOS* 104, no. 1, pp. 213–17.

Weisgerber, Gerd

1984 "Makan and Meluhha—Third Millennium B.C. Copper Production in Oman and the Evidence of Contact with the Indus Valley." In Bridget Allchin, ed., *South Asian Archaeology 1981*, pp. 196–201. Cambridge.

Wickede, Alwo von

1990 *Prähistorische Stempelglyptik in Vorderasien.* Munich.

Wiggermann, Franz

1985–86 "The Staff of Ninšubura: Studies in Babylonian Demonology, II." *Jaarbericht Ex Oriente Lux* 29, pp. 3–34.

1989 "Tišpak, His Seal, and the Dragon Mušhuššu." In O. M. C. Haex, H. H. Curvers, and P. M. M. G. Akkermans, eds., *To the Euphrates and Beyond: Archaeological Studies in Honour of Maurits N. Van Loon*, pp. 117–33. Rotterdam and Brookfield, Vt.

Wilcke, Claus

1987 "Die Inschriftenfunde der 7. und 8. Kampagnen (1983–1984)." In Barthel Hrouda, ed., *Isin-Išān Baḥrīyāt*, vol. 3, *Die Ergebnisse der Ausgrabungen, 1983–1984*, pp. 83–120. Munich.

Winter, Irene J.

1981 "Royal Rhetoric and the Development of Historical Narrative in Neo-Assyrian Reliefs." *Studies in Visual Communication* 7, no. 2, pp. 2–38.

1986 "The King and the Cup: Iconography of the Royal Presentation Scene on Ur III Seals." In Marilyn Kelly-Buccellati, ed., *Insight Through Images: Studies in Honor of Edith Porada*, pp. 253–68. BM 21.

1987 "The Legitimation of Authority Through Image and Legend: Seals Belonging to Officials in the Administrative Bureaucracy of the Ur III State." In McGuire Gibson and Robert D. Biggs, eds., *The Organization of Power: Aspects of Bureaucracy in the Ancient Near East*, pp. 69–93. Studies in Ancient Oriental Civilization 46. Chicago.

Wiseman, Donald J.

1960 "The Goddess Lama at Ur." *Iraq* 22, pp. 166–71.

Woolley, Sir C. Leonard

1934 *The Royal Cemetery: A Report on the Predynastic and Sargonid Graves Excavated Between 1926 and 1931.* Joint Expedition of the British Museum and of the Museum of the University of Pennsylvania to Mesopotamia: Ur Excavations, vol. 2. London.

1962 *The Neo-Babylonian and Persian Periods.* Joint Expedition of the British Museum and of the Museum of the University of Pennsylvania to Mesopotamia: Ur Excavations, vol. 9. London.

Wright, Henry T., and Gregory Johnson

1975 "Population Exchange and Early State Formation in Southwestern Iran." *American Anthropologist* 77, pp. 267–89.

Wright, Henry T., Naomi Miller, and Richard Redding

1980 "Time and Process in an Uruk Rural Center." In Marie-Thérèse Barrelet, ed., *L'archéologie de l'Iraq du début de l'époque néolithique à 333 avant notre ère; perspectives et limites de l'interprétation anthropologique des documents*, pp. 265–84. Colloques internationaux du Centre National de la Recherche Scientifique, no. 580. Paris.

INDEX

Catalogue entries appear in boldface. Page numbers in italics denote illustrations other than those of entries.